Ontologies of Rock Art

Ontologies of Rock Art is the first publication to explore a wide range of ontological approaches to rock art interpretation, constituting the basis for groundbreaking studies on Indigenous knowledges, relational metaphysics, and rock imageries.

The book contributes to the growing body of research on the ontology of images by focusing on five main topics: ontology as a theoretical framework; the development of new concepts and methods for an ontological approach to rock art; the examination of the relationships between ontology, images, and Indigenous knowledges; the development of relational models for the analysis of rock images; and the impact of ontological approaches on different rock art traditions across the world.

Generating new avenues of research in ontological theory, political ontology, and rock art research, this collection will be relevant to archaeologists, anthropologists, and philosophers. In the context of an increasing interest in Indigenous ontologies, the volume will also be of interest to scholars in Indigenous studies.

Oscar Moro Abadía works as associate professor at Memorial University of Newfoundland (Canada). He specialises in the study of the history and the epistemology of Pleistocene art.

Martin Porr is associate professor of archaeology and a member of the Centre for Rock Art Research + Management at the University of Western Australia.

Ontologies of Rock Art

Images, Relational Approaches, and Indigenous Knowledges

Edited by
Oscar Moro Abadía and
Martin Porr

Routledge
Taylor & Francis Group

LONDON AND NEW YORK

First published 2021
by Routledge
2 Park Square, Milton Park, Abingdon, Oxon OX14 4RN

and by Routledge
52 Vanderbilt Avenue, New York, NY 10017

Routledge is an imprint of the Taylor & Francis Group, an informa business

British Library Cataloguing-in-Publication Data
A catalogue record for this book is available from the British Library

Library of Congress Cataloging-in-Publication Data
Names: Moro Abadía, Óscar, editor. | Porr, Martin, editor.
Title: Ontologies of rock art : images, relational approaches and indigenous knowledges/[edited by] Oscar Moro Abadía and Martin Porr.
Description: Abingdon, Oxon ; New York : Routledge, 2020. | Includes bibliographical references and index.
Identifiers: LCCN 2020039814 (print) | LCCN 2020039815 (ebook) | ISBN 9780367337803 (hardback) | ISBN 9780429321863 (ebook)
Subjects: LCSH: Rock paintings. | Petroglyphs. | Ontology. | Art and philosophy.
Classification: LCC GN799.P4 O58 2020 (print) | LCC GN799.P4 (ebook) | DDC 759.01/13--dc23
LC record available at https://lccn.loc.gov/2020039814
LC ebook record available at https://lccn.loc.gov/2020039815

ISBN: 978-0-367-33780-3 (hbk)
ISBN: 978-0-429-32186-3 (ebk)

Typeset in Baskerville
by MPS Limited, Dehradun

Contents

Illustrations

Figures

Table

Contributors

Benjamin Alberti is a professor of anthropology at Framingham State University and lectures at the Universidad Nacional de Córdoba, Argentina. He has published widely on archaeological theory, sex/gender, masculinity, and anthropomorphism in South American archaeology and Bronze Age Crete. Currently, he is researching anthropomorphism and materiality in northwest Argentina and the archaic rock art of northern New Mexico.

Lee J. Arnold is an associate professor, a Quaternary scientist, and specialist in geochronology. His research focuses on reconstructing archaeological, palaeoecological, and palaeoenvironmental histories using luminescence dating techniques, with a particular emphasis on single-grain optically stimulated (OSL) dating applications and advancements. Lee obtained his DPhil in geography at the University of Oxford, UK in 2006 and has held research positions at the Universities of Adelaide and Wollongong, Australia, and the Spanish National Research Centre for Human Evolution (CENIEH), where he was the director of the National Luminescence Dating Facility between 2009 and 2014.

Jeremy Ash is an archaeologist at the Monash Indigenous Studies Centre at Monash University, Australia. His work focuses on the archaeology of the recent past, with a current research focus on archaeological and Indigenous story-telling, transformations in social landscapes, and the archaeology of missions. His projects involve close research collaborations with communities in Torres Strait, the Northern Territory, and Victoria (Australia).

Johan Berthet is a geomorphologist and director of Styx4D, a research company that specialises in the study of mountain landscapes. He studied alpine and fluvial environments at the EDYTEM Laboratories (Université Savoie Mont Blanc, France), from which he then focused on researching geomorphological dimensions of archaeological site formation processes around the world. He specialises in the deployment of high-resolution 3D digital mapping tools in difficult-to-access landscapes. He is an experienced and passionate speleologist and canyoneer.

Carolyn E. Boyd is the Shumla Endowed Research Professor in the Department of Anthropology at Texas State University, USA. She is the founder of Shumla Archaeological Research & Education Center (www.shumla.org), which was established to preserve the rock art of the Lower Pecos Canyonlands in southwest Texas and Coahuila, Mexico. Boyd is ex-officio head of research for Shumla and serves as vice president on the organization's board of directors. She is author of *Rock Art of the Lower Pecos and The White Shaman Mural: An Enduring Creation Narrative*, which received the 2017 Scholarly Book Award from the Society for American Archaeology.

John Bradley is an associate professor based at the Monash Indigenous Centre at Monash University, Australia. He has been undertaking research with Yanyuwa families for 40 years. He has acted as senior anthropologist on two historical land claims over Yanyuwa country, and worked on issues associated with language and cultural management with Yanyuwa elders and the Yanyuwa li-Anthawiriyarra Sea Ranger Unit. His research is directed towards issues associated with Indigenous ontologies, epistemologies, and axiologies, and their place in the academy. He is the author of Singing Saltwater Country, and has just completed a two-volume encyclopaedia of the Yanyuwa language.

Liam M. Brady is an associate professor and Australian Research Council Future Fellow at Flinders University, Australia. He has worked in the field of Indigenous archaeology for over 20 years. His research has focused on challenging Western-oriented approaches to interpreting and understanding the archaeological record, generating new insights into patterns of social interaction, and drawing attention to new ways of thinking about research practice with Indigenous people. He is the author of *Pictures, Patterns and Objects: Rock-art of the Torres Strait Islands, Northeastern Australia*, and co-editor of the award-winning *Rock Art in the Contemporary World: Navigating Symbolism, Meaning and Significance*.

Brendan Cassidy is a senior lecturer in computing at the University of Central Lancashire. His research interests lie in the area of Virtual and Augmented Reality (VR/AR) and is principle investigator for the EPSRC-funded WE ARe ABLE project which investigates the potential use of Augmented Reality devices and assistive technologies. Brendan also has an interest in the use of VR/AR to create Immersive learning experiences for pedagogical purposes and collaborating between diverse users to create effective learning experiences for their specific student cohorts.

Amy A. Chase is a PhD candidate at Memorial University of Newfoundland, Canada. Her research interests include European Paleolithic visual cultures, rock art, pigment, and the symbolic behavior and cognition of Neandertals. Her PhD project, supervised by Dr. Oscar Moro Abadía and Dr. Francesco d'Errico, focuses on the scientific analysis of pigments from the Mousterian and Aurignacian at El Castillo Cave (Cantabria, Spain).

John Creese is an assistant professor of anthropology at North Dakota State University, USA. His research interests include archaeological theory, landscape and settlement archaeology, personhood and the body, and community and Indigenous archaeologies. His current fieldwork focuses on collaborative Indigenous archaeology in the Western Great Lakes of North America. He has published on topics such as rock art and relational ontologies, emotion-work and material culture, and Iroquoian architecture and settlement organization.

Joe Crouch majored in geology (BSc) and Australian Indigenous archaeology (BA Hons) at Melbourne University, Australia. He has been involved in teaching Monash University archaeology field schools on Aboriginal Country across Victoria since 2006. His primary research interest is Torres Strait seascape settlement, being the focus of his ongoing PhD. He has worked as an archaeologist (research and consulting) in Australia (Victoria, Queensland) and Melanesia (Torres Strait, Papua New Guinea, Solomon Islands) for 17 years.

Bruno David is a professor in archaeology at the Monash Indigenous Studies Centre (Monash University, Australia), and a chief investigator in the Australian Research Council Centre of Excellence for Australian Biodiversity and Heritage. He works closely with Indigenous communities in Australia and Papua New Guinea, especially on how people create places and (hi)stories about Country (Aboriginal engagements in, and notions of, place). Since 2017, he has been working on archaeological projects in partnership with the GunaiKurnai Land and Waters Aboriginal Corporation (East Gippsland, southeastern Australia). His latest books are *The Oxford Handbook of the Archaeology and Anthropology of Rock Art* (2018) and *The Oxford Handbook of the Archaeology of Indigenous Australia and New Guinea* (2021), both co-edited with Ian J. McNiven.

Jean-Jacques Delannoy is a professor and geomorphologist based at the Université Savoie Mont Blanc, France, and senior member of the Institut Universitaire de France. He was founding director of the EDYTEM laboratories, a Centre of Excellence that specialises in landscape archaeology and environmental sciences. He is president of the Lascaux International Committee and a senior member of the Chauvet Cave Scientific Research Team. He is a key contributor to the conceptualization and realization of the Chauvet Cave Replica Centre. His recent books include the *Atlas de la Grotte Chauvet-Pont d'Arc* and the 978-page textbook *Géographie Physique: Aspects et Dynamique du Géosystème Terrestre*.

José M. de Prada-Samper is a folklorist. His main areas of interest are the Bleek and Lloyd Collection of |Xam ethnography and the living culture of contemporary Khoisan descendants in the Karoo and the Cederberg and Olifant River Valley areas. He is the author of, among others, the book *The Man Who Cursed the Wind* (2016), a collection of oral narratives from the Karoo, and co-author of *On the Trail of Qing and Orpen* (2016). He

lives in Barcelona and is a research associate in the Department of Archaeology at the University of Cape Town, South Africa.

Inés Domingo Sanz is an ICREA Research Professor at the University of Barcelona (Section of Prehistory and Archaeology), Spain, since 2010, and vice president of the World Archaeological Congress (2017–2023). She has extensively published in the field of rock art. Her current research projects seek to bridge the gap between scientific and heritage approaches to one of Europe's most extraordinary bodies of rock art: Levantine rock art (awarded UNESCO World Heritage Status in 1998). Her research has been awarded a prestigious 2018 European Research Council (ERC) Consolidator Grant.

Fredrik Fahlander is associate professor of archaeology in the Department of Archaeology and Classical History, Stockholm University, Sweden. His research focuses on relational ontologies, new materialism and posthumanism in general, and burial archaeology and Bronze Age rock art in particular. Fahlander is currently directing the research project "Digital images for research and the public," financed by The Swedish National Heritage Board. The project aims at combining two- and three-dimensional technologies to develop a documentation strategy for rock art research, heritage preservation, and for making the rock art publicly available.

Severin Fowles is associate professor of anthropology at Barnard College and Columbia University, USA. He is the author of *An Archaeology of Doings: Secularism and Study of Pueblo Religion* and the co-editor of *The Oxford Handbook of Southwest Archaeology*. His work examines the colonial and pre-colonial histories of image production, place-making, and political relations in northern New Mexico.

Joanna Fresløv was born in Hastings, UK, where she developed an early interest in history, archaeology, and flint knapping. She completed an honours degree in archaeology at La Trobe University, Australia. Since graduating, she has been involved in research in the Arawe Islands (Papua New Guinea) and southwest Tasmania (Australia). She currently works for an Aboriginal Traditional Owner group in rural southeast Australia, the GunaiKurnai, completing a PhD on the archaeology of Holocene landscapes of southwest Tasmania, and participating in research with the Monash Indigenous Studies Centre. Her interests are landscape archaeology and stone tools.

Richard Fullagar is Honorary Professorial Fellow at University of Wollongong, Australia, and adjunct associate professor in history and archaeology at Flinders University, Australia. His main area of expertise is use-wear and residue analysis. He has published extensively on the function of flaked and ground stone tools from many archaeological sites in Australia, Papua New Guinea, Asia, and the Pacific region.

Devlin Gandy is currently a PhD candidate in archaeology (archaeogenetics) at the University of Cambridge, UK. He also received his MPhil in archaeology

from the University of Cambridge and graduated from the University of California, Berkeley, with a BA in anthropology. As citizen of the Cherokee Nation of Oklahoma, his research and academic work explores the potential for archaeology as a decolonizing practice capable of empowering Indigenous self-determination and sovereignty.

Helen Green is the Kimberley Foundation Australia's recipient of the five-year Rock Art Dating Fellowship awarded by the Ian Potter Foundation. Her research uses a range of geochemical techniques to understand and date mineral accretions forming in association with Aboriginal rock art in northwest Australia's Kimberley region. These techniques include uranium-thorium dating, radiocarbon dating, and stable isotope analysis, alongside characterization techniques such as X-ray diffraction analysis, scanning electron microscopy, and electron microprobe analysis.

GunaiKurnai Land and Waters Aboriginal Corporation (GKLaWAC) is the Prescribed Body Corporate that represents the Traditional Owners of GunaiKurnai Country from the Brataualung, Brayakaulung, Brabralung, Krauatungalung, and Tatungalung family clans-Gippsland, southeast Australia. GKLaWAC Country spans from the coast to the mountains in the north, and includes ten parks and reserves co-managed with government agencies. It has a membership of more than 600 Traditional Custodians/ Owners, all of whom have proven ancestral links to one of 25 Apical Ancestors registered in the Native Title Consent Determination.

Jamie Hampson is a senior lecturer in the Humanities Department at the University of Exeter, UK. He has a PhD in archaeology from the University of Cambridge, and an undergraduate degree in history from Oxford. Prior to his arrival in Exeter, Jamie lectured at the University of Western Australia. He was also a PI and a Marie Curie Global Research Fellow at Stanford University and the University of York. Jamie works primarily on rock art, identity, and Indigenous heritage projects in southern Africa, Australia, and the USA. His most recent book is *Rock Art and Regional Identity: A Comparative Perspective.*

Graham Harman is a distinguished professor of philosophy at the Southern California Institute of Architecture in Los Angeles, USA. His most recent book is *Art and Objects* (2020). He is the editor of the journal *Open Philosophy*, editor of the *Speculative Realism* series, and co-editor of the *New Metaphysics* series. He currently resides in Long Beach, California.

Emmanuelle Honoré is a researcher specializing in prehistory, especially the social aspects of the transition from hunting and gathering to pastoralism in Northeast Africa. She has been involved in fieldwork in Egypt (Gilf-el-Kebir) and Sudan (Gezira), where she co-directs the Gezira Archaeological Project. She has held a number of post-doctoral position at the universities of Cambridge and Oxford and is currently a EU-funded Marie Skłodowska-

Curie grant-holder at the Centre d'Anthropologie Culturelle of the Université Libre de Bruxelles. She is co-editor in chief of the peer-reviewed journal *Afrique: Archéologie & Arts*.

Andrew Meirion Jones is presently a professor of archaeology at the University of Southampton, UK (from 2001–2021). From 2021 he will be professor of archaeology in the Department of Archaeology and Classics, Stockholm University, Sweden. His main research interest is the archaeology of art, particularly the later prehistoric art of Western Europe. More recently he has focused on the ontological character of past images. This research has produced *The Archaeology of Art: Materials, Practices, Affects* (co-written with Andrew Cochrane, Routledge, 2018) and *Images in the Making: Art, Process, Archaeology* (co-edited with Ing-Marie Back Danielsson, 2019). He is currently working on an edited volume entitled *Diffracting Digital Images. Art, Archaeology, and Cultural Heritage* (Routledge, forthcoming).

Amanda Kearney is a Matthew Flinders Professorial Fellow and anthropologist at Flinders University, Australia. Her research is informed by the disciplines of cultural geography and ethnic studies and addresses themes of Indigenous experience, cultural wounding and healing, land rights, and the prevailing impact of settler colonial violence on Indigenous lives, lands, and waters. This research has developed with the kind support of Yanyuwa families in the southwest Gulf of Carpentaria, Australia. Since 2008, Amanda has also undertaken ethnographic research with African descendant communities in Salvador, Bahia, and Brazil, examining affirmative action and black rights movements as pathways towards communal strength.

Matthew McDowell studies late quaternary (c. 130,000 years ago-present) fossils from across Australia, specializing in the palaeoecology of small mammal remains from ancient owl roost deposits. He is interested in how climate change, megafauna extinctions, the arrival of Aboriginal peoples and, later, of Europeans in Australia has shaped the biogeography of Australian mammals, and the implications for mammal conservation today. He has published some 40 scientific papers in high-impact journals including *Science and Nature Communications*, the most recent of which focus on how the mammal fauna of Tasmania and southeastern Australia changed over the past 20,000 years.

Laure Metz obtained her PhD at the Aix-Marseilles Université (France) in 2015, her thesis on the function of Neanderthal stone tools titled "Néandertal en armes?". A specialist in the functional analysis of stone artifacts, she has held research positions at Harvard University (2016–2019) and the University of Connecticut (2019–ongoing) in the USA. She is a member of the joint research centre UMR 6972 of the CNRS (France). She co-leads research projects on the organisation of human societies dating between 120,000 and 42,000 years ago at Mandrin Cave (Drôme) and the Grand Abri aux Puces (Vaucluse), both in France.

Jerome Mialanes is a research officer at the Monash Indigenous Studies Centre, Monash University, Australia. He specialises in Indigenous stone tool technologies of New Guinea and Australia. His major research interests include the archaeology of the southern coast of New Guinea, Arnhem Land, Victoria, and North Queensland (Australia).

Oscar Moro Abadía works as associate professor at Memorial University of Newfoundland, Canada. He specialises in the study of the history and the epistemology of Pleistocene art. His research on rock art has been published in *Cambridge Archaeological Journal, Journal of Archaeological Research, Journal of Archaeological Method and Theory, World Art, History of Human Sciences, Journal of Anthropological Research,* and *Journal of Social Archaeology*.

Russell Mullett is Kurnai, a descendent of the tribal people of Gippsland (southeastern Australia), whose Country covers over 23 million hectares of mountains, plains, and coastline. He has been involved for over 30 years in GunaiKurnai cultural heritage matters. Russell has held a number of roles, including appointment as Inspector under the Commonwealth Aboriginal and Torres Strait Islander Heritage Act of 1987, and an Inspector/Authorised Officer under the Victorian Aboriginal Heritage Act of 2006. These appointments extended over 19 years of service in the legal protection of Aboriginal cultural heritage. He has project-managed and been team leader in archaeological surveys, overseeing the recording and documentation of archaeological places to the required legislative standards, and managed ethnohistorical research projects, for which he acted as convenor/mediator for Elders Committees. He has been appointed to various Boards including the Aboriginal Co-operatives Museum of Victoria Aboriginal Cultural Heritage Advisory Committee, Victorian Coastal Council, Alpine Advisory Committee, and is currently on the Victorian Aboriginal Heritage Council Ancestral Remains Policy and Repatriation Committee.

John Parkington is Emeritus professor and senior research scholar in the Archaeology Department at the University of Cape Town, South Africa, where he has taught since 1966. His interests are in the landscape archaeology of hunting and gathering people in southern Africa.

Fiona Petchey is Associate Professor and Deputy Director at the Radiocarbon Dating Laboratory at the University of Waikato, New Zealand. She specialises in the pretreatment and AMS dating of archaeological materials. Her research has focused on potential anomalies caused by natural 14C variation and taphonomic changes. She has used this knowledge in combination with Bayesian statistical methodologies to solve chronological problems in archaeology.

Martin Porr is associate professor of archaeology and a member of the Centre for Rock Art Research + Management at the University of Western Australia. He has published widely on European Palaeolithic art and archaeology, the Aboriginal art and rock art of northwest Australia, the relevance of postcolonial approaches to archaeological practice, and critical and social

theoretical aspects of archaeological and rock art research. He has conducted fieldwork in Germany, Thailand, Australia, India, and the Philippines. Most recently, he published the co-edited volume *Interrogating Human Origins: Decolonisation and the Deep Human Past* (Routledge, 2020).

David Robinson is a reader in archaeology at the University of Central Lancashire, UK. He has excavated at World Heritage sites such as Stonehenge and Avebury as well as conducting fieldwork at rock art sites in Karnataka, India. His primary interest is in Native California, where he is the principle investigator for a series of projects on the Wind Wolves Preserve, working with, and continually learning from the Tejon Indian Tribe and other Native Californians. He applies theoretical, analytical, and immersive approaches to rock art and cache caves to understand the long-term history of these remarkable people.

Colin Rosemont is a writer, documentary, and ethnographic filmmaker. He completed his master's degree in environmental studies from the University of Oregon, USA. Through collaborative work with professional archaeologists, Tejon Tribal members, and land conservationists alike, his work looks at the possibility and extent of collaborative, co-constitutive knowledge production of the past in ongoing efforts to decolonise methodologies and re-inscribe social histories into the landscape.

Lynette Russell is an Australian Research Council Laureate Professor, and deputy director of the Australian Research Council Centre of Excellence in Australian Biodiversity and Heritage, at Monash University, Australia. She is an anthropological historian specializing in Australian Aboriginal societies. She is the author of many books, most recently the award-winning *Australia's First Naturalists: Indigenous Peoples' Contribution to Early Zoology*, a collaboration with the acclaimed zoologist Penny Olsen.

Bryn Tapper is a PhD candidate in the Department of Archaeology, Memorial University of Newfoundland, Canada. His current research examines the rock art of the Mi'kmaq, Wolastoqiyik, and Pestomuhkati First Nations of Atlantic Canada, with a particular focus on the ways in which petroglyphs document Indigenous lifeways and experiences before and following European colonization.

Chris Urwin conducts archaeological research in partnership with Indigenous communities in Australia and Papua New Guinea. He is a postdoctoral research fellow at Monash University and the Australian Research Council Centre of Excellence for Australian Biodiversity and Heritage. He has worked at the Melbourne Museum as curator of the First Peoples archaeology collection. He investigates contemporary Indigenous understandings of colonial-era collecting practices, and how people build and remember ancestral places.

Robert J. Wallis is a staff tutor in art history at the Open University, UK. He was professor of visual culture and associate dean in the School of Communications, Arts and Social Sciences at Richmond, the American International University in London, where he also led the Research Centre

for International Visual Arts and Cultures and was director of the MA in Art History and Visual Culture. He is interested in the archaeology and anthropology of art and religion, the representation of the past in the present, and the archaeology of falconry. He is a Fellow of the Society of Antiquaries of London, a Fellow of the Royal Anthropological Institute, and a Senior Fellow of the Higher Education Academy.

David S. Whitley digs holes in the ground for a living. He resides in a blue oak forest outside of Tehachapi, California. His latest book is *Cognitive Archaeology: Mind, Ethnography and the Past in South Africa and Beyond*, edited with J.H.N. Loubser and G. Whitelaw (Routledge, 2020).

Peter Whitridge is a professor in the Department of Archaeology at Memorial University of Newfoundland, Canada. His research has focused on the archaeological record of Inuit sociality and economy in Nunavut and Labrador, which are virtually devoid of rock art, but he is increasingly interested in the contemporary archaeological record closer to home which encompasses numerous spectacular graffiti sites.

Darryl Wilkinson is an assistant professor in the Religion Department at Dartmouth College, USA, whose research examines the religious traditions of the Indigenous peoples of the Americas. Drawing mainly on archaeological methods, his fieldwork is focused in two regions: the American Southwest and the Central Andes. His research in the Southwest is primarily concerned with the colonial period, and looks at how new kinds of sacred landscape emerged through the interaction between Roman Catholicism and Native ritual. Rock art that incorporates Christian iconography is one of the best means to explore such interactions, and for the past decade, Wilkinson has been engaged in a detailed study of Catholic rock art in the Rio Grande del Norte National Monument (New Mexico).

James Williamson is a PhD candidate in the Department of Archaeology at Memorial University of Newfoundland, Canada. His research interests include the uses of photogrammetry and 3D modelling in heritage studies, geospatial statistical approaches to archaeological data and the archaeology of Newfoundland. His PhD project, supervised by Professors Lisa Rankin and Peter Whitridge, is focused on the spatial analysis of Beothuk residential features in Central Newfoundland.

Vanessa N.L. Wong is a soil scientist and associate professor in the School of Earth, Atmosphere and Environment at Monash University, Australia. Her research focuses on human impacts on soil processes and applying soil science to understanding environmental change on natural and modified environments. She has published numerous peer-reviewed journal articles and is the current editor-in-chief for *Land Degradation and Development*.

Rachel Wood is a radiocarbon chemist and senior lecturer in archaeology at the Australian National University (ANU). Having completed her doctorate at

the University of Oxford on the chronology of the final Neanderthals in Spain, she moved to the ANU in 2011 as a radiocarbon chemist and subsequently obtained a post-doctoral fellowship to develop methods to better radiocarbon date tooth enamel.

Dagmara Zawadzka completed her PhD in art history at Université du Québec à Montréal, Canada. She holds an H.B.Sc. in anthropology from University of Toronto, and an MA in anthropology from Trent University. Dagmara studies Canadian Shield rock art and Indigenous arts. She has taught courses on Indigenous arts at Université du Québec à Montréal and University of Ottawa. She has published in the *Canadian Journal of Archaeology*, *Time and Mind: The Journal of Archaeology, Consciousness and Culture*, and *Ontario Archaeology*. She has also collaborated on the first-ever virtual exhibit of rock art in Canada (2019), "Images on stone": https://imagesdanslapierre.mcq. org/en/.

Foreword

What was an image, there and then?

Severin Fowles and Benjamin Alberti

The "Critic's Notebook" section of the *New York Times* recently included an essay comparing the contemporary street art of the Black Lives Matter movement in New York City to the cave art of Paleolithic France (Rodney 2020). "About 17,000 years ago, in the caves of Lascaux," the essay begins,

> ancestors drew on grotto walls, depicting equines, stags, bison, aurochs and felines. They wanted to convey to other humans a political reality crucial to their survival... [T]he caves in Southwestern France were not simply an exhibition space for local talent. They ... constituted a public square where a community shared critical knowledge.

Contemporary street art is "not very different," we are told. While their meanings have become more complex over the millennia, images are still being created to publicly convey important "symbols and signs." In making this comparison, the author offers not just a celebration of the latest wave of (extraordinary) anti-racist street art but also, it would seem, an attempt to naturalise and thereby legitimise it, to ground the art in an allegedly universal human experience that extends all the way back to the inaugural act of image production itself.

If some readers find such quick interpretive lurches across historical time and cultural space compelling, it is surely because they are moved by the basic affirmation of our shared humanity, or what in early anthropology used to be referred to as the "psychic unity of mankind." This was a key Boasian thesis, which from the beginning was carefully designed to advance an anti-racist politics by countering the invidious claim that different human groups have different—and differently valued—*natures*, rather than just different cultural expressions arising from a common biological wellspring. "One nature, multiple cultures" used to be the progressive slogan, in other words. And for most non-anthropologists, it still is.

In this sense, it is ironic that many contemporary anthropologists have come to argue that the *singularization of nature*—which, again, has long been celebrated as one of anthropology's most important gifts to anti-racist politics—is now an enemy to be struggled against. Eduardo Viveiros de Castro (2014) has been

an especially influential advocate of this shift, having apparently been convinced by his Indigenous Amazonian colleagues of the need to take seriously the idea that there is, perhaps, just one shared culture (or set of social relationships) differentially participated in by actors with a plurality of natures (or bodily positionalities). And some anthropologists have taken up this "one culture, multiple natures" claim as a new rallying cry for the discipline, at least insofar as they argue for a single politics of disciplinary decolonization (a single political culture) built around the ontological self-determination of a plurality of human worlds (multiple natures). Others, inspired by Bruno Latour (1993), target singularization itself as the problem, arguing that the only defensible anthropology is one that pursues multiple "naturecultures" without any preconditions or presumed commensurabilities whatsoever. Once considered a dangerous source of racism, then, radical alterity is increasingly lifted up on anthropological shoulders as a kind of sacred truth.

The politics of anthropology's ontological turn is confusing enough in the context of ethnographic studies of subaltern communities in the present. But it is that much more perplexing in the context of archaeological studies of the material remains of former communities who are no longer around to ontologically self-determine themselves. Of course, those former communities frequently have living descendants who care a great deal about what their ancestors left behind, and the rights of descendants not just to steward ancestral remains but also to control the discourse surrounding them is a major preoccupation of heritage studies. In practice, heritage and archaeology frequently occupy the same space, but they are not the same thing.[1] It matters how contemporary individuals and communities ground their identities in the past, how the remains of the past become targets of this identity work, and how conflicts surrounding archaeological remains become diagnostic of larger systems of epistemic authority and political struggle in the present. But for most archaeologists, the past also matters on its own terms—which is to say, in the terms of those who, once upon a time, directly helped make it what it was. Setting aside the more philosophical questions of if and to what degree we can ever actually know the past, such knowledge is at least an archaeological ambition, and its pursuit has been generative.

What is "the politics of ontology" (Holbraad and Pedersen 2014) in the study of the long-passed past, then? We would like to argue that it involves more than just heritage, important though this is. On one hand, the study of non-modern worlds, like that of non-Western worlds, is always simultaneously a study of the modern West, which gains a certain shape and value through contrasts with its others. When archaeologists portray the artists at Lascaux as having been "animists" or "shamans" or as embracing a "relational ontology," the usual implication is that modern Westerners no longer are. And whether one views that implicit comparison as part of a historical narrative of modernizing progress or tragic loss, a set of moral valuations has been erected, and there is a politics to that. On the other hand, to truly undertake an archaeology of "non-modern" rather than of "pre-modern" worlds—to systematically resist primitivism in one's study of the past—is to contribute to the exploration of human alternatives and

the possibility of being otherwise. That has a politics, too, insofar as it provincialises the modern Western world as one among many, inspiring us to imagine new sorts of futures that we might collectively pursue.

But let us consider these issues more specifically in relation to the theme of this volume: namely, the intersection of the ontological turn and rock art studies or, to put it another way, the ontology of images in the past. One way to sort through this theme is to clarify the core question that drives it. What, in short, is the distinctively ontological question posed within contemporary rock art studies?

Most who have considered this issue, including many authors in the present volume, are clear about what it is not. Asking "what an image means" is, as Andrew Jones (this volume; see also Porr, this volume) observes, part of a representationalist mode of inquiry that art historians sometimes discuss as the project of "iconography," that archaeologists recognise as having driven the "interpretive archaeology" of the 1980s, and that both have come to widely reject in recent decades. Of course, all images signify in one way or another (we would not perceive them as images if they did not), and some researchers have developed elaborate schemes to analyze the signifying process, Peircian semiotics being the most notoriously elaborate. Critics of representationalism, however, tend to reject the notion that images can be reduced to their meanings. Or they reject the assumption that images were necessarily produced to be vehicles of meaning at all. More fundamentally, there is now a widespread worry that the question of meaning tends to pull one's analysis out of the material world, away from the physicality of images and into a textualised realm that floats somewhere above the phenomena in question. Such critiques of representationalism can go too far. After all, images frequently *are* produced to convey specific meanings. Who, moreover, would even stop to consider an image if it was truly devoid of meaning? Minimally, we must acknowledge that every rock art image in this volume indexically signifies a past agency of some sort to us today and can reasonably be assumed to have done so in the past. But meaning is clearly not the question that concerns most archaeological participants in the ontological turn.

Inspired by the work of Alfred Gell (1998)—if not also by art historical writings on iconoclasm (e.g., Freedberg 1989; Latour and Weibel 2002) and anthropological writings on the circulation of non-Western art (e.g., Thomas 1991; Marcus and Myers 1995; Clifford 1988)—many archaeologists of the past two decades have turned to consider the question of the power and agency of images as a way out of the question of meaning. Inquiry into "what images do" often feels like an ontological intervention (see also Mitchell 2005, 33–34), particularly in comparison to a straw man version of representationalist analysis. At least, the question seems to take seriously the claims made in so many non-Western traditions that images do actually wield powers in the world, that they act as sovereign agents, that they have, as Frazer (1951) famously put it, a secret sympathy with that which they bear a likeness. Here is where we should be more specific about just what is meant by the "ontological turn," however. Gell's seminal work offered a new way of thinking about images as social phenomena indexically caught up in a "social-relational matrix" that also draws artists,

prototypes, and audiences or recipients of various sorts into its orbit. As such, his framework was a general one, as was his understanding of "art." In this sense, it is of a piece with other theoretical positions that are sometimes gathered together under the banner of the "new materialisms," which also seek to revise our ontological first principles so as to better analyze images as well as other things. And almost without exception, the power, agency, and lively vitality of things—that is, the question "What do things do?"—has emerged as central to these sorts of interventions.

But is the question of images' agency "ontological" simply because it deviates from a hardline representationalist position? Is the claim that images are material actants really any more ontological than the claim that images are vehicles of meaning? In his overview of the ontological turn in archaeology, Alberti (2016) draws a distinction between what he identifies as the "new archaeological metaphysics," which aims for better (i.e., realist) conceptualizations of the world, and a "critical ontological archaeology" that struggles not to eat up the varied ontological commitments of others or to mold them into a single metaphysics, but rather seeks to locate, hold onto, and, indeed, draw inspiration from the alterity of those commitments as part of the critical project of self-reassessment. Bearing this distinction in mind, let us more precisely consider what critical ontological archaeologists ask about rock art. If not the question of meaning or agency, then what?

Presumably, such archaeologists are obligated to place into question the very taken-for-granted categories that give their research an initial appearance of coherency. If a corpus of what we, as archaeologists, take to be self-evident rock art "images" has been assembled for contemplation, then this demands that we seriously consider whether "what an image was" might have been a good deal different for those in the past. Which is to say that critical ontological inquiry would look to operationalise the fundamental challenge of non-translatability that stands at the heart of the anthropological project. A category like "rock art" or "image" would be deployed "to probe the depths of its illegibility, inserting it into a non-Western setting precisely in order to document the extent and nature of its dissonance" Fowles (2013, xi), thereby learning something about the archaeological phenomenon of interest and, in a critical vein, about the contingent and limited scope of our own ontological commitments.

We hasten to add that any question worth referring to as ontological should be, as Moro Abadía and Porr put it in this volume's introduction, "slow and difficult." And when such questions are posed to ancient archaeological contexts that have only a very distant historical relationship to descendant communities, thoughtful speculation may be the most we can offer. After all, addressing the question "What is it?"—what is an image, what is a rock, what is an animal, what is a person, and so on—to a group of human interlocutors is one thing. In northern New Mexico where our own rock art research is based, for instance, Tiwa-speaking communities have indicated that their traditional word for "image" (*p'a qwi'ína*) is a composite of two other words, which broadly translate as "water" (*p'a*) and "line" (*qwi*) (Harrington 1907–1957), and this has helped us

think about Ancestral Pueblo images as something more like technological infrastructures or irrigation systems ("waterlines") insofar as they seem to have been designed to open up pathways along which life-bringing moisture could flow into Pueblo communities. But addressing the question "What *was* it?" to the images themselves—long after the world that produced them has passed and without directly descendant human interlocutors to guide us—that is another thing altogether. This is the situation we find ourselves in when we attempt to grapple with the pre-Pueblo images of our study area—the so-called Archaic rock art of New Mexico—which were produced for millennia by foragers who lived in worlds quite distinct from those recorded ethnographically (Alberti and Fowles 2018). "What was it?" becomes rhetorical when posed to Archaic images. For in truth, we are asking ourselves this question and responding with analyses of, say, the distribution of images in the landscape, their correlation with certain ecological features, their material composition, or the gestural manner in which they were produced. Such analyses may be sufficient to establish that the images in question were very different than our own modern, Western images; in the case of the Archaic rock art of northern New Mexico, for instance, we are especially struck by its systematic avoidance of bodily figuration, which suggests that Archaic images did not function iconically—at least in the iconic way that is so familiar to us today. Such observations might then lead us to propose a hesitant answer to the ontological question, but it will always be an answer that is only more or less plausible, more or less compelling.

There is a basic methodological difference between ethnography and archaeology in this regard. Ethnographers—as well as archaeologists working ethnographically with consultants—frequently bump into ontological statements that are simply true in the sense that they are truly stated (e.g., "what you refer to as 'pictures' or 'images,' we understand as waterlines"). Their task is then to explore *how* such statements are true and what the implications of these truths are.[2] Archaeologists grappling with the remains of the past in the absence of close historical descendants, in contrast, must slowly build toward ontological propositions that never really move beyond reasoned speculation. The ontological truths of others are a starting point for ethnographic inquiry, in other words, but they are aspirational endpoints for equivalent inquiries in archaeology.

This methodological distinction between ethnography and archaeology can become confused when archaeologists draw upon ethnographic data from historically unrelated groups in an effort to move analogically from the known to the unknown. Reading widely in global ethnography challenges us to confront the extraordinary plurality of human worlds, and this does important work when it prompts us to entertain a greater range of possibilities in our models of the past. But there is always the danger that comparative ethnography will lead to essentialised typologies that pre-populate the past with peoples "of" an ontology that had been defined elsewhere (cf. Descola 2013). When prehistoric Europeans start to look suspiciously like Amazonian perspectivists or Western Apache placemakers something has gone seriously wrong; we have reverted back to a Victorian-style anthropology. Taken to an extreme, we are left with an awkward,

binary opposition between the modern West and the rest, in which a Cartesian caricature of the former is opposed to the "relational" or "animic" ontology of a universalised non-Western and non-modern other. Rather than holding onto and being challenged by the alterity of others, ethnographic analogizing runs the risk of containing and limiting it. In the end, a critical ontological archaeology of rock art should lead us somewhere novel and unexpected. It should pursue difference in the past and offer glimpses of images that are unlike those known ethnographically, refashioning our operative analytical categories in the process.

One important way to facilitate this project, we suggest, is to abandon thinking of "ontology" as a noun altogether. We see four reasons for this move. First, if answering a restricted ontological question like "what was an image" is already very difficult using archaeological evidence, building a model to characterise an entire metaphysical system in the long-passed past—an ancient ontology—strikes us as downright impossible. Second, the notion that any human community was or is characterised by "an ontology" asserts a false coherence, as if one unifying system and one set of basic categories ever organised the experiences of all community members all of the time. Certainly, this is not the case in any community in the modern West. As Mitchell (2005, 6) observes, our own engagements with images swing massively between hard-headed materialism (in which images are regarded as mere lifeless objects) and a kind of enchanted animism (in which images are readily acknowledged as having an immanent power and vitality). Not only do our understandings of our world vary between individuals in the modern West; they vary *within* individuals as well. We have a remarkable ability, it seems, to embrace a double (or triple) consciousness and not get overly bothered by this. Such messiness and internal contradiction lend human life richness and complexity, but ethnographers of non-Western and non-modern societies have repeatedly been seduced by what Augé (1995, 48) refers to as the "totality temptation": the normative illusion that every native action is always a coherent microcosm, saturated by the total cultural system. The totality temptation is little more than an analytical form of primitivism, however, and use of the noun-form of ontology—particularly the singular noun form—perpetuates this (see also Fowles 2010; Harris and Robb 2012).

Third, the noun-form of ontology, despite its ambitions, still turns out to be largely indistinguishable from "culture" as the latter term was deployed by the so-called interpretive or cognitive anthropologists of the second half of the twentieth century (on this debate, see Carrithers et al. 2010). It is one thing to replace an analysis of other peoples' beliefs with an analysis of the truths they assert about their world. But it is another thing altogether to actually jettison one's own bedrock commitments to naturalism in the process. A common discursive strategy is to keep the focus on the truths of others and simply not discuss one's own truths. But this just perpetuates the Western claim that its analysts uniquely stand in a transcendent position outside the world, a position of non-position from which detached and dispassionate observations allegedly become possible. It remains wedded to a scientific naturalism, in other words, that derives its authority from what Donna Haraway (1988) referred to as the

"god trick." And in this way, it cannot help but provincialise non-Western and non-modern ontologies, effectively rendering them as cultural belief systems comprised of truth-claims rather than truths (for various positions on this critique, see Alberti et al. 2011).

Fourth, when the noun-form of ontology effectively becomes another word for culture, it is susceptible to the same critiques—notably, that it approaches a group's lived experiences as a normative possession (see Appadurai 1996, 12). We have our ontology (our culture); you have yours; they have theirs. Not only does this rest upon the nature/culture divide that purportedly prompted the ontological turn in the first place; it is more specifically linked to notions of ownership that are themselves part of the specific historical experience of the modern West.

In place of ontology's noun form, then, we find it more useful to engage the adjectival form and inquire into the *ontological commitments* of the past and present. We take it as axiomatic that all human communities are committed to the world being a certain way. These commitments may involve responsibilities, struggles, or aspirations, and they become decidedly "political" when they chafe against competing ontological commitments of others. The early period of European colonialism in Africa and the Americas provides us with particularly clear examples of such ontological politics, for example in the competition between a Catholic missionary's commitment to a world in which there is one transcendent God who has revealed Himself in history and an Indigenous community's commitment to a world in which each locality has its sovereign beings and forces, which are revealed continuously in different places (see Wilkinson, this volume). But there is no shortage of contemporary conflicts, of course, and it is significant that a great many implicate images in direct ways. The Hopi community of Arizona, for instance, recently protested when a Paris auction house put a number of objects up for sale—objects that were considered mixed-media ethnographic masks by the French auctioneers but were understood by the Hopi to be inalienable "Katsina Friends" who serve as "messenger[s] to the spiritual domain for rain and life blessings" and therefore cannot be bought, sold, or put on public display (Honanie and Lomahquahu 2015; see also Shannon and Lamar 2013). This was not a struggle between "animic" and "materialistic" ontologies but rather a searing moment of conflict when one community's commitment to the commodity form of art objects crashed into another community's commitment to the inalienability and mutual obligations of a specific group of non-human relatives and allies. One could also describe it as a conflict between competing commitments to what an image is or has the potential to be.

Ontological commitments are always implicated when images are produced, circulated, viewed, analyzed, reproduced, ignored, defaced, or discarded. In the case of the images currently proliferating in urban spaces throughout the United States, the overt commitment expressed is to a world in which Black lives really do matter (Figure F.1), even as it is entirely clear that this commitment is tragically still not shared by everyone in American society. But other, less overt ontological commitments are simultaneously being expressed: to what a public is

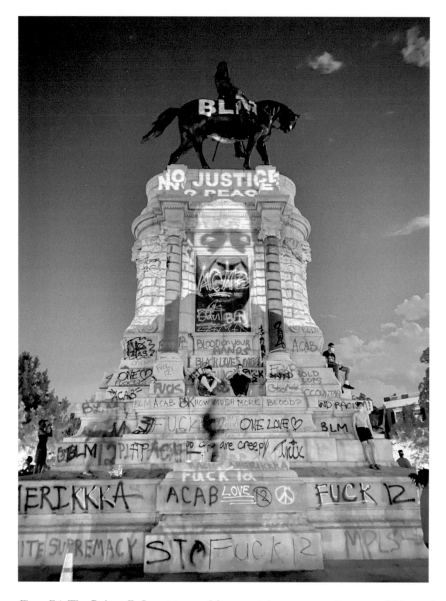

Figure F.1 The Robert E. Lee statue on Monument Avenue, near downtown Richmond, VA, transformed into a monument to George Floyd during the summer of 2020.
Source: Photograph by Joshua J. Jones.

or should be, to the power of transgression and civil disobedience, to the power of images to move an audience, to the power of attacking older images as a means of creating new ones, to artistic authorship, to representation, to the face as the seat of subjectivity, to the relationship between images and words, and so on.

Needless to say, those who are iconoclastically ripping down or painting over such images are expressing their own commitments: minimally, to private property but also, in their own way, to the power of images. And weaving through the tangle of these commitments, we suggest, is the thread that connects the Black Lives Matter movement to Lascaux Cave, which may not have been a "public square" but surely was a site where images nevertheless became caught up in complex, and perhaps competing, ontological commitments. It is to these commitments—commitments, in the end, to what an image was or could be—that an ontologically orientated archaeology of rock art might productively be directed.

Notes

1 For a sober recent assessment of the difference between archaeology and heritage in the context of research into Ancestral Pueblo remains, see Lekson (2019).
2 For an influential discussion of such ethnographic situations, see Henare et al. (2007). For an example of archaeologists working in an ethnographic mode and confronting comparable ontological claims, see Bradley et al. (this volume).

References cited

Alberti, Benjamin. 2016. "Archaeologies of ontologies." *Annual Review of Anthropology 45*: 163–179.

Alberti, Benjamin, and Severin Fowles. 2018. "Ecologies of rock and art in northern New Mexico." In *Multispecies Archaeology*, edited by S.E. Pilaar Birch, 133–153. London: Routledge.

Alberti, Benjamin, Severin Fowles, Martin Holbraad, Yvonne Marshall, and Christopher L. Witmore. 2011. "'Worlds otherwise': Archaeology, anthropology, and ontological difference." *Current Anthropology 52* (6): 896–911.

Appadurai, Arjun. 1996. *Modernity at Large: Cultural Dimensions of Globalization*. Minneapolis: University of Minnesota Press.

Augé, Marc. 1995. *Non-Places: Introduction to an Anthropology of Supermodernity*. Translated by John Howe. London and New York: Verso.

Carrithers, Michael, Matei Candea, Karen Sykes, Martin Holbraad, and Soumhya Venkatesan. 2010. "Ontology is just another word for culture: Motion tabled at the 2008 meeting of the group for debates in anthropological theory, University of Manchester." *Critique of Anthropology 30* (2): 152–200.

Clifford, James. 1988. *The Predicament of Culture: Twentieth-century Ethnography, Literature, and Art*. Cambridge: Harvard University Press.

Descola, Phillipe. 2013. *Beyond Nature and Culture*. Translated by Janet Lloyd. Chicago: The University of Chicago Press.

Fowles, Severin. 2010. *Analyst/Animist*. Paper delivered at the "Worlds Otherwise" session, Theoretical Archaeology Group Meetings, Brown University.

Fowles, Severin. 2013. *An Archaeology of Doings*. Santa Fe: School for Advanced Research Press.

Frazer, James. 1951. *The Golden Bough: A Study in Magic and Religion*. New York: The Macmillan Company.

Freedberg, David. 1989. *The Power of Images: Studies in the History and Theory of Response*. Chicago: The University of Chicago Press.

Gell, Alfred. 1998. *Art and Agency: An Anthropological Theory*. Oxford: Oxford University Press.

Haraway, Donna. 1988. "Situated knowledges: The science question in feminism and the privilege of partial perspectives." *Feminist Studies 14*: 575–599.

Harrington, John Peabody. 1907–1957. "Taos field notes." In *The Unpublished Papers of John Peabody Harrington*. Washington, DC: National Anthropological Archives, Department of Anthropology, National Museum of Natural History.

Harris, Oliver J.T., and John Robb. 2012. "Multiple ontologies and the problem of the body in history." *American Anthropologist 114* (4): 668–679

Henare, Amira, Martin Holbraad, and Sari Wastell (eds). 2007. *Thinking Through Things: Theorising Artefacts Ethnographically*. London: Routledge.

Holbraad, Martin, and Morten Axel Pedersen (eds). 2014. "The politics of ontology." *Fieldsights*, January 13. https://culanth.org/fieldsights/series/the-politics-of-ontology.

Honanie, Herman G., and Alfred Lomahquahu, Jr. 2015. "Hopi tribe demands return of sacred objects being sold illegally in Paris auction." *Media Fact Sheet*, May 20. Kykotsmovi: The Hopi Tribe. www.hopi-nsn.gov.

Latour, Bruno. 1993. *We Have Never Been Modern*. Translated by Catherine Porter. Cambridge: Harvard University Press.

Latour, Bruno, and Peter Weibel (eds). 2002. *Iconoclash: Beyond the Image-Wars in Science, Religion and Art*. Translated by Charlotte Bigg. Cambridge: MIT Press.

Lekson, Stephen. 2019. *A Study of Southwestern Archaeology*. Salt Lake City: University of Utah Press.

Marcus, George, and Fred Myers (eds). 1995. *The Traffic in Culture: Refiguring Art and Anthropology*. Oakland: University of California Press.

Mitchell, William John Thomas. 2005. *What Do Pictures Want?* Chicago: The University of Chicago Press.

Rodney, Seth. 2020. "Critics corner: New York's sidewalk Prophets are heirs of the artisans of France's Lascaux caves." *New York Times*, August 6. www.nytimes.com/2020/08/06/arts/design/street-art-nyc-george-floyd.html.

Shannon, Jennifer A., and Cynthia C. Lamar (eds). 2013. "Commentaries following The April 2013 Auction in Paris, France." *Museum Anthropology 36* (2): 101–112.

Thomas, Nicholas. 1991. *Entangled Objects: Exchange, Material Culture, and Colonialism in the Pacific*. Cambridge: Harvard University Press.

Viveiros de Castro, Eduardo. 2014. *Cannibal Metaphysics*. Translated and edited by Peter Skafish. Minneapolis: University of Minnesota Press.

Introduction

Ontology, rock art research, and the challenge of alterity

Oscar Moro Abadía and Martin Porr[1]

1 Introduction

Over the past ten years or so a growing number of contributions labeled as "ontological" have had an increasing impact on many areas in the social sciences. For instance, the concern with ontology has emerged as one of the most significant influences in social theory, philosophy, and the arts (e.g., Latour 2013; Benjamin 2015; Harman 2017). Similarly, while the ontological turn is not without critics (Todd 2016), ontological approaches have made important contributions to anthropological theory and practice (e.g., Descola 2013; Viveiros de Castro 2015a; Kohn 2015; Holbraad and Pedersen 2017; de la Cadena and Blaser 2018). In archaeology, the so-called "ontological turn" has also initiated new discussions on materialism, alterity, and realism (e.g., Alberti et al. 2011; Marshall and Alberti 2014; Jones 2017. In this discipline, the concern with ontology has generated many new avenues of research on landscapes (Creese 2011); personhood (Conneller 2004; Wilkinson 2013); the body (Harris and Robb 2012; Marshall and Alberti 2014); relational ontologies (Watts 2013; Porr 2018); humans, animals, and "other-than-human" beings (Weismantel 2015; Harrison-Buck and Hendon 2018); and the relationships of Indigenous and Western knowledges (David 2002; Alberti 2016).

As Benjamin Alberti has pointed out, in anthropology and archaeology, ontology is "often synonymous either with [a concern with] reality itself, 'what there is,' or peoples' claims about reality" (Alberti 2016, 164). While there are important differences between these two positions (in the first case, people live in and create different realities, in the second case, there is a reality that people experience or interpret differently), they both deal with alterity. In fact, if something can be said to unite ontological approaches, it is that "they promise new ways of engaging with alterity of various kinds" (Cipolla 2019, 613). This is evident, for instance, in the "ontological anthropological-inspired" approaches that are intended to "move from the epistemological critique of ethnographic *authority* to the ontological determination of ethnographic *alterity*" (Viveiros de Castro 2015b, 4). These authors seek to recognize how different ontologies and cosmologies are expressed in material culture. The search for difference is also central to the so-called "metaphysical approaches" inspired by the work of

Bruno Latour, Gilles Deleuze, and others. In this case, the quest is not only tied to the intention of understanding the "Other," but it expresses itself through the notion of "being-as-other" that seeks to "define how many *other forms of alterities* a being is capable of traversing in order to continue to exist" (Latour 2013, 13). An important element, in this context, is the recognition of the ontological basis of Western knowledge itself and the critique of its elevated position in accessing and representing reality. These are not trivial aspects and they can be regarded as key elements of the so-called "ontological turn." The recognition of ontological difference as the basis of alterity leads to the assertion that other ways of being and living need to be taken seriously. This orientation has not only epistemological and methodological implications but also ethical ones. It undermines the assumption of the dominant position of the scientifically trained observer and necessitates a greater degree of dialogue and collaboration.

The question of alterity is fundamental to understanding the current impact of ontological approaches in rock art research. In this field, the respective approaches are, in many ways, the culmination of a long (and incomplete) process of the recognition and acceptance of "difference" and "otherness" in rock images. In this introduction, we put this process into clearer perspective. In the first section, we analyze how, during the nineteenth and twentieth centuries, interest in the Other was framed from the position of an imbalanced power relationship founded on the belief in the biological and cultural inferiority of Indigenous peoples. The prevalence of the idea of 'primitive art' during the first half of the twentieth century illustrates this point. In the second section, we argue that, in more recent years, rock art researchers have promoted innovative ways of thinking about alterity. While this shift was influenced by a number of intellectual developments within the West such as poststructuralism, postmodernism, and the processes of decolonization, we suggest that the "ontological turn" must be seen as the most significant influence in this context. With reference to some of the chapters published in this collection, we examine the different ways in which ontology has promoted new views on alterity in rock art research. Finally, we conclude by exploring current and future trends of research into alterity in rock art studies. Some authors have suggested that, while ontological approaches have impacted theoretical frameworks and have made it more difficult to objectify other worldviews and ontologies, most research is still grounded in a restricted idea of otherness. In this setting we interrogate whether, in an environment dominated by the forces of neoliberalism, ontological approaches can still reach "the laudable aim of tak[ing] seriously radical difference and alterity" (Heywood 2012, 143).

2 Thinking about alterity in rock art studies: An historical overview

The history of rock art research can be interpreted as the slow and difficult recognition of alterity in rock art images. This statement does not imply that alterity has been fully recognized and accepted in rock art studies. In fact, many

researchers probably would question if this is even a desirable goal. Rather, it means that (a) Western scholars have historically been conscious of the fact that rock images were made in worlds different than their own, and (b) they have dealt with alterity in a variety of ways. Most importantly, over time, there has been a growing awareness of the importance of alterity as an independent factor that cannot be reduced to general or other causalities. In the early days of Palaeolithic art research, Western scholars realized that the meaning of cave paintings could not be interpreted with reference to modern con-temporary European art (Palacio-Pérez 2010, 2013; Moro Abadía and González Morales 2013). Instead, researchers looked at the arts of those Indigenous peoples who were supposed to be at a similar stage of cultural development within a universal unilineal cultural evolutionary framework (e.g., Lubbock 1865, 1870; Tylor 1865; Cartailhac and Breuil 1906). It is important to note that cultural evolutionism tended to soften difference or alterity by translating it into a "lower" evolutionary rung. In this setting, anthropologists, art historians, and archaeologists created the category of "primitive art" that, in some ways, was an inverted image of modern art. If the latter was defined by its creative imagination, nonutility and secular status as an object of disinterested contemplation (Shiner 2001; Moro Abadía 2006), "primitive art" was imagined in terms of its imitative nature, its religiosity, its utility, and its active ent-anglement in the mundane aspects of Indigenous societies (Price 1989; Shiner 1994; Errington 1998; Lowish 2015, 2018).

Early archaeologists and Palaeolithic art scholars, consequently, thought about alterity in terms of a number of monolithic categories. The concept of "primitive art" (a term that amalgamated Palaeolithic and Indigenous arts) contributed to the reduction of a great variety of images into one single category (see e.g., Porr 2019). In the case of European Palaeolithic art, the use of ethnographic parallels became widespread during the first half of the twentieth century. For instance, art historian Salomon Reinach argued that "our only hope of discovering *why* the troglodytes painted and carved, is to seek the information from the primitive peoples of to-day, whose conditions have been ethnologically ascertained" (Reinach 1912, 128). Reinach, who had read Spencer and Gillen's *The Native Tribes of Central Australia* (1899), suggested that prehistoric people in Europe had the same religion as the Arrernte people of Central Australia (for a review of the ways in which Australian Aboriginal arts were conceptualized during the first half of the twentieth century, please see Kuklick 2006 and Lowish 2015). Since, according to Spencer and Gillen, Arrernte paintings were part of a totemic cult seeking to multiply edible animals, Reinach concluded that Pleistocene cave art "was the expression of a religion, rude enough but intensely earnest—a religion built up of magic ceremonies and looking to a single end, the daily bread of its votaries" (Reinach 1912, 135–136). Ethnographic parallels of this kind were common in Palaeolithic art research until the second half of the twentieth cen-tury (as Ucko and Rosenfeld denounced in 1967). In the case of Indigenous arts, some scholars (typically anthropologists) elaborated a more complex view of "the Other." For instance, Franz Boas opened his seminal work *Primitive Art*

(1955, first published 1927) explaining that his ideas were grounded in two main axioms. First, the "fundamental sameness of mental processes in all races and in all cultural forms of the present day" (Boas 1955, 1). According to him, there was not such a thing as a 'primitive' way of thinking but "each individual in 'primitive' society is a man, a woman, a child of the same kind, of the same way of thinking, feeling and acting as man, woman or child in our own society" (Boas 1955, 2). Second, he asserted that

> each culture can be understood only as a historical growth determined by the social and geographical environment in which each people is placed and by the way in which it develops the cultural material that comes into its possession from the outside or through its creativeness.
>
> (Boas 1955, 4)

In terms of alterity, Boas was certainly aware of some of the problems associated with notions such as 'primitive art' and 'primitive culture.' For instance, he called into question the widespread idea that "primitive culture is almost stable and has remained what is for many centuries" (Boas 1955, 6). Instead, culture is "in constant flux, sometimes stable for a period, then undergoing rapid changes" (Boas 1955, 6). However, this type of anthropological understanding of Indigenous arts had little impact on rock art research until the late twentieth century.

During the 1960s and 1970s, structuralist and semiotic approaches became increasingly popular, especially in the study of European Palaeolithic art, which caused a widespread rejection of direct analogical comparisons and interpretations. For instance, in his seminal work *Préhistoire de l'art Occidental* (first published in 1965), Leroi-Gourhan argued that the previous generation of scholars "threw themselves enthusiastically into the construction of a prehistoric man made of pieces of Australians, Eskimos or Lapps" (Leroi-Gourhan 1971, 30). This construction was flawed because "there does not seem to exist a proper scientific way of making a demonstration [about the meaning of prehistoric art] using the comparative method" (Leroi-Gourhan 1971, 31). For this reason, Leroi-Gourhan proposed to abandon ethnographic comparisons and examine prehistoric art focusing exclusively on the information that Palaeolithic caves had to offer. Similarly, Laming-Emperaire called into question the ethnographical method to "transpose into the past what is accessible to us in the present" (Laming-Emperaire 1962, 136). She pointed out that analogies were established with reference to a number of "heterogenous societies whose only common point is their supposed 'primitiveness'" (Laming-Emperaire 1962, 138). However, these 'primitive' societies "can be very different from prehistoric groups and [...] they are often very different from each other" (Laming-Emperaire 1962, 138). Even if they never completely renounced to make use of ethnography to interpret the archaeological record, Leroi-Gourhan and Laming-Emperaire proposed a general structuralist and semiotic framework of interpretation that guided human artistic expressions in the past as well as the present. Overall, structuralism,

systems theory, and semiotics engendered new ways of thinking about difference in the 1960s. For instance, Lévi-Strauss suggested that history and ethnography

> are (concerned) with societies *other* than the one in which we live. Whether this *otherness* is due to remoteness in time (however slight), or to remoteness in space, or even to cultural heterogeneity, is of secondary importance compared to basic similarity of perspective.
>
> (Lévi-Strauss 1963, 14, his emphasis)

Anthropology's "main, if not sole, aim is to analyse and interpret differences" (Lévi-Strauss 1963, 14). More specifically, anthropologists deal "with systems of representations which differ for each member of the group and which, on the whole, differ from the representations of the investigator. The best ethnographic study will never make the reader a native" (Lévi-Strauss 1963, 16). These viewpoints fueled new approaches to Indigenous arts in the 1960s and 1970s. At that time, anthropologists began to examine non-Western arts as expressions of different cosmologies (e.g., Douglas 1970; Munn 1973) and systems of beliefs (e.g., Faris 1972; Seeger 1981). Even if in some parts of the world terms such as "primitive" and "tribal" art remained popular until the end of the twentieth century (e.g., Forge 1973; Rubin 1984; Schuster and Carpenter 1986–1988), it was increasingly recognized that Indigenous images had a range of meanings and uses that could be understood with reference to general structures and relationships as well as the contexts in which meanings were produced.

The last two decades of the twentieth century witnessed significant developments in the recognition of alterity. Within archaeology, these developments were spurred by at least two interrelated processes. First, under the influence of postprocessualism, academia witnessed the emergence of a much more critical understanding of the relationships between politics and science. Postprocessual archaeologists challenged the notion that "archaeology can be separated from current political events" (Shanks and Tilley 1987, 188). Instead, they suggested that archaeology operated "as part of a wider cultural discourse serving to reproduce the relationship between the dominant and the dominated" (Shanks and Tilley 1987, 189). While this issue was foremost framed in relation to class differences within Western societies, it was also applicable to the historical links between archaeology and colonialism on a global scale. Since the early 1980s, Bruce Trigger had argued that archaeologists had historically treated "native peoples in a detached and somewhat pejorative fashion" and they continued to treat them "as objects rather than as subjects of research" (Trigger 1980, 662). The circumstances surrounding the creation of the World Archaeological Congress in 1986 (when the British organizers banned South African and Namibian participants from the International Union of Prehistoric and Protohistoric Sciences Congress as a response to apartheid repression, see Golson 1988) illustrate the increasing political engagement of archaeologists during the 1980s. Second, in countries such as Australia, Canada, South Africa, and the United States, Indigenous communities had become more politically active in

the 1960s and the 1970s. Two decades later, their voices were increasingly heard in academic and public milieus. A number of media and social controversies illustrate this point. In Australia, the so-called "La Trobe affair" opposed arch-aeologists based at La Trobe University and the Tasmanian Aboriginal Land Council over the repatriation of archaeological materials in the 1990s (Allen and Golson 1995; Smith 2004). Another prominent example is presented by the disputes about the Lake Mungo remains (see overview in Griffiths 2018, 111–140). In the United States, Magistrate John Jelderks ruled that the so-called "Kennewick Man" could not be considered a Native American under the Native American Graves Protection and Repatriation Act (NAGPRA) in 2002 (Watkins 2004; Bruning 2006). This initiated a long legal battle that ended with the eventual repatriation and burial of the remains in 2017. In Canada, the Kwäday Dän Ts'ìnchi case, which started in 1999 when a group of hunters discovered mummified remains of a young individual in the traditional territory of the Champagne and Aishihik First Nations, marked the entrance of Aboriginal people in the archaeological arena (Beattie et al. 2000; Wylie 2014). In this case, scientists and provincial authorities worked together with Indigenous commu-nities for a genetic project to determine whether Kwäday Dän Ts'ìnchi had any descendants among living Indigenous groups. Overall, despite some occasional conflicts, collaboration between archaeologists and Indigenous communities has become the norm in countries such as Australia, Canada, the United States, and South Africa (Colwell 2016; Colwell-Chanthaphonh 2012). Moreover, in most of these places, it is now illegal to disturb Aboriginal sites without permits that usually require permissions from the relevant Traditional Owners.

These processes have fueled a number of critical reviews of the traditional conceptions of alterity in archaeology and rock art studies. For instance, notions such as "primitive" and "tribal" art have generally been rejected as outdated and inappropriate (Torgovnik 1990; Price 1989; Errington 1998). Similarly, other terms such as "prehistoric" and "Palaeolithic" art have been called into question (see, for instance, David and Denham 2006). Additionally, as Indigenous knowledges started to play a major role in archaeological debates, it became clear that even those scholars "who spurned the myth of the 'primitive' have employed a framework of objectification which allows the Other to speak only on our terms" (Shiner 1994, 233). With the dismantling of traditional conceptualizations and the emergence of Indigenous voices, new approaches to alterity have impacted rock art research during the last decade of the twentieth century. This resulted in the theoretical resurgence of ethnography during the 1990s. At that time, a number of authors reassessed ethnographic approaches to interpreting rock art images (Taçon and Chippindale 1998, 6). In a context of increasing collaboration with Aboriginal groups, archaeologists began to embr-ace the idea that "archaeological inquiry might be in any way influenced by, or held accountable to, Indigenous/Aboriginal understanding of their own history and cultural traditions" (Wylie 2014, 76). This explains, for instance, the pop-ularity of shamanism in rock art research. Initially developed by Lewis-Williams in South Africa (e.g., Lewis-Williams and Dowson 1990), this interpretive model

was soon evoked to explain rock images from Europe and North America (Clottes and Lewis-Williams 1998; Whitley 2000). In terms of the engagement with alterity, the case of shamanism is relevant because it forced rock art researchers to take Indigenous knowledges seriously (in some places, as David Whitley argues in his chapter, shamanistic theories somewhat foreshadowed ontological approaches). However, as other authors have pointed out (see Emmanuelle Honoré's chapter in this collection), 'shamanism' has also sometimes been used as an overarching category, with echoes of the universalism of evolutionism, that reduces the variety of traditions to a uniform explanatory model (Jones 2017).

The most relevant advances in the recognition of alterity during the 1990s were probably made in the field of landscape archaeology. The systematic study of the interrelationship between sites, artifacts, rock art, and landscapes had been an area of archaeological inquiry since the 1970s. However, in these early studies, landscapes were mainly understood as the physical and ecological environments in which human behavior takes place (David and Thomas 2008). It was only in the 1990s and under the influence of post-processualism that archaeologists moved toward a more socially-oriented conception. As David and Thomas (2008) pointed out, the most significant influence in this process was the increasing engagement of Indigenous peoples in archaeological research. This involvement promoted a widespread "realization that environmental notions of landscape archaeology did not by themselves accurately reflect Indigenous peoples' own notions of their landscapes or the reasons why they lived in certain ways" (David and Thomas 2008, 35). In this context, a number of archaeologists started to reframe the study of landscape through the lenses of Indigenous knowledges (Layton 2003; McGlade 2003; Hirsch 2006) and this orientation became particularly relevant in the field of rock art research. Based on studies in places such as Australia, North America and South Africa, researchers increasingly appreciated that rock images are an integral part of sacred landscapes and they needed to be understood with reference to the cosmologies and alterities of which they were a part (Smith 2003; Smith and Blundell 2004; Whitridge 2004; Norder 2012).

3 Alterity and the ontological turn

As previously outlined, scholars have engaged with issues related to alterity since the early days of rock art research. At one level, 'early anthropology' and 'prehistoric archaeology' were founded on the idea that the then-called 'savages' thought differently to Westerners. In this setting, during most parts of the twentieth century, archaeologists, anthropologists, and art historians tended to think about 'difference' with reference to uniform categories. Otherness was conceptualized in terms of the 'Primitive Other'; that is, a generalized universal 'Primitive' upon whom ideas about society, culture, and art could be projected. Similarly, the meaning of rock images was viewed in relation to broad totalizing categories such as 'totemism' or 'sympathetic magic,' which were often related to

universal schemes of historical progression. Moreover, it is also important to note that questions of alterity were often secondary compared to other issues in rock art research, such as chronology, style, and classification. Few approaches attempted to engage with the motivations and perspectives of past actors. However, with the turn of the twenty-first century, archaeologists began to think about alterity more explicitly and in new ways. This was partly a product of the impact of the postmodernist critique in academia and partly a result of processes of decolonization. First, postmodernism called into question Eurocentric thinking and was critical of traditional ways of conceptualizing 'otherness,' including the concept of 'primitive art.' Second, the emergence of community archaeology made it more difficult to objectify other alterities. While twentieth-century archaeologists had the tendency to understand difference in cultural, not ontological terms (González-Ruibal 2019, 38), in countries such as Australia, Canada, and the United States, it was the recognition that Indigenous peoples were "here and now" that pushed alterity toward the center of academic debates (Harris and Cipolla 2017).

If there is one theoretical development that has forced rock art scholars to think about alterity otherwise during the past decade, it is the 'ontological turn.' In archaeology and anthropology, the epistemological framework that dominated theoretical debates in the 1980s and the 1990s was pretty exhausted by the turn of the twenty-first century. In this historical context, archaeologists began to look at ontology as a way of reviving disciplinary debates. Benjamin Alberti (2016) has identified two sources of inspiration for ontological research in archaeology. First, philosophers such as Martin Heidegger, Hans Gadamer, Michel Serres, and Bruno Latour have inspired the so-called "metaphysical archaeologists" to call into question the modern Cartesian ontology and its constituting dichotomies (human/thing, human/animal, nature/society, present/past, science/religion, and so on). These authors have proposed a relational ontology according to which things are mainly constituted by their relationships. Second, anthropologists and social theorists such as Eduardo Viveiros de Castro, Philippe Descola, Martin Holbraad, and Tim Ingold have inspired "ontological anthropology-inspired approaches" that seek to "reconfigure archaeology theoretically and conceptually on the basis of Indigenous theory" (Alberti 2016, 164). These developments, together with the fact that scholars are often doing archaeology with Indigenous peoples, have provided the main impetus for explicit archeological research on alterity. Alterity is here "a function of our own conceptual inadequacy" (Holbraad 2012, 247), an "equivocation" reflecting our inability to "understand that understandings are necessarily not the same, and that they are not related to imaginary ways of "seeing the world" but to the real worlds that are being seen" (Viveiros de Castro 2004, 11). The main difference with traditional anthropological accounts is that these authors propose to conceptualize difference in ontological, not cultural, terms. In other words, while twentieth-century anthropologists assumed that there was one reality and multiple understandings of it, the starting point of ontological approaches is that "there are multiple realities or worlds, period" (Blaser 2014, 52).

Both strands have impacted research on rock art in different ways. For inst-ance, some of the aforementioned philosophers and anthropologists have directly inspired scholars in their explorations of the ontology of past images. In the collection of chapters in this volume, for example, Harman builds on Object-Oriented-Ontology to examine the aesthetic aspects of rock art, Jones and Porr draw on the work of several philosophers to call into question repre-sentationalism in rock art research, and Moro Abadía and Chase draw on Viveiros de Castro's notion of "controlled equivocation" to investigate Neanderthal cosmologies. More generally, rock art scholars have freely applied a number of ideas and concepts from the ontological literature to their materials and images. This has generated a great deal of studies that, for the sake of explanation, we can consider in terms of two different traditions of research. We suggest that, for a number of historical and political circumstances, ontological approaches have differently impacted research in (a) Europe and (b) those countries that constituted the settler-colonial world.

In Europe, since the 1970s, moves toward the semiotic structure of rock art constituted a kind of initial recognition of cosmological pluralities, and a way of getting to aspects of 'alterities' relating to Upper Palaeolithic artists (Conkey 1978). However, landscape theory provided the initial source of in-spiration for explicitly ontological approaches in most European counties. This is related to the fact that, in this part of the world, the ontological turn connected with a long-established tradition of research on the landscapes of rock art (especially in the UK and the Scandinavian countries). For instance, under the influence of phenomenology and other theoretical developments, scholars such as Richard Bradley (1997, 2001, 2006), Christopher Chippindale (Chippindale and Nash 2004), Felipe Criado (Criado and Villoch 2000), Knut Helskog (1999), George Nash (Nash and Chippindale 2002), and Kalle Sognnes (2001) have investigated how the location of rock images within particular landscapes re-flected specific cosmologies. No doubt, these works have opened new ways to conceptualize landscapes as places of alterity and cultural otherness. However, it has been argued that this tradition of research was still grounded in the "distinction between the natural landscape and the landscape as overlaid with cultural beliefs" (Jones 2017, 174). This binary contrast (between a *natural* and a *cultural* landscape) is, precisely, what recent ontological approaches attempt to overcome. Instead of assuming that there are *objective* landscapes that people experience differently, these approaches, that largely originated in Australia and North America (e.g., Smith and Blundell 2004; David and Denham 2006), suppose that different people live in different landscapes. In this setting, rock images appear to be a point of access for archaeologists and anthropologists to understand other alterities (e.g., Creese 2011, 2017; Porr 2018; Alberti and Fowles 2018; Zawadzka 2019). Moreover, in the past years, a number of scholars have been critical of the "anthropocentric view of landscape" promoted by early phenomenological approaches. They have argued that, in traditional research, "the physical and natural landscape is dependent on the anthropocentric human perception" (Norder 2012, 388). Instead, they conceptualize landscapes as active

or, to use a popular term, as "sentient" (Peterson 2011). This is, for instance, a conception shared by recent works on animism (e.g., Ingold 2006; Brown and Walker 2008; Sillar 2009; Porr and Bell 2012). These ideas are at the core of some of the chapters included in this collection. For instance, Jones examines how rock images from agrarian communities are dynamically related to different modes of landscapes and Fahlander analyzes the anthropomorphic figures from the Mälaren Bay as a means to understand the functions and purposes of Bronze Age rock art in Scandinavia.

If ontological approaches have promoted new avenues of research in Europe, it has been in those countries with a long colonial history that they have made a greater impact, especially in Australia, the United States, South Africa, and Canada. While archaeological research in each of these countries has followed different intellectual trajectories, the greater impact of the 'ontological turn' in these places is, broadly speaking, related to a number of factors. First, beyond some important differences, these nations share parallel colonial histories that have engendered similar outcomes. For instance, they are home to Indigenous communities that have long suffered the consequences of European colonialism (e.g., Armitage 1995; Knafla and Westra 2010; Nettelbeck et al. 2016) and academic scholars have been increasingly receptive toward the cultural and political demands of Aboriginal people (e.g., Nicholas and Andrews 1997; Watkins 2001; McNiven and Russell 2005). Second, in these places, there is a long tradition of rock art studies that goes back to the end of the nineteenth century and has been vibrant since the 1970s and 1980s (e.g., Molyneaux 1984; Vastokas 1990). Scholars from these countries have been exposed to cultural difference more than their European colleagues and, for this reason, they have been increasingly receptive toward Indigenous knowledges. Without denying the differences between countries such as Australia, United States, South Africa, and Canada, rock art studies in these places have followed broadly similar developments in the past 30 years. For instance, since the advent of community archaeology in the late 1990s, collaborative protocols with Aboriginal communities have gradually been instituted in these territories (Marshall 2002; Colwell-Chanthaphonh and Ferguson 2008; Wyley 2015). As a result of this process, archaeological research in these places is today undertaken in the context of binding agreements with Indigenous communities (Guilfoyle and Hogg 2015; McAnany and Rowe 2015). Additionally, there has been an increase of community-based cultural maintenance and revitalization projects, local heritage consultancies and collaborative management initiatives (Ross et al. 2011; King 2020). These institutional developments have had a number of theoretical, practical, and methodological consequences for archaeological and rock art research (Chapman and Wyley 2015). Around the turn of the twenty-first century, "epistemological alterity" was increasingly recognized and Indigenous accounts accepted as a legitimate source of knowledge. While this idea was present in a number of late twentieth-century works (see, for instance, Taçon and Chippindale's (1998, 6) vindication of "informed methods"), it has only become common ground in rock art studies during the last 20 years. It is now that we are

experiencing "the return of the grand ethnographic analogy to archaeology" (Alberti 2016, 164). In this collection, chapters by Brady et al.; David et al.; Domingo, Porr (Australia); Boyd, Hampson, Robinson, Wilkinson (United States); Tapper, Zawadzka, Creese (Canada); and Parkington (Africa) illustrate the theoretical resurgence of ethnography in rock art research. Ethnographical methods are being reformulated and adjusted in light of new requirements and insights (see Domingo's chapter in this collection). If, traditionally, ethnographic comparisons served to justify Western interpretations, today ethnographic information is often considered as a privileged source of information that can be used to question the elevated epistemological and ontological position of the Western observer and interpreter.

The recognition of the value of Indigenous knowledges has opened the door to new discussions about difference. In the fields of archaeology and anthropology, a number of authors have called for an acceptance of radical alterity (Salmond 2014; Viveiros de Castro 2015b; Holbraad and Pedersen 2017). These authors have argued that, while there has been an increasing interest in the 'Other' since the end the twentieth century, this interest has been framed within an epistemological paradigm grounded in the idea that Western science is superior to all others. Moreover, according to these authors, epistemology has served to justify the political hegemony of the Western upper-middle classes over other peoples. For this reason, supporters of radical alterity have argued that the recognition of Indigenous knowledges is intrinsically linked to the recognition of Indigenous political claims (Gnecco and Dorothy 2015). They suggest that we need to go one step further and move from "questions of knowledge and epistemology toward those of ontology" (Henare et al. 2006, 8). The question is not so much whether Indigenous people can contribute to interpretations of rock images, for even the more traditional scholars would admit this. The real concern is whether Western science is superior to other knowledges and, therefore, deserves a higher status. As we examine in the conclusion, radical approaches are still rare in rock art research. Archaeologists and anthropologists have tended to *integrate* Indigenous knowledge within their scientific traditions instead of *replacing* them for radical ontological programs.

The distinction between the different impacts of ontological approaches in Europe and in those countries with a long colonial history is, of course, a simplification. Rock art scholars from both areas often share approaches and interpretative frameworks. For instance, archaeologists from Europe, Australia, and North America have developed an interest in "relational ontologies" according to which "all things are constituted by their relations" (Alberti 2016, 166). As Craig Cipolla has recently pointed out, in archaeology "emphasis on relationality takes influence from structuralism" (Cipolla 2019, 616). This somewhat explains the impact of relational approaches in rock art research, a field in which Leroi-Gourhan and Laming-Emperaire played a leading role during the 1960s and 1970s (Moro Abadía and Palacio-Pérez 2015). As Lévi-Strauss explained, Leroi-Gourhan's "main goal was to study the relationships among things rather than things themselves" (Lévi-Strauss 1999, 203–204). Similarly, Laming-Emperaire

suggested that "animals and the relationships between them (or with humans) played the essential role [in palaeolithic art]" (Laming-Emperaire 1962, 294). The main difference between structural and ontological approaches is the fact that, while Leroi-Gourhan sought "to reduce the chaotic diversity of empirical facts to invariant relationships" (Lévi-Strauss, 1963, 203–204), contemporary ontological research seeks to situate the various meanings of the relationships between human and nonhuman agents in their ontological context. They are consequently much more open to the chaotic character and indeterminacy of the real world as well as situated material engagements and the active role of agency. More recently, the emphasis on relationality has been fueled by new approaches to things (e.g., Ingold 2007; Witmore 2007; Hodder 2012). From this viewpoint, the past is to be seen "as a network of relationships that continually reconstitute the past itself" (Shanks 2007, 593). In the case of rock art research, relational approaches reject the representationalism of traditional scholarship and promote new views on the relationships between images, natural features, and human and nonhuman agents. The works by Parkington and de Prada, Boyd, Zawadzka, Honoré, Fahlander, and Wallis, included in the section entitled "Humans, animals, and more-than-human beings," illustrate the variety of relational approaches in rock art research.

To conclude, it is important to note that ontological approaches are currently expanding to inspire new engagements with images, landscapes, and Indigenous ontologies. While early ontologically inspired approaches initially focused either on Holocene art (Europe) or Indigenous arts (Australia, South Africa, United States, Canada), in the past five years, a diversification beyond this initial core of interest has been observed. In this volume, Moro Abadía and Chase interrogate whether ontological theory can provide new insights in material culture from another hominin species (Neanderthals), Robinson et al. examine the emergence of virtual reality rock-art platforms as novel and new entities, and Whitridge and Williamson look at contemporary *graffiti* to reconstruct modern Western ontologies. This diversification is also reflected in the fact that ontological research is expanding from its original focus on 'pure' ontologies. For instance, there is the issue of whether specific communities have multiple ontologies that somehow (relationally) coexist (McNiven 2016, 34). Moreover, the question of syncretism is becoming more and more relevant in ontological research. For example, in the section entitled "Syncretism, contact, and contemporary rock art," Wilkinson studies New Mexico rock art that is Catholic *and* Indigenous, Tapper analyzes how a number of motifs reflect the impact of colonization and Catholicism on the Mi'kmaw cosmologies of Eastern Canada and Jamie Hampson examines how the ontologies and the rock images from the Trans-Pecos region of far-west Texas changed with the arrival of new people in the sixteenth century.

4 Conclusion

As we have examined in this introduction, recent discussions on ontology and alterity have been marked by the different ways in which archaeologists

conceptualize the relationships between Western and Indigenous knowledges. Broadly speaking, we can distinguish three main positions with blurred boundaries. First, some archaeologists have commented on the impossibility of incorporating Indigenous knowledges within Western science (e.g,. McGhee 2008; Holtorf 2009; Stump 2013). These scholars have argued that whereas cultural values are incommensurable (so "different cultures may be right"), the same cannot be said about scientific knowledge "because the history of science illustrates that later theories or technical solutions are more effective than earlier ones" (Stump 2013, 284). For this reason, these authors (typically associated with critical realism, Archer et al. 1998; Hartwig 2007; Sayer 2011) often consider that the ontological turn rests on an epistemic fallacy (Graeber 2015, 24). Second, some archaeologists have argued "for a complementary epistemology that equally integrates and recognizes the potentials and limitations of different approaches of analysis and understanding" (Porr and Bell 2012, 184). In the context of community archaeology, these scholars have suggested that Indigenous knowledges are, in fact, *knowledges* and, therefore, they must contribute to a better understanding of the past. There is much variation within this position, and while for some the role of archaeologists is to learn from Indigenous perspectives without calling into question the scientific project (the question is then what aspects of Western science are worth keeping and which ones need to be revised), for others Indigenous forms of knowledge enable viewpoints that science cannot (especially when examining Indigenous material culture). Moreover, these archaeologists seem to agree that the relationships between Western and Indigenous knowledges are a practical and political issue. For this and for ethical reasons, they advocate for intense collaboration between archaeologists and Aboriginal people. Again, positions vary between those who support different forms of collaboration under the control of Western institutions and those who advocate for a host-guest paradigm in which archaeologists are the guests of Indigenous communities who have "every right to control archaeological research" (McNiven and Russell 2005, 236). Other alterities are consequently recognized either as other valid approaches to reality or as realities themselves. Finally, there is a third position that seeks to dismantle the current epistemological framework of scientific research that promotes "epistemic injustice" (Kidd et al. 2017) and "epistemic violence" (Marker 2003) and calls for knowledge democratization. In this framework, "archaeologists become facilitators for studying, understanding, and interpreting the past in ways that people in the present find relevant, compelling, and most of all, useful" (Atalay et al. 2014, 17).

These positions continue to have different effects on rock art studies. In Europe, a significant number of scholars embrace the traditional view of archaeology and focus on conventional epistemological questions. In this continent, most rock art research, largely dominated by Palaeolithic art scholars, is conducted under the usual precepts of scientific research. While European scholars have largely contributed to ontological debates (especially in the field of Holocene arts), the question of alterity remains secondary. This is partly related to the Eurocentric

bias of Old World archaeology and partly to the fact that there are no contemporary Indigenous people in Western and Central Europe (see however the Sámi people living in Northern Europe) and, therefore, the perception of alterity is inevitably different. Inversely, it is not surprising that the issue of difference has become central to scholars working in places such as Australia, the United States, South Africa, and Canada. These countries all have a long history of colonialism that has resulted in comparable outcomes. Indigenous narratives about the origins and the meaning of rock 'art' have forced archaeologists to increasingly recognize the alterity that exists in these images.

This historical review of the ways in which researchers have thought about alterity in rock art studies shows that, in this discipline, difference has been generally understood in terms of what Craig Cipolla has called a "worldview-focused approach," i.e., as an exploration of other worldviews. Additionally, a number of rock art researchers have developed an increasing interest in relationality. While there is nothing wrong with this orientation (which, after all, is the logical outcome of the history of rock art research), as we advance in our exploration of difference, we need to get ready to face more and more complex challenges as well as situations in which our conceptions and ideas are increasingly being tested and called into question. We conclude now by briefly reviewing some of these challenges.

To begin, no matter how fascinating recent publications are, we are a bit too comfortable with our discussions on ontology as 'worldviews.' In this setting, we should try to think 'out of the box' and force ourselves to critically examine our own assumptions about 'otherness.' First, as we have reviewed in this introduction, we have conceptualized alterity and difference through the lenses of the divide between 'us' and the 'other.' In so doing, we have privileged 'ourselves' as 'norms' and 'everyone else' as something other than the accepted standard. This entails the serious risk of replicating some of the pitfalls of evolutionism. For this reason, we need to take a step further in our discussions on alterity and recognize that other people are 'themselves' and not simply 'others' (this is, after all, what Indigenous people have claimed over the past 30 years). Second, the journey toward the recognition of alterity is not just a one-way ticket to other worlds, but it involves a return to ourselves. In other words, explorations of alterity cannot simply consist in the edifying affirmation of human diversity, but they need to interrogate our 'otherness.' As Ghassan Hage has pointed out, "if the otherness of these cultures speaks to us, then there is [...] something about us that is already other" (Hage 2011, 8). This "otherness-within-us" (Hage 2012, 301) or "being-us-other" (Latour 2013, 162) allows us to think that "we can be radically other than what we are" (Hage 2011, 8). The awareness of our 'otherness' opens up the possibility to promote significant change, i.e., to challenge the historical dependencies of research (based on a Western ontology and knowledge production) and, more importantly, to rethink the ongoing imbalanced existing power relationship with other peoples. Finally, if we are going to explore different conceptions of alterity, we need also to consider alternative conceptions of ontology beyond our 'comfort zone.'

For instance, instead of focusing only on ontology as "worldview," we should also engage with those ontological approaches that relate to questions around the theory of being. From this viewpoint, the ontological turn "is not so much a matter of 'seeing differently' [...] it is above all a matter of seeing *different things*" (Holbraad and Pedersen 2017, 4). We are convinced that these propositions need to be explored further, especially in their connection with the political dimensions of alterity and ontology. We hope that the chapters included in this collection will contribute to substantive and productive discussions of these questions, which will be vital for the future of rock art studies and rock art itself.

Note

1 We would like to thank Mario Blaser, Craig N. Cipolla, Bruno David, Andrew M. Jones, and Ian McNiven for their comments on earlier drafts of this introduction. All errors remain our own.

References cited

Alberti, Benjamin. 2016. "Archaeologies of ontologies." *Annual Review of Anthropology* 45: 163–179.

Alberti, Benjamin, and Severin Fowles. 2018. "Ecologies of rock and art in Northern New Mexico." In *Multispecies Archaeology*, edited by Suzanne E. Pilaar Birch, 133–153. London: Routledge.

Alberti, Benjamin, Severin Fowles, Martin Holbraad, Yvonne Marshall, and Christopher L. Witmore. 2011. "'Worlds otherwise': Archaeology, anthropology, and ontological difference." *Current Anthropology 52* (6): 896–911.

Allen, Jim, and Jack Golson. 1995. "A short history of the Tasmanian affair." *Australian Archaeology 41* (1): 43–57.

Archer Margaret, Roy Bhaskar, Andrew Collier, Tony Lawson, and Alan Norrie (eds). 1998. *Critical Realism: Essential Readings*. New York: Routledge.

Armitage, Andrew. 1995. *Comparing the Policy of Aboriginal Assimilation: Australia, Canada and New Zealand*. Vancouver: UBC Press.

Atalay, Sonya, Lee R. Clauss, Randall H. McGuire, and John R. Welch (eds). 2014. *Transforming Archaeology: Activist Practices and Prospects*. Walnut Creek: Left Coast Press.

Beattie, Owen, Brian Apland, Erik W. Blake, James A. Cosgrove, Sarah Gaunt, Sheila Greer, Alexander P. Mackie, Kjerstin E. Mackie, Dan Straathof, Valerie Thorp, and P. Troffe. 2000. "The Kwäday Dän Ts'ìnchi discovery from a Glacier in British Columbia." *Canadian Journal of Archaeology 24*: 129–147.

Benjamin, Andrew E. 2015. *Towards a Relational Ontology. Philosophy's Other Possibility*. Albany: State University of New York Press.

Blaser, Mario. 2014. "Ontology and indigeneity: On the political ontology of heterogeneous assemblages." *Cultural Geographies 21* (1): 49–58.

Boas, Franz. 1955 [1927]. *Primitive Art*. New York: Dover.

Bradley, Richard. 1997. *Rock Art and the Prehistory of Atlantic Europe: Signing the Land*. London: Routledge.

Bradley, Richard. 2001. "The authority of abstraction: Knowledge and power in the landscape of prehistoric Europe." In *Art and Contestation: Theoretical Perspectives in Rock Art*

Research, edited by Knut Helskog, 227–241. Oslo: Novus Forlag, The Institute for Comparative Research in Human Culture.

Bradley, Richard. 2006. "Danish razors and Swedish rocks. Cosmology and the Bronze Age landscape." *Antiquity 80*: 372–389.

Brown, Linda A., and William H. Walker. 2008. "Prologue: Archaeology, animism and non-human agents." *Journal of Archaeological Method and Theory 15*: 297–299.

Bruning, Susan B. 2006. "Complex legal legacies: The Native American Graves Protection and Repatriation Act, scientific study and Kennewick Man." *American Antiquity 71* (3): 501–521.

Cartailhac, Émile, and Henri Breuil. 1906. *La caverne d'Altamira à Santillane près Santander (Espagne)*. Monaco: Imprimerie de Monaco.

Chapman, Robert, and Alison Wylie (eds). 2015. *Material Evidence. Learning from Archaeological Practice*. London: Routledge.

Chippindale, Christopher, and George Nash. 2004. *Pictures in Place. The Figured Landscapes of Rock Art*. Cambridge: Cambridge University Press.

Cipolla, Craig N. 2019. "Taming the ontological wolves: Learning from Iroquoian Effigy objects." *American Anthropologist 121* (3): 613–627.

Clottes, Jean, and David Lewis-Williams. 1998. *The Shamans of Prehistory: Trance and Magic in the Painted Caves*. New York: Harry Abrams.

Colwell, Chip. 2016. "Collaborative archaeologies and descendant communities." *Annual Review of Anthropology 45*: 113–127.

Colwell-Chanthaphonh, Chip. 2012. "Archaeology and indigenous collaboration." In *Archaeological Theory Today*, 2nd edn, edited by Ian Hodder, 267–291. Cambridge: Polity Press.

Colwell-Chanthaphonh, Chip, and Thomas J. Ferguson. 2008. *Collaboration in Archaeological Practice. Engaging Descendant Communities*. Lanham: AltaMira Press.

Conkey, Margaret W. 1978. "Style and information in cultural evolution: Towards a predictive model for the Paleolithic." In *Social Archaeology: Beyond Subsistence and Dating*, edited by Charles L. Redman, Mary J. Berman, Edward C. Curting, William T. Langhorne, Nina M. Versaggi, and Jeffery C. Wanser, 61–85. New York: Academic Press.

Conneller, Chantal. 2004. "Becoming deer. Corporal transformations at Star Carr." *Archaeological Dialogues 11* (1): 37–56.

Creese, John L. 2011. "Algonquian rock art and the landscape of power." *Journal of Social Archaeology 11* (1): 3–20.

Creese, John L. 2017. "Art as kinship: Signs of life in the Eastern Woodlands." *Cambridge Archaeological Journal 27* (4): 643–654.

Criado, Felipe, and Victoria Villoch. 2000. "Monumentalizing landscape: From present perception to the past meaning of Galician megalithism (north-west Iberian Peninsula)." *European Journal of Archaeology 3*: 188–216.

David, Bruno. 2002. *Landscapes, Rock-art, and the Dreaming: An Archaeology of Preunderstanding*. London: Leicester University Press.

David, Bruno, and Tim Denham. 2006. "Unpacking Australian prehistory." In *The Social Archaeology of Australian Indigenous Societies*, edited by Bruno David, Bryce Barker, and Ian J. McNiven, 52–71. Canberra: Aboriginal Studies Press.

David, Bruno, and Julian Thomas. 2008. "Landscape archaeology: Introduction." In *Handbook of Landscape Archaeology*, edited by Bruno David and J. Thomas, 27–43. Walnut Creek: Left Coast Press.

de la Cadena, Marisol, and Mario Blaser (eds). 2018. *A World of Many Worlds*. London: Duke University Press.

Descola, Philippe. 2013. *Beyond Nature and Culture*. Chicago: The University of Chicago Press.

Douglas, Mary. 1970. *Natural Symbols: Explorations in Cosmology*. New York: Vintage.

Errington, Shelly. 1998. *The Death of Authentic Primitive Art and Other Tales of Progress*. Berkeley and Los Angeles: University of California Press.

Faris, James C. 1972. *Nuba Personal Art*. Toronto: Toronto University Press.

Forge, Anthony (ed). 1973. *Primitive Art and Society*. London: Oxford University Press.

Gnecco, Cristobal, and Dorothy Lippert (eds). 2015. *Ethics and Archaeological Praxis*. New York: Springer.

Golson, Jack. 1988. "The World Archaeological Congress: A new archaeological organisation." *Australian Archaeology 26*: 92–103.

González-Ruibal, Alfredo. 2019. "Ethical issues in indigenous archaeology: Problems with difference and collaboration." *Canadian Journal of Bioethics 2* (3): 34–43.

Graeber, David. 2015. "Radical alterity is just another way of saying 'reality'." *Hau: Journal of Ethnographic Theory 5* (2): 1–41.

Griffiths, Billy. 2018. *Deep Time Dreaming. Uncovering Ancient Australia*. Carlton: Black Inc.

Guilfoyle, David R., and Erin A. Hogg. 2015. "Towards an evaluation-based framework of collaborative archaeology." *Advances in Archaeological Practice 3* (2): 107–123.

Hage, Ghassan. 2011. "Dwelling in the reality of utopian thought." *Traditional Dwelllings and Settlement Review 23* (1): 7–13.

Hage, Ghassan. 2012. "Critical anthropological thought and the radical political imagery today." *Critique of Anthropology 32* (3): 285–308.

Harman, Graham. 2017. *Object-Oriented Ontology: A New Theory of Everything*. London: Pelican.

Harris, Oliver J.T., and John Robb. 2012. "Multiple ontologies and the problem of the body in history." *American Anthropologist 114* (4): 668–679.

Harris, Oliver J.T., and Craig C. Cipolla, C. 2017. *Archaeological Theory in the New Millennium*. New York: Routledge.

Harrison-Buck, Eleanor, and Julia A. Hendon (eds). 2018. *Relational Identities and Other-than-Human Agency in Archaeology*. Boulder: University of Colorado Press.

Hartwig, M. (ed). 2007. *A Dictionary of Critical Realism*. London: Routledge.

Helskog, Knut. 1999. "The shore connection. Cognitive landscape and communication with rock carvings in northernmost Europe." *Norwegian Archaeological Review 32* (2): 73–94.

Henare, Amira, Martin Holbaard, and Sari Wastell. 2006. "Introduction: Thinking through things." In *Thinking Through Things: Theorizing Artefacts Ethnographically*, edited by Amira Henare, Martin Holbraad, and Sari Wastell, 1–31. London: Routledge.

Heywood, Paolo. 2012. "Anthropology and what there is: Reflections on 'ontology'." *The Cambridge Journal of Anthropology 30* (1): 143–151.

Hirsch, Eric. 2006. "Landscape, myth and time." *Journal of Material Culture, 11* (1–2): 151–165.

Hodder, Ian. 2012. *Entangled. An Archaeology of the Relationships between Humans and Things*. London: Wiley.

Holbraad, Martin. 2012. *Truth in Motion: The Recursive Anthropology of Cuban Divination*. Chicago: The University of Chicago Press.

Holbraad, Martin, and Morten Axel Pedersen. 2017. *The Ontological Turn. An Anthropological Exposition*. Cambridge: Cambridge University Press.

Holbraad, Martin, Morten Axel Pedersen, and Eduardo Viveiros de Castro. 2014. "The politics of ontology: Anthropological positions." *Cultural Anthropology*. www.culanth.org/fieldsights/462-the-politics-of-ontology-anthropologicalpositions.

Holtorf, Cornelius. 2009. "A European perspective on indigenous and immigrant archaeologies." *World Archaeology 41* (4): 672–681.

Ingold, Tim. 2006. "Rethinking the animate, re-animating thought." *Ethos 71* (1): 9–20.

Ingold, Tim. 2007. "Materials against materiality." *Archaeological Dialogues 14* (1): 1–16.

Jones, Andrew M. 2017. "Rock art and ontology." *Annual Review of Anthropology 46*: 167–181.

Kidd, James, José Medina, and Gaile Pohlhaus, Jr. (eds). 2017. *The Routledge Handbook of Epistemic Injustice*. London: Routledge.

King, Thomas F. 2020. *Cultural Resource Management. A Collaborative Primer for Archaeologists*. New York: Berghahn.

Knafla, Louis A., and Haijo Westra. 2010. *Aboriginal Title and Indigenous Peoples: Canada, Australia and New Zealand*. Vancouver: UBC Press.

Kohn, Eduardo. 2015. "Anthropology of ontologies." *Annual Review of Anthropology 44*: 311–327.

Kuklick, Henrika. 2006. "'Humanity in the chrysalis stage': Indigenous Australians in the anthropological imagination, 1899-1926." *The British Journal for the History of Science 39* (4): 535–568.

Laming-Emperaire, Annette. 1962. *La signification de l'art rupestre paléolithique: Méthodes et applications*. Paris: Picard.

Latour, Bruno. 2013. *An Inquiry into Modes of Existence: An Anthropology of the Moderns*. Cambridge: Harvard University Press.

Layton, Robert. 2003. "The Alawa totemic landscape: Ecology, religion and politics." In *The Archaeology and Anthropology of Landscape. Shaping your Landscape*, edited by Peter J. Ucko and Robert Layton, 221–241. London: Routledge.

Leroi-Gourhan, André. 1971. *Préhistoire de l'art Occidental*. Paris: Éditions d'art Lucien Mazenod.

Lévi-Strauss, Claude. 1963 [1958]. *Structural Anthropology*. New York: Basic Books.

Lévi-Strauss, Claude. 1999. "Nous avons lui et moi essayé de faire à peu près la meme chose." In *Leroi-Gourhan ou les voies de l'homme. Actes du Colloque du CNRS, Mars 1987*, 201–206. Paris: Albin Michel.

Lewis-Williams, David, and Thomas A. Dowson. 1990. "Through the veil: San rock paintings and the rock face." *South African Archaeological Bulletin 45*: 5–16.

Lowish, Susan. 2015. "Evolutionists and Australian Aboriginal art: 1885-1915." *Journal of Art Historiography 12*: 1–35.

Lowish, Susan. 2018. *Rethinking Australia's Art History: The Challenge of Aboriginal Art*. London: Routledge.

Lubbock, John. 1865. *Pre-historic Times, as Illustrated by Ancient Remains, and the Manners and Customs of Modern Savages*. London: Williams & Northgate.

Lubbock, John. 1870. *The Origin of Civilization and the Primitive Condition of Man*. London: Longmans.

Marker, Michael. 2003. "Indigenous voice, community, and epistemic violence: The ethnographer's 'interests' and what 'interests' the ethnographer." *International Journal of Qualitative Studies in Education 16* (3): 361–375.

Marshall, Yvonne. 2002. "What is community archaeology?" *World Archaeology 34* (2): 211–219.

Marshall, Yvonne, and Benjamin Alberti. 2014. "A matter of difference: Karen Barad, ontology and archaeological bodies." *Cambridge Archaeological Journal 24* (1): 19–36.

McAnany, Patricia A., and Sarah M. Rowe. 2015. "Re-visiting the field: Collaborative archaeology as paradigm shift." *Journal of Field Archaeology 40*: 499–507.

McGhee, Robert. 2008. "Aboriginalism and the problems of Indigenous archaeology." *American Antiquity 73* (4): 579–597.

McGlade, James. 2003. "Archaeology and the evolution of cultural landcapes." In *The Archaeology and Anthropology of Landscape. Shaping your Landscape*, edited by Peter J. Ucko and Robert Layton, 459–484. London: Routledge.

McNiven, Ian J. 2016. "Theoretical challenges of indigenous archaeology: Setting an agenda." *American Antiquity 81* (1): 27–41.

McNiven, Ian J., and Lynette Russell. 2005. *Appropriated Pasts: Indigenous Peoples and the Colonial Culture of Archaeology*. Lanham: AltaMira Press.

Molyneaux, Brian L. 1984. *An Analysis and Interpretation of the Micmac Petroglyphs of Kejimkujik National Park* (3 vols). Nova Scotia: Parks Canada.

Moro Abadía, Oscar. 2006. "Art, crafts and Paleolithic art." *Journal of Social Archaeology 6* (1): 119–141.

Moro Abadía, Oscar, and Manuel R. González Morales. 2013. "Paleolithic art: A cultural history." *Journal of Archaeological Research 21* (3): 269–306.

Moro Abadía, Oscar, and Palacio-Pérez, Eduardo. 2015. "Rethinking the structural analysis of Paleolithic art: New perspectives on Leroi-Gourhan's structuralism." *Cambridge Archaeolgical Journal 25*: 657–672.

Munn, Nancy D. 1973. *Walbiri Iconography. Graphic Representation and Cultural Symbolism in a Central Australian Society*. Chicago: The University of Chicago Press.

Nash, George, and Christopher Chippindale. 2002. *European Landscapes of Rock Art*. London: Routledge.

Nettelbeck, Amanda, Russell Smandych, Louis A. Knafla, and Robert Foster. 2016. *Fragile Settlements. Aboriginal Peoples, Law and Resistance in South West Australia and Prairie Canada*. Vancouver: UBC Press.

Nicholas, George P., and Thomas D. Andrews (eds). 1997. *At a Crossroads. Archaeology and First Peoples in Canada*. Burnaby: Archaeology Press.

Norder, John. 2012. "The creation and endurance of memory and place among First Nations of Northwestern Ontario, Canada." *International Journal of Historical Archaeology 16*: 385–400.

Palacio-Pérez, Eduardo. 2010. "Cave art and the theory of art: The origins of the religious interpretation of Palaeolithic graphic expression." *Oxford Journal of Archaeology 29*: 1–14.

Palacio-Pérez, Eduardo. 2013. "The origins of the concept of 'Palaeolithic Art': Theoretical roots of an idea." *Journal of Archaeological Method and Theory 20* (4): 682–714.

Peterson, Nicolas. 2011. "Is the Aboriginal landscape sentient? Animism, the new animism and the Warlpiri." *Oceania 81* (2): 67–179.

Porr, Martin. 2018. "Country and relational ontology in the Kimberley, Northwest Australia: Implications for understanding and representing archaeological evidence." *Cambridge Archaeological Journal 28* (3): 395–409.

Porr, Martin. 2019. "Rock art as art." *Time and Mind. The Journal of Archaeology, Consciousness and Culture 12* (2): 153–164.

Porr, Martin, and Hannah Rachel Bell. 2012. "'Rock-art', 'animism' and two-way thinking: Towards a complementary epistemology in the understanding of material culture and 'rock-art' of hunting and gathering people." *Journal of Archaeological Method and Theory 19*: 161–205.

Price, Sally. 1989. *Primitive Art in Civilized Places*. Chicago and London: The University of Chicago Press.

Reinach, Salomon. 1912. "Art and magic." In *Cults, Myths and Religions*, edited by Salomon Reinach, 124–137. London: David Nutt.

Ross, Anne, Kathleen P. Sherman, Jeffrey G. Snodgrass, Henry D. Delcore, and Richard Sherman. 2011. *Indigenous Peoples and the Collaborative Stewardship of Nature. Knowledge Binds and Institutional Conflicts*. Walnut Creek: Left Coast Press.

Rubin, William (ed). 1984. *"Primitivism" in the 20th Century Art. Affinity of the Tribal and the Modern*. New York: The Museum of Modern Art.

Salmond, Amiria J.M. 2014. "Transforming translations (Part II): Addressing ontological alterity." *Hau: Journal of Ethnographic Theory 4* (1): 155–187.

Sayer, Andrew. 2011. *Why Things Matter to People: Social Science, Values and Ethical Life*. Cambridge: Cambridge University Press.

Shanks, Michael. 2007. "Symmetrical archaeology." *World Archaeology 39* (4): 589–596.

Sillar, Bill. 2009. "The social agency of things? Animism and materiality in the Andes." *Cambridge Archaeological Journal 9* (3): 367–377.

Seeger, Anthony. 1981. *Nature and Society in Central Brazil. The Suya Indians of Mato Grosso*. Cambridge: Cambridge University Press.

Spencer, Walter Baldwin, and Franck Gillen. 2010 [1899]. *The Native Tribes of Central Australia*. Cambridge: Cambridge University Press.

Schuster, Carl, and Edmund Carpenter. 1986–1988. *Materials for the Study of Social Symbolism in Ancient and Tribal Art: A Record of Tradition and Continuity* (3 vols). New York: Rock Foundation.

Shanks, Michael, and Christopher Tilley. 1987. *Social Theory and Archaeology*. Albuquerque: University of New Mexico Press.

Shiner, Larry. 1994. "'Primitive fakes,' 'Tourist art,' and the ideology of authenticity." *Journal of Aesthetics and Art Criticism 52* (2): 225–234.

Shiner, Larry. 2001. *The Invention of Art. A Cultural History*. Chicago: The University of Chicago Press.

Smith, Benjamin W., and Geoffrey Blundell. 2004. "Dangerous ground: A critique of landscape in rock-art studies." In *Pictures in Place. The Figured Landscapes of Rock Art*, edited by Christopher Chippindale and George Nash, 239–262. Cambridge: Cambridge University Press.

Smith, Claire. 2003. "Ancestors, place and people: Social landscapes in Aboriginal Australia." In *The Archaeology and Anthropology of Landscape. Shaping your Landscape*, edited by Peter J. Ucko and Robert Layton, 191–207. London: Routledge.

Smith, Laurajane. 2004. *Archaeological Theory and the Politics of Cultural Heritage*. London: Routledge.

Sognnes, Kalle. 2001. *Prehistoric Imagery and Landscapes. Rock Art in Stjordal, Trondelag, Norway*. Oxford: BAR.

Stump, Daryl. 2013. "On applied archaeology, Indigenous knowledge, and the usable Past." *Current Anthropology 54* (3): 268–298.

Taçon, Paul S.C., and Christopher Chippindale. 1998. "An archaeology of rock-art through informed methods and formal methods." In *The Archaeology of Rock-Art*, edited

by Christopher Chippindale and Paul S.C. Taçon, 1–10. Cambridge: Cambridge University Press.

Taçon, Paul, and Sven Ouzman. 2004. "Worlds within stone: The inner and outer rock-art landscapes of northern Australia and southern Africa." In *The Figured Landscapes of Rock Art: Looking at Pictures in Place*, edited by Christopher Chippindale and George Nash, 39–68. Cambridge: Cambridge University Press.

Todd, Zoe. 2016. "An indigenous feminist's take on the ontological turn: 'Ontology' is just another word for colonialism." *Journal of Historical Sociology 29* (1): 4–22.

Torgovnik, Marianna. 1990. *Gone Primitive: Savage Intellects, Modern Lives*. Chicago: The University of Chicago Press.

Trigger, Bruce G. 1980. "Archaeology and the image of American Indian." *American Antiquity 45* (4): 662–676.

Tylor, Edward B. 1865. *Researches into the Early History of Mankind and the Development of Civilization*. London: John Murray.

Ucko, Peter J., and Andrée Rosenfeld. 1967. *Paleolithic Cave Art*. London: World University Library.

Vastokas, Joan M. (ed). 1990. *Perspectives of Canadian Landscapes: Native Traditions*. North York and Ontario: York University, Robarts Centre for Canadian Studies.

Viveiros de Castro, Eduardo. 2004. "Perspectival anthropology and the method of controlled equivocation." *Tipití: Journal of the Society for the Anthropology of Lowland South America 2* (1): 3–22.

Viveiros de Castro, Eduardo. 2015a. *The Relative Native. Essays on Indigenous Conceptual Worlds*. Chicago: Hau Books.

Viveiros de Castro, Eduardo. 2015b. "Who's afraid of the ontological wolf: Some comments on an ongoing anthropological debate." *Cambridge Anthropology 33* (1): 2–17.

Watkins, Joe. 2001. *Indigenous Archaeology: American Indian Values and Scientific Practice*. Lanham: AltaMira Press.

Watkins, Joe. 2004. "Becoming American or becoming Indian? NAGPRA, Kennewick and cultural affiliation." *Journal of Social Archaeology 4*: 60–80.

Watts, Christophe (ed). 2013. *Relational Archaeologies. Humans, Animals, Things*. London: Routledge.

Weismantel, Mary. 2015. "Seeing like an archaeologist: Viveiros de Castro at Chavin de Huantar." *Journal of Social Archaeology 15* (3): 139–159.

Whitley, David. 2000. *The Art of the Shaman: Rock Art of California*. Salt Lake City: University of Utah Press.

Whitridge, Peter. 2004. "Landscapes, houses, bodies, things: 'Place' and the archaeology of Inuit imaginaries." *Journal of Archaeological Method and Theory 11* (2): 213–250.

Wilkinson, Darryl. 2013. "The emperor's new body: Personhood, ontology and the Inka sovereign." *Cambridge Archaeological Journal 23* (3): 417–432.

Witmore, C.L. 2007. "Symmetrical archaeology: Excerpts of a manifesto." *World Archaeology 39* (4): 546–562.

Wylie, Allison. 2014. "Community-based collaborative archeology." In *Philosophy of Social Science. A New Introduction*, edited by Nancy Cartwright and Eleonora Montuschi, 68–82. Oxford: Oxford University Press.

Wyley, Alison. 2015. "A plurality of pluralism: Collaborative practice in archaeology." In *Objectivity in Science: New Perspectives from Science and Technology Studies*, edited by Flavia Padovani, Alan Richardson, and Jonathan Y. Tsou, 189–210. New York: Springer.

Zawadzka, Dagmara. 2019. "Rock art and animism in the Canadian Shield." *Time and Mind 12* (2): 79–94.

Part I

Philosophical and historical perspectives

1 Rock art and the aesthetics of hyperobjects

Graham Harman

1 Introduction

When we speak of rock art, we seem to be in the realm of archaeology rather than aesthetics. It will be a question either of the primeval remains of ancient peoples, or of more recent productions by cultures who still ply an archaic trade of petroglyphs or rock-wall carvings. Usually it is the former, and the rock art in question is taken as a clue to the broader features of a long-ago world. Among other things, this means that any sort of aesthetic formalism seems to be ruled out in advance, if we define "formalism" as the kind of critique that remains within the limits of the work itself, rather than minutely examining the socio-environmental framework within which it was generated (see Harman 2019c). Paradoxically, in the case of rock art, the now absent society gains the upper hand over the still-present work of art.

Of course, it is well-known that formalism has been out of fashion in the arts since at least the mid-1960s. Here I am speaking not of this or that formalist style—whether of Helen Frankenthaler, Hans Hofmann, or Jackson Pollock—but of the intellectual justification used to promote or denigrate any formalist style in particular. In the art criticism of recent decades (just as in archaeology and philosophy during the same period), it has been easy to gain the moral high ground by passing beyond the limits of the work to that of a wider socio-political framework: especially if one focuses on the poor, the collective, and the non-European. Yet there is a sense in which formalism is inescapable in the arts. For example, while a given artwork might be rooted very much in a specific situation, there are always finite boundaries to how much of it is relevant to the art in question. When interpreting Picasso's *Guernica*, we might well call attention to Franco, Hitler, and perhaps the global war machine, but not to the universe as a whole. Nor is this just a mental shortcut: *Guernica* is simply not related to the universe as a whole in any real sense, but at most to a limited if indefinite number of surrounding factors. The artwork itself often tells us what to include or exclude from beyond its walls, though in many cases this can be supplemented by the critic's own social and biographical knowledge. And while debates might occur as to whether—for instance—some of the faces in *Guernica* are tasteless caricatures of Picasso's friends or ex-lovers, such debates aim

ultimately at a yes-or-no answer: all critical disagreement aside, each element in the universe is either deployed or not deployed in any particular artwork. In a non-trivial sense, the same holds true for archaeology and for everything else. For although holism is intellectually fashionable in our time, every portion of the cosmos is inherently cut off from every other, and is opened up to other zones only through some sort of genuine human or non-human labor.

Yet we can still say that art is more formalistic than archaeology, at least in a relative sense. Whereas in the limit case art can restrict itself to a visual play of lines and enclosed shapes with few if any ulterior associations, archaeology can never aspire to a focus this narrow, and must at least aim at a rough under-standing of the society in which a particular piece of rock art arose. The present article is written from the "art" perspective. I will try to zero in on the specifically *aesthetic* features of rock art, avoiding any speculation about the cultures that give rise to it, an exercise for which I lack professional qualifications in the first place. One seemingly easy way to do this would be to forget that we are dealing with art of a very ancient date, and behave instead as if we were observing works in a twenty-first-century gallery, thus placing rock art on the same stage as recent productions by Louise Bourgeois or Damien Hirst. Yet this would not really succeed, since the great age of such works certainly seems to have an *aesthetic* force all its own and not just a purely archaeological one. There is something about the primeval character of rock art that makes it different *qua artwork*, and not just qua cultural product, from any similar pieces that might be executed by a living artist.

Here it might seem that the easiest way to account for the special aesthetic force of extremely old works would be through an appeal to Immanuel Kant's notion of the *sublime*, referring to that which is "absolutely" large (the mathematical sublime) or "absolutely" powerful (the dynamical sublime) (Kant 1988, 103). Although Kant's mathematical sublime primarily refers to phenomena of over-whelming size, such as the nighttime vision of a vast and starry sky, it seems per-fectly legitimate to change this spatial sense of the sublime to a temporal one. Is there not something obviously sublime about the fact that the famous cave paintings at Lascaux have an estimated age of 17,000 years, dating to a pre-agricultural and pre-urban world whose contours we can hardly begin to surmise?

There has been at least one previous attempt to link object-oriented ontology (OOO) with the Kantian sublime. I refer to Steven Shaviro's claim that OOO is devoted too much to the sublime and not enough to beauty, an objection that has a certain surface plausibility (Harman 2011b; Shaviro 2011). After all, OOO emphasizes the withdrawal of real objects behind any attempt to know or manipulate them, and this seems like a good match for the overwhelming otherness of sublimity. Nonetheless, two obstacles immediately arise in Shaviro's path. The first is that for Kant even *beauty* is incommensurable with any concept, prose summary, or possible set of rules for generating beautiful objects, as Jacques Rancière has noted in a different connection (Rancière 2011, 64). Beauty for Kant belongs to the realm of *taste*, which must be a direct aesthetic experience, meaning among other things an experience that can never

be paraphrased in literal or conceptual terms. Meanwhile, the Kantian sublime is always treated as infinite (at least by contrast with the human scale) and as rather amorphous, whereas the object for OOO is always finite and fully articulated even if beyond our direct grasp. This leads us to the second problem with Shaviro's link between OOO and the sublime: namely, there may be no such thing in the first place, at least not in the Kantian sense. Timothy Morton's concept of the "hyperobject"—meaning an object distributed in time or space far beyond the human scale—functions in part as a rival and alternative to the sublime (Morton 2013). Rock art cannot be sublime, precisely because Morton demonstrates that the sublime in the sense of the "absolutely" large or powerful does not exist. In the nineteenth century, Georg Cantor stunned the mathematical world by proving that the single word "infinity" conceals the existence of a limitless number of different sizes of transfinite numbers. There is a sense in which Morton has provided the opposite service for philosophy, by showing that Kant's purportedly infinite sublime also serves as a cover for countless large *finite* magnitudes. Let's begin, then, with a brief explanation of these hyperobjects.

2 Hyperobjects

Some years ago, the journal *New Literary History* invited articles on OOO and literary criticism by me (Harman 2012a) and Morton (2012), followed with a moderately critical response by our occasional fellow traveler Jane Bennett (2012). The main difference between OOO and Bennett's position, of course, is that while OOO highlights the role of discrete individual objects in philosophy, Bennett—in the wake of Gilles Deleuze and others—adheres to a more continuous model of the cosmos. As she phrases her alternative position: "One [should] … understand 'objects' to be those swirls of matter, energy, and incipience that hold themselves together long enough to vie with the strivings of other objects, including the indeterminate momentum of the throbbing whole" (Bennett 2012, 227). Along with Deleuze, one can easily detect the influence of Baruch Spinoza and Henri Bergson in this passage as elsewhere in Bennett's work (Bennett 2010). Although she presents her position as more balanced than OOO, as able to account for both discrete individuals *and* the continuous character of reality, the continuum clearly has the upper hand in her work: the cosmos is primarily a "throbbing whole," and individual objects are generated as byproducts or swirls of this dynamic totality that precedes all more specific entities.

As an object-oriented thinker, Morton is inclined instead—as I am—toward the autonomous and primary character of individual entities. Despite Bennett's aforementioned skeptical attitude towards this standpoint, there is one place in her response where she does yield some ground. Citing Morton's rejection of models in which "flowing liquids become templates for everything else" (Morton 2012, 208). Bennett admits that "Morton succeeds in making me think twice about my own attraction to ontologies of becoming when he points out that they are biased toward the peculiar rhythms and scale of the human body" (Bennett

2012, 229). Ontologies of becoming remain fashionable today, in an age when Deleuze and more recently Gilbert Simondon (2005) still hold great prestige among theorists in the humanities, but Morton succeeds in reversing the relation such theorists assume between objects and continua. Whereas the Bergson-Deleuze-Simondon model posits that the flowing whole come first and objects are human-scaled derivatives of this whole, Morton counters that the purported continuous flow of syrup requires a human sensual apparatus: after all, a hypothetical four-dimensional being would see no flow at all, while the tiny and speedy neutrino cannot interact with syrup in the first place. What comes first, for Morton as for anyone else invested in OOO, is the discreteness of individuals at countless different scales; continuous flow is merely a local phenomenon relative to a perceiver of a specific dimension.

This brings us back to Morton's fertile notion of the hyperobject (Morton 2013; Harman 2019a, 2019b). Although originally designed for ecological purposes—by drawing our attention to the super-human time scales over which radioactive materials decay or plastic cups degrade in a landfill—hyperobjects also have an obvious *aesthetic* function, taking this word in its original Greek sense of "pertaining to perception." Morton (2013, 56) gives the gripping example of the artist Felix Hess, who recorded a week's worth of sound from his Manhattan apartment. When playing back the recording later at high speed, he heard an eerie droning noise in the background, which upon further inquiry turned out to be the shifting tone of the standing pressure wave over the Atlantic Ocean. Just as with the Pythagorean "music of the spheres" that planets supposedly generate in their orbits—inaudible to humans too accustomed to this cosmic dirge to notice it—Hess discovered a sound hidden from us due precisely to its familiarity and slow rate of change. This largely inscrutable object was present in the environment all along, blocked from our notice by its super-human scale.

Our environment is filled with such hyperobjects, which are taken for granted in our perception and use despite their almost timeless backstory. Morton speaks:

> I start the engine of my car. Liquefied dinosaur bones burst into flame. I walk up a chalky hill. Billions of ancient pulverized undersea creatures grip my shoes. I breathe. Bacterial pollution from some Archean cataclysm fills my alveoli—we call it *oxygen*.
>
> (Morton 2013, 58)

Although the Pythagorean music of the spheres is an especially famous example in the West, Morton also gives due credit to an important thinker of medieval Islam:

> Ar-Razi writes that gold, gems, and glass can disintegrate, but at much slower speeds than vegetable, fruits, and spices … How much would a ruby degrade between the time of Hipparchus and the time of Galen? So the degradation rate of a celestial body might be to that of a ruby as that of a ruby is to that of a bunch of herbs.
>
> (Morton 2013, 66)

The apparent solidity of rubies, just like the evident flux and flow of syrup, holds only for those who experience time at the scale of a human lifespan. For hypothetically long-lived and slow-moving aliens, we could imagine a ruby visibly disintegrating before their eyes. Does this mean that we are stuck with a relativism in which the question of whether flux or the individual is primary can only be decided *ad hoc* by a local beholder? Not quite. For whatever exists must exist as something definite, and as such it is different from everything else. Even if syrup were truly determined to be constantly changing and flowing rather than motionless, it would be *this* specific flow and no other. That point is already enough to establish that a flow is an object. Syrup is an object, oxygen is an object, a pillar of granite is an object, and the lowly mayfly is an object as well, despite its pitifully brief existence by contrast with the human lifespan. A hyperobject is simply an object whose duration or scale is too vast to be directly monitored by human beings.

But vast as hyperobjects are, they are not infinite, which is an oft-overlooked aspect of Morton's concept. As he puts it:

> Infinity is far easier to cope with. Infinity brings to mind our cognitive powers … But hyperobjects are not forever. What they offer instead is *very large finitude*. I can think infinity. But I can't count up to one hundred thousand.
>
> (Morton 2013, 60)

Although Kant's sublime is supposed to be a thoroughly overpowering experience for any human who observes the vastness of the sky or the turbulent sea, or who safely descries a distant tsunami or the collapsing of skyscrapers in lower Manhattan, the sublime—as he conceives it—is still defined in terms of infinity. In Kant's own words: "We call *sublime* what is *absolutely large* … *what is large beyond all comparison*" (Kant 1988, 103). Stated differently: "*That is sublime in comparison with which everything else is small*" (Kant 1988, 105; Harman 2020, Chapter 2). That is not the case with hyperobjects. One hundred thousand years is a very long time, a period much too long for humans to conceive of in meaningful concrete terms. But 3 million years is even longer, not to mention 4.5 billion or 14 billion years.

This is where Shaviro's friendly critique of sublimity in OOO misfires. Admittedly, OOO does conceive of objects as completely withdrawn or withheld: any perception or thought of "part" of an object does not really perceive a "part" of it, but a translation of that object that is something altogether different. In OOO terms, perception and thought encounter *sensual* objects rather than real ones. To perceive a dog is to fall short of the real dog itself, but not in the manner of capturing a measurable percentage of it: as if we could clearly observe 48% of a dog's features while only the other 52% remained beyond human access. The real dog is an integral unit, and the sensual version of the dog that I encounter cannot be considered as some specific portion of it. All this might make it seem as if the OOO real object were infinite in the same sense as the Kantian sublime. Nonetheless, elusive as the dog remains during our

interactions with it, we are well aware that the dog is finite, and equally aware that its finitude is different from that of the sky, a tsunami, or a fox. We could never validly say, in Kantian tones, that "the dog is large beyond all comparison," or that "in comparison with the dog everything else is small." After all, Kant adheres no less than OOO itself to the notion that our representation of the dog is not the dog-in-itself, and that our experience of the tsunami is something rather different from the tsunami-in-itself. This gap between reality and representation is not itself sublime, since sublimity refers to those special cases in which we appear to be confronted specifically with something of absolute size or power.

On this basis, we conclude that there is nothing inherently sublime about the thing-in-itself for Kant, and that the same holds for OOO's real objects. In fact, the unparaphrasable character of beauty is already enough to do the job. A dog or fox can easily be rendered beautiful by an artist, though it would be difficult or perhaps impossible to portray them as sublime. And while the Kantian sublime is said to outstrip the human scale completely, Morton is right that it paradoxically serves to *inflate* our importance: namely, by turning us into those entities who are at least able to "realize" that we are completely overpowered by something. By contrast, the experience of beauty is a more modest response to the incommensurability of a dog (or any entity) with direct human access to it. In short, it puts us in the presence of an equal: a dog that we cannot master, just as it cannot master us. The inaccessible is not the sublime, but simply the beautiful. It is that which can be approached only by taste, rather than by some sort of exhaustive or even partial cognitive prowess.

Let's pause briefly to take stock of where we have been in this article, and where we are still heading. We are trying to determine the specifically aesthetic character of rock art, as opposed to its archaeological dimension. But the irony so far is that no clear line of demarcation between archaeology and aesthetics has appeared. We have seen that there is a relative difference between the degrees of formalism required in the two cases: although art and archaeology—like everything else—deal with some self-contained range of entities that is smaller than the universe as a whole, art can potentially wall off most of its socio-politco-cultural surroundings in a way that archaeology often cannot. Archaeology has a natural link with hyperobjects, given the vast historical scales at which most archaeological objects operate, but in another sense the same is true of artworks, given their impenetrability by paraphrase or conceptual rules. As such, both archaeology and art share in the *finitude* that Kant openly ascribes to humans, despite his insistence that the sublime is infinite. Although there is no time to show this in detail, archaeology and art also both partake of the five other features Morton lists for hyperobjects: (1) viscosity, meaning that humans are entangled with them; (2) non-locality, meaning that one and the same hyperobject can have effects in discontinuous locations; (3) temporal undulation, meaning that hyperobjects generate space and time rather than being stationed inside them; (4) phasing, which is similar

to temporal undulation; and (5) interobjectivity, which entails that human-object interrelations are no different in kind from those between objects themselves. But since our purpose is to identify what makes rock art aesthetic and not just archaeological, we need to find some characteristic that belongs to art but *not* to archaeology, and we have already seen that hyperobjectivity belongs to both.

3 The coldness of formalism

As mentioned at the start, rock art would normally be assigned to the sphere of archaeology rather than aesthetics *per se*. Although relatively few artists have archaeological leanings, the converse is not true: it is by no means rare for archaeologists to study artworks unearthed from the sites they explore. Nonetheless, it is clear that the archaeologist's approach to art objects—whether it be rock art, ceramics, or beads—will not primarily be that of art critics. Their main purpose in examining such works will be to take them as clues to the society under investigation, not to weigh them against the later efforts of Michelangelo or Picasso. As we have seen, this entails that archaeologists will automatically tend to have a non-formalist bias in their treatment of these works. At the end of the day, *every* human pursuit draws formalist limits to its subject matter. Yet art is relatively more formalist than archaeology, since the range of any work's aesthetic effect will never coincide with the entirety of the culture in which it is lodged.

Now, OOO's emphasis on the object as cut off from its relations seems to make it a natural partner for formalism in the arts. But as I argued in *Art and Objects* (Harman 2020), the situation is more complicated than this. For one thing, the aesthetic formalism that descends largely from Kant makes the crucial mistake of assuming that autonomy must mean the specific autonomy of *two and only two* elements: (1) the physical artwork and (2) the human who beholds it. This attitude can be found, for instance, in Michael Fried's rejection of any human entanglement with the work as necessarily "theatrical." This attitude can be found both in his polemic against minimalism and in his historical work on anti-theatrical art in the age of Denis Diderot (Fried 1988, 1998). But even Fried is forced to admit that the principle of anti-theatricality begins to break down in the work of Gustave Courbet and is more or less *reversed* in the pivotal career of Édouard Manet (Fried 1990, 1996). And beyond this, OOO formalism does not require that all aspects of an artwork's environment be excluded, but only that *most* of them be left out as irrelevant.

In other words, there is no *a priori* reason to exclude socio-political or biographical factors from the interpretation of any given work, as long as we are aware that the influence of such factors does not amount to a relational free-for-all. Consider the case of a "site-specific" work of architecture, a genre of art that by necessity tends to have an especial awareness of its site. The architect may consider the sunlight, soil, weather patterns, and neighboring buildings of the project site. But such reflections are always finite, and many aspects of any

given site are always excluded from consideration, if only for reasons of mental fatigue. The same holds for other kinds of art. Even the most diligent account of the social background of Shakespeare's plays, as in the work of Stephen Greenblatt, will not be able—or even willing—to incorporate *all* aspects of Elizabethan society into its analysis (Greenblatt 2004). Nor will it be able to explain Shakespeare's work away as the mere expression of its time and place: among other problems, this would shed no light on why Shakespeare towered above those of his contemporaries who inhabited the same milieu. What OOO insists upon is simply that socio-political or other environmental aspects of a work to be considered must be *formalized*: by showing exactly how these aspects are both incorporated and transformed by the work itself, and also by accounting for how other aspects of the environment are excluded from it.

But since we have seen that archaeology and all other disciplines must also formalize their subject matter by cutting it off from whatever lies beyond their pale, this is not yet enough to capture what is specific to aesthetics. Before resuming our search for this special feature of art, we should note yet another feature that it shares with archaeology: a relative *coldness*. I use this term in Marshall McLuhan's oft-maligned sense of "cold" media, which refers to situations of low information density, by contrast with "hot" media which immerse us in saturated detail (McLuhan 1994). Though the distinction is simple, if controversial, there is something of an unresolved paradox in McLuhan's treatment of the theme (Harman 2012b). For in one sense he treats various media as *inherently* hot (e.g., radio) or cold (e.g., television), such that radio is an excellent medium for in-your-face abrasive personalities firing information rapidly at listeners, while television seems better suited to relaxed personae who require a high degree of viewer absorption. But in another sense, McLuhan treats hotness not as an essential property of certain media by contrast with others, but as a way of *heating* any given medium by filling it up with more and more information. This process continues until it gradually collapses and reverses into its opposite: an event that might be described in terms of a sudden *cooling* (McLuhan and McLuhan 1988). In any case, since this coldness is shared by both art and archaeology, our search for a feature specific to aesthetics continues.

Already we saw that for Kant, beauty resists both any descriptive paraphrase and any set of rules of producing it. Here at last we are on the verge of finding what is specific to aesthetics. Archaeology may certainly have aesthetic effects, but it need not have them: literal prose description is perfectly satisfactory for expressing most of the results of the field, even if good writers here—as in any field—occasionally lift their discipline to the level of an art form. But we have now encountered the word "literal" for the first time, and this is the key to the problem. For whatever art is, it *cannot* be literal, and Marcel Duchamp's famous readymades do not speak against this claim. What Duchamp showed is not that "everything is art," or that there is no difference between art and literal reality. What he did accomplish—and this is no small thing—was to show that the difference between the literal and the non-literal does not consist of a

permanent taxonomy of objects. That is to say, thanks to Duchamp it can no longer be said that "all paintings and sculptures are art" or that "all urinals and bicycle wheels are non-art." A great many paintings and sculptures are so mediocre that they fail to de-literalize their subject matter sufficiently to become artworks, where Duchamp succeeded in making art out of a certain number of urinals and bicycle wheels in various exhibitions—though we should not forget that it took him a great deal of work to pull this off, which goes to show that such homely objects are not *automatically* art merely because the artist decrees them to be so.

But what does "literalism" really mean? When we take something at face value, this means that *in principle* nothing is hidden from us. The thing is there for the taking, if only we succeed in itemizing its list of features. When David Hume (1993) spoke of objects as merely "bundles of qualities," he spoke as the greatest literalist in the history of philosophy, proclaiming that the object does not exist as something over and above whatever we can access through our senses. One need not be a strict Humean to be a literalist: someone might hold, for example, that many properties of things are buried too deep for the senses, and must be detected through a complex process of inference based on the use of costly scientific instruments. Nonetheless, science still has a strong tendency toward literalism insofar as all science pursues *knowledge*. If someone comes to us seeking knowledge about any given thing, there are two kinds of answer we can give: (1) we can tell them what it is made of, (2) we can tell them what it does, or (3) we can give both kinds of answers at once. For instance, if someone has never heard of Yale University, we can tell them the story of its founding and list the numerous physical and human elements of which it is composed, we can tell them about the functional effects that Yale has had on human society, or we can do both simultaneously. Elsewhere I have referred to these three forms of reduction as "undermining," "overmining," and "duomining," while arguing that they never succeed in exhausting what they describe, and arguing further that philosophy and the arts are similar in not being forms of "mining" and therefore not forms of knowledge (Harman 2012c, 2013).

What we see from the failure of mining (i.e., of knowledge) to exhaust its object is that there is a gap between objects and their qualities. While literalism holds that there is nothing more to an object than the sum total of its qualities, "figurativism" (to coin a term) adheres to the opposite principle: that an object is what can *never* be reached simply by totaling up all the qualities it possesses. As I have clarified elsewhere, Homer's famous metaphor "wine-dark sea" does not just mean that the Aegean Sea is of roughly the same color as certain types of wine (Harman 2018, Chapter 2). In that case we would merely have a literal—if faintly *outré*—statement, rather than the vague yet compelling wine/sea object that Homer brings before us. In any case, while archaeology is often literal, art can never be.

4 The case of rock art

The lesson of Duchamp was that pretty much any object can be de-literalized, as long as sufficient measures are taken to sever it from its own qualities. Of course, it took centuries of historical preparation and a good deal of irreverent boldness on Duchamp's part to make this happen, and even now the quality of his results can still be disputed (Harman 2014). What is aesthetically so interesting about rock art is that it exists at the confluence of two fields—art and archaeology—that share so much in common from the start. Both deal with hyperobjects: archaeology by concerning itself with objects of distant or ancient date, art by producing objects not directly accessible to us. Moreover, both are characterized by coldness in McLuhan's sense: archaeology by focusing on objects that provide vanishingly little information, art in requiring a great deal of participatory involvement by the beholder. When observing primeval artifacts in a museum, we often have something tantalizingly close to an aesthetic experience, given the cold and hyperobjective character of these objects. For their accompanying environmental information is so minimal that they verge on toppling over the edge of the literal, and falling into a void that is nonetheless finite rather than sublime.

But let's focus for a moment on the case of art. Since every artist depicts a different sort of content—however abstract it may be—every artist determines what will be de-literalized in his or her work. For example, the Lascaux painters of roughly 17,000 years ago give us de-literalized aurochs, horses, and deer, with other animals featured in the caves of Chauvet which are almost twice as old: perhaps 32,000 years. Of course, a contemporary artist could paint much the same thing: Alain Badiou goes so far as to argue that the Chauvet painters and Picasso paint the "same" horse, on the basis of his Platonist commitment to eternal truths (Badiou 2009, 16 ff.) Now, it just so happens that my mentor Alphonso Lingis has recently painted copies of the Chauvet animals on the wall of his home in Maryland, which means there is at least one "Chauvet cave wall" in current domestic use. Since Lingis would no doubt downplay his own skills as a painter, let's imagine instead that he had commissioned Picasso himself to execute these Chauvet reproductions on his wall, or perhaps on a cave-like rock wall in the basement of his home. I think it is clear that Picasso's Maryland animal-paintings would not be the same thing as the Chauvet paintings, Badiou notwithstanding. Nor would the difference consist in socio-political differences between the Stone Age and the twenty-first-century Baltimore exurbs, since it has not been demonstrated that the particulars of the environment have leaked into the Maryland copies commissioned by Lingis. Nor does the difference consist in market value, since we are speaking of the Chauvet and Maryland paintings as artworks rather than goods.

Instead, the difference is that in the Chauvet paintings, *time* has been de-literalized and attaches itself to the work as an aesthetic property, whereas in the Maryland reproduction this has not occurred—despite the great likelihood that

Picasso is destined for the canon of art for millennia to come. But how does one go about de-literalizing something like time? Earlier, we saw that the primary method of de-literalization is to separate an object from its qualities, thereby countering the chief philosophical error of Hume. Before considering what the "qualities" of time might be, the features from which an artwork would aspire to separe it, we need to be sure not to limit our sense of what "qualities" might mean. Qualities are not restricted to those detected by our sense organs. The qualities or properties of a thing might also refer in one direction (undermining) to their physical composition or causal backstory, and in the other (overmining) to their relations with other things.

Since no one is really sure about the origin or composition of time, let's look in the overmining direction and consider time in terms of its relations. This was the ostensible topic of one of the great disputes in the history of philosophy: the debate between G.W. Leibniz and Isaac Newton's surrogate, Samuel Clarke, which began in 1715 and ended with Leibniz's death the following year (Leibniz and Clarke 2000). The textbook view of the dispute is accurate enough: Clarke follows Newton in treating space and time as pre-existing containers in which the life and death of objects unfolds, while Leibniz regards space and time as *arising* from the relations between individual entities. A typical argument from Leibniz urges us to reject as meaningless the claim that the universe could have been created ten miles farther west than it was, or perhaps five days earlier: for in these cases, if the entire universe has moved in space or time, what standard of reference could possibly tell us it had moved? But if we scratch the surface of the debate, it turns out that we have not a relational conception of space and time versus a non-relational one, but two separate *relational* conceptions. In Leibniz's case this is a patent fact, and his relational theory clearly foreshadows Einsteinian relativity. But even in the "non-relational" Clarke/Newton model, the independence of space and time from individual things does not prevent them from being containers, so that they therefore exist primarily as a steady ruler and stopwatch to measure the adventures of individual things, and are nothing in their own right even if they are in some sense "prior" to what they contain. If everything were evacuated from Newtonian space and time they would not be non-relational continua, but relational ones in a state of waiting for specific entities to arrive on the scene and be positioned.

As Morton notes, what Leibniz got right is that *entities* are fundamental, and that time and space are produced through their interlinking. Yet it does not follow that space and time are relational, since this would imply—and Leibniz knew the contrary—that entities are exhausted by their mutual relations. Experience teaches that relationality is only half the story when it comes to space. Yes, every position in space is related somehow to every other, but only insofar as each position is what it is and not the others. Stated differently, the only reason I can relate my home in Long Beach to my office in Los Angeles by driving between them is that they are not the same place from the outset. Space cannot be identified with the *relation* between these two cities, but must also take their specific irreducible identities into account.

Time is a slightly different case, since OOO does treat time (unlike space) as existing in a purely relational sense (Harman 2011a). More specifically, it is the tension between an object that appears to our minds and its qualities insofar as they appear to our minds: the duel between an apple and the numerous shifting qualities that it displays from one moment to the next. But this only pertains to the temporality of the present instant, and merely illuminates the sensual experience of being there and observing the apple amidst changing conditions of light and mood, much in the way that phenomenology speaks of literal "adumbrations" of an otherwise stable intentional object (Husserl 1970). Yet the sense of time that interests us in the case of Chauvet is something completely different: time in a de-literalized, de-relationized sense that belongs to the rock art itself, and not in the sense of a flowing continuity known through direct experience. By analogy with Morton's concept of hyperobjects, we can call it "hyper-time." Whereas time in the everyday sense is something we experience directly and instantaneously, hyper-time involves the reification—in a good sense—of a temporal sequence. Something similar was already noticed in architectural theory. For as the young Peter Eisenman writes, as long ago as the early 1960s:

> To understand architectural form we must introduce the notion of movement and postulate that an experience of architecture is the sum of a large number of experiences, each one of them apprehended visually (as well as through the other senses), but accumulated over a much longer time span than is required for the initial appreciation of a pictorial work ...
>
> (Eisenman 2004, 9)

This is one of the most important ways—functionality is another—that architecture differs from visual art. Architecture is simply not legible at a glance, and for this reason *time* becomes one of its elements: or rather *hyper-time*, since even if it takes only three or four minutes to tour a small house, those few minutes are already a vast excess beyond what humans can perceive in an instant. In the case of rock art, however, the hyper-temporal element comes not from the individual need to view all its elements in sequence. Instead, it arises from a long collective passage through human history, as if we humans had all walked the halls together for 32,000 years before finally reaching the attic where the Chauvet paintings were stored.

References cited

Badiou, Alain. 2009. *Logics of Worlds: Being and Event II*. Translated by Alberto Toscano. London: Continuum.

Bennett, Jane. 2010. *Vibrant Matter: A Political Ecology of Things*. Durham: Duke University Press.

Bennett, Jane. 2012. "Systems and things." *New Literary History 43* (2): 225–233.

Eisenman, Peter. 2004. *Eisenman Inside Out: Selected Writings, 1963-1988*. New Haven: Yale University Press.

Fried, Michael. 1988. *Absorption and Theatricality: Painting and Beholder in the Age of Diderot*. Chicago: The University of Chicago Press.

Fried, Michael. 1990. *Courbet's Realism*. Chicago: The University of Chicago Press.

Fried, Michael. 1996. *Manet's Modernism: Or, The Face of Painting in the 1860s*. Chicago: The University of Chicago Press.

Fried, Michael. 1998. *Art and Objecthood: Essays and Reviews*. Chicago: The University of Chicago Press.

Greenblatt, Stephen. 2004. *Will in the World: How Shakespeare Became Shakespeare*. New York: Norton.

Harman, Graham. 2011a. *The Quadruple Object*. Winchester: Zero Books.

Harman, Graham. 2011b. "Response to Shaviro." In *The Speculative Turn: Continental Materialism and Realism*, edited by Levi R. Bryant, Nick Srnicek, and Graham Harman, 291–303. Melbourne: re.press.

Harman, Graham. 2012a. "The well-wrought broken hammer: Object-oriented literary criticism." *New Literary History* 43 (2): 183–203.

Harman, Graham. 2012b. "Some paradoxes of McLuhan's tetrad." *Umbr(a)* 1: 77–95.

Harman, Graham. 2012c. "The Third Table." In *The Book of Books*, edited by Carolyn Christov-Bakargiev, 540–542. Ostfildern: Hatje Cantz Verlag.

Harman, Graham. 2013. "Undermining, overmining, and duomining: A critique." In *ADD Metaphysics*, edited by Jenna Sutela, 40–51. Aalto: Aalto University Design Research Laboratory.

Harman, Graham. 2014. "Greenberg, Duchamp, and the next avant-garde." *Speculations V*: 251–274.

Harman, Graham. 2018. *Object-Oriented Ontology: A New Theory of Everything*. London: Pelican.

Harman, Graham. 2019a. "Hyperobjects and prehistory." In *Time and History in Prehistory*, edited by Stella Souvatzi, Adnan Baysal, and Emma L. Baysal, 195–209. London: Routledge.

Harman, Graham. 2019b. "The coldness of forgetting: OOO in philosophy, archaeology, and history." *Open Philosophy* 2: 270–279.

Harman, Graham. 2019c. "Three problems of formalism: An object-oriented view." In *New Directions in Philosophy and Literature*, edited by David Rudrum, Ridvan Askin, and Frida Beckman, 198–214. Edinburgh: Edinburgh University Press.

Harman, Graham. 2020. *Art and Objects*. Cambridge: Polity.

Hume, David. 1993. *An Enquiry Concerning Human Understanding*. Indianapolis: Hackett.

Husserl, Edmund. 1970. *Logical Investigations* (2 vols). Translated by J.N. Findlay. London: Routledge and Kegan Paul.

Kant, Immanuel. 1988 [1790]. *Critique of Judgment*. Translated by Werner Pluhar. Indianapolis: Hackett.

Leibniz, Gottfried. W., and Samuel Clarke. 2000. *Correspondence*. Indianapolis: Hackett.

McLuhan, Marshall. 1994. *Understanding Media: The Extensions of Man*. Cambridge: MIT Press.

McLuhan, Marshall, and Eric McLuhan. 1988. *Laws of Media: The New Science*. Toronto: University of Toronto Press.

Morton, Timothy. 2012. "An object-oriented defense of poetry." *New Literary History* 43 (2): 205–224.

Morton, Timothy. 2013. *Hyperobjects: Philosophy and Ecology After the End of the World.* Minneapolis: University of Minnesota Press.

Rancière, Jacques. 2011. *The Emancipated Spectator.* Translated by Gregory Elliott. London: Verso.

Shaviro, Steven. 2011. "The actual volcano: Whitehead, Harman, and the problem of relations." In *The Speculative Turn: Continental Materialism and Realism*, edited by Levi R. Bryant, Nick Srnicek, and Graham Harman, 279–290. Melbourne: re.press.

Simondon, Gilbert. 2005. *L'individuation à la lumière des notions de forme et d'information.* Grenoble: Millon.

2 Rock art and the ontology of images

The ecology of images in hunter-gatherer and agrarian rock art

Andrew Meirion Jones[1]

1 Rock art images and hunter-gatherer societies

The close relationship between rock art, or Cave art, and hunter-gatherer societies has long been assumed. Based on common patterns of aggregation and dispersal amongst hunter-gatherers, Margaret Conkey (1980) argued that certain Upper Palaeolithic Cave art sites—like Altamira, Spain—acted as aggregation locations. She based her arguments not only on the well-known Cave art at the site (see also Straus 1975–1976), but also the diversity of the design of engraved artifacts from the site (Conkey 1980, 616–617). Conkey's principal aim was to explore the potential identification of hunter-gatherer aggregation sites, but the link between hunter-gatherers and acts of spatialized marking is also made clear in her analysis (see also Conkey 1997, 346).

This theme is taken up by other authors (see e.g., David 2017, 160–1). Spatialized marking is discussed by Paul Taçon (1994) in his analysis of rock art in the Mann River region of New South Wales, Australia. At Roma Gorge, two distinct repertoires of rock art motifs are used to mark territorial divisions in the region. Taçon argues that these differences in art styles are associated with distinct regional clans. Here we see another important theme emerging in studies of hunter-gatherer rock art: the relationship between territory and social signaling. This relationship is formalized in Jo McDonald and Peter Veth's large-scale analysis of Holocene graphic systems in Australia (McDonald and Veth 2006). Here the two authors view stylistic differences as part of a social strategy on the basis of the work of Martin Wobst (1977). Here the assumption is that "different environments and their effects on prehistoric social networks will influence the amount of stylistic variability in a graphic system" (McDonald and Veth 2006, 98). This assumption is also evident in the application of the notion of "costly signaling theory" to cave art sites, such as Lascaux, France (Gittins and Pettitt 2017). The underlying assumption of each of these studies is clear: the production of rock art is a social strategy to signal difference between mobile hunter-gatherer populations. Alternatively, in a review of approaches to hunter-gatherer rock art, Mairi Ross (2001, 546) argues that many hunter-gatherers "used rock art as a navigational device which cognitively represented the environment as a network of places." Central to each of these approaches to

hunter-gatherer rock art is the assumption that images are representational; they either represent the environment as a network of places, or they are used to representationally signal social, or clan differences. That hunter-gatherer rock art motifs are understood as messages to be decoded is neatly captured in the title of David Lewis-Williams and Sam Challis' book on San Bushman rock art: *Deciphering Ancient Minds* (Lewis-Williams and Challis 2012).

Both the notion of different rock art styles as signals carrying information and the notion of rock art as navigational device is closely allied with the underlying assumption of representationalism. Representationalism is the philosophical notion that the world is composed of things with inherent attributes, and that these things are capable of being represented.

Representationalism is a system of thought that fixes the world as an object and resource for human subjects (Bolt 2004, 12). Representationalism is particularly associated with the post-Renaissance West. With its roots in Plato's mimetic theory of images (Plato 2007), during the Renaissance images are typically considered to be allegorical; in this sense, Renaissance images are often considered to represent other things (Eco 1986). These Renaissance ways of seeing are then embedded in the thought of philosophers such as Rene Descartes and Immanuel Kant. Some philosophical accounts, such as those of Martin Heidegger, argue that Descartes ushered in the new paradigm of representation and reduced the world to a picture (Bolt 2004, 16); by this Heidegger means that representationalism compels us to view pictures as so many representational copies of the real world. If he is correct, representational thinking, as we know it today, has only been with us since the seventeenth-century AD, though we might arguably observe precedents for this in the Renaissance world of the fifteenth-century AD. Given the historicity of representational thinking, the artist Barbara Bolt raises an important set of questions:

> What happened before representation? We know people made images and looked at them before Descartes, so how did they apprehend them if not as representations? What did the makers of these images think they were doing? And what of the cultures not under the sway of Cartesianism, for example pre-Socratic or Indigenous Australian cultures?
>
> (Bolt 2004, 14)

These questions are particularly pertinent to archaeologists who often study imagery produced long before the Renaissance. It has an especially important resonance for rock art researchers.

2 Images in the making and the relational ecology of images

We are faced then with a conundrum. Rock art researchers tell us that hunter-gatherer communities use rock art imagery to signal difference, or that rock art imagery is a navigational device to cognitively represent the environment.

Philosophers and art historians, on the other hand, tell us that this kind of representational thinking is a product of modernity, whose roots may have emerged during the Renaissance. Should we trust the assessments of philosophers and art historians? We probably should. Have rock art researchers then unthinkingly imported a modern ontology of the image-as-representation to their study of hunter-gatherer societies? This seems very likely. What emerges then are idiosyncratic hunter-gatherer communities who traverse landscapes marking and representing landscapes in ways very familiar to modern Westerners traversing cities; these are hunter-gatherers equipped with modern minds (for a similar observation regarding anatomical modernity see Ingold 2000a, 373–391). The commonplace view that images are representations is prevalent in much archaeological thinking. We see this crystallized in a recent remark by John Creese: "Art is often thought of as a *vehicle for ideas*. Its most salient attribute seems to be its ability to carry meaning, to act as a symbol or representation." (Creese 2017, 643; original emphasis). One of the effects of these views is that images are ontologically considered to be a particular kind of entity: images are a species of representation. In that sense, images are ontologically reduced; they become flat or one-dimensional.

To consider images in more than one dimension expands our understanding of the ontological complexity of images. If we consider images not as pre-existing and fixed entities, but think about images as they *move*: are made; engaged with; and altered over time; as four-dimensional *Images-in-the-Making*, then we begin to realize how ontologically complex and changeable images can be; by characterizing images as *four-dimensional* I simply mean that images change over time. In the edited volume *Images in the Making* Ing-Marie Back Danielsson and the author outline a four-dimensional understanding of images that recognizes their ontological variability. We argue that images are ongoing events or processes, and term the continuing intra-action between people and unfolding images as *imaging*. We argue that images are conditions of possibility, which assemble, draw together and meaningfully relate components of the world; images provide the conditions to make these meaningful relationships visible (Back Danielsson and Jones 2020). Rather than images simply acting as one-dimensional traces or representations of pre-existing entities, I instead argue for an understanding of images as gatherings, as things that reconfigure past relationships and map future relations.

This understanding of how images gather relations is echoed by Ben Alberti and Severin Fowles' ecological analysis of Archaic period rock art in the Rio Grande, New Mexico, USA. While retaining a sense of Archaic rock art as semiotic signs, they argue that rock art is one way in which humans attended to the ecological relations of the world around them. Rock art—depicting animal tracks and scat trails—is the result of Archaic hunter-gatherers "efforts to underline the natural signs around them, rather than to erase and write over these traces" (Alberti and Fowles 2018, 147). For Alberti and Fowles, rock art is a component of the interlinked ecologies that make places.

In a similar vein, David Robinson (2013) discusses the corresponding affects of Chumash rock art, California, USA. Robinson (2013, 72–3) argues that much Chumash rock art can "be interpreted as images that activated power through

affective transmorphic combinations that drew upon complex correspondences based upon materialities, place and imagery." The intra-relationships between rock art images and place are key to his analysis.

Australian rock art researchers have also argued for a more ontologically complex understanding of rock art motifs. For example, Martin Porr (2018) discusses the *Wandjina* figures of the *WanjinaWunggurr* community of the Kimberley region of western Australia. He notes that for the *Wanjina* rock art motifs are not inert, they are images with energies. Rather than images being painted in rock shelters, images are regarded as having *placed themselves* in rock shelters. This understanding reflects a cultural geography that relates images, people, space, time and the material environment to each other in a complex way (Porr 2018, 400). Engagements with images and places, which includes retouching and repainting, were therefore embedded in the intra-relationships between people and place in the Kimberley.

In another example, Brady and Bradley (2016) discuss the sorcery rock art site of *Kurrmurnnyini* in northern Australia's southwest Gulf country. They argue that at this site rock art motifs are drawn to elicit affects and effects, in particular to kill. Paintings are made to precipitate the death of individuals. Images of individuals' Ancestral Beings, such as dugongs or crocodiles, were painted at the site (Brady and Bradley 2016, 893), thereby hastening the demise of people linked to these Ancestral Beings. Brady and Bradley (2016, 887) contrast their analysis with previous approaches to rock art which have focused on the cultural meanings or messages embedded in rock art. Critically, they emphasize the importance of ontology and relationality in the capacity of rock art images to kill: only those men who had the King Brown Snake as their Ancestors could access its power to make the sorcery paintings at the site. The deadly power of rock art images was relationally connected to particular kinship connections, manifested at particular places in the landscape.

Based on a variety of analyses in North America and Australia, we can now appreciate that rock art images are not simply singular sign-vehicles sutured from their environments, rather rock art motifs are ontologically imbricated with landscapes and places. We are now in a position to realize that images might be different kinds of things, and that these ontologically complex images might have differing relationships with the world. If we understand images as ontologically open in this way, we can also consider how images participate in ecological, and manifold other, relationships. At this juncture we are now prepared to depart from our consideration of hunter-gatherers to instead consider the multiplicity of image making in prehistoric agrarian communities, such as Neolithic Britain and Ireland and Bronze Age Scandinavia.

3 Making a mark: Image making in Neolithic Britain and Ireland

The mark making traditions of Neolithic Britain and Ireland (c. 4050–2300 cal. BC) are spectacular and enigmatic. There are few examples of representational

images, and marks of an abstract linear, curvilinear, and geometric character predominate in a number of contexts: as open-air rock art in the north and west of Britain; in passage tombs in eastern Ireland, north Wales and Orkney; in the settlement architecture of the Orkney Neolithic; and on a suite of portable decorated artifacts found across Britain and Ireland.

Although the image making traditions of the British Neolithic begin with intercut linear marks cut into the walls of the flint mines of Sussex, southern England (Jones and Díaz-Guardamino 2019) around 4050 cal. BC, image making reaches a greater degree of complexity after 3500 cal. BC in a series of regions across Britain and Ireland. At this juncture a series of elaborately decorated artifacts are produced. It is also at this juncture that the major decorated passage tombs of eastern Ireland begin to be constructed (Bergh and Hensey 2013; Bayliss and O'Sullivan 2013). Analysis of the contexts of decorated artifacts indicates the close relationship between image making and working. This is clear from the outset with the Sussex flint mines, but it is also evident in the later decorated material. Image making seems to be caught up with the current of activities, such as monument building, flint mining, stone extraction and burial, and as such image making is closely related to specific materials and landscape locations. This is the case with some of the key artifacts from this later period, including the Monkton up Wimborne chalk block (Figure 2.1), associated with flint mining and burial (Green 2000) and the Graig Lwyd stone plaque, associated with quarrying for stone axe production (Williams and Kenney 2011).

Figure 2.1 The decorated chalk block from Monkton Up Wimborne, Dorset. Note the series of nested arcs carved on its surface.
Source: RTI image copyright Marta Díaz-Guardamino/Andrew Jones.

These same kinds of practices of image making and working resonate with passage tomb art. Passage tombs are built of specific materials from a variety of landscape locations (Cooney 2000, 136–137). The building of passage tombs also seems to closely relate to image making. As Robin (2009) has shown the initial construction of passage tombs begins with the interior chamber (Figure 2.2). This is followed by a succession of extensions to the passage that enters the chamber. During construction intensive mark making occurs at the junction points of the passages, and at key junctures in the chamber. This intensive working continues throughout the use of these monuments, and we can detect up to five phases of cumulative carving and re-carving in the interior of these monuments, beginning with linear and geometric marks, and culminating in three-dimensional sculptural designs (Jones 2004; Cochrane 2009). In a similar way, Antonia Thomas (2016) has shown that the episodes of carving at Neolithic settlement sites in Orkney, including Skara Brae and Ness of Brodgar, are closely connected with the rhythms of building and rebuilding.

These practices contrast with open-air rock art. Here we see much less evidence of reworking and erasure and motifs are juxtaposed rather than being superimposed. Analysis of rock art across Scotland (Freedman 2011) identified a few key landscapes—Kilmartin, Strathtay, and Galloway—with high densities of motifs against most other regions with minimal coverage of motifs. The same pattern

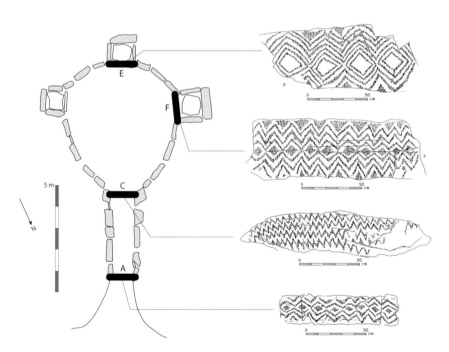

Figure 2.2 Plan of passage tomb Fourknocks I, Co. Meath, Ireland. Note how decoration relates to specific architectural features in the monument.
Source: Copyright Guillaume Robin. Used with permission.

seems to occur across Britain and Ireland (Bradley 1997; O'Connor 2006; Valdez-Tullett 2019). Instead of reworking panels, the practice in some rock art landscapes tends towards repetition and the additive concentration of activity in single panels, places or landscapes.

Each of these image making practices—rock art, passage tomb art, decorated artifacts—is ecological in that it is intimately interwoven with landscape features. For example, Bradley and Watson (2019) argue that the rock art site at Urlar, Strathtay, Scotland is situated on an outcrop that closely resembles the features of a Neolithic long barrow. They describe this phenomenon as "found architecture"; in this case, rock art is interwoven with the pre-existing features of the landscape which bear a resemblance to built architecture. As Elizabeth Shee Twohig and others have shown a number of Irish passage tombs incorporate pre-existing carved rock art panels within their construction. This is true of sites in the Loughcrew cemetery (Shee Twohig 2012) and sites such as Newgrange in the Boyne valley cemetery (O'Kelly 1982). Meanwhile, decorated artifacts are produced from materials caught up in other kinds of activities including flint mining, stone quarrying, monument building, and burial (Jones and Díaz-Guardamino 2019, 198–99).

Critically each image making practice appears to be ecologically related to significant aspects of the landscape, though in contrasting ways. Although similar motifs are found in differing contexts, the contrasting relationships forged with differing aspects of landscapes and differing contexts suggests that we may consider these differing image making practices as ontologically distinct though connected (Jones and Díaz-Guardamino 2019, 167–80). Importantly, each image making practice has a different relationship to time. Decorated artifacts are often ephemeral, being rapidly made and discarded or made and re-made. Passage tombs are composed of materials with deep histories, the making of these monuments is marked, while the continued significance of these sites is reiterated by image making in their interiors (Jones 2004). This may also be true of settlements in Neolithic Orkney (Thomas 2016). Rock art sites accrue histories over long periods of intra-action, as they are visited and re-visited, carved, and embellished.

Many of the images carved during the Neolithic of Britain and Ireland are hidden or ephemeral. Therefore, interpreting them as representations used in social signaling seems idiosyncratic and unhelpful. Instead we find that the image making practices of Neolithic Britain and Ireland are connective and multiple.

4 Image making in the southern Scandinavian late Neolithic and Bronze Age

The rock art traditions of Scandinavia are divided into two regions associated with different economic regimes: the hunters art of northern Scandinavia and the farmers art of southern Scandinavia, though the term "farmers art" is probably a misnomer and the southern Scandinavian art is probably better termed a "maritime art" (Ling 2008; Goldhahn et al. 2010; Skoglund et al. 2017). The

southern Scandinavian Late Neolithic and Bronze Age, with rock art images dating from 2350 to 500 cal. BC, is one of the richest concentrations of rock art in Europe (Goldhahn et al. 2010, 6); much of this rock art depicts images of humans, animals, metalwork, and equipment such as boats. Along with open-air rock art, carved images are found in barrow and cairn burials, while similar imagery is found on bronze work, including swords and razors (Kaul 1998).

At cairn/barrow sites like Sagaholm, near Jönköping, Sweden (Goldhahn 2016); Kivik, Bredarör, Scania, Sweden (Goldhahn 2009); and Mjeltehaugen, Giske, Norway (Goldhahn 2008) we find decorated kerb and cist stones within immense earth and stonebarrows (Figure 2.3); these images often depict animals, metalwork, and humans. On the basis of the positioning of the decorated stone slabs in these monuments they must have been incorporated during monument construction. In some cases, the materials used for monument construction came from significant places in the surrounding landscape. For example, the stone slabs used in the kerb of the Sagaholm cairn were derived from a specific form of red sandstone from Visingsö island, Lake Vättern, Sweden (Goldhahn 2008, 69), while the cist slabs for the Mjeltehaugen monument were probably quarried in Sunnfjord or Trøndelag at either end of the main distribution of carved ship images on the west Norwegian coast (Goldhahn 2008, 76).

Analysis of the open-air rock art of Scandinavia by Courtney Nimura (2016) indicates that the majority of the rock art is located close to water, and that this is especially true of ship motifs. Detailed analysis of ship motifs in regions like Bohuslän, Sweden, and Østfold, Norway (two of the regions with the highest concentration of ship motifs; Nimura 2016, 92, 108), suggest that these concentrate in regions characterized by bays and inlets. In that sense, these images might mark navigational routes through the landscape. The wider theme of the ship as a navigational metaphor has characterized much of the discussion of ships in the Scandinavian Bronze Age (Kaul 1998; Ballard et al. 2004; Bradley 2009) and ships have been seen as being fundamental to the circulation of materials, such as copper, from central Europe to southern Scandinavia (Kristiansen 1987). Notwithstanding the practical function and metaphorical significance of ships, other researchers have begun to question the simplistic equation of ship motifs with representations. For example, Fredrik Fahlander (2013, 2020) analyses an important group of ship motifs at Boglösa, Uppland, Sweden. He argues that the depiction of ship motifs at the shores edge was a way of articulating the relationship between motifs and landscape features. He also notes a number of partially completed ship and anthropomorphic images (Figure 2.4). These partial depictions only make sense, Fahlander argues, if we recognize that these images are not concerned with mimesis or representation, but with what rock art motifs do (Fahlander 2020). What these motifs do then, is articulate, or bring into focus, different relationships.

There are a number of motifs common to metalwork and rock art, such as ship motifs (Kaul 1998). Conversely, we also observe depictions of metal artifacts in rock art, particularly in the context of burial monuments (Goldhahn 2014). While these motifs have been regarded as components in grand cosmological schemes (Kaul 1998; Bradley 2009; Skoglund 2010), we might also regard them as elements

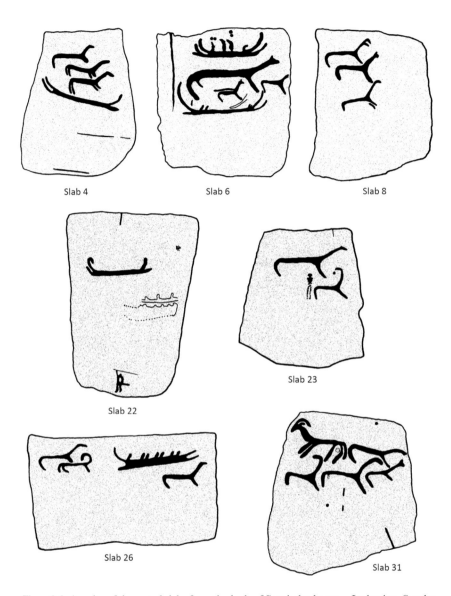

Slab 4 Slab 6 Slab 8

Slab 22

Slab 23

Slab 26

Slab 31

Figure 2.3 A series of decorated slabs from the kerb of Sagaholm barrow, Jönköping, Sweden.
Source: Copyright Joakim Goldhahn. Used with permission.

that connect or articulate different relationships. For example, Joakim Goldhahn (2014) argues that the accurate depiction of metalwork on the cist slabs of sites such as Rege, Rogaland, Norway and Kivik, Scania, Sweden relates to the depiction of specific pieces of metalwork: special objects with long biographies; things of renown. There is a symmetry between the deposition of these depicted artifacts and

Figure 2.4 A series of incomplete ship motifs from Boglösa, Sweden.
Source: Copyright Fredrik Fahlander. Used with permission.

the deposition of human individuals in the graves: both once possessed animacy and social regard. In most cases the depiction of metalwork on rock art is generic, but Goldhahn notes another important context where faithful 1:1 scale depictions of metalwork occur in rock art: in coastal locations, which he regards as places of maritime interaction and social transformation (Goldhahn 2014, 117). In both of these locations—coasts and burials—metalwork is portrayed accurately by being engraved in rock. Goldhahn notes that this mode of depiction is relational, setting up a relationship between rock, metal item and humans. He regards these special metal objects as being intimately linked to the biographies of particular people. Special objects are retrieved from outside Scandinavia, are depicted on rocks as they are brought back to Scandinavia, and their commitment to burial is commemorated on cist slabs in burial monuments.

Rock art motifs are ontologically complex during the Scandinavian Bronze Age. Much like the Neolithic of Britain and Ireland, we find that motifs could be regarded as relational and connective, and again they are ecologically connected to the landscape. Both regions are characterized by rock art motifs in a number of differing contexts, including open-air contexts, burial monuments and on portable artifacts. It is easy to comprehend that in each of these contexts rock art might ontologically differ. In the case of both Neolithic Britain and Ireland and Bronze Age Scandinavia we have learned that images are not one kind of entity. In the case of southern Scandinavia images of bronze artifacts and ships *may* act as representations, but they cannot be reduced to simply being representations; instead they are simultaneously representational and connective.

5 Agrarian rock art?

It is commonplace for archaeologists and anthropologists to draw hard and fast distinctions between the behaviour of hunter-gatherers and agriculturalists (see e.g. Bradley 1998; Ingold 2000b; Pluciennik 2008). No such distinctions will be drawn here. The thrust of my argument regarding approaches to hunter-gatherer rock art was that researchers present an ontologically narrow vision in

which rock art images are simply assumed to be representations. Instead I noted that several recent studies of hunter-gatherer rock art in North America and Australia highlight the way in which rock art is relationally connected to place and landscape. Such relational complexity suggests that we cannot seek to isolate a single generalized approach to hunter-gatherer rock art; rather each rock art tradition will differ depending on its varying local connections. Likewise, I believe we need to proceed from a working assumption that agrarian rock art also cannot be reduced to a single generalizing approach, and we should seek to explore the varied character of different traditions of agrarian rock art.

Having said this, in the case of my two examples, Neolithic Britain and Ireland and the southern Scandinavian Bronze Age, we begin to discern similarities. In both cases, rock art images are located in open-air settings. However, rock art images are also related to the construction of monuments—passage tombs in Neolithic Britain and Ireland and cairns and barrows in Bronze Age southern Scandinavia. Similar motifs are also found on portable artifacts, of chalk, stone, bone, antler and wood in the case of Neolithic Britain and Ireland, and bronze in the case of southern Scandinavia. In both cases rock art images appear to be connective, they draw together and relate different domains of activity. But is this connectivity true of agrarian rock art everywhere? I discuss examples from New Mexico, USA and the Limari Valley and Atacama Desert, Chile to assess the differences and similarities in agrarian rock art.

A sense of relational connectivity is evident in some agrarian rock art. For example, in New Mexico, imagery in kiva niches relate to those in caves, and masked katsina's figures may also be depicted in the landscape (Schaafsma 2009; Fowles 2013). Relational connections between rock art and the wider landscape are also an aspect of the Inkan rock art of the Atacama Desert, Chile, as noted by Andrés Troncoso (2019). However, we also observe rock art being situated along routeways and trails in regions such as New Mexico (Snead 2008) and the Limari Valley, Chile (Nash and Troncoso 2017); here, rock art appears to also act as a semiotic sign signaling territorial distinctions, though close analysis of hunter-gatherer rock art in the same landscapes in Chile shows that the agrarian rock art is demarcating particular landscape zones rather than simply tracts of territory; in this way agrarian rock art appears to differ substantially from hunter-gatherer rock art in both its location, and its production.

It is difficult to argue that agrarian rock art simplistically relates to particular ways of economically inhabiting the landscape. Though, in the two extended case studies (Neolithic Britain and Bronze Age Scandinavia) we could perhaps highlight the fact that the relational connectivity of agrarian rock art relates to the way in which landscapes are occupied as networks of related places (Jones 2006). How does this differ from hunter-gatherer rock art landscapes? Vergara and Troncoso (2015) describe this most clearly in their example of the hunter-gatherer and agrarian rock art of the Limari Valley, northern Chile. They offer a detailed picture of how rock art production and place and location are folded into modes of landscape occupation for hunter-gatherer and agrarian communities alike.

Notably, while there are differences in rock art production and location between the two communities, there are also commonalities.

In sum, we cannot expect to simply read off ontologies from our expectations concerning prehistoric economies. We cannot expect to say that hunter-gatherers will possess one kind of ontological outlook, while agriculturalists will possess another. Instead we should expect multiplicity and complexity. How then are we to assess ontologies?

6 Ontology from the ground up: Towards an ecology of rock art images

Alberti (2016, 164) emphasizes two distinct views on ontology within the archaeological literature when he points out: "One can conceptualize ontology either as a people's 'beliefs about' reality or as a people's reality, their actual ontological commitments. These are quite distinct positions." He goes on to point out that the first of these approaches "can be assimilated into a cultural or discursive construction argument where baseline 'reality' is untouched." In these conceptualizations, ontology simply equates to cosmology, or just equates to culture. In such cases we face well worn, and problematic, distinctions between nature and culture. These terms are a problem as they are conceived as both opposing and universalizing categories. As Tim Ingold (2000c, 340) so aptly puts it: "Understood as a realm of discourse, meaning and value culture is conceived to hover over the material world, but not to permeate it." Approaches to ontology that simply treat ontology as equivalent to worldview perpetuate these familiar distinctions between culture and nature. For this reason, I believe we must reject them. For similar reasons, anthropological approaches, such as Phillipe Descola's (Descola 2005), that impose fixed ontological schemas, such as animism, totemism, naturalism, and analogism onto the archaeological record are also, I believe, unhelpful (for attempts to operationalize Descola's schemas in archaeology see Borić 2013; Shapland 2013).

Both the application of defined ontological schemas and the notion of ontologies as worldviews imply top-down approaches that impose conceptual schemes onto a mute material world awaiting human action to give it meaning. Instead, I want to argue that our accounts must also acknowledge the vitality of materials (see e.g., Barad 2007; Bennett 2010). To do this, I approach ontology from a different direction: the ground up. Rather than creating distinctions between culture and nature, between worldviews and materials, I instead propose an ontological approach to rock art in which materials, images, and concepts are entangled. To do this, I want to return to Ben Alberti and Severin Fowles' characterization of rock art images as ecologies discussed at the beginning of this chapter. For Alberti and Fowles (2018, 151), "rock art is as much ecology as it is art." By this they mean that rock art is just one of the ongoing engagements undergone by rocks. Rock art is both a component of an ongoing historical tradition in which previous imagery is annotated and drawn into the work of the present. But rocks are not only subject to historical forces, but are also enmeshed

in multiple other agencies, including lichen growth, water action, microbial action, and animal activities:

> Thinking with mountain sheep and microbes about images, we see each site in the gorge as a place that has resulted from the subsuming of the human within a landscape that is already literate, filled with natural signs and unfolding according to a multispecies semiotics.
>
> (Alberti and Fowles 2018, 152)

Alberti and Fowles offer a compelling picture of rock art sites as components of intermeshed ecologies. Here we might think about rock art images as one component amongst a complex assemblage in which other-than-human agencies, such as geology, weather, microbial action, plant life, and animal activities intra-act with human agencies, including previous image making activities, modes of landscape habitation, and modes of economic behavior. Vergara and Troncoso (2015) offer a similarly complex image of rock art networks in their analysis of the way in which rock art making techniques intra-act with modes of landscape occupation in the Limari Valley, Chile. To consider rock art as part of more complex ecologies is to conceive of rock art images as part of an assemblage (see Hamilakis and Jones 2017; Jones and Cochrane 2018, 183–192; Jervis 2019; Back Danielsson and Jones 2020). Assemblages are relational and heterogeneous, and the configuration of the assemblage will depend on the particular capacities and agencies of the bodies out of which they are composed (Hamilakis and Jones 2017, 79). Assemblages are also dynamic and changeable. As cultural theorist Jane Bennett (2010, 20–38) argues, assemblages are active and affective: "Assemblages are not governed by any central head: no one materiality or type of material has sufficient competence to determine consistently the trajectory or impact of the group. The effects generated by an assemblage are, rather, emergent properties."

By thinking of rock art sites as assemblages I acknowledge the heterogeneous, emergent, and changeable character of rock art. In this conception, rock art images-as-assemblages are each ontologically distinct, as each rock art site is composed of a different kind of assemblage. Rock art assemblages might be constituted of distinctive geologies, histories, locales, relationships to landscape, relationship to neighboring rock art sites, and modes of landscape habitation, etc. This is what I imply by arguing for a non-hierarchical *ground-up* view of rock art ontologies; I take this to be what Alberti (2016, 164) means when he argues that discussions of ontology should force us to investigate the *ground* on which we stand.

My non-hierarchical approach to rock art ontologies has two important implications. First, it rejects hierarchical approaches to rock art interpretation, such as Taçon and Chippindale's (1998) distinction between ethnographically rich "informed" approaches as compared to "formal" approaches that do not rely on ethnography (for fuller critique of this approach see Jones 2017). Rather than taking an epistemological approach concerned with divining the correct

"meaning" of rock art images, an ontologically non-hierarchical approach is interested instead in what *composes* rock art images, and what rock art images *do*. In my conception of rock art images-as-assemblages ethnographic knowledge is simply another component of the assemblage, its inclusion may add to the assemblage, and thus alter our understanding of the ontological composition of rock art, but its absence does not render rock art ontologically meaningless.

Second, the notion of rock art images-as-assemblages forces us to re-evaluate the simplistic notion of images as representations. The view of each rock art site as relationally and ecologically connected to places in different ways offers a richer understanding of images as nodes in networks, as emergent gatherings points involved in reconfiguring past relationships and mapping future relations. The idea of rock art images as signs might be components of these assemblages, or they might not. One of the tasks of rock art analysis becomes instead to understand how images are ontologically composed, and if and how images might function as representations. Rather than thinking of representations as hierarchically prior to assemblages, instead representation should be considered as an emergent process and outcome of assemblages-in-the-making.

In this chapter I have used agrarian rock art as a device for questioning the ontological assumption amongst some rock art scholars that images should be considered representations. Instead I propose a notion of images-as-assemblages (see also Jones and Cochrane 2018, 183–92), as nodes in complex ecological networks, which offer an ontologically diverse account of images in which each image is dynamically related to different environments, landscapes, ecologies. Rather than an ontologically narrow view of images I propose an ontologically diverse view. It should go without saying that this ontological diversity should extend to accounts of the rock art of both agrarian and hunter-gatherer societies.

Note

1 Thanks to Oscar Moro Abadía and Martin Porr for the invitation to contribute to this edited collection. The chapter was originally written during a period of sabbatical leave in June 2019 and was revised during the Covid-19 lockdown in April 2020.

References cited

Alberti, Benjamin. 2016. "Archaeologies of ontology." *Annual Review of Anthropology 45*: 163–179.

Alberti, Benjamin, and Severin Fowles. 2018 "Ecologies of rock art in northern New Mexico." In *Multispecies Archaeology*, edited by S.E. Pilaar Birch, 133–153. London: Routledge.

Back Danielsson, Ing-Marie, and Andrew M. Jones. 2020. "Images in the making: An introduction." In *Images in the Making. Art, Process, Archaeology*, edited by Ing-Marie Back Danielsson and Andrew M. Jones, 1–16. Manchester: Manchester University Press.

Ballard, Chris, Richard Bradley, Lise N. Myhre, and Meredith Wilson. 2004. "The ship as symbol in the prehistory of Scandinavia and Southeast Asia." *World Archaeology 35* (3): 385–403.

Barad, Karen. 2007. *Meeting the Universe Halfway: Quantum Physics and the Entanglement of Matter and Meaning.* Durham: Duke University Press.

Bayliss, Alex, and Muiris O'Sullivan. 2013. "Interpreting chronologies for the Mound of the Hostages, Tara and its contemporary context in Neolithic and Bronze Age Ireland." In *Tara: From the Past to the Future*, edited by Muiris O'Sullivan, Chris Scarre and Maureen Doyle, 26–104. Bray: Wordwell.

Bennett, Jane. 2010. *Vibrant Matter: A Political Ecology of Things.* Durham: Duke University Press.

Bergh, Stefan, and Robert Hensey. 2013. "Unpicking the chronology of Carrowmore." *Oxford Journal of Archaeology 32* (4): 343–366.

Bolt, Barbara. 2004. *Art Beyond Representation. The Performative Power of the Image.* London: IB Tauris.

Borić, Dusan. 2013. "Theater of predation: Beneath the skin of Göbekli Tepe images." In *Relational Archaeologies. Humans, Animals, Things*, edited by Christopher Watts, 42–64. London: Routledge.

Bradley, Richard. 1997. *Rock Art and the Prehistory of Atlantic Europe. Signing the Land.* London: Routledge.

Bradley, Richard. 1998. *The Significance of Monuments: On the Shaping of Human Experience in Neolithic and Bronze Age Europe.* London: Routledge.

Bradley, Richard. 2009. *Image and Audience. Rethinking Prehistoric Art.* Oxford: Oxford University Press.

Bradley, Richard, and Aaron Watson. 2019. "Found architecture: Interpreting a cup-marked outcrop in the southern Highlands of Scotland." *Time and Mind 12* (1): 3–31.

Brady, Liam M., and John J. Bradley. 2016. "'Who do you want to kill?': Affectual and relational understandings at a sorcery rock art site in the southwest Gulf of Carpentaria, northern Australia." *Journal of the Royal Anthropological Institute 22* (4): 884–901.

Cochrane, Andrew. 2009. "Additive subtractions: Addressing pick dressing in Irish passage tombs." In *Archaeology and the Politics of Vision in a Post-Modern Context*, edited by Julian Thomas and Vítor Oliveira Jorge, 163–185. Cambridge: Cambridge Scholars Publishing.

Conkey, Margaret W. 1980. "The identification of prehistoric hunter-gatherer aggregation sites: The case of Altamira." *Current Anthropology 21* (5): 609–630.

Conkey, Margaret W. 1997. "Beyond and between the caves: Thinking about context in the interpretative process." In *Beyond Art. Pleistocene Image and Symbol*, edited by Margaret W. Conkey, Olga Soffer, Deborah Stratmann, and Nina G. Jablonski, 343–367. San Francisco: University of California Press.

Cooney, Gabriel. 2000. *Landscapes of Neolithic Ireland.* London: Routledge.

Creese, John L. 2017. "Art as kinship: Signs of life in the Eastern Woodlands." *Cambridge Archaeological Journal 27* (4): 643–654.

David, Bruno. 2017. *Cave Art.* London: Thames and Hudson.

Descola, Philippe. 2005. *Beyond Nature and Culture.* Translated by Janet Lloyd. Chicago: The University of Chicago Press.

Eco, Umberto. 1986 [1959]. *Art and Beauty in the Middle Ages.* New Haven: Yale University Press.

Fahlander, Fredrick. 2013. "Articulating relations: A non-representational view of Scandinavian rock art." *Archaeology After Interpretation. Returning Materials to Archaeological Theory*, edited by Benjamin Alberti, Andrew M. Jones, and Joshua Pollard, 305–324. Walnut Creek: Left Coast Press.

Fahlander, Fredrik. 2020. "The partial and the vague as visual mode in Bronze Age rock art." In *Images in the Making. Art, Process, Archaeology*, edited by Ing-Marie Back Danielsson and Andrew M. Jones, 202–215. Manchester: Manchester University Press.

Fowles, Severin. 2013. *An Archaeology of Doings. Secularism and the Study of Pueblo Religion.* Santa Fe: SAR Press.

Freedman, Davina. 2011. "Kilmartin in context I: Kilmartin and the rock art of prehistoric Scotland." In *An Animate Landscape. Rock Art and the Prehistory of Kilmartin, Argyll, Scotland*, edited by Andrew M. Jones, Davina Freedman, Blaze O'Connor, Hugo Lamdin-Whymark, Richard Tipping, and Aaron Watson, 282–311. Oxford: Oxbow.

Gittins, Rhiannon, and Paul Pettitt. 2017. "Is Palaeolithic cave art consistent with costly signalling theory? Lascaux as a test case." *World Archaeology 49* (4): 466–490.

Goldhahn, Joakim. 2008. "From monuments in landscape to landscapes in monuments: Monuments, death and landscape in Early Bronze Age Scandinavia." In *Prehistoric Europe. Theory and Practice*, edited by Andrew M. Jones, 56–85. Malden: Wiley-Blackwell.

Goldhahn, Joakim. 2009. "Bredarör on Kivik: A monumental cairn and the history of its interpretation." *Antiquity 83* (320): 359–371.

Goldhahn, Joakim. 2014. "Engraved biographies. Rock art and the life histories of Bronze Age objects." *Current Swedish Archaeology 22*: 97–136.

Goldhahn, Joakim. 2016. *Sagaholm. North European Bronze Age Rock Art and Burial Ritual.* Oxford: Oxbow.

Goldhahn, Joakim, Ingrid Fuglestvedt, and Andrew M. Jones. 2010. "Changing pictures: An introduction." In *Changing Pictures. Rock Art Traditions and Visions in Northern Europe*, edited by Joakim Goldhahn, Ingrid Fuglestvedt, and Andrew M. Jones, 1–22. Oxford: Oxbow.

Green, Martin. 2000. *A Landscape Revealed: 10,000 Years on a Chalkland Farm.* Stroud: Tempus.

Hamilakis, Yannis, and Andrew M. Jones. 2017. "Archaeology and assemblage." *Cambridge Archaeological Journal 27* (1): 77–84.

Ingold, Tim. 2000a. "'People like us': The concept of the anatomically modern human." In *The Perception of the Environment. Essays in Livelihood, Dwelling and Skill*, edited by Tim Ingold, 373–391. London: Routledge.

Ingold, Tim. 2000b. "From trust to domination: An alternative history of human-animal relations." In *The Perception of the Environment. Essays in Livelihood, Dwelling and Skill*, edited by Tim Ingold, 61–76. London: Routledge.

Ingold, T. 2000c. "On weaving a basket." In *The Perception of the Environment. Essays in Livelihood, Dwelling and Skill*, edited by Tim Ingold, 339–348. London: Routledge.

Jervis, Ben. 2019. *Assemblage Thinking and Archaeology.* London: Routledge.

Jones, Andrew M. 2004. "By way of illustration: Art, memory and materiality in the Irish Sea and beyond." In *The Neolithic of the Irish Sea: Materiality and Traditions of Practice*, edited by Vicki Cummings and Chris Fowler, 202–213. Oxford: Oxbow.

Jones, Andrew M. 2006. "Animated images. Images, agency and landscape in Kilmartin, Argyll, Scotland." *Journal of Material Culture 11*: 211–225.

Jones, Andrew M. 2017. "Rock art and ontology." *Annual Review of Anthropology 46*: 167–181.

Jones, Andrew M., and Andrew Cochrane. 2018. *The Archaeology of Art. Materials, Practices, Affects.* London: Routledge.

Jones, Andrew M., and Marta Díaz-Guardamino. 2019. *Making a Mark: Image and Process in Neolithic Britain and Ireland.* Oxford: Oxbow.

Kaul, Flemming. 1998. *Ships on Bronzes. A Study in Bronze Age Religion and Iconography.* Copenhagen: PNM Studies in Archaeology and History.

Kristiansen, Kristian. 1987. "Centre and periphery in Bronze Age Scandinavia." In *Centre and Periphery in the Ancient World*, edited by Michael J. Rowlands, Mogens Larsen, and Kristian Kristiansen, 74–95. Cambridge: Cambridge University Press.

Lewis-Williams, David, and Sam Challis. 2012. *Deciphering Ancient Minds: The Mystery of San Bushman Rock Art.* London: Thames & Hudson.

Ling, Johan. 2008. *Elevated Rock Art. Towards a Maritime Understanding of Rock Art in Northern Bohuslän, Sweden.* Gothenburg: GOTARC Series B, Gothenburg Archaeological Thesis 49.

McDonald, Jo, and Peter Veth. 2006. "Rock art and social identity: A comparison of Holocene graphic systems in arid and fertile environments." In *Archaeology of Oceania. Australia and the Pacific Islands*, edited by Ian Lilley, 96–115. Malden: Wiley-Blackwell.

Nash, George, and Andrés Troncoso. 2017. "The socio-ritual organisation of the upper Limarí Valley: Two rock art traditions, one landscape." *Journal of Arid Environments 143*: 15–21.

Nimura, Courtney. 2016. *Prehistoric rock art in Scandinavia. Agency and Environmental Change.* Oxford: Oxbow.

O'Connor, Blaze. 2006. "Inscribed landscapes." PhD diss., University College Dublin.

O'Kelly, Michael J. 1982. *Newgrange. Archaeology, Art and Legend.* London: Thames and Hudson.

Plato. 2007. *The Republic.* Translated by Desmond Lee. London: Penguin.

Porr, Martin. 2018. "Country and relational ontology in the Kimberley, Northwest Australia: Implications for understanding and representing archaeological evidence." *Cambridge Archaeological Journal* 28 (3): 395–409.

Pluciennik, Mark. 2008. "Hunter-gatherers to farmers?" In *Prehistoric Europe. Theory and Practice*, edited by Andrew M. Jones, 16–34. Malden: Wiley-Blackwell.

Robin, Guillaume (2009). *L'architecture des signes: L'art pariétal des tombeaux néolithiques autour de la mer d'Irlande.* Rennes: Presses Universitaires de Rennes.

Robinson, David. 2013. "Transmorphic being, corresponding affect: Ontology and rock art in South-Central California." In *Archaeology After Interpretation. Returning Materials to Archaeological Theory*, edited by Benjamin Alberti, Andrew M. Jones, and Joshua Pollard, 59–78. Walnut Creek: Left Coast Press.

Ross, Mairi. 2001. "Emerging trends in rock-art research: Hunter–gatherer culture, land and landscape." *Antiquity 75* (289): 543–548.

Schaafsma, Polly. 2009. "The cave in the kiva: The kiva niche and painted walls in the Rio Grande Valley." *American Antiquity 74* (4): 664–690.

Shapland, Andrew. 2013. "Shifting horizons and emerging ontologies in the Bronze Age Aegean." In *Relational Archaeologies. Humans, Animals, Things*, edited by Christopher Watts, 190–208. London: Routledge.

Shee Twohig, Elizabeth. 2012. "Inside and outside: Visual culture at Loughcrew, Co. Meath." In *Visualising the Neolithic*, edited by Andrew Cochrane and Andrew M. Jones, 125–139. Oxford: Oxbow.

Skoglund, Peter. 2010. "Cosmology and performance: Narrative perspectives on Scandinavian rock art." In *Changing Pictures. Rock Art Traditions and Visions in Northern Europe*, edited by Joakim Goldhahn, Ingrid Fuglestvedt, and Andrew M. Jones, 127–138. Oxford: Oxbow.

Skoglund, Peter, Johan Ling, and Ulf Bertilsson. 2017. *North Meets South. Theoretical Aspects on the Northern and Southern Rock Art Traditions in Scandinavia.* Oxford: Oxbow.

Snead, James E. 2008 *Ancestral Landscapes of the Pueblo World*. Tucson: University of Arizona Press.

Straus, Lawrence. 1975–1976. "The Upper Palaeolithic cave site of Altamira (Santander, Spain)." *Quaternaria 19*: 135–147.

Taçon, Paul. 1994. "Socialising landscapes: The long-term implication of signs, symbols and marks on the land." *Archaeology in Oceania 29*: 117–129.

Taçon, Paul S., and Christopher Chippindale. 1998. "An archaeology of rock-art through informed methods." In *The Archaeology of Rock Art*, edited by Christopher Chippindale and Paul S. Taçon, 1–10. Cambridge: Cambridge University press.

Thomas, Antonia. 2016. *Art and Architecture in Neolithic Orkney. Process, Temporality and Context*. Oxford: Archaeopress.

Troncoso, Andrés. 2019. "Rock art, ontology and cosmopolitics in the Southern Andes." *Time and Mind 12*: 1–12.

Valdez-Tullett, Joana. 2019. *Design and Connectivity: The Case of Atlantic Rock Art*. Oxford: British Archaeological Reports.

Vergara, Francisco, and Andrés Troncoso. 2015. "Rock art, technique and technology: An exploratory study of hunter-gatherer and agrarian communities in pre-Hispanic Chile (500 to 1450 CE)." *Rock Art Research 32* (1): 31–45.

Williams, John. L., and Jane Kenney. 2011. "A chronological framework for the Graig Lwyd axe factory, an interim scheme." *Archaeology in Wales 38*: 3–21.

Wobst, Martin. 1977. "Stylistic behavior and information exchange." In *For the Director: Research Essays in Honor of J. B. Griffin*, edited by Charles E. Cleland, 317–342. Ann Arbor: Anthropological Papers 61, Museum of Anthropology, University of Michigan.

3 Rock art, shamanism, and the ontological turn

David S. Whitley

1 Introduction

I admit experiencing surprise if not confusion when I read a decade ago that archaeological theory was then experiencing an "ontological turn." This emphasized the importance of relational theories of being in interpretations of non-Western prehistory, in opposition to a (static) Western binary view of existence which putatively had driven previous archaeological interpretation. *How could this be new?* I at first thought, recognizing that the last three decades of research on shamanism and rock art were exactly predicated on acknowledging the ontological distinctions in the groups we studied. But once this surprise wore off, a larger question arose: Why were many archaeological theorists incapable of seeing how this earlier research had foreshadowed their own?

A facile reply would be poor scholarship on the part of the (recent) proponents of this theoretical movement. A kinder interpretation might suggest that rock art research was always marginalized in archaeology and thus simply has been overlooked. But I believe that significant fundamental issues instead have been at play; ones not acknowledged by these essentially passive explanations. These involve contemporary ontological commitments: perceptions about the nature of social reality, including the confusion of universalism with uniformity, and the resulting false belief that shamanism involves a projection of an essentialist, ideal-typic model onto the past, with the related and radical but empirically ungrounded commitment to radical alterity; and an overemphasis on the role of human agency in social life, to the near exclusion of social and cultural structure. Shamanistic rock art studies were actively, not passively, ignored from this perspective, because they contradict these recent theoretical commitments.

I start in the following with a brief review of some of the shamanistic rock art literature to demonstrate that, indeed, many of the concerns of the recent ontological turn have always been included in this research. Next is a discussion of the confusion of universality with universalism, to counter the belief in radical alterity that is current in some recent archaeological research. I conclude by summarizing some longer points made in a recent paper (Whitley 2020) concerning the tie between archaeological theory and neoliberalism, to explain the recent rise of archaeological theories effectively devoid of social and cultural structure.

Note that my point is not to argue that all rock art, nor even all hunter-gatherer rock art, is shamanistic. Clearly it is not. My point rather is to emphasize that all rock arts are not wholly different from all other rock arts, everywhere and for all time. Our goal should be to discover both the cross-cultural similarities and the differences in these different corpora of art. Instead of jumping on theoretical bandwagons, we also need to critically assess the assumptions underlying our theories and ontological commitments, including their intellectual histories. This is especially critical now, as some strains of archaeological theory are quickly but unwittingly becoming handmaidens to right-wing political movements. Right-wing politics are the wrong way for archaeology to advance its research program.

2 Shamanism and the first ontological turn

That research on shamanism requires acknowledging an ontological view distinct from the Western Enlightenment perspective is obvious to anyone familiar with the ethnographic literature. This should also be clear even to those who have only read popular publications, such as Carlos Castaneda's (1968, 1991) best-selling early books on Yaqui religion. His titles alone (*A Yaqui Way of Knowledge* and *A Separate Reality*, respectively) give this away. Castaneda of course has been criticized as a fabulist but, whether ultimately true or not, he started his academic career as a scholar (his first book was the published version of his MA thesis at the University of California, Los Angeles). Castaneda was a fixture in the UCLA Anthropology department (the "UCLA School of Shamanism," as it has sometimes been called) during the early 1970s, where he had recently graduated and where I was a student at the time. Castaneda was often enlisted to give classroom lectures, and I attended many of these. The emphasis of Castaneda's lectures was the importance of what he called "ethnohermeneutics." By this Castaneda meant attaining an emic understanding of the culture under anthropological investigation: the epistemology, ontology, and phenomenology of a given society, interpreted in their own terms. Although many (perhaps most) of his readers have focused on the psychedelics and visionary experiences described in Castaneda's first two books, an anthropological reading shows them to emphasize the explicit intellectual, philosophical, and perceptual conflicts between the Cartesian and the Native American worldviews. Castenada set himself up as an embodiment of Western rationalism in a kind of dim-witted battle against its (seemingly smarter) indigenous foil, represented by the Yaqui shaman Juan Matus. This was a narrative device that emphasized the distinctions between the two, dramatically illustrating that the Yaqui world could only be understood by shedding Western presuppositions. Castaneda had been a journalist, which is to say a professional writer, before he became a student of anthropology later in his life. He likely used this journalistic style because he knew how to communicate beyond dry academic prose, as his book sales and resulting fame demonstrated.

Conkey (1997) has noted, in this regard, that rock art research underwent a revolution in the 1980s and 1990s resulting from the use of ethnographic sources.

But this is only part of that story. Rock art research was revolutionized not simply due to the use of ethnography but instead because the appropriate interpretive methods were employed to understand the ethnographic sources—as Castaneda would have emphasized. In western North America, for example, Julian Steward (1929)—an ethnographer and anthropological theorist of substantial renown—published an early synthesis of California and Great Basin rock art, but he concluded that then-contemporary Native Americans knew nothing about the art.[1] Heizer and Baumhoff (1962), both likewise well-versed in ethnographic and ethnohistorical research, came to an equivalent conclusion. Yet as subsequent research has demonstrated, repeatedly (e.g., Whitley 1994a, 1998a, 2000a; Zedeño and Hamm 2001; Carroll 2007; Stoffle et al. 2011a, 2011b), substantial ethnography in fact exists on the making and meaning of rock art in this region, despite the failure of these early researchers to recognize this information. This resulted for one primary reason. Earlier researchers did not apprehend the ontological distinctions that made the ethnographic statements logical, consistent and informed, instead inferring that the commentary was incoherent gibberish signaling a lack of any knowledge about the art. Put another way, many ethnographically relevant statements about rock art can only be recognized as such when the ontological differences between the Western and the indigenous worldviews are themselves understood. The success of ethnographically informed rock art research, much of which has focused on shamanistic arts, signaled a tacit ontological turn in rock art research, and in archaeology then more generally.

Though overlooking the shamanism literature, Jones (2017) summarized recent ontological approaches to rock art research. His identified topics provide a useful platform for discussing the earlier shamanistic analyses. Following Alberti (2016), Jones distinguished between metaphysical versus anthropologically inspired approaches to ontology, noting that the latter are more common in rock art research. Although there has been a discussion of ontological metaphysics in the shamanistic studies (e.g., Carroll et al. 2004; Whitley 2009; Whitley and Whitley 2012), most likewise address anthropological interests. I highlight Jones' topics below and how they have been discussed and developed in the rock art and shamanism studies.

2.1 Transformation and personhood

Jones (2017, 173) cited "transmorphism" as a key affective trait that could be found in rock art as exemplary of an ontological perspective; other authors consider the nature of personhood (especially involving other species) as a second important variable (e.g., Wallis 2009; Creese 2011; Harwood and Ruuska 2013). The two concepts are related in shamanistic rock art studies. Lewis-Williams (1981) first illustrated the significance of the relational ontologies of shamanistic societies with the ethnographic commentary he highlighted in his groundbreaking book on San rock art, emphasizing symbolic relationships and linguistic connections between categories of people and certain animal species. For example:

I asked !Kun/obe why the !Kung performed an Eland Bull dance, she replied: "The Eland Bull dance is so-called because the eland is a good thing and has much fat. And the girl is also a good thing and she is all fat; therefore they are called the same thing."

<div align="right">(Lewis-Williams 1981, 127)</div>

Even more directly, Lewis-Williams' discussions and illustrations of therianthropes—conflations of humans and animals—can only be understood in ontological terms as transformational, involving a comingling of species. As I have noted, in a parallel example:

As one Yokuts informant said of a bear shaman performing the yearly Bear Dance: "Spectators said to [the shaman], 'If you are a bear, let's see your hair!' At once the black painted portions [of his body] turned into hair all over the man's limbs." Masked and costumed animal dancers were not merely humans wearing animal disguises, they were individuals who, having these same species as spirit helpers, had supernaturally transformed into them.

<div align="right">(Whitley 2000a, 119–120)</div>

Therianthropes are a widely occurring theme in shamanistic arts, signaling the special relationship that existed between humans and their spirit helpers, often but not always animal in form. In eastern California and the Great Basin, for example, the bighorn (or mountain) sheep (*Ovis canadensis*) was a common shaman's spirit helper. The equivalence between the shaman and this tutelary spirit is portrayed by partially transformed zoomorphs (bighorns with plantigrade human feet; Figure 3.1). Shamanistic rock art itself, in other words, illustrates the complex relational concept of being achieved and maintained by the shaman, including the shaman's transformed sense of personhood.

This was expressed not solely through graphic illustrations, however, but in terms of agency; specifically, the stated origin of shamanistic rock art. Rock art was commonly attributed to the actions of a spirit, often diminutive in size. Consultants' statements (in different languages), for example, claimed that:

[Pictographs] were painted on the rocks by [supernatural] brownies (*ya'hi'iwal*) who are about the size of a 5-yr.-old child.

<div align="right">(Voegelin 1938, 58)</div>

Petroglyphs …are said to be *tutuguuvo?pi*, marked by *tutuguuviwi* [spirit helpers].

<div align="right">(Laird 1976,123)</div>

[Rock art is made by] "something like a baby called *pah or oh*."

<div align="right">(Irwin 1980, 32)</div>

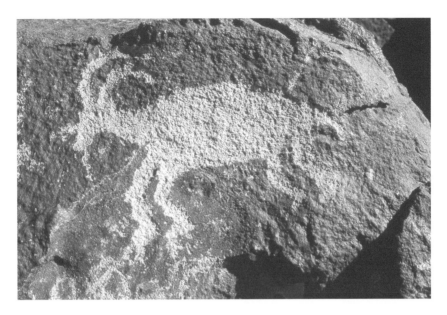

Figure 3.1 Bighorn sheep engraving, Big Petroglyph Canyon, Cos Range, California. Note the flat plantigrade feet signaling that this is a therianthrope rather than a biological bighorn.

Source: Photo by D.S. Whitley.

[T]he Indians attributed all such markings to the doctor's helpers.

(Laird 1984, 302)

The rock drawings are supposed to represent spirits and have been made by the spirits themselves. Each spirit draws its own picture.

(Hultkrantz 1987, 94)

We talk about the little people, the *De-ju-gu-oos* that are responsible for making [the] original drawings. They were for the powerful people who knew how to read [the markings] and use those and they could grow from there.

(Stoffle et al. 2011a, 29)

Places with *tumpituxwinap* [rock art] are used by religious specialists during ceremonial activities because these rock paintings are believed to be derived from supernatural authorship.

(Stoffle et al. 2011b, 14)

Physical transformation combined with the shaman's loss of their own agency illustrate the shift from a binary relationship to a unitary state of being,

emphasizing a kind of personhood distinct from our Western view. These ethnographic comments apparently were especially problematic to early researchers who dismissed them as evidence that Native Americans knew nothing about the art and that it was not part of their heritage (Whitley 1992, 2013). But this was just ontological confusion: the actions of a shaman and their spirit helper, in fact, were indistinguishable (Gayton 1948; Applegate 1978; Siskin 1983; Laird 1984). To state that the art was made by a spirit helper was simply another way of saying that it was made by a shaman, without potentially violating the taboo against naming the dead. Rather than gibberish, "The ethnographic comments instead reflect widespread cultural beliefs that are based on specific kinds of knowledge, and a non-Western/scientific ontological system" (Whitley 2013, 84). As Zawadzka thus observed for another North American region:

> Canadian Shield rock art is especially associated with medicine men, vision questing youth and the *maymaygwaysiwuk*, other-the-human-beings who live within cliffs on water and who were also credited with the creation of some images … Images are especially believed to be a record of dream visions … Through dream visions, humans acquired the help, knowledge and protection of other powerful other-than-human persons in exchange for abiding by a series of obligations towards the guardian spirit … rock art created in this context sealed the relationship between humans and other than-human-persons and enhanced the efficacy of the blessings obtained in dreams.
>
> (2019, 83–84)

Recognizing the importance of humans' special relationships with animal species in shamanistic societies, it has been possible in one case to identify the individual Yokuts shaman-artist responsible for painting a site due to his totemic association with a beaver, rarely portrayed in the regional paintings and linked to the *Tokeluywich* moiety (Whitley 1992, 1994a, 2000b; see Figure 3.2): sometimes, contrary to Jones' (2017) unsupported assertion that such an effort is "delusional," it is possible to identify structures like moieties archaeologically. In another case, the ethnography describes a shaman's use of a specific site to seek power from the Kawaiisu spirit Yahwera, the Master of the Game who controlled hunters' access to deer (Whitley 2000a, 78–79; Figure 3.3). The shaman, in this example, was central to the relationship of all hunters to their prey, with the shaman implementing the spiritual reciprocity required for hunting success. Reichel-Dolmatoff (1967, 1971), in his ethnographic studies of shamanistic rock art in lowland South America, elaborated at length on this origin of Tucano (sometimes "Tukano") rock art and its relationship to Waí-maxsë their Master of the Animals (and Fishes). Tucano symbolism, however, was ultimately linked to sexuality and thus fertility:

> With a red pigment they paint on the rocky walls the animals which the hunters need, thus reaffirming their request to Waí-maxsë. Next to the figures, or within their bodies, they paint the signs which, according to the Tucano, symbolize fertility: rows of dots that signify drops of semen,

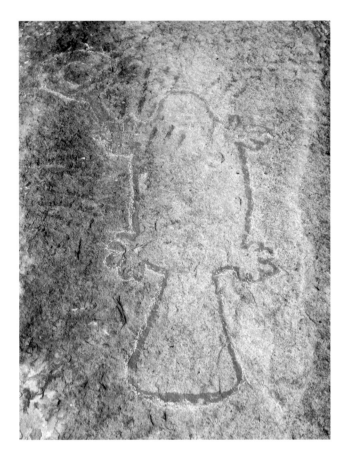

Figure 3.2 Red beaver painting from the Tule Painted Rock site (CA-TUL-19), Tule River
Indian Reservation, California. Beaver were associated with the *Tokeluywich*
moiety among the Yokuts who occupied this area. The *Tokeluywich* shaman
Mayemai lived and practiced at this village at the turn of the twentieth century
and is believed to have painted parts of this site (Whitley 1992, 103).
Source: Photo by D.S. Whitley.

lines in zigzag which signify the succession of generations, or lines which fill
up the body of the animal and signify its fecundity.

(Reichel-Dolmatoff 1967, 111)

Keyser and Whitley (2006) and subsequently McGranaghan and Challis (2016)
and Challis (2019) have thus identified so-called hunting magic practices as
components of some shamanistic rock art traditions, keyed to the special re-
lationships between shamans, hunters, and prey. They have demonstrated that
shamans were the necessary bridge upon which these relationships were

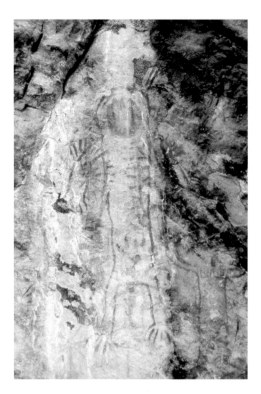

Figure 3.3 A painted anthropomorphic figure at the Back Canyon site (CA-KER-2412), *cugʲʷamihava?adi*, Greenhorn Mountains, California. A Kawaiisu story recounts a vision quest which involved meeting Yahwera, the Master of the Game who controlled deer and thus hunters' fortunes. This encounter occurred inside the rock art site, indicating that it served as a portal to the supernatural.
Source: Photo by D.S. Whitley.

established. That is, these relationships required the active participation of shamans with the production of rock art a key performative element in their practices.

As should then be clear, the explicit adoption of an ontological perspective was the foundation of ethnographically based shamanistic rock art interpretations. Absent this change, the ethnographic data would have remained unrecognized. The putative lack of such evidence would then continue to serve as justification for the colonialist claim that rock art has no connection to contemporary indigenous people, as was argued by Heizer and Baumhoff (1962) and has been parroted by many others, thereby continuing to strip indigenous peoples of their rightful heritage.

2.2 The ontology of images

Jones (2017) correctly notes that most attempts to decipher the symbolic meaning of rock art treat the motifs as iconographic or semiotic images, akin to texts. This is also true for some shamanistic interpretations. There are, however, important exceptions within this literature, likely representing the most direct efforts to consider the ontology of the imagery. These start with Lewis-Williams' (1986, 1992, 1995, 2015; Jolly 1986) discussion of the ethnographic account from a descendant of a San painter, collected in the 1980s. This described both the making of pigment, requiring the use eland's blood which thus resulted in motifs that themselves were considered "reservoirs of potency" (Lewis-Williams 2012, 24), and the active ritual use of the paintings involving dancers touching and rubbing the images to acquire this power. As I have noted similarly, likewise arguing against purely textual exegesis:

> At issue is ultimately a historical undercurrent of the West's Judeo-Christian heritage and its longstanding bias against "pagan idolatry," whereby spiritual potency is invested in material objects. This legacy contributes to our inability to see objects as more than functional implements, made by humans, or (lately) intellectualized as abstract signs and symbols representing other concepts.
>
> (2009, 178; see also Whitley 1996, 160)

Rock art motifs were thus material spiritual beings in their own right, one result of which was their use in shamanic sorcery (Whitley 2000a). But another is the continuing concern that many Native Americans hold for these sites, recognizing that, with their potential destruction, powerful "sickness" would be released into the world (Whitley 1996, 2000a). Recognition of this ontological distinction, derived from research on shamanism and rock art, is a key issue in the indigenous repainting of sites and thus in heritage management (Whitley 2001a).

A second example of concern with the ontology of images in the shamanism literature is the study of the tools used to make Mojave Desert engravings and the implications derived therefrom. Based on foreign materials analyses, these were quartz hammerstones, selectively utilized because, when struck, quartz reacts with a photon glow due to its triboluminescent/piezoelectric properties, considered a visible demonstration of the potency of this rock. Pertinent ethnography indicates that shamans also broke up quartz to acquire the power it contained, visually manifest in the resulting glow. Concentrations of broken quartz near rock art sites, and offerings of quartz crystals placed in cracks near rock art panels, are common in the region (Whitley 2001b; Whitley et al. 1999), augmenting our understanding of ritual practices at the sites and emphasizing the perceived inherent potency of the individual motifs.

In another example, Keyser and Taylor (2006) analyzed Columbia Plateau incised art arguing that its creation was analogous to ritual gashing, undertaken during shamanic and non-shamanic vision questing. Noting that supplicants

practiced mutilation to both release and acquire supernatural power, and that this could require drinking the released blood and eating pieces of their own removed flesh, they drew a parallel to the northern California practice whereby non-shamans ground cupules into specific rocks (known colloquially as "baby rocks") and collected the resulting powder. They either ingested this powder or inserted it into the woman's vagina to enhance her fertility, demonstrating in this case the perceived potency of the rock itself and how it could be used for direct material effect (Whitley 2000a, 98–101).

Acknowledgment of the ontological significance of rock art motifs has thus been central to understandings of the shamanistic art, how it was used in active performance, and how it should be managed as a heritage resource.

2.3 Landscapes of rock art

Numerous studies of shamanic rock art have involved analyses of landscape at both the regional and panel scales. I have argued, for example, that the distribution of Native Californian rock art sites represents a landscape of power, both in a spiritual and politico-economic sense (Whitley 1998; Whitley and Whitley 2012). Understanding this distribution requires attention to the symbolism of the sites as portals to the supernatural world, the distribution of water as the abode of spirits, how the landscape was conceptualized with respect to gender and power, and the correlation between habitation and rock art sites. Francis and Loendorf (2002) and Loendorf (2004) have shown how the elevational/topographical distribution of specific motifs in the Dinwoody region, Wyoming, mirrors Numic conceptualizations of the world, with images of "water people" at the lowest elevations, "ground people" at mid-elevations, and "sky-people" at the top, and how these distinctions structured vision questing, with supplicants intentionally traveling to specific locales to obtain relationships with specific kinds of beings. Arsenault (2004) looked at the geographical distribution of Algonkian sites and how this relates to beliefs about sacred places along with the importance of visual and acoustical effects at these sites. Emphasizing that landscape is socially created and serves as a kind of topographical mnemonic, Loubser, Hann and I have argued that "landscape constitutes a strong force in the prescriptive aspects of cultural performance and the interpretation of meanings" (Whitley et al. 2004, 218). In an ethnographic study, Van Vlack (2012) has included rock art sites in her analysis of shamanistic pilgrimage trails, considering especially their performative characteristics. She notes that:

> Cultural narratives that link people to place are at the core of ontological and epistemological understandings, historic memory, and [Traditional Ecological Knowledge]. Places retain memories of human interactions in the same manner that people retain memories of place and associated interactions.
>
> (Van Vlack, 96–7)

Concern at the scale of the rock art panel, in contrast, was first emphasized by Lewis-Williams and Dowson (1990) when they characterized the lithic panel or support as a veil between worlds. Dozens of studies relating the placement and nature of motifs to characteristics of rock art panels, especially cracks and holes suggestive of movement in and out of different worlds, have resulted (e.g., Keyser and Poetschat 2004).

2.4 Sensorial/affective aspects of rock art

Jones (2017) identifies sensorial and affective studies of rock art as components of recent ontological approaches to rock art although, strictly, these concern phenomenology more than ontology, per se. This point aside, as Rozwadowski (2012) has emphasized, no aspect of shamanistic rock art interpretation has been more prominent than the concern with the phenomenology of visions and of the imagery that results from trance experiences. These phenomena were effectively codified in Lewis-Williams and Dowson's (1988) neuropsychological model, which has been used analytically in many contexts. Equally important, however, has been the identification of the characteristic somatosensory effects of altered states of consciousness (ASC). There is a range of variation in these bodily, sensory and emotional reactions such that no two ASC experiences may be the same but, cross-culturally, all such experiences typically will fall within certain limits. They are embodied reactions, in this sense (Culley 2003, 2008; Whitley 2009, 2013; Hampson 2016) and, because ASC experiences are often ineffable, they served as widely used metaphors for these experiences (Lewis-Williams and Loubser 1986; Whitley 1994a, 2000a, 2001b, 2013, 2019).

Additional phenomenological approaches to shamanistic rock art include Mazel's (2011) landscape level analysis of color and sound in Didema Gorge, South Africa, and Liwosz's (2017, 2018) studies of two sites in the Mojave Desert, which emphasize auditory characteristics.

The first ontological turn in archaeology resulted in detailed understandings of the origin and symbolic meaning of rock art in many parts of the world. Instead of being ignorant of or inimical to a concern with relational ontologies, shamanistic rock art research instead exactly required acknowledging ontological distinctions that are markedly different from our Cartesian worldview for their interpretive success—as would necessarily be required, as Castaneda emphasized a half-century ago.

3 Radical alterity versus empirical reality

Jones argued against the utility of shamanistic rock art interpretations, claiming that they are an overgeneralization of anthropological models, illustrating a "fixed and unitary category ... as an overarching approach to swaths of global rock art" (2017, 176). I suspect that many proponents of recent ontological (and animistic) approaches share this opinion, and that it partly explains why shamanistic studies have been ignored. More at issue here, I believe however, is the ontology of contemporary social reality rather than empirical circumstances

involving shamanistic interpretations. I consider two contemporary social onto-logical commitments that have contributed to the rejection of shamanistic re-search in the following: the belief in radical (or near-radical) alterity, and the neoliberal reaction against socio-cultural structure. But let me start with the simple empirical issue first.

Jones' claim that all shamanistic interpretations are effectively equivalent and that they are an essentialist, one-size-fits-all projection onto the past is simply false, itself resulting from an essentialist model of shamanism and its projection onto all shamanistic research. In my own publications, for example, from the start I have explicitly identified the diversity in shamanistic beliefs and practices that occurred in Native California (e.g., Whitley 1992, 2000a, 2006, 2011), in-cluding among adjacent tribal groups, and also how these differ from non-shamanistic religions (and their rock art) in this same region. These have included identifying distinctions in the age, gender and social identities of the artists; ritual contexts; ownership/use of sites; imagery; and change over time, among others (e.g., Whitley 1994b; Whitley et al. 1999). They have included considerations of the social and ideological implications of Native Californian shamanistic social systems which are markedly different from the shamanism and its social context among the San (compare Lewis-Williams 1982; Whitley 1994b; Whitley and Whitley 2012), to cite one comparative case. And, as I have noted with respect to Native California alone:

> [T]he hunter-gatherer cognitive world was varied, quite complex, and … we should expect that their religious, ritual, and symbolic systems would be equally rich, nuanced and variable. Ethnographic Native Californian religions demonstrate this point: these varied from barely elaborated forms of shamanism, to formal shamanic cults and secret societies, to priestly World Renewal religions, with almost every variation in between. Similar variability is evident worldwide. The tendency to conceptualize hunter-gatherer religions as an opposition between either shamanism or totemism, as if all hunter-gatherer religions can be satisfactorily placed into one of these two categories, reduces a diverse empirical reality to near-unrecognizable simplicity.
>
> (Whitley 2014, 1276)

The recent rejection of shamanistic interpretive approaches by some researchers has not then resulted from the research alone and its putative failings. Instead, I contend, it partly involves a social ontological commitment—a perception of social reality—primarily derived from western post-modernism. This is radical alterity (e.g., Keesing 1990), itself a form of extreme relativism: the belief that all cultures are inherently different and, effectively therefore, all generalizations across cultures are invalid. The result is that cross-cultural ethnography, and the concepts that it employs, are themselves suspect. As with many post-modern concerns, this is an extreme position on a smaller point. Yes, for example, sci-entific theories entail philosophical and ideological assumptions, but this does not

mean that science is wholly or exclusively philosophical or ideological, or irre-deemably biased (one value of scientific method is that it can help remove such biases). Likewise, while there may be differences in the characteristics of one culture versus another, no one has demonstrated that every cultural trait (nor any constellation of such traits), everywhere, is different from every other, and it is massively implausible that such would be the case. Indeed, there are countless ethnographic studies that support specific similarities between societies and cultures; not least of these are shared mythic corpora and ritual-belief systems among certain tribal groups in a given region.

The idea that all cultures are somehow (magically) entirely unique, further-more, is predicated on the equally false notion that they are somehow and ev-erywhere siloed into distinct ethno-geographic groups. Yet we have known, since Barth's (1969) careful study of territorial boundaries, that ethnic co-residence was common, even among small scale, rock-art-producing societies (e.g., Stoffle and Zedeño 2001). We also know that such circumstances occurred prehistorically; for example, at Teotihuacàn with its well-known Oaxacan enclave (e.g., White et al. 1998).

Certain shared traits and similarities in fact do not reduce societies or cultures to full equivalence, nor does this circumstance remove all variability from the societies and cultures under study. Traits may be universal, in the sense that all humans and human societies have some form of them, but this does not mean that they ne-cessarily are everywhere uniform (Menon and Cassaniti 2017). Christianity and its many variants, for example, as well as Judaism and Islam are all monotheistic, Abrahamic religions. Instead of somehow being incorrect (or "delusional") to label them as such, this classificatory label has significant implications for understanding their history and origin, and at least certain of their beliefs. It has both great empirical and heuristic utility; it is silly to contend otherwise.

The key point here is that, as with the implications of Abrahamic religions, "shamanism" rightly is where research to understand a specific religious system starts, not where it stops. Instead of eliminating potential variability, it provides a basis upon which local differences can be explored and understood. This is easily illustrated by the different meanings shamanistic Native American cultures at-tributed even at the level of individual motifs. In Native California generally the zigzag is understood as symbolic of the Sidewinder rattlesnake (*Crotalus cerastes*), reflecting the pattern this snake makes as it moves through sand. In the Northern Plains, in contrast, the zigzag represents lightning and thus its source, the mythic Thunderbird, modeled on the pattern of lightning often seen in the sky. But in both cases the origin of this image is a common entoptic pattern that is visualized during an altered state of consciousness: the origin of the motif but not its meaning. Zigzag/rattlesnake, moreover, is specifically associated with girls' puberty initiations in southwestern California, because rattlesnakes are believed to guard women's vaginas and (in a symbolic inversion) this snake was a pre-ferred spirit helper for females. Sidewinders and Diamondback (*Crotalus atrox*) rattlesnakes, in South-Central California in contrast, were thought guardians of the supernatural. Entering this realm required passing by them and they are

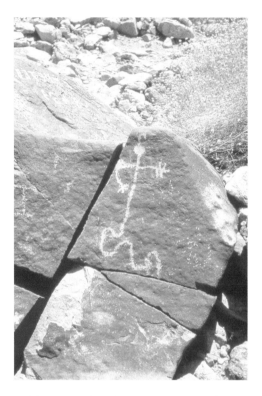

Figure 3.4 An engraved human-rattlesnake therianthrope, McCoy Springs site, Colorado
Desert, California. Rattlesnakes, as dangerous and therefore supernaturally
powerful beings, were commonly referenced spirits in far Western North
American shamanistic beliefs, but their specific function and meaning varied by
region and tribe. This example emerges from a crack in the rocks which shamans
used to move back and forth between the natural and supernatural realms.
Source: Photo by D.S. Whitley.

often painted at shamans' sites, signaling these locations as portals to that world.
In the Great Basin, as third example, they were the spirit helpers of rattlesnake
shamans, giving those shamans the power to cure snake bites (Whitley 2000a).
Figure 3.4, from the California Desert, depicts a human-rattlesnake conflation,
emerging out of a crack in the rocks, an entrance to the supernatural world,
showing the supernatural power obtained and special relationship maintained by
a rattlesnake shaman.

The irony of course is that any discussion of conceptual categories such as
relational ontologies in fact requires cross-cultural ethnographic generalizations,
though this is often implicit (Whitley 2020). Yet as Costa and Fausto (2010, 95)
have noted, the ontological turn privileges "the order of concepts over the order
of practice." More to the point, researchers can only plausibly discuss non-binary

relational ontologies as widely applicable outside of the west because this distinction itself is a widely accepted anthropological generalization. Despite how fashionable it has become to deny this fact, all of our research depends on generalized social/anthropological concepts and unstated analogies. Empirically speaking, radical alterity is in fact radically implausible. Denying this reality results in the twin problems of not recognizing there is this problem, as well as the confusions resulting from operating under this false social ontological commitment.

4 Ontology and the neoliberal turn

The second issue contributing to a turn from shamanistic rock art interpretations has been the overemphasis on individual agency and the (effective) exclusion of concern with structure in much recent archaeological theory: arguments for bottom-up (individual action) rather than top-down (structural) social and cultural processes. Shamanistic interpretations, involving a series of specific structural features and shared general beliefs, are considered unacceptable from this perspective.

Skousen and Buchanan (2015, 1), for example, contend that "human and non-human entities, places, things, and knowledge were situated in a world of relationships and were hence continuously constructed, negotiated, and in a state of becoming." Deriding any concern with social or cultural structure, they argue that social life is constantly in a state of flux, movement and change. Pauketat (2011), arguing for the dominance of bottom-up social processes, proclaims that:

> [I]f there is a religious dimension to so much of what people do, then religious practices are continuously exposed to the circumstances and agendas of networks or landscapes in flux. And this historical process means that structuralist or cognitivist positions, often borrowed from ethnology via analogy, can no longer be allowed.
>
> (2011, 229)

Pauketat contradicts himself in his strident assertion: if the religious dimension of peoples' action is a historical process, then it is partly a predetermined, top-down and structural aspect of social life inasmuch as the past then influences the future.[2] But this is not the main point of concern, which instead is the radical belief that social life is primarily bottom-up. This would be a world created of and by individual humans during their daily lives, perhaps reacting to their surroundings: social life without social or cultural structures, such as shamanism. Human social relations, from a bottom-up perspective, are inherently subjective and constantly in flux, while structures such as stable religions (or, apparently, phenomena like kinship, systemic racism or gender inequalities) did not exist. As noted elsewhere, however, these beliefs treat:

> social life ontologically [as if] flattened to individual transactional relationships, viewed as fluctuating mesh-works or entanglements, with the existence

of long-lasting social structures like class and gender inequality analytically ignored. It is of course correct that social life can be conceptualized as a web of relationships. This is the basis for formal network analyses. But, outside of such analyses, this conceptualization is only trivially true.

<div style="text-align: right">(Whitley 2020, 27)</div>

The radical emphasis on individual experiences and interactions, without constraining structure, furthermore, reifies subjectivity and subjective experiences including, not incidentally, the psychological.[3] But, as Geertz (1973, 49) put it, this makes humans "unworkable monstrosities." Theoretical research for the last century in anthropology and sociology in fact has emphasized the importance of integrating human action and agency with social and cultural structures—from Durkheim to Weber to Parsons and beyond. For as Giddens (1984, 219) has observed, "Every research investigation in the social sciences or history is involved in relating action to structure."

Why then has the bottom-up view of social life not only become widespread, but accepted by many without question for the prehistoric past? The answer, I contend, lies outside of archaeology and anthropology in the presuppositions that support our contemporary social ontology, through the rise of neoliberal political-economic theory. Harvey (2007, 3) noted that:

> Neoliberalism has … become hegemonic as a mode of discourse. It has pervasive effects on ways of thought to the point where it has become incorporated into the common-sense way many of us interpret, live in, and understand the world.

I have described the origins and implications of neoliberalism in archaeological theory elsewhere (Whitley 2020; see also Chomsky, 1999; Harvey 2007; Springer et al. 2016). Some summary points will suffice here:

- Neoliberalism developed during the 1930s as a political—economic theory in reaction to the extreme statism of Fascism, National Socialism, and Communism.
- It emphasized the primacy of micro-economics (individual behavior in economic exchanges), as supported by Friedrich von Hayek and Milton Freidman, and is now (among other things) associated with "trickle-down" economic policies.
- It valorized individual liberty, freedom, and private property rights as paramount, including the unfettered freedom of the global capitalist markets.
- It remained a somewhat obscure academic theory until the 1970s, when an active campaign was undertaken by corporate interests to promote it.
- This campaign saw fruition in the elections of Margaret Thatcher in the UK and Ronald Reagan in the US.
- Social relations in neoliberalism are viewed as entirely transactional in

nature, with society atomized into individuals, often seen simply as "consumers." As Margaret Thatcher famously proclaimed, "There is no such thing as society: there are individual men and women, and there are families."

- Government and especially governmental control through regulations and laws, and thus structure, are vilified. Ronald Reagan, equally famously, stated that "Government is not the solution to our problems; government is the problem."

- The contradiction between limited governmental control and the need to protect free-market capitalism has been resolved through an emphasis on law and order, and militarism. The primary role of government is to serve, and preserve, free-market interests. Neoliberalism is internally contradictory in this sense.

- Although Reaganism and Thatcherism were marketed as simply a "return" to conservative values, they instead represented a major change in sociopolitical structure and social relations. Bill Clinton and Tony Blair subsequently normalized this change with their "Third Way."

- The outcomes of neoliberal policies include severely increased income inequality, deregulation, privatization of former community functions (such as schools) into business enterprises, fragmentation of society and social norms, and the demise of unions, among others.

- Neoliberal thought was partly introduced into ostensibly liberal (in the traditional sense of this term) academic thought through post-modernism, including by Thomas Kuhn's relativism, Francois Lyotard (and his famous challenge to meta-narratives as well as his emphasis on micro- rather than macro-analyses), and especially by Michel Foucault (who believed that neoliberalism offered more autonomy to individuals relative to the state, and who used it to critique the left).

- Most perniciously, it has become a widely accepted "commonsense" worldview: the way many people perceive human social relations and the natural order of things. Worse, this social ontological commitment has been implicitly but unwittingly adopted by many people who would otherwise oppose its socio-political implications. It is an ideology and, like many ideologies, it is a system of unquestioned belief rather than a reflection of reality, as developed through critical thinking, analytical reasoning and empirical research.

There is no better evidence of this last point than the significant number of archaeologists who now apparently believe that the neoliberal model of contemporary society, as an ever-changing web of transactional relationships, is an appropriate analog for prehistoric, pre-capitalist societies. It is easy to understand in this context why shamanistic interpretations would then be ignored and/or derided: they emphasize exactly the kinds of social relations and structure that neoliberalism condemns. The irony of course is the wrong-headed view that

shamanistic interpretations impose essentialist models on the past, because they fail to conform to twenty-first-century, post-industrial, capitalist neoliberal ideology.

The point here is not to suggest that individual agency has no place in human social life. Nor does this mean that cultural or social structure causes behavior, in a pure top-down sense. But it also does not mean, as Pauketat seems to contend, that social life is entirely or mostly bottom-up, where: "individual behaviors are produced as adaptations to an environment, and culture is later extrapolated as a result of behavioral adaptations" (Lonner et al. 2019, 6). As a century of anthropological and sociological research has shown, instead, the problem exactly is to integrate structure and action, as Giddens (1984) emphasized. Structure and human agency, in fact, mutually constitute one another: they are co-constitutive for, as Menon and Cassaniti have observed, "human beings become fully human only as members of their cultural communities, absorbing as they mature the symbolic inheritance and the behavioral practices of the community" (2017, 5). Or put another way, emphasizing the psychological element of this process, "psyche and culture … make each other up" (Shweder 1991, 73).

Neoliberalism sold the idea of an entirely bottom-up social life in the interests of global, corporate capitalism (even though this has always been a utopian dream). The adoption of this social ontological ideology leaves no place for the socio-cultural structure implied by a shamanistic religion—let alone religion in more general terms. I would hope that educated academics, including archaeologists, can see through the ideology of Thatcher–Reaganism, and keep it from pre-determining their interpretations of the past.

5 Conclusion

There is an anthropological irony in the circumstances I have discussed here. The first half-century of American cultural anthropology, dominated by Franz Boas and his students, had a central aim. This was to demonstrate that all people shared a fundamentally common human nature: culture, language and race (as it was then called) did not perfectly correlate, their empirical research demonstrated, and it was a mistake then to divide different societies, cultures and individuals into rigid, siloed categories. This was a challenge when Boas started his agenda. Jim Crow ruled in the southern United States; exclusionary regulations limited or prevented immigration by Asians and southeastern Europeans; and the Ku Klux Klan experienced a nationwide revival, partly directed against African-Americans but, in the Southwest, against Catholics—all involving widespread racist beliefs and fears of the "other."

It is clear that, a century later, the West is experiencing a similar resurgence of xenophobic nationalism and racism. The causes of this are complex but the manifestations are straightforward: diversity is vilified, divisions are glorified. The appropriate social role for archaeology, at this moment, I argue, is to counter these tendencies and beliefs. We can show that prehistoric peoples were, in certain cases, very different from contemporary societies and populations. The ontological distinctions between their cognitive systems and our own are a key

example of this diversity. But we need to be equally mindful of the importance of our shared human traits, the unity this promotes, and our role in advancing this information. I believe that shamanistic rock art research has demonstrated its ability to highlight cultural distinctions meanwhile also emphasizing underlying but widely possessed human tendencies and capabilities, and it should be acknowledged and continued for this fact.

Notes

1 Creese (2011, 4) identified Steward's (1955) presuppositions about the *nature: culture* dichotomy as a pernicious characteristic of his ontological commitments. Steward's concern with cultural evolution, and his need to deploy the western Shoshone as the "base-level stage" of human sociocultural level, reducing their culture to an entirely gastric emphasis, also contributed to his blind-sidedness in this regard (Stoffle and Zedeño, 2001).
2 Pauketat (2011) is careful in this and other papers to admit the existence of structure, even noting that there cannot be one without the other. Yet at the same time he denies ("can no longer be allowed") structuralist approaches, trying to have it both ways. The predictable result is contradiction and confusion, stemming from an ideologically driven but empirically flawed conceptualization of social reality.
3 Arguably, the emphasis on social life as networks in a constant state of flux could be said to reflect the contemporary reality of what Manuel Castells (2004) has labeled our current "network society." But, as Castells makes clear, this has resulted from the recent transformation of the world by information technology: "Decentralized and flat," as Elliot (2014, 294) describes it, "rather than pyramidal and hierarchical, are the new boundaries without borders in the network society." That such a conceptualization of social life is inappropriate for pre-internet, ancient societies is obvious, but the promotion of this claim entails an irony. The recent archaeological approach, overemphasizing individual human agency to the near-total exclusion of structure, could be viewed as a kind of Whig History: "the recounting of the past to vindicate the present" (Fuller, 2000, 23). Our contemporary "network society" is the way that it is, from this contorted view, because societies have always been unbounded transactional networks, "constantly in the state of becoming." Castells, who based his argument on detailed empirical analysis, would surely disagree. And archaeologists, who pride themselves on the ability to investigate change over time, should see through this ruse.

References cited

Alberti, Benjamin. 2016. "Archaeologies of ontology." *Annual Reviews in Anthropology* 45: 163–179.
Applegate, Richard B. 1978. *?Atishwin: The Dream-Helper in South-Central California*. Socorro: Ballena Press.
Arsenault, Daniel. 2004. "From natural settings to spiritual places in the Algonkian sacred landscape: An archaeological, ethnohistorical and ethnographic analysis of Canadian Shield rock-art sites." In *The Figured Landscapes of Rock-Art: Looking at Pictures in Place*, edited by Christopher Chippindale and George Nash, 289–317. Cambridge: Cambridge University Press.
Barth, Fredrick. 1969. *Ethnic Groups and Boundaries*. London: Allen Unwin.
Carroll, Kristen Jean. 2007. "Place, performance and social memory in the 1890s ghost dance." PhD Diss., University of Arizona.

Carroll, Alex K., María Nieves Zedeño, and Richard W. Stoffle. 2004. "Landscapes of the ghost dance: A cartography of Numic ritual." *Journal of Archaeological Method and Theory 11*: 127–156.

Castaneda, Carlos. 1968. *The Teachings of Don Juan: A Yaqui Way of Knowledge*. Berkeley: University of California Press.

Castaneda, Carlos. 1991. *A Separate Reality: Further Conversations with Don Juan*. New York: Simon and Schuster.

Castells, Manuel (ed). 2004. *The Network Society: A Cross-Cultural Perspective*. London: Edward Elgar.

Challis, Sam. 2019. "High and mighty: A San expression of excess potency control in high-altitude hunting grounds of southern Africa." *Time & Mind 12*: 169–185.

Chomsky, Noam. 1999. *Profit Over People: Neoliberalism and Global Order*. New York: Seven Stories Press.

Conkey, Margaret W. 1997. "Making a mark: Rock art research." *American Anthropologist 99*: 168–172.

Costa, Luiz, and Carlos Fausto. 2010. "The return of the animists: Recent studies of Amazonian ontologies." *Religion and Society 1* (1): 89–100.

Creese, John L. 2011. "Algonquian rock art and the landscape of power." *Journal of Social Archaeology 11* (1): 3–20.

Culley, Elisabeth V. 2003. "Examining metaphorical reasoning in rock art production: Conceptualizations of self in Coso Range imagery." *American Indian Rock Art 29*: 69–82.

Culley, Elisabeth V. 2008. "Supernatural metaphors and belief in the past: Defining an archaeology of religion." In *Belief in the Past: Theoretical Approaches to the Archaeology of Religion*, edited by D.S. Whitley and K. Hays-Gilpin, 67–83. Walnut Creek: Left Coast Press.

Elliot, Anthony. 2014. *Contemporary Social Theory: An Introduction*. London: Routledge.

Francis, Julie E., and Lawrence L. Loendorf. 2002. *Ancient Visions: Petroglyphs and Pictographs from the Wind River and Bighorn Country, Wyoming and Montana*. Salt Lake City: University of Utah Press.

Fuller, Steve. 2000. *Thomas Kuhn: A Philosophical History of Our Times*. Chicago: The University of Chicago Press.

Gayton, Anna H. 1948. "Yokuts and Western mono ethnography." *University of California Anthropological Records 10*: 1–290.

Geertz, Clifford. 1973. *The Interpretation of Culture*. New York: Basic Books.

Giddens, Anthony. 1984. *The Constitution of Society*. Berkeley: University of California Press.

Hampson, Jamie. 2016. "Embodiment, transformation and ideology in the rock art of trans-Pecos Texas." *Cambridge Archaeological Journal 26* (2): 217–241.

Harvey, David. 2007. *A Brief History of Neoliberalism*. New York: Oxford University Press.

Harwood, Carolyn, and Alex K. Ruuska. 2013. "The personhood of trees: Living artifacts in the Upper Peninsula of Michigan." *Time & Mind 6*: 135–158.

Heizer, Robert F., and Martin A. Baumhoff. 1962. *Prehistoric Rock Art of Nevada and Eastern California*. Berkeley: University of California Press.

Hultkrantz, Ake. 1987. *Native Religions of Western North America: The Power of Visions and Fertility*. New York: Harper Row.

Irwin, Charles N. (ed). 1980. *The Shoshoni Indians of Inyo County, California: The Kerr Manuscript*. Socorro: Ballena Press.

Jolly, Pieter. 1986. "A first-generation descendant of the Transkei San." *South African Archaeological Bulletin 41*: 6–9.

Jones, Andrew M. 2017. "Rock art and ontology." *Annual Review of Anthropology 46*: 167–181.

Keesing, Roger. M. 1990. "Theories of culture revisited." *Canberra Anthropology 13* (2): 46–60.

Keyser, James D., and George Poetschat. 2004. "The canvas as the art: Landscape analysis of the rock-art panel." In *The Figured Landscapes of Rock-art: Looking at Pictures in Place*, edited by Christopher Chippindale and George Nash, 118–130. Cambridge: Cambridge University Press.

Laird, Carobeth. 1976. *The Chemehuevis*. Banning: Malki Museum.

Laird, Carobeth. 1984. *Mirror and Pattern: George Laird's World of Chemehuevi Mythology*. Banning: Malki Museum.

Lewis-Williams, J. David. 1981. *Believing and Seeing: Symbolic Meanings in Southern San Rock Paintings*. London: Academic Press.

Lewis-Williams, J. David. 1982. "The economic and social context of southern San rock art." *Current Anthropology 23* (4): 429–449.

Lewis-Williams, J. David. 1986. "The last testament of the southern San." *South African Archaeological Bulletin 41*: 10–11.

Lewis-Williams, J. David. 1992. "Ethnographic evidence relating to 'trance' and 'shamans'." *South African Archaeological Bulletin 47*: 56–60.

Lewis-Williams, J. David. 1995. "Modelling the production and consumption of rock art." *South African Archaeological Bulletin 50*: 143–154.

Lewis-Williams, J. David. 2012. "Rock art and shamanism." In *A Companion to Rock Art*, edited by Jo McDonald and Peter Veth, 17–33. Oxford: Wiley Blackwell.

Lewis-Williams, J. David. 2015. "Texts and evidence." *South African Archaeological Bulletin 70*: 53–63.

Lewis-Williams, J. David, and Thomas. A. Dowson. 1988. "The signs of all times: Entoptic phenomena in Upper Palaeolithic art." *Current Anthropology 29* (2): 201–245.

Lewis-Williams, J. David, and Thomas. A. Dowson. 1990. "Through the veil: San rock paintings and the rock face." *The South African Archaeological Bulletin 45*: 5–16.

Lewis-Williams, J. David, and Johannes Loubser. 1986. "Deceptive appearances: A critique of southern African rock art studies." *Advances in World Archaeology 5*: 253–289.

Liwosz, Chester R. 2017. "Petroglyphs and *puha*: How multisensory experiences evidence landscape agency." *Time and Mind 10*: 175–210.

Liwosz, Chester R. 2018. "Benchmarks: Ontological considerations at two Mojave Desert petroglyph labyrinths." PhD. diss., University of California Santa Cruz.

Loendorf, Lawrence L. 2004. "Places of power: The placement of Dinwoody petroglyphs across the Wyoming landscape." In *The Figured Landscapes of Rock-Art: Looking at Pictures in Place*, edited by Christopher Chippindale and George Nash, 201–216. Cambridge: Cambridge University Press.

Lonner, Walt J., Kenneth D. Keith, and David Masumoto. 2019. "Culture and the psychology curriculum: Foundations and resources." In *The Handbook of Culture and Psychology*, edited by David Matsumoto and Hyisung C. Kwang, 3–44. Oxford: Oxford University Press.

Mazel, Aron. 2011. "Time, color and sound: Revisiting the rock of Didema Gorge, South Africa." *Time & Mind 4* (3): 283–296.

McGranaghan, Mark, and Sam Challis. 2016. "Reconfiguring hunting magic: Southern Bushman (San) perspectives on taming and their implications for understanding rock art." *Cambridge Archaeological Journal 26*: 579–599.

Menon, Usha, and Julia L. Cassaniti. 2017. "Introduction: Universalism without uniformity." In *Universalism without Uniformity: Explorations in Mind and Culture*, edited by Julia L. Cassaniti and Usha Menon, 1–22. Chicago: The University of Chicago Press.

Pauketat, Timothy R. 2011. "Getting religion: Lessons from ancestral Pueblo history." In *Religious Transformation in the Late Pre-Hispanic Pueblo World*, edited by Donna M. Glowacki and S. Van Keuren, 221–238. Tucson: University of Arizona Press.

Reichel-Dolmatoff, Gerardo. 1967. "Rock paintings of the Vaupes: An essay of interpretation." *Folklore Americas 29* (2): 107–113.

Reichel-Dolmatoff, Gerardo. 1971. *Amazonian Cosmos: The Sexual and Religious Symbolism of the Tukano Indians*. Chicago: The University of Chicago Press.

Rozwadowski, Andrzej. 2012. "Shamanism, rock art and history: Implications from a Central Asian case study." In *Working with Rock Art: Recording, Presenting and Understanding Rock Art Using Indigenous Knowledge*, edited by Benjamin W. Smith, Knut Helskog, and David Morris, 193–204. Johannesburg: Wits University Press.

Shweder, Richard. 1991. *Thinking Through Cultures*. Cambridge: Harvard University Press.

Siskin, Edgar E. 1983. *Washo Shamans and Peyotists: Religious Conflict in an American Indian Tribe*. Salt Lake City: University of Utah Press.

Skousen, B. Jacob, and Meghan E. Buchanan. 2015. "Advancing an archaeology of movements and relationships." In *Tracing the Relational: The Archaeology of Worlds, Spirits, and Temporalities*, edited by Meghan E. Buchanan and B. Jacob Skousen, 1–19. Salt Lake City: University of Utah Press.

Springer, Simon, Kean Birch, and Julie MacLeavy (eds). 2016. *The Handbook of Neoliberalism*. New York: Routledge.

Steward, Julian H. 1929. "Petroglyphs of California and adjoining states." *University of California Publications in American Archaeology and Ethnology 24* (2): 47–238.

Steward, Julian H. 1955. *Theory of Culture Change: The Methodology of Multilinear Evolution*. Chicago: The University of Chicago Press.

Stoffle, Richard W., Kathleen A. Van Vlack, Hannah Z. Johnson, Phillip T. Dukes, Stephanie C. De Sola, and Kristen L. Simmons. 2011a. *Tribally Approved American Indian Ethnographic Analysis of the Proposed Delamar Valley Solar Energy Zone*. Tucson: Bureau of Applied Anthropology of the University of Arizona.

Stoffle, Richard W., Kathleen A. Van Vlack, Hannah Z. Johnson, Phillip T. Dukes, Stephanie C. De Sola, and Kristen L. Simmons. 2011b. *Tribally Approved American Indian Ethnographic Analysis of the Proposed Milford Flats South Solar Energy Zone*. Tucson: Bureau of Applied Anthropology of the University of Arizona.

Stoffle, Richard W., and María Nieves Zedeño. 2001. "Historical memory and ethnographic perspectives on the Southern Paiute homeland." *Journal of California and Great Basin Anthropology 23*: 229–248.

Keyser, James D., and Michael W. Taylor. 2006. "The blade cuts two ways: Using ethnographic analogy to interpret the Columbia Plateau Scratched Style." In *Talking with the Past: The Ethnography of Rock Art*, edited by James D. Keyser, George R. Poetschat, and Michael W. Taylor, 200–221. Portland: Oregon Archaeological Society.

Van Vlack, Katherine A. 2012. "Puaxant Tuvip: Powerlands, Southern Paiute cultural landscapes and pilgrimage trails." PhD diss., University of Arizona.

Voegelin, Erminie W. 1938. *Tubatulabal Ethnography*. Berkeley: University of California Anthropological Records 2: 1–90.

Wallis, Robert J. 2009. "Re-enchanting rock art landscapes: Animic ontologies, nonhuman agency and rhizomic personhood." *Time & Mind 2*: 47–70.

White, Christine D., Michael W. Spence, Hilary Le Q. Stuart-Williams, and Henry P. Schwarcz. 1998. "Oxygen isotopes and the identification of geographical origins: The valley of Oaxaca versus the valley of Mexico." *Journal of Archaeological Science 25*: 643–655.

Whitley, David S. 1992. "Shamanism and rock art in far western North America." *Cambridge Archaeological Journal 2*: 89–113.

Whitley, David S. 1994a. "Shamanism, natural modeling and the rock art of far western North American hunter-gatherers." In *Shamanism and Rock Art in North America*, edited by Solveig A. Turpin, 1–43. San Antonio: Special Publication 1, Rock Art Foundation, Inc.

Whitley, David S. 1994b. "By the hunter, for the gatherer: Art, social relations and subsistence change in the Great Basin." *World Archaeology 25*: 356–373.

Whitley, David S. 1996. *Guide to Rock Art Sites: Southern California and Southern Nevada*. Missoula: Mountain Press.

Whitley, David S. 1998. "Meaning and metaphor in the Coso Petroglyphs: Understanding Great Basin rock art." In *Coso Rock Art: A New Perspective*, edited by Elva Younkin, 109–174. Ridgecrest: Maturango Museum.

Whitley, David S. 2000a. *The Art of the Shaman: Rock Art of California*. Salt Lake City: University of Utah Press.

Whitley, David S. 2000b. "Use and abuse of ethnohistory in the far west." *1999 International Rock Art Congress Proceedings*, *1*: 127–154. Tucson: American Rock Art Research Association.

Whitley, David S. 2001a. "Rock art and rock art research in a worldwide perspective: An introduction." In *Handbook of Rock Art Research*, edited by D.S. Whitley, 7–54. Walnut Creek: AltaMira Press.

Whitley, David S. 2001b. "Science and the sacred: Interpretive theory in US rock art research." In *Theoretical Perspectives in Rock Art Research*, edited by Knut Helskog, 130–157. Oslo: Novus Press.

Whitley, David S. 2006. "Rock art and rites of passage in far western North America." In *Talking with the Past: The Ethnography of Rock Art*, edited by James D. Keyser, George R. Poetschat, and Michael W. Taylor, 295–326. Portland: Oregon Archaeological Society.

Whitley, David S. 2009. *Cave Paintings and the Human Spirit: The Origin of Creativity and Belief*. New York: Prometheus Books.

Whitley, David S. 2011. "Rock art, religion and ritual." In *Oxford Handbook of the Archaeology of Ritual and Religion*, edited by Timothy Insoll, 307–326. Oxford: Oxford University Press.

Whitley, David S. 2013. "Archaeologists, Indians, and evolutionary psychology: Aspects of rock art research." *Time and Mind 6*: 81–88.

Whitley, David S. 2014. "Hunter-gatherer religion and ritual." In *Oxford Handbook of the Archaeology and Anthropology of Hunter-Gatherers*, edited by Vicki Cummings, Peter Jordan, and Marek Zvelebil, 1221–1242. Oxford: Oxford University Press.

Whitley, David S. 2020. "Cognitive archaeology revisited: Agency, structure and the interpreted past." In *Cognitive Archaeology: Mind, Ethnography and the Past in South Africa and Beyond*, edited by David S. Whitley, Johannes H.N. Loubser, and Gavin Whitelaw, 19–47. London: Routledge.

Whitley, David S., Ronald I. Dorn, Joseph M. Simon, Robert Rechtman, and Tamara K. Whitley. 1999. "Sally's rockshelter and the archaeology of the vision quest." *Cambridge Archaeological Journal 9*: 221–246.

Whitley, David S., Johannes H.N. Loubser, and Don Hann. 2004. "Friends in low places: Rock art and landscape on the Modoc plateau." In *The Figured Landscapes of Rock-art: Looking at Pictures in Place*, edited by Christopher Chippindale and George Nash, 217–238. Cambridge: Cambridge University Press.

Whitley, David S., and Tamara K. Whitley. 2012. "A land of visions and dreams." In *Issues in Contemporary California Archaeology*, edited by Terry Jones and Jennifer E. Perry, 255–314. Walnut Creek: Left Coast Press.

Zawadzka, Dagmara. 2019. "Rock art and animism in the Canadian Shield." *Time and Mind 12*: 79–94.

Zedeño, María Nieves, and Kathryn Hamm. 2001. "The Ethnoarchaeology of the Pahute and Rainier Mesas." In *American Indians and the Nevada Test Site: A Model of Research and Cooperation*, edited by Richard W. Stoffle, María Nieves Zedeño, and David B. Halmo, 98–121. Washington, DC: U.S. Government Printing Office.

4 Ontology and human evolution

Neanderthal "art" and the method of controlled equivocation

Oscar Moro Abadía and Amy A. Chase[1]

1 Introduction

As we have already pointed out, there is hardly a more rudimentary or degraded form of industry than that of our Mousterian Man. His use of one simple material only, stone (apart probably from wood and bone), the uniformity, simplicity, and rudeness of his stone implements, and the probable absence of all traces of any pre-occupation of an aesthetic or of a moral kind, are quite in agreement with the brutish appearance of this energetic and clumsy body, of the heavy-jawed skull, which itself still declares the predominance of functions of a purely vegetative or bestial kind over the functions of mind (Boule 1923, 238).

The extent and nature of symbolic behaviour among Neandertals are obscure. Although evidence for Neandertal body ornamentation has been proposed, all cave painting has been attributed to modern humans. Here we present dating results from three sites in Spain that show that cave art emerged in Iberia substantially earlier than previously thought [...] Collectively, these results show that cave art in Iberia is older than 64.8 thousand years (ka). This cave art is the earliest dated so far and predates, by at least 20ka, the arrival of modern humans in Europe, which implies Neandertal authorship (Hoffmann et al. 2018b, 912).

No matter how different the aforementioned conceptualizations of Neanderthals are, there is, in the end, a recurrent theme that has informed archaeological research of these archaic humans since the end of the nineteenth century. Simply put, archaeologists have conceptualized Neanderthals with reference to conceptualizations of anatomically modern humans (hereafter AMHs). As the paragraph from the English translation of Boule's *Fossil Men* illustrates, early conceptualizations of Neanderthals tended to be our own species (as archaeologists have understood it) seen in a "distorting mirror" (Kuper 1988, 5). If *Homo sapiens* were defined by their moral values, sophisticated tools, and artistic skills, Neanderthals were said to be without ethical concerns, technically rudimentary, and unable to express artistic behaviour. This understanding remained largely unchallenged until the turn of the twenty-first century (Trinkaus and Shipman 1992; Stringer and Gamble 1993). At that time, some scholars suggested that Neanderthals were able to create symbolic artefacts, especially 'personal ornaments' (d'Errico et al. 1998, 2003; Zilhão 2007). Since

then, the traditional depiction of Neanderthals has been almost completely reversed, to the point that today an increasing number of archaeologists tend to consider these hominins to have been as intelligent, skilled, and creative as AMHs (Wynn and Coolidge 2011; Zilhão 2012; Villa and Roebroeks 2014). This trajectory has culminated in the publication of the aforementioned paper in *Science,* in which some scholars claim Neanderthal authorship of cave art based on Uranium-Thorium (U-Th) dating of calcite layers covering red pigment markings in three Spanish caves (Hoffmann et al. 2018b).

In this chapter, we look at current developments in ontology to explore whether we can succeed in promoting an alternative account of Neanderthal 'art,' one that is not an overly simplistic version of our own ideas about 'modern people' and 'art.' As several authors have pointed out, research in the social and human sciences has recently been reoriented towards ontological questions (e.g., Holbraad and Pedersen 2017; Harman 2017), including archaeological research (e.g., Alberti et al. 2011; Alberti 2016; Jones 2017; Cipolla 2019; Morini 2019). In this discipline, the 'ontological turn' has resulted in multiple approaches that, for the sake of explanation, Craig Cipolla has recently cataloged into three related but distinct orientations: (A) worldview-focused approaches seeking to explore non-Western Worldviews, (B) relations-focused approaches with their emphasis on relationality, and (C) worlds-focused approaches that take the existence of multiple worlds seriously (Cipolla 2019, 615–617). Besides their differences in archaeology, these varieties of ontological inquiry share—at least—a common trait: they have exclusively focused on Modern Humans. In other words, they have not been applied (yet) to explore other hominins' material records. However, if archaeologists have examined the ontologies of many prehistoric people—including groups from the Neolithic (e.g., Nanoglou 2009; Jones 2020), the Bronze Age (e.g., Fahlander 2018; Shapland 2013) and the Iron Age (e.g., Gosden 2008; Frie 2020)—we see no reason why they cannot examine ontological questions related to other hominin groups, especially Neanderthals. After all, "Neandertals are the best-studied of all extinct hominins, with a rich fossil record sampling hundreds of individuals" (Villa and Roebroeks 2014, 1). After almost 150 years of research, archaeologists have documented an impressive number of Neanderthal archaeological sites within a geographical range that extends from the Near East to Western Europe (Mellars 2010; Villa and Roebroeks 2014). Additionally, in recent years, geneticists have made significant progress decoding the Neanderthal genome (Green et al. 2010; Pääbo 2014). In short, we have enough archaeological and genetic information to pose an ontological inquiry into what might have been the Neanderthals' theory of reality.

This essay, which intends to pursue this inquiry, has four parts. In the first, we examine the different theories about Neanderthal artistic and symbolic artefacts since the end of the nineteenth century. We show how archaeologists have depicted Neanderthals either as inferior or as equal to *Homo sapiens,* but always with reference to the terms and characteristics we use to define Modern Humans. In the second part, we wonder whether it is possible to "view differently many of the interpretative processes traditionally used in the Paleolithic" (Gamble and

Gittins 2007, 112) and modify our own ideas about Neanderthal 'art' to the point of making viable inferences regarding Neanderthal cosmologies. In the third part, we argue that, while this is a difficult task and not something we are attempting to do here, Eduardo Viveiro de Castro's perspectival anthropology provides us with an alternative standpoint from which to think critically about Neanderthal 'art' and alternative ontologies. Finally, in the last two sections, we discuss some of Viveiros de Castros' ideas with reference to the 'art' created by the late Neanderthals of Western Europe.

2 Neanderthals are us: Conceptualizing Neanderthal art

Immediately after the recognition of the prehistoric antiquity of humankind in 1860, archaeologists discovered a number of Paleolithic statuettes and paintings in the caves of Southern France and Northern Spain (Moro Abadía and González Morales 2013; Palacio-Pérez 2013). This, together with the arrival into Europe of Indigenous arts expropriated from the Americas, Africa, and Australasia, reinforced an idea that became popular in most Western countries during the second half of the nineteenth century: the belief that 'art' was a universal activity documented in all times and all places (for a discussion on the ways in which Indigenous arts were appropriated by Western scholars, please see Myers 2002; Morphy 2007; Lowish 2018). For instance, art historian Salomon Reinach wrote in 1908:

> No society, however rudimentary, has altogether ignored art. It is to be found in embryo in the strange tattooed devices that cover the body of the savage, as also in his efforts to give an agreeable shape to the handle of this hatchet or of his knife.
>
> (Reinach 1908, 2)

This certainly did not mean that all artistic traditions were considered of the same value (arts from small-scale societies, as well as prehistoric art, were reduced to the label of 'primitive arts'), but the discovery of prehistoric paintings reinforced the idea that art was "an ahistorical, transcultural, universally valid category of object" (Errington 1998, 54; Morphy and Perkins 2006; Morphy 2007).

Moreover, in the context of these early conceptualizations of prehistoric art, another view became popular among archaeologists and anthropologists: the notion that art was a hallmark of humankind—that is, an experience exclusive to Modern Humans. In other words, art was one of the experiences that separated Modern Humans from their hominin ancestors. For instance, in the second edition (1912) of *Ancient Types of Man* (first published in 1911), Arthur Keith explained that:

> It is in France itself that we find evidence as to the period at which the Cro-Magnon men appeared in Europe. Their brains were large, and we

naturally expect signs of a high mental development. In their hands, art reached a stage of realism which has never been surpassed; they engraved the animals they hunted on bone and ivory with the accurate eye and hand of the true artist.

(Keith 1912, 69)

Art, as the culmination of culture, was said to have originated with *Homo sapiens*. In this climate of opinion, it is not strange that Neanderthals were excluded from the artistic realm. As several authors have pointed out (e.g., Hammond 1982; Van Reybrouck 2002; Sommer 2006), Marcelin Boule's description of the La Chapelle-aux-Saints Neanderthal highly influenced the interpretation of these hominins in the scientific (and non-scientific) milieus of the first half of the twentieth century. Boule begins one of the papers that he devoted to La Chapelle-aux-Saints with some considerations about *Homo sapiens*. He writes that "they were already *Homo sapiens*, with a very developed brain [...], a straight forehead and a perfect vertical stature. The tools and works of art that they have left are also the evidence of their superiority" (Boule 1911, 3). These remains "could be distinguished at first sight" (Boule 1911, 3) from the Neanderthal remains discovered at sites such as Spy, La Naulette, and Krapina. According to Boule, Neanderthal anatomical remains were distinguished by "the inferiority of some morphological traits" (Boule 1911, 3). He concluded by arguing that Neanderthals were biologically incapable of artistic behaviour. In contrast, he suggested that:

the Grimaldi type (i.e. *Homo sapiens*), who certainly was contemporary of the Neanderthal type [...] is not without resemblance with the Bushmen. Archaeological discoveries by Piette, Cartailhac, Capitan, Breuil, Lalanne led us to suggest the existence of more or less strong links between the Quaternary artists from our countries [...] and the predecessors of the last Bushmen, whose artistic productions sometimes look extraordinarily similar to the oldest figurations of our countries.

(Boule 1911, 229)

As these words illustrate, a number of images and artifacts from Paleolithic and Indigenous societies were amalgamated into a label—'primitive art'—that encapsulated, in a highly pejorative way, more of what these representations and objects were not ('modern art') than what they had in common. This interpretation remained largely unchallenged until the 1960s and 1970s. At that time, a number of specialists introduced important changes in the interpretation of Paleolithic images (e.g., Laming-Emperaire 1962; Leroi-Gourhan 1965). In particular, under the influence of structuralism and semiotics, some archaeologists explored the symbolic dimensions of prehistoric art. They argued that Paleolithic images constituted highly structured symbolic systems governed by a number of rules and principles. For instance, Leroi-Gourhan (1965) suggested that Paleolithic imagery reproduced a system in which male and female qualities were

complementary. Such interpretive efforts were clearly focused on demonstration of the ways in which this prehistoric art was congruent with cognitively sophisticated art-making practices usually associated with concepts of 'modern' and 'artists.'

This symbolic paradigm introduced some changes to the conceptualization of the material culture of Neanderthals. In particular, since images were not exclusively conceptualized in terms of their 'beauty' or their 'realism,' a number of non-figurative representations, such as the 'signs,' enjoyed unprecedented popularity. Within this conceptual framework, the period witnessed an increasing ambivalence towards some of the objects created by Neanderthals. The case of the *Grotte du Renne* at *Arcy-sur-Cure* can illustrate this point. Leroi-Gourhan excavated this site between 1948 and 1966. In the Châtelperronian levels (with radiocarbon ages for this site that range from ca. 21,000 to ca. 49,000 BP), he discovered a number of 'personal ornaments' that he described in the following way:

> A number of personal ornaments (*objets de parure*) have been discovered, including canines of fox (*Alopex*) and perforated or grooved incisors of bear and bovid. One of the pendants is a fossil shell (*Rynchonella*) that shows grooves for suspension. More curious are two bone rings very similar of those discovered in the overlying Aurignacian levels (VII). Some bone fragments with engravings representing "hunting marks" ("*marques de chasse*") complete this batch of the oldest known personal or decorated objects.
> (Leroi-Gourhan 1961, 10)

In a context in which most people believed that art was exclusive to modern people, Leroi-Gourhan hesitated to attribute these objects to Neanderthals. This is why he suggested that they may have been created by a group of people that he named *Homo post-néanderthalensis*:

> Speaking about the accepted division between *Homo neandethalensis* and *Homo sapiens*, we have introduced during the last years the concepts of *preneanderthalensis* and *presapiens* which put into question any categorical distinction and suggest the possible existence of *Homo 'post-néanderthalensis'*. If such creatures had existed, they would have been close to those who produced [the 'personal ornaments' discovered] in the levels VIII-XI at *Arcy*.
> (Leroi-Gourhan 1958, 140)

The increasing ambiguity towards Neanderthal artwork saw the emergence of new conceptualizations at the turn of the twenty-first century. At that time, a number of scholars began to propose the 'multiple-species model' which asserted that art and symbolism had *independently* originated among different groups of people, including the late Neanderthals of Europe (e.g., d'Errico et al. 1998; d'Errico 2003; Zilhão 2012; Nowell 2010; Shea 2011). These authors argued that Neanderthals created the 'personal ornaments' excavated by Leroi-Gourhan from the Châtelperronian levels of *Grotte du Renne* (d'Errico et al. 1998). The idea

of Neanderthal symbolism was initially reserved for a number of pigments and objects of 'personal ornamentation' found in the so-called 'transitional' techno-complexes of Europe (d'Errico et al. 2003; Cabrera Valdés et al. 2006; Caron et al. 2011; Zilhão 2012; Hublin et al. 2012). However, in the last ten years, an increasing number of authors have suggested that Neanderthals also created cave art (Pike et al. 2012; Rodríguez-Vidal et al. 2014; Hoffmann et al. 2018b). In particular, the recent publication of some U-Th dates on carbonate crusts overlying what these scholars term "paintings" in the caves of La Pasiega, Maltravieso, and Ardales (Spain) has suggested that cave art in Spain may be more than 65,000 years old (Hoffmann et al. 2018b). According to these scholars, "the implication is […] that the artists were Neandertals" (Hoffmann et al. 2018b, 913). Whether we agree with this statement is not the issue here: the point is that recent conceptualizations of Neanderthal art are based on the idea that Neanderthals and Modern Humans had similar cognitive abilities and, therefore, developed similar kinds of behaviours, including art and symbolism. In this sense, these approaches have contributed to the development of Paleolithic archaeology in three fundamental ways. First, they have called into question a number of prejudices and biases rooted in traditional representations of Neanderthals. Second, they have significantly enlarged the number of materials and images discussed in terms of art and symbolism. And third, they have inspired archaeologists (White et al. 2020) to argue for a more holistic understanding of these images within a wider archaeological context of Neanderthal remains, which leads us to some important challenges.

3 Understanding Neanderthal cosmologies: Challenges

During the last 150 years, Neanderthals have passed from being portrayed as our antithetical ancestors to being depicted as our cognitive equals. This certainly does not mean that the dominant opinion today is that Neanderthals were 'modern' and equal to living populations. Instead, in archaeology, views vary from those who see Neanderthals as incapable of a range of modern behaviours to those who regard them as (more or less) 'modern.' However, that is not the point. The point is that Neanderthals have been characterized in different ways, but typically with reference to modern people. This characterization poses a number of epistemological and interpretive challenges. In fact, since the 1960s, a number of scholars have warned of the dangers of projecting our modern ideas on our interpretations of people from other times or other cultures. For instance, Quentin Skinner, and John Dunn called into question anachronism in the history of ideas (Dunn 1968; Skinner 1969); J.G.A. Pocock criticized the Whig interpretation of political history (Pocock 1962); Thomas Kuhn reacted against the 'whiggish history of science' (Kuhn 1977); Hans Gadamer insisted that historical interpretation could not be submitted to the measure of the present (Gadamer 1979); and George Stocking censored 'presentism' in the field of anthropology (Stocking 1968). As a result of these critiques, most historians, anthropologists, and archaeologists today agree that,

in interpretive terms, scholars dealing with materials from other times or other cultures should put themselves in the position of the people who made those materials. This is, for instance, what Thomas Kuhn suggested in an essay first published in 1968: "Insofar as possible, the historian should set aside the science that he knows [...] Dealing with innovations, the historians should try to think as they did" (Kuhn 1977, 110). These considerations are relevant to promoting alternative conceptualizations of Neanderthal art. Paraphrasing Viveiros de Castro, we can argue that conceptualizing the Neanderthal world as though it was an illusory version of our own is to imagine an overly simplistic form of relationship between Neanderthals and ourselves (Viveiros de Castro 2004, 16). For this reason, instead of imagining Neanderthals as opposed (or as analogous) to Modern Humans, we should try to infer *their own* views. This is not an easy task. In fact, the understanding of the archaeological record is subjected to a number of interpretive constraints and challenges. These issues are somewhat encapsulated in Wittgenstein's famous statement: "If a lion could speak, we could not understand him" (Wittgenstein 1958, 225). On the one hand, we are dealing with an increasing corpus of archaeological materials attributed to Neanderthals and other hominin groups. On the other, we cannot participate in the producers' culture and experience, which is—according to Wittgensten—necessary for understanding them.

Besides these general interpretive issues (that are common to any form of archaeological inquiry), there are a number of specific issues that make the task of reconstructing Neanderthals' cosmologies particularly challenging. To begin, archaeological and anthropological interpretations are grounded on the idea that social scientists and the people they study are the 'same' and 'other.' On the one hand, 'archaeologists' and 'past people' (or 'anthropologists' and 'natives,' to use Viveiros de Castro's distinction—2015a, 3) belong to the *same* species. On the other, they are said to be part of *different* cultures (or to be ontologically *different*). However, the relationships between Neanderthals and Modern Humans cannot be easily understood in these terms. This is related to the fact that their phylogenetic, evolutionary, and archaeological relationships are far from clear. For instance, while today Neanderthals and Modern Humans are considered to be different species, a number of twentieth-century paleoanthropologists suggested that they belonged to the same species (e.g., Chase and Dibble 1987; Tattersall and Schwartz 1999). Furthermore, a number of authors have demonstrated that Neanderthals had "a role in the genetic ancestry of present-day humans outside of Africa" (Green Richard et al. 2010, 710; Fu et al. 2015; Mendez et al. 2016). However, the same authors suggest that "this role was relatively minor given that only a few percent of the genomes of present-day people outside Africa are derived from Neandertals" (Green Richard et al. 2010, 710). More recently, to complicate things, some scholars have argued that "African individuals carry a stronger signal of Neanderthal ancestry than previously thought" (Chen et al. 2020, 667). Finally, the archaeological relationships between Neanderthals and Modern Humans are also very complex. For instance, in France, Neanderthal authorship of Upper-Paleolithic symbolic

materials is mainly based on the association of Neanderthal skeletal remains with Châtelperronian assemblages at the sites of Saint-Césaire and Arcy-sur-Cure (d'Errico et al. 1998; Hublin et al. 2012). However, the idea that Neanderthals created Châtelperronian industries has been called into question (Higham et al. 2010; Gravina et al. 2018). As these examples illustrate, the relationships between Neanderthals and Modern Humans are unclear, and this makes any reconstruction of Neanderthals' cosmologies difficult.

In the second place, the label 'Neanderthal' poses a number of interpretive problems. Anthropological interpretations typically refer to groups of people with distinguishable traits, boundaries, or features. For instance, ethnographies focus on the study of particular human societies. However, in archaeology, due to the scarcity of the archaeological record, we conceive human prehistory with reference to very broad labels. There is, for instance, the Iron Age, the Bronze Age, the Neolithic, the Paleolithic, the Solutrean, the Aurignacian, and the Magdalenian. These cultural-chronological distinctions have contributed to reducing a variety of human groups living in different times and places into single categories. This tendency towards reductionism is particularly strong in the case of human evolution. We speak, for instance, of *Homo habilis*, *Homo erectus*, or *Homo ergaster* to refer to groups of hominins that occupied vast territories for thousands (even millions) of years. In the case of Neanderthals, this label condenses a variety of hominin groups that lived in Europe and Southwestern Asia from ca. 400,000 to 40,000 years ago. While some authors have established a number of basic distinctions between these hominins (see, for instance, Howell's split between 'Classic' and 'Southwest Asian' Neanderthals, Howell 1957), archaeologists and paleoanthropologists use this label in a broad sense. They suggest, for instance, that 'Neanderthals buried their dead,' or that 'they developed symbolic behaviour,' without fully realizing that these kinds of statements would be considered as platitudes if they were made about anatomically modern people. Similarly, the label 'Neanderthal art' supposes the existence of a homogeneous well-defined group of hominins and, in so doing, it hinders our interpretation and further understanding of the *concrete* material culture produced by these hominins. These interpretive problems are certainly not exclusive to Neanderthal research. For instance, we use the category of 'Modern Humans' in the same monolithic way. It is only recently that we have begun to examine the diversity of cultural trajectories behind the variety of materials associated with this group of people (see, e.g., d'Errico et al. 2019).

Finally, when examining Neanderthal cosmologies, there is an interpretive problem that has do to with the nature of archaeological research. In fact, Neanderthals' archaeological record is the result of a research history that has been informed by (A) a number of ideas and prejudices about these hominins, and (B) a number of beliefs about symbolism and art. Therefore, this archaeological record is not only biased by these ideas, but it is the *product* of these preconceptions. The important point here is that we cannot promote an interpretation of Neanderthals' 'art' *ex novo* (anew) because we are constrained to ground our understanding on materials that are the result of a long history of selective (biased) research. In this

setting, playing with Viveiros de Castro's words, our problem is how to create the conditions of the ontological self-determination of the Neanderthals when all we have at our disposal are our own ontological presuppositions (Viveiros de Castro 2015b, 11).

4 Viveiros de Castro's perspectival anthropology

As we have seen in the previous section, there are a number of challenges that make the interpretation of Neanderthal 'art' particularly challenging. While most of these challenges cannot be overcome, we suggest in this section that Viveiros de Castro's method of controlled equivocation provides us with an alternative standpoint from which we can critically approach the question of Neanderthal 'art.' First, we briefly present his theory of Amerindian perspectivism and his method of controlled equivocation (Viveiros de Castro 1998, 2004, 2013a, 2013b, 2015a, 2015b). Second, we suggest that his idea that "different kinds of beings see the same things differently"—a statement that implies "not a plurality of views of a single world, but a single view of different worlds"—may be useful to interpret Neanderthals' 'art' (Viveiros de Castro 2004, 6–7).

As many authors have pointed out (Alberti 2016; Jones 2017; Cipolla 2019), the leading role of Viveiros de Castro in ontological debates is related to the impact of his work on Amerindian 'perspectivism' in the field of anthropology. He uses this term to refer to "a set of ideas and practices found throughout indigenous America" (Viveiros de Castro 2004, 5). In Amerindian cosmologies, the universe is populated by different kinds of beings (e.g., humans and animals) each of which has the same type of soul; that is, the same set of cognitive capacities. This explains why beings of the same kind see the world in the same way (Viveiros de Castro 1998, 477). To be precise, in Amerindian cosmologies, beings of the same kind (either human or other-than-human) see each other as humans see themselves. For instance, "animals impose the same categories and values on reality as humans do: their worlds, like ours, revolve around hunting and fishing, cooking and fermented drinks, cross-cousins and war, initiation rituals, shamans, chiefs, spirit" (Viveiros de Castro 1998, 477). What changes from one kind of being (e.g., humans) to another (e.g., animals) is the "'objective correlative,' the referent of these concepts" (Viveiros de Castro 2004, 6). In other words, animals see things as people, but the things that they see are different from the things that people see:

> What to us is blood, is maize beer to the jaguar; what to the souls of the dead is a rotting corpse, to us is soaking manioc; what we see as a muddy waterhole, the tapirs see as a great ceremonial house.
>
> (Viveiros de Castro 1998, 477–478)

This perspectivism (or difference of perspective) is not grounded on cognitive differences but, rather, "is located in the bodily differences between species,

for the body and its affections [...] is the site and instrument of ontological differentiation and referential disjunction" (Viveiros de Castro 2004, 6).

Viveiros de Castro's theory has a number of methodological implications. In his work, he did not seek to decipher the Amerindian cosmology from a Western viewpoint. Instead, he sought to make explicit the equivocation consisting "in imagining that when the jaguar says 'manioc beer' he is referring to the same thing as us (i.e., a tasty, nutritious and heady brew)" (Viveiros de Castro 2004, 6). In other words, the problem is not to state that jaguar's 'manioc beer' is, *in fact*, human blood; the problem is to fully understand that, when talking about 'manioc beer' and 'human blood,' anthropologists and Amerindians are referring to *different* things. This equivocation is the "condition of possibility of anthropological discourse" (Viveiros de Castro 2004, 10). Anthropology is possible because "different kinds of beings see the same things differently" (Viveiros de Castro 2004, 7) and this variety of views generates misunderstandings (or 'equivocations'). As Viveiros de Castro indicates, anthropologists' goal is not "to unmake the equivocation," but quite the opposite, to fully "emphasize or potentialize" it (Viveiros de Castro 2004, 10). In this sense, 'equivocation' is not a mistake, but rather a "failure to understand that understandings are necessarily not the same, and that they are not related to imaginary ways of 'seeing the world' but to the real worlds that are being seen" (Viveiros de Castro 2004, 11).

Viveiros de Castro's perspectival anthropology (that has been rarely applied to archaeology, see however Mary Weismantel's remarkable work (2015) on the art of Chavín de Huantar) provides us with an alternative standpoint with which to think about Neanderthals' 'art.' To begin, it is important to keep in mind that, from our modern viewpoint, the archaeological record of Neanderthals comprises *similar things* to the archaeological record of Modern Humans, including a variety of tools, objects, artifacts, and animal bones. This is related to the fact that, for more than 100 years, archaeologists have looked for the same relics of past activity in different contexts. However, as we mentioned in section 3, the question is not determining whether Neanderthals were able to do the same things that AMHs did, and even less so to establish whether they were cognitively inferior or equal to us. The point is to say something significant about *their* cosmologies. To do so, we need to consider that those things that, *from our viewpoint*, are the same, were not necessarily the same for Neanderthals and AMHs. For instance, when we find an almost complete skeleton in a Châtelperronian level, we speak about a 'Neanderthal burial.' However, following Viveiros de Castro's example, we can suggest that what Modern Humans see as a 'burial' (a structure related to the act or ceremony of putting a dead body into a grave in the ground), Neanderthals saw in a different way (for instance, as a non-ritualized non-ordinary practice). The challenge, of course, is to determine what Neanderthal views were expressed through this buried skeleton. Besides the obvious fact that this is a difficult task, we should start by accepting that the perspectives of early Modern Humans and those of Neanderthals were not *necessarily* the same. For instance, following Viveiros de Castro, one can wonder whether Neanderthals' and AMHs' bodily experiences

were different enough to generate different perspectives on things. The point is that they probably saw things differently, even if those things look similar in our eyes. To illustrate this point, we examine in section 5 how these ideas can be applied to the question of Neanderthal 'art.'

5 The 'art' of the late Neanderthals of Western Europe and the method of controlled equivocation

In this section we seek to apply Viveiros' ideas to current debates on Neanderthal 'art.' To begin, two theoretical clarifications are in order. First, there is the question of whether bodily and cognitive differences between species can explain ontological differences (i.e., whether AMHs and Neanderthals must have different ontological orientations because they are two different species). In this setting, Viveiros de Castro suggests that "the human form is, literally the form from which all species emerge." Perspectivism is based on "the presupposition that each living species is human in its own department, human for itself (humano *para si*), or better, than everything is human for itself (todo para si é humano) or anthropogenic" (Viveiros de Castro 2013b). In other words, since all "species apprehend themselves more or less as intensely as humans" (Viveiros de Castro 2013b), differences in the genome of modern and non-modern human populations are not considered from an ontological viewpoint. Second, and related to the previous point, if we agree that species differences are irrelevant ontologically speaking, then we cannot speak about *a* Neanderthal ontology (as we do not speak of *an* AMH ontology). Instead, we should speak about multiple ontologies associated to multiple Neanderthal groups. For this reason, in this section we are going to refer to the late Neanderthals that live in Western Europe (especially France and Spain) approximately at the moment in which AMHs arrived into that part of Europe. These people were different from the Neanderthal groups of South Asia in many ways. In particular, they manufactured a number of objects and artefacts that have warranted the label of 'artistic' and/or 'symbolic.' Focusing on this group of people, we are trying to avoid the trap of the 'one-species-one-cognition' axiom that contrasts '*the*' Neanderthals and '*the*' AMHs as two monolithic categories without realizing that, in fact, these were evolving entities.

During the last two decades, a number of archaeologists have suggested that the late Neanderthals from Western Europe created two main kinds of artwork. First, an increasing number of archaeologists have argued that Neanderthals manufactured 'personal ornaments' and other symbolic artefacts (Roebroeks et al. 2012; Peresani et al. 2013; Dayet et al. 2014, Hoffmann et al. 2018a). Second, in the last ten years, some archaeologists have suggested that Neanderthals created rock art (Pike et al. 2012; Rodríguez-Vidal et al. 2014; Hoffmann et al. 2018b). While both statements have been called into question, we will discuss in this section these two forms of artwork with reference to Viveiros de Castro's method of controlled equivocation.

5.1 Late Neanderthals' body ornaments

During most of the twentieth century, so-called 'personal ornaments' were considered one of the symbolic markers of the 'human revolution' associated with the arrival of AMHs into Europe (White 1982; Bar-Yosef 2002; Klein 2003). This consensus began to weaken in 1998, when Francesco d'Errico and others published an important paper in which they suggested that Neanderthals made the personal ornaments found in Grotte du Renne and other Châtelperronian sites (d'Errico et al. 1998). Since then, an increasing number of archaeologists have argued that "Neandertals began to produce a richer archaeological record, including bone tools [and] personal ornaments at the time when AMHs started colonizing Europe" (Villa and Roebroeks 2014, 6; see also Mellars 2005; Higham et al. 2014). Besides the fact that there is an ongoing debate about who created these artifacts (Higham et al. 2010; Mellars 2010; Hublin et al. 2012), the interesting point is that archaeologists assume that the 'personal ornaments' found in Aurignacian (likely associated with AMHs) and Châtelperronian (likely associated with Neanderthals) levels are, in fact, *the same kinds of objects*. The corollary of this is that, in Western Europe, AMHs and late Neanderthals interpreted (or 'saw') these artifacts in the same way (that is in the same way as us, i.e., as 'personal ornaments'). However, following Viveiros de Castro, we can suggest that what we call 'personal ornaments' were, for AMHs and Neanderthals, two different things.

In the case of AMHs, the making of beads has been documented at many sites in Africa dated to about 80,000 years ago (Bouzouggar et al. 2007; d'Errico et al. 2019). In Europe, beginning in the Aurignacian, we see a remarkable intensification in the manufacturing of these objects. For instance, approximately 3500 to 4000 objects termed to be 'beads' have been recovered from the sites of Blanchard, Castanet, La Souquette, Brassempouy, Isturitz, Gatzarria, Regismont, Fumane, Vogelherd, Geissenklösterle, and Hohle Fels alone. This abundance contrasts markedly with the scarcity of 'ornaments' associated with the Neanderthals from Western Europe. For instance, in France, Grotte du Renne and Quinçay are the only sites that have yielded 'personal ornaments' (around 40, but most of them coming from the controversial Châtelperronian layers of Grotte du Renne). In Belgium, Trou Magritte is the only site in which archaeologists have documented one ivory 'ring' associated with Neanderthals. In Germany, no 'ornaments' have been securely attributed to Neanderthal sites. Additionally, it is important to note that so far Neanderthals appear to have produced 'body ornaments' "only after Modern Humans arrived in western Europe and Proto-aurignacian or Early Aurignacian populations occupied neighboring regions" (Hublin et al. 2012, 18748). With these ideas in mind, one could argue that AMHs and Neanderthals saw what we call 'personal ornaments' in very different ways. For AMHs, these artefacts were part of a long-established tradition that originated in Africa and, as they expanded throughout different parts of the world, including Europe, bead-making continued. The considerable number of these objects has led archaeologists to

speculate about their meanings. It has been suggested that they were markers of ethnic, social, and personal identity (Joyce 2005; White 2007); reflected the establishment of social and exchange networks (d'Errico and Vanhaeren 2007; Vanhaeren and d'Errico 2011), and were related to the acquisition of language (d'Errico et al. 2003; Kuhn and Stiner 2007). In the case of the Neanderthals from Spain, France, Italy, and Germany, 'personal ornaments' are rare. They come from a limited number of sites and they were not produced in such significant numbers as are found in most archaeological sites of AMHs. Given this situation, it is hard to imagine how these items could have been part of ethno-linguistic marking or that they formed part of exchange networks. Instead, Neanderthal 'ornaments' appear to have been the product of occasional individual initiatives.

Finally, it is important to note that the notion of 'body ornament' is problematic from an ontological viewpoint. For instance, as Ann Stahl has recently argued, the modern notion of 'ornament' (as a decorative object used to make something or someone look more attractive) builds on the view that "adornment is representation rather than an ontologically significant practice that, through intimate bodily engagements, produced subjects" (Stahl 2018, 204). In a similar vein, Joanna Miller has suggested that body ornaments made by the Mamaindê (Nmabikwara) from the Mato Grosso (Brazil) are related to an exchange system "that points towards ontological rather than sociological distinctions" (Miller 2009, 76).

5.2 'Neanderthal rock art'

During the last ten years, a number of archaeologists have suggested that groups of late Neanderthals created cave art in Spain. In 2012, based on the Uranium-series dating of calcite deposits, a group of scholars suggested a minimum age of 40.8 thousand years old for a red disk motif in El Castillo (Spain) (Pike et al. 2012). More recently, in 2018, a team led by Dirk Hoffmann presented dating results for three Spanish caves (La Pasiega, Maltravieso, and Ardales) suggesting that what they refer to as 'cave art' in Iberia may be older than 64,000 years (Hoffmann et al. 2018b). Since these dates predate, by thousands of years, the arrival of AMHs in Western Europe, these archaeologists suggested Neanderthal authorship. While these dates have been seriously contested (e.g., Aubert et al. 2018; Pearce and Bonneau 2018; Pons-Branchu et al. 2020; White et al. 2020), let us imagine for a moment that groups of Neanderthals created 'cave art' in Western Europe in a chronology that, broadly speaking, ranges from 40,000 to 65,000 years BP. In that case, we can *either* assume that they made the same thing that AMHs did (i.e., but some 20,000 years earlier so, in a strict evolutionary logic, they should be considered as 'precursors' of AMHs) *or* we can try to explore the different ways in which AMHs and Neanderthals understood or cognized images on cave walls. In the case of AMHs, starting around 45,000 years ago, they created cave art in many places around the world, including Europe (García-Diez et al. 2013; Clottes 2016), Indonesia (Aubert et al. 2014, 2018) and Australia (Bruno et al. 2013). While cave

art includes a great variety of motifs and themes (e.g., human depictions and non-figurative representations), animals played a preeminent role in these corpora of visual imagery. For instance, in the area under scrutiny (Western Europe), many Paleolithic representations appear to be animals or parts thereof (Sauvet 2019). In the case of Neanderthals, it is important to note that the rock images so far attributed to them are all non-figurative representations, including the red disk motif from El Castillo, the red scalar form sign from La Pasiega, the red hand stencil from Maltravieso and the red pigments from Ardales (Hoffmann et al. 2018b). Additionally, and this is an important point, *figurative portable art (statuettes, engravings, carvings) is so far absent from Neanderthal archaeological contexts* (this is one of the key archaeological reasons why there is skepticism about claims for Neanderthal 'art'). What can we infer from these observations?

To begin, we can state that AMHs represented animals in a great variety of media and supports, including cave art. This may be related to the fact that, at a certain moment, they needed or wanted to differentiate themselves from the animals that they so abundantly represented. In other words, it is possible that they began to represent animals because they perceived them as different entities. In accordance with Viveiros de Castro, one could suggest that, by representing the difference between humans and animals, Paleolithic artists were perhaps expressing the translation of an 'equivocation' onto the cave walls or into figurines; that is, celebrating the differences in perspectives between them and the animals in order to maintain relations (with animals). It can also be argued that the primacy of animals as the images of cave and portable art has more to do with the relationships/connections with animals than with a need of distancing from them. For instance, some Native American cosmologies insist that in order to 'be' human one must have a relationship with animals (see some instances in Harrod 2000). These relationships, of course, changed across time and space (please keep in mind that we are talking about 25,000 years of animal imagery by AMHs) but it can be argued that it was the necessary relationships with animals—and it is not just any animal, but specially selected ones (bison, horse, etc.)—that mobilized the image-making in caves. Furthermore, in assessing the archaeological record, we can equally suggest that the groups of Neanderthals living in Western Europe from 40,000 to 65,000 years ago did not experience that feeling. Even if, for the sake of explanation, we accept that they did make images on cave walls, the point is that they did not represent animals. In other words, the Neanderthals from Western Europe did not express the difference in perspectives between them and other animals (or, at least, they did not feel the need to or did not want to express those differences in the same way that AMHs did). This example is intended to illustrate that, in Western Europe, groups of AMHs and Neanderthals could have seen/understood their relationships with other animals in different ways.

To sum up, there are many different possible perspectives concerning Neanderthals' and AMHs' differential understandings of 'animality.' For instance, it is possible that the Neanderthals from Western Europe were not concerned about differentiating themselves from other animals (whereas AMHs

were). However, it can also be argued that these groups of Neanderthals established a kind of connection or relationship with certain animals, wherein these animals were not part of their image-making world (whereas AMHs were invested in those relationships and mobilized the making of a variety of images of them for millennia and in all sorts of media). These are just some suggestions that might be worthy to explore from an ontological standpoint.

6 Some concluding thoughts

In this chapter, we have argued that the current concern with ontological questions cannot be directed only to ethnographic case studies or the archaeology of 'recent' periods, but it needs to be extended to all areas of archaeological research. This is related to the fact that differences between human populations are not only adaptive, technological, or cognitive, but they are *also* ontological. These differences explain, for instance, how anatomically modern people did not make 'artistic' images and objects in some contexts and profusely manufactured them in others. Similarly, ontological differences can explain how cultural trajectories led in some cases to the production of figurative images, while in other cases they did not. In this context, concerns with the orientation towards the reality of Pleistocene populations add new levels of complexity and amplify the issue of dealing with radical alterity beyond the known ethnographic and historical record. Moreover, human origins research engages with multiple species, and therefore multispecies approaches that look at the inter and intra-connection between different species should be promoted (Pilaar Birch 2018).

In this spirit, and following Severin Fowles' suggestion in the CA Forum on Theory in Anthropology, we have tried in this chapter to "take seriously the ontological implications of Pleistocene encounters between *Homo sapiens* and Neanderthals, encounters that both radicalize the notion of alterity and bring the boundary between human and nonhuman to a height of uncertainty" (Alberti et al. 2011, 899). To do so, we have examined the 'art' of the late Neanderthals of Western Europe with reference to Viveiros de Castro's method of controlled equivocation. We conclude now with some critical thoughts on our own work. This will allow us to take into consideration some alternative perspectives and, perhaps, to anticipate certain reactions that this chapter will engender.

As we have seen in the first part of this chapter, Neanderthals have been conceptualized either as inferior or as (at least partially) equal to AMHs in important ways. These conceptualizations are flawed because they promote a view of Neanderthals that is dependent on our views and what we consider to be the key characteristics of modern people. For this reason, we have suggested that we should probe the archaeological record to describe Neanderthal cosmologies; that is, to understand the different ways in which they saw themselves and other people and entities. A main challenge to inferring Neanderthal cosmologies derives from the fact that, as we work with established categories of objects, the archaeological record of Neanderthals and AMHs are comprised of the same kinds of things: stone tools, bone objects, etc. While this cannot be changed

(unless we look for and bring into focus other 'kinds' of evidence), we should at least consider the possibility that Neanderthals and AMHs saw and understood those things differently. For instance, we have argued that, based on the number of 'personal ornaments' found in Châtelperronian and Aurignacian contexts in Western Europe, it is likely that the groups of Neanderthals and AMHs living in this area around 45,000 years ago understood these artefacts in very different ways. Similarly, we have claimed that the fact that the groups of Neanderthals living in France and Spain did not represent animals reveals important information about how these hominins thought about and perceived themselves.

However, a number of objections can be raised to these statements. For instance, one could argue that, by suggesting that Neanderthals did not create representational art we are implying that they were cognitively and culturally inferior to AMHs. This is not the case. Archaeological research has sufficiently demonstrated that Neanderthals were cognitively advanced hominins. Moreover, we have no problem accepting that they had the technical skills necessary to create 'personal ornaments' or make a painting on a rock surface. However, we cannot pose the question on cognitive terms *only*. And the reason for this is that there is no link between 'being cognitively advanced' and 'making art' (as it is demonstrated by the fact that many groups of AMHs did not develop figurative art). In other words, the association between art, symbolism, and cognition (either in Neanderthals or AMHs) needs to be critically unpacked. To do so, once we accept that Neanderthals were intelligent people, we need to move forward and try to understand them 'in their own right.' In other words, we need to move from an 'assimilation paradigm' (in which Neanderthals are assimilated to AMHs) to an 'alterity model' seeking to establish their specific views and perspectives. Moreover, it is important to keep in mind that ontological theory can modify not only the way in which we think about Neanderthals, but also the ways in which we conduct archaeological research on these hominins. Ontology has the potential to generate new questions that can translate into new archaeological practices. If, instead of looking for the same kinds of things in Neanderthal and AMH contexts, we start looking for what is specific to Neanderthal groups, we would be in the position of exploring new interpretive possibilities instead of confirming what we think we already know.

To answer to Wittgenstein's paradox, it is likely that if a Neanderthal could speak (and, it is likely that they had developed language anyhow, please see Dediu and Levinson 2018), we probably could not fully understand him/her. But the same can be said about an Anatomically Modern Human living 20,000 years ago. However, this difficulty should not make us lose sight of our one certainty, that traditional conceptualizations are defective in a number of ways. Repeating the same questions over and over (e.g., whether Neandertals were more or less intelligent than AMHs or whether they could do the same things as modern people did) has brought us to a dead end. For this reason, we have explored in this chapter new avenues with which to think about Neanderthals differently. This, of course, does not guarantee the validity of ontological approaches, let alone the success of our strategy. However, to conclude, if we could make a

Neanderthal speak, we would at least make explicit the 'equivocation' that lies at the core of the anthropological (and archaeological) project, i.e., that "understandings are not necessarily the same" and, therefore, that when a Neanderthal and an AMH looked at the same object ('same' from *our* perspective) they were probably seeing different things.

Note

1 We are grateful to Bryn Tapper, Mario Blaser, Margaret Conkey, Francesco d'Errico, Manuel R. González Morales, Andrew M. Jones, and Martin Porr for their comments on previous drafts of this chapter. Any mistakes remain, of course, our own.

References cited

Alberti, Benjamin. 2016. "Archaeologies of ontologies." *Annual Review of Anthropology 45*: 163–179.

Alberti, Benjamin, Severin Fowles, Martin Holbraad, Yvonne Marshall, and Christopher L. Witmore. 2011. "'Worlds otherwise': Archaeology, anthropology, and ontological difference." *Current Anthropology 52* (6): 896–911.

Aubert, M., A. Brumm, M. Ramli, T. Sutikna, E.W. Saptomo, B. Hakim, M.J. Morwood, G.D. Van Den Bergh, L. Kinsley, and A. Dosseto. 2014. "Pleistocene cave art from Sulawesi, Indonesia." *Nature 514* (7521): 223–227.

Aubert, Maxime, Adam Brumm, and Jillian Huntley. 2018. "Early dates for 'Neanderthal cave art' may be wrong." *Journal of Human Evolution 125*: 215–217.

Aubert, M., P. Setiawan, A. Oktaviana, A. Brumm, P.H. Sulistyarto, E.W. Saptomo, B. Istiawan, T.A. Ma'rifat, V.N. Wahyuono, F.T. Atmoko, J.-X. Zhao, J. Huntley, P.S.C. Taçon, Dan Dediu, and Stephen C. Levinson. 2018. "Neanderthal language revisited: Not only us." *Current Opinion in Behavioral Sciences 21*: 49–55.

Bar-Yosef, Ofer. 2002. "The upper Paleolithic revolution." *Annual Review of Anthropology 31* (1): 363–393.

Boule, Marcellin. 1911. "L'homme fossile de la Chapelle-aux-Saints." *Annales de Paléontologie 6*: 1–271.

Boule, Marcellin. 1923. *Fossil Men. Elements of Human Palæontology.* Translated by E.R. Jessie and J. Ritchie. London: Gurney and Jackson.

Bouzouggar, Abdeljalil, Nick Barton, Marian Vanhaeren, Francesco D'Errico, Simon Collcutt, Tom Higham, Edward Hodge, Simon Parfitt, Edward Rhodes, Jean-Luc Schwenninger et al. 2007. "82,000-year-old shell beads from North Africa and implications for the origins of modern human behavior." *Proceedings of the National Academy of Sciences of the United States of America 104* (24): 9964–9969.

Bruno, David, Bryce Barker, Fiona Petchey, Jean-Jacques Delannoy, Jean-Michel Geneste, Cassandra Rowe, Mark Eccleston, Lara Lamb, and Ray Whear. 2013. "A 28,000 year old excavated painted rock from Nawarla Gabarnmang, northern Australia." *Journal of Archaeological Science 40* (5): 2493–2501.

Cabrera Valdés, Victoria, J.M. Maillo Fernández, Anne Pike-Tay, M.D. Garralda Benajes, and Federico Bernaldo de Quirós. 2006. "A Cantabrian perspective on late Neanderthals." In *When Neanderthals and Modern Humans Met*, edited by Nicholas J. Conard, 441–466. Tübingen: Kerns Verlag.

Caron, François, Francesco d'Errico, Pierre Del Moral, Frédéric Santos, and João Zilhão.

2011. "The reality of Neandertal symbolic behavior at the Grotte du Renne, Arcy-sur-Cure, France." *PLoS ONE 6* (6): e21545.

Chase, Philip G., and Harold L. Dibble. 1987. "Middle Paleolithic symbolism: A review of current evidence and interpretations." *Journal of Anthropological Archaeology 6* (1): 263–296.

Chen, Lu, Aaron B. Wolf, Wenqing Fur, Liming Li, and Joshua M. Akey. 2020. "Identifying and interpreting Neanderthal ancestry in African individuals." *Cell 180*, 677–687.

Cipolla, Craig N. 2019. "Taming the ontological wolves: Learning from Iroquoian effigy objects." *American Anthropologist 121* (3): 613–627.

Clottes, Jean. 2016. *What Is Paleolithic Art? Cave Paintings and the Dawn of Human Creativity.* Translated by Robert D. Martin. Chicago: The University of Chicago Press.

Dediu, Dan, and Stephen Levinson. 2018. "Neanderthal language revisited: Not only us." *Current Opinion in Behavioral Sciences 21*: 49–55.

d'Errico, F., J. Zilhão, M. Julien, D. Baffier, and J. Pelegrin. 1998. "Neanderthal acculturation in Western Europe: A critical review of the evidence and its interpretation." *Current Anthropology 39*: 1–44.

d'Errico, Francesco. 2003. "The invisible frontier. A multiple species model for the origin of behavioral modernity." *Evolutionary Anthropology: Issues, News, and Reviews 12* (4): 188–202.

d'Errico, Francesco, Christopher Henshilwood, Graeme Lawson, Marian Vanhaeren, Anne-Marie Tillier, Marie Soressi, Frédérique Bresson et al. 2003. "Archaeological evidence for the emergence of language, symbolism, and music-an alternative multidisciplinary perspective." *Journal of World Prehistory 17* (1): 1–70.

d'Errico, Francesco, and Marian Vanhaeren. 2007. "Evolution or revolution? New evidence for the origin of symbolic behaviour in and out of Africa." In *Rethinking the Human Revolution: New Behavioural and Biological Perspectives on the Origin and Dispersal of Modern Humans*, edited by P. Mellars, K. Boyle, O. Bar-Yosef, and C. Stringer, 275–286. Cambridge: McDonald Institute for Archaeological Research.

d'Errico, F., M. Vanhaeren, K. Van Niekerk, C.S. Henshilwood, and R.M. Erasmus. 2015. "Assessing the accidental versus deliberate colour modification of shell beads: A case study on perforated Nassarius Kraussianus from Blombos Cave Middle Stone Age levels." *Archaeometry 57* (1): 51–76.

d'Errico, Francesco., Africa Pitarch Martí, Ceri Shipton, Emma Le Vaux, Emmanuel Ndiema, Steve Goldstein, Michael D. Petraglia, and Nicole Boivin. 2019. "Trajectories of cultural innovation from the Middle to Later Stone Age in Eastern Africa: Personal ornaments, bone artifacts, and ocher from Panga ya Saidi, Kenya." *Journal of Human Evolution 139*: 1–22.

Dayet, Laure, Francesco d'Errico, and Renata Garcia-Moreno. 2014. "Searching for consistencies in Châtelperronian pigment use." *Journal of Archaeological Science 44* (1): 180–193.

Dunn, J. 1968. "The identity of the history of ideas." *Philosophy xliii*: 85–104.

Errington, Shelly. 1998. *The Death of Authentic Primitive Art and Other Tales of Progress.* Berkeley: University of California Press.

Fahlander, Frederik. 2018. "The relational life of trees. Ontological aspects of 'tree-ness' in the Early Bronze Age of northern Europe." *Open Archaeology 4*: 373–385.

Frie, Adrienne C. 2020. "Parts and wholes: The role of animals in the performance of Dolenjska Hallstatt funerary rites." *Arts 9* (2), no. 53.

Fu, Qiaomei, Mateja Hajdinjak, Oana Teodora Moldovan, Silviu Constantin, Swapan Mallick, Pontus Skoglund, Nick Patterson et al. 2015. "An early modern human from Romania with a recent Neanderthal ancestor." *Nature 216* (524): 216–219.

Gadamer, Hans-Georg. 1979. "The problem of historical consciousness." In *Interpretive Social Science: A Reader*, edited by Paul Rabinow and William M. Sullivan, 103–160. Berkeley: University of California Press.

Gamble, Clive S., and Erica Gittins. 2007. "Social archaeology and origins research: A Paleolithic perspective." In *A Companion to Social Archaeology*, edited by Lynn Meskell and Robert W. Preucel, 96–118. Malden: Blackwell.

García-Diez, M., D.L. Hoffmann, J. Zilhão, C. De Las Heras, J.A. Lasheras, R. Montes, and A.W.G. Pike. 2013. "Uranium series dating reveals a long sequence of rock art at Altamira Cave (Santillana Del Mar, Cantabria)." *Journal of Archaeological Science 40* (11): 4098–4106.

Gosden, Chris. 2008. "Social ontologies." *Philosophical Transactions of the Royal Society B 363*: 2003–2010.

Gravina, Brad, François Bachellerie, Solène Caux, Emmanuel Discamps, Jean-Philippe Faivre, Aline Galland, Alexandre Michel et al. 2018. "No reliable evidence for a Neanderthal-Châtelperronian association at La Roche-à-Pierrot, Saint-Césaire." *Nature. Scientific Reports 8* (15134).

Green, Richard E., Johannes Krause, Adrian W. Briggs, Tomislav Maricic, Udo Stenzel, Martin Kircher, Nick Patterson et al. 2010. "A draft sequence of the Neandertal genome." *Science 328* (5979): 710–722.

Hammond, Michael. 1982. "The expulsion of the Neanderthals from human ancestry: Marcellin Boule and the social context of scientific research." *Social Studies of Science 12* (1): 1–36.

Harman, Graham. 2017. *Object-Oriented Ontology: A New Theory of Everything*. London: Pelican.

Harrod, Howard L. (ed). 2000. *The Animals Came Dancing: Native American Sacred Ecology and Animal Kinship*. Tucson: University of Arizona Press.

Higham, Thomas, Roger Jacobi, Michèle Julien, Francine David, Laura Basell, Rachel Wood, William Davis et al. 2010. "Chronology of the Grotte du Renne (France) and implications for the context of ornaments and human remains within the Châtelperronian." *Proceedings of the National Academy of Sciences of the United States of America 107* (47): 20234–20239.

Higham, Tom, Katerina Douka, Rachel Wood, Christopher Bronk Ramsey, Fiona Brock, Laura Basell, Marta Camps et al. 2014. "The timing and spatiotemporal patterning of Neanderthal disappearance." *Nature 512* (1): 306–309.

Hoffmann, D.L., D.E. Angelucci, V. Villaverde, J. Zapata, and J. Zilhão. 2018a. "Symbolic use of marine shells and mineral pigments by Iberian Neandertals 115,000 years ago." *Science Advances 4* (2): Eaar5255.

Hoffmann, D.L., C.D. Standish, M. García-Diez, P.B. Pettitt, J.A. Milton, J. Zilhão, J.J. Alcolea-González et al. 2018b. "U-Th dating of carbonate crusts reveal Neanderthal origin of Iberian cave art." *Science 359*: 912–915.

Holbraad, Martin, and Morten Axel Pedersen. 2017. *The Ontological Turn. An Anthropological Exposition*. Cambridge: Cambridge University Press.

Howard, D.L., and H.E.A. Brand. 2018. "Palaeolithic cave art in Borneo." *Nature 564* (7735): 254–257.

Howell, Francis Clark. 1957. "The evolutionary significance of variation and varieties of 'Neanderthal' man." *The Quarterly Review of Biology 32* (4): 330–347.

Hublin, Jean-Jacques, Sahra Talamo, Michèle Julien, David Francine, Nelly Connet, Pierre Bodu, Bernard Vandermeersch et al. 2012. "Radiocarbon dates from the Grotte du Renne and Saint-Cesaire support a Neandertal origin for the Châtêlperronian." *Proceedings of the National Academy of Sciences of the United States of America 109* (46): 18743–18748.

Jones, Andrew M. 2017. "Rock art and ontology." *Annual Review of Anthropology 46*: 167–181.

Jones, Andrew Meirion. 2020. "An archaeology of affect: Art, ontology and the carved stone balls of Neolithic Britain." *Journal of Archaeological Method and Theory 27*: 545–560.

Joyce, Rosemary. 2005. "Archaeology of the body." *Annual Review of Anthropology 34*: 139–158.

Keith, Arthur. 1912. *Ancient Types of Man.* London: Harper & Brothers.

Klein, Richard. 2003. "Paleoanthropology. Whither the Neanderthals?" *Science 299* (5612): 1525–1527.

Kuhn, Thomas. 1977. "The history of science." In *The Essential Tension: Selected Studies in Scientific Tradition and Change,* 105–126. Chicago: The University of Chicago Press.

Kuhn, Steven L., and Mary C. Stiner. 2007. "Paleolithic ornaments: Implications for cognition, demography, and identity." *Diogenes 214*: 40–48.

Kuper, Adam. 1988. *The Invention of Primitive Society. Transformations of an Illusion.* London: Routledge.

Laming-Emperaire, Annette. 1962. *La signification de l'art rupestre paléolithique. Méthodes et applications.* Paris: Picard.

Leroi-Gourhan, André. 1958. "Études des restes humains fossiles provenant des grottes d'Arcy-sur-Cure." *Annales de Paléontologie 44*: 87–148.

Leroi-Gourhan, André. 1961. "Les fouilles d'Arcy-sur-Cure." *Gallia Préhistorique 4*: 3–16.

Leroi-Gourhan, André. 1965. *Préhistoire de l'Art Occidental.* Paris: Mazenod.

Lowish, Susan. 2018. *Rethinking Australia's Art History: The Challenge of Aboriginal Art.* London: Routledge.

Mellars, Paul. 2005. "The impossible coincidence. A single-species model for the origins of modern human behavior in Europe." *Evolutionary Anthropology 14*: 12–27.

Mellars, Paul. 2010. "Neanderthal symbolism and ornament manufacture: The bursting of a bubble?" *Proceedings of the National Academy of Sciences of the United States of America 107* (47): 20147–20148.

Mendez, Fernando L., G. David Poznik, Sergi Castellano, and Carlos D. Bustamante. 2016. "The divergence of Neandertal and modern human Y chromosomes." *American Journal of Human Genetics 98* (1): 728–734.

Miller, Joanna. 2009. "Things as persons. Body ornaments and alterity among the Mamaindê (Nambikwara)." In *The Occult Life of Things. Native Amazonian Theories of Materiality and Personhood,* edited by Fernando Santos-Granero, 60–80. Tucson: The University of Arizona Press.

Morini, Ryan S. 2019. "'What are we doing to these Shoshone people?': The ontological politics of a Shoshone grinding stone." *American Anthropologist 121* (3): 628–640.

Moro Abadía, Oscar, and Manuel R. González Morales. 2013. "Paleolithic art: A cultural history." *Journal of Archaeological Research 21*: 269–306.

Morphy, Howard. 2007. *Becoming Art: Exploring Cross-Cultural Categories.* New York: Berg.

Morphy, H., and M. Perkins. 2006. *The Anthropology of Art: A Reader.* Oxford: Blackwell.

Myers, F.R. 2002. *Painting Culture. The Making of an Aboriginal High Art.* Durham and London: Duke University Press.

Nanoglou, Stratos. 2009. "Animal bodies and ontological discourse in the Greek Neolithic." *Journal of Archaeological Method and Theory 16* (3): 184–204.

Nowell, April. 2010. "Defining behavioral modernity in the context of Neanderthal and anatomically modern human populations." *Annual Review of Anthropology 39*: 437–452.

Pääbo, Svante. 2014. *Neanderthal Man: In Search of Lost Genomes.* New York: Basic Books.

Palacio-Pérez, E. 2013. "The origins of the concept of 'palaeolithic art': Theoretical roots of an idea." *Journal of Archaeological Method and Theory 20* (4): 682–714.

Pearce, David G., and Adelphine Bonneau. 2018. "Trouble on the dating scene." *Nature. Ecology and Evolution 2*: 925–926.

Peresani, Marco, Marian Vanhaeren, Ermanno Quaggiotto, Alain Queffelec, and Francesco d'Errico. 2013. "An ochered fossil marine shell from the Mousterian of Fumane Cave, Italy." *PLoS ONE 8* (7): e68572.

Pike, Alistair W.G., Dirk L. Hoffmann, Marcos García-Diez, Paul B. Pettitt, Javier Alcolea, Rodrigo de Balbín, César González Sainz et al. 2012. "U-series dating of Paleolithic art in 11 caves in Spain." *Science 336*: 1409–1413.

Pilaar Birch, Suzanne E. 2018. *Multispecies Archaeology.* London: Routledge.

Pocock, J.G.A. 1962. "The history of political thought: A methodological enquiry." In *Philosophy, Politics and Society*, edited by Peter Laslett and W. G. Runciman, 183–202. Oxford: Blackwell.

Reinach, Salomon. 1908. *Apollo. An Illustrated Manual of the History of Art throughout the Ages.* Translated by Florence Simmonds. New York: Charles Scribner's sons.

Rodríguez-Vidal, Joaquín, Francesco d'Errico, Francisco Giles Pacheco, Ruth Blasco, Jordi Rosell, Richard P. Jennings, Alain Queffelec et al. 2014. "A rock engraving made by Neanderthals in Gibraltar." *Proceedings of the National Academy of Sciences of the United States of America 111* (37): 13301–13306.

Roebroeks, Wil, Mark J. Sier, Trine Kellberg Nielsen, Dimitri De Loecker, Josep Maria Parés, Charles E.S. Arps, and Herman J. Mücher. 2012. "Use of red ochre by early Neandertals." *Proceedings of the National Academy of Sciences of the United States of America 109* (6): 1889–1894.

Sauvet, G. 2019. "The hierarchy of animals in the Paleolithic iconography." *Journal of Archaeological Science: Reports 28.* www.sciencedirect.com/science/article/pii/S2352409X19301932?via%3Dihub.

Shapland, A. 2013. "Shifting horizons and emerging ontologies in the Bronze Age Aegean." In *Relational Archaeologies: Humans, Animals, Things*, edited by C. Watts, 190–208. London: Routledge.

Shea, John J. 2011. "*Homo sapiens* is as *Homo sapiens* was: Behavioral variability versus 'behavioral modernity' in Paleolithic archaeology." *Current Anthropology 52* (1): 1–35.

Skinner, Q. 1969. "Meaning and understanding in the history of ideas." *History and Theory viii*: 3–53.

Sommer, Marianne. 2006. "Mirror, mirror on the wall: Neanderthal as images and 'distortion' in early twentieth-century French science and press." *Social Studies of Science 36* (2): 207–240.

Stahl, Ann B. 2018. "Efficacious objects and techniques of the subject: 'Ornaments' and their depositional context in Banda, Ghana." In *Relational Identities and Other-than-Human Agency in Archaeology*, edited by Eleanor Harrison-Buck and Julia A. Hendon, 197–236. Louisville: University Press of Colorado.

Stocking, George W. 1968 [1965]. "On the limits of 'presentism' and 'historicism' in the historiography of the behavioral sciences." In *Race, Culture and Evolution: Essays in the History of Anthropology*, edited by George W. Stocking, 1–12. New York: Chicago University Press.

Stringer, Chris, and Clive Gamble. 1993. *In Search of the Neanderthals*. New York: Thames and Hudson.

Tattersall, I., and J.H. Schwartz. 1999. "Hominids and hybrids: The place of Neanderthals in human evolution." *Proceedings of the National Academy of Sciences of the United States of America 96* (13): 7117–7119.

Trinkaus, Erik, and Pat Shipman. 1992. *The Neandertals: Changing the Image of Mankind*. New York: Alfred A. Knopf.

Vanhaeren, Marian, and Francesco d'Errico. 2006. "Aurignacian ethno-linguistic geography of Europe revealed by personal ornaments." *Journal of Archaeological Science 33*: 1105–1128.

Vanhaeren, Marian, and Francesco d'Errico. 2011. "L'émergence du corps paré. Objets corporels paléolithiques." *Civilisations 59* (2): 59–86.

Van Reybrouck, David. 2002. "Boule's error: On the social context of scientific knowledge." *Antiquity 76* (291): 158–164.

Villa, Paola, and Wil Roebroeks. 2014. "Neandertal demise: An archaeological analysis of the modern human superiority complex." *PLoS ONE 9* (4): e96424.

Viveiros de Castro, Eduardo. 1998. "Cosmological deixis and Amerindian perspectivism." *The Journal of the Royal Anthropological Institute 4* (3): 469–488.

Viveiros de Castro, Eduardo. 2004. "Perspectival anthropology and the method of controlled equivocation." *Tipití: Journal of the Society for the Anthropology of Lowland South America 2* (1): 3–22.

Viveiros de Castro, Eduardo. 2013a. "The relative native." *HAU: Journal of Ethnographic Theory 3* (3): 473–502.

Viveiros de Castro, Eduardo. 2013b. "Some reflections on the notion of species in history and anthropology." Translated by Frederico Santos Soares de Freitas and Zeb Tortorici. *Emisférica 10* (1).

Viveiros de Castro, Eduardo. 2015a. *The Relative Native. Essays on Indigenous Conceptual Worlds*. Chicago: HAU Books.

Viveiros de Castro, Eduardo. 2015b. "Who's afraid of the ontological wolf: Some comments on an ongoing anthropological debate." *The Cambridge Journal of Anthropology 33* (1): 2–17.

White, Randall. 1982. "Rethinking the Middle/Upper Paleolithic transition." *Current Anthropology 23* (2): 85–108.

White, Randall. 2007. "Systems of personal ornamentation in the Early Upper Palaeolithic: Methodological challenges and new observations." In *Rethinking the Human Revolution: New Behavioural and Biological Perspectives on the Origin and Dispersal of Modern Humans*, edited by P. Mellars, K. Boyle, O. Bar-Yosef, and C. Stringer, 287–302. Cambridge: McDonald Institute for Archaeological Research.

White, Randall, Gerhard Bosinksi, Raphaëlel Bourrillon, Jean Clottes, Margaret W. Conkey, Soledad Corchón Rodríguez, Miguel Cortés-Sánchez et al. 2020. "Still no archaeological evidence that Neanderthals created Iberian cave art." *Journal of Human Evolution 144*: 1–7.

Weismantel, Mary. 2015. "Seeing like an archaeologist: Viveiros de Castro at Chavín de Huantar." *Journal of Social Archaeology 15* (2): 139–159.

Wittgenstein, Ludwig. 1958. *Philosophical Investigations.* Translated by G.E.M. Anscombe. Oxford: Basil Blackwell Ltd.

Wynn, Thomas, and Frederick L. Coolidge. 2011. *How to Think Like a Neandertal.* New York: Oxford University Press.

Zilhão, João. 2007. "The emergence of ornaments and art: An archaeological perspective on the origin of 'behavioral modernity'." *Journal of Archaeological Research 15*: 1–54.

Zilhão, João. 2012. "Personal ornaments and symbolism among the Neanderthals." In *Origins of Human Innovation and Creativity,* edited by Scott Elias, 35–49. Developments in Quaternary Science Series, no. 16. Amsterdam: Elsevier.

Part II

Rock art and Indigenous knowledges

5 A lesson in time

Yanyuwa ontologies and meaning in
the Southwest Gulf of Carpentaria,
Northern Australia

John Bradley, Amanda Kearney, and Liam M. Brady[1]

1 Introduction

*Nakari ridinja nungka rikarrangu nya-mangaji ni-maliji, kilha-nyngkarri nyinku wuka
ngala yinda wukanyinjawu, yinbayawu ji-awarawu, barra bawuji wakara ki-yabarri
ni-wurdu, ngabaya jibiya baji ki-yibarra ni-maliji ajinjala yinku rdiyangu kurda kur-
dardi ji-wankalawu.*

From yesterday perhaps, or maybe early this morning those hand prints, the
spirit beings heard your words, when you spoke and sang for this country, so
that was what they did, they felt good, so the spirit beings from this place put
their hand prints in the cave for you, they are newly made, they are not from
a long time ago.

This opening quote comes from senior Yanyuwa woman Mavis Timothy *a-
Muluwamara*, Aboriginal owner of sections of lands and waters throughout the
southwest Gulf of Carpentaria, northern Australia (Figure 5.1). Her statement was
recorded during ethnographic and archaeological fieldwork across Yanyuwa
country in July 2019. On this particular occasion, we were traveling to Vanderlin
Island with Mavis and a group of her Yanyuwa family members, including Warren
Timothy, Graham Friday, Ruth Friday, and Joanne Miller. Our intention for the
day was to record any "rock art" that was located in the area, in the company of
Yanyuwa who could speak to its presence, or absence (see Brady et al. 2016;
Figure 5.2). We were to be guided by Yanyuwa and to also spend time visiting
country around Liwingkinya and Walala, the large freshwater lake that sits north-
centrally on Vanderlin Island. This part of country is only occasionally returned to
these days by its Yanyuwa owners, due to distance and the challenges that come
with the cost of local travel in this remote part of Australia.[2] The area that en-
compasses Walala and Liwingkinya is often referred to as *ngabaya awara* or a place
where the presence of other spiritual entities is powerfully felt, thus great care is
needed to negotiate and apprehend this country. Over the course of a few days we
came across two bright red ochre hand stencils in a rockshelter at Liwingkinya
(Figures 5.3 and 5.4). Mavis' explanation of these hand stencils is what compels
this discussion of Yanyuwa ontologies, "rock art" and meaning. As will become
clear throughout this chapter, there is a lesson in time, intention, and the relational

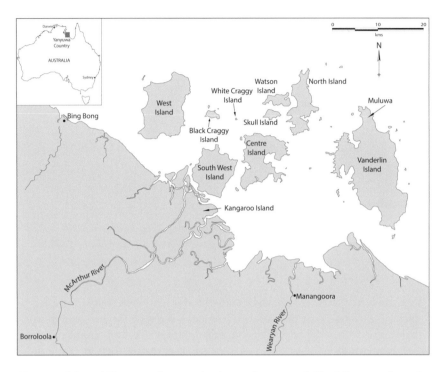

Figure 5.1 Map of Yanyuwa Country in the southwestern Gulf of Carpentaria region, Northern Territory, Australia.

that comes from these hand stencils when considered through a Yanyuwa frame of understanding. We are aware that hand stencils perhaps represent one of the oldest and most common forms of "rock art" worldwide, with many different approaches to their study especially in relation to accessing their meaning, significance, and in some identifying their authorship (e.g., Walsh 1979; Snow 2006; Aubert et al. 2014; Pettitt et al. 2014). However, it was because of the insistence of the Yanyuwa elders that we came to document these hand stencils as recent supervital additions to the place known as Liwingkinya.

Committed to grappling with the ontology of culturally and self-determined meanings in what the Western tradition might call "rock art," this chapter problematizes epistemic habits of "knowing and reading meaning in rock art," and offers extension to the possible discourse on "rock art" as an agent itself, whilst also being, if time and circumstances require, purposefully made, altered, or entirely erased by non-human agents present in country. In other words, this chapter works to unpack Mavis' explanation for the hand stencils we saw on this day, utilizing an Indigenous epistemology and ontology to do so. What she makes clear for us in her opening statement is that the hand stencils we saw at Liwingkinya had been made the day before or that very morning, by spirit beings—the *Namurlanjanyngku*—that live in this particular part of Yanyuwa country. They made these fresh hand stencils for us, as they had heard our voices

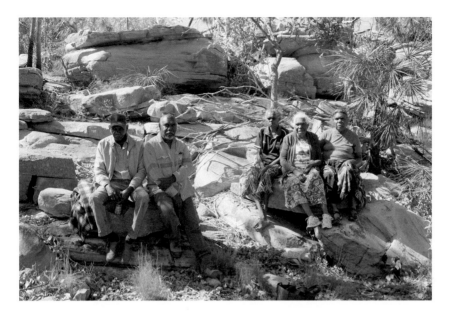

Figure 5.2 Team of senior Yanyuwa *jungkayi* and *ngmirringki* (Graham Friday, Warren Timothy, Joanne Miller, Mavis Timothy, Ruth Friday) visiting Liwingkinya, picture taken in July 2019.
Source: Photo courtesy by Amanda Kearney.

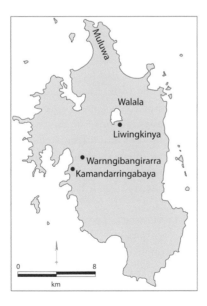

Figure 5.3 Map of Vanderlin Island showing key places mentioned in text.

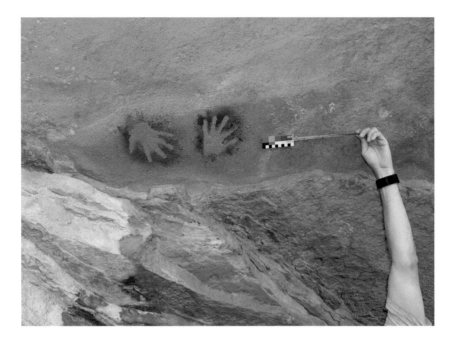

Figure 5.4 Liwingkinya hand stencils made by the *Namurlanjanyngku* just before we
arrived in the area.
Source: Photo courtesy by John Bradley.

on country, knew of our interest and had heard us, and in particular had heard
Bradley, with a group of senior Yanyuwa women, sing the *kujika*[3] for this country
earlier on the previous day. Bradley, whilst visiting the Yanyuwa camp, had
undertaken to *yinbayarra* (sing the ancestral songline), with Mavis and two other
senior Yanyuwa women, Dinah Norman and Jemima Miller. The act of singing
the *kujika* for this country, specifically from Liwingkinya and Walala, had, ac-
cording to Mavis, *yarrungkayarra*, that is, "woken up the spirit beings." As these
spirit beings had not heard this *kujika* sung for some time, it had stirred them and
made them happy. The spirit beings had thus anticipated our visit, responded in
anticipation of our arrival and were fully communicative in the knowledge of the
accompanying return of their human Yanyuwa kin. Since we had travelled with
the proper Yanyuwa kin for this country, that is both *ngimirringki* and *jungkayi*, the
spirit beings had responded.[4]

 In this opening testimony, Mavis is speaking of a part of Yanyuwa country for
which she is a senior owner, a *ngimirringki*. As *ngimirringki*, she traces her sub-
stantive kinship to this place through her father, her father's father, and gen-
erations of kin belonging to the *Rrumburriya* clan.[5] The place is Liwingkinya, a
high rocky outcrop on Vanderlin Island, the largest of islands in the expanse of
Yanyuwa saltwater country in the southwest Gulf of Carpentaria. As *ngimirringki*
for this place, and as a person whose *ardirri* (spirit child)[6] came from neighbouring
country, at Muluwa, Mavis is bound to this part of country in the most profound

way possible.[7] Thus, when she speaks of and for this place, she is an authority and knows how to read country, what country might be trying to convey, how it communicates and knows people, and the world it is a part of. In which case, it is imperative that we begin this chapter with her words, for they have been shared by an authority for place, a speaker of the language that makes up this part of country. Mavis' words carry with them a truth for knowing place and for understanding the elements of place, including what might be described as "rock art," and the temporality of this place, what might be described as simultaneously past, present, future, and now.

Since 1980, we have been working with Yanyuwa families in the southwest Gulf Country (see Kearney and Bradley 2020). Bradley, a fluent speaker of the Yanyuwa language, has, since 1980, been involved in documenting Yanyuwa culture. He has collaborated on language maintenance efforts, and Yanyuwa-determined projects including film, and digital animations of Ancestral narratives and songs. Kearney was introduced to members of the community, by Bradley, in 1999 and her collaborations with Yanyuwa have led to the documenting of Yanyuwa narratives of cultural wounding and healing and the exploration of cross-generational knowledge exchange. Brady, an archaeologist, arrived in Borroloola in 2010, with Yanyuwa support, to record aspects of Yanyuwa cultural and maritime heritage, in particular the many rock art sites spread across Yanyuwa country in collaboration with Bradley, Kearney, and the *li-Anthawirrayarra* Sea Rangers. This most recent project began in the midst of the community drafting an Indigenous plan of sea/land management and has been embraced by the community as a way of enhancing details of the region's cultural significance. Coming to more fully appreciate a Yanyuwa ontology that locates people in the land and waters of their ancestors, and locating those ancestors in this present moment, has been key to understanding the meaning of places and their tangible markers of human and non-human presence.

2 The setting and scene

Any writing of the immense and beautiful freshwater lake at Walala (the home of *Bujimala*, the Rainbow Serpent Ancestral Being), or Muluwa, the Wave Ancestral Being (a huge sand dune that dominates Cape Vanderlin on the northern reaches of Vanderlin Island), or the caves and rocky outcrops of Liwingkinya implicates a world of relational knowledge. Most notably it requires knowledge of other places, each of which is pivotal to the actions of Ancestral Beings that moved through this country (e.g., Brady et al. 2016, 2018). The places that are bound through a relational substance, henceforth explained here, through its ancestral links, include Liwingkinya, Kamandarringabaya, Muluwa, and Warnngibangirarra (see Figure 5.3). A Yanyuwa ontology of country, which groups places through a relational understanding of Ancestral Beings and their movements through country, is key to how we as researchers might approach visits to this part of the southwest Gulf of Carpentaria, the sequence through which we come to learn and how we then write of this understanding.

In regard to the ontology of Yanyuwa country and in particular the places noted previously, the concept of time and the nature of origins need explaining. From a Yanyuwa viewpoint, the past is an inseparable part of a contemporary understanding of both the land and sea. In Yanyuwa there are words used to describe the far distant past; many stories begin with *wabarrangu ambuliyalu*, "a long time ago before." The word *ambuliyanynguwarra* is a noun that refers to the "oldest of things," of "a time far," nearly beyond comprehension and yet also of things that are still also present, observable, and important. *Wankala* means "times long past" and by adding a human-centred plural prefix, *li-wankala*, the word tells of "people belonging to long times past" or human ancestors. These terms have, at their heart, an understanding of time and place-depth, not as a discrete moment, but as part of ongoing processes.[8]

On a map, each of these places on Vanderlin Island is, in a physical sense, a separate location (see Figure 5.3), and yet they are in a Yanyuwa understanding entirely connected to each other (and with others further afield; see below). No place on Yanyuwa country exists in isolation, each and all are linked through the actions of Ancestral Beings, in this instance, it is the *Namurlanjanyngku* (see also Bradley 1997; Yanyuwa Families, Bradley, and Cameron 2003; Bradley with Yanyuwa Families 2010, 2016; Brady et al. 2016; Kearney et al. 2020). The Yanyuwa world is thus configured through a deeply held relational ontology. This relational ontology is also conveyed through language, as Yanyuwa language is also distinguished by directional markers. Such knowledge is held in the language not just as stories but also with a specificity to location by the use of complex directional markers that in some ways relate to western cardinal direction. No movement across country or sea, either by Ancestral Beings, humans, winds, or other entities can be discussed without recourse to these directional markers.

Liwingkinya sits on the southern end of Walala. The landscape consists of low sandstone rock stacks, many of them decorated with paintings, stencils, and prints and made with red and yellow pigments. Apart from the "rock art," there is little evidence of occupation found here—of the eight sites we recorded here, only one shelter contained a small shell midden, grindstones, and grinding bases. People generally do not like camping here because of the heavy presence of spirit beings (Yanyuwa Families, Bradley, and Cameron 2003, 69).

Walala is a vast and numinous place, and because of Liwingkinya's proximity to the lake it is often also called by the name Walala. This area is frequently visited by the *Namurlajanyngku*. They are human-like, though tall and very skinny and deep red ochre in color. They live within the walls of rockshelters and easily slip into the rocky crags and crevices that are in the area. They move freely throughout the area, interacting with deceased Yanyuwa kin (*li-wankala*); they sing, dance, run, and paint in the rockshelters that dominate the landscape. They also playfully interact with their living kin, they are not a harmful presence, rather they tease, steal, and then return what they have stolen. They take of the country and are a continual enlivening presence here, in both the presence or absence of everyday Yanyuwa visits.

It is noted by Mavis that these spirit beings acutely feel the absence of their human kin in the present day and is expressed here in her discussion about this: "a whiteness has enveloped the country and the spiritual entities of the land have retreated to the caves because they are only hearing English and they are dreadfully afraid." Such entities then respond happily when kin are present, an expressive articulation that can be read in country by Yanyuwa.

Their actions in this place brought it first into being during the Yijan (the Dreaming, or Ancestral Past).[9] The *Namurlanjanyngku* are held to always be travelling through this country, speaking with *Bujimala* that inhabits Walala, still curled up in its depths, watching and listening. *Bujimala* is a "stationary Dreaming," explained in Yanuuwa as *jibiya baji*, belonging to that place alone. The *Namurlanjanyngku* that belong to this country still stand high up on the rugged rocky ranges (a land form known in Yanyuwa as *jidalbirringki*) and look out over their country, just as they did in the Ancestral Past when they stood on this rocky range and looked north to Muluwa (Cape Vanderlin) and decided to travel there in their making and marking of Yanyuwa country. On arrival at Muluwa the *Namurlanjanyngku* looked far to the northwest where they saw another group of spirit beings standing in Marra and Wandarrang country (see Figure 5.3). From Yanyuwa country they began to call out to these other spirit beings, exchanging knowledge of particular ceremonies and celebrating their kinship to and with each other. This entire region can be carefully mapped through the originary actions of these two groups of spirit beings (e.g., Yanyuwa Families, Bradley, and Cameron 2003).

As they continued their travels, the *Namurlanjanyngku* then left Muluwa and returned south to a place some 3 km to the northeast called Ruwuyinda. Here, they were tired and weary of traveling so they placed themselves on the rock wall of a shelter called Warnngibangirarra. They remain here, in the rock, yet what remains in these walls is not a "rock painting," nor "rock art," rather these markings/presences are the embodiment and essence of the actual spirit being entities (e.g., Merlan 1989; Taçon 1989; Chaloupka 1993; Blundell and Woolagoodja 2012; Porr and Bell 2012). It is here in the rock walls that they rest, observing over their country, and responding to their human kin. The spirit beings present at this place, on the rock surface, are part of a political landscape that traces its roots to a period of ancestral creation. Their ongoing presence illuminates a Yanyuwa epistemology and ontology in which the ancestors are ever present, their law is ongoing, and they are moving through place in ways that defies a past/present/future logic, it is an ever-now.

There are Yanyuwa men and women who acknowledge the presence of the "rock art" at Liwingkinya, Kamandarringabaya, and Warnngibangirarra as kin, *li-ngatha li-nganji* (they are our kin), this is a reference to the active present as the time of these ancestors and Yanyuwa kinship with them, Yanyuwa people are themselves Lawful bodies on place. Thus, these embodied presences are intimate expressions of relatedness in action (e.g., Brady and Bradley 2016; Brady et al. 2016). This is not "kin as metaphor" but actuality.

Kamandarringabaya, another place of importance to this story, is also located on Vanderlin Island, south of Walala and Liwingkinya and sits on the eastern shore of Victoria Bay on the mid-western coast of the island. It too is an important Dreaming place for the *Namurlanjanyngku* and is distinguished as a large rockshelter, with a large and dense shell midden strewn across the shelter floor. Archaeological excavations undertaken here in the early 2000s revealed evidence of occupation spanning some 1,700 years (Sim and Wallis 2008, 99), yet for Yanyuwa this is a place that has been continually inhabited, this place is the original "home of the *Namurlanjanyngku*." Over 100 hand prints and hand stencils (along with motifs such as foot stencils, linear and geometric designs, bird tracks) are found on the rock walls, overhangs, and in crevices across the shelter (other features at the site include hammerstones, flaked stone, and grinding patches). According to a Yanyuwa understanding, these images are not the work of humans, but rather were placed there by the *Namurlanjanyngku*. In a small crevice near the rear of the shelter there is also a white, skinny *Namurlanjanyngku*, emerging partly from between two rocks. As Johnson Timothy, a senior owner for Vanderlin Island, once explained to Bradley (ethnographic fieldnotes, 1985),

> [w]hite people look and they see a cave, that's all, they look and might see that painting, that hand, then they go away. They think they know this country, but you know that caves not just a cave, he's something else, lot of meaning for this country.

In Yanyuwa knowledge and orality, the most powerful way to understand country is through knowledge of *kujika*. The knowledge we present here about these places is always reinforced by a reference to the *kujika* verses that belong to the country and the entities that dwell there (see also Bradley with Yanyuwa Families 2010). The *Namurlajanyngku* spirit beings are sung in the Tiger Shark *kujika* that travels from Manankurra, a mainland place on Yanyuwa country to the south (see Figure 5.1) and eventually completes its path at Walala. The site of Kamandarringabaya is not on the path of this *kujika*, rather the *Namurlajanyngku* are sung as they move through Liwingkinya. The *kujika* maps country, and the movement and behaviours of the spirit beings, as follows:

Namurlangajarra
Dirrinydirri
The *Namurlajanyngku* spirit beings
Move through the rocky country of Liwingkinya
Namurla ngajarra
Kumuyangu kumu
Dirrinydirri
The *Namurlajanyngku* spirit beings
Dance in the caves
As they move through the rock country
of Liwingkinya.

Even though the name of the country is not called in the *kujika* verses, knowledge of the *kujika*'s path tells the singer and the hearer that the *kujika* has arrived at Liwingkinya because the *Namurlajanyngku* are being sung and through a relational understanding of the other places such as Kamandarringabaya and Warnngibarningirarra are also being sung, the *Namurlajanyngku* are present at all these places, all at the same time. *Kujika* are complex visions of country. Each clan holds a number of them that are used during ceremonial performance. *Kujika* present a summation of a clan's lands and waters, the entities that are ancestral to them and the names that people can carry. Though appearing linear in structure, *kujika* will reach out and bring "into line" entities that might dwell away from the path of the *kujika*. *Kujika* are the "original soundtrack" of the country, placed into the land and sea by Ancestral Beings. These songs are always present in the land and sea, even if not being sung they are there. It is as if human beings become the mere "loud speaker" for these pre-existing songs (see Bradley with Yanyuwa Families 2010).

When one climbs up high onto the rocks of Liwingkinya and looks north, the full expanse of Walala reveals itself. In the past, water could only be collected here by women and children from the southern end of the lake, while the northern end was reserved for fully initiated men (*li-nguwibi*). The lake is both a place to obtain water but it is also home to *Bujimala*. Rainbow Serpents are volatile creatures, they do not appreciate unlawful behaviour on country, and can manifest in their powerful form as cyclones. In the *kujika* for this part of country there are verses relating to Walala and *Bujimala*. These verses occur quite soon after the singing of Liwingkinya, thus linking these places in significant ways. The *kujika* descends down the rocky ranges and comes to the still waters of the lake, where it continues to run through country:

Walala yiyarni
Wunyibunyiburr
The country of Walala
Is still and without wind
Walala yiyarni
Kunjburru
The waters of Walala
Are still, there is now breeze
Wirarra kababulji
Darridarri
The Rainbow Serpent stirs
In the depths of the Walala
It moves
Windiji burru
Barlminya dala
The Rainbow Serpent
Stirs in the waters of Walala
Its back is moving

Ngambingambi
Warakulamba
The Rainbow Serpent coils itself
Around in the waters of Walala
Yirambayamba
Ngambingambi
The mouth of the Rainbow Serpent
Is there at Walala
Na-miriyi
Bulbulbarima
The Bottle-nosed Dolphin
Moves quietly through the waters of Walala
Walala yarna
Ngajikunjiyu
The shoreline of Walala
Is surrounded in deep shade.

Liwingkinya is *nyiki-nganji*, or kin, to Walala. These two places are bound to one another through story, song, and human activity and marks of that activity can be seen in the rockshelters. The oral traditions that still hold Liwingkinya have survived by not being frozen on the printed page but by repeated telling and singing. Each narrative can contain more than one message. The listener too is part of the event; a good listener is also expected to bring different life experiences to the story of these places each time they are spoken or sung about and all people then learn different things as these places are reanimated by speech and song. These songs and stories compel the listener to think about ordinary experiences in new ways. For Yanyuwa men and women who know their country, singing and story-telling is the most valued form of expression, an art that encompasses a kind of truth that lives beyond the restricted frameworks of positivism, empiricism, and what the West might call common sense.

3 Understanding: Ontological and epistemic habits

It was in 2019 that we first encountered the possibility of freshly manifest "rock art" deliberately placed into country by spirit beings, in anticipation of our visit. This has been not only revelatory but gives us an opportunity to further expand both our appreciation of this physical presence in place, and our understandings of time, relative to a series of ontological and epistemic habits, both those of the researchers, their respective disciplines, and also of our Yanyuwa collaborators and their ancestors. In undertaking this project, we have been guided by "methodological openness," which has required abandoning the imposition of set research agendas and disciplinary "discourse," slowing down the research process, listening and engaging in dialogue, and being fully available to Yanyuwa kinship, social order, and more broadly, Indigenous epistemology and ontology (Brady and Kearney 2016). We have had to try and find a new language to speak

of "rock art," challenged by the fact that in Yanyuwa, there is no such thing as "rock art," rather it is understood through a framework of ancestral intentionality (see Kearney et al. 2020; see also Porr and Bell 2012).

"Rock art" is generally referred to by senior Yanyuwa men and women as *ki-wankalawu* (belonging to times long past), *liyi-wankalawu* (belonging to the old people), or *ki-ngabayawu* (belonging to spiritual entities). Another Yanyuwa word that might be used is *wuyu*, which translates as "a random mark," and it is infrequently used. Similarly, the verb for drawing or marking, *balirrantharra*, is never used to describe these images. Instead, the term *yibarrantharra* ("placing" or "putting"), is used in both a transitive and reflexive sense. This is the only Yanyuwa term easily or more commonly adopted to describe or explain the act of images "being placed onto the rock face."

In order to trace the context in which this methodological openness operates, it is necessary to flag the operating centre, that is the intellectual heritage which compels border thinking and openness as opposed to closed thinking. By engaging with Indigenous knowledge in its discrete location, there can emerge a broader understanding and appreciation for ontological expansion. However, this requires not assuming a necessary synergy between multiple ways of knowing, but rather arranging them in relation to an often dominant other, that is a Western paradigm of science, and modernity. Much is needed to offset the pervasive familiarity with Western knowledge that defines anthropology and archaeology. This begins with the very spatial organisation of place and how places are perceived and brought into relation. Whilst our 2019 field research may have specifically targeted Liwingkinya, finding and recording eight "rock art" sites, it is clear from the writing, we cannot isolate the Liwingkinya's red ochre hand stencils from Walala, Muluwa, Warnngibangirarra, and Kamangdarringabaya. This relational ontology is rendered peripheral in many Western articulations of the Australian land mass, its ecologies, and sites of archaeological or other social and cultural significance. The tendency in those instances is to isolate places, render them spatially distinct, whether through GPS coordinates or the limitations of legal and environmental protections. This process traces its roots to what Thiong'o (1986, 55) describes as a colonial habit of mapping the land into three categories: the border, the centre, and the outside. This process not only works to classify the place world, as a spatial geography, but also the inner social worlds of human relations. Both people and places can be centre, border, and beyond. It is our membership into one of these categories, that decides whether we receive the privileges that are associated with the centre, or whether our existence and needs become part of the periphery, with status as the "other" compelling some to live on the edge, beyond the limits of central care. In the narratives of colonial writing and more dominant Western ways of knowing all power concerning these three categories are out of the control of any Indigenous agency.

Our experiences over the last four decades have taught us that it is possible to become aware that Yanyuwa, if not all Indigenous story-telling, must end and begin

with understandings of country, because these stories are inseparable from country. The land and sea are not simply a backdrop against which stories are told. Named places such as those described previously become the premise through which it is understood that the land, rivers, sea, and islands are why the stories even exist in the first place. These stories disrupt quite powerfully any assumption that the land is a possession that can be owned by anyone and that it exists only as a place where history can be made or from which simple meanings can be derived. For Yanyuwa, their narratives of place are a demonstration of how the land is created from and sustained through ontological, epistemological, and axiological specificity and commitments that create a place for people to know themselves. Mavis' testimony arose at a moment when a counter-political narrative was needed to reinstate a very particular country-centric view. Being *ngimirringki* for this part of country determined that she was the person to make such an adjustment to the narrative.

The need to adjust the narrative of place is more broadly generated by a Western understanding of Yanyuwa and other Indigenous countries, the knowledges and laws they contain, and the continued pressure from outside government and non-governmental forces that surround issues of land ownership and authority to speak. Story-telling, particularly about important places such as Walala and Liwingkinya, are intense acts of knowledge production and transmission. Important places demand respectful telling and revealing.

The country described, and all it contains, is not a mere backdrop and unspecified location, rather it is the substance, upon which the speaker draws. As Basso (1996) suggests, the land is mnemonic with its own set of memories that are given voice as the needs arise and by those people that know the stories that live in place. In a Yanyuwa way of knowing, the land is said to remember and constructs memories that are given voice by the people who live on and know the places that are being spoken about. For the most part, these understandings are carried through oral traditions. They rest within the culture that creates them, however even when written, with a care given to issues associated with translation it is possible to see how these narratives, related as they are to the land, interrupt and reimagine settler colonialism's attempt to sever the earth through borders, naming, attributing value or disavowing it, alternative ownership rights, and ideas of development as a need to measure progress. One of "rock art's" defining features is that it is a visible link to the country's relational qualities, but also a signpost back to its ongoing, earlier understandings, and despite intrusions by outsiders into these inscribed landscapes, the people who understand the ontological links present in this imagery reconstruct a totally different view of what is often rendered as inert landscape.

4 A lesson in time: Yanyuwa ontologies and meaning

By using the stories and songs from Liwingkinya, Walala, and Kamandarringabaya, we have been able to hear and engage an Indigenous voice, more specifically a Yanyuwa voice, that speaks to self-determined understandings of Indigenous kinship, land, and politics. Such stories are vital in the context of

decolonising existing approaches to Indigenous knowledge, and more specifically "rock art." The Yanyuwa story presented here works to both deconstruct colonial ways of coming to know, as well as constructing and providing alternative visions of the way that people understand their own country, their own past, and how this still speaks to the present.

In an oral culture, sustained by Yanyuwa for generations, such processes do not occur in a linear fashion. Stories too are interrelated, and what might be considered a story from the deep past, rises up to join to a story about the present; thus, past and present too can become an unreliable way to find stability in narrative. For Yanyuwa men and women, agency is circulated through human and non-human worlds in the creation and maintenance of land and sea. Through the processes of colonization, the corruption of essential categories of Indigenous conceptions of the world has led to a disconnect between how this agency is manifested by Indigenous people. The West demands certainty about expression of culture, and this can be seen in the term "rock art," it is as if there must be "art," even if the language of the culture has no similar word (e.g., Heyd 2012; Porr and Bell 2012). Thus, in this chapter we have attempted to lay bare another ontological reality involving "rock art" and the families who belong to the sites that we have visited.

Through a comparison between the epistemological-ontological divide and a Yanyuwa conception of country and thought, we argue that agency has erroneously become exclusive to humans, thereby removing non-human agency from what constitutes a society. This process is accomplished in part by mythologizing the stories that Yanyuwa people tell about their country and separating and compartmentalising Yanyuwa knowledge about their country in order for colonialism to operationalize itself. One example is the aforementioned term "rock art" used to describe the actions of Ancestral Beings. To assume this action can be understood solely through measurement, photography and scientific methods of analysis (e.g., dating, pigment sourcing), is to presume to know too much on behalf of Western epistemology and ontology and perhaps to overlook other ontologies for "making sense" of country and its features. Colonization operates through such assumptions in this part of Australia and has the potential to leave Yanyuwa narratives underestimated in their potential to guide meaning making and understandings, thus relinquishing them to the borderlands of knowledge.

It is easy to record, translate, type, and place Yanyuwa narratives of country and ancestral action within a text, following the conventions proscribed by the Western academy. However, within the daily functioning of Yanyuwa Law, these places and the narratives and songs that uphold them are embedded with complex rules of copyright and ownership. They are, if understood, illustrative of just how complex these land-based, land-owning kinship systems are, and then, when contrasted with the way that the state collects information, or the academy wants to write about Indigenous people and their lands and waters, it is possible to see how it actually renders all that complexity invisible. This act of reductionism and bordering also reduces these complex social systems to simply aggregations of people who happen to be Indigenous and have some stories, dances, and songs.

5 Final reflection

> *"...they are newly made, they are not from a long time ago..."*

As this quote from senior Yanyuwa woman Mavis Timothy a-Muluwamara reflects, our interactions with the images and embodiments of the *Namurlajanyngku* at Liwingkinya and more broadly around Walala should be considered a lesson in time. By this we mean that our own ontologies of time have been tested, and warranted abandoning, in light of Yanyuwa knowledge, story, and song. Conventional Western notions of past and present collapse in the moment that Ancestral Beings are known to be actively creating markers in place and leaving freshly applied hand stencils for us to see. Do we dismiss this as "local knowledge," or do we fully engage with the fact that this is the case? In order to sustain commitment to a research agenda that prioritizes ontological self-determination, as the ontological turn has encouraged, requires that we take this information seriously and come to know what it means and how to write of it. Combined, Yanyuwa sources of insight have revealed that "rock art" can be the result of a spirit being's actions, it can be freshly painted, it can be an act aimed at pleasing visiting kin, and it can be an expression of the communicative capacity of Ancestral Beings who wish to convey emotional states and the Law of country openly or in this case visually.

We do not want to write of this explanation for the hand stencils as "metaphor," nor to position this knowledge as an outlier explanation for what we have otherwise encountered as researchers. Rather, we wish to write of this as the guiding interpretive understanding of images and presences that exist at Liwingkinya. Elsewhere, and in a similar vein we have written of the likelihood of the converse to what we have found at Liwingkinya, that is, of paintings disappearing, as a result of a prolonged absence of Yanyuwa kin, and country being lonely and "low down" (Brady and Bradley 2014; Brady et al. 2016). In this instance, we were asked to record a painting of a *yirrikirri* (donkey) that Dinah Norman a-Marrngawi remembered seeing at a rockshelter on South West Island. When we could not find the painting at the shelter, Dinah explained that "[o]ld people must have taken it away, too many of them have died you know." In this instance, the absence of a known presence in country was focused on the relationship between the agency of the ancestors and the health and well-being of the community and country. The inability to see this known *yirrikirri* was directly related to the events happening in the community. The ontology which governs this response by country is one that is capable of understanding just how country and ancestral beings express a suite of emotional and ecological states, both those of health and wellness and those of loneliness and decline.

The bright red hand stencils that we saw at Liwingkinya in July 2019 are the *Namurlajanyngku*. The hand stencils may still be there, but then again, they may not. This will depend on the intent of the *Namurlajanyngku* and other determinants, including the health of Yanyuwa and their country (see Brady et al. 2016).

This is the ontology that governs Yanyuwa country as part of a heavily responsive and communicative land and seascape which is made vital by a "nested ecology"—one which pivots on interrelations between realms, inclusive of the personal ecology, social ecology, environmental ecology, cosmic, and spiritual ecology (Wimberley 2009). The onus is on us, as researchers (archaeologists, anthropologists, etc.), and on the reader to stretch the sinews of their mind to comprehend what this all means. Elsewhere we have written of how these challenges may enrich the ontological turn, so too we argue that attempting to think through an Indigenous epistemology and ontology, when generously shared by Aboriginal collaborators need not call for a comprehensive representation or refashioning to make it easier for Western academia to comprehend (see Brady et al. 2018; Kearney et al. 2020). To attempt a Western translation or rendering of this would do a disservice to Yanyuwa and would do little to challenge the orthodoxy of Western ways of knowing (Kearney 2017). It is not until we are compelled to reconsider what we know, or what we think we know, in order to enrich our disciplinary practice and our own minds.

While this chapter is a discussion ostensibly about the recording of "rock art" across Yanyuwa country, it became increasingly obvious as we travelled with various families, and old field notes were re-examined and discussed with Yanyuwa family members, that our ethnography was also about breaking free from a habit of creating silences that the western academy can impose upon knowledge. As documenters of knowledge we also became aware of issues surrounding agency and ways that we could bring this into the academy as an important point of discussion. Here we have considered a series of Indigenous places and their associated "rock art" that is replete with meaning, grounded in a well-founded and understood logic and reason.

Notes

1 We wish to express our gratitude to all Yanyuwa families for their continued support and guidance in our coming to learn of Yanyuwa Country, Law and ways of knowing. Funding for this research was provided by the Australian Research Council (DP1093341, DP170101083).

2 Today, most Yanyuwa live in Borroloola, some 40 km inland from the coast. From here, people must travel a considerable distance along the river systems in order to access their sea country. At present, Yanyuwa families only intermittently visit the offshore islands. Length of time spent visiting the islands varies and is influenced by several factors, including boat access, weather, jobs, fuel costs, health, availability of fresh water, sea conditions, school, and desires to be back in town (see Kearney and Bradley 2015).

3 *Kujika* are ancestral songlines that describe the creative travels, actions and events of Ancestral Beings (also known as Dreamings) during the Ancestral Past (also known as the Dreaming) (see note 9).

4 *Jungkayi* are the children of the women of the patriline who are associated with the Ancestral Beings of particular parts of country. *Jungkayi* status is inherited through the *kudjaka* (mother), *mimi* (mother's father), and *ngabuji* (father's mother and father's mother's brother). *Ngimirringki* have patrilineal relationships to particular Ancestral Beings and country. Considered the 'owners' of these parts of the land/water, one gains

ngimirringki status through their *kajaja* (father), *kanku* (father's father), *kukurdi* (mother's mother) and *kuku* (mother's brother).

5 The Yanyuwa clan system organizes people, plants, animals and various phenomena (rain, lightning, etc.) into four clan groups: Wuyaliya, Wurdaliya, Rrumburriya, and Mambaliya-Wawukariya.

6 *Ardirri* are the spirit children that inhabit the land and sea. They are placed in the earth by Ancestral Beings. This spirit child is born in the form of a human child, and then inhabits the body of this living person, residing deep within their bones (Bradley with Yanyuwa Families 2016, 399, 408).

7 Mavis carries the bush name (*na-wunyingu*) *a-Muluwamara*, that is the name derived from Muluwa, on Cape Vanderlin. The suffix –*mara* denotes an intense belonging to or the idea of being activated by, in this instance the place Muluwa. The prefix a- is a female prefix.

8 In Yanyuwa, various locative terms can also be used for time. For example, *juju* can mean both "a long way away," but also, "a long time ago." *Bajingulaji* can mean "there at that specific place" but can also mean, "it happened there at that specific time," while *marnajingulaji*, "here at this same place" can also mean "it happened right here at that time."

9 Dreaming (or as we prefer, the Ancestral Past) in the words of Indigenous Australian people, is a subtle and complex term (see Wolfe 1991). Dreaming places are often the stopping points for Ancestral Beings as they travelled through country, and may often be distinguished by physical markers that are either the bodies of the Ancestral Beings, the objects they carried or the result of their actions (Hume 2000; Rose 2000, see also Griffiths 2018). According to many Aboriginal cosmologies, Ancestral Beings are responsible not only for shaping the land and sea, but they are also what imbue it with significance and meaning and value, which includes the presence of humans.

References cited

Aubert, Maxime, Adam Brumm, Muhammad Ramli, Thomas Sutikna, E. Wahyu Saptomo, Budianto Hakim, Michael J. Morwood, Gerrit D. van den Bergh, L. Kinsley, and Anthony Dosseto. 2014. "Pleistocene cave art from Sulawesi, Indonesia." *Nature 514* (7521): 223–227.

Basso, Keith. 1996. *Wisdom Sits in Places: Landscape and Language among the Western Apache.* Albuquerque: University of New Mexico Press.

Blundell, Valda, and Donny Woolagoodja. 2012. *Keeping the Wandjinas Fresh: Sam Woolagoodja and the Enduring Power of Lalai.* Fremantle: Fremantle Arts Centre Press.

Bradley, John. 1997. "Li-Anthawirrayarra, People of the Sea: Yanyuwa relations with their maritime environment." Unpublished PhD diss., Northern Territory University.

Bradley, John, with Yanyuwa Families. 2010. *Singing Saltwater Country: Journey to the Songlines of Carpentaria.* Crows Nest: Allen & Unwin.

Bradley, John, with Yanyuwa Families. 2016. *Wuka nya- nganunga li- Yanyuwa li-Anthawirriyarra: Language for us, the Yanyuwa Saltwater People: A Yanyuwa Encyclopedic Dictionary, Volume 1.* Melbourne: Australian Scholarly Publishing.

Brady, Liam M., and John J. Bradley. 2014. "Images of relatedness: Patterning and cultural contexts in Yanyuwa rock art, Sir Edward Pellew Islands, SW Gulf of Carpentaria, Northern Australia." *Rock Art Research 31* (2): 157–176.

Brady, Liam M., and John J. Bradley. 2016. "'Who do you want to kill?' Affectual and relational understandings at a sorcery rock art site in the Southwest Gulf of Carpentaria, Northern Australia." *Journal of the Royal Anthropological Institute 22*: 884–901.

Brady, Liam M., John J. Bradley, and Amanda Kearney. 2016. "Negotiating Yanyuwa rock art: Relational and affectual experiences of place in the Southwest Gulf of Carpentaria, Northern Australia." *Current Anthropology* 57 (1): 28–52.

Brady, Liam M., John Bradley, and Amanda Kearney. 2018. "Rock art as cultural expressions of social relationships and kinship." In *Oxford Handbook of the Archaeology and Anthropology of Rock Art*, edited by Bruno David and Ian J. McNiven, 671–694. Oxford: Oxford University Press.

Brady, Liam M., and Amanda Kearney. 2016. "Sitting in the gap: Ethnoarchaeology, rock art and methodological openness." *World Archaeology* 48 (5): 642–655.

Chaloupka, George. 1993. *Journey in Time, the World's Longest Continuing Art Tradition: The 50,000 Year Story of the Australian Aboriginal Rock Art of Arnhem Land*. Sydney: Reed.

Griffiths, Billy. 2018. *Deep Time Dreaming: Uncovering Ancient Australia*. Carlton: Black Inc.

Heyd, Thomas. 2012. "Rock 'art' and art: Why aesthetics should matter." In *A Companion to Rock Art*, edited by Jo McDonald and Peter Veth, 276–293. Malden: Blackwell Publishing.

Hume, Lynne. 2000. "The dreaming in contemporary Aboriginal Australia." In *Indigenous Religions*, edited by Graham Harvey, 125–138. London: Cassell.

Kearney, Amanda. 2017. *Violence in Place: Cultural and Environmental Wounding*. Abingdon: Routledge.

Kearney, Amanda, and John Bradley. 2015. "When a long way in a bark canoe becomes a quick trip in a boat: Changing relationships to Sea Country and Yanyuwa watercraft technology." *Quaternary International* 385: 166–176.

Kearney, Amanda, and John Bradley (eds). 2020. *Reflexive Ethnographic Practice: Three Generations of Social Researchers in One Place*. New York: Palgrave Macmillan.

Kearney, Amanda, John Bradley, and Liam M. Brady. 2020. "Nalangkulurru, the Spirit People and the Black-Nosed Python: Ontological self-determination and Yanyuwa rock art, northern Australia's Gulf Country. *American Anthropologist* 122 (4).

Merlan, Francesca. 1989. "The interpretive framework of Wardaman rock art: A preliminary report." *Australian Aboriginal Studies 1989* (2): 14–24.

Pettitt, Paul, Alfredo M. Castillejo, Paul Arias, and Roberto O. Peredo. 2014. "New views on old hands: The context of stencils in El Castillo and La Garma Caves (Cantabria, Spain)." *Antiquity 88* (339): 47–63.

Porr, Martin, and Hannah R. Bell. 2012. "'Rock-art', 'animism' and two-way thinking: Towards a complementary epistemology in the understanding of material culture and 'rock-art' of hunting and gathering people." *Journal of Archaeological Method and Theory 19*: 161–205.

Rose, Deborah. 2000. *Dingo Makes Us Human: Life and Land in Australian Aboriginal Culture*. Cambridge: Cambridge University Press.

Sim, Robin, and Lynley Wallis. 2008. "Northern Australian offshore island use during the Holocene: The archaeology of Vanderlin Island, Sir Edward Pellew Group, Gulf of Carpentaria." *Australian Archaeology* 67: 95–106.

Snow, Dean R. 2006. "Sexual dimorphism in upper palaeolithic hand stencils." *Antiquity 80* (308): 390–404.

Taçon, Paul S.C. 1989. "From the 'dreamtime' to the present: The changing role of Aboriginal rock paintings in Western Arnhem Land, Australia." *The Canadian Journal of Native Studies 9*: 317–339.

Thiong'o, Ngũgĩ wa. 1986. *Decolonising the Mind*. Nairobi: East African Educational Publishers.

Walsh, Grahame L. 1979. "Mutilated hands or signal stencils? A consideration of irregular hand stencils from central Queensland." *Australian Archaeology 9*: 33–41.

Wimberley, Edward T. 2009. *Nested Ecology: The Place of Humans in the Ecological Hierarchy*. Baltimore: Johns Hopkins University Press.

Wolfe, Patrick. 1991. "On being woken up: The dreamtime in anthropology and in Australian settler culture." *Comparative Studies in Society and History 33* (2): 197–224.

Yanyuwa Families, John Bradley, and Nona Cameron. 2003. *Forget about Flinders: A Yanyuwa Atlas of the South West Gulf of Carpentaria*. Brisbane: J.M. McGregor Ltd.

6 Paradigm shifts and ontological turns at Cloggs Cave, GunaiKurnai Country, Australia

Bruno David, Joanna Fresløv, Russell Mullett, Jean-Jacques Delannoy, Fiona Petchey, GunaiKurnai Land and Waters Aboriginal Corporation, Jerome Mialanes, Lynette Russell, Rachel Wood, Lee J. Arnold, Matthew McDowell, Johan Berthet, Richard Fullagar, Vanessa N.L. Wong, Helen Green, Chris Urwin, Laure Metz, Joe Crouch, and Jeremy Ash[1]

1 Introduction

Today in archaeology we focus much on *meaning*, both how, in the past, symbolic worlds were devised and engaged; and how, in the present, we try to make sense of that past. In this chapter, we explore the intersection of these two dimensions of archaeological meaning-making. We do so not through "rock art" as conventionally defined, but through the symbolism of stone as cultural expressions at Cloggs Cave, a GunaiKurnai Aboriginal site excavated twice over a period of nearly 50 years, and that thus affords a double interpretative vision set some 50 years apart and incorporating multiple cultural perspectives. The recent re-excavation and redating of Cloggs Cave, one of the first true caves to have been archaeologically excavated in Australia, enables us not just to better understand the site's antiquity and chronostratigraphic sequence in light of recent technological developments—a common theme when revisiting previously excavated sites—but more poignantly through new perspectives to undertake a fundamental revisioning of how that site and its cultural landscape can be understood today.

2 Cloggs Cave: Physical and intellectual setting

At its entrance, Cloggs Cave lies at 72.3 m above sea level in the foothills of the Australian Alps, in the lands of the Krauatungalung clan of the GunaiKurnai cultural group near the town of Buchan in southeastern Victoria (Figure 6.1). The 12-m long × 5-m wide × 6.8-m high cave, with its tall, domed ceiling, is entered through an opening in a limestone cliff (Figures 6.2a and 6.3). The cave

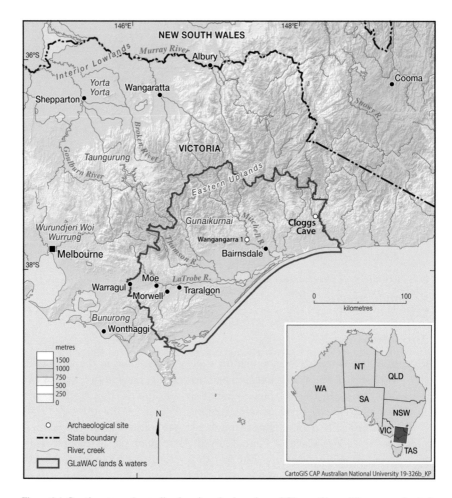

Figure 6.1 Southeastern Australia showing the location of Cloggs Cave. The names in *italics*
　　　　represent Aboriginal First Nations.
Source: Artwork by CartoGIS Services, The Australian National University.

has a flat floor of soft sediments that slopes down fairly steeply from south and
southeast to north and northwest. Indirect sunlight dimly lights most parts of the
cave for much of the day.

Cloggs Cave was originally excavated by Josephine Flood in 1971–1972 as part
of her doctoral studies. John Mulvaney had published the first Pleistocene ages for
an Aboriginal site in the country in 1962, just nine years prior to the Cloggs Cave
excavations. His discoveries at Kenniff Cave in central Queensland in 1960–1964,
1,300 km north of Cloggs Cave, had revealed a radiocarbon age of 12,900 ± 170
BP for cultural deposits (Mulvaney 1962, 137), with further excavation and dating
pushing back the timing to 16,130 ± 140 BP two years later (Mulvaney 1964). The
deep-time Aboriginal occupation of the continent had been announced, yet the

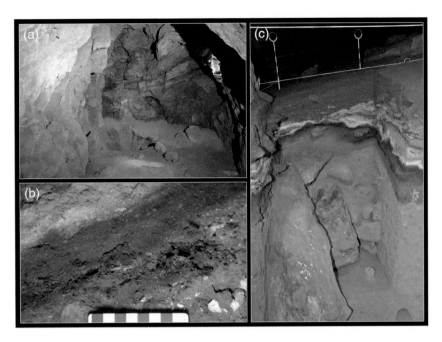

Figure 6.2 Cloggs Cave: (a) The main chamber, looking north from the upper chamber in January 2019, with the original collapsed pit of the 1971–1972 excavation in mid-view on the floor. Most of the rocks at the rear of the cave were piled from the excavation and lie over pre-existing roof-fall; (b) Owl roost bone burnt by overlying fires, east wall of the 1972 pit, prior to excavation of Square P35. The black layer is SU2BL. Note an apparently complete, fire-blackened rodent skull visible in the centre of the image, indicating the high quality of bone preservation. The scale is in 1-cm units; (c) The upper part of Square P35 after excavation of XU57, dug on the east side of the 1971–1972 pit. The upper stringline is laid horizontally, giving a sense of the slope of the current surface. Note the ashy microlayers in the upper part of the deposit.

Source: Photos by Bruno David.

nature and antiquity of much of Australia's archaeology remained a mystery (Mulvaney and Joyce 1965).

With a preoccupation for regional sequences and early ages (but see McBryde 1966), similar and older radiocarbon dating results were soon obtained from multiple regions. In 1967, ages of 21,450 ± 600 BP (originally 21,450 ± 380 BP) were obtained from Nawamoyn, and 22,900 ± 1000 BP and 24,800 ± 1600 BP from Malangangerr, both in Arnhem Land at the northern end of the continent, 3,100 km from Cloggs Cave (White 1967a, 1967b, 1967c). In 1967–1968, the Burrill Lake rock shelter in New South Wales 350 km northeast of Cloggs Cave was excavated, revealing a similarly old cultural deposit going back to 20,830 ± 810 BP (Lampert 1971). In 1968 and 1971, radiocarbon ages going back to 23,700 ± 850 BP and, more controversially, 31,000 ± 1650 BP came from excavations at Koonalda Cave in the Nullarbor Plain in South Australia, 1,900 km

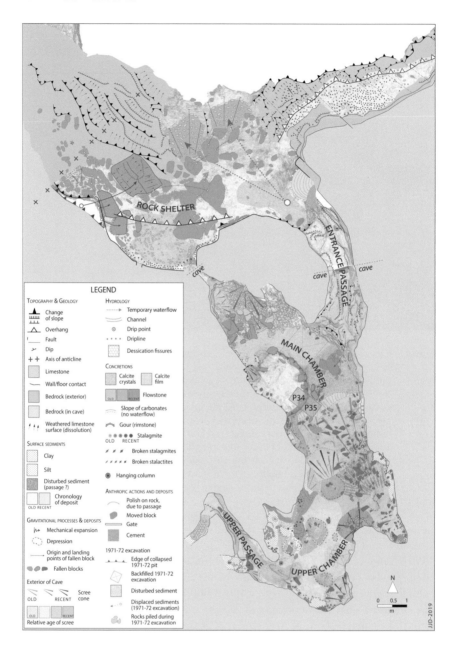

Figure 6.3 Geomorphological map of Cloggs Cave.
Source: Artwork by Jean-Jacques Delannoy.

northwest of Cloggs Cave (Gallus 1968a, 1968b, 1971; Wright 1971a; see also Walshe 2017). In 1970, ages of 30,250 ± 950 BP and 32,750 ± 1250 BP, with an even older but less certain age of 38,500 + 2950 –2150 BP came from Lake Mungo in New South Wales, 600 km northwest of Cloggs Cave (Bowler et al. 1970).

Cloggs Cave thus enters the scene in 1971 at a time when Australia's Aboriginal antiquity was being rapidly pushed further back in time at a number of key sites in northern, eastern, and southern Australia, and promising research on the Pleistocene was also under way at Devil's Lair in Western Australia (Dortch and Merrilees 1971; Dortch 1979). But none of these early sites had come from the mountainous region of southeastern Australia close to Canberra, Sydney, and Melbourne, where the homes and university bases of virtually all professionally trained Australian archaeologists lay. And in this rapidly developing world of an Australian archaeology largely consumed by a "search for older sites" (Flood 1980, 254), Flood was attracted to Cloggs Cave both for its potential to reveal in situ faunal remains and deep, Pleistocene archaeological deposits for the mountainous region of the Southern Uplands, especially having just excavated across the Canberra-Monaro landscape numerous small and shallow granite, sandstone, and shale rock shelters and one open site with exclusively Middle to Late Holocene deposits (see Flood 1973, 1980, 254).

3 Cloggs Cave: The 1971–1972 excavations

Stratified archaeological deposits occur both under the shallow overhang outside the cave, with its extensive view of the Buchan River valley and the undulating hills to the north, and in its cavernous chamber. Flood (1980, 259) excavated an area of 7.5 m^2 outside the cave, where cultural sediments went down to c. 1-m depth. Inside the cave, the main excavation consisted of a 2 × 2-m pit (four juxtaposed 1 × 1-m squares, S, T, SS and TT) against the back wall of the main chamber.

The main 2 × 2-m excavation revealed a complex, c. 2.4-m deep cultural sequence across most of the pit. Its northern c. 70 cm was bordered by a vertical disconformity spanning from c. 1-m depth to the base of the excavation. In those northern sediments lay a much older, pre-cultural set of well-stratified layers containing extinct megafauna and a suite of smaller, regionally extinct as well as extant animal remains. We now know that the vertical disconformity represents the northern edge of a 6,000–6,500-year-old subsidence crater that rapidly became infilled with redeposited sediments, but this was not known at the time (Delannoy et al. 2020). Here Flood excavated in typically 5–10-cm subhorizontal arbitrary spits, sometimes cutting through layers, including across the mixed edge of the vertical disconformity in continuous spits.

Four radiocarbon ages were obtained from the main pit inside the cave: 22,980 ± 2000 BP (ANU-1220) for the megafauna layer; 17,720 ± 840 BP (ANU-1044) at the rocky base of the infilled subsidence crater, a level associated with stone artefacts; 13,690 ± 350 BP (ANU-1182) from about midway down the cultural deposit, still part of the infilled subsidence crater; and 8720 ± 230 BP (ANU-1001) from the top of the microstratified ash layers capping the sequence

(our SU2, Section 4) (e.g., Flood 1974, 1980, 260). However, to obtain enough charcoal for radiocarbon ages, comminuted pieces and ash had been gathered from across the thick, sub-horizontal spits that sometimes spanned multiple layers. Furthermore, the pretreatment chemistry of the day, a simple acid leach, is now known to have been inadequate, especially for limestone cave sediments. Given the complex stratigraphy, thick horizontal spits and technical difficulties in dating, it is difficult to know what to make of the original ages, hence the need for re-excavation and redating (see Section 4).

Many more artefacts were excavated in the external rock shelter and passageway (924 stone artefacts) than inside the cave (70 stone artefacts), despite the deeper cave deposits. A small amount of freshwater mussel shell (*Velesunio ambiguus*) was found on the surface and topmost layer of the rock shelter, but none was found in the cave. In contrast, animal bone occurred in all layers of all excavated squares both outside and inside the cave (Flood 1995, 21). Most of the bone inside the cave came from owl roosts (Hope 1973, 251; see also Flood 1980, 275). Two radiocarbon ages were obtained from the squares outside: 1040 ± 65 BP (ANU-1181) from Square G Spit 6 A and 1110 ± 70 BP (ANU-1183) from Square W Spit 5 (Flood 1980, 266). Both ages came from layers c. 60 cm below surface and midway through the deposit (Flood 1973, Figures 39–40).

Flood (1973, 286) distinguished the external rock shelter cultural assemblage from that of the cave, arguing that the cave was virtually abandoned c. 10,000 years ago, and that people transferred their activities to the outer rock shelter when milder conditions prevailed at the start of the Holocene (Flood 1980, 268; 2007, 52). However, climatic conditions were never severe at Cloggs Cave and seemed stable throughout its occupation. Faunal species from alpine and sub-alpine environments such as mountain pygmy possum (*Burramys parvus*) were absent from all layers including the lowest ones, suggesting that even during the height of the last glacial maximum, a period thought to be covered by the dated cave sequence, surrounding vegetation was very similar to the modern one (Flood 1974, 181–82; 2007, 53). Despite finding no signature of climate change through the cultural sequence, Flood (1980, 275) suggested that warmer post-glacial conditions may have influenced this shift in habitation, and the comparable climate meant that today's food resources would have also been available.

Natural bone accumulations either predominate or exclusively account for the analysed fauna inside the cave (Flood 1973, 288; Hope 1973). Jeannette Hope, the archaeozoologist who studied the faunal remains at the time, concluded that "there is no direct evidence" (Hope 1973, 7) that people were implicated in any of the bone accumulation analysed from the cave, thus putting into question the interpretation of Cloggs Cave around the food quest and adaptation to a cold, and then warming environment. Finally, Flood noted that the abandonment of the cave at the end of the Pleistocene may also indicate that when the climate warmed sufficiently to allow open-air living, caves changed their status from mundane but essential home and hearth to locations imbued with "awe and fear" only used as burial places (Flood 1980, 268, 275), although no caves in GunaiKurnai Country were or are known to have been used for burials.

4 Re-excavating and redating Cloggs Cave: 2019

In 2019 we undertook a new, small excavation from the southeast wall of the 1972 main pit, which had remained opened for 47 years. During the intervening years between the original and new excavations, c. 50 cm had collapsed from the upper c. 1.25 m of the southeast wall. We began by cleaning the southeast section, creating a new vertical face for a 50 × 50-cm square (Square P35) dug down to a mean depth of 125.7 cm below surface. Below that depth, the original southeast face of the 1972 pit had remained largely intact, because the lower part of the pit had been partially buried and then filled with the collapse of the upper part of the pit, so a 50 × 50-cm square (Square P34) was juxtaposed against the base of Square P35's northwest wall. The northwest face of Square P35 (dug from the surface to 125.7-cm depth) was thus flush with the southeast face of Square P34 (dug from 125.7 to 227.7-cm depth), creating a continuous 2.28-m deep stratigraphic profile to a slightly lower depth than Flood's original dig in this part of the pit. Excavation proceeded in arbitrary excavation units (XUs) of typically <2-cm (and at times <1-cm) thickness following and usually thinner than the stratigraphic layers (SUs) in which they lay.

The cave and its surroundings were accurately mapped in three dimensions using LiDAR, the sediments were geomorphologically investigated, and the stratigraphic sequence was dated through a combination of 40 accelerator mass spectrometry (AMS) radiocarbon, nine optically stimulated luminescence (OSL), and nine uranium-series (U-series) ages. In the process, new details came to light on how the cave had been used (Delannoy et al. 2020, presents a detailed geomorphological-archaeological history of the cave).

4.1 The sediment sequence

The 2019 excavations inside the cave were undertaken to the immediate south of the vertical disconformity that contains the megafauna bones to the north, as revealed by Flood's original excavations (1974, 1984). The major sediment layers of our Squares P34 and P35 are broadly similar to those of Flood's (1980) Squares S, SS, T, and TT south of the vertical disconformity, although there are also some differences given the collapse of her original walls, Square P35 being entirely positioned c. 50–100 cm to the southeast of her excavations. The key aspects of the excavated sequence for the topic of this chapter is the presence of an c. 1.8-m deep deposit of poorly differentiated and at times rocky layers (SU3A–3G) beneath a complex set of 76 finely stratified and mostly ash-rich layers (SU2A–SU2BX) topped by two continuous but thin layers (incorporating also a minor lens) of brown (dry Munsell: 7.5YR 4/2–10YR 4/3) sandy loam (SU1A–SU1C) (Figure 6.4). The microstratified SU2 has a combination of more or less localised thin layers and smaller lenses, some of which gradually inter-merge while others have well-defined, sudden boundaries. An important sub-layer is SU2AR, a 1–2-cm thick deposit of brown sandy loam spread across much of the southeastern part of Square P35 about a third of the way down the full SU2 sequence (Figure 6.4). SU2AR was redeposited from upslope, indicating that SU2 does not represent a short-lived, archaeologically

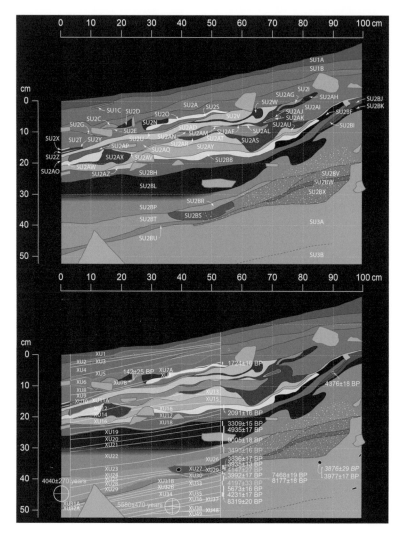

Figure 6.4 Top: XU codes for the upper section of the southeast wall of the 1972 pit in the area of Square P35. Bottom: AMS ("BP" ages) and OSL ages (circles with crosshair lines), the circle diameter representing the larger width of the gamma spectrometer probe in the sample spots.

Source: Artwork by Bruno David.

instantaneous event, but rather accumulated through the repeated building of fires both before and after a hiatus in burning. The duration of this hiatus, represented by the redeposited sandy loam, is difficult to tell but could theoretically measure in anything from days to many years. The microstratified sub-layers, SU2I to SU2BH, are almost entirely devoid of charcoal (despite most being ashy from fires), so detailed radiocarbon dating is not possible for this part of the sequence.

4.2 The dating

Flood's original four conventional radiocarbon ages were obtained in an era when large quantities of charcoal were needed prior to the development of accelerator mass spectrometry, and all her ages were aggregates of multiple and widely spread pieces of charcoal, sometimes including ash also. Her radiocarbon age of 8720 ± 230 BP for the upper part of the microstratified ash layers near the top of the sequence was superimposed by a layer of sandy loam containing only two geometric microliths, suggesting to Flood that people had virtually abandoned the cave c. 10,000 years ago (e.g., Flood 1974, 180). However, new dating presented here tells a very different story.

Squares P34–P35 were dated from the base of SU3G to near the top of the microstratified ash layers of SU2 (Figure 6.4). The entire c. 1.7 m from the base of the excavation to SU3A, representing the infilled subsidence crater, built up rapidly between 6,500 and 6,000 years ago (the full stratigraphic sequence and radiocarbon and OSL ages will be published elsewhere; see Delannoy et al. (2020), for the geomorphology and uranium-series ages). This was followed by a marked slowing of sedimentation from SU3A onto the base of the ashy layers of SU2 c. 4400 cal BP. It is not until c. 20 cm higher up, though, that the dense microstratified layers of repeated fires begin, c. 2000 cal BP (2091 ± 16 BP; see Figure 6.4). The thin, mostly ash layers of SU2 then cease c. 1600 cal BP (1724 ± 16 BP), with a single fire built more recently, c. 100 cal BP (142 ± 25 BP) (see next section for details and implications). These results signal continued use of the cave by people, and the building of fires until at least c. 1600 cal BP in the area of Square P35.

4.3 The animal bones

The excavated faunal remains are dominated by small mammals. For SU2 they consist of nine species of rodents, seven species of small marsupials, six species of medium-sized marsupials, and two specimens of large (>5000 g) marsupials (Table 6.1). The vast majority of bones identified to genus and/or species (97.4%) consist of mammals that have a maximum body mass of 250 g or less. Similarly, species with maximum body masses that exceed 900 g are predominantly represented by juveniles that weigh considerably less than adults.

Though the remains of the carnivorous *Dasyurus viverrinus* are present, there is little to no evidence of mastication by mammalian predators. In addition, all of the mammalian species identified are predominantly nocturnal, and few are known to have been eaten by Aboriginal people. None of the bones examined show evidence of cut marks, deliberate breakage or crushing/chewing.

Almost all of the bones excavated from the microstratified layers of SU2—XU5–XU31—were consistently burnt brown-black. However, none was burnt grey or calcined, stages of burning that would require high temperatures (600–800°C) that in Aboriginal Australia are usually only achieved in cooking fires. Bones may be blackened by a hot fire if they occur in sediments beneath a fireplace, but this should also result in higher grades of burning for at least some

Table 6.1 Number of identified specimens (NISP), by animal taxon, recovered from the upper 31 XUs of Square P35.

XU	1	2	3	4	5	6	7A	7B	8	9	10	11A	11B	11C	12	14	15	16
Rattus lutreolus	6	1	1	.	.	1	.	1	7	6	5	1	.	.	.	1	3	1
Rattus fuscipes	.	1	.	.	.	1	.	1	.	1	.	1
Pseudomys novaehollandiae	13	2	.	.	21	7	.	.	1	2	3
Pseudomys higginsi	2
Pseudomys gracilicaudatus
Pseudomys oralis	1	1	5	1	.	1	.	.	2	2	1	1
Mastacomys fuscus	7	1	.	.	2	.	.	3	4	2	1	1	1	1
Conilurus albipes	.	1	1	1
Onychogalea fraenata
cf. itPetrogale sp. indet.
Potorous sp. indet.
Pseudocheirus peregrinus	1
Petaurus breviceps	1	1	.	.
Cercartetus nanus	2	1	1
Cercartetus lepidus
Acrobates pygmaeus
Peramelidae sp. indet.	2	1	1	1	1
Perameles nasuta
Isoodon obesulus	1
Dasyurus viverrinus
Sminthopsis cf. leucopus	7	1	.	1	1	2	1	.	.	6	4	1	.	.	1	.	.	1
Antechinus swainsonii
Antechinus swainsonii

17	.	5	3	.	8	.	.	.	2	1	1	2	1	10	13	.	.	1	.	3	.	22	
18	5	9	5	2	28	2	.	.	10	2	.	1	.	45	56	2	.	.	.	3	15	48	
19	9	11	2	.	33	1	.	.	21	.	.	2	.	56	86	8	20	67	
20	11	8	10	2	37	1	.	6	26	1	.	6	.	63	89	.	1	.	.	17	40	65	
21	8	1	15	1	14	.	.	.	8	2	.	3	.	16	40	5	17	18	
22	1	.	.	.	8	.	.	.	6	.	.	3	.	2	7	2	6	6	
23	.	1	1	.	.	2	1	
24	1	5	.	.	.	1	1	.	.	
25	1	1	.	
26	
27	1	1	3	1	
28	.	.	.	2	2	1	.	5	4	2	.	
29	.	.	.	1	1	
30	0	.	
31A	1	1	.	
31B	2	.	2	.	2	2	.	4	
Maximum body mass (g)	68	129	30	1900	1850	990	990	15	43	10	160	900	1640	145	100	120	90	10,900	8000	200	26	225	200
Nocturnal	*	*	*	*	*	*	*	*	*	*	*	*	*	*	*	*	*	*	*	*	*	*	*
Predominantly juveniles	.	.	.	*	*	*	*	*	*	*

bones. Therefore, it appears that numerous cool fires were deliberately lit in the cave over a long period of time for reasons other than food preparation. It is of relevance to note the near-total absence of charcoal pieces among the ash-rich sub-layers of SU2, probably indicating the burning of soft woods, twigs, bark, or dry grass.

All in all, the faunal remains excavated from Squares P34 and P35 are more consistent with an owl roost deposit than an Aboriginal occupation site as conventionally perceived. However, evidence also suggests Aboriginal people repeatedly came to Cloggs Cave. Numerous fires were lit over a considerable period of time but only reached temperatures high enough to blacken bone (c. 200°C). The consistent absence of large and diurnal mammal remains, bone burnt (grey or calcined) in high-temperature cooking fires (600–800°C) and low frequency of bone fragmentation all suggest that when deposited, the upper levels (SU2) of this part of Cloggs Cave are not a result of campfires used to cook meat foods. Rather, evidence of frequent cool fires indicates that beginning sometime between 4,400–2,000 years ago, and especially after 2,000 years ago, the Old People periodically visited the cave for reasons other than vertebrate animal food processing and consumption.

4.4 The cultural materials

4.4.1 Flaked stone artefacts

Squares P34 and P35 revealed very few cultural objects, despite the 2.3-m deep sediment sequence. Only 15 flaked stone artefacts weighing in total 763.6 g were found in the entire deposit, all from the redeposited Mid-Holocene levels: five were found in SU3B, two in SU3C, and eight in SU3D–SU3G. Only one of the eight artefacts (from Square P35 XU85, in SU3C) analysed for use-wear shows evidence of use (a cortical flake with transverse use-wear indicating scraping action on semi-hard material such as fresh or dry plant matter or dry skin, microchipping from transverse scraping action, and edge rounding likely on soft matter). A feature of this assemblage is the absence of small flakes and flaked pieces <5-mm long (the excavated sediments were sieved in 2-mm mesh and sorted in controlled conditions at the Monash University archaeology laboratories). Their absence indicates that stone artefacts were not manufactured on-site but brought already prepared into the cave. It is of interest that in Squares P34–P35, the microstratified hearth layers of SU2 possess no stone artefacts at all (although a small, 10.5-cm long portable grindstone with mineral and animal residues was found from this level in an adjacent area; it is undergoing analysis and will be presented elsewhere). We will return to this pattern in the next section.

4.4.2 Standing stone

A fully buried, upright standing stone was uncovered towards the middle of Square P35, its base at 23.7-cm depth (Figure 6.5). It is 28.1-cm tall, 12.2-cm wide, 7.4-cm thick, weighs 2098 g, and is burnt all around. The stone came from the local

limestone inside the cave, not outside, as indicated by its surface weathering. For some members of the GunaiKurnai community today, the stone's shape is re- miniscent of a bird, with its "beak" pointing upwards and natural grooves framing the folded "wings" in correct anatomical position below the "head," although there are no definitive flaking, cutting, or grinding marks on the rock, and thus no signs that it was artificially shaped by people (see Figure 6.5b).

The stone cannot be balanced in a stable upright position on a level surface, and must therefore have been carefully nestled into the ground. It was stood upright by positioning its flat, longitudinally angled base parallel with the slope of the thin whitish ash and underlying brown loamy layers in which it was laid. That thin layer of whitish ash, together with a small amount of the underlying brown sandy loam, had been dug to shallow depth to sink the standing stone into. The base of the standing stone was then surrounded by a low "mound" of mixed, inter-leaved greyish-white ash (SU2AY-SU2BB) and brown sandy loam (SU2BH). The width of the shallow mounded area around the standing stone was a maximum 6 cm to the south and southeast, 4 cm to the west, and 2 cm to the north, and c. 2-cm thick all around except for at its upslope eastern side, where a c. 25-cm wide but shallow (1–2-cm deep) depression indicates where the mounding sediments had been collected from. The standing stone had been positioned on the edge of the western end of the shallow depression that was formed during its construction.

The standing stone was put in place in XU14, but its base intruded down into XU17 (the interface between the SU2BB ashy white layer at the base of the densely microstratified hearth layers and the underlying thin SU2BH brown sandy loam) (Figure 6.5a). It was positioned upright sometime after 2002–2117 cal BP (2091 ± 16 BP), the age of XU17, but before 1567–1696 cal BP (1724 ± 16 BP), that of XU8 higher up (the calibrated radiocarbon ages, each on a single piece of charcoal, are at 95.4% probability), and probably closer to the earlier of the two ages given it was built from XU14 a mere 3 cm above it. The standing stone was put in place shortly after a fire had been burnt creating the white ash at its base, before enough time had elapsed for eroding loamy sediments from upslope to deposit a new layer over it. Fires were then continuously built around the standing stone until all but its very tip was covered by the multiple ashy layers of SU2, and then by the buildup of the more recent layers of SU1. We know that the SU2 fires were not created in a single extended session around the standing stone, because a thin layer of redeposited brown sandy loam (SU2AR) accumulated from upslope, separating an underlying from an overlying set of ashy layers roughly a third up the standing stone's height.

The last fires around the standing stone appear to have been built 1567–1696 cal BP in XU8, being at the very top of the microstratified layers of Square P35. We do not know if other fires continued to be built nearby in other parts of the cave after that (excavations in progress are expected to reveal further details on this). A significantly more recent hearth dated to 6–281 cal BP (142 ± 25 BP) on a dry *Eucalyptus* leaf from XU7B is associated with broken bottleglass. In the

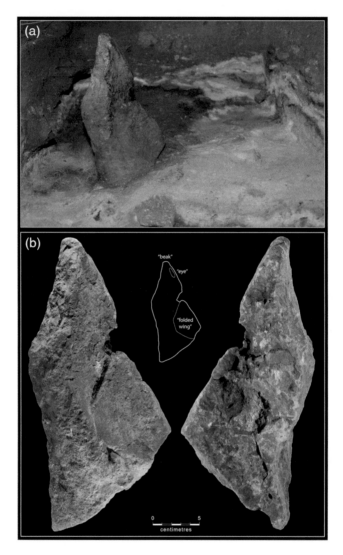

Figure 6.5 The Cloggs Cave Square P35 standing stone: (a) After excavation of XU14, showing the ashy level of SU2AY and SU2BB on which it was originally positioned. Note the absence of rocks around the base of the standing stone (photo by Bruno David). (b) The standing stone, showing its features reminiscent of a bird.

Source: Photos by Steve Morton.

Buchan region around Cloggs Cave, this period best dates to a phase of early colonial caving activity. All but the very tip of the standing stone would have long been buried by then.

5 GunaiKurnai ethnography: Of caves and birds

The country inland of the East Gippsland coast is rugged and remote with high mountains, steep gorges, dark ferny gullies, and many caves. There is not a single ethnohistorical or ethnographic account of the use of caves or rock shelters for habitation in this landscape, nor do present-day GunaiKurnai speak of caves as living places. This is not to say that such places are ignored or excised from the landscape. On the contrary, in the nineteenth century, and today, rocky features such as caves, rock shelters, holes, and standing stones were imbued by GunaiKurnai with cosmological significance through the spirit-beings and creatures with special powers who lived there, and through rituals and associations with individuals of special, "magical" standing within the community that made use of them. The stories about such landscape features speak of the ways of the spirit-world, ancestral connections, kinship and other social relationships between people and with places, and community history, each and together signalling a belonging to Country. Such places are often named after the special beings who reside in or frequent them.

To this day, the GunaiKurnai populate such secluded places with special beings, from "Hairy Men" or *dulagar* who inhabit the dark, closed forests; *nyol*, imp-like creatures who live in the dark ferny gullies and holes in the ground; and *nargun*, who live in the caves. These special, mostly spirit-beings but some flesh-and-blood creatures also, relate to all corners of Country, from the Mitchell River in the south to Buchan in the north to Wilsons Promontory and Corner Inlet in the west and Lake Tyers towards the east.

During the early colonial period of the mid- to late 1800s, information about caves and other secluded or difficult-of-access places within GunaiKurnai and neighbouring lands, was collected primarily by Alfred Howitt, a geologist, ethnographer, and Magistrate in East Gippsland, and the Rev. John Bulmer at the Lake Tyers Mission. As one of us (RM, a senior GunaiKurnai man) avows from personal experience and GunaiKurnai upbringing, caves continue to this day to often be associated with *nargun*. One of the first to describe in writing such associations was Howitt, who in 1875 explored the Mitchell River with two Aboriginal guides and found several caves and rock shelters, including what is now known as the "Den of Nargun." One of the two Aboriginal men, Bungil Bottle, said that this cave was inhabited by a creature called a *nargun* (*ngrung a narguna*) (Howitt 1875, 214 and 220). *Nargun* were described as partly made from stone (*wallung* in the local GunaiKurnai idiom), "except the breast and the arms and hands" (Howitt 1875, 220). The two men told Howitt that *nargun* lived in caves and waited there to catch unwary people and drag them into their lairs, and that spears and bullets were useless as anything thrown at them would turn back and wound the thrower (Howitt 1875, 220). Today, the Den of Nargun is widely considered a special women's place by the GunaiKurnai.

At Lake Tyers, where there are outcrops of Miocene limestone and small holes and caves, *nargun* were also called "Hairy Men" and were said to hunt small children. There is some disagreement between early colonial commentators and

later, often secondary accounts whether these *nargun* are male or female (see Brough Smyth 1878, Vol. 1, 456–457; Campbell and Vanderwal 1999, 48–49; Pepper 1980, 57). Bulmer was told by GunaiKurnai informants during the 1800s that, in pre-colonial times, a group of men once followed a *nargun* from a campsite to a cave at Toorloo on the northern end of Lake Tyers and disabled him by cutting his hamstring with reed and bone knives. To track the *nargun* they burnt the ground and followed its footprints to the cave (Pepper 1980, 57; Pepper and de Araugo 1985, 57).

Another *nargun* also lived at Lake Tyers in a small cave on the eastern Nowa Arm of the lake. A story is told by the GunaiKurnai at Lake Tyers that in colonial times a woman called Lilly fell into this hole and fought with the *nargun*, after which her body surfaced at Mystery Lake, about 6 km east of Lake Tyers, having travelled along an underground river to its exit (Massola 1968, 155).

In and around the Buchan River valley and Murrindal to the north, similar stories were told of special beings in caves. Here they were called *nyol*, who live in caves and holes but are less fearsome than *nargun* and more mischievous and imp-like. A story was told of a man who went possum hunting and was drawn down into a cave when he put his foot in a hole between two rocks. The cave was lit by a strange glow where he found little people called *nyol*. Although they were friendly and gave him food to eat and rugs to sleep on, they prevented him from getting back for some time before one eventually showed him to the surface (Massola 1968, 74–75). *Nyol* also live in dark ferny gullies like those at Kalimna to the west of Lakes Entrance.

Ancestral beings are also linked to caves. Loän, an important ancestral figure, lived by the Yarra River in Kulin Country, 200 km to the west of GunaiKurnai Country. One day he followed a swan feather southeastward, along the path of the swan migration to Corner Inlet and Wilsons Promontory in GunaiKurnai Country. Loän settled permanently in the mountains of the promontory in a cave overlooking the inlet (Howitt 1886, 416). He was said to be seen "wandering with a big spear" (Howitt 1886, 417).

There is another story about a rock or cave in the Corner Inlet region, this time associated with the ritual activities of a *mulla-mullung*, a "magic-man" or "medicine-man" with special powers. Here a GunaiKurnai man called Tankli dreamt that he was carried through the air over the sea at Corner Inlet, and led blindfolded to a cave at Yirik (Wilsons Promontory) by his father Bunjil-Bataluk, the lace-lizard and a *mulla-mullung* himself. In the cave, special instructions involving the use of quartz crystals and other matters were passed on, and Tankli eventually came out transformed into a *mulla-mullung* (quartz crystals (*groggin*) are widely known to have been the special weapons and means of *mulla-mullung*) (Howitt 1904, 408–409).

RM suggests that the standing stone in Cloggs Cave is in the shape of an eaglehawk (in GunaiKurnai language, *kwarnamerung*), and is probably related to the "magical" activities of *mulla-mullung* who undertook secret actions in secluded places, such as for healing or to harm particular individuals, and who flew through the skies as they travelled in spirit-form across GunaiKurnai Country

(flying is a characteristic special power of *mulla-mullung*). He suggests that through ritual association, the *mulla-mullang* took on the flying abilities of the eaglehawk. Howitt (1904, 410–11) also wrote that "The general belief as to the powers of the medicine-man are much the same" among the GunaiKurnai and surrounding "tribes." "He is everywhere believed to have received his dreaded power from some supernatural source, or being," and "It is a common belief that when two things are associated and together, any magical power possessed by the one will be communicated to the other." This GunaiKurnai cultural knowledge is widely retained within the GunaiKurnai community today (RM, personal experience; see also Pepper 1980, 34).

Given the shape of the excavated Cloggs Cave standing stone, we need to also ask whether birds have any other known special importance in GunaiKurnai cosmology of the ethnographic period. Here the literature abounds, as does current GunaiKurnai and neighbouring community knowledge. Birds feature prominently in oral traditions (e.g., for a GunaiKurnai story on how people became black, involving eaglehawk and crow and the burning of a cave, see Campbell and Vanderwal 1999, 42). Records from the early colonial period indicate that each member of GunaiKurnai society obtained a totemic affiliation (*thundung*, or "elder brother" of males; and *bauung*, or elder sister of females), with birds commonly featuring as totems (e.g., Howitt 1904, 135, 146). Totemic affiliation was transmitted patrilineaby, and as residence was patrilocal, individual totemic associations tended to be "perpetuated from generation to generation in the same locality, and in this manner have become localised" and through time commonly shared within families (Howitt 1904, 146). The crow (*Corvus* spp.) is also of special significance (in neighbouring groups, but in the late 1800s not among the GunaiKurnai, social organisation revolved around two highly significant moieties, eaglehawk and crow). Howitt (1904, 134–35) wrote:

> The crow is said to be the friend of the Kurnai. It was wrong to kill a crow, and in doing so, they thought, would bring on stormy weather. Tankowillin ... said when I spoke to him about this belief, 'I know that I should not kill and eat crow, but I have often eaten his children without his doing me any harm'. Crows have a habit of following people in the bush, flying from tree to tree, and peering down at the person followed while doing so; the Kurnai say that a crow understands their language, and answers their questions by its caw, which is their affirmative *ngaa*.

Of special significance also were the "sex totems," the emu-wren (*Stipiturus* sp.) (*yiirung*, here too "elder brother" of males) and the superb warbler (*Malurus cyaneus*) (*djütgun*, "elder sister" of females). Neither of these species could be injured, for to do so would be tantamount to injuring kin of that sex, with implications for social connections including actual or potential marriage partners and their families. "Fights between the sexes on account of the killing of the brother or sister totem" were widespread among neighbouring groups also (Pepper 1980, 37; Howitt 1904, 148–149).

All in all, nineteenth-century ethnographic records and current cultural knowledge is silent on bird-shaped standing stones and the use of Cloggs Cave specifically, but there is much general information on what caves and bird affiliations are all about cosmologically for the GunaiKurnai, and for neighbouring groups. Caves and rock shelters are important locations for Traditional Owners throughout GunaiKurnai Country. They feature in oral histories not as campsites or shelters for habitation, but as places steeped in ancestral (hi)stories and mystery. They are locations of fabulous creatures and of secluded places for ritual by powerful "magic men," both of which are normally avoided. Many birds have close totemic associations; they are kin who, like other family members, are protected, their harm the cause of much social insult, tension, and reprisal. Whether such totemic relationships entailed ritual renewal is unknown, and the secret rituals of *mulla-mullung* were undertaken away from residential camps and the eyes of the broader community.

6 Discussion

Australian archaeology in the late 1960s and 1970s was very much attuned to broader international trends of the time. Yet the Binford-inspired New Archaeology (e.g., Binford and Binford 1968; Binford 1972) from the USA had not been entirely embraced in Australia by the early 1970s, in many ways playing second fiddle to the UK's economic school (e.g., Clarke 1952; Higgs 1972) from which most of Australia's first generation of professionally trained archaeologists had come (e.g., Murray and White 1981), and to Birdsell's (1953, 1957) brand of cultural ecology. Here Birdsell (especially 1953, 1957) and Clarke's (1952) focus on environmental adaptations and subsistence basis for site and regional occupation remained more poignant points of reference when Cloggs Cave was first excavated. "Habitat and economy" (e.g., Lawrence 1969) was a catch-cry, with the archaeological record commonly read as strategic evidence for survival and the food quest, especially in supposedly harsh glacial-age environments (Jones 1968). And yet, another, more subtle influence was also playing in the background, barely heard in the archaeology of the day but soon after to make a significant mark: Aboriginal voices, usually read about through social anthropological texts (e.g., Stanner 1933-1934; Thomson 1949; Warner 1958; Munn 1973). These voices made more of kinship, cosmologies, ritual, ceremonial exchanges, meanings, and the social dimensions of actions, all of which spoke of how Aboriginal peoples made sense of their worlds through culture and social relations, rather than of "hunting and gathering" as an overarching economic endeavour. But in the late 1960s and early 1970s Australian archaeology, the logic and language of the food quest, trade (e.g., of stone raw materials for the making of tools towards the food quest) and survival in a cold environment remained prevalent, even when ethnographic texts were referenced (e.g., Wright 1971b; Flood 1973).

What are we to make, then, of an absence of food refuse, paucity of stone tools, absence of tool manufacturing debris, repeated building of cool fires, and

presence of a standing stone in the new excavation at Cloggs Cave (and who knows if any, and if so how many, of the latter may have gone unrecognised in the original excavations, given the large number of rocks then dug and discarded (see Figure 6.2c), the unprecedented nature of such finds in Australian archaeology, and a predisposition for seeing subsistence activity?). We are reminded of Christopher Chippindale's (2000, 608) apt words:

> Deposits once archaeologically excavated are destroyed, and equivalent errors in their capture cannot be repaired. This is why we have an increasing number of sites for which the old record is inadequate, yet field notes and museum collections—however good and full by the standards of their time—cannot now supply what was not captured then.

At least part of the problem is that we tend to lose sight of the evidence itself, and how it has been gathered as information to construct narratives already significantly pre-informed by interpretative frameworks. Those intellectually embedded data have stood as evidence for the stories told, but the archaeological details, as evidence for something partly pre-empted, have then been lost sight of to the point that the stories (read "models") become substitutes for the interpreted data themselves (data is to evidence as evidence is to the stories we tell). Once the original data and contexts of their capture (Chippindale 2000) are lost sight of—the contents of a site, the way knowledge of those contents has been shaped by the created categories used for analysis, and how those data are interpreted through particular paradigms and world views—then we are left with narratives that simply reproduce the attitudes of the time, and we are predestined to just repeat their embedded biases.

The first and second Cloggs Cave excavations were conducted nearly 50 years apart. What happened in Australian archaeology in the intervening years, and how have these developments altered archaeological attitudes and, consequently, how the site is now read? And how do collection methods limit the capture of data, and the stories that can be interpreted from those data? Other than significant technical innovations in dating, mapping and the like, there have also been a number of significant intellectual shifts. In Australia one of the first and most influential came in the late 1970s–mid 1980s with the work of Harry Lourandos and other socially oriented researchers (e.g., Bowdler 1976; McBryde 1978; Thomas 1981), part of a global movement towards what was often a more Marxist-inspired perspective (e.g., Bender 1978). Lourandos argued that the archaeological record needed to be interrogated for what it tells us about social change and not just stasis. Predominant thinking at the time, by Jones (e.g., 1977; Birdsell 1953; White 1971) and others, had it that, once the Australian continent had been colonised, human populations established ecologically "balanced conditions" with their environments (i.e., society and culture were subordinated to the ecological, as environmental adaptations; e.g., Lourandos 1980, 245). But, Lourandos noted, the archaeological evidence suggests instead that population densities had changed through time, as had both material technologies and the "artificial manipulation and expansion of

ecological niches" (Lourandos 1980, 259), such as in the use of artificial drainage systems towards eel "farming" in southwestern Victoria. Lourandos challenged conventional archaeological thinking that "Aboriginal population levels were largely controlled by climate as measured by rainfall" and associated environmental adaptations (Lourandos 2008, 69), as Birdsell (e.g., 1953, 1957) had argued and that had significantly shaped Australian archaeological thinking ever since (e.g., Jones 1977). Lourandos suggested instead that complex social networks, territoriality, and boundary maintenance had been socially managed by Aboriginal peoples through such things as regional art styles, and these active social engagements had histories that could be archaeologically traced. Aboriginal peoples had not simply responded to their physical environments through the food quest, but also enacted dynamic social relations within and between communities, through time engendering major demographic, technological, and ecological developments in their own right, and these could not simply be understood through the language and logic of adaptation. "[T]his new approach removed ['hunter-gatherers'] from their environmental constraints allowing them a dynamic history, just like other societies. 'Hunter-gatherers' no longer needed be viewed as passive, but as active agents within changing landscapes both natural and cultural" (Lourandos 2008, 71).

Lourandos's new perspective on the Australian Aboriginal past was part of a global archaeological movement towards a more social view of the past that shook the discipline in the latter years of the 1970s into the 1980s. It came also at a time when Aboriginal voices across Australia began to be more clearly heard by archaeologists. "Almost by definition," Preucel and Hodder (1996, 604) later wrote, "archaeology separates people from their past" (see also McNiven and Russell 2005). The late twentieth-century shifts in archaeological approach were also a reflection and consequence of the development of postcolonial thought as settler colonies began to recognise that their versions of the past shaped the present, shifting the paradigm from experts to collaborators. As Patrick Wolfe (2006, 387) noted, the ethos and success of settler colonialism depended on the elimination of the "native." In the case of archaeology, this "elimination" was at the very least achieved by restricting their presence to the deep past, and the severing of connections with present communities. Powerful Aboriginal commentary such as that offered by Roslyn Langford (1983) confronted this problem by emphasising that Aboriginal archaeology was not just a scientific playground, for it concerned Aboriginal pasts of Aboriginal presents. And archaeological research thus came with contemporary responsibilities not only for places and artefacts as relics of that past, but also for Aboriginal people today and into the future. As Ian McNiven (1998, 47) more recently wrote, the power to write about the past is a power "to control constructions of identity" (see also e.g., McBryde 1985). Indigenous calls for recognition of an *Aboriginal* heritage increased awareness that "archaeological" sites were living and breathing Aboriginal places, contemporary places that are meaningful to descendent populations today, and that present-day Aboriginal peoples had a right to their own (hi)story.

Late 1970s and 1980s archaeology also began to emphasise cultural symbols as

active social influencers, as persuasively argued by Hodder's *Symbols in Action* (1982) among many other texts of the day. Archaeologists were beginning to find interest in how communities socially constructed themselves through symbols and the cultural perspectives those symbols expressed, here, too, requiring a more social archaeology that was prepared to see the past as more than environmental challenges and responses.

Understanding Cloggs Cave today is thus more than extending back in time the known antiquity of Aboriginal Australia or understanding deep-time adaptations at the foothills of the High Country, critical questions at the time of its original excavation. Today it is about understanding a GunaiKurnai place in a way that addresses what the Old People did, as ancestors of people alive today. Each place has its own stories to tell. This is the reason why the GunaiKurnai Land and Waters Aboriginal Corporation, representing the Aboriginal peoples of Cloggs Cave and its surroundings, requested new excavations to be done: to better understand the site with new methods at hand, and new eyes. Instead of seeing Cloggs Cave as a regionally representative site, the question is now more one of particularities. What made Cloggs Cave special to the ancestors? What did they do there, and why? How can present-day knowledge held by present-day GunaiKurnai help better understand the site as a story-place? Archaeologists can read the buried signs from a largely sedimentary perspective, but local descendant communities can also interpret the archaeology, from the perspective of descendant cultural knowledge and GunaiKurnai world views. The question is, when archaeological details are revealed, what are we, in the plural, to make of them today?

7 Conclusion: Paradigm shifts and ontological turns

The new excavations at Cloggs Cave may have revealed critical new details of its archaeology, but it is not this alone that has caused us to rethink what happened there in the past. Rather, many, and perhaps all, of the elements of the new interpretations were already there from the beginning: the paucity or total absence of food remains inside the cave, the low density of stone artefacts, a dense layer of repeated cool fires, one (and perhaps other unrecognised) standing stones, and a significantly contrasting archaeological record outside versus inside the cave. All these indicated that the cave was used for something other than everyday occupation. Yet the upper stratigraphic levels inside the cave have many superimposed layers of ash indicative of repeated fires, and therefore of repeated sojourns into the cave. We now know that these rich upper levels in the area of Squares P34 and P35 began to build up some 4,400–2,000 years ago, and that the excavated standing stone was set upright in the ground close to 2,000 years or some 80 generations ago, after which cool fires were repeatedly burnt around it. But to make sense of this, in the words of Christopher Chippindale (2000, 609), "It is what we choose to look at, what we seek to capture that comes first," and here we need, we choose, something more than the archaeology.

As Flood (e.g., 1988) well-recognised in her reliance on historical accounts for

evidence of "moth hunting" as a seasonal subsistence and social gathering activity, it is ethnography, and GunaiKurnai voices, that give us the critical breakthrough (see Wright 1971b for another early 1970s archaeological delve into ethnographic texts for economic explanations, in this case for Koonalda Cave). First, evidence of people inside the part of Cloggs Cave presented here now progresses from the Mid-Holocene to c. 1,600 years ago, and possibly to more recent times given the large area of burning revealed by the original excavations of 1971–1972 beyond the now-radiocarbon dated area of Square P35. This now signals that the uppermost layers come close to ethnographic times. With this narrowing of the chronological gap between the uppermost archaeological layers and the time of GunaiKurnai ethnography, GunaiKurnai oral histories, cultural knowledge, and ethnographic documents enable us to better understand the cave.

Caves in GunaiKurnai Country and neighbouring lands are repeatedly and without known exception stated and documented to have been special locations, not for everyday habitation but for ritual and the activities of special beings. This also effectively warns archaeologists not to assume that such sites can be interpreted in the language and logic of "habitat and economy" so popular in archaeology especially in the 1970s. Today the archaeological story of Cloggs Cave has significantly turned from narratives of environmental adaptation, survival in a cold environment and the food quest, to readings of how GunaiKurnai ancestors made sense of their world through cultural actions that speak of numinous presences and social relations across the landscape. This is more than a "paradigm shift" but an ontological turn, to use the language of scientific theory. Thomas Kuhn's "paradigm" paradigm, devised in 1962 and of supreme currency into the 1970s, was about "universally recognised scientific achievements that for a time provide model problems and solutions for a community of researchers" (Kuhn 1970, viii). Here concerns for knowledge-creation focused on epistemology, on how knowledge is generated and on how paradigms shift through the interplay of ideological justification and methodological testing. The "ontological" interests of the 1990s are about something more, about how cultural world views inform how we understand things to *be* (e.g., David 2002). The "ontological turn" now takes into consideration that archaeological deposits were in many instances created by people with vastly different ontologies, vastly different world views to those of the investigating and interpreting archaeologists (because those sites were in many cases used a long time ago, and by people with different cultures to those of the archaeologists), and there are many ways of interpreting the archaeological record today, because there are many worldviews. In short, while a paradigm interprets findings through the scientific assumptions of the day, ontology prioritises the cultural world views by which existence is understood and in which interpretations are made, and this has implications for how we use data as evidence of, and for, the past (e.g., see Langton 2002 and David et al. 2012 for two examples of different ontological readings of a given phenomenon). In Chippindale's (2000, 605) eloquent words, "The data are not data at all, for they are practically never *given* to us by the

archaeological record. They are actually *capta*, things that we have ventured forth in search of and captured."

The new interpretations of Cloggs Cave stem not so much from its re-excavation as from the shifts in perspective that took place over the past 50 years about how to think of "archaeological" sites. Those changes were not just generated by archaeologists, but rather by a combination of influences, especially by Indigenous voices who called for their own cultural places and cultural ways to be better recognised. The crisis exposed by those callings was, and is, one of social injustice, and in archaeological practice it hit its target both as a critical commentary of readings of cultural records about peoples past that were largely positioned as pawns to environmental circumstances, and of the exclusion of Indigenous peoples today from their own ancestral (hi)stories and therefore from their own presence. Like people all over the world, Aboriginal peoples have, and have always had, social and cultural lives, not just subsistence economies. These shifts in how we understand archaeological sites such as Cloggs Cave are shifts in the position of archaeology towards the recognition of people's living ancestral sites today.

Note

1 We thank the GunaiKurnai Elders Council, the ARC Centre of Excellence for Australian Biodiversity and Heritage for funding this research, Harry Lourandos for useful comments on an earlier draft, and the Monash Indigenous Studies Centre at Monash University for research support.

References cited

Bender, Barbara. 1978. "Gatherer-hunter to farmer: A social perspective." *World Archaeology 10* (2): 204–222.
Binford, Lewis R. 1972. *An Archaeological Perspective*. New York: Seminar Press.
Binford, Sally R., and Lewis R. Binford (eds). 1968. *New Perspectives in Archaeology*. Chicago: Aldine.
Birdsell, Joseph. B. 1953. "Some environmental and cultural factors influencing the structuring of Australian Aboriginal populations." *American Naturalist 87* (834): 171–207.
Birdsell, Joseph. B. 1957. "Some population problems involving Pleistocene man." *Cold Spring Harbor Symposia on Quantitative Biology 22*: 47–69.
Bowdler, Sandra. 1976. "Hook, line, and dilly bag: An interpretation of an Australian coastal shell middens." *Mankind 10* (4): 248–258.
Bowler, Jim M., Rhys Jones, Harry Allen, and Alan. G. Thorne. 1970. "Pleistocene human remains from Australia: A living site and human cremation from Lake Mungo, western New South Wales." *World Archaeology 2* (1): 39–60.
Brough Smyth, Robert. 1878. *The Aborigines of Victoria, with Notes Relating to the Habits of the Natives of other Parts of Australia and Tasmania*. London: Trubner.
Campbell, Alastair H., and Ron Vanderwal. 1999. *John Bulmer's Recollections of Victorian Aboriginal Life, 1855-1908*. Occasional Papers, Anthropology and History 3. Melbourne: Museum Victoria.

Chippindale, Christopher. 2000. Capta and data: On the true nature of archaeological information. *American Antiquity 65* (4): 605–612.

Clarke, Grahame. 1952. *Prehistoric Europe: The Economic Basis.* London: Methuen.

David, Bruno. 2002. *Landscapes, Rock-Art and the Dreaming: An Archaeology of Preunderstanding.* London: Leicester University Press.

David, Bruno, Lara Lamb, Jean-Jacques Delannoy, Frank Pivoru, Cassandra Rowe, Max Pivoru, T. Frank, N. Frank, Andrew Fairbairn, and Ruth Pivoru. 2012. "Poromoi Tamu and the case of the drowning village: History, lost places and the stories we tell." *International Journal of Historical Archaeology 16* (2): 319–345.

Delannoy, Jean-Jacques, Bruno David, Joanna Fresløv, Russell Mullett, GunaiKurnai Land and Waters Aboriginal Corporation, Helen Green, Johan Berthet, Fiona Petchey, Lee J. Arnold, Rachel Wood, Matthew McDowell, Joe Crouch, Jerome Mialanes, Jeremy Ash, and Vanessa N.L. Wong. 2020. "Geomorphological context and formation history of Cloggs Cave: What was the cave like when people inhabited it?" *Journal of Archaeological Science: Reports 33*: 102461.

Dortch, Charles E. 1979. "Devil's Lair, an example of prolonged cave use in south-western Australia." *World Archaeology 10* (3): 258–279.

Dortch, Charles E., and Duncan Merrilees. 1971. "A salvage excavation in Devil's Lair, Western Australia." *Journal of the Royal Society of Western Australia 54*: 103–113.

Flood, Josephine. 1973. "The moth hunters: Investigations towards a prehistory of the south-eastern highlands of Australia." PhD diss., The Australian National University.

Flood, Josephine. 1974. "Pleistocene man at Cloggs Cave: His tool kit and environment." *Mankind 9* (3): 175–188.

Flood, Josephine. 1980. *The Moth Hunters: Aboriginal Prehistory of the Australian Alps.* Canberra: Australian Institute of Aboriginal Studies.

Flood, Josephine. 1988. "No ethnography, no moth hunters." In *Archaeology with Ethnography: An Australian Perspective*, edited by Betty Meehan and Rhys Jones, 270–276. Canberra: Australian National University.

Flood, Josephine. 1995. *Archaeology of the Dreamtime.* Sydney: Angus and Robertson.

Flood, Josephine. 2007. "Late survival of megafauna in Gippsland: Dated faunal sequences from Cloggs and other Buchan caves." In *Selwyn Symposium 2007*, edited by M.L. Cupper and S.J. Gallagher, 51–54. Melbourne: The Geological Society of Australia.

Gallus, Alexander. 1968a. "Archaeological excavations at Koonalda, Nullabor Plain, 1957–67." *Journal of the Anthropological Society of South Australia 6* (7): 4–8.

Gallus, Alexander. 1968b. "Excavations at Koonalda Cave, South Australia." *Current Anthropology 9* (4): 324–325.

Gallus, Alexander. 1971. "Results of the exploration of Koonalda Cave 1956–1968." In *Archaeology of the Gallus Site*, edited by R.V.S. Wright, 87–133. Canberra: Australian Institute of Aboriginal Studies.

Higgs, Eric S. (ed). 1972. *Papers in Economic Prehistory.* Cambridge: Cambridge University Press.

Hodder, Ian. 1982. *Symbols in Action: Ethnoarchaeological Studies of Material Culture.* Cambridge: Cambridge University Press.

Hope, Jeannette H. 1973. "Appendix XIV: Analysis of bone from Cloggs Cave, Buchan, N.E. Victoria." In "The moth hunters: Investigations towards a prehistory of the south-eastern highlands of Australia," by Josephine Flood, 1–18. PhD diss., The Australian National University.

Howitt, Alfred W. 1875. "Notes on the Devonian rocks of North Gippsland." *Progress Reports of the Geological Survey of Victoria 3*: 181–249.

Howitt, Alfred W. 1886. "On the migrations of the Kurnai ancestors." *The Journal of the Anthropological Institute of Great Britain and Ireland 15*: 409–422.

Howitt, Alfred W. 1904. *The Native Tribes of South-East Australia*. London: Macmillan and Co. Limited.

Jones, Rhys. 1968. "The geographical background to the arrival of man in Australia and Tasmania." *Archaeology and Physical Anthropology in Oceania 3* (3): 186–215.

Jones, Rhys. 1977. "The Tasmanian paradox." In *Stone Tools as Cultural Markers: Change, Evolution and Complexity*, edited by Richard V.S. Wright, 189–1204. Canberra: Australian Institute of Aboriginal Studies.

Kuhn, Thomas S. 1970. *The Structure of Scientific Revolutions*. Chicago: The University of Chicago Press.

Lampert, Ronald. J. 1971. *Burrill Lake and Currarong*. Terra Australis 1. Canberra: The Australian National University.

Langford, Roslyn. 1983. "Our heritage – your playground." *Australian Archaeology 16*: 1–6.

Langton, Marcia. 2002. "The edge of the sacred, the edge of death: Sensual inscriptions." In *Inscribed Landscapes: Marking and Making Place*, edited by Bruno David and Meredith Wilson, 253–269. Honolulu: University of Hawai'i Press.

Lawrence, Roger. 1969. *Aboriginal Habitat and Economy*. Occasional Paper 6. Canberra: The Australian National University.

Lourandos, Harry. 1980. "Change or stability? Hydraulics, hunter-gatherers and population in temperate Australia." *World Archaeology 11* (3): 245–264.

Lourandos, Harry. 2008. "Constructing 'hunter-gatherers', constructing 'prehistory': Australia and New Guinea." *Australian Archaeology 67*: 69–78.

Massola, Aldo. 1968. *Bunjil's Cave: Myths, Legends and Superstitions of the Aborigines of South-East Australia*. Vancouver: Lansdowne Press.

McBryde, Isabel. 1966. "An archaeological survey of the New England region, New South Wales." PhD diss., University of New England, Armidale.

McBryde, Isabel. 1978. "Wil-im-ee moor-ring: Or, where do axes come from?" *Mankind 11* (3): 354–382.

McBryde, Isabel (ed). 1985. *Who Owns the Past? Papers from the Annual Symposium of the Australian Academy of the Humanities*. Melbourne: Oxford University Press.

McNiven, Ian J. 1998. "Shipwreck saga as archaeological text: Reconstructing Fraser Island's Aboriginal past." In *Constructions of Colonialism: Perspectives on Eliza Fraser's Shipwreck*, edited by Ian J. McNiven, Lynette Russell, and Kay Schaffer, 37–50. London: Leicester University Press.

McNiven, Ian J., and Lynette Russell. 2005. *Appropriated Pasts: Archaeology and Indigenous People in Settler Colonies*. Lanham: AltaMira Press.

Mulvaney, Derek John. 1962. "Advancing frontiers in Australian archaeology." *Oceania 33* (2): 135–138.

Mulvaney, Derek John. 1964. "The Pleistocene colonization of Australia." *Antiquity 38* (152): 263–267.

Mulvaney, Derek John, and Edmund B. Joyce. 1965. "Archaeological and geomorphological investigations at Mt Moffatt Station, Queensland, Australia." *Proceedings of the Prehistoric Society 31*: 147–212.

Munn, Nancy. D. 1973. *Walbiri Iconography: Graphic Representation and Cultural Symbolism in a Central Australian Society*. Ithaca: Cornell University Press.

Murray, Tim, and J. Peter White. 1981. "Cambridge in the bush? Archaeology in Australia and New Guinea." *World Archaeology 13* (2): 255–263.

Pepper, Phillip. 1980. *You Are What You Make Yourself to Be: The Story of a Victorian Aboriginal Family 1842–1980.* South Yarra: Hyland House.

Pepper, Phillip, and Tess De Araugo. 1985. *What Did happen to the Aborigines of Victoria: The Kurnai of Gippsland.* South Yarra: Hyland House.

Preucel, Robert, and Ian Hodder. 1996. "Constructing identities." In *Contemporary Archaeology in Theory: A Reader*, edited by Robert Preucel and Ian Hodder, 601–614. Oxford: Blackwell Publishers.

Stanner, William E.H. 1933–1934. "Ceremonial economics of the Mulluk-Mulluk and Madngella tribes of the Daly River, north Australia: A preliminary paper." *Oceania 4*: 156–175, 458–471.

Thomas, Nicholas. 1981. "Social theory, ecology and epistemology: Theoretical issues in Australian prehistory." *Mankind 13* (2): 165–177.

Thomson, Donald F. 1949. *Economic Structure and the Ceremonial Exchange Cycle in Arnhem Land.* Melbourne: Macmillan.

Walshe, Keryn. 2017. "Koonalda Cave, Nullarbor Plain, South Australia – Issues in optical and radiometric dating of deep karst caves." *Geochronometria 44*: 366–373.

Warner, William. L. 1958. *A Black Civilization.* New York: Harper.

White, Carmel. 1967a. "Early stone axes in Arnhem Land." *Antiquity 41*: 149–151.

White, Carmel. 1967b. "Plateau and plain: Prehistoric investigations in Arnhem Land, Northern Territory." PhD diss., The Australian National University.

White, Carmel. 1967c. "The prehistory of the Kakadu people." *Mankind 6* (9): 426–431.

White, J. Peter. 1971. "New Guinea and Australian prehistory: The 'Neolithic problem'." In *Aboriginal Man and Environment in Australia*, edited by Dereck J. Mulvaney and Jack Golson, 182–195. Canberra: Australian National University.

Wolfe, Patrick. 2006. "Settler colonialism and the elimination of the native." *Journal of Genocide Research 8*: 387–409.

Wright, Richard V.S. (ed). 1971a. "The cave." In *Archaeology of the Gallus Site*, edited by Richard V.S. Wright, 22–28. Canberra: Australian Institute of Aboriginal Studies.

Wright, Richard V.S. (ed). 1971b. "An ethnographic background to Koonalda Cave prehistory." In *Archaeology of the Gallus Site*, edited by Richard V.S. Wright, 1–16. Canberra: Australian Institute of Aboriginal Studies.

7 Lines of becoming

Rock art, ontology, and Indigenous knowledge practices

John Creese[1]

1 Introduction

This essay is about rock art and ancestral agency—how certain rock art practices reproduce a world of ancestral presence and relationship for many First Nations people of North America, historically and today. But, in making this argument, I wish to take a left fork off the well-beaten path of constructivism in which a culturally particular ontology is shown to be responsible for the distinctive nature of the rock art—its form, its settings, and its practices. Pursuing an alternate (no doubt more bumpy) track, I suggest that there is something more fundamental at work in the way ancestral agency flows through rock art than explanations rooted in notions of worldview would have it. Building on Norder's (2012) distinction between maker/meaning and user/caretaker frameworks for interpreting the rock art of the Canadian Shield, I see the user/caretaker model as symptomatic of a much broader set of relational knowledge practices common to Indigenous peoples of the region (cf. Zawadzka 2019). Resisting the tendency to explain these practices in terms of an off-the-shelf ontological model such as animism, I seek instead to reframe the problem as one of understanding how certain routine forms of action and attention shape emergent worlds—not just their perception or imagination by enculturated subjects—but the worlds themselves. This leads to a definition of ontology as ontogeny—sets of relations that tend to disclose (and foreclose) others within the self-transforming processes of emergent assemblages. Three corollaries are that ontologies are: (1) endemic to particular assemblages of practice; (2) inherently entangled with the actions and apparatuses of knowing; and (3) moving targets, defined in particular ongoing relations of disclosure rather than in fixed states of being. Drawing on examples of rock art, stone cairns, and medicine wheels of the Canadian Shield and Northern Plains, I show how a landscape of ancestral presence and agency was *realized* (as opposed to merely perceived, imagined, or experienced) in particular modes and media of action and attention. This, finally, leads to some conclusions about the value of Indigenous ways of knowing for rethinking archaeological epistemology "after interpretation" (e.g., Alberti, Jones, and Pollard 2013).

2 From decipherment to care

The rock art of the Canadian Shield region is generally attributed to the an-
cestors of today's Northern Algonquian peoples, especially the Cree, Innu, and
Anishinaabe (Dewdney and Kidd 1962; Jones 1981; Zawadzka 2019). The pri-
mary medium is red ochre, applied as paint to vertical cliff faces of Precambrian
rock, although rarer petroglyphs and even "lichen glyphs" are known (Dewdney
and Kidd 1962). Sites, dating anywhere between about 2500 BP and the last
century (Aubert et al. 2004), are closely associated with historic water routes
(Conway and Conway 1989; Norder and Carrol 2011; Zawadzka 2013), and
consist of panels of one or more figures that archaeologists usually describe as
anthropomorphic, zoomorphic, geometric, or abstract. Iconographic, stylistic,
and, to a lesser degree, compositional parallels can be made between the rock
art and imagery found in other Anishinaabe media, including clothing, bags,
drums, and birch bark scrolls used in the ceremonial practices of the *Midéwiwin*
and other medicine societies (Dewdney and Kidd 1962; Rajnovich 1994;
Vastokas 2003; Creese 2011). These parallels have been used, in combination
with Northern Algonquian ethnohistory, ethnography, and oral tradition, to
build up a fairly robust interpretive framework for "reading" rock art (Conway
1992; Rajnovich 1994; Weeks 2012; Lemaitre 2013).

Such readings have suited the preoccupations of a humanist archaeology bent
on recovering what it perceives as lost systems of meaning.[2] On the other hand,
they may be of somewhat limited interest to many contemporary Anishinaabe
people. In his Indigenous community-based work in northwestern Ontario,
Norder (2007, 2012) has observed that "reading" the images—that is, providing
authoritative representational interpretations of their content—is a matter of
ambivalence for contemporary community members: "Regardless of who I
talked to," he reports, "the uniform answer was that there was little to no
knowledge of the makers or the meaning of the rock art sites" (2012, 393).
Norder makes a persuasive argument that today, rock art's salience for First
Nations people lies not in the paradigm of "maker/meaning"—so cherished by
archaeologists—but in a framework of "user/caretaker." In practice, caretaking
rock art sites involves taking responsibility for maintaining good relationships
with these places and the spirits that inhabit them, for everyone's benefit. This
can range from making prayers and tobacco offerings, to prohibitions on pho-
tography, to studious avoidance. An elder interviewed by Shkilnyk (1985) de-
scribes the user/caretaker ethic as follows:

> Our people used to believe there is a spirit that dwells in those cliffs over
> there. Whenever the Indians thought something like that, they put a marker.

> And you can still see these markers on the old reserve. Sometimes you see
> paintings on rocks. These mean something; they were put there for a
> purpose ... The rock paintings mean that there is a good spirit there that will
> help us on the waters of the English River. You see a cut in the rocks over

there; that's where people leave tobacco for the good spirit that inhabits that place.

<div align="right">(Shkilnyk 1985, 71)</div>

Practices of caretaking, then, rather than decipherment, are the predominant concern of many contemporary Anishinaabe people who engage with rock art sites (see also Twance 2017). One could say that meaning is not the issue, or, perhaps more accurately, that meaning is intrinsic to the relationships that are established through repeated acts of care and attention. To the extent that rock paintings "mean something," that meaning seems to emerge from users' directed involvement with images as ancestral *marks*, indexes of a formerly (and therefore, potentially again) recognized spiritual presence, and all those practices of caretaking that are correspondingly fitting. Norder suggests that this situation reflects a kind of drift in social memory, writing that, "temporal distance, social change, and/or lack of cultural or oral transmission shifted the knowledge of maker and meaning out of the social memory of the descendants" (2012, 393).

I want to explore another possibility: that the user/caretaker framework has always been the primary way that rock art sites have had salience for Anishinaabe and other Indigenous peoples of the region, even at the time of their creation. This is not to suggest that there is no value in iconographic and con-textual analysis, or that images have no iconographic referents. What I am suggesting, however, is that meaning was *from the outset* inseparable from practices of care and attentiveness to the quality of the relationships in which it took place (cf. Creese 2011).

Historical, archaeological, and contemporary sources support this position. The earliest written reports about sacred sites in the region refer to many of the same activities of caretaking Norder observes today (e.g., Thwaites 1896-1901, Vol. 10, 164; Vol. 50, 286); sites were said to be the home of *maymaygwaysiwug*, spirits who dwelt in the cliffs, and are described as locations of prayer and tobacco offering by travelers (Dewdney and Kidd 1962, Arsenault and Waller 2008). Remarkably, underwater archaeology at sites like DhKm-1 in the Lake-of-the-Woods region de-monstrates that the practice of making offerings at rock art sites stretches back some 12 centuries or more at some locations. A small Laurel-type ceramic pot (ca. AD 800) was recovered some 16 m below water level just beneath the rock face. More recent offerings include nineteenth-century bottle glass, late nineteenth- and twentieth-century Ironstone pottery (Alfred Meakin), and a large quantity of textiles and clothing of diverse styles and periods (Colson 2006, 376–377, 545). Caretaking sites in the form of gift-giving thus appears to be a tradition of considerable antiquity.

Recent ethnographic work demonstrates that while receiving "messages" from the spirits may be the explicit goal of visiting a site, future-orientation, and the contextual relevance of the "message" to the "reader" are the primary hallmarks of the encounter. In her study of *mazinaabikiniganan* (rock images) near Batchewana, Ontario, Twance (2017, 67) notes that her informants, "made it very clear when speaking to me that they were providing their own under-standings of the mazinaabikiniganan [rock art images] and that in no way did

they intend their interpretations to be a singular definition of the images." Rather than generating authoritative readings, long-standing Anishinaabe rock art practices foster a sense of responsiveness, connection, and personal biographical relevance. Twance quotes Chief Dean Sayers on the use of the Agawa Rock as a setting for annual puberty fasting ceremonies:

> We come here to do ceremonies. We pray, we try to fulfill our obligations. Also historically, this place has been a place for our people to get clarity on what are our responsibilities. What are we supposed to do? How can we hone or clarify the work that we need to do? What kind of guidance and support can we get from the spirits here? How can they help us in our work that we need to do as Anishnaabe? So you come here and it's a place of vision so you can get that clarity. The fasters come here and they get that clarity on their roles and responsibilities and I understand that's always been the case for this particular place.
>
> (Twance 2017, 70)

3 Toward an etiology of ancestral intent

In such practices, the indexical quality of the images takes priority over the symbolic (cf. Peirce 1998, Crossland 2014); the images' meaning is primarily structured by the recognition that they *were put there for a purpose*, as Shkilnyk's (1985) informant tells us. Their relevance depends not on any uniquely correct reading, but on an etiology of ancestral or spiritual intent, the recognition of which is available to anyone through appropriately directed attention. Rodney, one of Twance's informants, describes visiting the Agawa site with his grandfather as a child:

> My grandfather, Tommy Agawa, took me up there in 1976 … so one time I asked my grandfather—I asked him, "Who put that on those rocks down there?"—he was really quiet and I said, "Why did they put them there?" He was sitting there really quiet and then he said, "Those been there for a long time—since forever is what I was told. It was your ancestors that put them there and they put them there for you", and he pointed at us, us kids.
>
> (Twance 2017, 74)

Being attuned and responsive to the ancestral intent present at rock art sites is a precondition for the kinds of relational connections with place, with animals, with spirits, from which appropriate care and associated well-being can be made to flow. Indeed, any attempt to fix the meaning of the images for all times and people would run counter to the logic by which they serve to foster ongoing, responsive, living connections with certain other-than-human persons. This might explain why "reading" rock art is not only not done, but even dismissed when the subject is raised (Norder 2012, 393). Where reflexive indexicality is the

preeminent way of knowing, there can be no authoritative reading standing outside and above each particular reading, because the agencies involved—spirits and people alike—are continuously alive to each other and the conditions of their unfolding relational engagements.

These ways of knowing, I suggest, shaped the distinctive manner in which the more complex rock art sites of the Shield took shape over the centuries. One might describe the larger sites as *thoughtful palimpsests*. In general, there is a loose organization to the figures in any given site, which were sometimes added in small groups, sometimes singly, over indeterminate stretches of time (Dewdney and Kidd 1962, 70; please see Figure 7.1). With a few noteworthy exceptions, panels in the Canadian Shield tradition do not exhibit the kind of clearly structured compositional "scene setting" that is evident in, for example, the Plains Biographical tradition (e.g., Keyser and Klassen 2001). Associations between figures are suggestive but underdetermined; at the same time, during painting, respect was clearly given to existing images (not to mention features of the rock itself, such as crevices, mineral deposits, and quartz veins) as new ones were added (Arsenault and Zawadzka 2014; Zawadzka 2016, 19): figures that substantially obscure others are known but uncommon (Dewdney and Kidd 1962, 10). The result is a kind of indexical dialogue, one in which later experiences of the numinous were conditioned, but not dictated, by the recognition of those that came before.

An interesting parallel can be drawn here with the Western Apache use of narrative discussed by Basso (1996). Specific mythic narratives, intimately tied to particular places on the landscape, gain meaning in each retelling in relation to some contemporary referent, such as the improper behavior of a community member. Western Apache people call this "hunting with stories" (Basso 1996, 58–61). Epistemologically, the practice follows the same relational logic that we have outlined for rock art; the story's significance is not fixed in advance but realized circumstantially in reference (typically oblique) to a contemporary subject of concern (Basso 1996). Experientially, this exerts a strong "pull" on the story's target; the person so "hunted" may reconsider their wayward behavior.[3]

The idea that knowing is first and foremost a relational practice of reciprocal care is widespread among Algonquian and other First Nations peoples of the midcontinent. Lokensgard, for example, observes that protocols of reciprocity are central to Blackfoot epistemologies of personhood. A person is recognizable by their willingness to engage in relationships of respect and accountability. Blackfoot personhood is thus conditional, "a status that must be achieved and maintained" by all those behaviors of cultivated reciprocity—for example sharing the pipe—that identify someone as *niitsitapi*, a real person (Lokensgard 2018, 126–127).

Importantly, relational philosophies of knowing are not limited to "traditional" settings. Writing about contemporary Indigenous research methods, Cree scholar Shawn Wilson (2008) argues that First Nations ontologies only make sense within what he calls a relational axiology, or ethic of responsibility toward the subject of one's knowledge claims. Taking aim at the ways in which Western knowledge systems assume and promote the knower as a detached observer, he writes provocatively: "who cares about those ontologies? It's not the

Figure 7.1 Cuttle Lake pictographs.
Source: Dewdney and Kidd 1962, 70; reprinted with permission from the University of Toronto Press.

realities in and of themselves that are important; *it is the relationship that I share with reality*" (2008, 74; my emphasis).

4 Lines of becoming[4]: Ontology as ontogeny

Accordingly, we may expand and qualify Norder's user/caretaker framework in terms of a relational-indexical way of knowing. As we have seen, such an outlook is by no means limited to Anishinaabe practices surrounding rock art. In Algonquian studies and beyond, it has recently garnered attention under such labels as "relational ontology" and "animism" (e.g., Watts 2013; Zawadzka 2016, 2019) in the context of the so-called ontological turn (e.g., Harvey 2005; Alberti et al. 2011; Alberti 2016; Harris 2016; Cipolla 2019). Zedeño (2008), for instance, examines the animistic principles of Plains medicine bundles, which, like rock art sites, carry and transmit ancestral and other-than-human agency. Drawing on foundational Anishinaabe ethnographies by Hallowell (2010) and Black (1977), she notes the way that certain "index objects" in bundles animate others by association. Such objects include red ochre and quartz crystals—significantly, the constituent materials of rock art. Indeed, rock art sites could be productively understood as bundles writ large.[5] Like bundles, they have complex biographies that involve original parts that may be inherently animate, as well as later additions that gain animacy by association. And like bundles, they seem to connect people and things through their unique histories of association, gaining power through the relations they gather (Zedeño 2008; cf. Pauketat 2013). Twance (2017) quotes informant Sayers who explains that rock art sites cannot be viewed in isolation: "They are connected to everything— what's out there, what's coming—land, history, politics, place" (Twance 2017, 36).

At this point, it is tempting to attribute the nature of the rock art of the Canadian Shield to this widespread Algonquian relational ontology, to treat it as one more expression of a culturally distinctive set of premises about the nature of reality. However, some qualifications are in order. Ontology must not be rendered simply worldview, or even ideation. For once it is, it slips beyond the active, materially engaged knowledge practices through which real worlds take shape. The instant ontology becomes synonymous with belief, we fall back into an old habit of mind that Ingold (2011, 178) has called *hylomorphic*, according to which, in the act of making, form is imposed on an inert world from without. Ontology, so abused, serves as an exogenous factor (like environment, its "natural" counterpart), acting *upon* practices such as art-making, rather than unfolding *within* them. Even as archaeologists have sought to move from explanations based in "social ontologies" to those that are more "critically ontological" (Alberti 2016), there seems to be an inevitable slippage towards hylomorphism when ontology takes the burden of explanation.

An alternative direction, and one that will be pursued throughout the rest of this essay, is to view ontology as *endemic* to any particular relational assemblage (Deleuze and Guattari 2004; DeLanda 2006). From this standpoint, the intra-actions of an assemblage (Barad 2007) do not reflect or encode extrinsic

knowledge, they are themselves processes of mind (Kohn 2013). For our purposes, then, an ontology will be *that characteristic of a total set of relationships through which the possibility of certain others is disclosed* (as opposed to a blueprint for action standing outside or above those relationships). In this sense, ontology is inherent to and inseparable from practices of knowing, not just because, as the saying goes, "you won't find what you're not looking for," but because the activities and apparatus of looking are always already part of an assemblage's emergent reality. Drawing on Bohr's quantum mechanics, Barad (2007) discusses the demonstrable contingency of the "object" we wish to understand and the "agencies of observation" we use to examine it. What this means, in effect, is that "observations of the world do not simply represent the world; they help to bring the world into being" (Jones 2014, 326).

This definition of ontology helps to address the "one world vs. many" paradox that has been raised in recent ontological discussions (Alberti 2016; Cipolla 2019). The apparent schism is over whether we should be seeking a new archaeological "metaphysics," a one-world meta-ontology that performs better than Cartesianism for archaeological interpretation (e.g., posthumanisms of various flavors), or whether we should be emphasizing and exploring the lived realities of multiple unique and incommensurate historical worlds by embracing a "radical essentialism" (Henare, Holbraad, and Wastell 2007). However, the notion that these two positions are irreconcilable springs from the lingering representationalist assumption that ontologies can be somehow purified and extracted from actual historical landscapes of action and their associated knowledge practices (more on this term to come). In such a view, there must always be a level of unreality to ontologies—they remain abstractions that can bear only an uncertain relationship to truth, to real reality "out there."

By contrast, defined as sets of relations that tend to disclose (and foreclose) others within the self-transforming processes of an unfolding assemblage (its *ontogenesis*), we can see that ontologies are never closed or fixed—they are moving targets, just as any assemblage is in a constant state of becoming (Deleuze and Guattari 2004). So it is only for the sake of rhetorical convenience that ontologies are presented as coherent, internally consistent, and immutable (Harris and Robb 2013). Just as assemblages can be more or less territorialized (DeLanda 2006), more or less blackboxed (Latour 2005), more or less characterized by fittingness (Hodder 2012), and so on, the same applies to ontologies, since the latter are intrinsic to the former. There is no problem, then, in recognizing multiple realities in one—worlds within worlds—just as there is no difficulty understanding assemblages themselves as nested, multiscale, and variably delimited phenomena.

5 Indigenous epistemologies and relational knowledge practices

In this alternative definition of ontology, there is precious little room for its distinction from epistemology. Epistemology and ontology are co-constitutive in the same movement of practice. For it is in precisely those activities through

which certain relationships are disclosed that reality is shaped. Contemporary Indigenous scholarship has much to offer archaeology on this point, and one can observe in it the condensation and generalization of many of the ideas we have so far discussed with reference to rock art and relational-indexical ways of knowing. Wilson (2008, 73) writes:

> In an Indigenous ontology there may be many realities, as in the constructivist research paradigm. The difference is that, rather than the truth being something that is "out there" or external, reality is in the relationship that one has with truth. Thus, an object or thing is not as important as one's relationships to it. This idea could be further expanded to say that reality *is* relationships or sets of relationships. Thus there is no one definite reality but different sets of relationships that make up an Indigenous ontology. Therefore reality is not an object, but a process of relationships, and an Indigenous ontology is actually the equivalent of an Indigenous epistemology.

Strathern's (1988) happy phrase "knowledge practices," captures this dual epistemological/ontological movement particularly well. In archaeology, for example, the assemblage of accelerator mass spectrometers, Bayesian statistical programs, total stations, Cartesian grids and the routine activities of dating, survey, and mapping together constitute a body of knowledge practices through which abstract, measurable space-time becomes meaningful as a tool for producing authoritative knowledge about the past. Importantly, this is not an argument for reducing ontology to epistemology; I am not suggesting that ontologies are fully determined by perception. As Fowler and Harris (2015, 135) put it, "electrons may be waves or particles, but this does not mean they could be anything." Reality isn't just what we wish it to be—however, possibilities for being are in a real sense shaped by those intra-actions of which the knower is a part.

Generalizing the point, it is to such knowledge practices and their enabling assemblages that we should turn if we want to understand how certain historical realities take shape. Thus, the interpretative challenge that interests us is not one of ontological model-fitting ("is this a case of 'animism'?", and so on), but attending to the distinctive ways in which people, as Ingold puts it, "find the grain of the world's becoming and follow its course while bending it to their evolving purpose" (2011, 211).

6 Ancestral presence, distributed agency, and extended mind

With this in mind, our path now clearly diverges from the comfortable constructivist one we had been strolling along. We can no longer be satisfied to show how people acted *as if* rock art manifested ancestral and spiritual intentions based on certain exotic ontological premises. Rather, we seek to understand how their

knowledge practices realized (in the fullest sense) certain immanent possibilities for assemblages to distribute agency and cognition over time and generations.

Leaving aside for the moment questions about the ontological status of "ancestors" and "spirits" (and recalling that reducing ontology to belief is at odds with our purpose), we can begin with our earlier description of rock art sites as *thoughtful palimpsests*. It may be tempting to think of this description as merely figurative. After all, what or who is doing the thinking? Me alone, confronting it? The artists, dead and gone? What about the panel itself? Of course, from a relational standpoint, a reasonable answer can only include *all of the above, together*.

In a remarkable cliff setting at Cuttle Lake, Ontario, in a panel located some seven meters above the water (please see Figure 7.1), Dewdney and Kidd (1962), and Rajnovich (1980) document a complex palimpsest of canoes, animal forms, hand prints, "tally marks," dots, lines, and amorphous "smudges" (Dewdney and Kidd 1962, 70–71; Rajnovich 1980, 6—9). Figures, often occurring in pairs, cluster tightly, in many cases touching or slightly overlapping, but never obscuring each other. At least two distinct pigment colors are recognizable: (1) a translucent "wine-red" used in the depiction of four canoes with occupants, a quadruped (probable moose), and one of the smudges, and (2) a translucent "orange-red" used for the other images (Rajnovich 1980, 8). The presence of an uneven calcareous wash at the site, with some images below it and others above, indicated the diachronic nature of the composition to Dewdney and Kidd (1962, 61). In a return visit, Rajnovich (1980) failed to confirm Dewdney and Kidd's stratigraphic hypothesis, but Dewdney and Kidd's photograph (1962, 61) supports their interpretation, as do numerous similar observations made by Colson (2006) at other sites in Northwestern Ontario.[6] Each figure traces not only the movements of a particular artist, but also that artist's recognition of the site as an evolving field of other such traces, and so on back to the first inscription (and even before, since features of the rock face or setting can themselves be attributed to various other-than-human agencies [e.g., Arsenault and Zawadzka 2014; Zawadzka 2016, 14, 19]). Of course, these recursive relational qualities are most evident in panels where the marks are nonrepresentational. Colson (2006, 271) reports amorphous ochre "smears" as the most common figure type in her extensive Lake-of-the-Woods survey. Likewise, Zawadzka's use of DStretch software at the Greyrock site on Lake Anima Nippising reveals a series of linear abstractions and repaintings including finger marks (2019, 86). Scanning electron microscope studies of pigment from Mazinaw Lake, Ontario, has revealed microstratigraphic evidence for repainting (Colson 2006, 380). These characteristics are similarly evident in an assemblage of hand prints and ochre wash at Lac la Croix, in the Quetico region (Creese 2011, 17), or further afield, in a series of repeated linear tool grooves and ochre applications at Writing-on-Stone (Barry 1991, 82). The result is an expanding self-referential web of intergenerational call and response; a deep time conversation in which the evolving medium—an unfolding assemblage of traces—is tantamount to the message *I recognize your recognition*.

Of course, limiting this assemblage to the rock face and its images alone is

quite arbitrary, and without belaboring the point, we can see that each figure also points to much else besides, both iconically and indexically. Prominently, for example, each image or image-set directly indexes lines of movement, both at the microscale of the artist's gesture, and less immediately, a series of associated pathways and trips to, from, and past the site. Most historically recorded activities involving rock art sites occurred during travel, as people paused at these well-known locations to make tobacco offerings and prayers. Those prayers, frequently enough, involved requests for safe passage. Geospatial studies confirm an association between rock art sites and important water routes through the Shield country (e.g., Norder and Carrol 2011). Major sites and site clusters are found at central and/or dangerous points within these route networks (Zawadzka 2013). And of course, many of the figures themselves relate to themes of water travel and the water *Manitouwak* who might influence it (depictions of canoes and paddlers, water serpents, fish, turtles, moose, thunder birds, and water panthers to name a few [Creese 2011]). Such images serve double duty as both icons and indexes of actual and prospective trips. So the relational network of ancestral traces—the palimpsest of images—collectively points toward, and is substantially structured by, a much broader set of entanglements, especially the network of water routes to and through these nodal places (Creese 2011; Norder 2012; Zawadzka 2019).

Understood in this way, rock art sites in the Shield have much in common with other landscape-scale assemblages that archaeologists working in the maker/meaning framework have had difficulty making sense of: the stone cairns, alignments, and medicine wheels of the Northern Plains. Unlike rock art images, the forms of these alignments are rarely iconic, though medicine wheels have been likened to other kinds of circles—burial lodges, camp circles, and sun dance grounds, for example.

However, in many cases there is no necessary iconic referent at all. Sundstrom (2003), quoting Linderman 1931, discusses the stone cairns of Pryor Gap, Montana. According to Linderman, Crow people built up a number of cairns as they passed through the gap each year. Each rock was "a prayer that the person would live to make the journey again" (Sundstrom 2003, 270). Here we find a knowledge practice that utilizes the indexical affordances of stones to mark a prayer and a passage. And like the rock art sites, each stone points not only to a single prayer, but to still other stones and prayers and trips, extending back through time and outward in space such that the growing cairns themselves become a measure of the cyclical movement of generations.

Well-dated medicine wheels, though more structured than simple cairns, also reveal evidence of similar developmental processes. Indeed, even more than the stone cairns of Pryor Gap, medicine wheels exhibit all the hallmarks of the *thoughtful palimpsests* that we have seen at rock art sites. Additions to these alignments retained some degree of reference to and improvisation upon an existing form set out by others. As reported by Goodjohn (1997), Siksika people continued to regularly visit the Majorville medicine wheel in Alberta in the 1990s. The central cairn of the Majorville wheel (please see Figure 7.2) has been

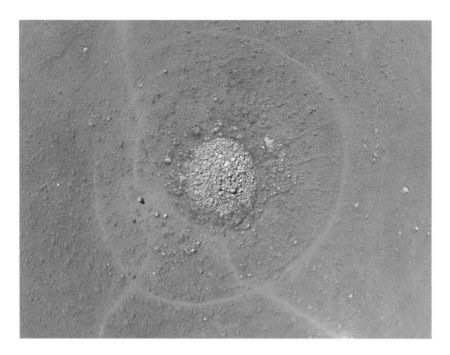

Figure 7.2 Majorville medicine wheel and cairn, Alberta.
Source: Photo courtesy the Royal Alberta Museum.

radiocarbon dated to 4500 BP, and Calder (1977) provides evidence for continuous use from the Oxbow Complex, ca. 5200 BP, through six subsequent cultural phases into the historic period, with younger layers expanding outwards. Goodjohn quotes an informant regarding the practices of an elder considered knowledgeable about the wheel: "[He] goes to the wheel quite often. Before he goes, he takes a stone and prays over it. Then he takes it and puts it on the pile in the middle of the wheel as an offering" (Goodjohn 1997, 137).

Dating of the Big Horn medicine wheel in Wyoming has been more contentious, but excavations confirm that it is a "composite structure," with central cairn and some of the outer cairns constructed as many as several centuries prior to the rim and spokes (Liebmann 2002, 63).

More than anything else, the activities of passing by, fasting or praying with, and building up these alignments drew people's attention toward the passings, prayers, and building up of others. As a knowledge practice, expanding a cairn or medicine wheel in this way brought people's attention into a pragmatic alignment with others who passed before—their ancestors—such that a previous generation's activities and intentions could be known, quite literally and directly, to condition and enable one's own.

The critical point is this: the knowledge practices evident at rock art sites and medicine wheels do not simply reflect a worldview in which ancestors' and non-human others' intentions were imagined to be active within the present. Such places took shape in a continuously self-referential relation to actual trips travelled, marks made, and prayers prayed. People didn't come to *believe in* a world of continuous ancestral presence; their knowledge practices attuned them to the real ways in which past people's actions and intentions continuously cascade into the present through a myriad of indexical routes.

These ideas, of course, are not entirely foreign to us. Gell (1998) notes the way in which art objects, through the same interpretive logic described here—abduction to a cause—operate to distribute the intentions of artists, patrons, and users over time and space, with various social effects. However, for Gell, this agency remains largely "delegated," a power granted to the world of things by humans through their characteristic ways of reacting to them. Others go further, emphasizing the emergent agency of assemblages (e.g., DeLanda 2006; Bennett 2010;), and exploring the ways in which mind and cognition are distributed beyond the limits of the biological brain and body (Clark 2008; Malafouris 2013), leaking, as it were, into the wider world. Malafouris, for example, argues persuasively that "thinking is not something that happens 'inside' brains, bodies, or things" but "emerges from contextualized processes that take place 'between' brains, bodies, and things" (2013, 78).

In many ways, then, the thoughtful palimpsests of rock art sites, stone cairns, and medicine wheels are prototypical examples of distributed agency and extended cognition, for the thinking in question is neither given in the marks themselves, nor arbitrarily imposed on them by viewers, but unfolds transgenerationally in the form of a materially mediated call and response. We can now see how a world of ancestral presence and relationship takes shape for Algonquian and other First Nations people, not because of certain immutable ontological commitments, but through specific modes of action and attention.

7 Archaeological interpretation as a relational knowledge practice

In closing, I want to take some lessons from this for archaeological interpretation. It has been suggested that the shift toward ontology in archaeological thought has rendered the epistemological quandaries of the last century moot (Alberti, Jones, and Pollard 2013; Alberti 2016). And in some ways, this makes sense. After all, the epistemological concerns that animated the postprocessual vs. processual debate, for example, were largely founded on premises that segregated the world of brute matter ("hard" archaeological evidence) from the softer worlds of society (the purely intersubjective) and ideation (the purely mental), not to mention nature from culture, behavior from meaning, and so on (Harris and Cipolla 2017). As all these modernist edifices have tumbled down, so have the epistemological crises they generated.

On the other hand, the case study examined here indicates that

epistemological concerns cannot be so easily dispensed with. If we are to un-
derstand the ontogeny of worlds, rather than engage in ontological model-fitting,
we must attend to the way that specific knowledge practices (in the past and,
indeed, our own) structure the relationships between knowers and known. Such
relationships beget others (and foreclose still others), so that how one attends to
the world is tantamount to making it.

Notes

1 I am very grateful for comments on an earlier draft of this chapter from Tyrel Iron Eyes
 and two anonymous reviewers—it is much improved thanks to your input. I would also
 like to thank Oscar Moro Abadía and Martin Porr for organizing this collection and for
 their tremendous patience and graciousness along the way.
2 This is not to deny the contribution or sophistication of such work. Scholars such as
 Jones (1981, 74–77), Rajnovich (1994, 20), and Vastokas (2003) clearly acknowledge the
 multiplicity, context-dependence, and ambiguity of meanings that might be derived
 from rock art images.
3 Intriguingly, Conway's (2016) informant, Anishinaabe elder Fred Pine, describes a si-
 milar experience of being worked on by spirits in his encounters with rock art.
4 cf. Deleuze and Guattari, 2004, 297.
5 This comparison can only be pushed so far. Bundle contents are often secret or per-
 sonal in nature, while rock art sites are publicly visible and open to a range of viewers.
6 Colson (2006, 261–263) has documented a number of cases in the Lake-of-the-Woods
 area where mineral deposits appear stratigraphically between painting episodes, de-
 monstrating repeated visits over extended periods of time.

References cited

Alberti, Benjamin. 2016. "Archaeologies of ontology." *Annual Review of Anthropology 45* (1):
 163–179.
Alberti, Benjamin, Severin Fowles, Martin Holbraad, Yvonne Marshall, and Christopher
 Witmore. 2011. "'Worlds otherwise': Archaeology, anthropology, and ontological dif-
 ference." *Current Anthropology 52* (6): 896–912.
Alberti, Benjamin, Andrew M. Jones, and Joshua Pollard (eds). 2013. *Archaeology after
 Interpretation: Returning Materials to Archaeological Theory.* Walnut Creek: Left Coast Press.
Arsenault, Daniel, and Steven Waller. 2008. "Echo spirits who paint rocks: Memegwashio
 dwell within echoing rock-art site Eigf-2." *American Indian Rock Art 34*: 191–201.
Arsenault, Daniel, and Dagmara Zawadzka. 2014. "Spiritual places: Canadian Shield
 rock art within its sacred landscape." In *Rock Art and Sacred Landscapes*, edited by Donna
 L. Gillete, Mavis Greer, Michele H. Hayward, and William B. Murray, 117–137. New
 York: Springer.
Aubert, Maxime, Alan Watchman, Daniel Arsenault, and Louis Gagnon. 2004. "L'art
 rupestre du bouclier canadien: Potentiel archéométrique." *Canadian Journal of Archaeology
 28* (1): 51–74.
Barry, Patricia S. 1991. *Mystical Themes in Milk River Rock Art.* Edmonton: University of
 Alberta Press.
Barad, Karen. 2007. *Meeting the Universe Halfway: Quantum Physics and the Entanglement of
 Matter and Neaning.* Durham: Duke University Press.

Basso, Keith. 1996. *Wisdom Sits in Places: Landscape and Language Among the Western Apache.* Albuquerque: University of New Mexico Press.

Bennett, Jane. 2010. *Vibrant Matter: A Political Ecology of Things.* Durham, NC: Duke University Press.

Black, Mary B. 1977. "Ojibwa power belief system." In *Anthropology of Power,* edited by Raymond Rogelson and Richard Adams, 141–151. New York: Academic Press.

Calder, James M. 1977. *The Majorville Cairn and Medicine Wheel Site, Alberta.* Ottawa: National Museums of Canada.

Cipolla, Craig. 2019. "Taming the ontological wolves: Learning from Iroquoian effigy objects." *American Anthropologist 121* (3): 613–627.

Clark, Andy. 2008. *Supersizing the Mind: Embodiment, Action, and Cognitive Extension.* Oxford: Oxford University Press.

Colson, Alicia. 2006. "An obsession with meaning: A critical examination of the pictograph sites of the Lake of the Woods." PhD diss., McGill University.

Conway, Thor. 1992. "Ojibwa oral history relating to 19th-century rock art." *American Indian Rock Art 15*: 11–26.

Conway, Thor. 2016. *Discovering Rock Art.* Ring Creek: Thor Conway.

Conway, Thor, and Julie Conway. 1989. "An ethno-archaeological study of Algonkian rock art in Northeastern Ontario, Canada." *Ontario Archaeology 49*: 34–59.

Creese, John L. 2011. "Algonquian rock art and the landscape of power." *Journal of Social Archaeology 11* (1): 3–20.

Crossland, Zoe. 2014. *Encounters with Ancestors in Highland Madagascar: Material Signs and Traces of the Dead.* Cambridge: Cambridge University Press.

DeLanda, Manuel. 2006. *A New Philosophy of Society.* London: Continuum.

Deleuze, Gilles, and Felix Guattari. 2004. *A Thousand Plateaus.* London: Continuum.

Dewdney, Selwyn, and Kenneth E. Kidd. 1962. *Indian Rock Paintings of the Great Lakes.* Toronto: University of Toronto Press.

Fowler, Chris, and Oliver J.T. Harris. 2015. "Enduring relations: Exploring a paradox of new materialism." *Journal of Material Culture 20* (2):127–148.

Gell, Alfred. 1998. *Art and Agency: An Anthropological Theory.* Oxford: Clarendon Press.

Goodjohn, Mitchell T. 1997. "Sacred sites and secular reasoning: Managing the Majorville Medicine Wheel area." MSc. thesis, University of Calgary.

Hallowell, A. Irving. 2010. "Ojibwa ontology, behavior and world view." In *A. Irving Hallowell, Contributions to Ojibwe Studies: Essays, 1934-1972,* edited by Jennifer S.H. Brown and Susan E. Gray, 535–568. Lincoln: University of Nebraska Press.

Harris, Oliver J.T. 2016. "Becoming post-human: Identity and the ontological turn." In *Creating Material Worlds: The Uses of Identity in Archaeology,* edited by Elizabeth Pierce, Anthony Russel, Adrían Maldonado, and Louisa Campbell, 17–37. Oxford: Oxbow Books.

Harris, Oliver J.T., and Craig N. Cipolla. 2017. *Archaeological Theory in the New Millennium: Introducing Current Perspectives.* New York: Routledge.

Harris, Oliver J.T., and John Robb. 2013. "Multiple ontologies and the problem of the body in history." *American Anthropologist 14* (4): 668–679.

Harvey, Graham. 2005. *Animism: Respecting the Living World.* New York: Columbia University Press.

Henare, Amiria, Martin Holbraad, and Sari Wastell (eds). 2007. *Thinking Through Things: Theorising Artefacts Ethnographically.* New York: Routledge.

Hodder, Ian, 2012. *Entangled: An Archaeology of the Relationships Between Humans and Things.* Oxford: Wiley-Blackwell.

Ingold, Tim, 2011. *Being Alive: Essays on Movement, Knowledge and Description.* New York: Routledge.

Jones, Andrew M., 2014. "Meeting pasts halfway: A consideration of the ontology of archaeological material evidence." In *Material Evidence: Learning from Archaeological Practice,* edited by Robert Chapman and Alison Wylie, 324–338. New York: Routledge.

Jones, Tim E.H. 1981. *The Aboriginal Rock Paintings of the Churchill River.* Saskatoon: Saskatchewan Archaeological Society.

Keyser, James D., and Michael A. Klassen. 2001. *Plains Indian Rock Art.* Vancouver: University of British Columbia Press.

Kohn, Eduardo. 2013. *How Forests Think: Toward an Anthropology Beyond the Human.* Berkeley: University of California Press.

Latour, Bruno. 2005. *Reassembling the Social: An Introduction to Actor-Network-Theory.* Oxford: Oxford University Press.

Lemaitre, Serge. 2013. *Kekeewin ou kekeenowin: Les peintures rupestres de l'Est du bouclier canadien.* Montréal: Recherches Amérindiennes au Québec.

Liebmann, Matthew. 2002. "Demystifying the Big Horn Medicine Wheel: A contextual analysis of meaning, symbolism, and function." *Plains Anthropologist 47*: 61–71.

Lokensgard, Kenneth H. 2018. "The ontological turn, Indigenous research, and *Niitsitapi* protocols of reciprocity." In *Rethinking Relations and Animism: Personhood and Materiality,* edited by Miguel Astor-Aguilera and Graham Harvey, 115–132. New York: Routledge.

Malafouris, Lambros. 2013. *How Things Shape the Mind: A Theory of Material Engagement.* Cambridge: MIT Press.

Norder, John. 2007. "Iktomi in the land of the Maymaygwayshi: Understanding lived experience in the practice of archaeology among American Indians/First Nations." *Archaeologies 3* (3): 230–248.

Norder, John. 2012. "The creation and endurance of memory and place among First Nations of Northwestern Ontario, Canada." *International Journal of Historical Archaeology 16* (2): 385–400.

Norder, John, and Jon Carrol. 2011. "Applied geospatial perspectives on the rock art of the Lake of the Woods region of Ontario, Canada." *International Journal of Applied Geospatial Research 2* (4): 76–91.

Pauketat, Timothy R. 2013. "Bundles of/in/as time." In *Big Histories, Human Lives: Tackling Problems of Scale in Archaeology,* edited by John Robb and Timothy R. Pauketat, 35–56. Santa Fe: SAR Press.

Peirce, Charles S. 1998. *The Essential Peirce: Selected Philosophical Writings.* Bloomington: Indiana University Press.

Rajnovich, Grace. 1980. "Paired morphs at Cuttle Lake in Northwestern Ontario." *Arch Notes 80* (1): 6–9.

Rajnovich, Grace. 1994. *Reading Rock Art: Interpreting the Indian Rock Paintings of the Canadian Shield.* Toronto: Natural History Inc.

Shkilnyk, Anastasia. 1985. *A Poison Stronger than Love: The Destruction of an Ojibwa Community.* New Haven: Yale University Press.

Strathern, Marilyn. 1988. *The Gender of the Gift: Problems with Women and Problems with Society in Melanesia.* Berkeley: University of California Press.

Sundstrom, Linea. 2003. "Sacred islands: An exploration of religion and landscape in the Northern Great Plains." In *Islands on the Plains: Ecological, Social, and Ritual Use of*

Landscapes, edited by Marcel Kornfeld and Alan J. Osborn, 258–300. Salt Lake City: University of Utah Press.

Thwaites, Ruben G. (ed). 1896–1901. *The Jesuit Relations and Allied Documents* (73 vols). Cleveland: Burrows Brothers.

Twance, Melissa. 2017. "'It was your ancestors that put them there and they put them there for you': Exploring Indigenous connections to mazinaabikiniganan as land-based education." M.Ed. thesis, Lakehead University.

Vastokas, Joan M. 2003. "Ojibwa pictography: The origins of writing and the rise of social complexity." *Ontario Archaeology 75*: 3–16.

Watts, Christopher M. (ed). 2013. *Relational Archaeologies: Humans, Animals, Things*. New York: Routledge.

Weeks, Rex. 2012. "Midé rock-paintings: Archaeology by formal and informed methods." *Cambridge Archaeological Journal 22* (2): 187–207.

Wilson, Shawn. 2008. *Research Is Ceremony: Indigenous Research Methods*. Winnipeg: Fernwood Publishing.

Zawadzka, Dagmara. 2013. "Beyond the sacred: Temagami area rock art and Indigenous routes." *Ontario Archaeology 93*: 159–199.

Zawadzka, Dagmara. 2016. "L'agentivité de l'art rupestre: Un exemple du bouclier canadien." Paper presented at the Emerging Research Meetings, Centre for Interuniversity Research on Quebecois Literature and Culture, University of Quebec at Montréal, March 22, 2016.

Zawadzka, Dagmara. 2019. "Rock art and animism in the Canadian Shield." *Time and Mind 12* (2): 79–94.

Zedeño, María N. 2008. "Bundled worlds: The roles and interactions of complex objects from the North American Plains." *Journal of Archaeological Method Theory 15*: 362–378.

8 Art, representation, and the ontology of images

Some considerations from the *WanjinaWunggurr* tradition, Kimberley, Northwest Australia[1]

Martin Porr[2]

1 Introduction

This chapter will engage with insights that have been gained into the ontological scheme connected to the *WanjinaWunggurr* art tradition in the Kimberley, Northwest Australia, over the last few decades. I understand 'ontological scheme' as the collection of interrelated practices, ideas, statements, and perspectives that give meaning, create, and contribute to a particular material art tradition. In this chapter here, this is the *WanjinaWunggurr* tradition. Even though I am using the term 'scheme' in singular, this does not necessarily mean that the scheme forms a coherent and complete whole, which would consequently be static and unchanging. We are dealing with a vibrant and living tradition that is kept alive and cared for by many actors and knowledge holders. As such, it is also unstable, evolving, disputed, and negotiated. However, the importance and primacy of Aboriginal views in this respect is recognised and emphasised. Understanding and communicating this ontological scheme within the framework of a single chapter is obviously an impossible task in the light of the available ethnographic evidence, the views of our Aboriginal friends and teachers and the available literature. Therefore, apart from providing some connecting and guiding aspects in this context, I want to focus on arguing that an engagement with these questions necessitates a critical assessment of the notion of representation in rock art studies (Cochrane and Jones 2018; Jones and Díaz-Guardamino 2019).

I want to argue that the notion of representation needs to be related to the ontology of images and is, consequently, entangled in the wider understanding of the creation of meaning and significance through human practices, perception, and interpretation. As such, images are always 'in the making' in the same way that human beings are always in the making. This orientation makes it necessary to embrace a considerable variability in the relationships between human beings, images, and their dialectic constitution. These elements have to be viewed critically and their ontological status should not be assumed in advance of an analytical engagement. The ontology of images depends on the ontology of the image's maker and perceiver and *vice versa*. I consequently want to argue for a considerable amount of instability in this context, not only between but also within societies. After establishing the necessity to engage with the ontological

dimension in the context of rock art research, I want to illustrate some aspects of these propositions with reference to the art of the Northwest Kimberley, Northwest Australia. The geographical region that is the focus of this case study is the home to the famous *WanjinaWunggurr* tradition.[3] The depth and richness of the available contextual information is exceptional, and it allows insights into the respective ontological scheme that establishes complex relationships between rock art images, the social construction of places, the landscape, and a multitude of other aspects of the environment. The *WanjinaWunggurr* tradition incorporates the well-known *Wanjina/Wandjina* images that are generally conceptualised by the respective Aboriginal Traditional Owners as spirit beings that were not painted by humans. At the same time, these images were regularly retouched and repainted, which draws attention to the unstable boundary between the meanings of the categories of 'object,' 'image,' and 'being' in this cultural tradition. As a consequence, it needs to be recognised that the Traditional Owner's engagement and conceptualisation of the art is much more variable than is sometimes conveyed in the literature. It is, therefore, important to resist an essentialisation of *WanjinaWunggurr* art and its cultural meanings and include an acknowledgement of interpretative variability, which is also a consequence of the acceptance of the active role of human agency and creativity. As I have previously argued elsewhere, these dynamics are best described within a framework of relational ontology (Porr 2018).

In my discussions, I will draw mostly on published sources and texts. However, in this, I will focus on publications that are either published directly by *WanjinaWunggurr* Traditional Owners or are based on long-term ethnographic research relationships. A large number of publications exist that deal with the rock art of the Northern Kimberley. However, not all of them engage significantly with Aboriginal perspectives and ideas. Even less are based on long-term relationships with Traditional Owners. I want to stress at this stage that the sources that I will use are recent ethnographic views and concepts. They represent authorised views by current or recent Traditional Owners, some of them senior knowledge holders. However, this situation does not easily translate into a model for an understanding of older art forms, neither in the Kimberley nor elsewhere. I do not want to imply that Aboriginal people in the Kimberley represent an ancient or original condition of human image production. Indeed, they have been portrayed in such a way far too often (McNiven and Russell 1997, 2005; McNiven 2011). In this case, we also have to resist the 'denial of coevalness' (Fabian 1983) and situate our research partners firmly in the present, together with all other present societies. However, even though these questions are beyond the aims of this chapter, this situation does not mean that we cannot learn from each other about the interpretation of the past or cannot reflect together on what this might even mean. These possibilities are, however, complicated by the very real circumstances in which research takes place. Ontological schemes are also entangled in social and political power relationships. Some reflections on these aspects will form the last part of this chapter.

2 Images, representation, and the establishment of meaning

Rock art research or the concern with images on rock surfaces has developed into a diverse and sophisticated endeavour over the last 150 years or more. It is, of course, not possible to even provide a basic overview of the history of rock art research here. Thankfully, there are many excellent contributions that have provided valuable and critical surveys of the relevant literature in recent decades (McDonald and Veth 2012a; David 2017; David and McNiven 2019). Dividing this history into clear-cut phases is probably of limited use. The beginning of a serious engagement with rock art is often regarded to be the acceptance of Palaeolithic parietal art in the early twentieth century, but mobiliary art had been recognised in Palaeolithic occupation layers already in the mid-nineteenth century (Moro Abadía and Gonzáles Morales 2008, 2013). The concern with rock art images traditionally falls within the realm of archaeology with respective interpretative challenges and orientations. Indigenous art forms and respective ethnographic insights have only been reluctantly integrated in the interpretation of archaeologically accessible art expressions. Archaeological interpretation has been plagued by a wide range of issues in this respect that can mostly be related to universalising and progressive understandings of alterity and global history (see Moro Abadía and Porr in this volume). More recently, this situation has not only become much less Eurocentric but also much more theoretically and methodologically diverse, partly due to an engagement with and an integration of Indigenous perspectives. Diversity in theoretical approaches and methods is certainly a key emphasis of recent surveys of the field. This situation probably mirrors the current situation in archaeology more broadly. Rock art research and the concern with rock images is now seemingly guided by a multitude of aims. Following McDonald and Veth (2012b, 5), 'rock art can signal information at many levels, and has agency between culture groups in the same time and space and intergenerationally,' and it can also have a 'role in ideational, sensory, social organisational, religious, hierarchical, territorial, and economic domains.' Hence, 'the information content of rock art, when viewed within its larger archaeological or anthropological context, can inform on multiple aspects of past behavioural systems' (McDonald and Veth 2012b, 5). An increase in the diversity of available approaches and perspectives is certainly a positive development. However, how can their status and applicability be evaluated? Which should be prioritised and why? I would argue that these questions can only be explored when the underlying ontological assumptions of the respective approaches are explored. Without being able to delve into these issues in greater detail, some preliminary observations can be made.

The aforementioned assertions that 'rock art can signal information at many levels' and that its information content 'can inform on multiple aspects of past behavioural systems' revolve around the notion of information. In both cases, rock art is conceptualised as the carrier of information. Or, rock art is conceptualised as a container of different types of information that has meaning in relation to different

contexts. Correctly and analytically establishing the correlations between these elements consequently allows insights into 'multiple aspects of past behavioural systems.' One could argue that the approaches are consequently situated in a broadly functionalist framework in which rock art is seen as the carrier of socially relevant information and allows its exchange between different actors. The key aspect is that the actors, the art and the information are conceptualised as separate entities, which subsequently form particular stable relationships over time or 'behavioural systems.' The entities are assumed to exist independently from their interactions with each other. As such, these considerations are reflective of a realist ontology. There is nothing unusual about this conclusion. Realism can be regarded as the default ontology of the modern Western world (Descola 2013). Its origins can be traced back to the so-called pre-Socratics, an assorted group of thinkers from different parts of the Greek-speaking world, who were active over a period of over 150 years from the sixth to the fifth centuries BC (Whitmarsh 2015). The pre-Socratics proposed an understanding of the cosmos that is independent from an individual's perspective and that continues to exist irrespective of its individual elements. Reality can be understood by adopting a neutral and detached position (Whitmarsh 2015, 58–59). In a broad sense, this orientation has been preserved until the present day as ontological realism and has been significantly enhanced through and since the European Enlightenment philosophies. Archaeology itself depends on a realist ontology and it is the source of archaeology's powerful metaphors of detection and discovery: 'The ontology of the world is a matter of discovery for the traditional realist' (Barad 2007, 41, see also Thomas 2004). Realism or naturalism (cf. Descola 2013) assume that the actor or observer is separate from the world that consists of a range of discrete entities. Consequently, only one reality (or nature) exists. Differences in perspectives, perceptions, interpretations, or experiences are seen as epistemological, i.e. they are a consequence of different types of engagements with the world. In the modern Western world, realism generally has a common-sensical quality and it forms the foundation of a wide range of everyday, political, and legal practices. However, realism has been extensively critiqued for a long time, not only in the social but also in the natural sciences.

The idea that reality exists as an assemblage of entities that are separate from their representation or relationships has possibly most prominently been questioned in physics. The Newtonian understanding of a world of forces and objects within a neutral three-dimensional space was fundamentally rejected during the late-nineteenth and early-twentieth centuries. This history is well-known and not of crucial importance to the argument presented here. However, during this time, significant foundations were established about the nature and knowability of reality that have repercussions well beyond theoretical physics. For example, quantum theory is currently not foremost understood as a theory of elementary particles but rather 'a theory about the representation and manipulation of information' (Bub 2004 see also 2017). It is not necessary and possible to delve deeper into this field here. However, this observation is a useful reminder that the notion of 'information' is far from self-evident and needs to be treated in a critical fashion. Within a realist ontology, it is assumed that the world is divided into independently existing

representations and entities that can be represented. Successful representations have a one-to-one correspondence with reality or those entities that are represented. This orientation has been termed 'representationalism' and it is foundational to Western thought. 'Representationalism is so deeply entrenched within Western culture that it has taken on a common-sense appeal. It seems inescapable, if not downright natural' (Barad 2017, 48). However, the basic assumptions of representationalism have been questioned in variable ways. In the case of the philosophy of science, there is little agreement how it can even be established that representations accurately reflect reality. It is not clear how the ontological gap between entities and their representations can be bridged. In a paradoxical fashion, both elements are supposedly deeply connected and separated from each other at the same time. A further question concerns the aspect of the alleged existence of entities independently from all practices of engagement or observation, while their very existence can only be established through the creation of a relationship (of engagement or observation etc.). To overcome this contradiction, for example, Barad (2007, 2011, 2017) has suggested to:

> call into question representationalism's claim that there are representations, on the one hand, and ontologically separate entities awaiting representation, on the other, and focus inquiry on the practices or performances or representing, as well as the productive effects of those practices and the conditions for their efficacy.
>
> (Barad 2007, 40)

The resulting 'agential realism' reflects a relational ontology in which phenomena replace entities as the basic units of existence. However, phenomena are not independent objects with inherent boundaries and properties. They also are not the effect of the inseparability of the observer and the observed: 'rather, *phenomena are the ontological inseparability of intra-acting "agencies"*' (Barad 2007, 333; highlight in the original). As such, this approach recognises the dynamic and unstable character of reality and that any aspect of the latter must be understood as ontological entanglements. These fundamental principles are not a product of the human mind or rationality. Intra-actions 'are natural processes rather than external impositions on the natural world' (Barad 2007, 332).

If we assume that the world is relationally constituted, how do we have to think the relationships between people, meanings, and images? In the last two decades, quite a few authors have engaged with so-called relational approaches within the social sciences, particularly in social anthropology and archaeology (Strathern 1988; Alberti and Marshall 2009; Marshall and Alberti 2014; Alberti 2016; Ingold 2017; Jones 2017; Jones and Díaz-Guardamino 2019). A relational understanding asserts that human beings do not *have* relationships but are *constituted by* relationships. In general terms, relations and beings are not separate from each other but are mutually constituted. Relationships give rise to the beings in which they are implicated. Ingold (2018, 103) has described this understanding with reference to Barad's terminology outlined above: 'Beings not

so much interact as *intra-act*; they are inside the action.' These considerations are, of course, overall connected to the so-called ontological turn in the social sciences, which has also impacted the fields of social anthropology, archaeology, and rock art studies (Alberti et al. 2011; Kohn 2015; Alberti 2016; Holbraad and Pedersen 2017; Jones 2017). A key consequence of this development is the shift from an epistemological interpretation of difference to an ontological one. Difference is no longer a result of different ways of relating to one reality, the result of different epistemologies. Rather, difference is either viewed as a consequence of seeing different worlds or creating different worlds. Epistemology is no longer naïve. It does not simply allow the observation of a separate world and leaves the latter unaffected. Rather, it becomes entangled in the creation of worlds. The shift from epistemology to ontology does not leave behind the former. Rather, it reconfigures the relationship between these two elements and opens up the latter to investigation and critique. Therefore, Indigenous epistemologies are important because they show us the variability of the ways worlds can be created and they allow us to understand how worlds and ways of knowing intersect with each other. Consequently, nature or reality cannot be regarded as a given background to human (cultural or social) difference. This understanding is encapsulated in Viveiros de Castro's notion of multi-naturalism that is opposed to multi-culturalism (Viveiros de Castro 2015). Within a relational ontological understanding, not only the Western distinctions between nature and culture and animality and humanity become blurred. It also affects the understanding of life and death or the animate and the inanimate. Ingold (2018, 17–25) has illustrated the consequences of this shift with reference to A. Irving Halloway's classic work with the Anishinaabe in Canada (see also Ingold 2000, 89–110). Ingold's discussion takes as a starting point the famous exchange between Hallowell and William Berens about stones: 'I once asked an old man: Are *all* the stones we see about us here alive? He reflected a long while and then replied, "No! But *some* are"' (Hallowell quoted in Ingold 2000, 96; emphasis in the original). One of the key insights that can be gained from this exchange and subsequent elaborations is that among the Anishinaabe stones are not a clear-cut category with fixed characteristics. Linguistically, the word for 'stone' is included in the 'animate noun' category. They share this category with trees, the sun and moon, thunder as well as artifacts like kettles and pipes. However, as Hallowell observes, Anishinaabe informants generally do not relate to these objects very differently to Western observers. Rather, more extensive discussions reveal that the animate character of stones cannot be conceptualised as an internal or categorical quality. Rather, it is a consequence of acts of relational engagement:

> The nature of the things one encounters, their essence, is not given in advance but is revealed only 'after-the-fact,' and sometimes only after the lapse of some considerable period of time, in the light of subsequent experience—which of course may differ from one person to another.
>
> (Ingold 2000, 97)

Among the Anishinaabe, no categorical distinction is made between living and non-living things. Animate and inanimate are not mutually exclusive features. Rather, objects or phenomena can shift from one class to the other, depending on context. Such a thinking is fundamentally *antitaxonomic* as it resists universalising and context-independent systems of classification or representation (see also Black 1977).

Developing these considerations further, Ingold (2015) has argued that we have to abandon the idea of objects altogether and think the *world without objects*. The meaning of objects emerges from their relational engagements as parts of the flows of materials over time. Such a notion of a relational establishment of meaning necessitates the inclusion of the temporal dimension. Things do not just exist; they, rather, occur: 'This is to admit them into the world not as nouns but as verbs, as going-on. It is to bring them to life' (Ingold 2015, 16). Life here is not understood as an inherent quality of objects or phenomena. Rather, objects are *in life* where the latter is seen as a reflection of the dynamic quality of reality itself. The example discussed is only one case of many Indigenous philosophies in which it is recognised that 'all forms of existence have within them a vital animating force' and, consequently, the qualities of life are extended to the category of being (Povinelli 2016, 17). All of these aspects must be considered in the context of the making and the establishment of meaning of images and artefacts as well. Ingold (2013) has proposed that the making of artefacts and images should rather be seen as a process of growth, in which the maker participates and intervenes in the flow of materials, which are never static. Designs are not imposed onto the world (as representationalism suggests). Rather, what the maker does

> is to intervene in worldly processes that are already going on, and which give rise to the forms of the living world that we see all around us—in plants and animals, in waves of water, snow and sand, in rocks and clouds—adding his own impetus to the forces and energies in play.
>
> (Ingold 2013, 21)

It is not the representation that creates the artefact or the image, but the engagement with materials within a particular situation.

As mentioned above, these considerations fundamentally necessitate the inclusion of the temporal dimension into the establishment of the meaning of images (which, are very much undetermined in all directions, especially against so-called natural objects or features and other artefacts). These aspects have been explored, for example, by Manning (2015), in a recent chapter titled *Artfulness*. Here, she argues that objects are usually theorised out of time and relegated beyond experience. They are also conceptualised out of movement and engagement. In contrast, Manning argues, any object or image must be seen within temporally complex relationships. Art is always art of time.

> The art of time makes this more-than of the object felt, and it does so by activating the differential of time in the making, the difference between what

was and what will be. For all actualization is in fact differentiation. The in-act is the dephasing of the process toward the coming into itself of an occasion of experience. In this dephasing, the differences in kind between the not-yet and the will-have-been are felt, but only at the edges of experience. They are felt in the moving, activating the more-than.

(Manning 2015, Loc. 1361)

Continuing the theme of the antitaxonomic character of relational ontological engagement, she asserts that the experience of the object or image can never achieve completeness: 'we know it not in its fullness, in its ultimate form, but as an edging into experience.' For her, these processes are not captured with the notion of knowledge but rather meaning is established through intuition, which is non-representational and non-linguistic. As such, these are speculative propositions on the edges of the thinkable: 'The art of time is the proposition art can make to a world in continual composition' (Manning 2015, Loc. 1427). As I will discuss in the following sections, important elements of these discussions can enhance our understanding of the Aboriginal art and rock art of the Northwest Kimberley.

3 The *WanjinaWunggurr* art of the Northwest Kimberley

The Kimberley in Northwest Australia has a human history that extends to at least 50,000 years ago (Veth et al. 2019). The region also exhibits one of the most complex and diverse records of art anywhere in the world (Travers and Ross 2016; Harper et al. 2019; Moore et al. 2020). It is home to Aboriginal people with cultural traditions that integrate aspects of so-called rock art into ongoing cultural practices and philosophies. The best known of these relate to the Northwest and Central Kimberley and form the so-called *WanjinaWunggurr* cultural bloc. It has to be stressed, however, that rock art is a part of many more Aboriginal groups' culture in the Kimberley (Ryan and Akerman 1993; O'Connor et al. 2013; Balme and O'Connor 2015). Radiometric dating efforts suggest that some rock art expressions in the Kimberley are at least 16,000 years old and that *WanjinaWunggurr* art is at least 5,000 years old (Watchman et al. 1997; Ross et al. 2016). These findings not only draw attention to the great antiquity of the rock art in this region. They also suggest a persistence of equally continuous and dynamic Aboriginal cultural traditions over a considerable amount of time. In this chapter, I will restrict my discussion to the ethnographic dimensions of the art. I will return to the issue of the relationship between Indigenous and scientific perspectives in the concluding section of this chapter.

Since the 1930s, authors have discussed the many layers of meaning of *WanjinaWunggurr* rock art and have unequivocally documented the autochthonous nature of these paintings, while providing a wealth of information on their roles in *WanjinaWunggurr* culture' (Blundell and Woolagoodja 2012, 474). The *WanjinaWunggurr* cultural bloc, located in the Northwest and Central

Kimberley, can be conceptualised as an expression of wider Indigenous Australian ontological schemes (Porr 2018). Aboriginal Traditional Owners of the *WanjinaWunggurr* community also understand their homeland as a life-affirming entity, 'Country,' that equally comprises land, sea, and sky. It encompasses the belief in *Wanjina/Wandjina* creator ancestors, who are anthropomorphic beings, but can also appear in animal form (Figure 8.1). *Woongudd/Wunggurr* is the name given to the sacred life force, which is often depicted as a snake (Figure 8.2). *Gwion/Geeyorn* constitute another important class of beings, who can appear in various forms, including plants and vegetation (Figure 8.3). These different creator beings exist in a past–present–future continuum that is called *Lalai* (or *Larlan* or *Larlay*) (Oobagooma et al. 2016). With their actions, they create Country as a rich meshwork of tangible and intangible elements. *Lalai* is used by *WanjinaWunggurr* Traditional Owners to describe the rich collection of narratives that convey how and when the land, the sea, the heavens, and all that is within them came into existence and continue to exist. For the members of the respective communities, *Lalai* as a framework for social order and engagement with the natural and supernatural worlds. It explicates patterns of governance, responsibilities, accountability, and entitlements. *Lalai*, consequently, relates to the moral rules for social behaviour and this encompasses all beings and the care for Country. It is equally a body of sacred knowledge as well as common and daily practice (Blundell et al. 2017).

For Traditional Owners of the *WanjinaWunggurr* communities, the boundaries between mythical, natural, and human-made phenomena is often fluid and these Western categories often have no significance. The traces of Creator beings and their creative acts are found throughout Country. From a Western perspective, these can equally be human-made artefacts or natural formations. The latter include mountains, rivers, waterfalls, islands, mangroves, vine thickets, rock art and stone arrangements. So-called *WanjinaWunggurr* rock art is truly 'an art of country,' because it is one of the key elements through which the people of the respective Indigenous communities 'construct a distinct cultural landscape as well as individual and group identities based on multiple connections to land' (Blundell 2003, 159). The importance of the connection between people and Country draws attention to the fact that the *WanjinaWunggurr* way of being prioritizes relationships over essences. It is fundamentally relational. Technical definitions or categories, taxonomies, and classifications play minor roles in this ontology. The meaning and significance of rock images, artifacts, or places are constituted primarily by their contexts, by their relative spatiality and by their position in narratives that constitute Country (Oobagooma et al. 2016; Porr and Matthews 2016). This understanding is antitaxonomic as individual elements cannot be independently categorised. They cannot be removed or displaced to compare them with each other and separated from their context. In this sense, an image or a place can acquire the status of a person, who is also a unique consequence of a myriad of historical and present relationships. In the local Indigenous understanding, the relationship between people, place, and landscape is constructed according to a relational ontology that focuses on processes and

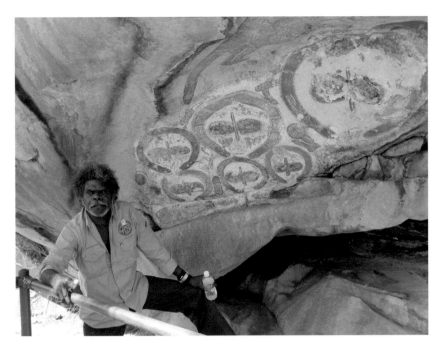

Figure 8.1 Sylvester Mangolamara at Munurru, one of the Wanjina caves where his grandfather, Goonack, taught him the meaning of the images.
Source: Mangolamara et al. 2019, 61.

context. It stresses involvement over disassociation, dynamic specific development over classification. Within this logic, so-called rock art, natural features, human and non-human beings constitute each other and can become mutually exchangeable as dynamic products and expressions of Country and *Lalai* (Porr 2018, 402) (Figure 8.4).

It is important to recognise that this way of being and knowing cannot be understood with reference to a collection of knowledge and meanings that exists independently from bodily situated knowledge holders. The significance of images and places is relationally constituted in a complex and dynamic dialectic between socially shared meanings, stories, etc., and individual insights and experiences. Meaning is situated spatially and temporally. It also needs to be actively acquired through bodily engagement. It would, therefore, be wrong to understand this knowledge as a fixed set of representations that are contained in the minds of members of the *WanjinaWunggurr* community and could be transmitted in some way. The understanding of images is not acquired through the reception of already existing meanings. Rather, it is a process of ongoing and increasing involvement, engagement, and enskillment. Even though processes of learning rely fundamentally on the bodily experiences of each learner, they are also socially guided and communicated. These processes are entangled into the

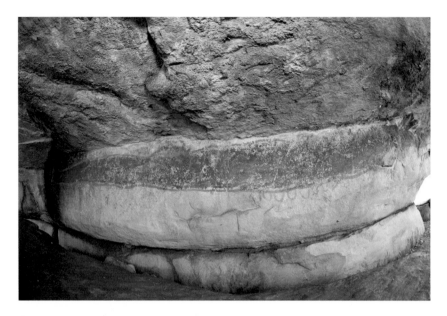

Figure 8.2 "Wunggurr with her eggs."
Source: Minindil, quoted in Mangolamara et al. 2019, 112.

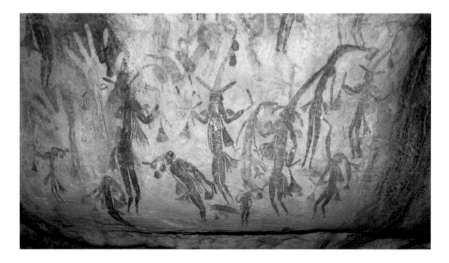

Figure 8.3 "Gwion look different because they haven't all got full uniform yet like a boss.
That is why Gwion all look different and they dress themselves different for
different corroboree and have different job to do like look after trees or special
country."
Source: Sylvester Mangolamara, quoted in Mangolamara et al. 2019, 162.

Figure 8.4 "You can see the Wunggurr; he is lying in country."
Source: Sylvester Mangolamara, quoted in Mangolamara et al. 2019, 107.

life course of community members (and often differentiated according to age and gender) (Mowaljarlai and Malnic 1993; Blundell and Woolagoodja 2005; Bell 2009, see Taylor 2013 for a Central Australian perspective). They are also never entirely finalised. Doring and Nyawarra (2014, 12) stress the importance of living knowledge that is debated and established in dialogue and reflection (see also Mangolamara et al. 2019, 42). They assert that one of 'the most overlooked and least understood ingredient of Gwion [Kimberley] rock art is the depth of conversation spoken in private among *munnumburra* [Senior Knowledge Holders].' They emphasise that Gwion rock art is not silent, 'but truly comes alive in the local language with song and every specific detail of flora and fauna as Wunan references.' The term *Wunan* refers here is the Ngarinyin word for the encompassing mechanism that connects all aspects of reality. It also establishes the relational meaning of the art in context:

> The complex realm of Gwion rock art is the antithesis of European art collected in public museums. It must be acknowledged, conserved and managed as a different art experience combining intimate conversation and discrete viewing as an intense form of education.
>
> (Doring and Nyawarra 2014, 12)

These insights can be linked to the general considerations outlined earlier. Referring to Holloway's ethnography among the Anishinaabe, Ingold (2018)

stresses that the shift towards an ontological perspective necessitates an acknowledgment of the significance of the role of reflection, interrogation, and the education of attention. Enskilment is achieved through continuing conversations and about a world that is continuously becoming. It is, consequently, no surprise that vocal Aboriginal knowledge holders have criticised not only archaeological approaches towards Kimberley rock art but also anthropological concepts. It echoes earlier criticisms, which have been directed at the objectification of Aboriginal ontologies and, for example, the use of the notion of Dreamtime (cf. Stanner 1958). Doring and Nyawarra (2014, 5) have rejected the latter term in the context of the Aboriginal understandings of images and related concepts because of its 'many inappropriate colonial connotations.' During a significant earlier dispute about Aboriginal rights related to the practice of the repainting of rock images (see, e.g., O'Connor et al. 2008), the late David Mowaljarlai asserted the Aboriginal understanding of the images in the Kimberley in a famous statement in the journal *Antiquity*:

> Someone told me recently that 'rock art is dead.' If 'Art' was dead, that would not matter to we Aborigines. We have never thought of our rock-paintings as 'Art.' To us they are IMAGES. IMAGES with ENERGIES that keep us ALIVE—EVERY PERSON, EVERYTHING WE STAND ON, ARE MADE FROM; EAT AND LIVE ON.
>
> (Mowaljarlai et al. 1988, 691)

According to David Mowaljarlai, the images do not represent. They exist like beings or persons. Their ontology cannot be understood with reference to their representation of abstract categories that are located in the minds of their observers. They rather gain their meaning through the involvement in the complete meshwork of processes, forces and narratives that contribute to their existence. Human beings and their agencies are only a part of these interrelated pathways, lines, and dynamic materials. In this sense, the images are not painted but they grow and are grown (Ingold 2011, 2015; Porr and Bell 2012).

It is, therefore, not an accident that knowledgeable *WanjinaWunggurr* Traditional Owners overwhelmingly describe the images not in terms of representations. They do not describe them in terms of what they are but what they do. They talk about their agency in relation to their own agency and the agency of forces, materials, animals, humans, and (natural) landscape features and so on (Figure 8.5). As was mentioned earlier, these agencies are expressed in narratives and stories that can either refer to individual, personal, or mythological dimensions, which often merge into each other. For *WanjinaWunggurr* Traditional Owners, everything is an expression of the original and all-encompassing life force of Woongudd: '*Woongudd has the power for creation. Woongudd is sacred. Woongudd is everywhere; he is on top and he is on the earth, underground and in the sea, everywhere*' (Eewaambood, quoted in Mangolamara et al. 2019, 91).

Woongudd, however, is often described as acting through a snake and is depicted accordingly. While *Wanjina/Wandjina* and *Woongudd/Wunggurr* are

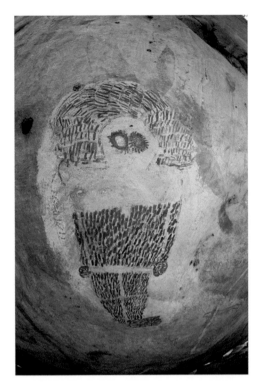

Figure 8.5 "This is *Walanganda*. He is travelling to his country and rested here. *Walanganda* is the Milky Way. You can see the stars in his head."
Source: Louis Karadada, quoted in Mangolamara et al. 2019, 62.

sometimes used interchangeably, it is more common to refer to the former as powerful individual persons, who have their own story and place in Country:

> *The Wandjina carried clouds as they travelled all over the country from the big battle at Wanalirri in Ngarinyin country. When they found their home, their uunguu, they put themselves on the walls and stayed in that place.*
>
> (Goonack, quoted in Mangolamara et al. 2019, 59)

> *Where the Wandjina put themselves is bang-ganan. It means the rocks with paintings on are bang-ganan, a strong foundation and you can't take them out. They belong there. They look out over the country, they are protecting it. They are watching to see which people are coming. They look out from their cave and listen to who is coming.*
>
> (Eewaambood, quoted in Mangolamara et al. 2019, 46)

Wanjina/*Wandjina* are specifically associated with rain:

> *Wandjina and Woongudd together make the rain. If Wandjina and people work together they can make safe rain. If people do the wrong thing then the Wandjina and the Woongudd will make a dangerous rain, a bad cyclone.*
>
> (Yorna, quoted in Mangolamara et al. 2019, 117)

Within the *WanjinaWunggurr* ontology, no contradiction exists between the *Wanjina/Wandjina* as mythological ancestors and beings and their existence as a painting that needs to be regularly refreshed by knowledgeable and authorised Traditional Owners:

> *These paintings need to be touched up a bit to make it look good to the next generation. The old people did it and we should be doing it to keep it going. After the wet when there is water here you could come and make a camp to freshen them up. You make it fresh so that the Wandjina will smile again, make them happy and make country better.*
>
> (Yorna, quoted in Mangolamara et al. 2019, 48)

In this case, the necessity to follow the appropriate rules is stressed as well as the convergence of different agencies of the painter, the paint, the rock and the *Wanjina/Wandjina*:

> *Gurdwiiynj is the bloodwater sap; you mix it with red ochre and white gum from a tree to make the paint. You make a brush by getting a stick and you chew the end of it to make a brush. And then you sing or talk and wake up the rock and the rock goes 'ooo osh' [inhales] and suck'em up paint. You need to be qualified to refresh'em up again, go through all the Law business.*
>
> (Sylvester Mangolomara, quoted in Mangolamara et al. 2019, 46)

Other images are similarly described in terms of their actions (Figure 8.6). In fact, they are referred not even as if they are confined to a particular location but as travellers, guardians, taking care of their tasks and duties: '*Gwion travel out to inspect the country and see if people are caring for country in the proper way, respecting the bush and not wasting food*' (Sylvester Mangolamara, quoted in Mangolamara et al. 2019, 168).

The statements outlined here, and the more general observations outlined above, question the applicability of representationalism in the context of an engagement with the ontology of *WanjinaWunggurr* art. A relational orientation moves beyond the aim of matching representations with objects. It opens up the way to a dynamic and variable understanding that focusses on the relationships that constitute people and Country.

4 Conclusion: Research and ontology in the Kimberley

In recent decades, a range of Aboriginal Corporations in the Kimberley have conducted self-funded research projects to aid the continuation of current cultural knowledge and practices. This is addressed through various endeavours and initiatives, which include community-based cultural maintenance and revitalisation

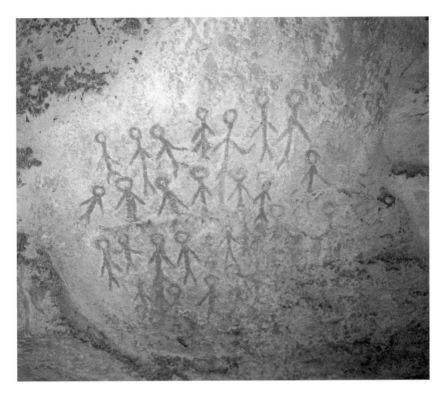

Figure 8.6 "*Warraridjay* walk around man and woman together. They walkabout. The *Gwion* they come out from the cave and this lot. *Warraridjay* come out and walk around too. Bush tucker they have to paint 'em them own tucker. Too many tucker along the bush."

Source: Minindil, quoted in Mangolamara et al. 2019, 171.

projects (Blundell et al. 2017; Mangolamara et al. 2019; Marshall et al. 2020). At the same time, a range of high-profile university-based research projects have considerably advanced knowledge about the rock art in the Kimberley (Ross et al. 2016; Travers and Ross 2016; Veth et al. 2018; Harper et al. 2019; Finch et al. 2020; Moore et al. 2020). These projects have been invaluable in correcting some of the persisting myths about the art (related, for example, to pre-Aboriginal authorship; see e.g., McNiven and Russell 1997; Redmond 2002; Porr and Bell 2012) and have enormously increased the understanding of the temporal complexity and depth of the rock art in the Kimberley.

All academic archaeological and rock art research in Australia is today conducted with a great amount of awareness of the cultural importance of rock art as well as other material evidence to Aboriginal people. All research follows collaborative protocols that are backed up by legally binding agreements. However, despite these efforts, Senior Traditional Owners continue to express their frustration about the design and character of archaeological and rock art research. In

the volume that forms the source of most quotes in this chapter, jointly published by the Dambimangari and Wunambal Gaambera Aboriginal Corporations, Yorna (Donny Woolagoodja) criticises the practice of archaeologists and rock art specialists to categorise Aboriginal rock art into stylistic groups in relative age order with attempts to establish absolute dates or spatial patterns (Mangolamara et al. 2019, 16). His choice of words is significant: '*This method is disrespectful to the very substance of Lalai.*'

This statement appears not only to be reflective of the ontological differences between a Western and the *WanjinaWunggurr* understanding of the art that has been outlined earlier. It seems also somewhat reminiscent of an earlier conflict that played out in the 1980s, which revolved around the rights of Aboriginal people to repaint images and the significance of this practice in relation to the preservation of cultural heritage (Mowaljarlai et al. 1988; Walsh 1992). Clearly, in the Western perception, the material aspects of the art are irreparably affected or even destroyed through the repainting of images (especially if these practices did involve pigments and paint that were regarded as non-traditional). This was the position taken by some archaeologists and rock art enthusiasts, who emphasised the importance of the art as a reflection of humanity's heritage and the necessity to preserve it for posterity as much as possible. Others, however, supported the Aboriginal position in this conflict and stressed that the significance of the art needs to be seen foremost as a part of a living tradition (Mowaljarlai et al. 1988, 694; Bowdler 1988). While the tensions between the universal and local significance of heritage has been discussed extensively elsewhere (Harrison 2015, 2018), it is obvious that this conflict is also a conflict between different ontologies that has important political dimensions (de la Cadena and Blaser 2018). The interpretation of Kimberley rock art was entangled in the colonial struggles about the interpretation of Australian Aboriginal heritage from the first written reports in the early nineteenth century (McNiven and Russell 1997, 2005). Yorna's statement above is not so much surprising against this background of competing ontological schemes. It is rather surprising that this statement is not directed at politicians, tourists, or pastoralists. It is directed at academic researchers, who claim to have engaged with the colonial foundations of archaeology for many decades. It is certainly the case that archaeological and rock art research in Australia has progressed a lot in terms of collaborative approaches with Aboriginal Traditional Owners. Similarly, several authors have engaged with the deep epistemological, ontological, and historical foundations of their disciplines (David 2002; Brady 2009; McDonald and Veth 2012a; Brady et al. 2016; McNiven 2016; Harper et al. 2019). However, Yorna's statement shows that problems persist, and future research must consequently address this challenge that should not be trivialised. It is a recognition of the ontological dimensions of scientific practice and their effects as a world-building practice. These processes are necessarily entangled in present power structures (Blaser 2013). Aboriginal Traditional Owners in every part of Australia have been painfully aware of these processes from the first contacts with European explorers, sailors, and settlers (Povinelli 2002; Rose 2004). While a lot of progress

has been achieved, I would argue that future academic research needs to be much more aware of these aspects and has to engage with them on a much deeper level. A critical engagement with the ontologies of rock art, images, relational approaches, and Indigenous knowledge must necessarily lead towards a newly calibrated engagement with the ontologies of academic practice itself and its equally world-building and world-destroying capacities.

Notes

1 Aboriginal and Torres Strait Islander readers are advised that this text contains an image of a person who is now deceased.
2 This chapter has profited enormously from the insights from many people over the years. Even though I am responsible for any errors that might be contained in the text, having just my name on it, does not do justice to the realities of authorship. I have gained much knowledge through the long-term engagement with Leah Umbagai, Janet Oobagooma, Kim Doohan, Richard Kuba, Michaela Appel, Eva Raabe, and my colleagues at the Centre for Rock Art Research & Management at UWA as well as Jacqueline Matthews. The text has profited immensely from the thoughtful comments by Oscar Moro Abadía and Ian McNiven. I also want to thank the Traditional Owners of the Wunambal Gaambera Aboriginal Corporation for allowing me to reproduce the photos in this chapter. I feel honoured to have received this permission and that they are happy with the content of this chapter. The work on this chapter has also profited from my CI role in the Australian Research Council project 'Kimberley Visions - The Origins of Rock Art Provinces in Northern Australia' (LP150100490).
3 In this chapter, I am following the spelling conventions set out in the latest publication authorised by Senior Wunambal Gaambera and Dambeemangaddee Knowledge Holders and Traditional Owners (Mangolamara et al. 2019, 16, 262–263). Hence, the spelling that is used is the one that is appropriate for the respective place and/or speaker. In relation to key concepts discussed in this chapter, Wunambal Gaambera speakers use Wanjina, Wunggurr, and Gwion, and Woddordda (Dambeemangaddee) speakers use Wandjina, Woongudd, and Geeyorn. Because of historical reasons, the spelling of WanjinaWunggurr is retained for the whole community (which, in fact, encompasses several language groups).

References cited

Alberti, Benjamin. 2016. "Archaeologies of ontology." *Annual Review of Anthropology 45*: 163–179.

Alberti, Benjamin, Severin Fowles, Martin Holbraad, Yvonne Marshall, and Christopher L. Witmore. 2011. "'Worlds otherwise': Archaeology, anthropology, and ontological difference." *Current Anthropology 52* (6): 896–911.

Alberti, Benjamin, and Yvonne Marshall. 2009. "Animating archaeology: Local theories and conceptually open-ended methodologies." *Cambridge Archaeological Journal 19* (3): 344–356.

Ball, Philip. 2017. "A world without cause and effect." *Nature 546*: 590–592.

Balme, Jane, and Sue O'Connor. 2015. "A 'port scene', identity and rock art of the Inland Southern Kimberley, Western Australia." *Rock Art Research 32* (1): 75–83.

Barad, Karen. 2007. *Meeting the Universe Halfway. Quantum Physics and the Entanglement of Matter and Meaning*. Durham: Duke University Press.

Barad, Karen. 2011. "Nature's queer performativity." *Qui Parle: Critical Humanities and Social Sciences 19* (2): 121–158.

Barad, Karen. 2017. "Troubling time/s and ecologies of nothingness: Re-turning, re-membering, and facing the incalculable." *New Formations: A Journal of Culture/Theory/Politics 92*: 56–86.

Bell, Hannah Rachel. 2009. *Storymen*. Cambridge: Cambridge University Press.

Black, Mary B. 1977. "Ojibwa taxonomy and percept ambiguity." *Ethos 5*: 90–118.

Blaser, Mario. 2013. "Ontological conflicts and the stories of peoples in spite of Europe." *Current Anthropology 54* (4): 547–568.

Blundell, Valda. 2003. "The art of country: Aesthetics, place, and Aboriginal identity in north-west Australia." In *Disputed Territories: Land, Culture and Identity in Settler Societies*, edited by David Trigger and Gareth Griffiths, 155–185. Hong Kong: Hong Kong University Press.

Blundell, Valda, and Donny Woolagoodja. 2005. *Keeping the Wandjinas Fresh: Sam Woolagoodja and the Enduring Power of Lalai*. Fremantle: Fremantle Arts Centre Press.

Blundell, Valda, and Donny Woolagoodja. 2012. "Rock art, Aboriginal culture, and identity: The Wandjina paintings of Northwest Australia." In *A Companion to Rock Art*, edited by Peter Veth and Jo McDonald, 472–488. Chichester: Wiley-Blackwell.

Blundell, Valda, Kim Doohan, Daniel Vachon, Malcolm Allbrock, Mary Anne Jebb, and Joh Bornman (eds). 2017. *Barddabardda Wodjenangorddee: We're Telling All of You. The Creation, History and People of Dambimangaddee Country*. Derby: Dambimangari Aboriginal Corporation.

Bowdler, Sandra. 1988. "Repainting Australian rock art." *Antiquity 62*: 517–523.

Brady, Liam M. 2009. "(Re)engaging with the (un)known: Collaboration, Indigenous knowledge, and reaffirming Aboriginal identity in Torres Strait Islands, NE Australia." *Collaborative Anthropologies 2*: 33–64.

Brady, Liam M., John J. Bradley, and Amanda J. Kearney. 2016. "Negotiating Yanyuwa rock art. Relational and affectual experiences in the Southwest Gulf of Carpentaria, Northern Australia." *Current Anthropology 57* (1): 28–52.

Bub, Jeffrey. 2004. "Quantum mechanics is about quantum information." *arXiv*. doi: 10.1007/s10701-004-2010-x.

Cochrane, Andrew, and Andrew Jones. 2018. *The Archaeology of Art. Materials, Practices, Affects*. New York: Routledge.

David, Bruno. 2002. *Landscapes, Rock-Art and the Dreaming: An Archaeology of Preunderstanding*. London: Leicester University Press.

David, Bruno. 2017. *Cave Art*. London: Thames & Hudson.

David, Bruno, and Ian McNiven (eds). 2019. *The Oxford Handbook of the Archaeology and Anthropology of Rock Art*. Oxford: Oxford University Press.

de la Cadena, Marisol, and Mario Blaser (eds). 2018. *A World of Many Worlds*. London: Duke University Press.

Descola, Philippe. 2013. *Beyond Nature and Culture*. Chicago: The University of Chicago Press.

Doring, Jeff, and Paddy Nyawarra. 2014. "Gwion artists and Wunan law: The origin of society in Australia." *Rock Art Research 31* (1): 3–13.

Fabian, Johannes. 1983. *Time and the Other. How Anthropology Makes its Object*. New York: Columbia University Press.

Finch, Damien, Andrew Gleadow, Janet Hergt, Vladimir A. Levchenko, Pauline Heaney, Peter Veth, Sam Harper, Sven Ouzman, Cecilia Myers, and Helen Green. 2020. "12,000-year-old Aboriginal rock art from the Kimberley region, Western Australia." *Science Advances 6* (6): aay3922.

Harper, Sam, Peter Veth, and Sven Ouzman. 2019. "Kimberley rock art." In *Encyclopedia of Global Archaeology*, 1–16. Cham: Springer International Publishing.

Harrison, Rodney. 2015. "Beyond 'natural' and 'cultural' heritage: Toward an ontological politics of heritage in the age of Anthropocene." *Heritage & Society 8* (1): 24–42.

Harrison, Rodney. 2018. "On heritage ontologies: Rethinking the material worlds of heritage." *Anthropological Quarterly 91* (4): 1365–1384.

Holbraad, Martin, and Morten Axel Pedersen. 2017. *The Ontological Turn. An Anthropological Exposition, New Departures in Anthropology.* Cambridge: Cambridge University Press.

Ingold, Tim. 2000. *The Perception of the Environment. Essays in Livelihood, Dwelling and Skill.* London: Routledge.

Ingold, Tim. 2011. *Being Alive. Essays on Movement, Knowledge and Description.* London: Routledge.

Ingold, Tim. 2013. *Making. Anthropology, Archaeology, Art and Architecture.* London: Routledge.

Ingold, Tim. 2015. *The Life of Lines.* London: Routledge.

Ingold, Tim. 2017. "On human correspondence." *Journal of the Royal Anthropological Institute (N.S.) 23* (1): 9–27.

Ingold, Tim. 2018. *Anthropology. Why it Matters.* Cambridge: Polity.

Jones, Andrew M. 2017. "Rock art and ontology." *Annual Review of Anthropology 46*: 167–181.

Jones, Andrew M., and Marta Díaz-Guardamino. 2019. *Making a Mark. Image and Process in Neolithic Britain and Ireland.* Oxford: Oxbow.

Kohn, Eduardo. 2015. "Anthropology of ontologies." *Annual Review of Anthropology 44*: 311–327.

Mangolamara, Sylvester, Lily Karadada, Janet Oobagooma, Donny Woolagoodja, Jack Karadada, and Kim Doohan. 2019. *We are Coming to See You.* Derby: Dambimangari Aboriginal Corporation/Wunambal Gaambera Aboriginal Corporation.

Manning, Erin. 2015. "Artfulness." In *The Nonhuman Turn*, edited by Richard Grusin. Minneapolis: University of Minnesota Press.

Marshall, Melissa, Kadeem May, Robin Dann, and Lloyd Nulgit. 2020. "Indigenous stewardship of decolonised rock art conservation processes in Australia." *Studies in Conservation* 1. doi: 10.1080/00393630.2020.1778264.

Marshall, Yvonne, and Benjamin Alberti. 2014. "A matter of difference: Karen Barad, ontology and archaeological bodies." *Cambridge Archaeological Journal 24* (1): 19–36.

McDonald, Jo, and Peter Veth (eds). 2012a. *A Companion to Rock Art.* Chichester: Wiley-Blackwell.

McDonald, Jo, and Peter Veth. 2012b. "Research issues and new directions: One decade into the new millennium." In *A Companion to Rock Art*, edited by Jo McDonald and Peter Veth, 1–14. Chichester: Wiley-Blackwell.

McNiven, Ian J. 2011. "The Bradshaw Debate: Lessons learned from critiquing colonialist interpretations of Gwion Gwion rock paintings of the Kimberley, Western Australia." *Australian Archaeology 72*: 35–44.

McNiven, Ian J. 2016. "Theoretical challenges of Indigenous archaeology: Setting an agenda." *American Antiquity 81* (1): 27–41.

McNiven, Ian J., and Lynette Russell. 1997. "'Strange paintings' and 'mystery races': Kimberley rock-art, diffusionism and colonialist constructions of Australia's past." *Antiquity 71*: 801–809.

McNiven, Ian J., and Lynette Russell. 2005. *Appropriated Pasts: Indigenous Peoples and the Colonial Culture of Archaeology.* Oxford: AltaMira Press.

Moore, Mark W., Kira Westaway, June Ross, Kim Newman, Yinika Perston, Jillian Huntley, Samantha Keats, Corporation Kandiwal Aboriginal, and Michael J.

Morwood. 2020. "Archaeology and art in context: Excavations at the Gunu Site Complex, Northwest Kimberley, Western Australia." *PLOS ONE 15* (2): e0226628.

Moro Abadia, Oscar, and Manuel R. González-Morales. 2008. "Paleolithic art studies at the beginning of the twenty-first century. A loss of innocence." *Journal of Archaeological Research 64*: 529–551.

Moro Abadía, Oscar, and Manuel R. Gonzáles Morales. 2013. "Paleolithic art: A cultural history." *Journal of Archaeological Research 21*: 269–306.

Mowaljarlai, David, and Jutta Malnic. 1993. *Yorro Yorro—Everything Standing up Alive. Spirit of the Kimberley*. Broome: Magabala Books Aboriginal Corporation.

Mowaljarlai, David, Patricia Vinnicombe, Graeme K. Ward, and Christopher Chippindale. 1988. "Repainting of images on rock in Australia and the maintenance of Aboriginal culture." *Antiquity 62* (237): 690–696.

O'Connor, Sue, Anthony Barham, and Donny Woolagoodja. 2008. "Painting and repainting in the west Kimberley." *Australian Aboriginal Studies 2008* (1): 22–38.

O'Connor, Sue, Jane Balme, Jane Fyfe, June Oscar, Mona Oscar, June Davis, Helen Malo, Rosemary Nuggett, and Dorothy Surprise. 2013. "Marking resistance? Change and continuity in the recent rock art of the southern Kimberley, Australia." *Antiquity 87* (336): 539–554.

Oobagooma, Janet, Leah Umbagai, Kim Doohan, and Martin Porr. 2016. "Yooddooddoom: A narrative exploration of the camp and the sacred place, daily life, images, arranged stones and Lalai Beings." *Hunter Gatherer Research 2* (3): 345–374.

Porr, Martin. 2018. "Country and relational ontology in the Kimberley, Northwest Australia: Implications for understanding and representing archaeological evidence." *Cambridge Archaeological Journal* 28 (3): 395–409.

Porr, Martin, and Hannah Rachel Bell. 2012. "'Rock-art', 'animism' and two-way thinking: Towards a complementary epistemology in the understanding of material culture and 'rock-art' of hunting and gathering people." *Journal of Archaeological Method and Theory 19*: 161–205.

Porr, Martin, and Jacqueline Maree Matthews. 2016. "Thinking through story." *Hunter Gatherer Research 2* (3): 249–274.

Povinelli, Elizabeth A. 2002. *The Cunning of Recognition. Indigenous Alterities and the Making of Australian Multiculturalism*. Durham: Duke University Press.

Povinelli, Elizabeth A. 2016. *Geontologies. A Requiem to Late Liberalism*. Durham: Duke University Press.

Redmond, Anthony. 2002. "'Alien abductions', Kimberley Aboriginal rock-paintings, and the speculation about human origins: On some investments in cultural tourism in the northern Kimberley." *Australian Aboriginal Studies 2*: 54–64.

Rose, Deborah Bird. 2004. *Reports from a Wild Country. Ethics for Decolonisation*. Sydney: University of New South Wales.

Ross, Anne. 2020. "Challenging metanarratives: The past lives in the present." *Archaeology in Oceania 55*: 65–71.

Ross, June, Kira Westaway, Meg Travers, Michael Morwood, and John Hayward. 2016. "Into the past: A step towards a robust Kimberley rock art chronology." *PLoS ONE 11* (8): e0161726.

Ryan, Judith, and Kim Akerman (eds). 1993. *Images of Power. Aboriginal Art of the Kimberley*. Melbourne: National Gallery of Victoria.

Stanner, William E.H. 1958. "The Dreaming." In *Reader in Comparative Religion: An Anthropological Approach*, edited by William A. Lessa and Evon Z. Vogt, 158–167. New York: Harper and Row.

Strathern, M. 1988. *The Gender of the Gift: Problems with Women and Problems with Society in Melansia*. Berkeley: University of California Press.

Taylor, Affrica 2013. "Caterpillar childhoods: Engaging with the otherwise worlds of Central Australian Aboriginal children." *Global Studies of Childhood 3* (4): 366–379.

Thomas, Julian. 2004. *Archaeology and Modernity*. New York: Routledge.

Travers, Meg, and June Ross. 2016. "Continuity and change in the anthropomorphic figures of Australia's northwest Kimberley." *Australian Archaeology 82* (2): 148–167.

Veth, Peter, Cecilia Myers, Pauline Heaney, and Sven Ouzman. 2018. "Plants before farming: The deep history of plant-use and representation in the rock art of Australia's Kimberley region." *Quaternary International 489*: 26–45.

Veth, Peter, Kane Ditchfield, Mark Bateman, Sven Ouzman, Marine Benoit, Ana Paula Motta, Darrell Lewis, and Sam Harper. 2019. "Minjiwarra: Archaeological evidence of human occupation of Australia's northern Kimberley by 50,000 BP." *Australian Archaeology 85* (2): 115–125.

Viveiros de Castro, Eduardo. 2015. *The Relative Native. Essays of Indigenous Conceptual Worlds*. Chicago: HAU Books.

Walsh, Grahame L. 1992. "Rock art retouch: Can a claim of Aboriginal descent establish curation rights over humanity's cultural heritage?" In *Rock Art and Ethnography*, edited by Michael J. Morwood and D.R. Hobbs, 47–59. Melbourne: Australian Rock Art Association.

Watchman, Alan L., Grahame L. Walsh, M.J. Morwood, and C. Tuniz. 1997. "AMS radiocarbon dating age estimates for early rock paintings in the Kimberley, NW Australia: Preliminary results." *Rock Art Research 14*: 18–26.

Whitmarsh, Tim. 2015. *Battling the Gods. Atheism in the Ancient World*. New York: Alfred A. Knopf.

9 Shifting ontologies and the use of ethnographic data in prehistoric rock art research

Inés Domingo Sanz[1]

1 Introduction

In Europe, the use of ethnographic information in rock art research dates back to the early discoveries of prehistoric art at the end of the nineteenth century (Ripoll 1986; Lewis-Williams 1991; Moro Abadía and González Morales 2005; Domingo et al. 2018). The original use as a primary source for analogical reasoning based on a purely comparative approach (especially in the area of rock art interpretation) has long proven to be unsuitable. Analogy was misused in rock art research to provide single interpretive frameworks for, most often, European prehistoric rock art, including totemism, hunting-magic, and shamanistic theories. These theories were generally based on reductionist interpretations of the cultures under study and disregarded temporal, spatial, and sociocultural distances between the compared human groups. Today it is widely accepted that interpreting rock art from different cultures without adequate informants is an unattainable goal, since similar images hold different meanings in different cultures and contexts (Macintosh 1977; Morphy 1989; Domingo et al. 2016; Smith et al. 2016). Moreover, as I have learned from Aboriginal people in Western Arnhem Land, there might not be a 'real meaning' for a specific subject matter even within a particular society, since knowledge may be classified and images may hide both profane and sacred information, with their deeper meanings only accessible to particular groups (Mountford 1956; Berndt 1983; Taçon 1989). In the last few decades, there has been a shift in the values placed on ethnographic observations, from the early use of analogy as a source of inspiration in the interpretation of hunter-gatherer rock art, to the most recent use of ethnoarchaeology to challenge conventional archaeological perspectives (Brady and Kearney 2016).

This chapter explores the historical evolution of the use of ethnographic observations and data collected among living societies to improve our interpretation and understanding of rock art of the past. First, I review the history of the uses of ethnographic analogies in European rock art research. This history reveals the polyvalence of analogical reasoning in archaeology, and surveys—in an informative manner—the different ways in which ethnographic accounts have been used in the past. Few scholars would disagree today that the early uses of analogies in rock art

research were inadequate and grounded on western-European ethnocentric thinking. Yet it is misleading to believe that all concepts of analogy are inadequate to improve our understanding of rock art. It is also arbitrary and erroneous to rule out all ethnographic information from our current interpretations. In this sense, archaeologists can, and should, reject analogies in some contexts and embrace them in others. In the second part of this chapter I support the continuing use of ethnographic data to inform studies on the rock art of past societies, provided that it is based on an ontological shift in the use of ethnographic information. My aim is to illustrate how a controlled use of analogies can be used to critically reflect and test archaeological interpretations of past rock art, to provide alternative interpretations, and to contribute to our understanding of the processes of creation and use of past rock art, especially those invisible in the archaeological record.

2 Analogy and rock art research: A short historical overview

Early analogical approaches to rock art were founded in the ideas of late eighteenth-century Victorian evolutionary anthropologists and their concept of unilinear progress within civilizations. At that time, anthropologists considered cultures as products of an evolutionary scale, with European cultures at the top (i.e., most evolved) and Aboriginal groups at the bottom, considered the most primitive of humankind. They fostered the belief that certain human groups lived frozen in the past, as unchanged cultures for which time had stood still. Based on this assumption, contemporary Aboriginal people (especially hunter-gatherer groups) were seen as living fossils described as being in the 'primitive' stage of civilization (Griffiths 1996). As such, they were studied to shed light on human origins and unravel our ancient past (Spencer 1901). These statements implicitly contributed to promoting discriminatory and racist perceptions of Aboriginal people by conveying to the world an image of a static and moribund culture (Hiscock 2008; May 2009).

While Europeans considered Aboriginal peoples to be 'fossilized' societies, or prehistoric survivals, they viewed themselves as being the result of progress, change, and evolution; as civilizations who had a clear and significant history (Clifford 1988: 220–221; Griffiths 1996, 24–25; May 2009). Based on these ideas, there was a widespread belief that travelling to places where people exhibited economic or technological similarities to those seen in the European archaeological record was like travelling back in time. Few people realized that these approaches ignored temporal and cultural distances between the cultures being compared, denying variation and cultural change among Aboriginal people and typically overlooking their history (for a more detailed explanation, please see Chaloupka 1993; Clarke 2003, 79; Hiscock 2008). The case of Australian Aboriginal people constitutes a good example of these misplaced beliefs (for an overview, please see discussions in McNiven and Russell 2005). As I will show in the following paragraphs, Western scholars at the end of the nineteenth century

and the beginning of the twentieth century looked to this country, among others, for inspiration in their interpretations of European Paleolithic art.

The Aboriginal groups living in Australia at the time of contact with European populations were hunter-gatherers with technologies that included stone, bone, wood, animal, and fiber tools. Based on their use of such materials and on their cultural practices, nineteenth- and twentieth-century anthropologists immediately described these people as 'Stone Age men' (Mountford 1949, 1963; Idriess 1963, XII) and compared them to Paleolithic European populations (see, e.g., Tylor 1865, 1871; Spencer 1901; Taylor 1927).

Ethnographic analogies were particularly popular among rock art researchers. In this context, Baldwin Spencer and Francis J. Gillen's *The Native Tribes of Central Australia* (1899), which explored the lives, behaviors, and practices of a number of central Australian Aboriginal groups, inspired numerous authors in their search for the meaning of Paleolithic art. For instance, art historian Salomon Reinach drew a number of parallels between Australian Aboriginal rock art and European Paleolithic art. Reinach's theory was based on a number of similarities that he identified between both societies: both were hunter-gatherers, and both produced painted art, including animal depictions (Reinach 1903). Moreover, in both cases, access to the art was restricted. In the Australian Aboriginal societies, sacred paintings were taboo to women, children, and uninitiated men, while in the case of Paleolithic art, the location of the paintings deep within caves was understood as a sign of restriction (Domingo et al. 2017). Reinach assumed that European "troglodytes were approximately on the same religious plane as the Aruntas" (Reinach 1912, 132), and, therefore, that their paintings were "the expression of a religion, rude enough but intensely earnest—a religion built up of magic ceremonies and looking to a single end, the daily bread of its votaries" (Reinach 1912, 135–136).

In the first half of the twentieth century, ethnographic and ethnohistorical information was systematically utilized as both a source of inspiration for direct analogies between past and present human groups and to promote new inter- pretations of European Paleolithic paintings, including totemism (Tylor 1871; Frazer 1922), art-as-magic theories (Breuil 1914, 1952; see also Bégouën 1920) and, more recently, the theory of shamanism (Lewis-Williams and Dowson 1988; Lewis-Williams 1991; Clottes and Lewis-Williams 1996). These theories had two things in common: First, they used ethnographic accounts to promote inter- pretations of Paleolithic art. Second, they reduced the role of rock art to a single monolithic function. This is particularly astonishing since, in their 1899 book, Spencer and Gillen had already distinguished between the making and use of rock paintings (including zoomorphic and geometric designs) in ordinary and sacred contexts, thus already demonstrating that rock art had multiple functions.

In the field of rock art research, ethnographic analogies remained unchallenged until the 1960s. It was at that time that Leroi-Gourhan and Laming-Emperaire warned about "the dangers of ethnographic comparison" (Leroi-Gourhan 1958, 307), preferring to analyze the art according to structural features and int- errelations. They suggested that Paleolithic images composed a "system polished

in the course of time [...] wherein there are male and female divinities whose actions do not overtly allude to sexual reproduction, but whose male and female qualities are indispensably complementary" (Leroi-Gourhan 1968, 118). A number of authors at the time began to suggest that the extraordinary variety of Paleolithic images could not be reduced to a single meaning. For instance, Ucko and Rosenfeld (1967, 7) argued that rock art included both religious and secular themes, as well as a whole series of signs that helped humans adapt, coexist, and share specific natural and cultural landscapes. Similarly, Conkey suggested that it was not possible to support hypotheses defending a single meaning for the thousands of paintings and sites, chronologies, and contexts encompassed under the term 'Paleolithic art' (Conkey 1987, 414). Building upon ethnographic data, a number of publications have recently suggested that rock art has multiple functions and meanings that are not even accessible to all members of a particular community (Lewis and Rose 1988; Layton 1992; Taylor 1996; Domingo and May 2008; Domingo et al. 2018) and, therefore, the possibility of interpreting art from another culture without informants is rather remote (Macintosh 1977; Chippindale and Tacon 1998, 7; Berndt and Berndt 1999 , 413; May and Domingo 2010; Domingo 2011; Domingo et al. 2016; Smith et al. 2016).

If direct ethnographic analogies have lost their appeal in rock art research, the last years have witnessed the theoretical resurgence of ethnoarchaeology (see, e.g., Van Reybrouck 2012; Alberti 2016). In fact, ethnoarchaeology emerged in the 1960s as a way of testing hypotheses and was associated with a 'New Archaeology' (Binford 1967). While processual archaeologists called into question traditional direct analogies (Gould 1978; Wylie 1985), they promoted the idea of using ethnoarchaeology for testing archaeological hypotheses. Later on, with the development of contextual and processual archaeology, ethnoarchaeology acquired new values as a way to explore alternative perspectives on material culture and to emphasize the role of material culture, not only as a cultural product, but also as an active producer of social actions. Today, ethnoarchaeology is generally considered an acceptable way of observing and examining material products resulting from human activities and practices (artifacts, structures, landscapes, and so forth) in a living context. Ethnoarchaeological approaches allow us to observe daily interactions between humans and objects, as inert materials are transformed into active agents of social, economic, and/or cultural practices. They also provide a basis to reflect on the archaeological invisibility of many aspects of human cultures which do not survive in the archaeological record but play an important role in people's lives (e.g., perishable materials or intangible heritage such as music, songs, dances, stories, ceremonies, beliefs, or the cultural values of unaltered landscapes and places). Last, ethnoarchaeology is also essential for understanding other ways of doing, thinking, or relating to nature and culture that differ from our Western ontologies (Politis 2015). These different ontologies (i.e., different understandings about how the world is) can provide new approaches and suggest alternative research questions that we would otherwise have never imagined (Hernando 1995, 28; Politis 2002). As I examine in the following section, such

observations may be of great significance for archaeological theory and may promote the development of more critical approaches to the archaeological study of rock art. My ethnoarchaeological approach to rock art is shaped by this last definition of ethnoarchaeology.

3 A case study: The rock art from Western and Southern Arnhem Land (Northern Territory)

The examples discussed in this chapter focus on rock art from Western and Southern Arnhem Land (Northern Territory). This region has a complex recent history following several consecutive external periods of contact. These contact periods started in the seventeenth century with the interaction between Aboriginal groups and Makassar fishermen arriving from the region of Sulawesi in search of trepang and other trade items. Early contact introduced changes in foraging, diet, society and ideology, as well as material culture. It also caused changes in settlement patterns of coastal Aboriginal groups (Hiscock 2008, 280). These early contacts were followed by the fleeting visits of European sailors and, later, British settlements and Christian missions in the area. These had a dramatic impact on Aboriginal societies and caused a significant disruption of their traditional lifestyles (e.g., Smith 2004; Hiscock 2008; May et al. 2015). Prior to European arrival, cultural diversity was one of the key features of Australian Aboriginal and Torres Strait Islander groups, including a large number of discrete languages, cultural practices, and material products defining different cultural identities (Morwood 2002; Clarke 2003; Hiscock 2008). While these groups had several degrees of seasonal mobility associated with their foraging strategies, they maintained strong connections to particular parts of the country (Taylor 1996; May 2008). In the last 50,000 years (Clarkson et al. 2015) the study area was inhabited by a diverse array of Aboriginal populations with hunter-gatherer lifestyles. They were organized into flexible groups of extended families (Chaloupka 1981) with different aggregation patterns and sophisticated socio-cultural practices in which visual arts, religion, and law were strongly interrelated (Morphy 1991; Smith 2004). Both sacred and secular ceremonies played a significant role in the transmission of knowledge, the establishment of short- and long-distance social networks, the development of alliances, and the exchange of ideas and raw materials. In these ceremonies, beliefs, history, and cultural norms related to the *Djang* (also known as 'Dreaming,' or the corpus of beliefs and traditions related to the creation time) were celebrated and reinforced through dances, music, songs, stories, and ritual, along with visual arts of various media, including body art, rock art, and portable art (e.g., Berndt and Berndt 1970; Morphy 1991; Taylor 1996, Smith 2004).

The rock art sequence of this region illuminates important advancements in human adaptation to shifting environments, landscapes, and cultural contexts in pre- and post-contact periods, as illustrated through variations in subject matter, animal species and tools (Lewis 1988; Chaloupka 1993; Chippindale and Tacon 1998). After contact,

Aboriginal artists' depictions reflected the impacts that interactions with foreign societies had on their daily lives (e.g., Chaloupka 1993; May et al. 2010, 2015). Yet, at the same time, they managed to maintain their strong cultural belief systems. For example, local languages are still spoken, and ceremonies still take place today. Arnhem Land was declared Aboriginal reserve in the 1930s and this somewhat mitigated the impact of European invasion, allowing the perpetuation of a long-lasting connection to the land, embedded with religious associations and sacred sites, along with the ongoing production of rock art. It has been noted elsewhere (see, e.g., Taçon et al. 2008) that challenging times, such as periods of contact, are sometimes met with resistance, including retaining and empowering individual and group identities. This is certainly the case with regards to the strength of artistic practices observed today in Western Arnhem Land (Taylor 1996; Domingo and May 2008; May 2008).

As custodians of an inherited land, the duty of looking after their country is considered an integral part of Aboriginal obligations, and in some parts of Australia this includes painting or renewing rock art sites (Taçon 1989). This activity is only undertaken by individuals who are related to each particular site by descent—that is, by members of the local clan to which the lands belong (Smith 1994; Layton 2006). The cultural diaspora that took place after the European invasion caused a drastic reduction of these practices. Similarly, a main consequence of the population displacement caused by the arrival of Europeans was that, in some places, Aboriginal groups were deprived of their connection with their ancestral lands. As a result, today, Aboriginal people care for and conserve sites or motifs created by other, now extinct, Aboriginal clan groups (Clarke 2003, 95–96). In this setting, ancestral knowledge continues to be passed down to new generations through ceremonies, dances, songs, and stories that have their graphic representation in rock art and on portable formats such as bark or paper (Taylor 1996; May 2006, 2008). Some of these media forms were already in use prior to European contact, including body art and art produced on wood and large sheets of tree bark. Before this contact, bark paintings were used both in restricted contexts, such as ceremonies wherein they were later destroyed, and in public contexts where they were used as shelters (Berndt and Catherine 1999, 423). It is interesting to note that even if rock art is only occasionally created today, rock art from an artist's 'country' (homeland) is still a source of inspiration for most Western Arnhem Land artists. Likewise, a few of the elder artists of current generations learned to paint on rock from their more senior relatives, even though today their art is mainly produced on other media (May 2006, 62; 2008; Taylor 2016; May et al. 2019). Furthermore, there are enduring rights over the designs, motifs, and stories that each artist represents according to their lands of origin or social status. The right to depict a particular motif, or group of motifs, is inherited and/or earned (Taylor 1996; May 2006, 2008). Thus motifs, themes, and designs still encode the identity of the individual as well as their place in society, space, and time (May and Domingo 2010). This continuity provides us with a unique environment to explore questions concerning rock art production and consumption from some of the last artists and their direct descendants.

4 The 'ontological turn' and ethnographic approaches to rock art

As previously discussed, for much of the last century analogies became one of the main sources of information in the search for the meaning of Paleolithic art. However, it is now clear that direct analogies can contribute little with regards to interpreting the symbolic meaning of the art of past societies, especially when they are separated by thousands of years and kilometres. Similarly, it is no longer believed that similar technologies amount to two human groups being culturally analogous. Today it is widely accepted that cultural beliefs, values, and practices are unique to particular groups of people in specific times and places, as are the artistic practices of different human groups. If ethnographic and ethnoarch-aeological accounts have taught us anything, it is that interpreting the meaning of the art of a different culture can only be achieved when assisted by local people with inside knowledge (Taylor 1996; Smith et al. 2016; Domingo et al. 2016).

Australian rock art itself provides a unique example to illustrate the limits of ethnographic analogy even among contemporary hunter-gatherer societies. Interestingly, while the Aboriginal groups at the time of contact had relatively similar lifestyles (albeit with significant peculiarities resulting from adaptations to different environments and landscapes), they produced an impressive variety of rock art styles, including the figurative painted art from Arnhem Land and the Kimberley, the figurative engravings from the Burrup Peninsula, and the non-figurative art in Central Australia, just to name a few examples (for more detailed examination, please see Layton 1992; Flood 1997, or Morwood 2002). In this context, interpreting rock art from Central Australia through the lenses of Aboriginal knowledge from Northern Australia can lead to substantial mistakes, even if there are significant economic and technological similarities between both regions. Ethnoarchaeology has also proven that even in seemingly simple cases, the identification of figurative motifs by an outsider to a particular culture may be challenging. A classic example is MacIntosh's (1977) experience at Beswick Creek Cave (Northern Territory), where he found that 90% of the motifs that he recognized at this site did not correspond to the motifs described by an Aboriginal elder. My own experience with the interpretation of Aboriginal rock art scenes was quite similar (May and Domingo 2010; Domingo 2011; Domingo et al. 2016). Through analyzing motifs, patterns of distribution, and actions performed from an archaeological point of view, we deduced that specific social behaviors and particular gatherings were being depicted. But only with ethno-graphic information did we achieve a full comprehension of the specific activities represented and the complex social rules and regulations illustrated. Considering these compositional patterns and the archaeological context (several burials in the surroundings) we interpreted a scene at Injalak Hill with a person seemingly lying down in the context of a gathering as an activity or ceremony related to death (Figure 9.1, top). However, Aboriginal elder and artist Thompson Yulidjirri interpreted these patterns as characteristic of an initiation ceremony for a young man, often referred to as *Kunabibi* (May and Domingo 2010).

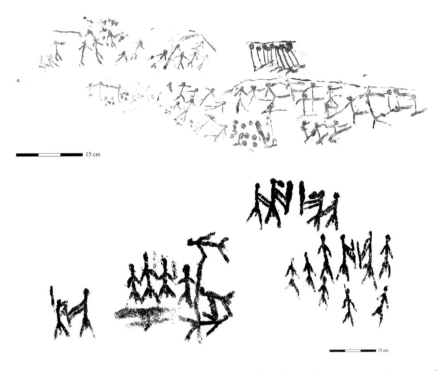

Figure 9.1 Top: Digital tracing of a scene at Injalak Hill (Gunbalanya) representing part of
an initiation ceremony for a young man (*Kunabibi*).
Source: Top: Drawing by Domingo 2011, reprinted by permission of Taylor & Francis Ltd. Bottom:
Digital tracing of a scene at Djulurii site (Wellington Range) reproducing different cer-
emonial sequences.

Similarly, we interpreted another scene at the Djulurii site with two pairs of
individuals facing one another, as a possible fight or battle (Figure 9.1, bottom).
Later on, an Aboriginal elder interpreted this scene as referring to specific cer-
emonial sequences completely unrelated to battles (Domingo et al. 2016).

With these examples, it should be evident to readers that interpreting the art of
prehistoric Europe (or elsewhere) based on the practices of contemporary
Aboriginal groups is unreasonable. As I have discussed elsewhere, focusing our
research efforts on deducing the symbolic meaning of the art, with or without
ethnographic analogy, only leads the discipline toward a dead end (Domingo
et al. 2016).

Similarly, the initial use of ethnographic analogies to infer a single function for
past rock art (totemism, hunting magic, and so forth) is now generally considered
a misleading practice (Ucko and Rosenfeld 1967; Taçon 1989; Taylor 1996;
May 2008). Ethnography has provided innumerable examples of how art was
used in both secular and ritual contexts to educate, reinforce, explain, illustrate,
remind or transmit traditional beliefs, practices, and knowledge on the land,

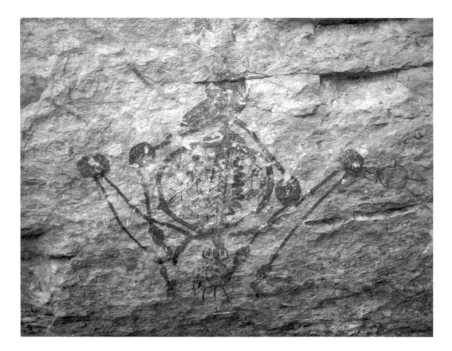

Figure 9.2 Sorcery figure at Injalak Hill (Gunbalanya). Distorted figures such as this were related to sorcery practices used against those acting outside the social code.

while marking the land with shared symbols. Totemism or magic functions (like the sorcery figures of Western Arnhem Land) may account for some of these potential meanings (Figure 9.2). However, there were many other possibilities as demonstrated by numerous accounts (Mountford 1956; Berndt and Catherine 1999; Chaloupka 1993; Taçon 1994). Some of these uses, especially educational roles, continue today in art produced on bark and paper (see Taylor 1996; May 2008).

Beyond the reasonable use of ethnographic and ethnoarchaeological approaches to understand the materiality, practices, beliefs, and symbolisms of current societies (González-Ruibal 2008; Hamilakis and Anagnostopoulos 2009), I suggest that ethnographic and ethnoarchaeological approaches can be an effective way of checking (and challenging) long-established archaeological interpretations. In other words, ethnographic accounts can assist us by revealing incorrect prejudices and assumptions, and help us to determine how biased our interpretation of the archaeological record is (Domingo et al. 2017, 298), revealing the range of ephemeral materials, actions, cultural beliefs, decisions, and practices involved in rock art production. The following examples illustrate these claims.

In Spain, the analysis of the thickness of Levantine rock art brush strokes combined with experimental archaeology led Alonso and Grimal (1996, 194–196)

to suggest feathers as the only potential brush used by Levantine artists. Their attempts to produce curved lines and to achieve well-defined borders with brushes of vegetable fiber were unsuccessful, even though one of them is an artist. While they achieved better results with a hair brush, they rejected their use arguing that it would have been far too difficult for Levantine artists to produce them (Domingo 2005, 107–108). Ethnoarchaeology and ethnographic accounts provide data for a critical discussion of such a discriminatory interpretation. The idea that pre-industrial societies were incapable of producing hair brushes underestimates the technical capabilities of human groups that were perfectly capable of making all the tools they needed for their daily activities. Moreover, Australian ethnographic collections demonstrate that the production of all sorts of brushes, including the use of materials such as feathers, weeds, bark, roots, as well as animal and human hair, was common. Such a variety of brushes has been also reported by several Australian rock art researchers (Flood 1997, 16–17; Morwood 2002, 112). We have also seen some of them used in our fieldwork campaigns. In Injalak arts and crafts (Gunbalanya), experienced artists with excellent technical skills can easily produce lines as delicate and fine as those observed in Levantine art (Figure 9.3, top). So, according to ethnography, Levantine brush strokes could have been achieved with a wide variety of brushes, dismantling Alonso and Grimal's hypothesis on the use of a single type of brush (feathers) to produce this art. Moreover, it cautions that mastering these techniques takes a long period of time (Taylor 1996), suggesting that even an experienced artist used to painting with industrial hair brushes might not necessarily master the use of handmade fiber brushes very quickly. Thus, experimental approaches should be based on long-term experience with the materials and methods being tested.

Similarly, through replication experiments, some European Paleolithic researchers suggested that hand-stencils were produced by blowing pigment through hollow tubes (e.g., Groenen 1988; Pettit, n.d.). This proposal has been widely accepted in the European archaeological literature, even though ethnographic accounts (see e.g., Spencer and Gillen 1899) and current ethnoarchaeological observations present an alternative technique consisting on mixing earth pigments with water and a binder and spitting the mixture directly from the mouth (Figure 9.3, bottom). In these two examples, ethnoarchaeology has served to either rule out or suggest alternative techniques for producing different sorts of motifs in European rock art.

In European Palaeolithic rock art, the number of unidentified motifs included under the terms 'signs' or 'symbols' is quite large (e.g., zigzags, tectiforms, claviforms, series of dots, and so forth). Through direct analogy Breuil (1952) identified traps, huts and shrines inhabited by spirits, while Lewis-Williams and Dowson (1988) identified projections of entopic mental imagery related to altered states of consciousness. In addition to simply assisting with the identification of the motifs depicted, I argue that analogies are useful in facilitating critical reflection on the degree of bias shown in archaeological inventories of prehistoric rock art. In our visits to different rock art sites in the study areas, I was often faced with motifs that, according to my European training in prehistoric art,

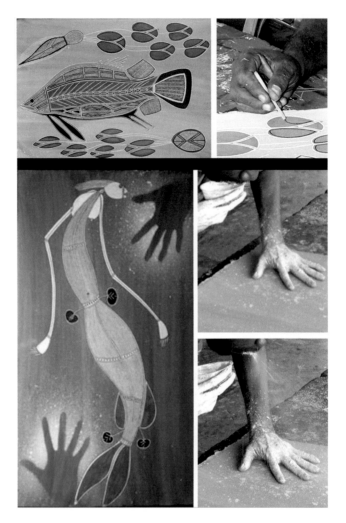

Figure 9.3 Top: *Namarnkol* (Barramundi) and water lilies depicted by Aboriginal artist
Gabriel Maralngurra in 2006. A fiber brush was used for the fine lines. Bottom:
Yawkyawk (female water spirit with fish tail) depicted by Aboriginal artist Isaiah
Nagurrgurrba in 2006. Hand stencils were produced by spitting paint from the
mouth.

I would have classified as non-figurative (Figure 9.4). Surprisingly though,
Aboriginal elders and artists described these images as figurative representations,
including a container, parts of a fish, a schematic version of the ancestral being
Namarrkon, and a representation of a snake (Domingo et al. 2016, 2017; Smith
et al. 2016). In my description of the art of this region, all of these figurative
images would have been excluded from the inventory records, resulting in a
partial or inaccurate view of this rock art tradition.

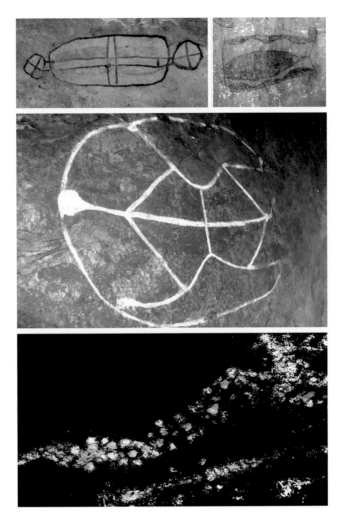

Figure 9.4 Figurative representations, including a container (top left), part of a fish (top right), a schematic version of the ancestral being *Namarrkon* (center) and a representation of a snake (bottom) consisting of a series of consecutive dots produced by spitting paint from the mouth.

If we focus on the depiction of *Namarrkon*, or the lighting man, the identification of this being is mainly based on the posture and the line representing a ray of lightning surrounding the human figure, rather than the style and the number of details (Figure 9.4). Today this being is still represented in other media with different styles and details, and he is often depicted with the stone axes he uses to cause storms. These changes in style are particularly interesting, as they do not specifically connote changes in significance and symbolism, or a significant social change, although Western approaches to rock art often rely on stylistic changes

to identify 'cultures.' With this example, I am not suggesting that European rock art should be interpreted based on interpretations given for equivalent depictions, patterns, or changes in Arnhem Land. Rather, my aim is to show how ethnoarchaeology contributes to building a more critical approach to rock art of the past.

Another important idea challenged by ethnographic accounts is the concept of 'art' itself. Interestingly, before European contact the distinction in Aboriginal societies between the Western categories of 'art' and 'craft' did not exist (Chippindale and Tacon 1998, 6; Clarke 2003, 89). To Aboriginal people, rock art is just one form of *Djang*, which also includes stories, songs, performances, and music, along with other forms of material art (e.g., bark paintings, wood carvings, body art), and many other artifacts imbued with cultural values. The range of materials related to the sacred is quite broad, with no clear distinction between what we call, in Western terms, the 'secret' and the 'secular.' As such, both ordinary and secret artifacts were often decorated with sacred designs (Berndt 1983, 31). Moreover, it was the context of use and not necessarily the context of production that defined the secret/sacred status of the material culture (Berndt 1983, 32). In other words, Western categories such as the 'secret' and the 'secular' are simply irrelevant in certain ethnographic and archaeological contexts. The same can be said about the Western divide between 'arts' and 'crafts.' This distinction, one that has largely oriented the interpretation of Paleolithic art (Moro Abadía and González Morales 2013), is also inadequate to understand most Aboriginal art forms. In fact, to Aboriginal people, the many forms of cultural expression that we categorize under the terms 'arts' and 'crafts' are only part of an indivisible whole. Thus, rock art can only be fully understood in close relation to the other tangible (e.g., bark/body paintings, other sacred objects) and intangible (e.g., dances, songs, ceremonies, stories, beliefs, etc.) expressions of *Djang*, along with the culture and the landscape to which it is strongly connected. This is certainly fascinating, as it is in stark contrast with the perspectives and approaches employed by Western rock art researchers for nearly a century, which focused mainly on imagery and meaning.

While the question of the *meaning* of art can hardly be approached using direct ethnographic analogies, there are a number of fields in which ethnography is generating new avenues of research focused on the *context* in which images and objects were produced. In this context, technical approaches to ancient rock art through archaeometry and experimental archaeology (e.g., Fritz and Tosello 2007; Rivero 2016), along with landscape perspectives (e.g., Bradley 2000; Nash and Chippindale 2001) represent a step forward in attempts to understand the processes and places of art production on a global scale. However, archaeological approaches to ancient rock art still contain many gaps which must be filled in order to gain a more comprehensive understanding of what it means to produce art in such contexts.

Another area in which ethnoarchaeology is having a significant impact on rock art research is ontology. In this area, we are witnessing a shift from a focus on the concrete meaning of the final definitive product (that is, the images or objects

discovered at archaeological sites) to an interest in the contingent, technical, and embodied processes of making past imageries. This interest has been fuelled by the fact that, as Thompson Yulidjirri, a senior artist from Kunbarlanja, has pointed out, for Aboriginal people art is not an end, but simply a gateway to culture (May 2006, 43). In Aboriginal contexts, art is like a story board used to illustrate oral stories and share knowledge in conjunction with dance, songs, and sacred objects (Parker 1997). Together these elements constitute an educational system implemented to preserve and pass down cultural components. As part of this information exchange process, an apprenticeship system would be in place, where children—starting from a young age—would be trained not only in basic life-skills like hunting, gathering, and tracking, but would also learn painting skills and ancestral stories and laws related to art (Parker 1997). This teacher/apprentice system continues today in the form of fine art on bark and paper (Taylor 1996, 70–101; May 2008).

Through ethnoarchaeology (incorporating the ontologies of the artists, their contemporaries, and their descendants within the regions of study), it becomes clear that art manufacturing is more than just a collection of techniques, raw materials, and tools, as actions and techniques are also embedded with cultural significance. Places and materials are not selected simply based on their availability; rather, they are active components of different cultural traditions, practices, and beliefs (Alcock 2013) that are often invisible in the archaeological record. During the making of art, Aboriginal artists connect to their land and their ancestors through the meanings that imbue the paintings, the places where they paint, and the materials they use. In this sense, a work of art implies a connection with the culture, land, and history of the artist's people that is essential to most Aboriginal groups in Australia and elsewhere.

As part of this creative process, not only the paintings, but also the places and raw materials used in the manufacturing of art are connected to *Djang*. For instance, while pigments are collected from different sources, the finest quality materials and sources have special religious significance and associated *Djang* stories, and are highly prized and traded (Mountford 1956, 11; Ravenscroft 1985, 101; Chaloupka 1993). Some scholars have noted the existence of gathering rights related to specific coloring materials, along with sources being governed by tribal traditions (Ravenscroft 1985, 101; Parker 1997, 21). Kurulk clan members consider white paint to be the transformed feces of an ancestral being, the King Brown Snake; as such, it is considered to be a powerful substance. Since this being is active during the wet season, they do not collect this pigment at this time of the year to avoid disturbing the snake and being harmed (Taylor 1996, 59–60, 130). This sort of cultural belief and practice would be impossible to track in the archaeological record.

Berndt (1983) describes the preparation and manufacture of sacred materials as a ritual act, wherein people would take great care with regards to the traditional materials and conventions used, and sometimes sing throughout the process. He also notes that the presence of sacred objects in the ritual ground (which could include paintings on different media, such as rock, bark, or bodies,

along with other ritual items) gives more effect to the rituals, drawing attention to the active role of material culture in sacred performances.

Similarly, Dobrez (2014) explains that the technical choices related to the process of art creation are not exclusively driven by mechanical considerations, but are also imbued with cultural significance. For instance, making a stencil involves powerful actions for Aboriginal peoples, such as the act of touching the rock and spitting personal fluids (considered to be powerful in themselves); these fluids are then mixed with coloring materials which are also steeped in symbolic value. In this way, it is not just the hand-stencil that is important, but the entire process of producing it, which leaves traces on the rock, and today on bark and paper (please see Figure 9.2, bottom).

Colors, outline shapes, figure proportions, and infill patterns, as well as the artist's chosen subject matter, are also culturally and socially regulated (Taylor 1996; Smith et al. 2016). Moreover, patterns which may be mistakenly considered as merely decorative from a Western perspective are indeed often indicative of the artist's social identity (Taylor 1996). For instance, particular designs (e.g., semicircles, elongated diamonds) are used to distinguish the paintings of different clans (Chippindale and Tacon 1998, 7). Similar designs are also used in body paintings in ceremonial contexts (Layton 1992, 97).

Selection of the place in which artists make their images is also culturally determined. While in archaeology changing styles and superimpositions are usually interpreted as signs of changing cultures, for Aboriginal people they are both a sign of continuity and evidence of the significance of the place derived from *Djang*. The presence of many painted layers illustrates that many generations of artists have fulfilled their responsibility of looking after the country by refreshing the powers of that particular place. The Aboriginal perception that the place is more important than the art prompts us to turn our attention away from the paintings themselves and to use them as a gateway for exploring the natural and cultural landscapes surrounding them. Moreover, the constant reuse of the same spaces draws attention to a topic rarely explored in the archaeology of art, namely the process of consumption of art throughout time. Ethnoarchaeology provides multiple examples of the continuous uses and reinterpretations of past forms of art over different generations, raising new research questions: How often and for how long was the art used? How did new artists interact with existing art? Do superimpositions of different artworks or styles reflect more than simply a shift in art practice? In certain areas, some of the old paintings dating back hundreds or even thousands of years are utilized today to share ideas, norms, stories, and traditions (Domingo 2011). Moreover, today, old paintings remain an inspiration for Aboriginal artists in this region and serve as a tool for educating local community members and tourists. This aspect is rarely considered in archaeological approaches to rock art.

The examples listed above are just a few of the many illustrations of how ethnoarchaeological research can move from a traditional use of analogical reasoning to a critical use of ethnographic information to examine where, why, and how rock art was produced and consumed, considering not only the social,

cultural, and ontological practices involved in artistic production but, more importantly, also the materiality of these representations.

5 Some concluding thoughts

In this chapter, I briefly explored the historical evolution of the use of ethnographic and ethnohistoric information in the context of rock art research. Early uses of direct analogies between present and past societies (either other cultures or the ancestors of contemporary Aboriginal people) have long been abandoned, especially when focusing on the meaning of the art. But can these analogies be maintained in some way? Examples discussed in this chapter demonstrate that analogies can still be useful to test and critically reflect on archaeological interpretations of past rock art, as well as to provide alternative hypotheses and integrate current and historical Aboriginal knowledge and ontologies into rock art research.

Today, the controlled and ethical use of ethnographic information is contributing to a more global picture of the processes, experiences, and practices involved in the making of art. This allows us to reflect on the bias of the archaeological record, illustrating how significant parts of artistic productions may have disappeared. Thus, through ethnoarchaeology, it is possible to identify how practices related to rock art production crystallize in the archaeological record, as well as what types of data may be absent, allowing us to consider possible ways to demonstrate the presence of these missing elements.

Ethnoarchaeological analyses grant us the ability to observe and analyze the value and significance of art production processes and uses, identify gaps and limitations in the archaeological record, test hypotheses, and construct a more critical theoretical and methodological framework to examine past and present rock art.

More importantly, they teach us other ways of doing, thinking, or relating to nature and culture that differ from our Western ontologies. These different ontologies challenge our Western approaches to rock art, opening new research avenues and allowing for an explicit discussion of the broader implications of researching rock art as a whole, and how we might begin to understand the methods, intentions, and contexts under which it was produced.

Note

1 The reflections summarized in this chapter build upon a long-term collaboration with colleagues from different Australian universities (particularly, Professor Claire Smith, Dr. Sally May and Gary Jackson) with long-term experience collaborating and learning from Aboriginal elders and artists from several communities in Western Arnhem Land and the Barunga region of the Northern Territory (Australia). This is important to note, since the results of any ethnoarchaeological research will certainly depend on the capacity of the researchers to engage with the community and to develop long-term relations and mutual trust. This long-term research has been funded by many different sources over the years, with the last projects being HAR2016-80693-P, funded by the

Spanish Ministry of Science, Innovation and Universities; and ERC-CoG *LArcHer* project, funded by the European Research Council (ERC) under the European Union's Horizon 2020 research and innovation programme (grant agreement No 819404).
I also thank Oscar Moro Abadía and Amy Chase for their precious editing work and external reviewers for their comments and suggestions.

References cited

Alberti, Benjamin. 2016. "Archaeologies of ontologies." *Annual Review of Anthropology 45*: 163–179.

Alcock, Sharon. 2013. "Painting country: Australian Aboriginal artists' approach to traditional materials in a modern context." *AICCM Bulletin 34* (1): 66–74.

Alonso, Ana and Alexandre Grimal. 1996. *El Arte rupestre prehistórico de la cuenca del Río Taibilla (Albacete y Murcia): Nuevos planteamientos para el estudio del Arte Levantino.* Barcelona: Ana Alonso Tejada.

Bégouën, Henri. 1920. "Un dessin relevé dans la caverne des Trois-Frères, à Montesquieu-Avantès (Ariège)." *Comptes-rendus des séances de l'Académie des Inscriptions et Belles Lettres 64* (4): 303–310.

Berndt, Ronald M. 1983. "A living Aboriginal art: The changing inside and outside contexts." In *Aboriginal Arts and Crafts and the Market*, edited by Peter Loveday and Peter Cooke, 29–36. Darwin: Australian National University.

Berndt, Ronald M., and Catherine Berndt. 1970. *Man, Land & Myth in North Australia. The Gunwinggu People*, Sydney: Ure Smith.

Berndt, Ronald M., and Catherine Berndt. 1999 [1964]. *The World of the First Australians.* Canberra: Aboriginal Studies Press.

Binford, Lewis R. 1967. "Smudge pits and hide smoking: The use of analogy in archaeological reasoning." *American Antiquity 32*: 1–12.

Bradley, Richard. 2000. *An Archaeology of Natural Places.* London: Routledge.

Brady, Liam M., and Amanda Kearney. 2016. "Sitting in the gap: Ethnoarchaeology, rock art and methodological openness." *World Archaeology 48* (5): 642–655.

Breuil, Henri. 1914. "A propos des masques quaternaires." *L'Anthropologie 25*: 420–422.

Breuil, Henri. 1952. *Quatre cents siècles d'art parietal.* Paris: Centre d'études et de documentation préhistorique.

Chaloupka, George. 1981. "The traditional movement of a band of Aboriginals in Kakadu." In *Kakadu National Park Education Resources*, edited by Tony Stokes, 162–171. Canberra: Australian National Parks and Wildlife Service.

Chaloupka, George. 1993. *Journey In Time: The 50,000 Years Story of Aboriginal Rock Art of Arnhem Land.* Sydney: Reed New Holland.

Chippindale, Christoffer, and Paul Tacon (eds). 1998. *The Archaeology of Rock-Art.* Cambridge: Cambridge University Press.

Clarke, Philip. 2003. *Where the Ancestors Walked.* New South Wales: Allen and Unwin.

Clarkson, Chris, Mike Smith, Ben Marwick, Richard Fullagar, Lynley A. Wallis, Patrick Faulkner, Tiina Manne, Elspeth Hayes, Richard G. Roberts, Zenobia Jacobs et al. 2015. "The archaeology, chronology and stratigraphy of Madjedbebe (Malakunanja II): A site in northern Australia with early occupation." *Journal of Human Evolution 83*: 46–64.

Clifford, James. 1988. *The Predicament of Culture: Twentieth Century Ethnography, Literature and Art.* Cambridge: Harvard University Press.

Clottes, Jean, and David Lewis-William. 1996. *Los chamanes de la prehistoria, tránsito y magia en las cuevas decoradas.* Barcelona: Ariel.

Conkey, Margaret. 1987. "New approaches in the search for meaning? A review on research in 'Paleolithic' art." *Journal of Field Archaeology 14* (4): 413–430.

Dobrez, Patricia. 2014. "Hand traces: Technical aspects of positive and negative hand-making in rock art." *Arts 3*: 367–393.

Domingo, Inés. 2005. "Técnica y ejecución de la figura humana en el arte rupestre Levantino. Hacia una visión actualizada del concepto de estilo: Validez y limitaciones." PhD diss., Servicio de Publicaciones de la Universitat de València.

Domingo, Inés. 2011. "The rock art scenes at Injalak Hill: Alternative visual records of Indigenous social organisation and cultural practices." *Australian Archaeology 72*: 15–22.

Domingo, Inés, and Sally K. May. 2008. "La pintura y su simbología en las comunidades de cazarecolectores de la Tierra de Arnhem." In *Mundos Tribales: Una Visión Etnoarqueológica*, edited by Juan Salazar, Inés Domingo, José M. Azkárraga, and Helena Bonet, 78–91. Valencia: Museu de Prehistoria.

Domingo Inés, Sally K. May, and Claire Smith. 2016. "Communicating through rock art: An ethnoarchaeological perspective." In *Signes et communication dans les civilisations de la parole, Actes des congres des sociétés historiques et scientifiques*, edited by Olivier Buchsenschutz, Christian Jeunesse, Claude Mordant, and Denis Vialou, 9–26. Paris: Édition Electronique du CTHS.

Domingo, Inés, Claire Smith, and Sally K. May. 2017. "Etnoarqueologia y arte rupestre: Potencial, perspectivas y ética." *Complutum 28* (2): 285–305.

Domingo, Inés, Sally K. May, and Claire Smith. 2018. "Etnoarqueología y arte rupestre en el siglo XXI: De la analogía directa a la redefinición del método arqueológico." *Kobie 16*: 163–180.

Flood, Josephine. 1997. *Rock Art of the Dreamtime: Images of Ancient Australia*, Sydney: Angus and Robertson.

Frazer, James G. 1922. *The Golden Bough. A Study in Magic and Religion.* New York: Macmillan.

Fritz, Carole, and Gilles Tosello. 2007. "The hidden meanings of forms: Methods of recording palaeolithic parietal art." *Journal of Archaeological Method and Theory 14* (1): 48–80.

González-Ruibal, Alfredo. 2008. "De la etnoarqueología a la arqueología del presente." In *Mundos tribales. Una visión etnoarqueológica*, edited by Juan Salazar, Inés Domingo, José M. Azkárraga and Helena Bonet, 16–27. Valencia: Museu de Prehistòria de la Diputació de València.

Gould, Richard A. 1978. "Beyond analogy in ethnoarchaeology." In *Explorations in Ethnoarchaeology*, edited by Richard A. Gould, 249–293. Albuquerque: University of New Mexico.

Griffiths, Tom. 1996. *Hunters and Collectors.* Cambridge: Cambridge University Press.

Groenen, Marc. 1988. "Les représentations de mains negatives dans les grottes de Gargas et de Tibaran (Hautes-Pyrénées): Approche méthodologique." *Bulletin Société Royale Belge d'Anthropologie et de Préhistoire 99*: 303–310.

Hamilakis, Yannis, and Aris Anagnostopoulos. 2009. "What is archaeological ethnography?" *Public Archaeology: Archaeological Ethnographies 8* (2–3): 65–87.

Hernando, Almudena. 1995. "La etnoarqueología hoy: Una vía eficaz de aproximación al pasado." *Trabajos de Prehistoria 52* (2): 15–30.

Hiscock, Peter. 2008. *Archaeology of Ancient Australia.* New York: Routledge.

Idriess, Ion L. 1963. *Our Living Stone Age*. Syndey: Angus & Roberston.

Layton, Robert. 1992. *Australian Rock Art: A New Synthesis*. Cambridge: Cambridge University Press.

Layton, Robert. 2006. "Habitus and narratives of rock art." In *Talking with the Past. The Ethnography of Rock Art*, edited by J. Keyser, G. Poetschat, and M.W. Taylor, 73–99. Oregon: The Oregon Archaeological Society.

Leroi-Gourhan, André. 1958. "La fonction des signes dans les sanctuaires paléolithique." *Bulletin de la société préhistorique de France 55* (7–8): 307–321.

Leroi-Gourhan, André. 1968. *The Art of Prehistoric Man in Western Europe*. London: Thames and Hudson.

Lewis, Darrel. 1988. *The Rock Paintings of Arnhem Land, Australia: Social, Ecological and Material Culture Change in the Post-Galcial Period*. Oxford: BAR International Series 415.

Lewis, Darrel, and Deborah Rose. 1988. *The Shape of the Dreaming*. Canberra: Aboriginal Studies Press.

Lewis-Williams, David. 1991. "Wrestling with analogy. A methodological dilemma in Upper Palaeolithic art research." *Proceedings of the Prehistoric Society 57* (1): 149–162.

Lewis-Williams, David, and Thomas Dowson. 1988. "The signs of all times: Entoptic phenomena in Upper Palaeolithic art." *Current Anthropology 24*: 201–245.

Macintosh, Neil William George. 1977. "Beswick Creek Cave two decades later: A re-appraisal." In *Form in Indigenous Art*, edited by Peter J. Ucko, 191–197. Canberra: Australian Institute of Aboriginal Studies.

May, Sally K. 2006. "Karrikadjurren: Creating community with an art centre in Indigenous Australia." PhD diss., Australian National University.

May, Sally K. 2008. "Learning art, learning culture: Art, education, and the formation of new artistic identities in Arnhem Land, Australia." In *Archaeologies of Art: Time, Place and Identity*, edited by Inés Domingo, Danae Fiore, and Sally K. May, 171–194. Walnut Creek: Left Coast Press.

May, Sally K. 2009. *Collecting Cultures: Myth, Politics and Collaboration in the 1948 Arnhem Land Expedition*. Lanham: AltaMira Press.

May, Sally K., and Inés Domingo. 2010. "Making sense of scenes." *Rock Art Research 27*: 35–42.

May, Sally K., Inés Domingo, and Paul S.C. Taçon. 2015. "Arte rupestre de contacto: La versión Indígena de los encuentros interculturales en el noroeste de la Tierra de Arnhem (Australia)." In *La vitalidad de las voces Indígenas: Arte rupestre del contacto y en sociedades coloniales*, edited by Fernando Berrojadil, 83–106, México: Instituto de Investigaciones Estéticas de la Universidad Nacional Autónoma de México.

May, Sally K., Paul S.C. Taçon, Daryl Guse, and Meg Travers. 2010. "Paintings history: Indigenous observations and depictions of the 'Other' in Northwestern Arnhem Land, Australia." *Australian Archaeology 70*: 29–37.

May, Sally K., Josie Gumbuwa Maralngurra, Iain G. Johnston, Joakim Goldhahn, Jeffrey Lee, Gabirielle O'Loughlin, Kadeem May, Christine Ngalbarndidj, Murray Garde, and Paul S.C. Taçon. 2019. "'This is my father's painting': A first-hand account of the creation of the most iconic rock art in Kakadu National Park." *Rock Art Research 36* (2): 199–213.

McNiven, Ian J., and Lynette Russell. 2005. *Appropriated Pasts: Indigenous Peoples and the Colonial Culture of Archaeology*. Walnut Creek: AltaMira Press.

Moro Abadía, Oscar, and Manuel R. González Morales. 2005. "L'analogie et la représentation de l'art primitif à la fin du XIXe siècle." *L'Anthropologie 109* (4): 703–721.

Moro Abadía, Oscar, and Manuel R. González Morales. 2013. "Paleolithic art: A cultural history." *Journal of Archaeological Research 21*: 269–306.

Morphy, Howard. 1989. "Introduction." In *Animals Into Art*, edited by Howard Morphy, 1–17. London: Unwin Hyman.

Morphy, Howard. 1991. *Ancestral Connections: Art and an Aboriginal System of Knowledge*. Chicago: The University of Chicago Press.

Morwood, Michael. 2002. *Visions from the Past. The Archaeology of Australian Aboriginal Art*. Sydney: Allen & Unwin.

Mountford, Charles P. 1949. "Exploring Stone Age Arnhem Land." *National Geographic 96* (6): 745–782.

Mountford, Charles P. 1956. *Art, Myth and Symbolism. Records of the American-Australian Scientific Expedition to Arnhem Land*. Melbourne: Melbourne University Press.

Mountford, Charles P. 1963. "Australia's Stone Age men." In *Great Adventures with National Geographic*, 385–392. Washington, DC: National Geographic Society.

Nash, George, and Christoffer Chippindale. 2001. *European Landscapes of Rock Art*. London: Routledge.

Parker, Adrian. 1997. *Images in Ochre: The Art and Craft of the Kunwinjku*. East Roseville: Kangaroo Press.

Pettit, Paul. n.d. "All research projects: Hand stencils in Upper Palaeolithic cave art." Accessed February 1, 2020. www.dur.ac.uk/archaeology/research/projects/all/?mode=project&id=640.

Politis, Gustavo. 2002. "Acerca de la etnoarqueología en América del Sur." *Horizontes Antropológicos 8* (18): 61–91.

Politis, Gustavo. 2015. "Reflections about contemporary ethnoarchaeology." *Pyrenae 46* (1): 41–83.

Ravenscroft, Marion. 1985. "Methods and materials used in Australian Aboriginal art." *AICCM Bulletin 11* (3): 93–109.

Reinach, Salomon. 1903. "L'art et la magie: À propos des peintures et des gravures de l'Âge du Renne." *L'Anthropologie 14*: 257–266.

Reinach, Salomon. 1912. "Art and magic." In *Cults, Myths and Religions*, edited by Salomon Reinach, 124–137. London: David Nutt.

Ripoll, Eduardo. 1986. *Orígenes y significado del arte Paleolítico*. Madrid: Silex ediciones.

Rivero, Olivia. 2016. "Master and apprentice: Evidence for learning in palaeolithic portable art." *Journal of Archaeological Science 75*: 89–100.

Smith, Claire 1994. "Situating style. An ethnoarchaeological study of social and material context in an Australian Aboriginal artistic system." PhD diss., University of New England.

Smith, Claire. 2004. *Country, Kin and Culture: Survival of an Australian Aboriginal Community*. Kent Town: Wakefield Press.

Smith, Claire, Inés Domingo, and Gary Jackson. 2016. "Beswick Creek Cave six decades later: Change and continuity in the rock art of Doria Gudaluk." *Antiquity 90* (354): 1613–1628.

Spencer, Baldwin. 1901. *Guide to the Australian Ethnographic Collection in the National Museum of Victoria*. Melbourne: Albert J. Mullett, Government Printer.

Spencer, Baldwin, and Francis Gillen. 1899. *The Native Tribes of Central Australia*. New York: Macmillan.

Taçon, Paul S.C. 1989 "From the Dreamtime to the present: The changing role of Aboriginal rock paintings in Western Arnhem Land, Australia." *The Canadian Journal of Native Studies IX*(2): 317–339.

Taçon, Paul S.C. 1994 "Socialising landscapes: The long-term implications of signs, symbols and marks on the land." *Archaeology in Oceania 29*: 117–129.

Taçon, Paul. S.C., Matthew Kelleher, Graham King, and Wayne Brennan. 2008. "Eagle's Reach: A focal point for past and present social identity within the northern Blue Mountains World heritage area, New South Wales, Australia." In *Archaeologies of Art: Time, Place and Identity*, edited by Inés Domingo, Danae Fiore, and Sally K. May, 95–214. Walnut Creek: Left Coast Press.

Taylor, Griffith. 1927. *Environment and Race*. Oxford: Oxford University Press.

Taylor, Luke. 1996. *Seeing the Inside: Bark Painting in Western Arnhem Land*. Oxford: Clarendon Press.

Taylor, Luke 2016. "Recent art history in Rock Country: Bark painters inspired by rock paintings." In *Relating to Rock Art in the Contemporary World*, edited by Liam M. Brady and Paul S.C. Taçon, 327–356. Boulder: University Press of Colorado.

Tylor, Edward B. 1865. *Researches Into the Early History of Mankind and Development of Civilization*. London: John Murray.

Tylor, Edward B. 1871. *Primitive Culture: Researches into the Development of Mythology, Philosophy, Religion, Language, Art and Custom*. London: Bradbury, Evans, and Co., printers.

Ucko, Peter, and Andrée Rosenfeld. 1967. *Palaeolithic Cave Art*. London: World University Library.

Van Reybrouck, David. 2012. *From Primitives to Primates. A History of Ethnographic and Primatological Analogies in the Study of Prehistory*. Leiden: Sidestone Press.

Wylie, Alison. 1985. "The reaction against analogy." In *Advances in Archaeological Method and Theory*, Vol. 8, edited by M.B. Schiffer, 63–111. New York: Academic Press.

Part III

Humans, animals, and more-than-human beings

10 "When elephants were people"

Elephant/human images of the
Olifants River, Western Cape,
South Africa

John Parkington and José M. De Prada-Samper[1]

1 Soaqua, elephants, and paintings in the Olifants River Valley

> "Elephants are more numerous among the paintings of the region than elsewhere … which may mean that they were of special symbolic importance to the local Late Stone Age inhabitants."
>
> (Johnson and Maggs 1979)

In December 1660 Jan Danckaert and a small group of soldiers and explorers from the Dutch East India Company (VOC) settlement in Table Bay (Figure 10.1) crossed over from the coastal plains into the middle reaches of a large river (Thom 1952, volume 3, 315), some 170 kilometres north of the Cape. The VOC men reported seeing about 300 elephants there and promptly named the river after them. It is still the Olifants River, but it, or some part of it, was previously known as *Tharakamma* (seemingly a waterway named after local reeds, please see Nienaber and Raper 1980, 719) in the language of the local hunter-gatherers or pastoralists. At about the same time Danckaert's men met a group of 'small people' from whom they bartered honey. The people were those that Danckaert and later explorers, prompted by their (likely not hunter-gatherer) guides, called 'Soaqua' or 'Sonqua' (Jolly 2014) and who came to be known over the next few decades as 'bosjesmans,' later Bushmen (Parkington 1977, 1984). To archaeologists, these small people were persuasively among the last surviving hunter-gatherers of this part of the Cape. Although they disappeared within a century from the written records of travellers and settlers in this Olifants River, and were never well described, they have persisted in the work of archaeologists who have learnt much about their lives and settlement patterns (Parkington and Poggenpoel 1971, 1987). Amongst many other things, we have learned that the hunters and gatherers had for some time painted elephants in the caves and rock shelters either side of the river and beyond: it had been an Elephant River from long before Danckaert's time (Paterson 2007, 2018).

What happened to the Soaqua and the elephants? And more interestingly, what happened to the inter-species relationship they enjoyed, seemingly but enigmatically reflected in human/elephant painted imagery? Within 150 years of

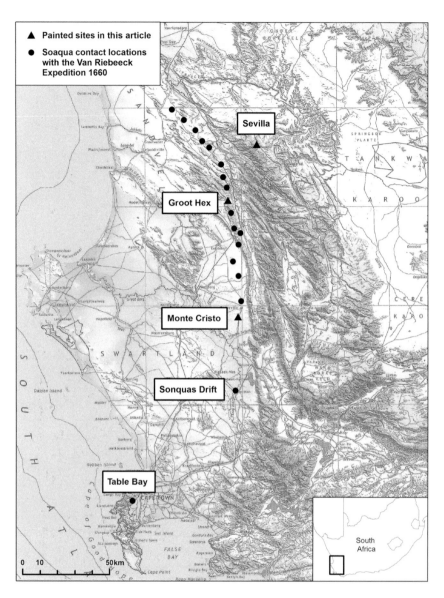

Figure 10.1 The western Cape context of the Olifants River Valley, with elephant/human images and meetings between colonists and Soaqua hunter-gatherers in the 1660s marked.

Source: Map by John Parkington.

Danckaert's meetings, all local elephants had gone and Soaqua descendants had become farm labourers, domestic servants and marginalised rural town dwellers. Soaqua survived genetically but were socially and culturally completely

dispossessed and their lives transformed. Elephants were reflected locally only in place names and, as we report here, in evocative painted imagery. The paintings symbolize the parallel disappearances of subject and artist. If the relationship between people and this iconic animal in pre-Danckaert times is to be reconstructed it needs to be achieved through an appropriately guided examination of these images informed by whatever archaeological, ethnographic, historic, and biological information we can bring to bear. We do this here.

The Soaqua and their ancestors who painted the elephants and other imagery, were members of the KhoeSan (sometimes Khoisan) population of hunters, gatherers, and pastoralists; the Aboriginal, pre-colonial occupants of southern Africa, the local First People (Parkington and Dlamini 2016). Although there may be debate on this, we take the view that the painters of the Olifants River were mostly Soaqua San, that is hunter-gatherers, with a perspective on their place in nature, more especially their relations with other species, appropriate to this life style and world view. It is likely, and indeed demonstrable from comparisons of recorded accounts and material survivals, that there were significant similarities between the worldview, cosmology, and value systems of Soaqua and those of other San groups who survived to be observed and recorded by scholars of the nineteenth and twentieth centuries.

There are many such accounts (see Barnard 1992 for a summary), but prominent among them are those from the Karoo in the mid-nineteenth and the Kalahari in the mid-twentieth centuries. The richness and relevance of the Bleek and Lloyd archive of stories and personal histories from |Xam informants from the mid-nineteenth century make this an obvious source of inspiration (Bleek and Lloyd 1911; Bank 2006). Given her prominence in the recent history of rock art research, we also make use of Megan Biesele's detailed observations from Kalahari Ju|'hoansi folklore and expressive culture in the mid- to late twentieth century (particularly her evocatively titled monograph *Women Like Meat*, Biesele 1993). A third, absolutely critical pillar in our work, comes from the long-held view of Mathias Guenther about what he terms the 'tolerance of ambiguity,' the notion of relational ontology or ontological flux, central to San thinking about their being in the world (Guenther 1989, 1999, 2015). We follow here the thread of recent publications (Dowson 2007; Low 2014; Guenther 2015) on this theme.

We have no Olifants River artists to ask about the meanings of painted images, as useful documentation long post-dated the last 'practising' Soaqua painter. It is also regrettably true that no amount of staring at the painted detail will result in the discovery of meaning, although we, and all other archaeologists, are convinced that this kind of close and sustained scrutiny is an invaluable prerequisite. As in most areas of archaeology, the meaning of painted images is arrived at by complex pattern recognition and hypothesis generation tested through analogies with arguably relevant sources of inspiration, often involving observations from the present and recent past. As we will see these analogies may as well be drawn from animal wildlife studies as from ethnographic accounts. We should note, though, that analogies generated from current, recent or historical descriptions do not in themselves reflect proof of the accuracy of our reconstructions, but

simply identify the most appropriate eyewitness or documented accounts available for our use in re-imagining the past. They point to relevant questions not certified answers.

We do not attempt a full description of all Olifants River elephant paintings here, but rather focus on a few images that conflate human and elephant characteristics. Our intention is to draw attention to these images and to offer an interpretation drawn from references to elephants in recent San ethnographies. It is our view that the significance of elephants to Soaqua artists is not fully captured in the general notion that elephants were powerful symbols of shamanistic practices and imbued with (unspecified) supernatural potency (Maggs and Sealy 1983, 48; Lewis-Williams and Dowson 1989, 138; Deacon 1994, 48). We argue, rather, that painters were intrigued by the specifics of human–elephant similarities, especially in the field of social relations, by the complex communication system employed by these highly sensitive, large mammals and by the human-like dependence of elephants on water through the water cycle. As regular observers of elephant behaviour from close at hand, Soaqua were sufficiently intrigued, we believe, that they incorporated these ideas into their painted compositions. In the context of Soaqua ontology, bolstered by references in a general San ethnography, the elephants they knew were people. It is here that we locate the elephant Soaqua relationship and the meaning of otherwise ambiguous images.

As Mathias Guenther has argued for many years, and as we do here, the key to understanding San beliefs, including those related to painted imagery, surely lies in the relational 'ontological flux' that links San people to other species of animals with whom they share a landscape. He refers to this as '(S)animism' in his paper (2015) on 'ontological flux in San myth, cosmology and belief,' and like him, we include the painted imagery in this cluster. Likewise, in his eloquent text, *Visionary Animal*, Renaud Ego writes (2019, 57):

> there is probably a fluidity specific to animism, one that manifests itself throughout San culture. Some standard dichotomies, for that matter, are of little help in understanding the San: material versus spiritual, real versus supernatural; indeed, humans versus animals, plants and phenomena—all are linked by a network of mutual connections and influences that unite them on another, simultaneously psychic and cosmological level, where they enjoy a deeper, shared identity. This fluidity characterises the San's very mentality, in which the real and the imaginary—the world of things and the world of ideas, the tangible and the potential—live in symbiosis. Storytelling, dancing and painting bring this network of dynamic forces to life, each in its own way.

2 Images: Painted

We begin with a superficially ambiguous image in a small rock shelter, Groot Hex Rivier, in the middle reaches of the Olifants River, a painting we refer to as the line of 'elephant-headed men.' The west-facing shelter offers some morning

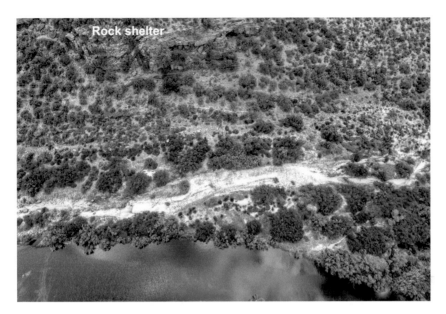

Figure 10.2 Top: The location of Groot Hex Rivier rock shelter, on the banks of the Olifants River. Bottom: A line of "elephanthropes," elephant-headed men from Groot Hex Rivier, Olifants River.

shade but very little protection for domestic use. Perhaps not surprisingly, then, there are no stone artifacts either in the site or on the gentle 30-metre slope down to the river (Figure 10.2). Nor does there appear to be any depositional depth in the shelter that might contain artifacts or foodwaste remains, which probably means this was never a favoured domestic living place. There are three sets of images here: to the left of the overhang are a few feint images that are very hard

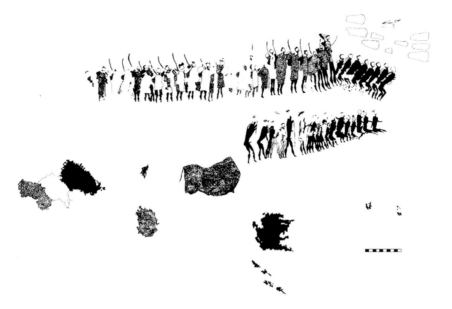

Figure 10.3 Sevilla male figures clothed and armed (above), naked and dancing (below).
This is likely a male initiation event.

to discern; to the right is an extremely interesting composition, also unclear in part, that we have previously interpreted as a male initiation event (Parkington 1989, 2002; Paterson 2018). In the centre of the shallow overhang is a line of figures, painted in red and juxtaposed to a fragmentary cross-hatched motif, all of which seems to form an intentionally composed and self-contained unit (Figure 10.2). There are six figures of different sizes, all facing right, seemingly moving or striding, certainly not 'motionless,' and, as far as preservation permits us to say, all similarly clothed and equipped. The cross-hatched motif dips into the space provided by the smaller figure second from the left, a juxtaposition that, complicated by staining and exfoliation, does not allow a definitive state-ment on its contemporaneity with the figures.

What is striking, and rare in the area, is the fact that despite a human-like striding gait, all six have elephant heads and feet, with easily recognized trunks. They are cloaked and carry bags slung over the shoulder, containing gear that is hard to source among ethnographically recorded San equipment (Figure 10.2). This procession resembles many other lines of figures, where the combination of cloaks, hunting bags and, often but not always, stashed bows and other gear, has prompted us to interpret them as males (Figure 10.3). These lines more often than not face right, include differentiated figures of various sizes but with a common equipment set. Because of equipment similarities and 'common pur-pose,' we do not consider the smaller elephant-headed figures as children (as has Jolly 2002, 88, see also Johnson and Maggs 1979) but rather a reflection of

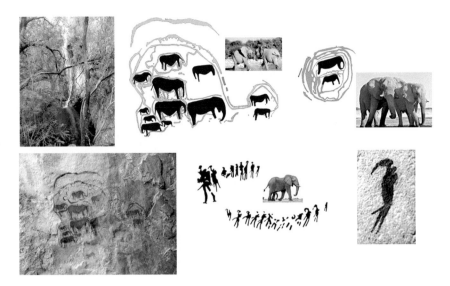

Figure 10.4 Site context, main panel, and elephanthropes from Monte Cristo.

individual bodily variation among individuals of the same status. This is a line of, perhaps, specific individuals, painted using a widespread conventionalised compositional choice.

The resemblance of the 'elephant-headed' line to these other lines of men refers to three levels of linkage: the biological, behavioural, and ontological. The posture, gait, and carriage are human but the morphology of heads and feet are clearly elephant: a reference to two distinct biological physiologies. The figures wear clothing and carry equipment that implies human roles and behavioural activities not conceivable for male elephants. Most significantly, though, the compositional implications of a set of elephant-headed, arguably male, armed and clothed 'people' challenge the ontological separation of the categories elephant and human. We argue the figures are ambiguous on all three levels and reflect a way of thinking by the artist that deliberately and richly conflates the ontological status of two species. They are not humans because humans do not have trunks, but they are not elephants because elephants do not wear cloaks. The term 'therianthrope' has been coined for such figures (Lewis-Williams 1981), and Paterson (2018) has suggested 'elephanthrope' in this case.

A second site, separated from the Olifants River by a rocky, mountain ridge of modest elevation, and some 40 kilometres south of Groot Hex Rivier, contains several figures that also seem to conflate human and elephant characteristics. This is the uniquely detailed and informative Monte Cristo site, located within metres of a waterfall-fed, shaded rock pool in a narrow ravine in the local sandstone bedrock (Figure 10.4, see also Parkington and Paterson 2017; Paterson 2007, 2018). The paintings here are placed on a sloping rock surface in a narrow,

overhanging cleft next to the pool and waterfall with virtually no opportunity for domestic use (Figure 10.4). There are no artifacts associated and absolutely no signs of occupation debris in the vicinity. There are four closely juxtaposed panels on the surface, depicting almost exclusively human and elephant figures and presenting an appearance of connectivity and coherent purpose.

The majority of the figures, all of which are rendered in red, are elephants of different sizes that we have previously interpreted as domestic, matriarchal groups depicted in social arrangements that closely resemble those described in the wildlife biological literature (Paterson 2007; Parkington and Paterson 2017). These are some of the 'elephants in boxes' (Maggs and Sealy 1983), so termed because of the surrounding and connecting red painted lines (Figure 10.4), some of them undulating, that we have argued to depict the 'sound lines' of elephant communication (Paterson 2007; Parkington and Paterson 2017). In addition there is a pair of elephants arguably a male and female 'in consort' (Figure 10.4). Regardless of the persuasiveness of this reading, there can be no doubt of the level of observational acuity, retentive memory, and drawing skills of the artists responsible for these images. The imagery is witness to the conceptual boldness of alert and highly observant people who lived among elephants all of their lives, and felt a close conceptual bond with them.

Of relevance to the present discussion is a series of seemingly human, or part-human, figures, rather crudely drawn by comparison with the Groot Hex Rivier figures, and not as well preserved in some cases (see Paterson 2018). A few, perhaps three, of these are located within the 'sound lines' (Figure 10.4), most are not and the conflation of human and elephant features is much clearer in some than in others, whilst some may be 'simply' human figures. All are painted in a red pigment and in juxtaposed arrangements that suggest a rough con-temporaneity and conceptual affinity with the elephants, although this may be disputed. Apart from a single bovid, there are no other painted images at the site. We take this to point to an intentional association of waterfall, pool, elephant, and painter.

The clearest image, highest up the sloping surface and quite isolated, is a single, rather slender figure, apparently naked, male, and facing left (Figure 10.4). It is human in pose, seemingly carrying a bag with protruding equipment, but has a clear elephant head and trunk. Despite this latter feature, the image bears some resemblance to other local, more obviously human male figures that carry equipment, even wield bows, whilst naked (Figure 10.5). The conceptual association of maleness, nakedness, and weapon-bearing transcends the species boundary implied by, but seemingly confounded by, the conflated, physical features of humans and elephants. Two of the three figures painted within the encircling lines, possibly all three, although not as clearly, are also elephant-headed, apparently naked, and appear to carry equipment (see Paterson 2018). Most interesting of all, are lines of figures, some but not all naked, most carrying hunting bags with equipment and many of them elephant-headed (Figure 10.4). These processions, although not as clear as they once were, mirror a common theme in local rock art, alluded to earlier, of

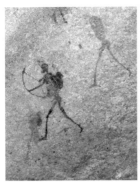 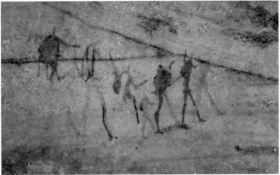

Figure 10.5 Male figures from Sevilla, naked, equipped, and armed.

armed and clearly (in some cases, less so in others) male figures that are hunters but who are not depicted hunting. As we have noted elsewhere (Parkington 2002; Parkington and Dlamini 2016) in relation to these images 'it is not hunting, but being a hunter that matters.' The large, dangling male appendages in some of these images (Figure 10.4), located in an elephant-dominated painted shelter, recall quite unambiguously the photographs of male elephants in musth (Figure 10.4, please see Paterson 2018).

We suggest here that the ambiguity implied in these conflations of humans, perhaps all male in this case, and elephants, penetrates deeply from the physical and physiological, though the behavioural into the conceptual roles of the depicted figures. In other words, both clearly human and more ambiguously not human groups are set in the same ontological space that defines males and their appropriate behaviours, expectations, and depictions. The ambiguity, to an outsider but obviously not to the painter, is comprehensive, far from superficial. Whether naked or clothed, these ambiguous figures are wholly consistent with local painting norms as expressed in human males. These are beings but elephant beings rather than human beings, and in that sense, perhaps, different 'people.'

Elsewhere in and around the Olifants River Valley, we have recorded hundreds of elephants painted in rock shelters (see Paterson 2018), but without explicit human features. What has struck us forcibly about these depictions is the extent to which aspects of elephant social organization have been deliberately incorporated in the compositions. Thus, the structural components recognized by wildlife biologists as organizing elephant social and life history, such as mother and calf unit, domestic herd, all male bachelor group, solitary adult male, and consort pair (Wittemeyer and Getz 2007: 673; Moss et al. 2011, 3), are detectable in the paintings. The Soaqua artists were clearly painting elephant societies as they saw them. Interestingly, elephant paintings are alike without being identical, each is located in a specific location, nearly always near to water.

3 Images: Narrated

> "Therefore their parts resemble humans, for they feel that they are people"
> (Guenther 2015, 278, quoting Lucy Lloyd's
> |Xam house guest, teacher, and
> informant Dia!kwain)

We have a wealth of stories from a wide range of San contexts across southern Africa that also refer to animal human relationships, some involving elephants but none of them, unfortunately, from Soaqua informants. The closest in time and space to the Olifants River images are the |Xam kukummi (tales, stories; singular kum) told by former prisoners, all at one time or another informants, teachers, and house guests of Wilhelm Bleek and Lucy Lloyd in Cape Town in the later part of the nineteenth century (Bleek and Lloyd 1911; Bleek 1924; Hewitt 1986; Guenther 1989; Lewis-Williams 2000; Hollmann 2004; Bank 2006; de Prada-Samper 2011). The |Xam were from a part of the central Karoo about 300 km northeast of the Olifants River Soaqua, arguably sharing a common expressive culture.

The |Xam, as do many other traditional peoples all over the world, believed that before them other people had inhabited the earth. This population was similar to them in many regards, yet very different in some crucial aspects. As also happens in the mythologies of other peoples, the |Xam often identified these primeval beings with the animals that shared the landscape with them. To a lesser degree, they also believed that certain heavenly bodies and natural phenomena had been people in the mythical past.

Since Bleek and Lloyd learned the nuances and fine details of the tradition they were recording as they went along, it is not surprising that it took them some time to realize the pivotal importance that this early 'humanity' had in |Xam thought and narrative. Around September 23, 1871, about seven months after he began dictating narratives to Bleek and Lloyd, ||Kabbo, one of the principal |Xam storytellers, referred to a character in the eland creation myth as "firste Busman" (sic), "first Bushman" (L.II.4, 509'),[2] with "first" probably meaning here "early," but it does not seem that Lloyd, who was the one recording the story, tried at that time to find out more about this. On January 6, 1873, when ||Kabbo began to dictate the long narrative about a man who brings home a lion cub insisting it is a dog, Lloyd interpreted the phrase !xwe-||na-s'o !k'e as being the name of the man, which she translated as "The first Busman" (L.II.26, 2320). Eleven days after this, on January 17, ||Kabbo referred to the girl who created the Milky Way as being "one of the !xwe-||na-s'o !k'e" (L.II.28, 2505'). He also gave a crucial bit of information about these beings which Lloyd paraphrased: "These !xwe-||na-s'o !k'e are said to have been stupid, & not to have understood things well" (Bleek and Lloyd 1911, 73).

It was only on September 2 of that year that Lloyd grasped the concept, and asked ||Kabbo to elaborate on it. His explanation reads, in part:

> The First Bushmen [*!xwe-||na-s'o !kui*] were those who first inhabited the earth …. When the first Bushmen, had passed away, the Flat Bushmen

[Swa-ka-!ke, the term he used for his own people] inhabited their ground. Therefore, the Flat Bushmen taught their children about the stories of the First Bushmen.

(Bleek and Lloyd 1911, 54–57; L.II.34, 3150'-3151')

In Dorothea Bleek's *Bushman Dictionary*, the literal meaning of *!xwe-||na-s²o !kui* is given as "first-there-sitting people" (Bleek 1956, 504). It is clear, that in the "sitting" (*s²o*) part, the verb has the "existential" sense of "staying." So a less literal, yet equally accurate, rendering would be "the first people who stood there." that is, "the first dwellers." Bleek and Lloyd variously rendered it as "the first Bushmen," "the early people," or, more commonly, "the early race." From now on, we will use the |Xam phrase or else call them 'first inhabitants,' which is also a plausible translation.[3]

Even after this breakthrough, it seems that Lloyd still felt unsure about what the *!xwe-||na-s²o !kui* actually were. The records of her work with |Haŋ≠kass'o, her last full-time |Xam teacher, in 1878–1879, show that, whenever an actor with an animal name appeared in a narrative, Lloyd systematically asked the storyteller about its nature. Hence the frequent explanatory gloss stating that a given character "was formerly a person," or some other similar formulation (see, for example, L.VIII.23: 8041,' Bleek and Lloyd 1911, 154–155, 214–215). That grasping the concept was crucial for Lloyd is shown in a statement by |Haŋ≠kass'o dictated on July 13, 1879, towards the end of his stay in Mowbray, which appears to be the answer to a direct question about this point: *Tchweŋ ta ku haξ óä: e !k²e ||khetən-||khetən (||xʌmki)*, that is, "All things (that is living creatures) were formerly people, the beasts of prey (also)" (L.VIII.30, 8629a,' the parentheses are Lloyd's).[4]

The lifestyle of these First Inhabitants is identical to that of the |Xam who told the stories to Bleek and Lloyd: they are nomadic hunter-gatherers who live off the land, organize in small bands, etc. Yet they are not humans with animal names, their names revealing an essential aspect of their nature. Nor can they be visualized necessarily as a mixture of animal and human, although some stories may suggest that. In some cases their animal nature is conveyed by physical traits, while in others it is their behaviour that reveals that nature. This anomalous behaviour is key to understand the First Inhabitants. They were foolish, as ||Kabbo said, and this foolishness often was revealed by an appalling lack of ethics. As Guenther has put it, these people were "wracked by the problems of food, greed, marriage and in-law problems and unable to control them" (Guenther 1989, 87). Their main flaw, Guenther points out, was that "their social forms and cultural patterns were inchoate" (Guenther 1989, 86). We will never know how the nineteenth century |Xam visualized these First Inhabitants when telling the stories, but perhaps one way they could have explained their nature to an outsider would have been: "When encountering one you may think it was a person like us, but if you looked closer, you would see the animal (s)he really was."

The most instructive figure in these stories is |Kaggen, usually translated as 'the Mantis,' but the inferences we draw are widespread, even ubiquitous across

the animal realm. | Kaggen is the key actor in a cast of first inhabitants who lived in times quite different, in some ways but not in others, from the later one occupied by |Xam hunters and gatherers. His wife was the Dassie, their adopted daughter the Porcupine, his grandson one or other Mongoose and his sister the Blue Crane (Bleek 1924). Elephant, although present in the stories, is not a direct relative. In these stories about unreal times, carnivores court herbivores and ambiguity abounds. The Mantis, for example, creates an eland in one story that raises serious doubt as to whether he *is* a mantis, is *only* a mantis or is simply *called* mantis? He certainly behaves like a hunter-gatherer male, going out of camp hunting, wearing leather sandal and cap, shouldering bags and wielding bow and arrow. He collects honey in his bag and is expected to bring it back home to his wife, living out the widespread San notion of honey as sexual metaphor. As a 'cannot-tell,' he is and is not a mantis, is and is not a person.

More relevant, perhaps, to our elephant theme is the story of '!Gwa!nuntu, the child and the elephants' (we have used a transcription by José de Prada-Samper), a kum (story) told to /Haŋ≠kass'o by his mother and retold by him to Lucy Lloyd in February and March 1878 (L.VIII.4: 6334–6413; L.VIII.5: 6414–6455). Briefly, !Gwa!nuntu, one of the first inhabitants, is sleeping in a hole from which he is busy digging honey, and loses his granddaughter, whom he has left above ground, to some passing elephants. One of the female elephants takes Tauho, the grandchild, replaces her with one of her own daughters and heads off back to her own house. After much repetitive interaction between !Gwa!nuntu and the elephant child, he realizes the exchange of girls, not because of any lack of physical resemblance or otherwise, but because the little elephant girl responds strangely to his question "art thou not eating as I am eating?" Whereas his grandchild had answered "I am eating as my grandfather is eating" (L.VIII.5: 6334), the little elephant child answered "rrrr! We are not used to eat these things" (L.VIII.5: 6339).

!Gwa!nuntu follows the elephant footprints back to the houses of the elephants and after some magical events, rescues her and returns her to her mother, his daughter. These magical events, the telling of the kum on another occasion with |Kaggen as protagonist (see Bleek 1924, 41–44), and a speculative interpretation of his name, may mean that !Gwa!nuntu is, in fact, a pseudonym of the Mantis. Of course, a rich story such as this opens up lots of avenues of discussion and thinking about |Xam expressive culture, the one we pursue here being initiated by an explanatory |Xam footnote in the kum translated by Lucy Lloyd as "when the elephants were people" (L.VIII.5: 6339). The story only works from a perspective in which !Gwa!nuntu, a person, perhaps Mantis, certainly a very similar trickster-figure, shares values and behaviours with 'the elephants,' who in some sense are competitors. The elephant child is not recognized from her appearance but by details of her language and eating habits. The elephants operate on this magical landscape just as !Gwa!nuntu does, and the two girl children are as coveted and vulnerable as one another.

KhoeSan peoples in general cast elephants in their folklore as aggressive outsiders and undesirable in-laws. In a Nama story recorded in southern

Namibia in the mid-nineteenth century (Bleek 1864, 61–64), a human girl is married to Elephant and lives with him and his blind mother. Her brothers are so afraid of their in-laws that she has to hide them when they come to visit. She decides to go away with the brothers and is followed by her husband. They escape by entering a rock that opens for the fugitives and shelters them. When her husband tries to do the same, the rock closes on him and does not open again, thus killing him. It is relevant to say that in the version of this story told by the Herero, the Elephants are replaced by the Damara (Beiderbecke 1880, 76–84), implying again rival groups.

The elephants are also portrayed as selfish people prone to monopolize water. Since this resource tends to be scarce in most of the areas where the KhoeSan live, this kind of behaviour characterizes elephants as dangerously unsocial beings. For example, in a Ju|'hoan story recorded by Megan Biesele (2009, 11–16), Elephant is the husband of Beautiful Aardvark Girl, whose brothers, in turn, are the Swifts. Elephant, we are told, was the first to find water, but he hid it from others and drank it alone. His wife finds out and tells her brothers, who eventually locate the waterhole and kill there their brother-in-law. They later become the swifts, who bring water.

The story of the Elephant Girl, cruelly slaughtered by her husband and in-laws, who considered she was "meat," is very widespread in the Kalahari. It presents elephants in a different light, showing that these creatures can have multiple meanings for the tellers of the narratives (see the extended discussion of the Ju|'hoansi form of this narrative in Biesele 1993, 139–170). The kum of !Gwa!nuntu certainly fits this pattern as in it elephants are indeed aggressive outsiders bent on kidnapping the children of other groups and use their physical superiority to intimidate them.

In some ways, these narrative images are remarkably reminiscent of the visual images of the rock art of the Olifants River Valley, although they differ in one key respect. The elephants in |Haŋ≠kass'o's story are not described as 'elephant-headed' but as elephants. They are elephants who at the time were 'people,' not hybrid elephant-humans, requiring us to investigate what 'when elephants were people' meant to |Haŋ≠kass'o and Lucy Lloyd (these likely not the same?). When and how did elephants stop being people? These complex questions are partly answered in a long and apparently, but necessarily, repetitive story of the Ant-eater and the Lynx, or the Anteater's "Laws" (Hewitt 1986, 116–120).

"The story that gives rise to the Anteaters "laws" was collected in four versions—two from ||Kabbo and one each from !Kweiten ta ||ken and |Haŋ≠kass'o" (Hewitt 1986, 116), in Mowbray, Cape Town (Bank 2006). Hewitt's summary of the llKabbo and |Haŋ≠kass'o versions is worth giving in full.

> The Anteater, a spinster, called out to a group of Springbok mothers who were passing by with their children. From each she demanded to know the sex of the child, and all replied that their children were male. One mother, however, admitted that her child was a girl, and the Anteater, by offering

food and appearing friendly, soon tricked the mother into handing her the child. The Anteater then quickly disappeared into her hole with the child, and called out to the distraught mother to go away. The Anteater kept the child to live with her, and in time the girl reached menarche. The Lynx, intending to marry the young Springbok, crept into the hole while the Anteater was out collecting food, and told her that the Anteater was not her real mother and that she had no need to stay with her. With the girl's consent, he carried her off, but the Partridge flew and told the Anteater of the abduction.

The Anteater followed the escaping couple by burrowing underground after them. The Lynx, seeing the earth bulging and trembling behind them, set a trap for the Anteater with his bowstring. The Anteater was caught in the string but called out denouncing the Lynx and saying that he should marry a she-Lynx, and eat Springbok as food. The Lynx also denounced the Anteater and told her to become a real Anteater and return to her hole. The Lynx went to the girl's parents and told them what the Anteater had said. The Springboks asked what they should do and the Lynx advised them that they should eat only bushes in future. "We beasts of prey must kill you and eat your flesh" said the Lynx, and the Springbok agreed. The Lynx then called the other animals together and they listened to his account of the Anteater's command. All of the animals then agreed to eat the foods appropriate to them and to marry their own kind. The Anteater then articulated the new order at great length. From that day on the animals truly became the animals they are today.

This wonderful tale, albeit rendered in Hewitt's own words, embodies all the San, in this case |Xam, concerns that find their way into their mythological worldview: the worry about losing a child, especially a girl-child to another group; the issue of childlessness; the significance of menarche in the lives of group members; the value of a carnivore–herbivore metaphor for describing male–female relations; the importance of distinguishing 'whom you marry from what you eat'; the dangers and possible consequences of conflict in small groups; the key differences between the way the world was (old order) and the way it is (new order); and critically, the value of animal actors in voicing significant truths. After the promulgation of the 'laws' elephants were elephants, the losses being located in deeply cultural spheres such as language, sex, and food choices. When the girl elephant said "rrrr! We are not used to eat these things," she was articulating this upcoming transformation.

4 Images: Ethnographic

"Metaphor, in other words, has a multiplier effect on experience"

(Biesele 1993, 201)

One difference between the |Xam stories and the ethnographic accounts of the following century is the explicit and direct comments on human animal relations made by Kalahari San groups, compared with the implicit relationships of the kukummi. In a section on understanding Ju|'hoan folktales, Megan Biesele noted that:

> Every one of the folk concepts is based in some way on the power of animals. Animals are used as metaphorical operators to mediate, within the bounds of these concepts, away from undesirable states and toward desired ones of coolness, maturity, individual and social well-being, safety and hunting and gathering success.
>
> (Biesele 1993, 88)

And

> But what might a Ju|'hoan need animal power for, beyond protein nourishment? There are several realms of life in which Ju|'hoansi believe human beings cannot act all by themselves. Things like curing the sick by calling on supernatural sources of power, travelling to another world to plead for those dying, bringing game into range, changing the weather, fending off attacks by lions—all seem to the Ju|'hoansi to demand a source of power which is beyond ordinary human grasp. Accordingly, they seek ways of transcending human limitations, mediators between men and the forces of the atmosphere, metaphors with the strength to bridge worlds. Animals, because they are visible, visibly powerful, and near to hand, are a good choice for these purposes.
>
> (1993, 89)

Ju|'hoansi clearly recognized the kinds of help each animal species could offer, behavioural habits and capacities that humans would do well to emulate or, in some instances, avoid. But, as Biesele recounts, such ideas and such emulations are far from superficial, perhaps seemingly quaint, beliefs, as they have clear adaptive value.

> Expressive forms both codify and condense meaning. Condensation is accomplished partly by redundancy of reference, partly by the widely allusive interconnections among the items and attributes chosen to bear significance in an expressive system. Condensation produces economy: if experience gained in one context can be used, through metaphorical connections, in other contexts, a kind of mental efficiency is promoted. Such condensation is adaptive because it allows a smaller amount of experience to have a larger experiential impact. Metaphor, in other words, has a multiplier effect on experience.
>
> (Biesele 1993, 201)

What then could elephants offer to Ju|'hoansi, or Soaqua, hunter-gatherer groups? Megan Biesele's investigation of Kalahari Ju|'hoansi attitudes to elephants and particularly elephant meat are especially helpful (Biesele 1993) in establishing likely elephant significance and offer a potential viewing of elephants by Soaqua hunters and gatherers of the Olifants River. Quoting her informants, she notes that: "When it's dead, an elephant smells bad, like a dead person" (Biesele 1993, 149). Of elephant meat "You don't eat it because it's like a person" (Biesele 1993, 150). Elephants resemble people because "the female has two breasts and they are on her chest like a woman's. When she's young they stick out and when she gets old they fall. Also, her crotch is like a woman's with long labia" (Biesele 1993, 150). Of males "they have an arse like a person's arse" (Biesele 1993, 150). "When they run, elephants really get into the swing of it and begin to dance, just like people" (Biesele 1993, 150). There seems little doubt that, in the Kalahari at least, elephants reminded humans of themselves.

This human-like quality of elephant lives and behaviours would not be surprising to people in another context who have spent time observing and describing elephant behaviour, most notably biologists such as Cynthia Moss (1988), Karen McComb (McComb et al. 2011), Gay Bradshaw (2004; Bradshaw et al. 2005), Katy Payne (1998), Lucy Bates (Bates et al. 2008), and Joyce Poole, Harvey Croze, and Phyllis Lee (Poole et al. 2011). These scientists, with decades of near-continuous monitoring of elephant groups, seem to us to be good models for the painters of elephants in the Olifants River and surrounds. Without wishing to underestimate any differences in intent or intellectual context, our position is that Soaqua painters were as well, if not better, acquainted with elephants as the biologists are. When trying to discover the level of !Kung knowledge of animal behaviour Blurton Jones and Konner report that they "appear to know a good deal more about many subjects than do the scientists" (1976, 328).

In addition, published wildlife papers and books present detailed accounts of the physiology, life histories, behavioural ecology, and communication systems of elephant societies, on which we wish to draw. Even a cursory glance at this literature will convince the reader that these accounts are effectively anthropological studies applied to a species other than humans. In these 'elephanthographies,' elephant individuals are given human names (Teresia, Tallulah, Tania, Tolstoy), their kin relations are established over several generations and their life histories recorded, in many cases from birth to death (Moss 1988; Moss et al. 2011). In part, this 'anthropocentric' approach was based on the unmistakable similarity of elephant and human intellectual, social, ecological, and demographic characteristics, a point underlined and emphasized many times in the wildlife and more popular literature (Bradshaw 2004; Siebert 2006). Kinship is self-evidently the key to understanding interindividual behaviours across generations of elephants and successful social cohesion is a manifest outcome of these relationships. As a 'metaphorical operator' (Biesele 1993, 88), the elephant must surely have been seen as ideal to

mediate toward the desirable state of social coherence. On the upside elephants are communicative, socially coherent experts on water management, on the downside they are large and occasional bullies.

5 Ontological flux in image making

The therianthropic, elephant-headed, human-bodied images of the Olifants River rock painting sites of Groot Hex Rivier and Monte Cristo encourage us to enquire about the conceptual meaning of these conflations in the minds of the Soaqua painters. Significantly, of course, the demands of physical reproduction in image form mean that any conceptual conflation needs to be given static, material expression, wherein the intangible ambiguity of ontological flux is a more difficult objective. The 'elephant' and 'people,' not to mention 'male,' 'cloaked,' 'processional,' 'right-facing,' and perhaps more, components need to be visible to the viewer and 'elephant-headed men' is one solution: only then can the conceptual implications be read by contemporary viewers. For outsiders it is far more difficult.

As Guenther (2015, 278) explains, ontological flux manifests in myth, ritual, and daily life. Indeed, it permeates San thought so deeply that it must have made conversations between Lucy Lloyd and |Haŋ≠kass'o very fraught and prone to misperception. Flux may result in any of the following: a hunter retelling the hunt by mimicking his prey; a hunter identifying closely with his prey whilst in pursuit; women 'acting' the roles of adult eland cows whilst welcoming the new maiden into the herd; a ritual specialist feeling oneness with his animal helper whilst in trance; elephants striding across the first order landscape 'when they were people.' Is the ambiguity drawn from a sympathy bond, a temporary transformation or mythical (un)reality? Can we hope to distinguish these contexts in painted or engraved imagery? Should we try?

We are in agreement with Anne Solomon (1997, 9) that human animal conflations (therianthropes) should not give free rein to one particular hypothesis at the expense of others. In some circumstances, the context and content of the image may help identify the more precise conceptual meaning intended. As Pippa Skotnes (1994) has argued, rock art sites need to be considered as specific compositions in specific places, historically and spatially located, rather than mere representatives of a generalized notion of supernatural potency and its relationship to spiritual practitioners. In the case of the six striding elephant-headed figures from Groot Hex Rivier, for example, we see little or no evidence of a dance occasion, clear reference to group behaviour and many details that reproduce the configuration of otherwise clearly human, male, clothed, and armed figures from local rock paintings. Under these circumstances we are inclined to read these as first order elephant 'people' and, thus, 'cannot-tells.' The cross-hatched motif may encourage others to posit a trance occasion.

At Monte Cristo, the contexts are more mixed, with some elephant-headed male figures within the confines of a clearly matriarchal domestic elephant herd,

others incorporated into a processional line that may include elephant-like as well as 'normal' human figures, seemingly all male (Paterson 2018). Here too, though, we argue that the references and associations point as much toward the parallel, seemingly rival, possibly affinally related, elephant and human societies of the first-order landscape than to trance-related or trance-induced visions. Communication, represented visually by the 'sound lines,' is a prominent feature of the image sets. In both Groot Hex Rivier and Monte Cristo the canvases seem to have been chosen because of their location to water rather than any obvious domestic potential and appear to refer to deeply embedded notions of elephants, water, and social movements.

The explanation 'when the elephants were people' footnoted by |Haŋ≠kass'o through Lloyd to explain the notion of elephants behaving as hunter-gatherers might be expected to do, does not mean that the elephants looked like humans, nor that they were 'elephant-headed,' but that they operated as human beings (people) did, whilst still being elephants. The fact that human 'maleness' and its associated trappings were literally transferred to partly elephant-like figures implies that the conflation ran extremely deep. These were not humans who could become elephants, but elephant people in the relational ontological sense of imperfect human beings with animal traits.

We suggest that the Ju/'hoansi folktales and |Xam kukummi help reveal one potential strand in the Soaqua elephant-human special relationship in presenting the former as neighbours, competitors, rivals, or inlaws. Whilst ontologically 'people,' the elephants remained physically imposing and occasionally moody competitors for the water sources on the shared landscape of the Olifants River Valley. "The elephant was the one who first found water. He hid it from people and drank it alone" (Biesele 2009, 11). Low (2014, 167) notes that "despite elephants being said to be 'like humans,' many Ju|'hoansi would be very happy to see elephants killed because they represent such a daily threat to their lives." Although we presume that the ancient relationships between Soaqua and elephants were less prone to trauma than recent human elephant interactions in zoos and reserves (Bradshaw 2004; Bradshaw et al. 2005; Siebert 2006), we cannot ignore the sheer bulk and looming menace of these very large mega-herbivores.

Soaqua may well have tinged their admiration of elephants, in the sense of 'animal operators' used by Megan Biesele, with a strong dose of wariness and caution. These were, after all people who could steal your daughter if you looked away.

Notes

1 John Parkington expresses his intellectual debt to earlier Western Cape rock art re-corders especially Hyme Rabinowitz, Percy Sieff, 'Ginger' Townley Johnson, Tim Maggs, Royden Yates and Tony Manhire. We are extremely grateful to Andrew Paterson and Bryn Tapper for their help with illustrations.
2 The reference "L.II.4, 509'" refers to the manuscript version of the text in the Bleek and Lloyd notebooks, kept in the Jagger Library of the University of Cape Town.

Most of the notebooks are divided between those preceded by B (for Bleek) and those preceded by an L (Lloyd). The roman numeral that follows the L notebooks is the code number for each informant, "II" being ||kabbo, "V" Dia!kwain, etc. An apostrophe following the number indicates that the page in question is in the left-hand side of the notebook. Scans of the full set of notebooks are available at http://lloydbleekcollection.cs.uct.ac.za/index.htm. In this website the notebooks derived from Bleek's work are preceded by WB, those of Lloyd by LL.

3 The phrase occurs throughout the records in variety of spellings; in all the quotations in this chapter we use a slightly simplified form of the one employed by Dorothea Bleek in the entry for *!xwe* in her *Bushman Dictionary* as quoted in note 2.

4 Lloyd's difficulties in grasping the concept can be better understood if we consider that it is utterly alien to European folklore, even if the latter includes many stories featuring animals that talk and act like humans. In the other southern African narratives Lloyd was familiar with, like those of the Bantu-speaking peoples, the characters with animal names resemble more those in Aesop's fables and European folktales than the actors in the stories told by ||Kabbo and the others. This applies also to the Nama stories published by Bleek in 1864 (in a book which, significantly, he titled *Reynard the Fox in South Africa*), although, on close examination, the animal-characters of those narratives resemble more those of the |Xam stories than the similar ones of the Zulu, Xhosa, and other Bantu-speakers.

References cited

Bank, Andrew. 2006. *Bushmen in a Victorian World: The Remarkable Story of the Bleek-Lloyd Collection of Bushman Folklore*. Cape Town: Double Storey.

Barnard, Alan. 1992. *Hunters and Herders: A Comparative Ethnology of the Khoisan Peoples*. Cambridge: Cambridge University Press.

Bates, Lucy. A., Katito N. Sayialel, Norah W. Njiraini, Joyce H. Poole, Cynthia J. Moss, and Richard W. Byrne. 2008. "African elephants have expectations about the locations of out-of-sight family members." *Biology Letters 4*: 34–36.

Beiderbecke, H. 1880. "The Fleeing Girls and the Rock, a Herero legend." *Folk-Lore Journal 2*: 76–84.

Biesele, Megan. 1993. *Women Like Meat: The Folklore and Foraging Ideology of the Kalahari Ju|'hoan*. Johannesburg: Wits University Press.

Biesele, Megan. 2009. *Ju|'hoan Folktales: Transcriptions and English Translations*. Victoria: Trafford Publishing.

Bleek, Dorothea F. 1924. *The Mantis and His Friends: Bushman Folklore*. Cape Town: T. Maskew Miller.

Bleek, Dorothea. 1956. *A Bushman Dictionary*. New Haven: American Oriental Society.

Bleek, Wilhelm Heinrich Immanuel. 1864. *Reynard the Fox in South Africa; or Hottentot Fables and Tales*. London: Trubner and Co.

Bleek, Wilhelm, Heinrich Immanuel, and Lucy C. Lloyd. 1911. *Specimens of Bushman Folklore*. London: George Allen.

Blurton Jones, N., and M.J. Konner. 1976. "Kung knowledge of animal behaviour, or the proper study of mankind in animals." In *Kalahari Hunter-Gatherers: Studies of the !Kung San and Their Neighbours*, edited by Richard B. Lee and Irven DeVore, 325–348. Cambridge: Harvard University Press.

Bradshaw, Isabel Gay A. 2004. "Not by bread alone: Symbolic loss, trauma and recovery in elephant communities." *Society and Animals 12* (2): 143–158.

Bradshaw, Gay A., Allan N. Schore, Janine L. Brown, Joyce H. Poole, and Cynthia J. Moss. 2005. "Elephant breakdown." *Nature 433*: 807.

Deacon, Janette. 1994. *Some Views on Rock Paintings in the Cederberg*. Cape Town. National Monuments Council.

De Prada-Samper, J.M. 2011. *La niña que creó las estrellas: Relatos orales de los bosquimanos |xam*. Madrid: Lengua de Trapo.

Dowson, Thomas A. 2007. "Debating shamanism in southern African rock art: Time to move on." *South African Archaeological Bulletin 62* (183): 49–61.

Ego, Renaud 2019. *Visionary Animal: Rock Art from Southern Africa*. Johannesburg: Wits University Press.

Guenther, Mathias Georg. 1989. *Bushman Folktales: Oral Traditions of the Nharo of Botswana and the /Xam of the Cape*. Stuttgart: Franz Steiner Verlag.

Guenther, Mathias Georg. 1999. *Tricksters and Trancers: Bushman Religion and Society*. Bloomington: Indiana University Press.

Guenther, Mathias Georg. 2015. "'Therefore their parts resemble humans, for they feel that they are people': Ontological flux in San myth, cosmology and belief." *Hunter-Gatherer Research 1* (3): 277–315.

Hewitt, Roger L. 1986. *Structure, Meaning and Ritual in the Narratives of the Southern San. Quellen zur Khoisan-Forschung 2*. Hamburg: Helmut Buske Verlag.

Hollmann, Jeremy C. 2004. *Customs and Beliefs of the |Xam Bushmen*. Johannesburg: Wits University Press.

Johnson, R. Townley, and Tim Maggs. 1979. *Major Rock Paintings of South Africa*. Amsterdam. Meulenhoff.

Jolly, Pieter. 2002. "Therianthropes in San rock art." *South African Archaeological Bulletin 57*: 85–103.

Jolly, Pieter. 2014. *Sonquasynthesis*. Cape Town: Pieter Jolly.

Lewis-Williams, J. David. 1981. *Believing and Seeing: Symbolic Meanings in Southern San Rock Paintings*. London: Academic Press.

Lewis-Williams, J. David. 1986. "Cognitive and optical illusions in San rock art research." *Current Anthropology 27* (2): 171–178.

Lewis-Williams, J. David. 1988. "'People of the Eland': An archaeolinguistic crux." In *Hunter-Gatherers 2: Property, Power and Ideology*, edited by Tim Ingold, David Riches, and James Woodburn, 203–212. New York: Berg.

Lewis-Williams, J. David (ed). 2000. *Stories that Float from Afar: Ancestral Folklore of the San of Southern Africa*. Cape Town: David Philip.

Lewis-Williams, J. David, and Thomas A. Dowson. 1989. *Images of Power: Understanding Bushman Rock Art*. Johannesburg. Southern Book Publishers.

Low, Chris. 2014. "Khoe-San ethnography, 'new animism' and the interpretation of Southern San rock art." *South African Archaeological Bulletin 69* (200): 164–172.

Maggs, Tim M.O'C., and Judith Sealy. 1983. "Elephants in boxes." *South African Archaeological Society Goodwin Series 4*: 44–48.

Manhire, Tony, John Parkington, and Royden J. Yates 1985. "Nets and fully recurved bows: Rock paintings and hunting methods in the western Cape, South Africa." *World Archaeology 17*: 161–174.

McComb, Karen, Graeme Shannon, Sarah M. Durant, Katito Sayialel, Rob Slotow, Joyce Poole, and Cynthia Moss. 2011. "Leadership in elephants: The adaptive value of age." *Proceedings of the Royal Society B 278*: 3270–3276.

Moss, Cynthia J. 1988. *Elephant Memories: Thirteen Years in the Life of an Elephant Family.* Chicago: The University of Chicago Press.

Moss, Cynthia J., Harvey Croze, and Phyllis C. Lee (eds). 2011. *The Amboseli Elephants: A Long-Term Perspective on a Long-Lived Mammal.* Chicago: The University of Chicago Press.

Nienaber, Gabriel Stefanus, and P.E. Raper. 1980. *Toponymica Hottentotic.* Pretoria: Raad vir Geesteswetenskaplike Navorsing.

Parkington, John. 1977. "Soaqua: Hunter-fisher-gatherers of the Olifants River Valley, Western Cape." *South African Archaeological Bulletin 32* (126): 150–157.

Parkington, John. 1984. "Soaqua and bushmen: Hunters and robbers" In *Past and Present in Hunter-Gatherer Studies*, edited by Carmel Schrire, 151–174. Orlando: Academic Press.

Parkington, John. 1989. "Interpreting paintings without a commentary: Meaning and motive, content and composition in the rock art of the western Cape, South Africa." *Antiquity 63* (238): 13–26.

Parkington, John. 2002. *Cederberg Rock Paintings.* Cape Town: Krakadouw Trust.

Parkington, John, and Nhlanhla Dlamini. 2016. *First People Ancestors of the San.* Cape Town: Krakadouw Trust.

Parkington, John, and Andrew Paterson. 2017. "Somatogenesis: Vibrations, undulations and the possible depiction of sound in San rock paintings of elephants in the Western Cape." *South African Archaeological Bulletin 72* (206): 134–141.

Parkington, John, and Cedric Poggenpoel. 1971. Excavations at De Hangen 1968." *The South African Archaeological Bulletin 26*: 3–36.

Parkington, John, and Cedric Poggenpoel. 1987. "Diepkloof Rock Shelter." In *Papers in the Prehistory of the Western Cape, South Africa*, edited by John Parkington and Martin Hall, 269–293. Oxford. British Archaeological Reports.

Paterson, Andrew. 2007. "Elephants (!Xo) of the Cederberg Wilderness Area: A re-evaluation of the San paintings previously referred to as 'Elephants in Boxes.'" *The Digging Stick 24* (3): 1–4.

Paterson, Andrew. 2018. "Elephanthropes of the Cederberg—When elephants were people." *The Digging Stick 35* (3): 1–6.

Paterson, Andrew, and John Parkington. 2016. "Observing and painting elephants: San rock art of the Cederberg Region South Africa: Symbiotic, symbolic and spiritual relationship." In *Páleo: Numero hors serie. Hommage a Norbert Aujoulat*, 128–141. Les Eyzies: Musée National de Préhistoire.

Payne, Katy. 1998. *Silent Thunder: In the Presence of Elephants.* London: Penguin Books.

Poole, Joyce H. 2011. "Behavioural contexts of elephant acoustic communication." In *The Amboseli Elephants: A Long-Term Perspective on a Long-Lived Mammal*, edited by Cynthia Moss, Harvey Croze, and Phyllis C. Lee, 125–161. Chicago: The University of Chicago Press.

Schmidt, S. 2013. *Catalogue of the Khoisan Folktales of Southern Africa Part II: The Tales (Analyses).* Cologne: Rudiger Koppe Verlag.

Siebert, Charles. 2006. "An elephant crackup?" *New York Times*, October 8. www.nytimes.com/2006/10/08/magazine/08elephant.html.

Skotnes, Pippa. 1994. "The visual as a site of meaning: San parietal painting and the experience of modern art." In *Contested Images: Diversity in Southern African Rock Art Research*, edited by Thomas A. Dowson and J. David Lewis-Williams, 315–330. Johannesburg. Witwatersrand University Press.

Solomon, Anne. 1997. "The myth of ritual origins? Ethnography, mythology and inter-pretation of San rock art." *South African Archaeological Bulletin 52*: 3–13.

Thom, H.B. 1952. *Journal of Jan van Riebeeck* (3 vols). Cape Town: Van Riebeeck Society.

Vinnicombe, Patricia. 1976. *People of the Eland: Rock Paintings of the Drakensberg Bushmen as a Reflection of their Life and Thought.* Pietermaritzburg: University of Natal Press.

Wittemeyer, George, and Wayne M. Getz. 2007. "Hierarchical dominance structure and social organization in African elephants, *Loxodonta africana.*" *Animal Behaviour 73*: 671–681.

11 Images-in-the-making

Process and vivification in Pecos River-style rock art

Carolyn E. Boyd

1 Introduction

On July 22, 2010, Matsihua, a Huichol shaman, visited the White Shaman rock art[1] mural for the first time. He stood awestruck before the complex assemblage of figures painted in red, yellow, black, and white. Stunned silence yielded to a deep outpouring of emotion. Through tears of joy he exclaimed, "These are my grandfathers, grandfathers, grandfathers. They are all here. All my grandfathers, all my ancestors, they are all here." Speaking affectionately and reverently, the Huichol shaman conversed with his kin, the ancestral gods from primordial time. Far from his village in Mexico, Matsihua celebrated an emotional reunion with his ancestors in the canyonlands of the Lower Pecos.

Archaic hunter-gatherers of the Lower Pecos Canyonlands of southwest Texas and Coahuila, Mexico, created some of the most complex rock art of the ancient world. The White Shaman mural is one of these great masterpieces. Approximately 2,000 years ago, Lower Pecos artists used a sophisticated graphic vocabulary of images to create this mural. They arranged images into an intricate composition to communicate multiple levels of meaning and perform multiple functions. Drawing on over 25 years of archaeological research and iconographic analysis, my collaborator Kim Cox and I identified patterns in the art that equate in detail to the mythologies of Uto-Aztecan-speaking people, most notably the ancient Nahua (Aztec) and the present-day Huichol. The identification of these patterns led to our interpretation of the White Shaman mural as a pictorial narrative relating the birth of the sun and the beginning of time (Boyd and Cox 2016). On July 22, 2010, Matsihua affirmed this interpretation.

Only recently have I begun to realize the magnitude of what occurred on that day. When Matsihua came to the Lower Pecos, Cox and I were already a couple of years into writing our manuscript about the White Shaman mural. We had identified many characters in the visual narrative but had not yet published our results. Matsihua, never having visited the mural and unaware of our interpretations, identified some of the same characters, calling them each by name. But it is less about what he said that day, than what he did that made this experience so important. He carried on a conversation with the imagery; figures painted thousands of years prior by Archaic period foragers were, to him, alive,

listening, communicating, and actively engaged with the present. Matsihua provided us a glimpse into the ontological character of Pecos River–style imagery.

Three decades of documentation and analysis of Pecos River–style rock art is revealing the considerable time, labor, and resources invested in the production of complex murals by foragers. Here I address the question of why this investment was so critical to the lives of people in the past, and why it continues to be important into the future. I suggest that the art was, and continues to be, engaged in the creation and maintenance of the cosmos. For indigenous communities today, the art is not simply a reflection of their past heritage but is part and parcel of their contemporary lives.

Exploring the image-making process of the rock art reveals a highly sophisticated metaphysics similar to but predating that of later Mesoamerican agriculturalists (e.g., Graulich 1997; López Austin 1997; Laack 2019). It was a transcendent reality: a reality in which everything was animated and empowered. Artists depicted and vivified the actors in these visual narratives through the selection of materials to make paint, placement of the mural on the landscape, paint application order, and through the portrayal of semantically charged attributes, such as color, paraphernalia, and body adornments. By analyzing patterns in these aspects of the image-making process we begin to identify choices made by the artist in the production of the murals. These choices reflect the framework of ideas and beliefs through which the artists interpreted and interacted with the art and the world. Although the people who produced the imagery thousands of years ago are not here to explain it for themselves, as evidenced by Matsihua's visit to the White Shaman mural, their myths and belief systems live on in the shared symbolic language of Native peoples living today.

2 Lower Pecos Canyonlands

The Lower Pecos Canyonlands are situated at the edge of the Edwards Plateau and the Chihuahuan Desert. The northern half of the region lies in southwest Texas, USA, and the southern half in Coahuila, Mexico. Near the region's center, the Pecos and Devils Rivers converge with the Rio Grande (Figure 11.1). Over the millennia these rivers and their tributaries have sliced through masses of gray and white limestone rock to create a dramatic landscape incised by deep, narrow gorges.

Rockshelters here contain some of the best-preserved and longest records of hunting and gathering lifeways in North America, from about 13,000 years ago to European contact (Shafer 2013; McCuistion 2019). Preserved within these dry rockshelters are deeply stratified deposits containing a wide assemblage of artifacts, such as tools made from wood, stone, and bone, matting, basketry, snares, fire-starting kits (Shafer 2013), and medicinal and sacramental plants such as peyote (*Lophophora williamsii*) and datura (*Datura stramonium*) (Boyd and Dering 1996; Terry et al. 2006). Preserved on the walls of these rockshelters are rock paintings, or pictographs, spanning greater than 4,000 years of production. These ancient paintings are transforming our perception of the past and

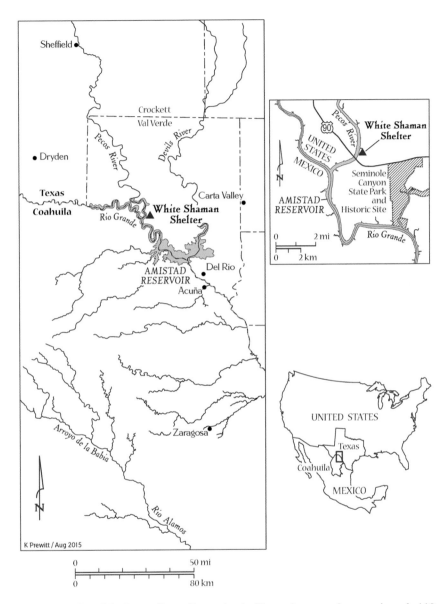

Figure 11.1 Map of the Lower Pecos Canyonlands. The region extends approximately 110 km north and 140 km south of the United States–Mexico border.

Source: Map by Kerza Prewitt. Courtesy of Shumla Archaeological Research and Education Center.

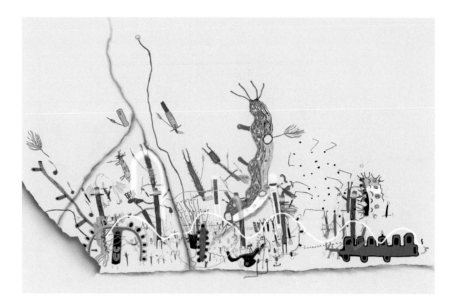

Figure 11.2 Pecos River-style mural at the White Shaman site. The mural is approxi-
mately 8 m long and 4 m high, which is small in comparison to many of the
Pecos River murals in the Lower Pecos.
Source: Illustration by the author.

providing a window into the lifeways of Archaic people living in the Lower Pecos
millennia ago.

The Archaic period (8900–1100 BP) in this region refers to an archaeological
culture defined by a mobile, foraging subsistence pattern consisting of a broad
diet of seasonally available wild plants and small game. The unpredictable,
semiarid climate, shallow soils, and deep canyons with narrow terraces prone to
catastrophic floods limited the means by which people could live off the land. As
a result, during the entire history of the region they were hunters of game,
gatherers of wild plants, and fishers (Dering 1999). Approximately 4,000 years
ago, these foragers began transforming the Lower Pecos region into a painted
landscape.

Pictographs in the Lower Pecos have been categorized into five styles or
classifications: Historic (Turpin 1989), Red Monochrome (Boyd 2013, 190–193;
Turpin 1984), Bold Line Geometric (Turpin 1986), Red Linear (Boyd et al.
2013), and Pecos River (Turpin 1995; Boyd and Cox 2016; Harrison 2018).
Pecos River–style (PRS hereafter), is by far the most abundant and visually
impressive rock art in the region. Easily recognized by its multicolored designs
and striking anthropomorphic (humanlike) and zoomorphic (animal-like) figures,
PRS murals are often ambitious in their scale and technical in their execution
(Figure 11.2). They are the defining archaeological phenomenon of the Lower
Pecos Canyonlands and the subject of this study.

3 Pecos River–style

Pecos River–style murals are located along canyon and rockshelter walls on both sides of the US/Mexico border. We know of more than 200 sites containing PRS imagery north of the Rio Grande. South of the river in Coahuila, Mexico, 35 murals have been identified, but there are likely far more in the secluded canyons of the Serranías del Burro (Turpin 2010, 41). Repeated scouring by flash floods and exposure to wind, sun, and rain through the years have
degraded the murals, however within the protection of hundreds of dry rockshelters some remain vivid. These inform our appreciation of how stunning and awe-inspiring the painted canyons once were and challenge our preconceptions of the art and its makers.

PRS panels range considerably in size and complexity. Some are quite small, less than a meter in length and height, and contain only a few figures. Others span as much as 150 m long, 15 m tall, and contain hundreds of figures. Of the 76 PRS murals documented by Shumla Archaeological Research & Education Center,[2] 34 extend greater than 3 m from the shelter floor and required a ladder or scaffolding to produce. With skilled and intentional brushstrokes, artists deftly painted murals on rough limestone canvases arching several meters overhead. The precision and clarity of lines found in PRS paintings would present a significant challenge for even the most skilled artist.

Artists used pigment crayons or pieces of ochre to sketch out and organize the elements in their compositions, implementing many of the tools used by artists through the ages, such as brushes, straight-edges, stencils, and oil paints. Through a formal analysis of the image-making process, we are learning that everything carried meaning: the ingredients in paint, the order of paint application, and even the choice of brushstroke. For example, figures often are portrayed with a series of lines entering or emanating from open mouths. These lines represent sound in the form of speech or song, and they represent breath or the sense of smell (Boyd and Busby, in preparation). To differentiate between inhalations and exhalations, or sound emanating from an open mouth, artists altered the direction of the brushstroke. As noted by art historian James Elkins (1999, 5),

> Paint records the most delicate gesture and the most tense. It tells whether the painter stood or crouched in front of the canvas. Paint is a cast of the painter's movements, a portrait of the painter's body and thoughts … Paint is water and stone, and it is also liquid thought.

Researchers have conducted chemical analyses and performed experimental archaeology[3] to identify possible paint recipes used by PRS artists. Hyman et al. (1996) conducted mineral analyses to determine the pigments present in the paintings at Panther Cave (41VV83) using powder X-ray diffraction (XRD) and scanning electron microscopy (SEM). They determined that red and yellow pictographs contain an array of iron oxide/hydroxide minerals, and that black

pictographs contain manganese minerals. Subsequent elemental analyses of paintings at ten sites in the region using portable X-ray fluorescence spectroscopy (pXRF) agree with the findings of Hyman et al. (1996) and Koenig et al. (2014).

Bu et al. (2013) used laser ablation-inductively coupled plasma-mass spectrometry (LA-ICO-MS) to identify the source of the iron oxide pigment used to produce red paintings. They concluded that artists likely extracted iron oxide from yellow siltstone pebbles readily found along canyon bottoms, processing these into pigments. To produce red pigments from yellow siltstones would have been a labor-intensive process, which included grinding the pebbles into a powder and separating the iron-rich components from the quartz matrix. The yellow, iron-rich powder was then heat treated and transformed into red pigment (Bu et al. 2013, 1090, 1097).[4]

In the late 1990s, researchers began working to identify the binder in the paint. Although early attempts to extract ancient DNA from the pictographs indicated the binder was from deer or bison (Reese et al. 1996), the results have not been replicated (Mawk et al. 2002). Ethnographic texts, however, suggest that deer tallow or marrow served as a binder (del Hoyo 1960, 492).

Using seventeenth- and eighteenth-century documents curated in the Archivo Municipal de la Ciudad de Monterrey in Mexico, Eugenio del Hoyo compiled over 3,000 words spoken by *los Borrados*, hunter-gatherers living in northeast Mexico and south Texas during contact. The Spanish name, Borrados, refers to tribes sharing the custom of painting their bodies and faces with fine, parallel lines (del Hoyo 1960, 491). According to del Hoyo (1960, 492), they made red and yellow paint from finely ground minerals and colorants extracted from plants and insects. In some cases, the organic colorants were mixed with the mineral pigments. Black paint was obtained from charcoal and minerals. They mixed pigments with water, saliva, prickly pear mucilage, and other plant extracts; however, the binding agent they used most frequently was deer fat (del Hoyo 1960, 492). Not only was deer fat an important food resource in Native America (Speth and Spielmann 1983), it possessed significant ritual value (Potter 1997, 358). Although we don't know exactly what binding agents the PRS artists used, there is a strong likelihood that they used ingredients similar to those reported by del Hoyo. And, because the paint includes organic materials, they can be extracted via plasma oxidation for radiocarbon dating. The 33 radiocarbon dates obtained from 19 Pecos River–style figures range from 4970 to 1290 cal BP (Chaffee et al. 1993; Bates et al. 2015). Pecos River–style murals may have been in production for at least 3,000 years.

Pictographic elements in PRS murals include anthropomorphs, zoomorphs, a wide range of geometric imagery, and enigmatic figures that are not identifiable as human or animal. Anthropomorphs are the most frequently depicted element (Figure 11.3). They typically range in size between 1–2 m; however, some are monumental, towering over 6 m tall. Headdresses of varying types, clusters of feathers at the waist, and wrist or elbow tassels often adorn these human-like figures. PRS artists typically portrayed anthropomorphs wielding paraphernalia, such as atlatls (spear-throwers), darts, staffs, and rabbit sticks.

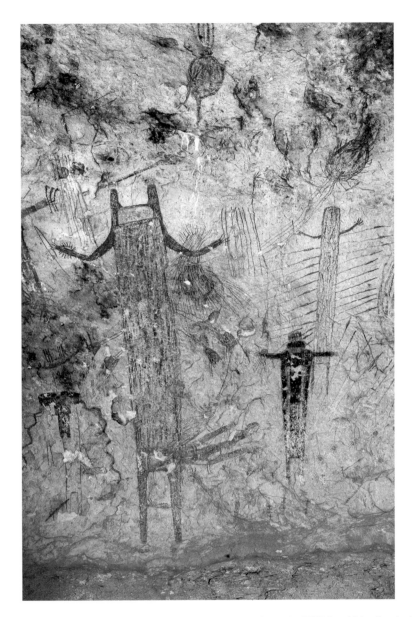

Figure 11.3 Pecos River-style imagery from Panther Cave (41VV83) within Seminole
Canyon State Park. The red anthropomorph portrayed with upraised arms, a
U-shaped head, and a feather-like adornment attached at the hip stands 3 m
high.

Source: Photograph courtesy of Shumla Archaeological Research and Education Center.

The most recurrent animals in PRS paintings are deer and felines; images of canines are rare, and bear are conspicuously absent from the assemblage. Birds often are small and easily overlooked. We often encounter sinuous, snake-like figures, and sometimes frogs and tadpoles. Some imagery resembles insects, such as caterpillars, dragonflies, and moths or butterflies. Other figures lack characteristics of either anthropomorphs or zoomorphs. These enigmatic figures range significantly in size, shape, and complexity. Sometimes they vaguely resemble plants, other times they are finely painted, amorphous shapes having no analog in the physical world.

Artists frequently included natural features in the wall, such as fissures, protrusions, and water seeps, into the images. Anthropomorphs and zoomorphs emerge from deep solution cavities, small depressions form eyes and mouths, protrusions in the rock form bodies, and figures disappear into large cracks in the wall. Over half of the documented PRS murals contain figures altered by rubbing, removing, or adding paint. When these events took place is unknown; it could have been done by the original artist, months later, hundreds of years later, or, perhaps, all the above. In some cases, altered figures are later touched up. The most common form of post-painting modification is incising, which is evidenced by repeated, deliberate, short incisions cut into the imagery. Some figures were rubbed and incised multiple times and in varying locations.

The murals' painting sequence reveals that they are well-ordered and carefully planned. Using a handheld digital microscope, my colleagues at Shumla and I have analyzed 525 locations of intersecting paint layers across six sites. The preliminary results are intriguing. Almost 99% of the locations follow a strict painting order. Artists applied black paint first, followed by red, then yellow, and finally white. As a result, elements of one figure are painted over and under elements of another figure, weaving them together to form a complex composition. To manage and diagram these complex stratigraphic relationships we used a software program called Harris Matrix Composer. The painting sequence reveals a sophisticated network of relationships within and among rock art figures at a single site. The larger context of mural stratigraphy provides evidence for compositions deliberately planned and executed.

Mobile bands of foragers in the Lower Pecos invested considerable resources, time, labor, and effort in the production of art. They constructed scaffolding, worked out complex compositions to communicate detailed narratives, and implemented a paint application order that required significant planning. They used straight-edges, stencils, and any number of other tools to ensure that the art was the best it could be, to produce truly exceptional paintings. They sacrificed precious fat from their diet to create paintings that they interacted with, not just visually, but through touch: incising and rubbing finely created figures.

In 2016, Cox and I proposed that PRS murals in general, and the White Shaman mural specifically, are pictorial narratives detailing sophisticated cosmological and mythological concepts. Using iconographic data from PRS archaeological sites, ethnohistoric, and ethnographic texts, we argue that the

rock art is a graphic manifestation of ancient, interrelated ideas traditionally associated with complex agricultural societies in Mesoamerica. The cosmological concepts expressed in the art predate the rise of the great Mesoamerican civilizations.[5]

The murals provide us with a snapshot in time, a glimpse into the deeply entrenched and widely shared symbolic world of indigenous Native America as it was expressed thousands of years ago and, in many respects, endures into the present. Insights into the stories communicated through the art, strong parallels with Mesoamerican mythologies, an increasing awareness of the complex image-making process, and my experience with Matsihua are coming together to shed light on how Archaic period foragers perceived the nature, structure, and constitution of reality.

4 Incarnated images

Ancient Mesoamericans lived in a universe in which everything was alive and equally real. In this perception of reality, every*thing*—including art—possesses the ability to make things happen. The images are animated, empowered, and vivified. James Maffie states (2014, 21–22), "at the heart of Aztec metaphysics stands the ontological thesis that there exists just one thing: dynamic, vivifying, self-generating and self-regenerating sacred power, force, or energy." It is energy-in-motion. The Aztec (Nahua) called this vivifying, sacred force *teotl*. All things possess this force; therefore, all things are sacred, all things have agency and all things contribute to the ongoing transformation of the cosmos (Maffie 2014, 29, 115). Because everything consists solely of *teotl*, no distinction between humans and non-humans exists. This reality endures among indigenous peoples living today throughout Mexico and the rest of Mesoamerica, including the Huichol[6] (Schaefer and Furst 1996, 12; Villegas 2016).

4.1 Inspired art works

The Huichol do not consider figures in ritual art to be simply representations or images of gods, they are gods in full right. From the moment they appear in the art, these deities are engaged in the creation and maintenance of the universe (Neurath 2010, 113, 120–121).[7] This is particularly true of exceptional, inspired works. Mediocre works of art tend to lack agency; therefore, depending on the ultimate consumer, Huichol artists may avoid making "great art" that reflects the delicate aspects of their traditional religion (Neurath 2010, 104).

I suggest that Lower Pecos muralists, like Huichol artists, created exceptional art with the intent of efficacy. The care with which they created the art suggests that the Archaic artist's objective was to produce exceptional, inspired, and powerful art. Not for the sake of art, but for the sake of life: to vivify their pantheon and engage them in the creation and maintenance of reality. In 2010, when Matsihua stood before the White Shaman rock art panel he was interacting with inspired art. He did not see a static, inert painting of mythological

characters, but a living and active gathering of deity-ancestors interacting with and creating the universe. He spoke to them and they spoke to him.[8]

4.2 Donning the skin of gods

Mesoamerican artists animated and differentiated their deities by means of semantically charged colors, body adornments, paraphernalia, and body postures (Maffie 2014, 87). Collectively, these attributes represented the "skin" of the gods (Magaloni Kerpel 2014, 12). Each god, like all creation, contained divine essences, which were distinct characteristics or imperceptible forces possessing agency (López Austin 1997, 13). The physical attributes selected by artists of the pre-Columbian and colonial-era codices, murals, and sculptures contained these distinct characteristics or essences. Diana Magaloni Kerpel (2014, 12) argues that images in the *Florentine Codex* became active subjects with their own viewpoint when Nahua artists donned them in the skin of the gods.

Likewise, anthropomorphic figures in PRS murals are portrayed with distinctive attributes, such as shape, color, paraphernalia, and body adornment. We have identified recurring patterns among attributes at sites throughout the region, such as masked, antlered anthropomorphs with wings, and anthropomorphs possessing red antlers tipped with black dots. Cox and I identified well-defined parallels between these patterns and analogues in present-day Huichol and ancient Nahua myth and ritual. These attributes, like those of characters portrayed in the codices, provide clues to who and what the figures represent.[9] They form the "skin" of the Lower Pecos pantheon. For this reason, Matsihua was able to recognize deities from Huichol religion in the White Shaman mural. Patterns in attribute data, coupled with ethnographic and ethnohistoric texts, facilitated our interpretation of the mural as a visual creation narrative (Boyd and Cox 2016). Color was one of the most productive lines of inquiry leading to our identification of deities in the Lower Pecos pantheon, particularly the colors black and red.

4.3 Color engenders life

Mesoamerican artists differentiated and enlivened deities through color (Dupey García 2015, 73). The Nahuatl couplet metaphor, *in tlilli, in tlapalli*, powerfully demonstrates this by uniting complementary, yet opposing concepts associated with black (*in tlilli*) and red (*in tlapalli*).[10] The holistic division of the cosmos into complementary oppositional pairs is one of the most distinctive components of Mesoamerican belief systems. In keeping with the reality that all things consist of just one thing—sacred energy (*teotl*), these paired oppositions are not a combination of metaphysically distinct things, but dual aspects of *teotl*. They are mutually dependent on one another and are in a constant cyclical tug-of-war with each other. For example, life and death are inseparable, you cannot have one without the other. The Nahuatl term for this relationship is *inamic* (Maffie 2014, 138).

Everything in the Nahua universe had an inamic partner: masculine-feminine, east-west, hot-cold, day-night, light-darkness, etc. The becoming of reality and the creation and perpetuation of the cosmos involve the struggle between inamic pairs and the alternating dominance of one inamic over its partner (Maffie 2014, 13). In this reality, black and red form an inamic pair: black is equated with death, cold, earth, water, west, femininity, and the world below, while red is equated with life, heat, sun, fire, east, masculinity, and the world above.

The juxtaposition of black and red invokes the idea of creation and the Nahua god of duality, fire, and time: Xiuhtecuhtli.[11] He is both male and female, red and black, day and night, fire and water, and he dwells in the primordial mountain at the center of the cosmos (Carrasco 1999, 103). Nahua artists activated the fire god by including attributes laden with the divine essence of the god, such as a black stripe across his eyes, an atlatl (spear-thrower), and an antler headdress representing flames (Seler 1902, 17, 37). Artists expressed the fire god's dual nature and the inamic struggle necessary for creation by painting images of the god red and black (León-Portilla 1990, 30–31). We have identified an analogue to this deity in PRS rock art (Figure 11.4).

As in Mesoamerica, Lower Pecos artists used color to distinguish and enliven deities. The anthropomorph that Kim Cox and I identified as the fire god in the White Shaman mural shares several attributes with the Nahua god of fire and time (Boyd and Cox 2016, 76–83, 124–130). These include, among others, his emergence from a crenellated arch motif identified as the primordial mountain (the center of the cosmos), a black stripe across his eyes, a red and black body, a red atlatl, and most significantly, red antlers. PRS artists, like those of the codices, incarnated images by covering them in the skin of the character they represent. However, not only color selection, but also painting sequence—the order in which the paint was applied to the wall—infused identity and life into the images.

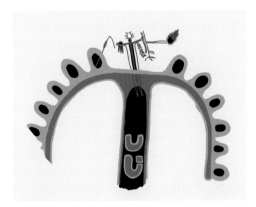

Figure 11.4 Pecos River-style anthropomorph in the White Shaman mural representing a god of fire emerges from a primordial mountain motif.
Source: Illustration by author.

4.4 A woven cosmos

As a result of the strict black, red, yellow, and white painting sequence, the Lower Pecos fire god in the White Shaman mural is sandwiched between the layers of color forming the primordial mountain motif. As stated earlier, in Nahua thought, the fire god dwells in and emerges from the primordial mountain at the center of the cosmos. The Lower Pecos fire god is not only visually at the center of the cosmos, but positionally painted into the mountain through the application sequence. The two figures—the anthropomorph and the arch—are literally woven together.

 Weaving was a root organizing metaphor used by Nahua cosmologies to portray the structure and working of reality and the cosmos (Klein 1982). In Nahua reality, the cosmos is a "grand weaving in progress" (Maffie 2014, 14). Like the Nahua, Lower Pecos artists lived in a woven cosmos, filled with baskets, nets, mats, and structures built through the intertwining of warp and weft. Even their murals are woven tapestries formed through the intertwining of colors and figures.

4.5 Materiality of color

In Mesoamerica, images were made to exist and live by the inherent, invisible force of the raw materials from which the paint was made (Dupey García 2015). For example, Nahua artists of the *Florentine Codex* used colorants made from plants and mineral pigments to produce the *same* color, indistinguishable without chemical analysis.[12] Their choice of pigment was motivated for reasons beyond obtaining a specific color. It was for instilling in the image the hot, luminous, solar force of organic materials (plants), or the cold, dark, telluric force of inorganic substances (minerals) (Magaloni Kerpel 2014, 35, 37–38). In Nahua mythology, the giant cosmic crocodile split in half at the origin of the world. Gods associated with the hot, dry, luminous forces of the world above (organic) arose from her upper half. From her lower half emerged the gods associated with the cold, wet, and dark world below (inorganic). Creation was brought about through combining different portions from the two halves of Cipactli's body. The universe perpetually regenerated itself by means of the interaction of these two complementary opposing forces. In the *Florentine Codex*, artists:

> blended mineral pigments and organic colorants in a ritual action similar to what was carried out by the gods at the origin of time. The goddess Coatlicue, as the earth itself, is painted in both substances: the mineral from the moist, dark, creative earth and the organic material from the sunlight that makes plants grow. Together, the substances form a complete, powerful being.
>
> (Magaloni Kerpel 2014, 38)

I suggest that artists of the Lower Pecos, like those of Mesoamerica, were alchemists that transmuted raw materials into divine beings. They combined

telluric and solar forces to produce meaning-full and potent paint. They united minerals obtained from the earth with organic ingredients obtained from plants and animals to produce vivid and vivified colors. Colors that through both their chromatic value and materiality engendered life in PRS imagery. If PRS anthropomorphs are gods in full right, infused with divine essence through color, attributes, and raw materials, then cutting into or incising these living entities was a powerful ritual act. This widespread practice in the Lower Pecos may have represented a type of bloodletting to release or tap into the divine force embodied in the art: a sacrifice from the gods. In Nahua reality, it was through the sacrifice of the gods that the sun was put into motion and time was born. And it was through their continued sacrifice that the cosmic order was maintained.

4.6 Transformation processes

Color meaning among the Nahua was not only determined by the inorganic or organic nature of raw materials used in paint, but by how the raw materials were processed. For example, Nahua deities who were associated with heat, such as fire and solar gods, were painted using red ochre or *tlauitl* (Dupey García 2015, 80). Inorganic materials whose provenance is of the earth, however, are not associated with heat, but with the cold, dark, telluric forces of the underworld. Through processing ochre, artists instilled the essence of fire into the pigment. They exposed yellow ochre to extreme heat in a fire to transform it into red ochre, thus, red ochre is considered a "burnt substance" and is associated with the sun and fire. It both emitted and received heat (Dupey García 2015, 80–81). The relationship of fire and solar gods with heat, therefore, is not only communicated through the color used to paint them (red), but how red pigment was produced. Form, color, materiality, and processing come together to vivify the Nahua pantheon and to express interrelationships between different layers of reality (Laack 2019, 319).

As discussed already, Lower Pecos artists used a similar process to obtain red pigment (Bu et al. 2013 1097). Although red ochre occurs naturally in the region, artists expended additional time and resources to transform yellow ochre via heat into red ochre. The process infused the raw material with the divine essence of fire. In the Lower Pecos, however, it appears that not only did color and raw material imbue images with life, but also the order in which the paint was applied.

4.7 Layers of meaning

Consider again the red antlers (flames) of the fire god (Figure 11.5). In addition to his presence in the White Shaman mural, we have identified this important deity at five other sites in the region. In each example, the artist tipped each red antler tine with a black dot. We have confirmed that in at least four of the six occurrences they painted the black dots prior to the red antlers.[13] This painting sequence instilled cycles of time and the spiritual meanings connected to these cycles into the imagery.

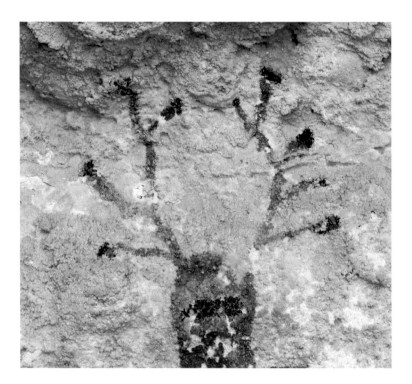

Figure 11.5 Close-up photograph of a fire god portrayed with a black stripe across its eyes
 and a black dot at the tip of each red antler tine.
Source: Photograph courtesy of Shumla Archaeological Research and Education Center.

In Huichol and Nahua stories of creation, the divine hero brings forth the
primordial human souls/water/stars out of the underworld at the dawn of time.
For the Huichol, the souls of the ancestors and life-giving water are carried
within the antlers of the deer (Fikes 2011, 1, 163). Artists graphically represented
this in Huichol yarn paintings by attaching dots or flowers to antlers or
portraying a human figure sitting on the flames of the fire god.

In the White Shaman mural, the divine essence of fire and sun are infused into
the small antlered anthropomorph emerging from the primordial mountain. The
watery souls of the ancestors, represented by the black dots, are sacrificed upon
the flames of the fire god, represented by the red antlers. Through this sacrifice
the sun is born and through the union of opposites—fire and water—the fire god
initiates creation and the beginning of human time of which he is also the
patron god.

One of the most important concepts in the Nahuatl language is "burning
water" (*atl tlachinolli*), a couplet metaphor uniting two opposing forces: water and
fire. It metaphorically represents the struggle between matter (black) and spirit
(red). If matter wins, the spirit is destroyed. If spirit wins, the body bursts into

flames, thus creating a new light that gives birth to the sun. All that exists on earth results from the union of these two opposed elements (Séjourné 1978, 72). The portrayal of red antlers with black dots in the White Shaman mural and other Pecos River–style iconography may represent this powerful metaphor: burning water.

And, just as there are complex interactions between colors, images, and raw materials, there are complex interactions between the images and celestial light. Rock art is part of, and inseparable from, the landscape. The White Shaman mural is located on the east side of the Pecos River, but faces due west. Just before sunset on the equinoxes, an arch of light illuminates the primordial mountain from which the fire-sun god emerges. Sunlight climbs the crenellations of the motif—step by step—while the rest of the panel remains in shadow. The fire god's attributes, color, painting order, context, interaction with light, and placement on the landscape infuse the deity with life, engaging it in the ongoing process of creation.

5 Conclusions

According to Isabel Laack (2019, 319),

> In contrast to European philosophies of language privileging linguistically expressed thoughts as the place where truth about reality is most directly revealed, the Nahua valued the arts as an important medium for revealing the underlying structure of reality and for communicating truth and meaning.

Line, color, design, form, organization of space, relationships among figures, raw materials: everything carried meaning and possessed the ability to make things happen. As demonstrated here, the same was true for the Archaic foragers of the Lower Pecos Canyonlands.

The image-making process of Pecos River–style rock art reveals a sophisticated metaphysics and reality akin to that of later Mesoamerican agriculturalists. It was a transcendent reality characterized by *becoming*: a world in motion, perpetually changing and unfolding through the cyclical struggle between inamic pairs. Combining inorganic and organic materials to make paint, artists united telluric and solar forces to vivify their pantheon. And, through the careful application of colors laden with meaning, they literally wove cycles of time into the murals.

Hunter-gatherer artists devoted significant time, planning, and resources to produce exceptional, and thereby, effective works of art. This was not for the sake of art, but for the sake of life. The paintings are powerful, sentient beings that possess their own point of view and intentionality. They exist in a liminal place, between the feminine earthly forces of the rock wall and the masculine solar forces acting upon it. According to Mesoamerican metaphysics, the point of intersection between heaven and earth—the place we find the paintings—is where the creative forces unite, create, and regenerate.

From their place on the shelter wall, the incarnated images look upon and interact with the creation for which they are responsible. They are actively and perpetually engaged in the maintenance of the Lower Pecos woven cosmos. From a Western perspective, rock art panels are viewed as a collection of lifeless, iconographic signs and symbols. The rock art of the Lower Pecos challenges that perception and proposes a reality in which the artists imbued images with life through the deliberate selection and processing of raw materials, placement on the landscape, and manner of execution. It raises new questions and challenges us to refine our methodologies to look for meaning in things we never thought carried meaning—not just in the art, but in all aspects of the archaeological record.

Notes

1 Although I use the term "art" to refer to the imagery, it is unlikely that its indigenous creators perceived it as such, at least not as defined by Western societies today (see Boyd 2003, 3–8).
2 Shumla Archaeological Research & Education Center (Shumla hereafter) is a non-profit organization dedicated to preserving the rock art of the Lower Pecos through documentation, research, education, and stewardship.
3 Phil Dering and I have found that the combination of ground mineral pigments, deer bone marrow, and the detergent-like juices extracted from the roots of yucca (*Yucca glauca*) makes an excellent paint (Boyd and Dering 2013, 180–181).
4 The dehydration of yellow iron hydroxide (goethite) into red iron oxide (hematite) via heat was performed by artists at least as far back as the Magdalenian period (c. 17,000–c. 12,000 BP) (Salomon et al. 2015).
5 Scholars long have predicted that Mesoamerican cosmological concepts persisted across time and across cultural, linguistic and geographical boundaries (Gossen 1986). López Austin (1997) has argued that these concepts came out of an earlier Archaic core of belief, perhaps as old as migration across the land bridge. In *The White Shaman Mural*, Kim Cox and I argue that Pecos River–style murals express this shared symbolic language. The canyons of southwest Texas and northern Mexico are not likely the birthplace of these ideas, but perhaps they are the location of the oldest existing documented graphic expressions of them. Whether this is the result of preservation bias or the first time the ideology was graphically codified has yet to be determined.
6 Johannes Neurath (2015, 60) suggests that the Huichol combine animistic and analogist tendencies.
7 According to Neurath (2005, 72), the artist who has a vision and effectively portrays it on a flat surface or in a sculpture engages in creating a cosmos *that already exists* (my emphasis). Cosmogonic transformations such as this imply a "twist in narrative logic" (Neurath 2005, 74). As an example, Neurath (2005, 74) uses the myth of the goddess of the sea, in which the goddess throws herself against a giant rock at the extreme western edge of the cosmos to become mist and rain. She is then transformed into the rock she threw herself against. "In other words, she throws herself at herself to become herself" (Neurath 2005, 74).
8 Shortly after his emotional reunion, Matsihua became very quiet, no longer sharing his observations or verbalizing names of ancestors. I was told by our translator that evoking the names of the gods would obligate Matsihua to make offerings at their shrines distributed across Huichol territory. Given the number of deities present in the mural, this would have been a significant undertaking.

9 Think, for example, about the attributes of Medusa from Greek mythology or Thor from Scandinavia. We recognize them in artworks by their very distinctive attributes—hissing snakes as hair and a mighty hammer. Even a basic knowledge of Medusa and Thor myths facilitates their identification.

10 The Nahuatl term *tlapalli* is commonly translated as "red," but also refers to "color for painting" (Wright Carr 2011, 286).

11 Xiuhtecuhtli is another name for Ometeol, the supreme Nahua deity or creative force (León-Portilla 1990, 33).

12 Although hybrid organic-inorganic pigments were used to produce pre-Columbian manuscripts, artist's palettes were primarily organic in origin. This contrasts with the palettes used for body painting, murals, and stone sculptures, which were primarily mineral in origin (Dupey García 2015, 2018, 187).

13 Due to poor preservation, we have not been able to confidently determine the painting sequence for the other two figures.

References cited

Bates, Lennon, Amanda Castañeda, Carolyn Boyd, and Karen Steelman. 2015. "A black deer at Black Cave: New pictograph radiocarbon date for the Lower Pecos, Texas." *Journal of Texas Archeology and History 2*: 45–57.

Boyd, Carolyn E. 2003. *Rock Art of the Lower Pecos*. College Station: Texas A&M University Press.

Boyd, Carolyn E. 2013. "Drawing from the past: Rock art of the Lower Pecos." In *Painters in Prehistory: Archaeology and Art of the Lower Pecos Canyonlands*, edited by Harry J. Shafer, 171–221. San Antonio: Trinity University Press.

Boyd, Carolyn E., and Ashley Busby (in preparation). "Soul expressions: Sensory signs in Pecos River–Style rock art." Manuscript on file at Shumla Archaeological Research and Education Center, Comstock, Texas.

Boyd, Carolyn E., and Kim Cox. 2016. *The White Shaman Mural: An Enduring Creation Narrative in the Rock Art of the Lower Pecos*. Austin: University of Texas Press.

Boyd, Carolyn E., and J. Phil Dering. 1996. "Medicinal and hallucinogenic plants identified in the sediments and the pictographs of the Lower Pecos, Texas Archaic." *Antiquity 70* (268): 256–275.

Boyd, Carolyn E., and J. Phil Dering. 2013. "Rediscovering ingredients in paintings of the Pecos River–style." In *Painters in Prehistory: Archaeology and Art of the Lower Pecos Canyonlands*, edited by Harry Shafer, 180–181. San Antonio: Trinity University Press.

Boyd, Carolyn E., Amanda M. Castañeda, and Charles W. Koenig. 2013. "A reassessment of red linear pictographs in the Lower Pecos Canyonlands of Texas." *American Antiquity 78* (3): 456–482.

Bu, Kaixuan, James Cizdziel, and Jon Russ. 2013. "The source of iron-oxide pigments used in Pecos River–style rock paints." *Archaeometry 55* (6): 1088–1100.

Carrasco, Davíd. 1999. *City of Sacrifice: The Aztec Empire and the Role of Violence in Civilization*. Boston: Beacon Press.

Chaffee, Scott D., Marian Hyman, and Marvin Rowe. 1993. "Direct dating of pictographs." *American Indian Rock Art 19*: 23–30.

del Hoyo, Eugenio. 1960. "Vocablos de la lengua quinigua de los borrados del Noreste de México." *Humanitas 1*: 489–515.

Dering, J. Philip. 1999. "Earth-oven plant processing in archaic period economies: An example from a semi-arid savannah in south-central North America." *American Antiquity* *64*: 659–674.

Dupey García, Élodie. 2015. "The materiality of color in the body ornamentation of Aztec gods." *RES: Anthropology and Aesthetics 65/66*: 72–88.

Dupey García, Élodie. 2018. "Making and using colors in the manufacture of Nahua Codices: Aesthetic standards, symbolic purposes." In *Painting the Skin: Pigments on Bodies and Codices in Pre-Columbian Mesoamerica*, edited by Élodie Dupey Garciá and María Luisa Vásquez de Ágredos Pascual, 186–205. Tucson: University of Arizona Press.

Elkins, James. 1999. *What Painting Is*. New York: Routledge.

Fikes, Jay C. 2011. *Unknown Huichol: Shamans and Immortals, Allies against Chaos*. Lanham: AltaMira Press.

Gossen, Gary. 1986. "Mesoamerican ideas as a foundation for regional synthesis." In *Symbol and Meaning beyond the Closed Community: Essays in Mesoamerican Ideas*, edited by Gary Gossen, 1–8. Albany: SUNY Press, Institute for Mesoamerican Studies.

Graulich, Michel. 1997. *Myths of Ancient Mexico*. Norman: University of Oklahoma Press.

Harrison, James. 2018. *Pecos River–Style Rock Art: A Prehistoric Iconography*. College Station: Texas A&M University Press.

Hyman, Marian, Solveig Turpin, and Michael Zolensky. 1996. "Pigment analysis at Panther Cave." *Rock Art Research 13*: 93–103.

Klein, Cecelia. 1982. "Woven heaven, tangled earth." In *Ethnoastronomy and Archaeoastronomy in the American Tropics*, edited by Anthony Aveni and Gary Urton, 1–35. New York: Annals of the New York Academy of Sciences.

Koenig, Charles W., Amanda M. Castañeda, Carolyn E. Boyd, and Karen L. Steelman. 2014. "Portable X-ray fluorescence spectroscopy of pictographs: A case study from the Lower Pecos Canyonlands of Texas." *Archaeometry 56*: 168–186.

Laack, Isabel. 2019. *Aztec Religion and Art of Writing*. Boston: Brill.

León-Portilla, Miguel. 1990 [1963]. *Aztec Thought and Culture*. Translated by Jack Emory Davis. Norman: University of Oklahoma Press.

López Austin, Alfredo. 1997. *Tamoanchan, Tlalocan: Places of Mist*. Translated by Thelma Ortiz de Montellano and Bernard Ortiz de Montellano. Boulder: University Press of Colorado.

Maffie, James. 2014. *Aztec Philosophy: Understanding a World in Motion*. Boulder: University Press of Colorado.

Magaloni Kerpel, Diana. 2014. *The Colors of the New World: Artists, Materials, and the Creation of the Florentine Codex*. Los Angeles: Getty Research Institute.

Mawk, Elmo, Marion Hyman, and Marvin Rowe. 2002. "Re-examination of ancient DNA in Texas rock paintings." *Journal of Archaeological Science 29*: 301–306.

McCuistion, Emily R. 2019. "The camel of time: Radiocarbon dating the Lower Pecos Canyonlands." Master's thesis, Texas State University.

Neurath, Johannes. 2005. "Ancestors in the making: A living tradition." Translated by Michelle Suderman. *Artes de México 75*: 71–74.

Neurath, Johannes. 2010. "Anacronismo, pathos y fantasma en los medios de expresión huicholes." In *Las artes del ritual: Nuevas propuestas para la antropología del arte desde el occidente de México*, edited by Elizabeth Araiza, 99–125. Zamora: Colegio de Michoacán.

Neurath, Johannes. 2015. "Shifting ontologies in Huichol ritual art." *Anthropology and Humanism 40* (1): 58–71.

Potter, James M. 1997. "Communal ritual and faunal remains: An example from the Dolores Anasazi." *Journal of Field Archaeology 24* (3): 353–364.

Reese, Ronnie, James Derr, Marion Hyman, Marvin Rowe, and Scott Davis. 1996. "Ancient DNA from Texas pictographs." In *Archaeological Chemistry V: Organic, Inorganic, and Biochemical Analysis*, edited by M.V. Orna. Washington, DC: American Chemical Society.

Salomon, H., C. Vignaud, S. Lahill, and N. Menguy. 2015. "Solutrean and Magdalenian ferruginous rocks heat-treatment: Accidental and/or deliberate action." *Journal of Archaeological Science 55*: 100–112.

Schaefer, Stacy B., and Peter T. Furst. 1996. "Introduction." In *People of the Peyote: Huichol Indian History, Religion and Survival*, edited by Stacy B. Schaefer and Peter T. Furst, 1–25. Albuquerque: University of New Mexico Press.

Séjourné, Laurette. 1978 [1957]. *Burning Water: Thought and Religion in Ancient Mexico*. London: Thames and Hudson.

Seler, Eduard. 1902. *Codex Fejérváry-Mayer: An Old Mexican Picture Manuscript in the Liverpool Free Public Museums (12014/M)*. Berlin and London: T. and A. Constable.

Shafer, Harry J. (ed). 2013. *Painters in Prehistory: Archaeology and Art of the Lower Pecos Canyonlands*. San Antonio: Trinity University Press.

Speth, John D., and Katherine A. Spielmann. 1983. "Energy source, protein metabolism, and hunter-gatherer subsistence strategies." *Journal of Anthropological Archaeology 1*: 1–31.

Terry, Martin, Karen L. Steelman, Tom Guilderson, Phil Dering, and Marvin W. Rowe. 2006. "Lower Pecos and Coahuila Peyote: New radiocarbon dates." *Journal of Archaeological Science 33* (7): 1017–1021.

Turpin, Solveig. 1984. "Pictographs of the Red Monochrome Style in the Lower Pecos River Region, Texas." *Bulletin of the Texas Archeological Society 55*: 123–144.

Turpin, Solveig. 1986. "Toward a definition of a pictograph style: The Lower Pecos bold line geometrics." *Plains Anthropologist 31* (112): 153–162.

Turpin, Solveig. 1989. "The iconography of contact: Spanish influences on the rock art of the Middle Rio Grande." In *Colombian Consequences: Archaeological and Historical Perspectives in the Spanish Borderlands West*, edited by D.H. Thomas, 277–299. Washington, DC: Smithsonian Institution Press.

Turpin, Solveig. 1995. "The Lower Pecos river region of Texas and Northern Mexico." *Bulletin of the Texas Archeological Society 66*: 541–560.

Turpin, Solveig. 2010. *El arte indígena en Coahuila*. Saltillo: Universidad Autónoma de Coahuila.

Villegas, Leobardo. 2016. "Dioses, mitos, templos, símbolos: El universo religioso de los huicholes." *Americanía 3*: 4–48.

Wright Carr, David C. 2011. "La tinta negra, la pintura de colores: Los difrasismos metafóricos translingüísticos y sus implicaciones para la interpretación de los manuscritos centromexicanos de tradición indígena." *Estudios de cultura náhuatl 42*: 285–298.

12 Rock art and relational ontologies in Canada

Dagmara Zawadzka

1 Introduction

For the past two decades, rock art research in Canada has been steadily experiencing a 'renaissance' as is demonstrated by the ever-growing body of literature (often produced by recent graduates) (e.g., Arnett and Morin 2018; Twance 2017) and renewed interest in areas that have been rarely studied since the 1980s (see Tapper, this volume). Though research in Canada has truly began only at the end of the 1950s, this vast country, where around 3000 pictograph and petroglyph sites are known, is important for explorations of ontologies and rock art. It is here that Alfred Irving Hallowell (1892–1974) worked with the Anishinaabeg in Manitoba (the Berens River Ojibwe, also known as Saulteaux). This led him to write his famous paper, "Ojibwa ontology, behavior, and world view" (Hallowell 1976) that contributed to the emergence of the ontological turn in Anthropology (e.g., Descola 2013; Ingold 2000). However, more relevant is the continuous importance of rock art for many Indigenous groups who, along with Ancestors, other-than-human persons, places, and paths, are embedded in a relational flow. Rock art continues to create and anchor experiences and identities, to influence and to teach. Ontological questions are increasingly explored in rock art. They help to challenge our notions of culture/nature, personhood, and object animacy as relationships, especially with other-than-human persons, are explored. Animism/'new Animism,' as a relational ontology, offers novel ways to investigate non-human agencies of art and landscapes. Ontological inquiries confront our disciplinary categories. Jones (2017) has discussed the recent trends of ontological approaches to rock art and how they open up new venues for rock art analysis. *Image* is no longer a two-dimensional inert representation as the importance of materials, of the rock surface, of the process of image making, as well as of its affective properties for its meaning and being, is explored. Jones (2017) goes on to discuss the *rock surface* (e.g., cracks and fissures) and the *landscape* and their interrelationship with *images* for comprehending rock art. Rock art and landscapes help to cultivate relationships between the human and non-human beings.

Explorations of rock art and relational ontologies have been undertaken especially in the Canadian Shield (e.g., Creese 2011; Norder 2012; Zawadzka 2019) and in southern British Columbia (e.g., Arnett 2016). The Canadian Shield is a vast

physiographic region that stretches from Labrador to north-eastern Alberta and from the Arctic Archipelago, to the Great Lakes. Canadian Shield rock art consists mainly of some 800[1] pictograph sites painted with red ochre on vertical cliffs on lakes and rivers and around 30 petroglyph sites carved near water bodies or in the forest. The rock art seems to date to the pre-contact and the post-contact period (seventeenth century onward) with some researchers arguing for an antiquity of 2,000 years or older (e.g., Rajnovich 1994, 46–49). However, this tradition's chronology remains problematic as it is mostly derived from relative dating techniques, such as reliance on ethnographic and ethnohistorical sources, subject matter analysis, and association with known archaeological sites (e.g., Jones 2006, 62–69; Rajnovich 1994, 41–51). This rock art is associated with Algonquian-speaking peoples, such as the Innu, Anishinaabeg (Ojibwe) and Cree (Figure 12.1). British Columbia is exceptionally rich in rock art with some 1300 petroglyph and pictograph sites on the Northwest Coast and inland, on the Interior Plateau. Rock art was created by diverse peoples such as the Coast Salish (Snuneymuxw, Squamish), the Interior Salish (Nlaka'pamux), the Nuu-chah-nulth, and the Kwakwaka'wakw. The dates of this rock art have been only determined through relative dating. Among the Coast and Interior Salish peoples, oral traditions and archaeological studies point to episodes of creation from the sixteenth to early twentieth centuries (Arnett 2016; Arnett and Morin 2018, 102, 107), though older dates based on stylistic analysis have been proposed (e.g., Adams 2003, 31).

This chapter will discuss how rock art ontologies are being engaged with in Canada by concentrating on examples from the Canadian Shield and the territories of the Coast and Interior Salish peoples of southern British Columbia. It will begin by tracing a sketch of the relational ontologies or animisms of Indigenous Algonquian-speaking and Salish peoples to better contextualise contemporary studies. It will then trace a brief history of the unfolding of animistic approaches to rock art whose roots go back to the 1970s. Finally, the impact of ontological approaches will be discussed through the lens of *landscapes* and *images*, as well as *categories*.

2 Relational ontologies of Indigenous peoples

Indigenous hunter-fisher-gatherers that live in what is now Canada had and continue to have varied beliefs, rituals, customs, and material culture expressions, yet they share some basic tenets about the nature of the world, its inhabitants and human roles and obligations as members of the universe. Their experience of the world can be summarised as animistic. The concept of animism has a long and complicated history in western scholarship. Traditionally, it was understood as the belief in spiritual beings and souls and the ascription of life and souls to inert objects (Tylor 1871) and it was considered as the earliest form of religion (e.g., Clodd 1905). Animism was shunned in anthropology as it became a pejorative term associated with the 'primitive.' Since the 1960s, studies of hunter-fisher-gatherers, conducted under the guise of symbolic anthropology propagated the Cartesian legacy of culture-nature/human-animal divides and they examined these peoples' beliefs and

Figure 12.1 A typical rock art cliff in the Canadian Shield, Lake Temagami, Ontario.
Source: Photo by Dagmara Zawadzka.

practices as metaphors of human society, especially when addressing human-animal relations (Willerslev 2007, 13–19). It is only in the last decade of the twentieth century that the term was gradually rehabilitated though what animism is has not been conceptualised in a similar manner. For example, Helvenston and Hodgson (2010) examine animism from a neuropsychological perspective, as an early religious belief spurred by perception and cognition of images that subsequently led to the attribution of soul and spirit to inanimate objects. The authors conceptualise animism as an evolutionary strategy. Other disciplines (philosophy, literature, religious studies) and social movements (environmentalism) have also turned to animism to explore humans' engagement with the world and its non-human members (Harvey 2006).

 In Anthropology, animism as a relational ontology emerged thanks to a greater understanding of Indigenous perceptions of environment and worldviews; incorporation of phenomenological insights; re-rereading of seminal ethnographic works (e.g., Hallowell) and a questioning of the rift between nature/culture, subject/object, as well as of 'personhood' (e.g., Descola 2013; Ingold 2000; Willerslev 2007). As a relational ontology, animism stresses the importance of situated experiences and knowledge, as well as the relevance of incorporating Indigenous voices and perspectives into the creation of knowledge, thus the taking of animism seriously (Porr and Bell 2012; Willerslev 2007, 2013). As a

relational ontology, it stresses as primordial the cultivation of relationships between humans and non-humans and the potential for personhood of non-humans (e.g., Hallowell 1976, 360–361; Harvey 2006; Herva and Lahelma 2020; Willerslev 2007). It challenges the divide between subject and object, human and non-human (e.g., Holbraad and Pedersen 2017; Knappett and Malafouris 2008). Human perspectives are no longer prioritised as other-than-human persons are also capable of 'a point of view' (Viveiros de Castro 1998, 479). Relational ontology also opens the discussion on agency of the non-human and the importance of materials (Ingold 2007). This agency (capacity to act and influence) is not contingent on the human agent and interaction with them (cf. Gell 1998), but rather stems from the physical properties of the being and the relational flux in which this being is engaged. Zedeño (2009) has discussed how agency and animacy (potential for personhood) can manifest themselves in material culture among Algonquian-speaking peoples: through the material and colour (e.g., copper and red ochre are inherently animate); through resemblance to animals or humans (effigies or animal parts); through use in activities that enhance communication or transfer power; and through association with other animate objects and landforms. Objects can be persons and humans will interact with them accordingly. For example, among Indigenous peoples around the Great Lakes and the Subarctic, drums are potent living entities that can talk to humans and influence them (Densmore 1913, 143; Speck 1977, 176–177). Animism has implications for how places and material culture are perceived and experienced and thus, how rock art is engaged with. Places emerge as alive and the abodes of other-than-human persons whose presence is manifested through the material properties of the rock outcrop and of the place (e.g., crevices, quartz veins, peculiar colours, cliff height, echo effect) and the location within the larger cultural landscape (e.g., nearby presence of effigy formations). Images emerge as agents in the relational flux that act and influence instead of being mere representation of a dream, an event or a being.

'All my relations' is a well-known expression that encapsulates this way of relational being and living in Indigenous North America. The non-humans with whom humans engage in reciprocal relationships are diverse, animate, and can possess various amounts of power that can fluctuate, and be beneficial or harmful to humans (Black 1977; Hallowell 1976, 381; Ingold 2000, 112–113; Jenness 1955, 37; Mohs 1987, 59–60). The scope of animate non-humans is large and includes other-than-human persons, animals, plants, places, and some objects of material culture (e.g., Brightman 1993; Drucker 1965, 88; Norder 2012; Teit 1900, 337–344, 354–355; Zedeño 2009). This broader notion of personhood has been first discussed by Hallowell (1976, 1992, 61–65) who coined the term 'other-than-human person.' Humans share an interiority with other-than-human persons, a soul, and qualities such as self-awareness, consciousness, and agency, yet they differ in their external envelope that might transform itself, thus indicating that appearances are deceptive (Hallowell 1976, 381; Viveiros de Castro 1998; see Arnett 2016, 307–308). This class of beings is populated by winds, the sun, the moon, some anthropomorphic and zoomorphic beings (e.g., Thunderbirds), as

well as some stones, animals, plants, and objects of material culture, such as medicine bundles. Other-than-human persons are also perceived as persons because they have the capacity for speech, movement, or have a peculiar and salient physical appearance (e.g., Hallowell 1976; Köhl 1985, 59, 62–64; Mohs 1987, 75; Teit 1900, 337). Cultivating social relations with them is especially important as they possess the most power and can help achieve a successful life (e.g., Hallowell 1976; Zedeño 2009). This animated state of the universe is reflected, for example, in Algonquian languages[2] that make a grammatical distinction between animate and inanimate genders. While most material culture is included in the latter category, some objects, and especially the spiritually powerful objects, such as drums and pipes, as well as stones, wind, other-than-human beings, plants, animals, and humans are included in the animate category (Craik 1982; Hallowell 1992, 61).

Experience is crucial in the animistic perception of the world. The context of relational engagement determines who or what a human met and interacted with (for example the type of an other-than-human person) especially since appearance can deceive (Hallowell 1976). Personal experiences (whether awake or in dreams) ratified by communal experiences (e.g., shamanic performances), oral traditions and traditional knowledge, maintain(ed) animistic conceptions (Hallowell 1934). For example, Hallowell (1934, 394–395) has thus explained the nature of Thunderbirds as being supported by the presence of birds and thunderstorms.

> The belief that Thunder and Lightning are the manifestations of a huge hawk-like bird (pinési·) may at first sight seem a preposterous idea, without the slightest empirical evidence in its favor. But consider the following facts. In April, when pinési· first appears, it inevitably comes from the south. This is likewise the month when the birds begin to arrive from the same direction. In the fall, thunderstorms move towards the south at the same time that the birds begin to disappear in this direction, following the Milky Way which stretches across the heavens almost north and south and called the "summer birds' trail." And these birds, like pinési ·, have disappeared by the end of October, are absent all winter and only reappear the following spring.

Situated experience, memories and practices, local cultural knowledge, and movement along paths sustain the relationship that people develop with landscapes. It is through this 'dwelling perspective' that humans can engage with all of their relations and recognise the agency of non-human components (Ingold 2000). Though located thousands of kilometres apart, the peoples of the Canadian Shield and of southern British Columbia share some similar beliefs regarding landscapes and those who dwell therein. These diverse peoples know that certain other-than-human persons shaped the landscape that we experience today. Among the Salish, the Transformers, such as Old Coyote, are persons that shaped the land and turned many beings (human and non-human) they encountered into stones (boulders, outcrops, cliffs), some of which became rock

art sites (Arnett and Morin 2018, 115; Mohs 1987; Teit 1900, 337). Among the Anishinaabeg of the Great Lakes, the culture hero Nanabush created Lake Superior (Köhl 1985, 460–464), and stone effigy formations are also believed to be beings turned to stone (Copway 1850, 95). Other-than-human beings often-times dwell in/are peculiar, salient locales. These can be mountains, rapids, falls, lakes and rivers, as well as boulders and rocks (e.g., Jones 1861, 85; Mohs 1987, 62; Teit 1900, 338). For example, among the Anishinaabeg, high mountains are the abodes of Thunderbirds (Jones 1861, 86), while for the Interior Salish people, it is the home of Old Man who makes rain and snow (Teit 1900, 341). The peculiar character of the places stemmed often from their visual qualities (particular colours, geomorphological shapes) or from their acoustic properties (e.g., Hind 1860, 2:70–71; Zawadzka 2011). Places in the landscape are remainders that humans are not alone because these locales are homes, sites of transformation or traces of travel, where important beings left behind their baskets or kettles (e.g., Speck 1915, 3; Teit 1900, 337). Despite these overarching similarities, the localised knowledge remains important. For example, the Teme-Augoma Anishnabe of northeastern Ontario, have a story regarding the Seal Rock on Lake Temagami. This story recounts a chase between an other-than-human person – a seal, and a mi•te•´ (medicine man).

> Once upon a time, on a small island in Lake Timagami, some people went ashore, and one of the women left her baby in a cradle-board on a rock, while she went a short distance off. When she came back, the baby was gone; it had been taken by a big manitu (magic) seal who lived in a rock and he had taken the child inside with him. The child's father was also a manitu, so he began burrowing and digging into the rock for his baby and he dug a channel. This hole is there yet. When he reached the baby, it was dead, and the seal was gone. It had dived and crossed two miles under water to Seal island and gone into a big rock there. He dove and followed, as he was mi•te•´ and came to the big rock where the seal had gone in. With his chisel he split the rock, but the seal escaped. The rock is there yet, split down the centre.
>
> (Speck 1915, 68)

The various locales in the story are spread out across the lake. An island named *As-kik Mi-nis-sing* or Seal Island has an unusual large dome rock, which, according to the story, was split with a chisel (Figure 12.2). Similar stories of babies kidnapped by other-than-human persons have been recorded in eastern Ontario, northwestern Ontario, and in Manitoba. All of these stories are tied to particular places in the landscape (Zawadzka 2016, 208).

In the Canadian Shield, rock art is most often associated with the *may-maygwaysiwuk*, medicine men, and puberty vision questing (e.g., Conway 1993; Rajnovich 1994; Hallowell 1992, 64). The *maymaygwaysiwuk*, who are credited with the creation of some sites, dwell within riverbank and lakeside cliffs and some rock art sites are identified as their homes (e.g., Conway 1993, 96, 100;

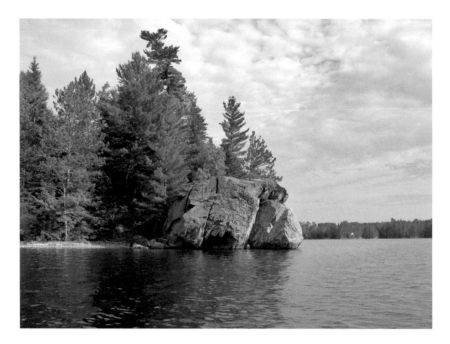

Figure 12.2 Split rock dome on Seal Island, Lake Temagami, Ontario.
Source: Photo by Dagmara Zawadzka.

Dewdney and Kidd 1967). They are known for their medicine (power and knowledge to heal) that they exchanged with medicine men for tobacco. Medicine men could enter the cliffs through cracks or by means of the rock opening up to admit them (e.g., Hallowell 1992, 90). Medicine men were also credited with the creation of rock art. The images represent their visions and places where medicine could be obtained (e.g., Rajnovich 1994). Fasting youth were also closely associated with rock art and the images were believed to enhance the efficacy of their dreams (e.g., Dewdney and Kenneth 1967, 22; Jones 2006).

Among the Salish, pictographs painted with red ochre are found on cliffs along lakes, rivers, and trails, while petroglyphs, carved on boulders and outcrops, are also found in close association with water (Lundy 1974). Oral traditions speak of Transformers who painted some sites or created the rock on which paintings were later applied (Arnett and Morin 2018, 107–109). Some sites were associated with salmon ceremonies (Lundy 1974, 298). Many sites were associated with spiritual initiation and obtaining of power (Lundy 1974, 316–317). Teit (1896) recounts that among the Nlaka'pamux, girls who had undergone puberty initiations, painted their dreams and ceremonial activities on boulders. The sites were also propitious places for the training of medicine men as they were associated with powerful and dangerous beings, such as the *Stl'aleqem*, who taught

medicine men (Arnett and Morin 2018, 112, 116–117). Arnett (2016) and Arnett and Morin (2018) argue that most of the paintings were created as a response to the devastating epidemics that came with European colonisation and were aimed at restoring the health and revitalise the heavily affected communities. Arnett (2016) identified two periods of production. Between the sixteenth to the nineteenth century, medicine men acquired their powers at rock art sites to help defeat the evil—stop the progression of the diseases. The nineteenth- to twentieth-century rock art associated with puberty rites was centred on ideas of fertility to augment the population and on revitalisation of traditional practices.

Power and agency emanates from rock arts of the Canadian Shield and British Columbia Salish peoples. Rock art locations were potent places where communication with other-than-human persons was and still is undertaken. Rock art could act by helping to cement dream visions and powers obtained. This brief summary also hints at the material importance of place, the particularities of the rock outcrop (cracks) and the creation of rock art locales through the activities of Transformers.

3 The road towards relational ontologies

Relational ontologies invite studies of rock art in its local context that eschew Western categories and a focus on the meaning of images (which is often kept secret) (e.g., Arnett and Morin 2018, 104). Such an approach explores how rock art acts and how it participates in the relational process by recognising the agency of the landscape and images and incorporating Indigenous insights on landscapes and its dwellers. The road towards relational ontologies was initiated already in the early 1970s, however it was gradual as researchers explored the materiality of places, recognised the importance of experience in studies of rock art and landscapes, paid greater attention to Indigenous ways of being and knowing, and finally combined these insights into an understanding of animate landscapes replete with agency and teeming with various persons.

The materiality of the place is an important component in recognising the agency of rock art as spiritual powers and other-than-human persons manifests themselves through colour, material, shape, as well as visual and audible properties (e.g., Radin 1914; Zawadzka 2011). Researchers began to delve into the materiality of landscapes (the importance of the rock surface and of landscape characteristics, such as effigies, their relationship to images, and their role in shaping human experiences) in the 1970s and 1980s. These explorations were begun in the Canadian Shield by Vastokas and Vastokas (1973) and Molyneaux (e.g., 1980, 1983). The Vastokases' study of the Peterborough Petroglyphs/ *Kinoomaagewaabkong* (The Teaching Rocks) in Ontario identified the site as a place 'charged with manitou' … and 'the meeting place of earth and sky' due to its peculiar characteristics such as the white crystalline limestone outcrop, the numerous cracks and fissures that criss-cross it and from which some petroglyphs seem to emerge, and due to the sound of an underground stream (Vastokas and Vastokas 1973, 49, 53). Vastokas and Vastokas (1973, 141) state that:

[t]he relationship between the artist and his medium … at this site is one of total cooperation between man and nature; the artist works with, rather than imposes himself upon, the natural environment, a fact that discloses a great deal about the artist's culture, about Algonkian world view and mythology.

Molyneaux, a student of Joan Vastokas, also incorporated physical properties of the sites into his interpretations drawing attention to crevices, colour, and effigies. Joan Vastokas and Molyneaux both included the rich ethnohistorical and ethnographic record that revealed the importance and agency of landscapes. They also both relied on the experience of place (Vastokas was influenced by Rudolf Otto's notion of the 'numinous' experience and by the philosopher John Dewey who bemoaned the separation of Western art from human experience [Vastokas 1992, 17–18]).

Since the 1970s, researchers paid greater attention to places and incorporated more Indigenous insights into their interpretations. They noted the particularities of the rock surface (cracks, white calcite deposits), visual phenomena (light reflecting from water onto rocks) or echoes (Figure 12.3). These were symbols and metaphors of a sacred landscape: cracks as portals to the abodes of the *maymaygwaysiwuk*, and white calcite deposits as excrements of Thunderbirds (e.g., Conway 1993, 89–90; Rajnovich 1994). A study by Wheeler and Buchner (1975) examined the nature of stones as powerful and animate and even alive, through Algonquian languages and their animate category. This was a time of the Durkheimian Tradition in animism studies, where animism was seen as symbolic (Willerslev 2013, 45–46). However, the quest for meaning was of great concern from the 1960s to the 1980s. This quest stressed unduly the primacy of images. It led to elaborations of various typologies while researchers explored ethnohistorical and ethnographic sources in order to elucidate what discrete images signified (e.g., Dewdney and Kenneth 1967; Rajnovich 1994).

In British Columbia, the 1970s were a rather fertile period (Hill and Hill 1974; Lundy 1974; Lundy 1979) dominated by studies of typology, style, and attempts at chronology through stylistic change. Despite the province's rich rock art heritage, it was rarely studied (e.g., York et al. 1993) and it is only since the 2000s that new research has been increasingly produced (e.g., Adams 2003; Arnett 2016).

Since the 1990s, landscape characteristics and the experiential dimension were further explored in the Canadian Shield by Steinbring (1992), Arsenault (1998), Norder (2003), and Zawadzka (2008), however, this time the emphasis shifted further away from attempts to decipher the images to the landscape context and phenomenology. Phenomenology plays an important role in ontological explorations (e.g., Ingold 2000; Willerslev 2013) and its beginnings can be traced back to Hallowell's work among the Ojibwe (Spiro 1976, 353–354). While Steinbring (1992) identified the types of phenomenological attributes that would influence site selection and Norder (2003) explored how these attributes could convey information in the landscape, Arsenault (1998) and Zawadzka (2008) embraced Tilley's (1994) phenomenological approach. However, Tilley did not ascribe agency to landscape and credited human actions as transformative of

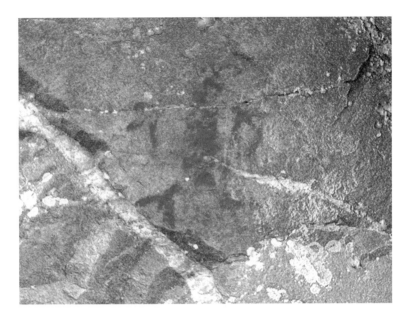

Figure 12.3 A Thunderbird clutching a quartz vein, Lake Mazinaw, Ontario.
Source: Photo by Dagmara Zawadzka.

spaces into places, a concept that ultimately is incompatible with relational ontology.

The rise of landscape approaches as championed by Christopher Tilley and Richard Bradley, problems with interpretation of images and a desire to move beyond the strictly sacred interpretations of rock art were among factors that turned attention away from images and their meanings[3] to cultural landscapes and that set the stage for, what Willerslev (2013, 48) has called the Ingoldian Tradition of animism as 'Being-in-the-world.' Ingold's take on phenomenology, his re-reading of ethnographic accounts of hunter-gatherers, his emphasis on relationality and on places and non-human agency as emerging through relationships, which conforms with Indigenous perceptions of the world, and his eloquent and erudite prose captured the hearts of researchers. These researchers explore rock art landscapes and images as embedded in multiple relations in space (e.g., Creese 2011; Zawadzka 2013) and time (Norder 2012; Arnett 2016) while questioning the established categories such as those of images, places, and rock art. Though Hallowell's insights and ethnographic and ethnohistorical sources were explored by researchers since the pioneering work of Selwyn Dewdney (the father of rock art research in Canada) and Joan Vastokas, animism and its related beliefs and practices were approached as a source of knowledge for the meaning of images and of landscape characteristics. The emergence of the 'ontological turn' in the 1990s did not initially have an impact on rock art

investigation. The 1990s were overall a period of downturn in rock art research in Canada and it is only since the 2010s that a full commitment to relational ontology has emerged.

4 Place, image, and relations in Canadian rock art

Relational approaches to rock art offer new ways of looking at the inter-connectedness of images, places, and landscapes, more holistic interpretations that move beyond the religious sphere (in an ironic twist as the Tylorian Animism was considered a 'primitive religion') and help to question or dismantle established categories. These approaches demonstrate how rock art, landscape, and various beings influence and complement each other while dwelling in the world (Ingold 2000). They show how the deep context of interactions tied to places generates relations and thus allows for life and powers to flow.

4.1 Landscapes and images

So far, few studies have examined how humans, non-humans, images, places, pathways and territories interacted with each other and were steeped in rela-tional ontology. Arnett (2016) gives us a unique and detailed study of the Nlaka'pamux (Interior Salish) rock art. Arnett (2016, 293) states that to under-stand the practice of rock art and its inherent non-human agency, one has to interlace together 'the relationships between the material culture and the land-scape, language, travel corridors, origin stories, colonization, ethnography, and intergenerational history.' Such rich contexts cannot be gleamed from images alone, and one needs access to and a comprehension of the rich ethnographic record, the knowledge of the immaterial (songs, stories) and its connection to the material (rock art), as well as insights from the living descendants for whom these sites continue to be of importance. Arnett skilfully weaves various strands of evidence (Indigenous language, terminology and stories; archaeology, geomor-phology of the place). Arnett (2016, 315–318) discusses the geomorphology of the sites and the 'stone people,' beings who after transformation became places were rock art was made, as well as places were power resides. These places beckoned people to create rock art, and they posses their own inherent non-human agency (Arnett 2016, 321–322). This agency stemmed among others from the place's geomorphology (veins, fissures, mineral deposits) that participated in rock art creation, thus further pointing to the agency of the rock (Arnett 2016, 352). Images are organic creations that link humans, other-than human persons that gift humans with the imagery, and the rock itself whose geomorphology is integrated in the image (Arnett 2016, 321–323). Rock art was meant to be seen and its power acknowledged as it was located along major water routes and trails where it could deter the nefarious effects of colonisation—physical or spiritual enemies that came to harm the Nlaka'pamux (Arnett 2016, 367, 393–395). In the end, we are privileged to a rare and deep, local and historical understanding of Nlaka'pamux rock art that emerges as historically contingent and implicated in

people's revitalisation and as a sentient agent that deters evil and anchors relationships in the landscape.

Creese (2011) also tackles landscapes and eschews the iconocentric traditional rock art study. He examines Algonquian landscapes of the Canadian Shield through 'being-in-the-world,' where humans were involved in the exchange of power with other agents and where rock art participates in maintaining relationships. He paints a moral landscape where maintaining proper reciprocal relationships is crucial for the flow of a good life. Rock art sites are liminal places where power was exchanged and where rock art anchored the presence of power and helped to experience it. I examine rock art as an agent implicated in building and maintaining relationships between Indigenous people of the Temagami area (northeastern Ontario), other First Nations and other-than-human persons (Zawadzka 2013, 2016, 2019). By examining the pictorial content, landscape attributes (geomorphology of sites and their surroundings) and the placement of the sites in relation to archaeological and sacred sites, traditional water routes, and band territories, I unveiled a landscape where rock art served a number of various functions. The sites functioned as sacred sites, navigational aids, mediums for the mediation of social boundaries, and possibly as deterrent art against Haudenosaunee (Iroquois) attacks in the seventeenth century. As sacred sites, some rock art sites were particularly suited for individual or communal rituals or for places where medicine men practiced their rites. Rock art's strong association with travel routes points to its role as a landmark and a liminal place in a journey where the assistance of other-than-human persons was solicited. Some salient sites located on major travel routes were suited for rituals where social boundaries were negotiated between the Teme-Augama Anishnabai and non-band members. I give a prominent place to pathways, as important actors that weave places, humans, and non-humans together. Similarly, the agency of images emerges as an important aspect of the relational process. By couching the images' discussion in the wider context of Algonquian art and image-making practices that point to an art made for honouring and propitiating other-than-human persons, for validating and cementing dreams, visions and relationships and for influencing others (e.g., sorcery, curing, hunting, magic), images emerge as animate agents that act. Ultimately, places, paths, images, humans, non-humans, and their actions all participated in the relational process.

The overview of these various studies points to the importance of the non-human agency of places, paths, and images and to the ever-present exchange of power within landscapes. A relational ontology of landscapes, however also helps to questions some of the assumptions of our discipline.

4.2 Categories

Relational approaches to rock art point to the importance of the place, paths, landscape, and immaterial elements (stories, rituals) alongside images that are all constitutive of each other. A relational approach also helps to break down the

Figure 12.4 Many connecting pathways. View onto various travel routes from the top of the Blindfold Lake site, northwestern Ontario.
Source: Photo by Dagmara Zawadzka.

dichotomy between place and path. Animistic landscapes emerge through mobility and flow. As Ingold (2000, 204) has stated,

> [t]o reach a place, you need cross no boundary, but you must follow some kind of path. Thus there can be no places without paths, along which people arrive and depart; and no paths without places, that constitute their destinations and points of departure.

Paths weave landscapes and allow for relationships to be born, to exist and to die. The power must flow! And paths allow it by letting humans and non-humans to travel and interact with each other (Figure 12.4).

The relational approach also points to the continuous importance of rock art for people. Norder (2012) has argued for a rock art perceived through the framework of user/caretaker instead of maker/meaning. Analysing rock art through the former context is more efficient because the original meaning of the images is often lost and emphasis can be put on the active engagement and continuous use of a rock art site. This user/caretaker perspective highlights the importance of the dialogue that takes place between humans and other-than-human persons and the

re-appropriation of rock art by Indigenous people. This perspective explains why rock art remained of importance to Indigenous users throughout time. Norder's argument can be developed further. Rock art is known to have a plurality of meanings that change depending on active engagement with these places and images (Norder 2012; Rajnovich 1994). The idea of original meaning does not hold up within a relational ontology where places and images are in a constant process of becoming and where images are not simple inert representations of the world (Ingold 2000, 111–131, 2010; Zawadzka 2019, 83). Rock art emerges from the process of maintaining relations between humans, places, images, and other-than-human persons. How people approach it, will depend on their knowledge, experiences, and the material properties of landscapes. Rock art participates in revealing and maintaining dynamic local knowledge that evolves with accrued experiences. The act of creation and subsequent interactions are of greater importance than what is on the rock as these engagements ignite emotions and beckon stories (Ingold 2010; Zawadzka 2019, 84). Rock art has agency, as well as powers that can wax and wane. Images and places participate in the reciprocal exchange of powers and they can gain or lose strength, they can be injured or healed (e.g., Norder 2003, 22). Both rock art and a person will be affected by their interaction. Just as people can gain strength from rock art and powers to act, places can also lose their powers (Zawadzka 2016, 200, 283). This plurality of fluid situated meanings and knowledges leads to rock art being known as 'teachings' that can sustain the relationships between humans and the land (e.g., Twance 2017). The framework of practical engagement allows to re-cast rock art sites in various contexts of use, allowing for their multifunctionality and for a flourishing of a multitude of relationships.

Rock art as a category is also subject to a closer scrutiny. The term 'rock art' has enjoyed a somewhat restrictive connotation, in part because of its adherence to limited modernist definitions of 'art' (Vastokas 1992; Zawadzka 2016, 8–11). The debate on the terminology (rock art vs. rock-art) is well known in our discipline. Rather, the problem lies in the apparent unsuitability of the term 'rock' to convey the true richness of the phenomena to which it is attached. Rock art is more than the surface on which images were painted or carved. It is the paths along which the place is located, the proximity of other places filled with agency and the larger placement within the territory of a group, it is the stories, the memories, and the experiences of people. In this complex sense, rock art can be understood as landscape art, teeming with activity, sociability, and living presence (Zawadzka 2016, 307–308). Though I in no way advocate for some new terminology, I think that to remind oneself of this reality broadens our horizons and understandings.

5 Conclusion

Rock art studies in Canada are increasingly caught up in relational ontologies. This chapter sought to present the latest studies from the Canadian Shield and southern British Columbia that engage with this approach and that indicate

8 *Dagmara Zawadzka*

how closely rock art is bound up with the landscape, experience, its human and non-human inhabitants, and the immaterial dimension of stories and memories. Relational approaches to rock art seem to have emerged organically from a previous solid base of landscape context studies, of a rich ethnographic and ethnohistorical record, and of a greater opening to Indigenous ways of being that have been steadily explored since the pioneering work of the 1970s. These insights were combined with theoretical advances of researchers of 'new animism' and have given a new direction to rock art studies and opened new avenues for its appreciation. Rock art is becoming popular again in Canada and undoubtedly, more interesting studies that incorporate Indigenous perceptions will be produced (see Twance 2017). However, in keeping with Indigenous understandings of local knowledge tied to place and its sharing and acquisition, we shouldn't expect to know everything about rock art lest we pay a price as the fasting boy did in a story told to Hallowell (Brown 2006, 24). The boy wanted to dream of all the leaves on all the trees in the world in order to have superior knowledge. He did not listen to the voice of an 'other-than-human' person who advised him against this feat. Finally, the voice said:

> 'Grandson,' … 'you've been dreaming of every tree in the world that bears a leaf but as soon as the leaves start to fall, you will get sick. Then, when all the leaves drop to the ground, your life will end. You can't blame me. It is your own fault. I told you it was not good to know everything.' [In the end] 'It is better to dream of many things than too much of one thing.'

Notes

1 The precise number of the sites is not known, however consultation with colleagues in Ontario (Bill Buchan), Manitoba (Jack Steinbring), and Saskatchewan (Tim Jones) indicate that there are at least 800 confirmed sites. The approximate number of BC rock art sites has been obtained from Doris Lundy.
2 This linguistic family stretches across Canada from the Maritimes to Alberta. Some Salish languages recognise the masculine and feminine genders (Gillon 2019).
3 A thorough discussion of issues surrounding the interpretation of rock art images is beyond the scope of this chapter. However problems with identifying what is represented and overarching and limited interpretations (such as shamanism) that failed to account for the plurality of situated rock art functions, incited researchers to turn towards landscapes and relational ontology that could better make sense of the complex phenomenon of rock art (e.g., Norder 2003, 2–23; Zawadzka 2016, 14–18, 70–71, 138).

References cited

Adams, Amanda. 2003. "Visions cast on stone: A stylistic analysis of the petroglyphs of Gabriola Island, B.C." MA thesis, University of British Columbia.
Arnett, Chris. 2016. "Rock art of Nlaka'pamux: Indigenous theory and practice on the British Columbia Plateau." PhD diss., University of British Columbia.

Arnett, Chris, and Jesse Morin. 2018. "The rock painting/Xela:ls of the Tsleil-Waututh: A historicized Coast Salish practice." *Ethnohistory 65* (1): 101–127.

Arsenault, Daniel. 1998. "Esquisse du paysage sacré algonquien: Une étude contextuelle des sites rupestres du Boulier canadien." *Recherches amérindiennes au Québec 28* (2): 19–39.

Black, Mary B. 1977. "Ojibwa power belief system." In *The Anthropology of Power: Ethnographic Studies from Asia, Oceania, and the New World*, edited by Raymond D. Fogelson and Richard N. Adams, 141–151. New York: Academic Press.

Brightman, Robert. 1993. *Grateful Prey: Rock Cree Human-Animal Relationships*. Berkeley: University of California Press.

Brown, Jennifer S.H. 2006. "Fields of dreams: Revisiting A. I. Hallowell and the Berens River Ojibwe." In *New Perspectives on Native North America: Cultures, Histories, and Representations*, edited by Sergei A. Kan and Pauline Turner Strong, 17–41. Lincoln: University of Nebraska Press.

Clodd, Edward. 1905. *Animism: The Seed of Religion*. London: Archibald Constable.

Conway, Thor. 1993. *Painted Dreams*. Minocqua: Northwood Press.

Copway, George. 1850. *The Traditional History and Characteristic Sketches of the Ojibway Nation*. London: Charles Gilpin.

Craik, Brian. 1982. "The animate in Cree language and ideology." In *Papers of the Thirteenth Algonquian Conference*, edited by William Cowan, 29–36. Ottawa: Carleton University.

Creese, John L. 2011. "Algonquian rock art and the landscape of power." *Journal of Social Archaeology 11* (1): 3–20.

Densmore, Frances. 1913. *Chippewa Music - II*. Bureau of American ethnology. *Bulletin 53*. Washington, DC: Smithsonian Institution.

Descola, Pierre. 2013. *Beyond Nature and Culture*. Translated by J. Lloyd. Chicago: The University of Chicago Press.

Dewdney, Selwyn, and Kenneth Kidd. 1967. *Indian Rock Paintings of the Great Lakes*. Toronto: University of Toronto Press.

Drucker, Philip. 1965. *Cultures of the North Pacific Coast*. San Francisco: Chandler Publishing Co.

Gell, Alfred. 1998. *Art and Agency: An Anthropological Theory*. Oxford: Clarendon.

Gillon, Carrie. 2019. "The expanded NP: Number, possessors, gender, animacy, and classifiers." In *Routledge Handbook of North American Languages*, edited by Daniel Siddiqui, Michael Barrie, Carrie Gillon, Jason D. Haugen, and Éric Mathieu, 114–148. New York: Routledge.

Hallowell, A. Irving. 1934. "Some empirical aspects of northern Saulteaux religion." *American Anthropologist 36* (3): 389–404.

Hallowell, A. Irving. 1976 [1960]. "Ojibwa ontology, behaviour, and world view." In *Contributions to Anthropology. Selected Papers of A. Irving Hallowell*, 357–390. Chicago and London: The University of Chicago Press.

Hallowell, A. Irving. 1992. *The Ojibwa of Berens River, Manitoba. Ethnography into History*, edited by Jennifer S.H. Brown. Fort Worth: Harcourt Brace Jovanovich College Publishers.

Harvey, Graham. 2006. *Animism: Respecting the Living World*. New York: Columbia University Press.

Helvenston, Patricia A., and Derek Hodgson. 2010. "The neuropsychology of 'animism': Implications for understanding rock art." *Rock Art Research 27* (1): 61–94.

Herva, Vesa-Pekka, and Antti Lahelma. 2020. *Northern Archaeology and Cosmology: A Relational View*. London: Routledge.

Hill, Beth, and Ray Hill. 1974. *Indian Petroglyphs of the Pacific Northwest*. Seattle: University of Washington Press.

Hind, Henry Y. 1860. *Narrative of the Canadian Red River Exploring Expedition of 1857, and of the Assinniboine and Saskatchewan Exploring Expedition of 1858* (2 vols). London: Longman, Green, Longman and Roberts.

Holbraad, Martin, and Morten Axel Pedersen. 2017. *The Ontological Turn: An Anthropological Exposition*. Cambridge: Cambridge University Press.

Ingold, Tim. 2000. *The Perception of the Environment. Essays in Livelihood, Dwelling and Skill*. London and New York: Routledge.

Ingold, Tim. 2007. "Materials against materiality." *Archaeological Dialogues 14* (1): 1–16.

Ingold, Tim. 2010. "Ways of mind-walking: Reading, writing, painting." *Visual Studies 25* (1): 15–23.

Jenness, Diamond. 1955. *The Faith of a Coast Salish Indian*. Anthropology in British Columbia, Memoir No. 3. Victoria: British Columbia Provincial Museum.

Jones, Andrew M. 2017. "Rock art and ontology." *Annual Review of Anthropology 46*: 167–181.

Jones, Rev. Peter. 1861. *History of the Ojebway Indians with Especial Reference to Their Conversion to Christianity*. London: A. W. Bennett.

Jones, Tim E.H. 2006. *The Aboriginal Rock Paintings of the Churchill River*. Saskatchewan: Saskatchewan Archaeological Society. First published 1981.

Knappett, Carl, and Lambros Malafouris (eds). 2008. *Material Agency: Towards a Non-Anthropocentric Approach*. Berlin: Springer.

Köhl, Johann G. 1985 [1860]. *Kitchi-Gami: Life Among the Lake Superior Ojibway*. St. Paul: Minnesota Historical Society Press.

Lundy, Doris. 1974. "The rock art of the northwest coast." MA thesis, Simon Fraser University.

Lundy, Doris. 1979. "The petroglyphs of the British Columbia Interior." In *CRARA '77: Papers from the Fourth Biennial Conference of the Canadian Rock Art Research Associates*, edited by Doris Lundy, 49–70. Heritage Record No. 8. Victoria: British Columbia Provincial Museum.

Mohs, Gordon. 1987. "Spiritual sites, ethnic significance, and native spirituality: The heritage sites of the Sto:lo Indians of British Columbia." MA thesis, Simon Fraser University.

Molyneaux, Brian L. 1980. "Landscape images." *Rotunda 13* (3): 6–11.

Molyneaux, Brian L. 1983. "The study of prehistoric sacred places: Evidence from Lower Manitou Lake." *Royal Ontario Museum Archaeology Paper 2*: 1–7.

Norder, John W. 2003. "Marking place and creating space in northern Algonquian landscapes: The rock-art of the Lake of the Woods Region, Ontario." PhD diss., University of Michigan.

Norder, John W. 2012. "The creation and endurance of memory and place among First Nations of Northwestern Ontario, Canada." *International Journal of Historical Archaeology 16* (2): 385–400.

Porr, Martin, and Hannah Rachel Bell. 2012. "'Rock-art', 'animism' and two-way thinking: Towards a complementary epistemology in the understanding of material culture and 'rock-art' of hunting and gathering people." *Journal of Archaeological Method and Theory 19* (1): 161–205.

Radin, Paul. 1914. "Religion of the North American Indians." *The Journal of American Folklore 27* (106): 335–373.

Rajnovich, Grace. 1994. *Reading Rock Art: Interpreting the Indian Rock Paintings of the Canadian Shield*. Toronto: Natural Heritage/Natural History Inc.

Speck, Frank G. 1915. *Myths and Folk-Lore of the Timiskaming Algonquin and Timagami Ojibwa*. Geological Survey no. 71. Department of Mines. Ottawa: Government Printing Bureau.

Speck, Frank G. 1977 [1935]. *Naskapi, the Savage Hunters of the Labrador Peninsula*. Norman: University of Oklahoma Press.

Spiro, Melford E. 1976. "Introduction." In *Contributions to Anthropology. Selected Papers of A. Irving Hallowell*, 353–356. Chicago and London: The University of Chicago Press.

Steinbring, Jack. 1992. "Phenomenal attributes: Site selection factors in rock art." *American Indian Rock Art 17*: 102–113.

Teit, James. 1896. "A rock painting of the Thompson River Indians, British Columbia." *Bulletin of the American Museum of Natural History 8*: 227–230.

Teit, James. 1900. "The Thompson Indians of British Columbia." *Publications of the Jesup North Pacific Expedition 1* (4): 163–392. Memoirs of the American Museum of Natural History, Vol. 2, Part 4. New York: G. P. Putnam's Sons.

Twance, Melissa. 2017. "It was your ancestors that put them there and they put them there for you. Exploring indigenous connection to Mazinaabikiniganan as land-based education." MA thesis. Lakehead University.

Tylor, Edward B. 1871. *Primitive Culture: Researches into the Development of Mythology, Philosophy, Religion, Art, and Custom*. London: John Murray.

Vastokas, Joan M. 1992. *Beyond the Artifact: Native Art as Performance*. Toronto: Robarts Centre, York University.

Vastokas, Joan M., and Romas Vastokas. 1973. *Sacred Art of the Algonkians: A Study of the Peterborough Petroglyphs*. Peterborough: Mansard Press.

Viveiros de Castro, Eduardo. 1998. "Cosmological deixis and Amerindian perspectivism." *Journal of the Royal Anthropological Institute 4* (3): 469–488.

Wheeler, Clinton J., and A.P. Buchner. 1975. "Rock art: A metalinguistic interpretation of the Algonkian word for stone." In *Papers of the Sixth Algonquian Conference, 1974*, edited by William Cowan, 362–371. Canadian Ethnology Service Paper 23, Mercury Series. Ottawa: National Museum of Man.

Willerslev, Rane. 2007. *Soul Hunters. Hunting, Animism, and Personhood among the Siberian Yukaghirs*. Berkeley: University of California Press.

Willerslev, Rane. 2013. "Taking animism seriously, but perhaps not too seriously?" *Religion and Society: Advances in Research 4*: 41–57.

York, Annie, Richard Daly, and Chris Arnett. 1993. *They Write their Dreams on the Rocks Forever: Rock Writings of the Stein River Valley British Columbia*. Vancouver: Talonbook.

Zawadzka, Dagmara. 2008. "Canadian Shield rock art and the landscape perspective." MA thesis, Trent University.

Zawadzka, Dagmara. 2011. "Spectacles to behold: Colours in Algonquian landscapes." *TOTEM. The University of Western Ontario Journal of Anthropology 19* (1): 6–37.

Zawadzka, Dagmara. 2013. "Beyond the sacred: Temagami area rock art and indigenous routes." *Ontario Archaeology 93*: 159–199.

Zawadzka, Dagmara. 2016. "Cultivating relations in the landscape: Animism and agency in the rock art of Temagami Region, Northeastern Ontario." PhD diss., Université du Québec à Montréal.

Zawadzka, Dagmara. 2019. "Rock art and animism in the Canadian Shield." *Time and Mind. The Journal of Archaeology, Consciousness and Culture 12* (2): 79–94.

Zedeño, Maria N. 2009. "Animating by association: Index objects and relational taxonomies." *Cambridge Archaeological Journal 19* (3): 407–417.

13 An ontological approach to Saharan rock art

Emmanuelle Honoré[1]

1 Introduction: Ontological approaches in the context of Saharan rock art studies

As several authors have pointed out, archaeology is a highly anthropocentric discipline (Jones 2012; Fowler 2013). A conventional definition of the discipline is that it concerns the study of past human life and activities. Hence, any kind of engagement with the world is seen from the viewpoint of human beings: what it makes for humans, what it changes to human life, and what it says about the human condition. For decades, archaeologists have mostly emphasized the genius of the human mind, our creative spirit, and the success of technical innovations that litter our long history (Latour and Lemonnier 1994). However, this paradigm has come under attack in recent years, as demonstrated by the rise of symmetrical archaeology (Witmore 2007; Shanks 2007), anti-humanist perspectives (Thomas 2002; Calvert-Minor 2010) and, in general, an increasing deconstruction of what Tim Hayward had qualified as 'human chauvinism' along with speciesism and anthropocentrism (Hayward 1997, 53–54).

In this setting, several authors have suggested that archaeology and anthropology have long retained an ethnocentric Western-oriented discourse (Descola 2005; Latour 2005; Atalay 2006; Colwell-Chanthaphonh et al. 2010), implicitly assuming that our own conceptions of the world make an effective canvas to describe and understand the lives, thoughts, and actions of people from other cultures or other time periods. Going against this assumption, the 'ontological turn' has had a massive impact in the field of anthropology since the 1990s. Social anthropologists have called into question their ways of understanding of peoples' being, becoming, and interacting in and with the world (Viveiros de Castro 1998; Bird-David 1999). In archaeology, as well as in rock art research, ontological approaches are relatively new (see, for instance, Watts 2013; Buchanan and Skousen 2015; Alberti 2016; Harrison-Buck and Hendon 2018; Lahelma and Herva 2019; Brück 2019) and there are entire areas of research in which the impact and application of ontological approaches have been minimal.

This last statement is particularly true for North African rock art studies, a field in which there is a long tradition of research mainly concerned with stylistic and chronological analyses. In the Sahara, this tradition goes back to the 1930s and

1940s, with the pioneering works of Lhote (1958) and Graziosi (1942). The initial concern of these early works was the description of animal and human motifs: animals were conceptualized in terms of palaeoecological implications, and humans viewed within the scope of anthropobiological considerations (Muzzolini 1986). As the corpus of rock art began to represent a large volume, the 1980s–1990s were a period marked by stylistic and chronological analyses (Le Quellec 1998, 231–271). This period witnessed a passionate controversy between those who advocated for a 'long chronology' arguing that Saharan rock art started at the end of the Pleistocene, and those who supported a 'short chronology' suggesting that Saharan rock art started from the 8th–7th millennia BC onwards (Le Quellec 2013a, 16–17). Stylistic and chronological questions still dominate the debate in Saharan rock art studies. Broader and more integrative approaches have been developed since the beginning of the twenty-first century, including paleoenvironmental, GIS, and landscape analyses (e.g., Barich 1998; Di Lernia and Gallinaro 2010; Lenssen-Erz 2012; Gallinaro 2013; Honoré 2019a). Despite how fascinating many of these publications are, they are still grounded in some implicit assumptions of traditional archaeology, and especially the view that rock art is a set of images representing things *lato sensu* and that our task is to ascribe meaning on it. In this setting, ontological approaches have had little impact on this field of research.

Ontologies are a theory of being and becoming. Any approach in archaeology is based on an ontology, on a view of how the world is constituted and organized. Thus far, in Saharan rock art studies, researchers have implicitly assumed that our own naturalist ontologies were universal and, thus, did not need to be discussed nor challenged in interpreting this rock art. Following the ontological turn, I argue that considering the existence of other ontologies, especially relational ontologies, is key to an understanding of Saharan rock art. The reluctance of scholars to examine Saharan rock art through the lens of ontological theory may be explained by a number of factors. The lack of Indigenous knowledge and the absence of what has been called a 'cultural legacy' (Burt 2013, 70) in the area somewhat explain the tendency of Saharan rock art researchers to consider rock art a static imagery. This is related to a widespread belief in archaeology wherein ontological approaches are only possible when archaeologists have access to Indigenous information. This is what Sam Challis implicitly suggested when he wrote that ontological approaches in South Africa were possible because of the fortunate access to "some, if not all, of the Indigenous idioms that may obtain in contexts of art belonging to 'traditional' belief systems" (Challis 2019, 17).

In this chapter, I challenge the aforementioned view and explore the potential of ontological and relational approaches to archaeological materials that are not associated to ethnographical data. First, I examine the anthropocentric foundation of our understanding of Saharan rock art with reference to a number of images 'representing' 'transmorphic beings' (Figure 13.1). Drawing upon the notion of transmorphism in Chumash belief (Blackburn 1975, 40), the term 'transmorphic beings' was originally coined by David Robinson to describe beings made by the combination of 'a collective range of parts' (human, animal, but also vegetable and probably astronomical bodies) in the Chumash imagery

(Robinson 2013, 67). Second, I seek to demonstrate that the absence of Indigenous knowledge on Saharan rock art does not make it impossible to reconstruct past ontologies. The challenge to approach ontologies, and especially relational ontologies (which are by essence non-material) from the material remnants of past cultures is widely shared and applies to any kind of archaeological material. In rock art imageries, ontologies constitute the invisible but significant canvas on which images were made. A relational approach can help to make ontologies appear like an after-image emerging from the corpus. And yet this relational approach must not only be image-based. Our own naturalistic ontologies have heavily influenced rock art studies (Moro Abadía et al. 2012) and directed interpretations towards the mere representational power of images. Saharan rock art studies still place a strong emphasis on representational images and their figurative value. This is probably related to the narrative nature of many of those images (Barbaza 2015). However, as Jones and Cochrane have pointed out (Jones and Cochrane 2018, 5–15), representational purposes constitute only a small fraction of motives and methods for the creation of art in many places and at different times, and Saharan rock art is certainly no exception to this. Evidence from the Saharan rock art corpus demonstrates that rock art was not only a way of displaying narratives, but also part of a wider engagement involving performance, gatherings, and ceremonies, making the invisible part of life visible (Honoré 2019b, 118–119).

2 Permeable essences: Transmorphic beings in Saharan rock art

The Round Heads of the Tassili n'Ajjer and the Akûkâs (or Akakus) in the Central Sahara (Algeria and Libya) are among the most popular images of

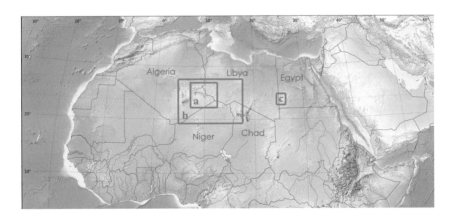

Figure 13.1 Map of distribution of Saharan rock art figures mentioned in the chapter: (a) Round Heads; (b) Theriantrops; (c) "Beasts."
Source: Copyright Emmanuelle Honoré.

Saharan rock art. These representations are some of the most ancient paintings in the Sahara, with a chronology that ranges from 10,000 to 4000 BCE, depending on the authors (Di Lernia 2019, 107). Additionally, these images illustrate, probably better than any other element in the archaeological record, many of our biases and prejudices in the interpretative process. Round Heads paintings were discovered in 1933 by the French Lieutenant Charles Brenans, who was exploring the mountainous massif of the Tassili n'Ajjer with his army detachment. He reported two sites containing prehistoric paintings. One of Brenans' men, Henri Lhote, returned to the site in 1956 with an expedition of 14 people and 30 camels. During four seasons between 1956 and 1962, his team of painters and photographers documented 400 panels of rock art that were exhibited in 1957–1958 at the *Musée des Arts Décoratifs* in Paris (Lhote 1957). The exhibition largely substantiated a number of widespread ideas about Saharan rock art in France and Europe. In particular, these paintings became one of the prototypes of primitive anthropomorphic representations, with their characteristic neckless head, round and disk-like, the lack of facial details and their corporeal ornamentation (Figure 13.2). Amongst the Round Heads, Henri Lhote distinguished a number of styles and sub-styles. He called one of these 'Martians' because of the supposed resemblance of these figures to space-suited astronauts (Lhote 1955, 70). Although he certainly did not intend to offer a scientific definition of the aforementioned style, the term passed into the common parlance of Western archaeologists. The use of such a contemporary imaginary is generally considered romantic, outdated, and misleading (Le Quellec 2009).

In interpretative terms, archaeologists have long assumed that the tall anthropomorphic figures of the Round Head paintings were part of a prehistoric religion. The term *Grands Dieux* first appeared in the writings of Henri Lhote (1958, pl. II). These 'Great Gods' consist of a series of oversized figures, up to 6 m high, in the style of Round Heads paintings. In his book *À la découverte des fresques du Tassili* (1958), Lhote described one of the figures as the 'Abominable Sandman,' belonging to the group of Martians (Figure 13.3). Another famous 'Great God' in Sefar of 2 m high has been called the 'Great White God,' the 'Fisher God'—as it seems to hold a fish, and another the 'Rain God,' as the figure is superimposed on a presumed rain cloud. While researchers agree that such figures in the group of Round Heads could have many interpretations (see for example the hypothesis of masks, in Lajoux 1977), the reiterate use of a religious terminology has contributed to a reduction of these numerous different interpretations into a single understanding that is based on Western constructs, and especially on our modern division between the natural and the supernatural. This religious interpretation of rock art was once common currency among rock art scholars. After all, at least until the 1980s, the understanding of prehistoric art was grounded on what Mary Douglas called 'the myth of pious primitive' (Douglas 1975, 81), the idea that Indigenous peoples are universally religious by nature—in the sense we give to 'religions.' Moreover, these interpretations assume that the authors of these paintings made a distinction between the natural ('normal' people) and the supernatural ('Gods').

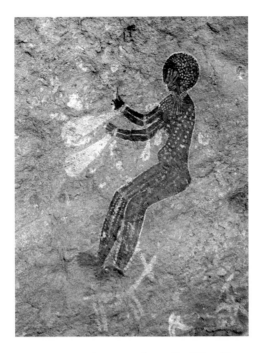

Figure 13.2 Round Head human figure on the wall of Tan Zoumaïtak shelter, Tassili n'Ajjer, Algeria (height: 0.72 m).
Source: Copyright Christian Mathis.

The so-called 'theriantrops' (figures mixing human and animal body parts in the Central Sahara) can also illustrate a number of widespread ideas about Saharan rock art (please see Figure 13.3). Images of anthropomorph-like beings are not uncommon in Saharan rock art. For instance, there are about 421 representations depicting a human body with an animal head in Central Sahara, mainly in the Messak and the Tassili n'Ajjer massifs, sharing some formal affinities (Le Quellec 2013b, 157). After Lewis-Williams' works on southern African rock art (Lewis-Williams 1981), the shamanistic hypothesis has been tentatively applied to the rock art record of the Central Sahara. A variety of images have been taken as signs of shamanism: rounded heads because of their deformed appearance (Fagnola 1995; Anati 1995), ovoid bodies (Soleilhavoup 1998), mushroom-like shapes (Samorini 1990, 1992), spirals, lines, and what would be qualified as formlings (Searight 1997), 'jellyfish' being interpreted as phosphenes (Fagnola 1995), motifs on animal coat overrunning it or looking like a ladder being interpreted as entoptic phenomena (Soleilhavoup 1998), and abstract images presumably resulting from altered states of consciousness (Anati 1988). Among such interpretations, floating humans and theriantrops have been viewed as potential images of shamans (Sansoni 1980, 1994). Likewise, because Round Head paintings do not fit the Western 'naturalistic' ideal, they have

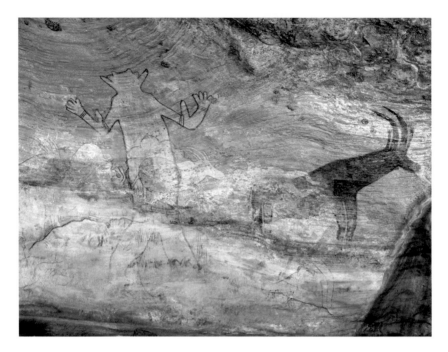

Figure 13.3 "*Grand dieu*" of Sefar, also named the White God or the Rain God, Tassili
 n'Ajjer, Algeria (height: 2.80 m).
Source: Copyright Christian Mathis.

sometimes been considered as inspired by hallucinations. In other words, they have
been regarded as evidence of 'the existence of an African shamanism, vanished in
Northern Africa while surviving in Southern Africa' (Soleilhavoup 1998, 32).

Rock art scholars have called into question the shamanistic paradigm (Muzzolini
1988–89, 1995; Le Quellec 1999, 2006). In particular, the universal application of
this paradigm to images from completely different cultural traditions is to be taken
with great caution. This constitutes an illustrative example of 'approaches that simply
slotted rock art into pre-existing, and overarching, anthropological categories' (Jones
2017, 176). In a recent paper, Soukopova compared Round Head down-headed
animals to San rain animals, suggesting they similarly depict altered states of con-
sciousness on the basis that 'they are both indeterminable as a species and apparently
very similar in form' (Soukopova 2011, 205). Without heeding the geographical and
chronological distance between the two groups, the author concludes that 'con-
sidering a possible common base of the African culture and its great conservatism, it
would not be surprising to find similar elements in the prehistoric Round Head art
and in the more recent San art' (Soukopova 2011, 206).

The search for formal analogies has often driven research on Saharan rock art.
This is the case, for instance, for a series of 35 images of 'composite' creatures

combining animal and human traits found at five rock art sites in the Gilf el-Kebir massif (SW Egypt). These images have been called 'the beast(s)' or 'the headless beast (s)' (Le Quellec et al. 2005; Kuper 2013). Their chronology varies according to author (Le Quellec et al. 2005; Kuper 2013; Honoré et al. 2016), but it can reasonably be assumed to date to around 6000 BC. Jean-Loïc Le Quellec has suggested Wadi Sūra paintings prefigure mortuary beliefs known in the Nile Valley at pharaonic times. He has argued that the 'headless beasts' show formal similarities with the great devourer Ammut; the 'swimmers' are analogous to the 'drowned of the Nun' (the primitive ocean) described in the Book of the Dead of the Egyptian New Kingdom; and the hand prints to the hieroglyphic sign Ka (Le Quellec et al. 2005, 196). More recently, Miroslav Bárta (2010, 2014) sees in one of these beasts depicted in white a formal comparison with the later God Nut from the pharaonic times (Figure 13.4). These formal similarities do not take into consideration the different chrono-cultural contexts, separated by at least three millennia and hundreds of kilometres.

Following recent advances in ontological and cosmological perspectives, one of the major weaknesses of the aforementioned theories (regarding either the Great God of Sefar or the Headless beast of Wadi Sūra and Wadi Ras) is that they take representations as fixed narrative entities, establishing a semiotic relationship between images that are often occurring within different and/or successive layers

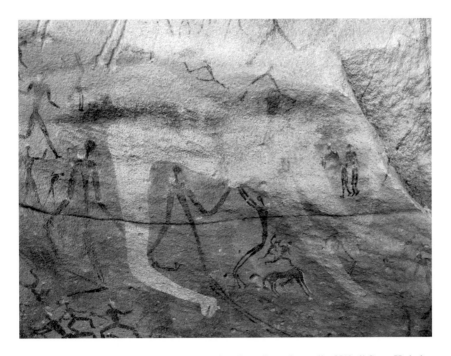

Figure 13.4 Complex scene including a white "beast" on the wall of Wadi Sūra II shelter, Gilf el-Kebir, Egypt.
Source: Copyright Emmanuelle Honoré.

of paintings. At Wadi Sūra II, for instance, hand representations constitute the earliest phase of paintings; the 'swimmers' are part of the next phase; and the so-called 'beasts' belong to a later phase. While superimpositions may sometimes be significant and motifs may dialogue even if they were not painted at the same time (Honoré and Ego 2020), there is no evidence of such an interaction at Wadi Sūra II. As this example illustrates, we often build narratives of past mythologies on the basis of our own intellectual background.

3 Approaching the ontological dimension of Saharan rock art images

In this section, I would like to provide a substantive example of how we can effectively apply ontological approaches to Saharan rock art, by developing a case study on the 'headless beasts.' In order to approach the ontological dimension of Saharan rock art images, I propose to consider two different dimensions that are somewhat intermingled in these 'transmorphic beings': first, the idea of combination, made visible in the mixing of elements from different beings; second, the idea of potential flux (which implies notions of connection, sharing, exchange, mutability and transformation). However, as we have seen in the previous section, scholars have only taken into consideration the combinative dimension, but not the element of flux in their interpretations of the Gilf el-Kebir 'headless beasts.' In this setting, most authors see these composite creatures as depictions of fixed mythological entities mixing animal and human parts.

A detailed examination reveals the complexity of these 'composite' representations. First, the so-called 'beasts' are indeed a combination of body parts, but those parts vary from one representation to another. For example, some images depict a long tail, others a short tail. Similarly, some representations have hooves, while others have paws or feet. In short, there are no two identical 'beasts.' All these variations make it difficult to support the idea of one unique and fixed entity within a formalized narrative frame. Second, it seems that different kinds of 'beasts' might coexist within the same scene. For example, on the wall of WG/73 shelter, a large beast is depicted with a smaller beast between its legs (Figure 13.5). This co-existence clearly contradicts the idea of one monolithic entity. Third, the Gilf el-Kebir beasts indeed consist of a combination of animal body parts, but human attitudes are also clearly expressed. This may reflect the idea of a life continuum expressed in trans-species beings that combine animal and human traits beyond our naturalistic classifications. Fourth, the so-called 'beasts' displayed in several scenes show different degrees of interaction with people. This explains why some authors have focused on the narrative aspects of these paintings. However, this relational aspect needs to be fully explored. For instance, 'beasts' are never depicted as self-contained entities; they exist *because* of the relationship they have with people. In other words, it seems that these representations were oriented towards the different elements of the world and not intended for humans themselves. Finally, the body of the 'beast' itself is not just a matter of appearance, and it is not only depicted to make internal properties visible through their physical

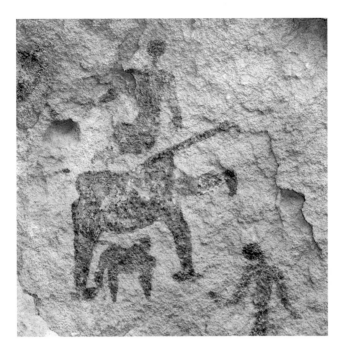

Figure 13.5 A "beast" with another "beast" between its legs on the wall of WG/73 shelter, Gilf el-Kebir, Egypt.
Source: Copyright Emmanuelle Honoré.

aspects. It is, in fact, a place of both action and interaction. The relationship with the surrounding human figures is one which includes not only having physical contact with the body of the beast, but also merging with it. Some human figures do extend their arms towards the beast, mostly to the 'points of entry' (or exit) of the body: where the head should normally be, the genitals, and the anus (Figures 13.4 and 13.6). Two beasts have got a human body half taken inside their own body at the upper point of entry/exit, between the two bumps where the head should be (Figure 13.7). One beast is depicted with the hand of a human figure pointing to its anus. Yet another beast is displayed with a multitude of small human figures just beneath an erect penis. As these examples illustrate, the active, performative, and transformative role of the beast's body should thus be considered to be as important as its formal variations. Such traits make these entities differ from *Ammut* or other deities to which they are usually compared.

The crucial point here is how we can shed light on the ontological swing of things in which these images were conceived. In such an approach, 'relationships, rather than things, constitute the basic structure of the world, the network which gives consistence to reality' (Carli 2016, 97). The careful examination of the beast figures and their context brings to light the fact that their relationships with the

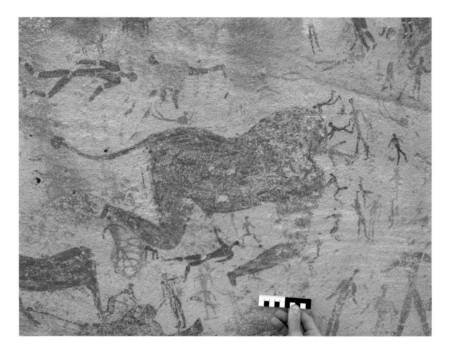

Figure 13.6 Human figures extending their arms towards the body of a "beast" on Wadi
 Sūra II shelter, Gilf el-Kebir, Egypt.
Source: Copyright Emmanuelle Honoré.

world are as important as their own individual descriptions—on which Saharan
rock art research has always put the focus. The varying appearance of beasts could
suggest, for instance, that the artists wanted to realize different entities sharing
animal traits and human attitudes. The beasts share characteristics that are ca-
tegorized by species in our naturalistic ontology. It is possible also that the painters
sought to represent how some beings change their appearance over time. They
could also have shown the merging of beings, or the transforming of some entities
under the action of others. In any case, they have conceptualized the body as being
more than a soul-and-mind carrier, as a place that could be a world in its own.

What this case study intends to show is that some Saharan rock art motifs can
be approached differently, not focusing only on their description as self-
contained entities, but also considering that they get their full life and power as
an active part of a whole. In order to offer a new interpretation of the 'Round
Heads' case, and especially the 'Great Gods' case, it is necessary to properly
describe the figures and their interactions. Another idea that we must reconsider
from an ontological viewpoint is the widespread assumption that Saharan rock
images are static and conceptually simple (that is, they represent beings or things
that correspond to one of our own conceptual boxes). At the same time, the

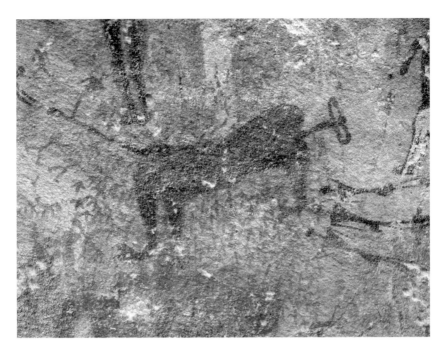

Figure 13.7 A "beast" surrounded by a multitude of simplified human figures on the wall of Wadi Sūra II shelter, Gilf el-Kebir, Egypt.
Source: Copyright Emmanuelle Honoré.

narrative aspect of Saharan rock art—which is an important trait in this corpus—needs to be reconsidered. For instance, in the Gilf el-Kebir, the dramatism of some images indicates the role of rock art images as conveyors of emotions. Several beasts are depicted with an outstretched tail, not only portraying movement, but also evoking fury (Figure 13.1). The whole scene suggests the feelings of fear and fascination experienced by the human figures around the beasts and conveyed to the viewer. Besides mere representational power, this opens new avenues of research on 'the sensory and affective character of rock art images' (Jones 2017, 172–173).

Beyond the traditional paradigm of symbolism, the lived dimension of rock art can be investigated with regards to the question of ontologies. At Wadi Sūra II, several scenes of collective gatherings showing dance and music evoke the context of feasts and performances within which rock art was presumably done (Honoré 2019b). The active power of images probably explains why so many superimpositions were done on the same panel, whereas more suitable surfaces for doing rock art were available in the vicinity. In most Saharan rock art studies, we have denied the possibility for images to be beings, entities, or things (rather than merely being *representations* of beings, entities, or things). In a discussion at the Sainsbury Research Unit in Norwich (UK) in January 2020, John Kelechi Ugwuanyi

reported a meaningful anecdote: Speaking about statuettes and fetishes kept at Museum of Archaeology and Anthropology at Cambridge, an African fellow told him that many of his ancestors were in prison in Cambridge. He said they were indeed captured with the intention of being displayed in the museum. This reminds us that artefacts are not always viewed as inert materials. Likewise, rock art images are not necessarily to be viewed as inert materials. We need to consider that they can embody beings or spirits themselves, instead of merely representing beings or spirits. This is why they are not always mere paintings or portraits.

4 The emergence of African pastoralism from an ontological viewpoint

It is remarkable that the aforementioned examples mostly refer to hunter-gatherer groups. Pastoralist practices spread from around the 7th millennium BCE in the Sahara. Archaeologists have examined the transition from hunter-gatherer groups to 'food producing' societies in Northern Africa from a variety of viewpoints, including demographic, social, and economic. However, in this chapter, I want to suggest that one of the fundamental changes defining this transition is the emergence of a new ontology associated with pastoralist groups. In the case of the rock art sites from the Eastern Saharan massifs (Gilf el-Kebir/Jebel el-'Uweināt region), a number of processes indicate this ontological transition: (1) A significant increase in the number of rock art sites; (2) a decrease in the number of figures depicted on each site—rock art sites become smaller; (3) a wider dispersal of rock art sites; (4) a reduction in the diversity of the themes; (5) a decrease in the human/animal ratio; and (6) the almost complete disappearance of depictions of large groups of human figures. Whether these changes are due to new populations spreading the practice of pastoralism is not the issue: the point is that such changes seem to indicate a renovation in the practice of rock art (1, 2); a new use of the territory (2, 3); the emergence of new visual and/or symbolic universes (4, 5, 6); a change in the conceptualization of human-animal relationships (5); and the development of new social activities and organizations (6).

I have suggested elsewhere that Saharan hunter-gatherer rock art was probably related to large events and gatherings occurring at certain times of the year and in permanent places (Honoré 2019a) and, therefore, probably had a performative dimension. In this setting, we can challenge the links between hunter-gatherer rock art and life events. For instance, in the Eastern Sahara, pastoralist rock art is more numerous and is spread throughout a myriad of small sites across the territory. This could mean that rock art evolved towards a more familial practice. Taking this question into account, a case can be made for a certain 'democratisation' of rock art. In the case of hunter-gatherer societies, it seems that rock paintings were made at a limited number of sites, probably on special occasions and by specific people. In the case of pastoralist societies, however, rock art has been documented in a larger number of sites and without a clear association with specific events, to the exception of usual pastoralist practices. Interestingly, the change in the size and dispersal of sites parallels the shift in the

size of human groups represented: it seems that the large sites with depictions of large groups of people specific to hunter-gatherer societies evolved towards smaller sites with depictions of smaller groups in pastoralist traditions. At the same time, I have documented a certain standardization in the way in which human images are represented. For instance, on the pastoralist site of WG/35 in the Gilf el-Kebir, in different layers of a painting, there is a repetitive motif of a couple gendered as a man and a woman, holding each other's hands and keeping the herd (please see Honoré 2015, Figure 4). What can be described as a family unit merges with the productive unit. Zooarchaeological evidence (bone remains found in hearths) indicates that pastoralists at that time still relied on hunting for their meat supply (Riemer 2007, 133–134). This probably means that different types of groups and organizations coexisted, depending on activities.

The change in the repertoire of rock art images is striking. It is a fact that with the arrival of pastoralist people in the area, cattle became of capital importance; this has been observed in all regions of the Sahara (Dupuy 1995, 164). However, despite this being transcribed by rock art images, archaeologists still underestimate both the role of cattle and the role of pastoralism in the change of subsistence strategies. For the Gilf el-Kebir, it has been stated that 'the pastoral component obviously did *not* play a major role within the subsistence strategies' (Riemer 2007, 134, my emphasis). This assumption is based on a reduction in the presence of bones of domesticated animals (less than 50%) and the high proportion of arrowheads in lithic assemblages. However, hunting and pastoralism are not mutually exclusive. In fact, we see an increasing diversity of food supplies rather than a straightforward replacement of earlier food sources (Honoré 2012, 33–40).

In archaeological research, pastoralism is often reduced to a subsistence strategy; this is probably related to the prominence of zooarchaeology and its economical emphasis when referring to animal domestication. However, the fact is that pastoralism encompasses a much greater number of changes, some of which are from an ontological order. In this setting, rock art images constitute, perhaps more than any other aspect of the archaeological record, a formidable gate for archaeologists into the ontologies and worldviews of past human groups. In the case of Saharan rock art, a number of changes indicate an ontological revolution. These changes include (1) The high dominance of cattle in the overall repertoire; (2) A change in the dimensions of the figures represented (for instance, cattle can be oversized compared to human figures); and (3) The importance of udders, depicted in details and often oversized as well, possibly stressing the importance of milk resources (please see Shaw 1936 about Mogharet el-Qantara and Honoré 2012 about WG/35). Analyses of absorbed residues in prehistoric pottery from Libya show that dairy products were extensively processed during the Middle Pastoral period (from 5200 to 3800 BCE) in the Libyan Sahara (Dunne et al. 2012). Scenes of milking are found in the rock art of the Messak in Libya (Lutz and Lutz 1995, amongst others), the Ennedi in Chad (please see Jesse et al. 2007, Figure 6), and the Libyan Desert (please see Figure 171 in van Noten et al. 1978). Some misleading views on the early pastoralist practices in Africa, and especially in North-East Africa, exist because archaeologists tend to rely on bone evidence and focus on meat consumption. This is problematic because, in

most cases, African pastoralism is not practiced for meat consumption. Additional changes include (4) The individualized and careful depiction of cattle coats indicating how they are valued, even on an individual level; (5) Alongside the individualized coats (Dupuy and Denis 2011 for the Tassili-n-Ajjer), the frequent depictions of collars at the neck of cattle, stressing the importance of appropriating animals (Honoré 2015); (6) The number of cattle associated to each herd keeper, showing that there is an extreme increase of livestock, which probably cannot be attributed to food subsistence considerations alone. Cattle are coveted riches and are key to social interactions. Several scenes of 'battle for cattle' are found in the rock art of the Eastern Sahara. According to the violence depicted, prehistoric people were ready to die for their cattle. A final change indicating an ontological revolution is (7) the symbolic dimension of cattle, which was indicated by Neolithic cattle burial practices (Di Lernia et al. 2013; Smith 2005) and echoed in some representations of seemingly headless bovines in rock art (Honoré 2012).

Altogether, these changes indicate that cattle played a central role in pastoralist cosmologies. It is not only that cattle held an obvious symbolic value, it is also that every interaction was organized and ruled by the intermediary of cattle. Most relationships of those early African pastoralist groups to the world revolved around this animal, thus defining a new prehistoric ontology: *'animal as anima.'*

5 Some concluding thoughts

Ontological approaches began in archaeology only a decade ago. In Saharan rock art research, scholars have traditionally worked out basic cultural and stylistic chronologies which they interpret, for the most part, from ecological and symbolic perspectives. As this chapter has demonstrated, these approaches present a number of limitations, among which are the 'representational' idea of rock art and the focus on formal analogies. Moreover, an analysis of these traditional interpretations demonstrates how we often build narratives about past mythologies on the basis of our own intellectual backgrounds. Something similar can be said about the importation of the shamanistic hypothesis to explain Saharan rock art—which could be viewed, however, as tentative—to introduce the idea of other ontologies. Ontological categories defined by anthropologists, such as Descola's four ontologies (animism, totemism, analogism, naturalism—Descola 2005), should be used for their heuristic value. Applying ready-made categories is not only naïve, it 'superimposes the model over the art, thus reifying the model itself' (Robinson 2013, 61). Archaeology must not be the poor relation to anthropology regarding the use of ontological theory.

For the aforementioned reasons, I have suggested in this chapter that ontological approaches may be an alternative standpoint to approach Saharan rock art images and, more importantly, to understand the main shift that this visual corpus reflects: the transition from hunter-gatherer to pastoralist societies. Changes in rock art practices between the two groups seem to indicate profound mutations in the way they viewed the world. Hunter-gatherer rock art refers to a world of permeable essences, with a life continuum expressed in transmorphic beings. Figures like the 'beasts' of Wadi Sūra/Wadi Ras do not appear as

composite bodies having a constant and stable identity. Rather, they are composed of different elements and recomposed in different contexts. The idea of a 'becoming' rather than a 'being' is expressed through such entities, and the process of transmorphism is made possible by and through the interaction between things *lato sensu*. Likewise, human beings are transformed by their contact with and passing through the body of beasts.

In Saharan pastoralist rock art, there is no trace of transmorphism, of the merging of beings and of composite entities. Pastoralist rock art reflects a world revolving around cattle. Relationality is still paramount. However, relationships exist primarily between humans and humans, or humans and cattle, all as distinct and stable entities. Relationships of humans with cattle revolve around caring, keeping, and breeding; and conversely, relationships of cattle with humans are set on companionship, value, and symbolic power. Although such relationships are essential to pastoralist life, they *participate* in defining what things are; a certain immutability of being is made visible through the standardization of formal appearances. Consequently, it does not seem too farfetched to argue that the way entities are depicted relates more to an essentialist ontology than the non-essentialist ontology transcribed in the previous hunter-gatherer rock art, as seen from the case studies in this chapter.

Even in the absence of Indigenous knowledge, images can help approach how past people negotiated their position within the world. In Saharan rock art, which goes with no 'cultural transmission,' ontologies appear like an after-image, the canvas on which the whole conception of life, things, and beings springs to life. In this chapter, I have tried to move away from the focus on meaning and the representational approach that have always prevailed in Saharan rock art research. However, I agree that such an attempt is still very tentative. More important than engaging with only the question of ontologies, reconnecting rock art to archaeology—as has been done for about two decades in our field of research (Gallinaro 2013; Di Lernia 2019)—conveys a vivid picture of the relationships of the last hunter-gatherers and the first pastoralists to the world around them. As such, the lived dimension of rock art, too often seen as an inert material, can still reappear.

Note

1 I would like to acknowledge the support of the European Commission and the Université Libre de Bruxelles for the COFUND Marie Skłodowska-Curie grant n°801505, of the British Academy for the Newton Follow-on grant NIFAL19\190009, and of the Sainsbury Research Unit at Norwich. I am very grateful to Oscar Moro Abadía, Martin Porr, and Amy Chase who brilliantly edited the text, as well as to the two anonymous reviewers whose comments greatly contributed to improve the text. All remaining errors are my own. I thank Christian Mathis for having provided illustrations.

References cited

Alberti, Benjamin. 2016. "Archaeologies of ontology." *Annual Review of Anthropology 45*: 163–179.

Anati, Emmanuel. 1988. *Origini dell'arte e della concettualità*. Milan: Editoriale Jaca Book.

Anati, Emmanuel. 1995. *Il museo imaginario della preistoria: L'arte rupestre nel mondo*. Milan: Editoriale Jaca Book.

Atalay, Sonya. 2006. "Indigenous archaeology as decolonizing practice." *The American Indian Quarterly 30* (4): 280–310.

Barbaza, Michel. 2015. "Les Trois Bergers. Du conte perdu au mythe retrouve." *Pour une anthropologie de l'art rupestre saharien*. Toulouse: Presses Universitaires du Midi.

Barich, Barbara. 1998. "The Wadi el-Obeyid cave, Farafra Oasis: A new pictorial complex in the Libyan Egyptian Sahara." *Libya Antiqua, Nuova Serie 4*: 9–19.

Bárta, Miroslav. 2010. *Swimmers in the Sand*. Prague: Dryada.

Bárta, Miroslav. 2014. "Prehistoric mind in context. An essay on possible roots of Ancient Egyptian civilization." In *Paradigm Found: Archaeological Theory – Present, Past and Future. Essays in Honour of Evžen Neustupný*, edited by Kristian Kristiansen, Ladislav Šmedja, and Jan Turek, 188–201. Oxford: Oxbow Books.

Bird-David, Nurit. 1999. "'Animism' revisited: Personhood, environment, and relational epistemology." *Current Anthropology 40* (1): 67–91.

Blackburn, Thomas. 1975. *December's Child: A Book of Chumash Oral Narratives*. Berkeley: University of California Press.

Brück, Joanna. 2019. *Personifying Prehistory. Relational Ontologies in Bronze Age Britain and Ireland*. Oxford: Oxford University Press.

Buchanan, Meghan, and Jacob Skousen (eds). 2015. *Tracing the Relational: The Archaeology of Worlds, Spirits, and Temporalities*. Salt Lake City: The University of Utah Press.

Burt, Ben. 2013. *World Art: An Introduction to the Art in Artefacts*. London: Bloomsbury.

Calvert-Minor, Chris. 2010. "Archaeology and humanism: An incongruent Foucault." *Kritike 4* (1): 1–17.

Carli, Riccardo. 2016. "Relational ontology in Nietzsche: An introduction." *Parrhesia 26*: 96–116.

Challis, Sam. 2019. "*RL-20*. Rock art research: Ontologies and contact." Call for Papers, *25*th Biennal Meeting of the Society of Africanist Archaeologists, Oxford – Third Circular: 17.

Colwell-Chanthaphonh, Chip, Thomas Ferguson, Dorothy Lippert, and Randall McGuire. 2010. "The premise and promise of indigenous archaeology." *American Antiquity 75* (2): 228–238.

Descola, Philippe. 2005. *Par-delà nature et culture*. Paris: Gallimard.

Di Lernia, Savino. 2019. "The archaeology of rock art in Northern Africa." In *The Oxford Handbook of the Archaeology and Anthropology of Rock Art*, edited by Bruno David and Ian J. McNiven. Oxford: Oxford University Press.

Di Lernia, Savino, and Marina Gallinaro. 2010. "The date and context of Neolithic rock art in the Sahara: Engravings and ceremonial monuments from Messak Settafet (southwest Libya)." *Antiquity 84*: 954–975.

Di Lernia, Savino, Mary Anne Tafuri, Marina Gallinaro, Francesca Alhaique, Marie Balasse, Lucia Cavorsi, Paul Fullagar, Anna Maria Mercuri, Andrea Monaco, Alessandro Perego, and Andrea Zerboni. 2013. "Inside the 'African Cattle Complex': Animal Burials in the Holocene Sahara." *PLoS ONE 8* (2): e56879.

Douglas, Mary. 1975. "Heathen darkness." In *Implicit Meanings: Essays in Anthropology*, 73–81. London: Routledge and Kegan Paul.

Dunne, Julie, Richard Evershed, Mélanie Salque, Lucy Cramp, Silvia Bruni, Kathleen Ryan, Stefano Biagetti, and Savino di Lernia. 2012. "First dairying in green Saharan Africa in the fifth millennium BC." *Nature 486* (7403): 390–394.

Dupuy, Christian. 1995. "Saharan nomadic pastoral peoples with a rock engraving tradition." In *Perceiving Rock Art: Social and Political Perspectives*, edited by Knut Helskog and Bjørnar Olsen, 146–168. Oslo: The Institute for Comparative Research in Human Culture.

Dupuy, Christian, and Bernard Denis. 2011. "Les robes des taurins dans les peintures de la Tassili-n-Ajjer (Algérie): Polymorphisme ou fantaisies?" *Cahiers de l'AARS 15*: 29–46.

Fagnola, Ferdinando. 1995. "Une nouvelle hypothèse d'étude pour les peintures du Tassili-Acacus, période des Têtes Rondes, d'inspiration présumée 'hallucinée.'" In *Actes de l'assemblée annuelle de l'AARS. Arles, 13-15 mai 1994*, 4–8. Arles: AARS.

Fowler, Chris. 2013. *The Emergent Past: A Relational Realist Archaeology of Early Bronze Age Mortuary Practices*. Oxford: Oxford University Press.

Gallinaro, Marina. 2013. "Saharan rock art: Local dynamics and wider perspectives." *Arts 2* (4): 350–382.

Graziosi, Paolo. 1942. *L'Arte rupestre della Libia* (2 vols). Naples: Edizioni della Mostra d'Oltremare.

Hayward, Tim. 1997. "Anthropocentrism: A misunderstood problem." *Environmental Values 6* (1): 49–63.

Harrison-Buck, Eleanor, and Julia Hendon. 2018. *Relational Identities and Other-than-Human Agency in Archaeology*. Louisville: University Press of Colorado.

Honoré, Emmanuelle. 2012. "Peintures rupestres et cultures pastorales dans le Sahara Egyptien." In *Les images: Regards sur les sociétés*, edited by Charlotte Leduc, Aurélie Salavert, and Théophane Nicolas, 17–53. Paris: Publications de la Sorbonne.

Honoré, Emmanuelle. 2015. "'Pastoralists' paintings of WG35, Gilf el-Kebir: Anchoring a moving herd in space and time." In *Rock Art: When, Why, to Whom?*, edited by Emmanuel Anati, 92–96. Capo di Ponte: Edizioni Atelier.

Honoré, Emmanuelle, Thameur Rakza, Brigitte Senut, Philippe Deruelle, and Emmanuelle Pouydebat. 2016. "First identification of non-human stencil hands at Wadi Sūra II (Egypt): A morphometric study for new insights into rock art symbolism." *Journal of Archaeological Science: Reports 6*: 242–247.

Honoré, Emmanuelle. 2019a. "Prehistoric landmarks in contrasted territories: Rock art of the Libyan Desert massifs, Egypt." *Quaternary International 503*: 264–272.

Honoré, Emmanuelle. 2019b. "The archaeology of sharing immaterial things: Social gatherings and the making of collective identities of the Eastern Saharan last hunter-gatherers." In *Towards a Broader View of Hunter Gatherer Sharing*, edited by David Friesem and Noa Lavi, 113–122. Cambridge: McDonald Institute Monographs.

Honoré, Emmanuelle, and Renaud Ego. 2020. "De singuliers espaces de temps: Regards croisés sur les arts rupestres du Sahara et d'Afrique australe." *Polygraphe(s) 2*: 14–23.

Jesse, Friderike, Birgit Keding, Nadja Pöllath, Marianne Bechhaus-Gerst, and Tilman Lenssen-Erz. 2007. "Cattle herding in the southern Libyan Desert." In *Atlas of Cultural and Environmental Change in Arid Africa*, edited by Olaf Bubenzer, Andreas Bolten, and Frank Darius, 46–49. Cologne: Heinrich Barth Institut.

Jones, Andrew. 2012. *Prehistoric Materialities: Becoming Material in Prehistoric Britain and Ireland*. Oxford: Oxford University Press.

Jones, Andrew. 2017. "Rock art and ontology." *Annual Review of Anthropology 46*: 167–181.

Jones, Andrew, and Andrew Cochrane. 2018. *The Archaeology of Art: Materials, Practices, Affects*. London: Routledge.

Kuper, Rudolph (ed). 2013. *Wadi Sura: The Cave of Beasts. A Rock Art in the Gilf Kebit (SW-Egypt)*. Cologne: Heinrich Barth Institut.

Lahelma, Antti, and Vesa-Pekka Herva. 2019. *Relational Archaeologies and Cosmologies in the North: Northern Exposures*. New York: Routledge.

Lajoux, Dominique. 1977. *Tassili n'Ajjer*. Paris: Éditions du Chêne.

Latour, Bruno. 2005. *Nous n'avons jamais été modernes: Essai d'anthropologie symétrique*. Paris: Éditions La Découverte. First published 1991.

Latour, Bruno, and Pierre Lemonnier. 1994. *De la préhistoire aux missiles balistiques: L'intelligence sociale des techniques*. Paris: Éditions La Découverte.

Le Quellec, Jean-Loïc. 1998. *Art rupestre et préhistoire du Sahara: Le Messak libyen*. Paris: Bibliothèque Scientifique Payot.

Le Quellec, Jean-Loïc. 1999. "Images de chamanes ou chamanisme imaginaire?" *Pictogram 11* (1): 34–44.

Le Quellec, Jean-Loïc. 2006. "Chamanes et martiens: Même combat! Les lectures chamaniques des arts rupestres du Sahara." In *Chamanismes et arts préhistoriques: Vision critique*, edited by Michel Lorblanchet, Jean-Loïc Le Quellec, and Paul Bahn, 233–260. Paris: Errance.

Le Quellec, Jean-Loïc. 2009. *Des Martiens au Sahara: Chroniques d'archéologie romantique*. Paris: Actes Sud.

Le Quellec, Jean-Loïc. 2013a. "Périodisation et chronologie des images rupestres du Sahara central." *Préhistoires méditerranéennes 4*: 1–46.

Le Quellec, Jean-Loïc. 2013b. "Aréologie, phénétique et art rupestre: L'exemple des théranthropes du Sahara central." *Les Cahiers de l'AARS 16*: 155–176.

Le Quellec, Jean-Loïc, Pauline de Flers, and Philippe de Flers. 2005. *Du Sahara au Nil. Peintures et gravures d'avant les Pharaons*. Paris: Fayard.

Lenssen-Erz, Tilman. 2012. "Adaptation or aesthetic alleviation: Which kind of evolution do we see in Saharan Herder rock art of Northeast Chad?" *Cambridge Archaeological Journal 22* (1): 89–114.

Lewis-Williams, David. 1981. *Believing and Seeing: Symbolic Meanings in Southern San Rock Paintings*. London: Academic Press.

Lhote, Henri. 1955. "Le Tassili-n-Ajjer. Description géographique et principaux groupes de roches peintes." *Actes du Congrès Panafricain de Préhistoire, IIe Session, Alger, 1952*: 67–72.

Lhote, Henri. 1957. *Peintures préhistoriques du Sahara: Mission H. Lhote au Tassili. Exhibition catalogue*. Paris: Musée des arts décoratifs.

Lhote, Henri. 1958. *A la découverte des fresques du Tassili*. Paris: Arthaud.

Lutz, Rüdiger, and Gabriele Lutz. 1995. *Das Geheimnis der Wüste. Die Felskunst des Messak Settafet und Messak Mellet, Libyen*. Innsbruck: Universitätbuchhandlung Golf Verlag.

Moro Abadía, Oscar, Manuel González Morales, and Eduardo Palacio-Pérez. 2012. "'Naturalism' and the interpretation of cave art." *World Art 2* (2): 219–240.

Muzzolini, Alfred. 1986. *L'art rupestre préhistorique des massifs centraux sahariens*. BAR International Series 318. Oxford: Archaeopress.

Muzzolini, Alfred. 1988–89. "L'état actuel des études sur l'art rupestre saharien: Pesanteurs et perspectives." *Ars Praehistorica 7–8*: 265–277.

Muzzolini, Alfred. 1995. "Les approches du monde symbolique dans l'art rupestre saharien: Préhistoire et science des religions." In *L'Homme méditerranéen. Mélanges offerts à Gabriel Camps*, edited by Robert Chenorkian, 179–193. Aix-en-Provence: Publications de l'Université de Provence.

Riemer, Heiko. 2007. "When hunters started herding: Pastro-foragers and the complexity of Holocene economic change in the Western Desert of Egypt." In *Aridity, Change and Conflict in Africa. Proceedings of an International ACACIA Conference held at Königswinter, Germany*

2003, edited by Michael Bollig, Olaf Bubenzer, Ralf Vogelsang, and Hans-Peter Wotzka, 105–144. Cologne: Heinrich-Barth Institut.

Robinson, David. 2013. "Transmorphic being, corresponding affect: Ontology and rock art in South-Central California." In *Archaeology after Interpretation: Returning Materials to Archaeological Theory*, edited by Benjamin Alberti, Andrew Jones, and Joshua Pollard, 59–78. New-York: Routledge.

Samorini, Giorgio. 1990. "Sciamanismo, funghi psicotropi e stati alterati di coscienza. Un rapporto da chiarire." *Bolletino del Camuno di Studi Preistorici 25/26*: 147–150.

Samorini, Giorgio. 1992. "The oldest representations of hallucinogenic mushrooms in the world (Sahara Desert, 9000–7000 BP)." *Integration, Journal of Mind-moving Plants and Culture 2/3*: 69–78.

Sansoni, Umberto. 1980. "Quando il deserto era verde. Ricerche sull'arte rupestre del Sahara." *L'Umana Avventura 11*: 65–85.

Sansoni, Umberto. 1994. *Le più antiche pitture del Sahara. L'arte delle Teste Rotonde*. Milan: Editoriale Jaca Book.

Searight, Susan. 1997. "Art rupestre et hallucinogènes." *Bulletin de la Société d'Études et de Recherches Préhistoriques Les Eyzies 46*: 46–62.

Shanks, Michael. 2007. "Symmetrical archaeology." *World Archaeology 39* (4): 589–596.

Shaw, William Kennedy. 1936. "Rock paintings in the Libyan Desert." *Antiquity 10* (38): 175–178.

Smith, Andrew. 2005. *African Herders: Emergence of Pastoral Traditions*. Walnut Creek: AltaMira Press.

Soleilhavoup, François. 1998. "Images chamaniques dans l'art rupestre du Sahara." *Pictogram 10* (1): 22–36.

Soukopova, Jitka. 2011. "The earliest rock paintings of the Central Sahara: Approaching interpretation." *Time and Mind: The Journal of Archaeology, Consciousness and Culture 4* (2): 193–216.

Thomas, Julian. 2002. "Archaeology's humanism and the materiality of the body." In *Thinking Through the Body: Archaeologies of Corporeality*, edited by Yannis Hamilakis, Mark Pluciennik, and Sarah Tarlow. New York: Kluwer Academic/Plenum Publishers.

van Noten, Francis, Hans Rotert, and Xavier Misonne. 1978. *Rock Art of the Jebel Uweinat [Libyan Sahara]*. Graz: Akademische Druck u. Verlagsanstalt.

Viveiros de Castro, Eduardo. 1998. "Cosmological deixis and Amerindian perspectivism." *The Journal of the Royal Anthropological Institute 4* (3): 469–488.

Watts, Christopher (ed). 2013. *Relational Archaeologies: Humans, Animals, Things*. London: Routledge.

Witmore, Christopher. 2007. "Symmetrical archaeology: Excerpts of a manifesto." *World Archaeology 39* (4): 546–562.

14 The faceless men

Partial bodies and body parts in Scandinavian Bronze Age rock art

Fredrik Fahlander[1]

1 Introduction

In southern Scandinavia, a particular style of Bronze Age rock art appeared during the early 2nd millennium BC. Although it shares some characteristics with the older and more widespread circumpolar hunter rock art, it comprises a distinct stylistic tradition of its own. Bronze Age rock art is mainly found along the former coastlines, with significant clusters in southwest Uppland, eastern Östergötland, Tjust, Scania, Bohuslän/Østfold, Sogn/Fjordane, and Trøndelag (Goldhahn et al. 2010, 4). The figures are pecked into the rocks and are made up of a limited repertoire of motifs (e.g., cup marks, boats, anthropomorphs, zoo-morphs, wheel crosses, foot soles, and weapons). There are no ethnographical or historical sources for this period and area, and consequently the social and cosmological contexts are unclear. While Bronze Age societies are generally assumed to be stratified chiefdoms, the areas containing this rock art are not located close to known settlement sites. It is thus an open question whether the figures were associated with an elite, a priesthood, or some other type of sub-group. Some have even argued that some motifs were made by foreign visitors (see different interpretations in Goldhahn and Ling 2013, 274). Because of this, the south Scandinavian rock art is only accessible through formal methods based on the imagery itself and their relations to the local context.

The design of each motif and its frequency varies, and to some degree follow different trajectories. In order to keep the discussion concise, this text focuses on the anthropomorphic figures in particular as a means to understand the functions and purposes of Bronze Age rock art in general. The anthropomorphs normally appear as simple stick figures, occasionally equipped with objects such as lures, spears, swords and shields. In some cases, bodily properties are emphasized, such as the hair, calves, and phallus. A few figures also appear to be hybrid creatures (or masked humans) wearing horns, wings, or beaks. Because of their simple yet varied appearance, the Bronze Age anthropomorphs remain open to almost any interpretation that might fit a particular narrative. Depending on their attributes, size, and relation to other motifs, they have been argued to represent a variety of things, including mythological beings or deities, human warriors, adorants,

dancers, swimmers, chiefs, or slaves (e.g., Marstrander 1963, 200–230; Malmer 1981, 76–84; Coles 2000, 48–55).

However, rather than prioritizing what the anthropomorphs might depict or represent, we may instead focus on the manner in which they were produced and the reasons for their production. Recent rock art research has balanced representational perspectives with greater attention to material and ontological aspects (Jones 2017; Fahlander 2018), arguing that images are not necessarily passive depictions of something somewhere else, but are material articulations with generative properties of their own. Representations of bodies, for instance, are not necessarily ontologically different from biotic bodies, meaning that images can be as associated with agency and personhood as any human being. Thus, instead of representing particular beings, anthropomorphic imagery may comprise a viable technology for controlling, affecting, and exploiting the animacies of the world.

Indeed, on closer scrutiny, there is clearly something more to these Bronze Age anthropomorphs than first meets the eye. To begin with, they are not particularly faithful representations of humans at all. Their bodily proportions are frequently skewed, with the legs disproportionately long and the calves exaggerated. Second, a substantial portion of the anthropomorphs lack one or several body parts: some do not have any arms or are missing one or both legs, others lack a torso, a few are headless, and some consist only of a pair of legs. Finally, many of these anthropomorphs are curiously generic, lacking any distinguishing features, and are sometimes even anonymized. Together, these observations provide a strong indication that the anthropomorphic motifs are designed to "present rather than represent" (Nakamura 2005, 22). For example, partial and vague designs may attract, confuse, create ambiguity and stress, as well as promote curiosity, fascination, and fear, and encourage subsequent reactions by humans and other-than-humans (Robb 2015, 172; Gell 1998). The generic and anonymous appearance of the anthropomorphic figures allows them to fulfil different purposes and be easily modified accordingly. Such generative properties resonate well with the perspective of Bronze Age rock art as part of a "vitalist technology" that aims to affect the world (Fahlander 2019a, b). In this text, I will pursue this idea through a case study of the anthropomorphic figures of the Mälaren Bay in eastern-central Sweden (Figure 14.1). The rock art in this area is well-documented and has been the subject of several in-depth studies (Kjellén and Hyenstrand 1977; Coles 2000; Ling 2013; Fahlander 2018).

2 The anthropomorphic figures of the Mälaren Bay

Although similar types of motifs are found in different regions of southern Scandinavia, Bronze Age rock art shows a certain degree of local variability in style and motif frequency, as well as in relation to the rock and the local environment. The rock art found on the shores of the Mälaren Bay is no exception to this diversity and displays a particular stylistic enunciation. The imagery is mainly from the Early Bronze Age (c. 1700–1100 BC), and the motifs are less

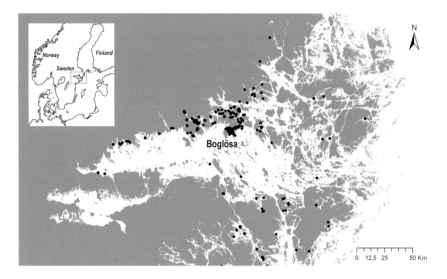

Figure 14.1 Map of the figurative rock art (black dots) in central-eastern Sweden. The water level is adjusted to Early Bronze Age levels.

expressive and narrative compared to those found in the other main rock art sites of the Late Bronze Age (c. 1100–500 BC). At present, the Mälaren region has been found to include over 19,000 cup marks and at least 2500 figurative motifs. Boats of different shapes and designs comprise two-thirds of the figurative motifs, while anthropomorphic figures are the second most common motif, followed by a variety of zoomorphs (Fahlander 2018). Although some rocks contain hundreds of motifs, they only rarely show signs of being planned compositions. Instead, individual motifs seem to have been added to the rocks cumulatively over several hundred years. Due to coastal uplift, the rock art is presently situated between 20 and 25 m above sea level in an agricultural landscape. When the rock art was produced during the Bronze Age, however, it was situated close to the water's edge in semi-secluded bays and inlets along the northern shores of the Mälaren Bay (Coles 2000, 124; Fahlander 2018, 61). The positioning of the imagery at the water's edge, often on small, rocky islets, is important: the rock art is clearly directed towards the water-world, and offers little room for people to venerate or even view the figures.

While the common boat motifs are evenly spread along the northern shores of the Mälaren Bay, the anthropomorphic figures are primarily found in a central cluster of rock art at Boglösa, close to the modern city of Enköping (Figure 14.1). Only a small number of these anthropomorphs are equipped with tools, weapons, and other objects (Figure 14.2a). About 10% have a single line running downwards from the back of the figure, indicating a sheathed sword (or a tail), and a dozen figures include disc-shaped objects that possibly indicate shields. There are also three examples of archers, a group with paddles, and a few

anthropomorphs holding sticks as if to herd a group of zoomorphs. Although thought-provoking and evocative, these outfitted anthropomorphs are exceptions; the majority of figures have neither associated gear nor any obvious relation to other motifs.

While the anthropomorphs are apparently simple and less informative from a representationalist perspective, closer examination of how they are designed and their relations to the landscape, the rock surface, and to other motifs reveals greater complexity. For example, the majority of the anthropomorphs lack one or more body parts (Figure 14.2b). This is not due to wear on the rock surface or because these motifs were left unfinished; the zoomorphs, for example, are always complete in the sense that they all have heads and four limbs. This partial mode is mainly restricted to anthropomorphs and boat motifs, and is found to a varying extent at all major Bronze Age rock art sites in southern Scandinavia; in the Mälaren region in particular, approximately 10–15% of the boat motifs and 70% of the anthropomorphs are partial. The most common anthropomorphic types are figures lacking one or both arms, followed by bodies lacking one or both legs; others are headless, and a few have no torso. Intriguingly, several motifs consist only of a pair of legs. In addition to this, many anthropomorphs have hyperbolic characteristics such as elongated legs and exaggerated calves (Figure 14.2c). There are also a small number of extraordinarily large anthropomorphic figures which are up to eight times taller than the normal size of 15–20 cm (including pairs of legs measuring over 50 cm). Significantly, the otherwise simply styled anthropomorphs are frequently depicted with feet (even the pairs of legs normally have feet). This relates the anthropomorphs to the representations of human footprints on the rocks, which are commonly referred to as "foot soles." Foot soles are life-sized depictions of bare feet (with or without toes), or oval shapes with a horizontal line interpreted as feet clad in footgear with lacing over the foot (Figure 14.2d). Foot soles occur as individual motifs, or in pairs oriented as if facing the shoreline. In a few instances, they are arranged so as to illustrate movement over the rock.

Another common trait among the Mälaren anthropomorphs is their generic and anonymous character. They have no hands, and their heads are rounded blobs without hair, a nose, or other distinguishing characteristics. They are virtually faceless and of no particular gender or age. This generic layout is not simply a consequence of the small format or the coarse medium of the rock. Indeed, the way the large-scale anthropomorphs are designed shows that the anonymization is deliberate, since although they are up to eight times taller than normal size, they are more or less enlarged copies and lack any added detail. Compare, for example, the 1.1-m disc-shaped figure with a normal-sized counterpart (Figure 14.3a). The only addition to the larger motif is the parallel lines outlining the body, indicating that the round object is carried on the figure's back. The head, legs, sword, and shield of the large anthropomorph show no additional individual characteristics (note that both figures are presented without arms). Another example is the 4.2-m Brandskog boat, carrying six large anthropomorphic paddlers and a seventh under the stern (Figure 14.3b). In this

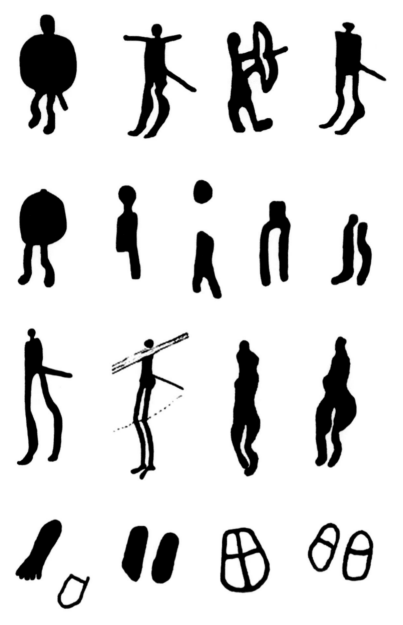

Figure 14.2 (a) Examples of anthropomorphs with objects (swords and shields); (b) A variety of partial anthropomorphs lacking body parts; (c) Anthropomorphs with hyperbolic attributes, elongated legs, and exaggerated calves; (d) Different versions of feet/footprints.

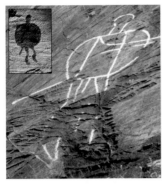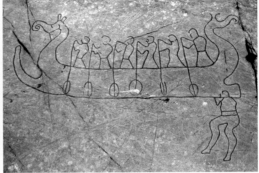

Figure 14.3 Left: A small and a large anthropomorph with circular bodies and swords (Boglösa 128:2 and 298). The lines in the upper-right part of the image are a superimposed boat motif. Right: The 4.2-m boat motif at Brandskog (Boglösa 109). Note the incomplete faces of the anthropomorphs.
Source: Photos Einar Kjellén, Enköpings Museum.

case as well, little extra visual information has been added to this huge motif. Although the simple crew strokes of the smaller boat motifs are more elaborated in this image, the anthropomorphs are nonetheless as generic as the normal-sized ones. In fact, the outlines of their heads are broken, and they have apparently been deliberately made faceless.

3 The allure of the partial and generic

The generic and partial character of Bronze Age anthropomorphs has not been subjected to systematic analysis as a specific visual mode (however, see Fahlander 2018, 78–82, 2020). In the history of rock art research, partial motifs have generally been interpreted as either unfinished or simplifications that nevertheless convey the essence of a particular motif. Marstrander, for instance (Marstrander 1963, 21) argued that the leg-pairs are *pars pro toto* representations; in other words, synecdoches or partial images of the body as a whole (see Nochlin 2001, 39). The partial anthropomorphs have also been interpreted as realistic depictions. Arthur Nordén, for example, described them as 'mutilated bodies' (Nordén 1926, 46; see also Lødøen 2015), while Bertil Almgren (1960, 52) argued that the armless anthropomorphs represented people whose arms were concealed by cloaks, and John Coles (2003, 219) suggested that some of them were captives whose arms were tied behind their backs (see also Bevan 2015, 25). The figures with disproportionate body parts have generally been discussed from a similarly representational perspective. The exaggerated calves have been interpreted as portraying shin greaves (Vogt 2006, 79), and the elongated legs as a representation of how human shadows are cast in oblique light (Meyering 2018). Hyperbolic extremities, in general, have also been understood as attributes

signifying spirits or other supernatural entities (Marstrander 1963, 217; see Schaafsma 2018, 412; Solomon 2008, 70), and anthropomorphs with distorted proportions have been interpreted as illustrating a changed state of consciousness or shamans during a transgressive state (Hampson 2016, 217; Tilley 2008, 169). As previously mentioned, foot sole motifs are generally interpreted as realistic representations of human feet. The variation in size has even been argued to represent humans of different ages and sexes moving over the rocks during initiation rites (Sognnes 2011). Others have interpreted the motif in symbolic terms: Almgren (1976, 24) suggested they denoted the path of an invisible deity that cannot be envisioned; Marstrander (1963, 230) saw them as apotropaic signs in general; and to Skoglund et al. (2017), foot soles symbolized the movement of the sun. In North American ethnography, images of footprints are argued to represent symbols of prayers or "paths taken" (Diaz-Granados and Duncan 2002, 215). Just as the anthropomorphs may not represent beings somewhere else, however, the foot soles need not necessarily be reduced to symbolic representations. In the following discussion, I argue that the partial and generic character of the Boglösa anthropomorphs makes more sense when they are interpreted as material articulations produced to affect the world.

4 Discussion: Anthropomorphic figures as vitalist devices

The above interpretations based on representational aspects of partial and anonymous Bronze Age anthropomorphic figures lack neither ingenuity nor merit. As previously mentioned, however, the figurative element is but one facet of imagery. On a general level, the simple and generic designs make the anthropomorphs less likely to represent individual deities or special categories of individuals. Instead of viewing these figures as representations of something particular, it is rewarding to discuss the partial and generic as a specific type of material articulation, created with a specific purpose in mind. To begin with, making something partial and incomplete adds certain qualities to an object or image. One interesting property of generic and partial imagery is its ability to draw attention (Nochlin 2001). In modern marketing, for example, company logos are commonly designed as partial and incomplete in order to catch the eye and convey a sense of creativity (Hagtvedt 2011). From a cognitive point of view, a missing attribute or lack of detail can also emphasize what is actually present. This technique has been employed by several modern artists, such as Cézanne in his many paintings of Mountain Saint-Victoire (Morvan 2006, 164). Other artists, such as Kandinsky and Klee, worked with abstraction and reduction in order to expose "what really is" (or should be), rather than how something appears (Ingold 2010, 91). There are, of course, differences between company logos, modern art, and rock art, but there are nonetheless concrete instances of partial rock art motifs that have attracted attention and provoked responses. One example concerns a partial zoomorphic motif that consists only of a pair of legs, a tail, a head, and a neck, and lacks a body. With the aid of detailed laser scanning,

it was established that someone at a later point in time scratched the area where the body should have been (Fahlander 2012, 103). Another case concerns a panel at Himmelstalund, outside the modern city of Norrköping, where a half-boat motif has been "supplemented" with a row of Iron Age runes (Nilsson 2012, 87).

Anthropomorphic representations can also be designed incomplete for other reasons. Douglass Bailey, for instance, has suggested that certain Neolithic anthropomorphic figurines were deliberately made partial in order for the viewer to see different things while mentally completing the object (Bailey 2007, 119). He encourages us to realize that the figurines are representations *for* and not representations *of* someone or something (Bailey 2013, 245). Harris and Robb (2013, 218) reason in a similar manner about ancient Greek anthropomorphic sculpture, which they argue works "much like the shop mannequins and models in catalogues nowadays: they present carefully generic individuals whose role is to provide a focus for the viewer to project himself or herself into the picture." In the case of Bronze Age rock art, however, it is important to recognize that the imagery was not necessarily made to be viewed only by humans. Indeed, the relatively low visibility of the petroglyphs, situated as they were at the water's edge, indicates that they were not primarily made to convey meaning. This resonates well with other ethnographic examples where certain figurative expressions and stylistic embellishments are primarily directed toward animals and other-than-humans (Keithahn 1940, 131; Gell 1998, 68; Lemonnier 2012, 51). In some ontologies, rock art is even believed to be the work of spirits (Hultkrantz 1986, 54; Gell 1998, 98; Rozwadowski 2017). In such instances, individual petroglyphs work more like magic "devices" than representational images. The primary function of such imagery is often to lure, attract, and evoke other-than-human beings. In ancient Egypt, for example, certain statues were produced to evoke and house specific deities (Meskell 2004, 89–90), and in Marquesan ontology, the tattooing of an anthropomorphic image of the godling Etua is a ritual performance intended to bring the entity into being. Gell stressed that such a tattoo is not a representation of something somewhere else, but *is* the being itself (Gell 1998, 191). Similar conceptions of anthropomorphic rock art motifs as "rock people" and entities with agency are not uncommon in ethnographic accounts (Wallis 2009). This type of imagery need not be a symbol of powerful deities or spirits but can, just as spoken spells and acts, have power in its own right, without a need for mediation by any other agency of spirits or gods (see Malinowski 1922, 427). It should be emphasized here that in general, ritual enactments in small-scale societies are rarely addressed to beneficial gods, as in the dominant world religions, but are rather directed at maintaining good relations with a variety of unpredictable powers, such as godlings, ancestors, and spirits (Boyer 2001, 147). Because these entities are believed to be inconsistent and unpredictable, such enactments entail a need to control and limit some powers while encouraging others.

If the anthropomorphs of Boglösa were made to bring an entity into being, the play between hyperbolic attributes on the one hand, and the lack of limbs on the other, could work to manipulate their agency. The question is thus not what kind

of creature has only one leg or no head, but instead what such an entity can or cannot do. Because spirits can be unpredictable, the powers of rock art need to be regulated, which can be achieved by adding or reducing details or attributes (see McGranaghan and Challis 2016). In such a scenario, partial anthropomorphs could be designed to restrict the agency of an entity by omitting an arm or a leg. Similarly, the enlarged attributes of some anthropomorphs or the addition of a weapon could be intended to evoke particular strengths of the entity in question (see Wyman 1983, 552; Schaafsma 2018, 411). For example, an anthropomorph with a phallus or a sword is not necessarily a virile man, and a horned anthropomorph may not represent a human with a mask or a hybrid creature: the main point of the attributes is that they are more likely to enhance and add powers or abilities to the entity in question.

The ambiguous and partial design might also catch the attention and curiosity of wandering spirits, enticing them to enter a statue, figurine, or anthropomorphic image. Just as labyrinths and abstract or complex figures are employed as apotropaic devices to confuse malevolent spirits and stop them from entering a body or place, the allure of the partial can also work as a cognitive trap to attract and capture different kinds of entities (Gell 1998, 68–69; Willerslev 2007, 102; Lemonnier 2012, 51). Instead of evoking a particular entity, the generic Boglösa anthropomorphs provide a material "body" for immaterial entities to occupy. The play between the distorted proportions and missing limbs of the anthropomorphs, although comprising a human morphology, could indeed evoke a similar sense of "awe" in other-than-humans as well as humans (Schaafsma 2018, 412). Thus, the partial anthropomorphs could, in a similar way to elaborated imagery, work as a kind of "fly paper" that certain entities cannot resist "occupying" (see Schaafsma and Tsosie 2009, 25). In such a scenario, the faceless and anonymous anthropomorphs attract interest and curiosity in general, while "complete" motifs are directed towards specific entities. For instance, the foot soles of different sizes and designs could be directed towards particular entities, and even lead them to certain spots. The pairs of legs, on the other hand, are fundamentally generic, allowing any entity to enter them and as a result become trapped in the rock, where it can be monitored and controlled (see Astor-Aguilera 2010, 171).

5 Rock, art, and water: The foundations of a vitalist technology

If the main function of the anthropomorphs is to work as lures to trap other-than-human beings, the question remains: why was this applied in certain semi-secluded bays along the coast of southern Scandinavia? In general, imagery intended to lure or control often shares attributes with what it aims to affect (i.e., sympathetic magic), although this need not always be the case (see McNiven and Brady 2012, 71). To understand the purpose of Bronze Age anthropomorphs, however, we cannot rely on the figurative content and design of the petroglyphs alone, but must also consider their mediality and the anthropomorphs' relation

to the environment. Several researchers have emphasized the importance of the rock itself as an integrated part of rock art (e.g., Hauptman-Wahlgren 1998, 91; Jones 2006; Bradley 2009; Gjerde 2010). Indeed, the mediality of the imagery, the smooth rock faces, are by no means passive "canvases." The rock face itself already has certain visual qualities due to the ores, ridges, cracks, and fissures that pattern it. The rock outcrops at the shoreline also express several biotic "behaviors" and animacy. Coastal uplift, for instance, regularly causes new islets to "grow" from the waters, and these are quickly filled with rock art. The smooth rocks store both heat from the sun in the daytime and the cold from the night air. Water emerges or disappears into cracks and fissures in the rock as if the rock were "drinking." The rocks thus express certain agentive properties that may have inspired beliefs that they were biotic and thus susceptible to manipulation (see Worliczek 2017). Because these animacies existed prior to human understanding, this relation between the rock art and the movements of the earth is not necessarily animistic in the traditional sense (Ingold 2006; Porr and Bell 2012, 187; see also Deleuze 1995, 143). The zone where the land meets the sea is *lively*, but not necessarily *living*.

Interestingly, several the anthropomorphic figures in the Mälaren area relate to, and are possibly inspired by, these properties of the rocks. For instance, two out of the three archer motifs are juxtaposed with other motifs that are separated from them by vertical cracks in the rock (Figure 14.4a). The crack between the archer and the game effectively complicates the otherwise intuitive reading of the two figures as representing a hunting scene. Other anthropomorphs relate more directly to properties of the rock. In one instance at Boglösa, the outline of an anthropomorph is based on a natural fissure in the rock (Figure 14.4b). Directly to the left of it is an example of how cracks have sometimes been widened by repeated hammering. The ways in which such motifs partly derive from cavities in the rock has been argued to represent a means of "reaching" something from inside the rock (e.g., Lahelma 2012, 24; Tilley 2008, 177). It is an open question whether these actions are intended to 'take' something out or "put" something in the rock (or both). In this particular case, however, the anthropomorph is turned towards the crack rather than emerging from inside it. Other anthropomorphs are more ambiguous in terms of their relation to the rock. One intriguing category of anthropomorphs is pecked across horizontal cracks that separate the legs below the knees from the rest of the body (Figure 14.5). These examples are hardly accidental, since there is often plenty of room to make images between the cracks, and no obvious direction is emphasized in the composition. But just as the previously mentioned anthropomorph partly based on the outline of a crack in the rock (Figure 14.4), none of these figures arguably emerge from inside the rock. Be that as it may, this design also resonates well with the general emphasis on legs and feet in Bronze Age rock art.

The above examples show that the relation between the cracks and fissures of the rock and the anthropomorphs need not necessarily be understood in visual terms. The way the pecked lines and the cracks and fissures of the rock interact suggest, rather, that the main objective was to integrate certain qualities of the

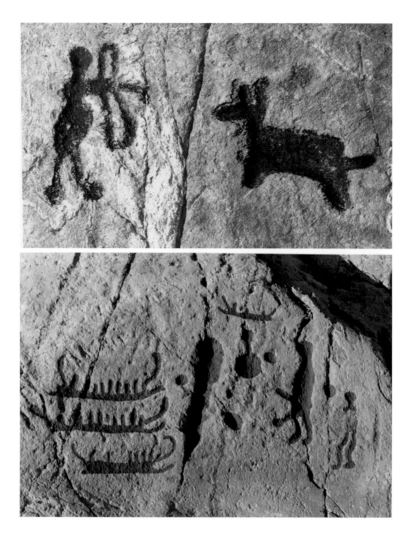

Figure 14.4 Top: An archer separated from game by a vertical crack in the rock. Bottom: An anthropomorph based partly on a natural cavity in the rock. Note the enlarged crack in the middle of the photo.

Source: Photos Einar Kjellén, Enköpings Museum.

rocks with the function of the petroglyphs. It would be too simple to suggest that the cavities in the rock are gateways to an "Otherworld," as often discussed in the northern Stone Age tradition of rock art (Lahelma 2012, 24). Although this is a viable possibility, there is nothing in the properties and animacies of the rock to substantiate such a hypothesis. To better understand the intricate relations between the animacies and visual aspects of the rock, an analogy with ritual tattooing is informative. Besides the fact that both technologies apply figurative

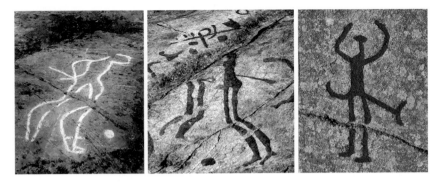

Figure 14.5 Examples of anthropomorphs pecked across cracks in the rock.
Source: Photos Einar Kjellén, Enköpings Museum.

patterns using repeated penetration, there are also ontological similarities between the skin and the rock face. Just as the skin emits and absorbs fluids, so too the cracks and fissures of the rock emit and absorb water. In tattooing, this membranous nature of the skin is sometimes utilized as a way to reach into the body and affect the psyche and organs, as well as to allow for the inside to transgress the body's physical boundaries (Gell 1993, 39). Tattooed imagery can thus be understood as a means to facilitate "portals" through which the outside can be affected, or vice versa (Lewis-Williams and Dowson 1990; Benson 2000, 249). A similar function may also apply to the foot soles and the anthropomorphic motifs: for example, the foot soles are well designed to be utilized as a "vault" or "anchor" by both the humans and other-than-humans who might stand in them. Similarly, the anthropomorphs pecked across cracks in the rocks would constitute a more explicit way of exploiting the biotic animacies of the rocks to enact or spirit away trapped other-than-human beings in the petroglyphs.

Such an interpretation is further substantiated if water is included in the mix. Like the rocks, water is not a passive materiality, but expresses a wide range of animacies. It can change form into ice, snow, mist, and hail, and then return to liquid form. Rain accumulates in puddles which increase and decrease in size depending on the flow of water and evaporation. Seawater changes color, makes waves, and withdraws or rises with the tides. The sea itself contains a plethora of life above and beneath the surface that is only temporarily visible. Driftwood, carcasses, and other items continuously land on the shores, while other objects are washed out to sea. The list goes on, but the point here is that water in different forms constitutes an important element in Bronze Age rock art (e.g., Bradley 2009, 141; Fahlander 2019a). To begin with, rock art in the Mälaren region is generally made close to the water's edge. This is illustrated by the way the same motifs in newer styles are found below older images as they follow the retreating waterline caused by coastal uplift (Fahlander 2018, 58). It has been argued that the placement of the motifs close to the waterline was intentional and

intended to allow water from waves to regularly splash over them (Helskog 1999; see Hauptman-Wahlgren 1998, 92). This phenomenon is still visible in areas with little or no coastal uplift (e.g., Nordén 1926, Figure 86). That water was important to the rock art is further supported by the fact that many figures are concentrated in areas that are regularly soaked by running water from a slump above the rock face, while adjacent surfaces are more or less left empty of petroglyphs (Malmer 1989, 14; Bradley 2009, 136). It has been suggested that this arrangement was deliberate because water, just as the light from fires, would visually animate the images and make them seem alive. Judging from how the anthropomorphs and cracks interact, however, the main function of water was not primarily visual, but rather the vitalist aspects of moving water were used to affect the petroglyphs or what was being trapped in them. Because the rock art was regularly washed by water, a stronger connection between the petroglyphs and the rock was established by using water as a medium to reach into the rock more effectively. Either way, the intentional use of water is reflected in the way rock art was made by pecking incisions in the rock. Painted imagery is bound to be washed away, while the incised figures withstand millennia of flowing water from waves and rain.

6 Conclusion

Southern Scandinavian Bronze Age rock art comprises a complex and varied type of material articulation, and we can only expect to grasp certain elements of its ontological connotations. Although this rock art is figurative to some extent, it is not likely to primarily depict or represent elements of myth and cosmology. By instead viewing petroglyphs as material articulations, the dilemma of representation can be partially bypassed, allowing for a change of perspective from viewing images as primary vehicles of meaning and symbolism to understanding what imagery can do in wider human and other-than-human sets of relations. The case study presented here focuses on the anthropomorphic figures of the Mälaren region in particular in order to investigate the functions of Bronze Age rock art in general. Although the majority of the anthropomorphs are simple stick figures, they are not passive and indifferent signs, but rather are carefully designed. Only a very few are equipped with weapons and gear, while the majority are partial and generic. It has been argued here that their partial and anonymous designs allow them to evoke, attract, lure, and control both humans and other-than-humans. In particular, legs and feet seem to occupy a special role in the function of the anthropomorphic figures. The legs are often exaggerated in length, with emphasized calves, even occurring as single pairs lacking a body. Although three-quarters of the anthropomorphs are partial, most of them have visible feet (even the pairs of legs). Feet also occur as single or paired foot soles. Moreover, a small number of anthropomorphs are also pecked across natural cracks in the rock, separating the legs from the rest of the body above the knees.

The anthropomorphic designs and their relations to the microtopography of the rock and water are a strong indication that they are as much "devices" as

they are images, pecked alongside the water in order to *do* something. Their generally low visibility and position close to the water's edge suggest that the rock art is probably not primarily directed towards other humans but rather is intended to evoke or trap other-than-human beings of the water-world. It is argued here that the partial and generic designs of the anthropomorphic figures aimed to catch the attention of and provide a means to control and hamper the powers of trapped entities. The water from rain, waves, or springs that repeatedly flows over the petroglyphs is a crucial element of such a vitalist technology; it is suggested that it either vitalized the figures or acted as a medium to relate the function of the petroglyphs to the animacies of the rocks and the sea.

Although this discussion focuses on Bronze Age anthropomorphic motifs in particular, this manner of approaching rock art as material articulations, and emphasizing ontological aspects in the design and their intricate relation to other materialities (rock and water) constitutes a formal method that may also prove viable for interpreting rock art from other periods and regions.

Note

1 This study was made possible by funding from The Swedish Foundation for Humanities and Social Sciences (Riksbankens Jubileumsfond P16-0195:1). I am grateful to the editors and Amy Chase for the final edit of the manuscript.

References cited

Almgren, Bertil. 1960. "Hällristningar och bronsåldersdräkt." *Tor 6*: 19–50.

Almgren, Bertil. 1976. *Hällristningarnas tro. Till tolkningen av de svenska hällristningarna från bronsåldern.* Uppsala: Uppsala University.

Astor-Aguilera, Manuel. A. 2010. *The Maya World of Communicating Objects: Quadripartite Crosses, Trees, and Stones.* Albuquerque: University of New Mexico Press.

Bailey, Douglas. W. 2007. "The anti-rhetorical power of representational absence: Incomplete figurines from the Balkan Neolithic." In *Image and Imagination: A Global Prehistory of Figurative Representation*, edited by Colin Renfrew and Iain Morley, 117–126. Cambridge: McDonald Institute.

Bailey, Douglas. W. 2013. "Cutting the earth/cutting the body." In *Reclaiming Archaeology: Beyond the Tropes of Modernity*, edited by Alfredo González-Ruibal, 337–345. London: Routledge.

Benson, Susan. 2000. "Inscriptions of the self: Reflections on tattooing and piercing in contemporary Euro-America." *In Written on the Body: The Tattoo in European and American History*, edited by Jane Caplan, 234–254. Princeton: Princeton University Press.

Bevan, Lynne. 2015. "Hypermasculinity and the construction of gender identities in the Bronze Age rock carvings of southern Sweden." In *Picturing the Bronze Age*, edited by Peter Skoglund, Johan Ling, and Ulf Bertilsson, 21–36. Oxford: Oxbow Books.

Boyer, Pascal. 2001. *Religion Explained. The Evolutionary Origins of Religious Thought.* New York: Basic Books.

Bradley, Richard. 2009. *Image and Audience: Rethinking Prehistoric Art.* Oxford: Oxford University Press.

Coles, John. 2000. *Patterns in a Rocky Land: Rock Carvings in South-West Uppland*. Uppsala: Uppsala University.

Coles, John. 2003. "And on they went... Processions in Scandinavian Bronze Age rock carvings." *Acta Archaeologica 74* (1): 211–250.

Deleuze, Gilles. 1995. *Negotiations 1972–1990*. New York: Columbia University Press.

Diaz-Granados, Carol, and James Duncan. 2002. *The Petroglyphs and Pictographs of Missouri*. Tuscaloosa: The University of Alabama Press.

Fahlander, Fredrik. 2012. "Articulating stone. The material practice of petroglyphing." In *Encountering Imagery: Materialities, Perceptions, Relations*, edited by Ing-Marie Back Danielsson, Fredrik Fahlander, and Ylva Sjöstrand, 97–116. Stockholm: Stockholm University.

Fahlander, Fredrik. 2018. *Bildbruk i mellanrum: Mälarvikens hällbilder under andra årtusendet fvt*. Stockholm: Stockholm University.

Fahlander, Fredrik. 2019a. "Petroglyphs as 'contraptions'—Animacy and vitalist technologies in a Bronze Age archipelago." *Time and Mind 12* (2): 109–120.

Fahlander, Fredrik. 2019b. "Fantastic beings and where to make them – Boats as object-beings in Bronze Age rock art." *Current Swedish Archaeology 27*: 191–212.

Fahlander, Fredrik. 2020. "The partial and the vague as a visual mode in Bronze Age rock art." In *Images in the Making. Art, Process, Archaeology*, edited by Ing-Marie Back Danielsson and Andrew M. Jones, 204–217. Manchester: Manchester University Press.

Gell, Alfred. 1993. *Wrapping in Images. Tattooing in Polynesia*. Oxford: Oxford University Press.

Gell, Alfred. 1998. *Art and Agency. Towards a New Anthropological Theory*. Oxford: Clarendon Press.

Gjerde, Jan M. 2010. *Rock Art and Landscapes. Studies of Stone Age Rock Art from Northern Fennoscandia*. Tromsø: Tromsø University.

Goldhahn, Joakim, Ingrid Fuglestvedt, and Andrew Jones. 2010. "Changing pictures – An introduction." In *Changing Pictures. Rock Art Traditions and Visions in Northern Europe*, edited by Joakim Goldhahn, Ingrid Fuglestvedt, and Andrew Jones, 1–22. Oxford: Oxbow Books.

Goldhahn, Joakim, and Johan Ling. 2013. "Bronze Age rock art in northern Europe: Contexts and interpretations." In *The Oxford Handbook of the European Bronze Age*, edited by Anthony F. Harding and Harry Fokkens, 270–290. Oxford: Oxford University Press.

Hagtvedt, Henrik. 2011. "The impact of incomplete typeface logos on perceptions of the firm." *Journal of Marketing 75*: 86–93.

Hampson, Jamie. 2016. "Embodiment, transformation and ideology in the rock art of Trans-Pecos Texas." *Cambridge Archaeological Journal 26* (2): 217–241.

Helskog, Knut. 1999. "The shore connection. Cognitive landscape and communication with rock carvings in Northernmost Europe." *Norwegian Archaeological Review 32* (2): 73–94.

Hultkrantz, Åke. 1986. "Rock drawings as evidence of religion: Some principal points of view." In *Words and Objects: Towards a Dialogue between Archaeology and History of Religion*, edited by Gro Steinsland, 42–66. Oslo: Norwegian University Press.

Ingold, Tim. 2006. "Rethinking the animate, re-animating thought." *Ethnos 71* (1): 9–20.

Ingold, Tim. 2010. "The textility of making." *Cambridge Journal of Economics 34*: 91–102.

Jones, Andrew M. 2006. "Animated images. Images, agency and landscape in Kilmartin, Argyll." *Journal of Material Culture 11* (1): 211–226.

Jones, Andrew M. 2017. "Rock art and ontology." *Annual Review of Anthropology 46*: 167–181.

Keithahn, Edward. L. 1940. "The petroglyphs of southeastern Alaska." *American Antiquity* 6 (2): 123–132.

Kjellén, Einar, and Åke Hyenstrand. 1977. *Hällristningar och bronsålderssamhälle i sydvästra Uppland*. Uppsala: Upplands fornminnesförening.

Lahelma, Antti. 2012. "Strange swans and odd ducks: Interpreting the ambiguous waterfowl imagery of Lake Onega." In *Visualising the Neolithic: Abstraction, Figuration, Performance, Representation*, edited by Andrew Cochrane and Andrew M. Jones, 15–33. Oakville: Oxbow Books.

Lemonnier, Pierre. 2012. *Mundane Objects: Materiality and Non-verbal Communication*. Walnut Creek: Left Coast Press.

Lewis-Williams, David, and Thomas Dowson. 1990. "Through the veil: San rock paintings and the rock face." *South African Archaeological Bulletin 45* (151): 5–16.

Ling, Johan. 2013. *Rock Art and Seascapes in Uppland*. Oxford: Oxbow.

Lødøen, Trond. 2015. "Treatment of corpses, consumption of the soul and production of rock art: Approaching Late Mesolithic mortuary practises reflected in the rock art of Western Norway." *Fennoscandia Archaeologica 32*: 79–99.

Malinowski, Bronislaw. 1922. *Argonauts of the Western Pacific*. London: Routledge & Kegan Paul.

Malmer, Mats. P. 1981. *A Chorological Study of North European Rock Art*. Stockholm: Stockholm University.

Malmer, Mats. P. 1989. "Bergkonstens mening och innehåll." In *Hällristningar och hällmålningar i Sverige*, edited by Sverker Janson, Erik B. Lundberg, and Ulf Bertilsson, 9–28. Stockholm: Forum.

Marstrander, Sverre. 1963. *Østfolds jordbruksristninger: Skjeberg*. Oslo: Universitetsforlaget.

McGranaghan, Mark, and Sam Challis. 2016. "Reconfiguring hunting magic: Southern Bushman (San) perspectives on taming and their implications for understanding rock art." *Cambridge Archaeological Journal, 26* (4): 579–599.

McNiven, Ian, and Brady, Liam. 2012. "Rock art and seascapes." In *A Companion to Rock Art*, edited by Jo McDonald and Peter Veth, 71–89. Hoboken: Blackwell Publishing Ltd.

Meskell, Lynn. 2004. *Object Worlds in Ancient Egypt: Material Biographies Past and Present*. Oxford: Berg.

Meyering, Lisa-Elen. 2018. "Fleshing out the stickman: A hypothesis about the long-legged anthropomorphs in Scandinavian rock art." In *Giving the Past a Future*, edited by James Dodd and Ellen Meijer, 136–142. Oxford: Archaeopress.

Morvan, Berenice. 2006. *Impressionism*. Paris: Terrail.

Nakamura, Carolyn. 2005. "Mastering matters. Magical sense and apotropaic figurine worlds of neo-Assyria." In *Archaeologies of Materiality*, edited by Lynn Meskell, 18–45. Oxford: Blackwell Publishing Ltd.

Nilsson, Per. 2012. "The beauty is in the act of the beholder." In *Encountering Imagery. Materialities, Perceptions, Relations*, edited by Ing-Marie Back Danielsson, Fredrik Fahlander, and Ylva Sjöstrand, 77–96. Stockholm: Stockholm University.

Nochlin, Linda. 2001. *The Body in Pieces: The Fragment as a Metaphor of Modernity*. London: Thames & Hudson.

Nordén, Arthur. 1926. *Östergötlands bronsålder: Beskrivande förteckning med avbildningar av lösa fynd i offentliga och enskilda samlingar, kända gravar samt hällristningar*. Uppsala: Uppsala University.

Harris, Oliver J.T., and John Robb. 2013. "The body in history: A concluding essay." In *The Body in History: Europe from the Palaeolithic to the Future*, edited by Oliver J.T. Harris and John Robb, 213–244. Cambridge: Cambridge University Press.

Hauptman-Wahlgren, Katty. 1998. "Encultured rocks. Encounter with a ritual world of the Bronze Age." *Current Swedish Archaeology 6*: 85–97.

Porr, Martin and Hannah R. Bell. 2012. "'Rock-art', 'animism' and two-way thinking: Towards a complementary epistemology in the understanding of material culture and 'rock-art' of hunting and gathering people." *Journal of Archaeological Method and Theory 19*: 161–205.

Robb, J. 2015. "What do things want? Object design as a middle range theory of material culture." *Archeological Papers of The American Anthropological Association 26*: 166–180.

Rozwadowski, Andrzej. 2017. "Rock art of Northern, Central, and Western Asia." In *The Oxford Handbook of the Archaeology and Anthropology of Rock Art*, edited by David Bruno and Ian McNiven, 1512–1576. Oxford: Oxford University Press.

Schaafsma, Polly. 2018. "Human images and blurring boundaries. The Pueblo Body in cosmological context. Rock art, murals and ceremonial figures." *Cambridge Archaeological Journal 28* (3): 411–431.

Schaafsma, Polly, and Will Tsosie. 2009. "Xeroxed on stone: Times of origin and the Navajo holy people in canyon landscapes." In *Landscapes of Origin in the Americas*, edited by Jessica Joyce Christie, 15–31. Tuscaloosa: University of Alabama Press.

Skoglund, Peter, Courtney Nimura, and Richard Bradley. 2017. "Interpretations of footprints in the Bronze Age rock art of South Scandinavia." *Proceedings of the Prehistoric Society 83*: 289–303.

Sognnes, Kalle. 2011. "These rocks were made for walking." *Oxford Journal of Archaeology 30* (2): 185–205.

Solomon, Anne. 2008. "Myths, making, and consciousness. Differences and dynamics in San rock arts." *Current Anthropology 49* (1): 59–86

Tilley, Christopher. 2008. *Body and Image: Explorations in Landscape Phenomenology II*. Oxford: Berg.

Vogt, David. 2006. *Helleristninger i Østfold og Bohuslän: En analyse av det økonomiske og politiske landskap*. Oslo: Oslo University.

Wallis, Robert. 2009. "Re-enchanting rock art landscapes. Animic ontologies nonhuman agency and rhizomic personhood." *Time and Mind 2* (1): 47–70.

Willerslev, Rane. 2007. *Soul Hunters: Hunting, Animism, and Personhood among the Siberian Yukaghirs*. Berkeley: University of California Press.

Worliczek, Elizabeth. 2017. "Naturally occurring asbestos: The perception of rocks in the mountains of New Caledonia." In *Environmental Transformations and Cultural Responses*, edited by Eveline Dürr and Arno Pascht, 187–214. New York: Palgrave Macmillan.

Wyman, Leland C. 1983. *Southwest Indian Drypainting*. Albuquerque: University of New Mexico Press.

15 Hunters and shamans, sex and death

Relational ontologies and the materiality of the Lascaux "shaft-scene"

Robert J. Wallis

1 Introduction

The 'scene in the shaft' (*la scéne du puits*) of the cave of Lascaux (Figure 15.1) in the Dordogne region of France is one of the most enigmatic and well-known in the cave art corpus, located in perhaps the most iconic of caves. In this chapter I offer a sustained examination of the artwork following the 'archaeology of art' proposed by Jones and Cochrane who argue that 'any approach to archaeological art must begin with the material from which the artwork is composed' (2018, 21). I begin by a process of induction with a formal analysis, considering the use of pigment and paint, techniques of production, and the way in which artist and materials were involved in a process of 'intra-action' and 'affect.' I also take account of natural features of the rock surface and how the tangible relationships between image and surface indicate an active dialogue between them, and therefore between the maker, the artwork, and the process of making. Further attention to the location, morphology, and archaeology of the shaft enables discussion of the intra-action between artist, image, rock surface, objects, and the cave locale. This assemblage of visual and material elements presents a range of possible affects which I explore in terms of ethnographic data on hunter-gatherer communities, drawing upon Willerslev's (2007) ethnography of the animist Siberian Yukaghir.

2 The materiality of the 'shaft-scene'

The visual elements of the shaft-scene consist of an anthropomorphic figure, a bison, a bird, a rhinoceros, and geometric elements comprising a double series of dots and three lines with convergent elements, traditionally interpreted as a spear, spear-thrower, and staff (upon which the bird sits). The rhino and dots are thought to have been produced in a different phase and are therefore treated as separate elements (so I shall not discuss them further here). Opposite the scene, across the shaft, is a horse 'set apart and isolated on the facing wall but nonetheless capable of being interpreted into the Scene' (Aujoulat 2005, 158). Aujoulat (2005, 158) proposes, 'the originality of this panel lies in its narrative potential,' but I want to focus not on what is assumed to be 'represented,' which

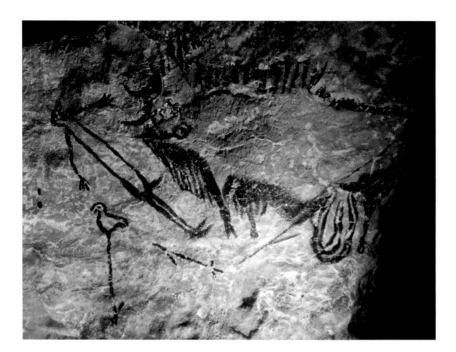

Figure 15.1 The precise facsimile of the Lascaux "scene in the shaft" (*la scène du puits*) displayed at the 'Lascaux III' exhibition, Paris, 2015.
Source: Photo taken by author, reproduced with the permission of Olivier Redout.

may tell us more about modern Western ontologies than about those of the hunter-gatherer artist(s) of the shaft-scene, but rather the materiality of the art-work and how working inductively might facilitate discussion of ontological issues emerging from the relations between these visual and material elements. Avoiding the assumption that the artwork is a 'scene' at all, which can be read in a narrative sense, I choose to hyphenate the traditional title of the work, as Chippindale and Taçon (1998, 6) have done for rock-art, 'in a slight attempt' to form a critically aware 'portmanteau.'

The imagery is monochrome in black, the pigment composed of an oxide of manganese and barium. The making of the pigment required locating the oxide, crushing it and mixing it with water (without additional binding agents), bringing hard and wet materials together to make something new, a transfor-mation which was a creative act in itself. Jones and Cochrane discuss the material qualities of making paint as more than simply mixing a pigment substrate and carrier substance, but rather a magical, alchemical process of transforming 'base' materials into a new form which has magical effects (Jones and Cochrane 2018, 23). Applying the pigment was also affective. The horse, rhino, upper line and belly of the bison plus the pelvis and legs of the an-thropomorph, were sprayed, the rest painted. The paint was applied in fine

layers (except on the rhino where there is much thicker application [Aujoulat 2005, 158], supporting the idea that it was produced in a different period). In order to perform the spraying, the artist would have taken paint into the mouth and then ejected it through pursed lips or a blow-pipe (Breuil 1950, 360), in a highly interactive, embodied processes (see also Lorblanchet 1991, 30; Lewis-Williams 2002, 219). Using the two techniques of painting and spraying the artist has displayed very clearly—'schematically' as Bataille (1955, 117) put it—the key elements of concern; as in many other rock art traditions, the clarity rather than naturalism of the image was of particular concern.

The cave wall of the shaft is made from limestone and the rock is unusually hard in this part of the cave (Aujoulat 2005, 177). Unlike other areas, where the surface is too friable or there are contaminants which make the application of paint difficult (Breuil 1950, 358), the shaft presents numerous possible surfaces where imagery could have been located—but only the shaft-scene was executed. And the surface itself was by no means an inert blank canvas, the artist influenced in choosing where to paint, how to paint, and possibly what to paint, by virtue of certain pre-existing natural features in the cave wall (ff. e.g., Bataille 1955, 62). A cupule in the rock surface is the basis for the eye of the bison, a simple black arc of paint forming the eye lid. The two horns of the beast are based on natural ridges in the rock surface. A distinct bulge in the rock surface emphasizes the bulk of the animal's form, as well as its powerful musculature (Figure 15.2). The artist used engraved lines, as well as pigment, to enhance elements of the outline (Breuil 1950, 359), a technique used in other caves in the Vézère Valley, such as Font du Gaume. These subtleties of rock morphology and artistic technique are often lost in photographic reproductions in books which flatten out the rock face and frame the 'scene' (e.g., Leroi-Gourhan 1965, fig. 74; Sanders 1968, 135), exacerbated by such techniques as heliogravure (e.g., Windels 1948), as if it should be appreciated like a picture in an art gallery.

These formal properties can be approached in terms of how art-making involves an active and creative 'intra-action' between maker and materials; that is 'material and people as they work in partnership' (Jones and Cochrane 2018, 22–23). This relationship between maker and materials must also be considered in terms of the wider cave environment in which artist and the materials came together. The materials used in the making of cave art, comprising pigment, paintbrushes and other tools, the surface of the cave wall, and such other things as ladders, lighting, and possibly assistants, can then be understood as active and agentive rather than passive and inert.

The unfolding process of making the artwork resulted in a number of 'affects,' defined by Jones and Cochrane (2018, 25) as 'the effect a given object or practice has on its beholder, and its beholder's "becomings".' The cave interior is a dark, damp and cool place in which to work and the surrounding, ever-present stone is hard when touched, brushed against and knocked. The established name of the 'shaft' is somewhat inappropriate, as the locale comprises a recess in a gully-like feature below the 'Apse,' known as the 'Great Fissure.' A number of features combine to make this an unusual choice of location in the cave for the artist, and

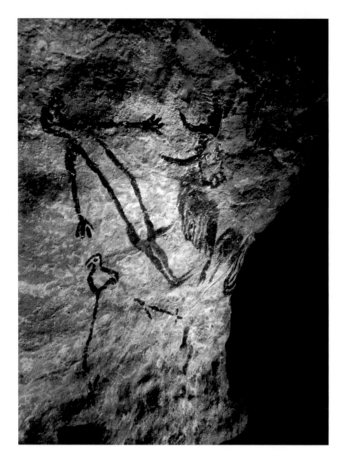

Figure 15.2 The curve of the rock surface emphasises the bulk of the bison's form, as well as its powerful musculature.

Source: Photo taken by author at the Lascaux III exhibition, reproduced with the permission of Olivier Redout.

one which would have made executing the artwork particularly challenging. The 'shaft' descends vertically for around 5 m and is difficult to access (although there may have been a separate entrance in prehistory [Breuil 1950]). Descending from the Apse would have required equipment, possibly assistants, and would have been dangerous. The Great Fissure narrows in places to just 70 cm across (Aujoulat 2005, 42). Entering and moving through the cave would not have been straightforward, but highly interactive, requiring crouching, touching the cave wall, and squeezing through narrow apertures, all of which may have facilitated altered sensory experience.

 The part of the shaft where the scene is positioned is not an obvious one in order to stand and work comfortably. Bataille (1955, 110) states that 'midway down, four yards or so below the floor of the Apse, a narrow platform brings one opposite a

rock shelf ... bearing [the] images.' It would have been difficult to illuminate this area because the cave wall is chromatically dense, meaning more light was needed to illuminate the artwork than in other areas, and because of the high level of carbon dioxide in the shaft. This exceeds 6% in summer and autumn, affecting the flame of a lamp which is 'often extinguished when it reaches 3%' (Aujoulat 2005, 46). These higher levels of carbon dioxide might indicate why an 'abnormally high number of lamps' were deposited at the foot of the shaft (Aujoulat 2005, 46).

The material conditions of the shaft, then, suggest that the artist chose this site because it was a difficult place to work, tucked away and well removed from those areas of the cave where the art is more highly concentrated. These material conditions would have had significant affects on the maker of the work, including an element of risk in accessing the shaft, and requiring an awkward, cramped posture in low light and low oxygen conditions, in order to work on a chromatically dense rock surface. The application of the pigment, too, would have affected the artist. The toxic properties of manganese dioxide (Lewis-Williams 2002, 219) may have been well-known and chosen specifically for the work, and the technique of spraying used to make part of it, which involved ingesting the pigment, would have facilitated this, adding to the magic of making. The making of the shaft-scene was clearly an embodied and transformative one, affecting the senses in ways which must have accentuated the intensity of the work.

In terms of the wider archaeology of Lascaux and the shaft in particular, it is worth noting that the faunal remains tend towards cervids (reindeer and red deer). Glory's excavations in Lascaux showed that c. 95% of remains were cervids (reindeer and red deer), with wild boar and horses also present (Aujoulat 2005, 26). A reindeer antler baton was found at the foot of shaft-scene and Girod and Massénat (1900) have interpreted such batons as shaman's drum-hammers, like those used by the Saami in Fennoscandia as well as by many Siberian shamans. If a percussive instrument was used in the shaft then the monotonous sound would have echoed around the chamber and had a dramatic effect on the hearing of anyone present, magnifying the altered sensory experience induced by the other material factors.

The baton was found among a number of lamps, the most complete and well-known being a rose-colored sandstone lamp (22.4 cm long, 10.6 cm wide and 3 cm thick) bearing marks upon the upper face of the handle. Carbonized fragments of juniper and coniferous wood in the concave section indicate the combustible substances, along with animal fat, used in the illumination. The burning of these pungent substances must have had an impact on the artist's sense of smell. It is plausible that the smoke created by the lamps obscured vision during the making of the artwork, and when viewing it, and that the shifting shadows of this smoke enhanced ways of seeing the work. Smoke must have been central to the experience of making and beholding the shaft-scene, since the numerous fragments of charcoal found in the stratigraphy of Lascaux indicate that many hearths were lit in the cave (Aujoulat 2005, 55).

The engravings upon the handle of the lamp are found in several other areas in the cave and it is often assumed that these marks, while abstract, represent

something, such as the hoof marks of animals, or that they are 'symbols' or 'signs' (Aujoulat 2005, 54–55). The two lines juxtaposed with these marks, one short and jagged at the top of the handle, the other longitudinal along the axis of the handle, are arguably also relevant. Jones and Cochrane (2018, 117) propose that it is useful to consider image making as gestural. Rather than seeing some of the marks on the lamp as signs, others as inconsequential, when making them the artist worked interactively with the materials, including the tool used to engrave the mark and the sandstone itself. Sandstone is mainly composed of quartz and is a hard material to work, responding differently to the softer limestone of the cave wall. While making the lamp, the artist would have been attentive to the materials and responded experimentally to the flow between hand, tool, and stone, resulting in creative gestures.

The gestural lines on the lamp relate materially to others in the art of Lascaux and not only the nested engraved symbols repeated elsewhere in the cave. It is notable that both the spear/spear-thrower super-positioned with the bison, and the stick of the staff, are 'broken.' Approaching these fragmented lines as gestures rather than as representations, they can be related to other marks in the shaft-scene, such as the separate strokes used to make the mane and beard of the bison, perhaps even the fingers, feet, and penis of the man. Viewed in this way these marks are connected in ways which cut across the artistic media of parietal art (on the cave wall) and portable art (on the lamp), and go beyond that of representation, style or composition. The decoration on the lamp, just like the shaft-scene itself, can be approached as relational, intra-active, and gestural.

In terms of materials, the pigment, tools, stone, air, light, and locale all had an impact on the artist; in terms of processes, the making of a psychoactive pigment, painting, and spraying it, and the engraving of certain features were all embedded in affecting the moment of making; and in terms of experiences, entering the cave, perhaps descending shaft, the cold temperature, the texture of the rock, the low, flickering light, smoke, and low oxygen levels, too, all must have had a transformative affect on the artist, and one which arguably pertains to shamanistic experiences, a subject to which I shall return.

3 Approaching meaning

Having considered the materiality of the shaft-scene and its transformative affects, I now turn to the imagery itself and how it might be approached. Reading the 'scene' as either a 'hunting' (e.g., Bataille 1955, 140; Mithen 1988) or a 'hunting magic' narrative (e.g., Reinach 1903; Windels 1948; Breuil 1950, 361; Gombrich 1950) assumes that the artist has attempted to represent an actual or imagined event. But art and imagery are not always representational (Jones and Cochrane 2018, 117) and focusing immediately on what is 'represented' may tell us more about modern Western ontologies than about those of the prehistoric past. What we are looking at may not be a representation of a predetermined plan for a 'scene,' 'a process of transferring a concept into material form' (Jones and Cochrane 2018, 23), but rather an assemblage resulting from human intra-action with materials, processes, and the resulting experiences.

Ingold (2013, 96) proposes that the role of the artist is 'to allow the forces and flow of material that bring the work into being.' The words of the artist Paul Klee resonate here: '[a]rt does not reproduce the visible but makes visible' (Ingold 2019, 559). This is not to say that the imagery in the shaft-scene did not begin as an idea and does not 'resemble' things (Jones and Cochrane 2018, 117), but that '[w]e cannot read art and images directly; they are slippery and difficult to pin down' (Jones and Cochrane 2018, 6). Moving away from the idea of inter-pretation, and especially the notion that the imagery is a 'scene' which can be 'read' in a logical way, the composition of the artwork suggests relationships between visual and material elements with epistemological and ontological consequences which are enigmatic to Western eyes and not straightforward to interpret.

Bahn (1988) has argued persuasively that interpreting cave art imagery ex-clusively in terms of hunting and hunting magic is problematic. Only rarely is a wounded animal shown unambiguously and there is no clear example of a hunter preying upon a game animal. The eviscerated bison in the shaft-scene can be read as a wounded, dying animal, but the 'spear' does not penetrate the body at a clear entry or exit point, and this is an exceptional example, not the norm. The bird-headed anthropomorph does not hold a weapon and is not depicted in a hunting pose. While spears and spear throwers have been identified, these images can be interpreted in other ways. They might, as I have set out earlier, be gestural rather than representational.

It is notable that not all of the species depicted were those that were hunted regularly. The faunal remains from Lascaux tend towards cervids (reindeer and red deer) with some horse, rather than such large game animals as bison and auroch. Images of cervids and horses predominate at Lascaux (e.g., Windels 1948, 55), while bison, just 4.3% of all the animals depicted (Aujoulat 2005, 158), and auroch, are rare. The depiction of cervids and horses tallies with the faunal remains of what was hunted but the bison and auroch do not. The idea that the production of cave art can be attributed to hunting cannot account for all of the imagery. The correlation between the species depicted and the faunal remains of hunted species indicates a hunting connection, but not one which explains all of the art.

An alternative proposal which has fallen in and out of favor over the last century of thinking on cave art, is that some of the art relates to shamanistic practices (e.g., Lommel 1951; Kirchner 1952; Kühn 1956). I have already pointed to the possibility that the affective outcomes of making the shaft-scene are suggestive of shamanistic experiences. The shamanistic interpretation of cave art was popularized by Eliade (1964) who proposed that '[the] role of the cave in Paleolithic religions appears to have been decidedly important [a symbol] of passage into another world, of a descent to the underworld' (Eliade 1964, 51). In terms of the shaft-scene, he argued '[t]he bird perched on a stick is a frequent symbol in shamanic circles … already found in the celebrated relief at Lascaux (bird-headed man) in which Horst Kirchner has seen a representation of a shamanic trance' (Eliade 1964, 481); furthermore that '[r]ecent researches have

clearly brought out the "shamanic" elements in the religion of the Paleolithic hunters. Horst Kirchner has interpreted the celebrated relief at Lascaux as a representation of a shamanic trance' (Eliade 1964, 503).

The idea of cave painting being associated with shamanism fell out of favor thereafter, particularly in light of Ucko and Rosenfeld's (1967) work which demonstrated how much previous interpretation was arbitrary. Davenport and Jochim (1988), however, pointed innovatively to the shared avian features of the 'wounded man' and the bird-topped staff, arguing that the shaman is shown in a moment of transformation and that the bird on the staff is a spirit-helper, perhaps similar to the Mongolian Darhad shaman's *ongon*. And in the same year Lewis-Williams and Dowson (1988) proposed a controversial neuropsychological model for interpreting certain cave art imagery as deriving from altered states of consciousness. Lewis-Williams has since argued that the shaft-scene does not present 'a real-life tragedy' because the 'death' of the anthropomorph is rather a metaphoric representation of the shaman's trance experience, with the erect penis 'common in altered states and in sleep,' with sex 'sometimes associated with shamanistic travel' (Lewis-Williams 2002, 265). Close attention to the formal properties suggests the anthropomorph is more complex than this, for the artist has rendered the feet and penis in a similar way, and perhaps the fingers too. For Lewis-Williams the bison is a 'spirit bison' with the painted image 'fixing the spirit animal' onto the rock (Lewis-Williams 2002, 265). Interestingly, Lewis-Williams is interested in the materiality of the shaft-scene, proposing, as I have mentioned, that the toxic properties of the manganese dioxide in the paint may have induced an altered state, and viewing the rock face as a metaphorical 'veil' between the everyday world and the spirit world, and one which the shaman would have touched in order to facilitate shamanic travel. In summary, Lewis-Williams sees the shaft-scene as an individual shaman's hallucination reproduced in an artwork. I have engaged critically with the history of this thinking on cave art and shamanism, and contributed to it myself (e.g., Wallis 2002, 2013, 2019). I think Lewis-Williams' shamanistic interpretation of the shaft-scene is interesting, informed by strong relations of relevance, but with only limited attention to the importance of materiality and exaggerating what is represented in the 'scene,' the individual shaman and his hallucinatory vision, without attention to the broader animic ontological setting within which shamans operate.

I want to draw upon Viveiros de Castro's (e.g., 1988) discussion of perspectivism and shamanism at this juncture. He theorizes Amazonian animisms as perspectival, relational ontologies in which shamans are able to adopt the perspectives of others (such as jaguar-persons) and so mediate between human-persons and other-than-human persons in a wider-than-human world. I have explored how this sort of animic thinking makes shamans important and necessary because they claim to be able to see as others do and so have the potential to communicate effectively between human and other-than-human persons (Wallis 2013; Harvey and Wallis 2016). Attempting to negotiate social harmony between these diverse persons is an aim and ambition in a world in which persons are in constant flux and conflict, since external appearance is no

confirmation of inner essence ('soul'), sexual relations across species are a necessity, and cannibalism arises when persons must eat other persons (Harvey 2005). Discussing San rock art in terms of animism, Dowson proposes that:

> Many hunter-gatherer groups around the world see a parallel between hunting and sexual intercourse and marriage ... Both activities can be thought of as rites of regeneration ... [C]onsumption follows killing as birth follows intercourse, and both acts are integral to the reproductive cycles, respectively, of animals and humans.
>
> (Dowson 2007, 56)

For many animist hunter-gatherers, hunting, shamanism, sex, reproduction and death are, then, inter-related.

4 Hunters, shamans, sex, and death in animist ontologies

Dowson further argues that San rock art should be approached not as 'narratives of daily routine' nor as visual expressions of shamans' hallucinations, but as 'embodied revelations of personal engagements with the world; engagements through which each human and non-human animal sought to maintain the circulation of vital forces' (Dowson 2007, 58). Furthermore, 'the significance of death and hunting was not metaphorical, it was very real, and essential for the regeneration of life' (Dowson 2007, 56). If this view of animism might be rather abstract, if not idealized (Porr and Bell 2012, critiquing my work [Wallis 2009] similarly), then it is important to consider how animist thinking is not only diverse (e.g., Harrison-Buck and Hendon 2018) but also pragmatic.

Willerslev (2007) discusses the practicalities of imitation, transformation and sex for Siberian Yukaghir hunters and shamans. Prior to hunting, hunters bathe to remove their human scent, dress themselves in imitation of prey, and during the hunt make animal calls and move seductively towards the quarry. The hunter 'seeks to induce in the animal master-spirits an illusion of a lustful play ... As a result, the spirits come to believe that what is going on is not a premeditated kill but a "love-affair" with the hunter' (Willerslev 2007, 48). One of Willerslev's informants describes how he had sex with the female Owner spirits in his dreams before a hunting expedition:

> They live in a wooden house. There is a barn, too. I assume they keep the animals in the barn. They are always glad to see me, the three sisters. When I arrive, they are a little drunk [presumably because of vodka sacrificed in preparation of the hunt]. They start to play around with my penis, edging up to me ... When I wake up I know that this season I will have good luck in hunting.
>
> (Willerslev 2007, 175).

Sexual relations with owner spirits and prey are important for Yukaghir hunters because this enables them to seduce their quarry in advance of the hunt and so facilitate success. It is not only seduction but also sexual contact itself which is important; the female Owner spirits 'play around' with the hunter's penis, 'edging up' their bodies to him. But this act of engagement and the transformative mimesis of quarry is dangerous, risking the hunter becoming prey, stranded in the world of the spirits. Siberian shamans also engage in sexual encounters with animal owners and animal-spirits, and they too must be careful in these relationships lest they are consumed by the spirits, transformed irrevocably by them, or die from sicknesses caused by them (e.g., Eliade 1964; Hamayon 1996; Znamesnski 2003).

While shamanism has been characterized by Eliade (1964) as a 'technique of ecstasy' in which practitioners alter their consciousness by varying means, typically the monotonous sound produced by the rhythmic beating of a frame-drum, I am interested in how Hamayon (1996, 1998) emphasizes the importance of shamans' erotic and sexual relations with spirits. She argues against the negative connotations of isolating trance, ecstasy, and altered states of consciousness as defining features of shamanisms, these having been used to demonize Siberian shamans in the past. Hamayon contends instead that shamanic séances among the Evenk (Tungus) and Buryat are themselves 'sexual encounters,' arguing that the 'marriage' between shamans and their helpers is more significant in understanding what these shamans do than the ecstasy, mastery of spirits, or journeying emphasized by other scholars (Harvey and Wallis 2016, 102–103).

While Siberian shamans have also been seen as professional religious leaders (e.g., Eliade 1964), Willerslev (2007, 124) recognizes Yukaghir shamanic specialization as 'a question of degree' and that hunters themselves are able to shamanise. For one informant, 'virtually everyone can shamanise; it is just that some are better at it than others' (Willerslev 2007, 124). This view accords with shamanism among the Indian Sora for whom 'shamanship' is 'a talent or inclination as much as an activity and is spread variously among persons who practice it to varying degrees' (Vitebsky 1993, 22). Willerslev further proposes that while shamans control the animal spirits to secure hunting success, 'Yukaghir hunters are in fact at a halfway stage toward full shamanship,' because in imitating his prey, the hunter 'moves, as it were, in between human and animal perspectives' (Willerslev 2007, 124, 127). Having discussed how hunting, shamanism, sex, and death are inter-related for the Yukaghir, as for many animist hunter-gatherer communities, I now consider the relevance of this thinking to understanding the shaft-scene (ff. Bataille 1955, 125–126), emerging inductively from the distinctive material and visual evidence rather than as interpretations imposed onto the artwork.

5 Hunting and shamanism, sex and death in the Lascaux shaft-scene

The making of the shaft-scene was clearly a material and embodied one, affecting the artist's senses in ways which would have accentuated the intensity of

the work. Entering the cave itself would have been awkward and transformative, moving from the world of the everyday to a radically different and potentially dangerous world. Making the art required an awkward, cramped posture in low light and oxygen conditions to work on a chromatically dense rock surface. Ingesting the pigment containing manganese dioxide in order to spray it, would have had psychoactive effects. Other archaeological elements found in the shaft may have been involved in the performance: the reindeer antler baton used as a drum-beater, the monotonous sound made by this instrument echoing around the chamber and having a dramatic effect on hearing, the lamps illuminating the locale, their smoke impacting sight and smell. This was no straightforward art-making, but one which involved an intense material environment which bombarded the senses of the maker with various transformative effects. It can be argued that

> artists and makers see beyond the constraints of the world that they occupy in order to fashion new ontologies. They do this by creating works that have a dramatic or sensational impact on the viewer, altering their perception of reality.
>
> (Jones and Cochrane 2018, 187)

The shaft scene is a distinctive example of a dramatic and sensational artwork, one which reflects altered perceptions of reality, and as such presents a range of possible affects which are suggestive of certain ontological parameters. While the concept of shamanism has been controversial in cave art studies (Wallis 2019), the intra-active and affective material properties of the shaft-scene do support a shamanistic connection.

The bison in the shaft-scene, for example, is usually interpreted as eviscerated, the long line crossing the animal from the top of the tail and across the haunch, extending beyond the belly, as a spear. It is notable that this 'spear' demarks the spilled entrails from the rest of the body. The head is lowered, the mane erect, perhaps indicating a posture of aggression, if not the charge, as also noted by Bataille (1955, 110), and in a poetic flourish for the two bison in the 'Nave': their 'bristling erect fur, the shaggy heads, the searching, furious gaze in the eyes ... a deep-chested, thunderous anger—bewildered, erotic, and blind' (Bataille 1955, 105–106). In addition to highlighting this aggressive posture, I note that the posture is also one the male bison adopts when courting a mate (e.g., Lott 1974). The artist seems to have depicted the animal in various modes of being, then, at once in a posture of aggression and mating display at the fore-end, and dead, with guts exposed, at the other. The entrails spilling from the belly might also be interpreted as enlarged testicles, reinforcing the possibility that the artist has emphasized the sexuality of the beast. What is being expressed may not be one moment in time, as would be expected in a narrative, but possibly two elements of being; at the height of power—aggressive and sexual, and at death.

The spear juxtaposed with the bison is suggestive of hunting as is the spear-thrower below it, but the bison itself was not a favored game animal, found in

just 4.3% of the faunal remains. The horse opposite the scene, however, was a significant element in the faunal remains. Since the pigment comprising the back line, head and chest of the horse has been applied via spraying, just like the upper line and belly of the bison plus the pelvis and legs of the anthropomorph, it is possible that the artist who made the shaft-scene also made the horse. Contrary to previous thinking, if the shaft-scene relates to hunting then it is the horse, which I consider an integral part of the ensemble, which is most relevant, not the bison. This hunting association is reinforced by not only the spear and spear-thrower but also the bird-topped stave, because towards the end of this staff, the line is interrupted and the termination takes a triangular or barbed shape, comparable with the 'broken' spear and spear thrower—and the gestural marks upon the lamp.

The staff, like the bison, has other hunting and sexual associations. The drum is the tool most often cited as the means by which Siberian shamans are able to journey to other realms, but animal-headed staffs are also prominent (e.g., among the Buriats and Tuvans [Znamesnski 2003, 143, 266]). Davenport and Jochim (1988; ff. Kirchner 1952, Glory 1964) make a connection between these Siberian shamans' staffs, the bird-topped staff in the shaft-scene and the spear thrower from Mas d'Azil which is decorated with a bird. The bird on the spear-thrower has been identified as 'Le coq de Bruyère,' and Davenport and Jochim agree that the bird depicted across these media is a large grouse such as the blackcock (or black grouse) (*Tetrao tetrix*) or capercaillie (*Tetrao urogallus*). The supra-ocular comb in-dicates a male of the species and Davenport and Jochim suggest the eye of the anthropomorph resembles a supra-ocular comb, reinforcing a grouse connection in the shaft-scene. Interestingly in another rock art tradition, Lahelma points to the example of a rock engraving at Kanozero, Kola Peninsula, 'where an ithyphallic figure brandishing an elk-headed staff is faced by a capercaillie' (Lahelma 2019, 221), which he interprets persuasively in terms of sex, hunting and shamanism. It is notable that the male capercaillie is well-known for being a powerful bird with a striking mating display (e.g., Hjorth 1970). The bird-topped staff in the shaft-scene, then, suggests both a hunting and a sexual association, and the staff is analogous to Siberian bird-topped shamans' staffs which these shamans use in their sexual and erotic relations with the spirits they marry.

The possibility that the bird is a capercaillie has implications for understanding the anthropomorph. Shown as a 'stick figure,' the artist has shown precisely the features which are important; realism is not a concern. Like the bison, the an-thropomorph also has dual status, both human and bird. With the four digits of a bird, rather than the five fingers of a human, the figure is not only bird-like at the head (Davenport and Jochim, 1988). The second digit of the right hand is dis-located, making an association with the 'broken' spear, spear-thrower, and bird-topped stave. The anthropomorph's erection is echoed and reinforced by the same shape used at the feet, and possibly the four digits of each hand. The figure can be interpreted as being in a state of not only arousal but heightened sexu-ality. Like the bison, the figure is also shown at the height of life, with an erect penis, but possibly also dead, the erect penis resulting from a severed spine.

In my conclusion I summarize how the material, archaeological, and visual properties of the shaft-scene I have examined pertain to the themes of aggression, sexuality, transformation, and death, themes which are of particular concern to many animist shamans and hunters, including among the Yukaghir.

6 Conclusion

While traditionally it has been held that 'the originality' of the Lascaux shaft-scene 'lies in its narrative potential' (Aujoulat 2005, 158), in this chapter I have proposed, drawing on Jones and Cochrane's (2018) 'archaeology of art,' that analysis should begin with the material and visual properties of the artwork, its location and associated archaeology before proceeding to the matter of interpretation. Rather than approaching the 'scene' as a narrative or straightforwardly representational, I have examined how the assemblage of material and visual elements in the shaft presents a range of possible intra-actions and affects. The shaft was a difficult place to work, tucked away and well removed from those areas of the cave where the art is more highly concentrated. The artist would have performed in an awkward, cramped posture in low light and low oxygen conditions, on a chromatically dense rock surface. The toxic properties of the paint may have been known and chosen specifically for the work as was the technique of spraying which required ingesting the pigment, all of which added to the transformative affections of making. The shaft-scene was not an imposition of an idea and will onto materials and form but rather the artist was influenced in choosing where to paint, how to paint and possibly what to paint, by virtue of pre-existing natural features in the cave wall, using engraving to enhance certain elements. Experimenting and improvising, the artist was attentive to the forces and flow of the material, the artwork and the locale. These dynamic intra-actions had transformative affects on the artist(s) and those who viewed the artwork, suggestive of adjusted perspective.

In terms of imagery, the bison is shown from a variety of viewpoints, simultaneously in a posture of aggression, mating display and death, the latter possibly as a result of hunting, although this animal comprises a low percentage of the faunal remains. The anthropomorph is both human and bird, with visual similarities across the digits of the bird-like 'hands,' the feet and erect penis, and so like the bison shown both sexually aroused and dead. The dislocated second digit of the right hand cites the 'broken' spear, spear-thrower, and bird-topped stave, as well as the marks upon the sandstone lamp found in the shaft. The bird-topped staff recalls the spear thrower from Mas d'Azil, reinforcing a hunting association, and one which is also indicated by the image of a horse, an important component of the faunal remains. The bird-topped stick is also comparable with Siberian shamans' animal-headed staffs, while the reindeer antler baton found in the shaft refers to another important component of the artists' diet and may have been a drum-beater, like those used by Siberian shamans. The bird atop the staff may be a large grouse such as the capercaillie which is a powerful bird with a striking mating display, reinforcing the associations between

the visual elements in the shaft in terms of hunting and sexuality, themes which are enmeshed for Siberian hunters and shamans.

I have suggested the key themes of aggression, sexuality, transformation, and death are important to understanding the shaft-scene. These themes concern animist hunter-gatherer communities recorded ethnographically who must negotiate a world filled with persons, only some of whom are human, such as among the Yukaghir (Willerslev 2007). Hunters modify their behavior and appearance in order to adopt the perspectives of their quarry and seduce them, and shamans adjust themselves in perspective in order to engage in sexual relations with animal helpers and owner-spirits in order to, inter alia, control the hunter's prey. For the Yukaghir these roles are not mutually exclusive, for shamanic specialization is 'a question of degree' which concerns both shamans and hunters if they are to both manage successfully the dangers of human–animal relations. For the hunter, mimesis might result in becoming prey; for the shaman, death by the spirits. Rather than mutually exclusive, hunting and shamanic practice are interwoven in the animic ontologies within which many hunter-gatherers are embedded. This dynamic is arguably articulated in the material, archaeological, and visual properties of the Lascaux shaft-scene, an artwork which, I conclude, was active in the pragmatic negotiation of hunter-shaman practice.

References cited

Aujoulat, Norbert. 2005. *Lascaux: Movement, Space and Time.* London: Thames and Hudson.
Bahn, Paul G. 1988. "Where's the beef? The myth of hunting magic in palaeolithic art." In *Rock Art and Prehistory: Papers Presented to Symposium G of the AURA Congress, Darwin 1988*, edited by Paul G. Bahn and Andrée Rosenfeld, 1–13. Oxbow Monograph 10. Oxford: Oxbow.
Bataille, Georges. 1955. *Lascaux or the Birth of Art.* Lausanne: Skira.
Breuil, Henri. 1950. "Lascaux." *Le Bulletin de la Société Préhistorique Française 45* (6, 7, 8): 355–363.
Chippindale, Christopher, and Paul S.C. Taçon (eds). 1998. *The Archaeology of Rock-Art.* Cambridge: Cambridge University Press.
Davenport, Demorest, and Michael Jochim. 1988. "The scene in the shaft at Lascaux." *Antiquity 62*: 559–562.
Dowson, Thomas A. 2007. "Debating shamanism in southern African rock art: Time to move on." *South African Archaeological Bulletin 62* (185): 49–61.
Eliade, Mircea. 1964. *Shamanism: Archaic Techniques of Ecstasy.* New Jersey: Princeton University Press.
Girod, Paul, and Élie Massénat. 1900. *Les stations de l'Âge du Renne dans les vallées de la Vézère et de la Corrèze.* Paris: J.-B. Baillère et fils.
Glory, André. 1964. 'L'énigme de l'art quaternaire peut-elle être résolue par la théorie du culte des Ongones?'. *Revue des Sciences Religieuses 38* (4): 337–388.
Gombrich, Ernst H. 1950. *The Story of Art.* London: Phaidon.
Hamayon, Roberte N. 1996. "Shamanism in Siberia: From partnership in supernature to counterpower in society." In *Shamanism, History, and the State*, edited by Nicholas Thomas and Caroline Humphrey, 76–89. Ann Arbor: University of Michigan Press.

Hamayon, Roberte N. 1998. "'Ecstasy' or the West-Dreamt Siberian Shaman." In *Tribal Epistemologies: Essays in the Philosophy of Anthropology*, edited by Helmut Wautischer, 175–187. Aldershot: Ashgate.

Harrison-Buck, Eleanor, and Julia A. Hendon (eds). 2018. *Relational Identities and Other-Than-Human Agency in Archaeology*. Louisville: University Press of Colorado.

Harvey, Graham, 2005. *Animism: Respecting the Living World*. London: Hurst and Co.

Harvey, Graham, and Robert J. Wallis. 2016. *Historical Dictionary of Shamanism* (2nd edn). Lanham: Rowman and Littlefield.

Hjorth, Ingemar. 1970. "Reproductive behaviour in Tetraonidae, with special reference to males." *Viltrevy: Swedish Wildlife Research 7* (4): 183–596.

Ingold, Tim. 2013. *Making: Anthropology, Archaeology, Art and Architecture*. London: Routledge.

Ingold, Tim. 2019. "Art and anthropology for a sustainable world." *Journal of the Royal Anthropological Institute 25* (4): 659–675.

Jones, Andrew M., and Andrew Cochrane. 2018. *The Archaeology of Art*. London: Routledge.

Kirchner, Horst. 1952. "Ein archäologischer Beitrag zur Urgeschischte des Schamanismus." *Anthropos 47*: 244–286.

Kühn, Herbert. 1956. *The Rock Pictures of Europe*. London: Sidgwick and Jackson.

Lahelma, Antti. 2019. "Sexy beasts: Animistic ontology, sexuality and hunter-gatherer rock art in Northern Fennoscandia." *Time and Mind: The Journal of Archaeology, Consciousness and Culture 12* (3): 221–238.

Leroi-Gourhan, André. 1965. *Préhistoire de l'Art Occidental*. Paris: Lucien Mazenod.

Lewis-Williams, J. David. 2002. *The Mind in the Cave: Consciousness and the Origins of Art*. London: Thames and Hudson.

Lewis-Williams, J. David, and Thomas Dowson. 1988. "The signs of all times: Entoptic phenomena in upper Paleolithic art." *Current Anthropology 29*: 201–245.

Lommel, Andreas. 1951. *Shamanism: The Beginnings of Art*. New York: McGraw Hill.

Lorblanchet, Michel. 1991. "Spitting images: Replicating the spotted horses of Pech Merle." *Archaeology 44* (6): 25–31.

Lott, Dale. F. 1974. "Sexual and aggressive behaviour in Bison." In *The Behaviour of Ungulates and Its Relation to Management*, edited by Valerius Geist and Fritz R. Walther, 382–394. Morges, Switzerland: International Union for Conservation of Nature and Natural Resources.

Mithen, Stephen. 1988. "Looking and learning: Upper palaeolithic art and information gathering." *World Archaeology 19*: 297–327.

Porr, Martin, and Hannah Bell. 2012. "'Rock-art', 'animism' and two-way thinking: Towards a complementary epistemology in the understanding of material culture and 'rock-art' of hunting and gathering people." *Journal of Archaeological Method and Theory 19*: 161–205.

Reinach, Salomon. 1903. "L'art et la magie: A propos des peintures et des gravures de l'âge du renne." *L'Anthropologie 14*: 257–266.

Sanders, Nancy K. 1968. *Prehistoric Art in Europe*. London: Penguin.

Ucko, Peter J., and Andrée Rosenfeld. 1967. *Palaeolithic Cave Art*. New York: McGraw-Hill.

Vitebsky, Piers. 1993. *Dialogues with the Dead: The Discussion of Mortality among the Sora of Eastern India*. Cambridge: Cambridge University Press.

Viveiros de Castro, Eduardo. 1998. "Cosmological deixis and Amerindian perspectivism." *Journal of the Royal Anthropological Institute (N.S.) 4*: 469–488.

Wallis, Robert J. 2002. "The *Bwili* or 'Flying Tricksters' of Malakula: A critical discussion of recent debates on rock art, ethnography and shamanisms." *Journal of The Royal Anthropological Institute 8* (4): 735–760.

Wallis, Robert J. 2009. "Re-enchanting rock art landscapes: Animic ontologies, non-human agency and rhizomic personhood." *Time and Mind: The Journal of Archaeology, Consciousness and Culture 2* (1): 47–70.

Wallis, Robert J. 2013. "Exorcising 'spirits': Approaching 'shamans' and rock art animically." In *Handbook of Contemporary Animism*, edited by Graham Harvey, 307–324. Durham: Acumen.

Wallis, Robert J. 2019. "Art and shamanism: From cave painting to the white cube." *Religions 10* (54): 1–21.

Willerslev, Rane. 2007. *Soul Hunters: Hunting, Animism and Personhood among the Siberian Yukaghirs*. Berkeley: University of California Press.

Windels, Fernand. 1948. *Lascaux: "Chapelle Sixtine" de la Préhistoire*. Montignac: Centre d'Études Préhistoriques.

Znamesnski, Andrei. 2003. *Shamanism in Siberia: Russian Records of Indigenous Spirituality*. Boston: Kluwer Academic Publishers.

Part IV

Syncretism, contact, and contemporary rock art

16 Communities of discourse

Contemporary graffiti at an abandoned Cold War radar station in Newfoundland

Peter Whitridge and James Williamson

1 Introduction

While the survival of ancient parietal art to the present implies that numerous individuals may have viewed it, much occurs in such concealed or difficult to access locations (caves, rockshelters, cliff faces) that it seems rather to have been addressed to a small and esoteric community. The frequent superimposition of images also hints at a closed community of viewers, in that only those who were ongoing participants in the discourse would be conversant with its earlier iterations. This is analogous to contemporary graffiti, which is often situated in inaccessible locations, employs esoteric conventions, and characteristically overwrites earlier panels. Although the motives for contemporary graffiti production (Adams and Winter 1997; Macdonald 2001; Dickinson 2008; Merrill 2015) seem far removed from those of ancient rock art, these resemblances suggest underlying practical, structural and—arguably—ontological commonalities among at least some of these disparate forms of parietal marking. We take "ontologies" here to refer to the culturally, socially and practically configured understandings of the world that informed the thoughts and actions of the communities of artists who produced parietal art (including graffiti). While there is of course no reason to suspect any inherent cultural commonality amongst them, we assert that the act of engaging in a socially targeted visual discourse (i.e., a common purpose) by applying tools or pigments to found surfaces (i.e., a common medium) in concealed and peripheral locations (i.e., a common setting) leads parietal artists to share real practical affordances and visual understandings that amount to seams of ontological resemblance and overlap amongst the historical networks defined by community-artist-pigment-surface-setting associations.

To illustrate this, we take up a body of contemporary graffiti at the abandoned Cold War military installation of Red Cliff, near St. John's, Newfoundland and Labrador, that began to emerge about a decade ago, and continues to evolve as new pieces obscure the old. This case reveals a number of interesting graffiti features, some of which are homologous with rock art. In the first place the graffiti instantiates a "community of discourse," or really numerous intersecting ontological communities that read and interpret the imagery based on a set of mutually understood discursive conventions, and

engage with it by superimposing or counterposing their own images in meaningful ways. This constitutes a deliberately "conflictual discourse," since earlier works—substantial outlays of time, materials, and effort—are deliberately, and seemingly invariably, effaced by later ones, as with some traditional rock art. In the graffiti case this is often related to a self-conscious "performance of authorship," exemplified by the hermeneutically murky tag that signs large pieces or constitutes the entire instance of a simpler throw-up. All of this transpires within unusual "crypto-public" contexts, including marginal urban spaces such as alleyways, the semi-public backs of buildings, abandoned structures, and visible but inaccessible sites on elevated or secured walls, bridges, and other structures. The examples discussed here occur at an actively deteriorating mid-twentieth-century ruin, which because of the site's relative isolation is unpoliced and so receives only sporadic visitors attracted, often, by its very concealment, as well as by the spectacular graffiti that has accumulated there. This echoes the marginal situation of much surviving rock art, on cliff faces and in caves and overhangs. The repeated overlaying of graffiti on earlier examples, and on a still older built surface, produces a palpable temporal depth, stretching the graffiti site in time and enacting a "multitemporality."

What we argue here, already well-attested by an expanding archaeology of the contemporary world (Harrison and Schofield 2010; Graves-Brown et al. 2013; Harrison and Breithoff 2017; González-Ruibal 2019), is that contemporary phenomena such as graffiti are accessible not only by way of sociological or social theoretic hermeneutics, but also archaeological ones (e.g., Oliver and Neal 2010). Likewise, research on ancient rock art might more explicitly entertain insights from studies of recent parietal markings, because, ultimately, a straightforward graffiti/rock art distinction is impossible to sustain. In the next sections we consider the case for treating rock art, graffiti, and graffiti art as interpretively consonant, and review recent archaeological attention to ancient and contemporary graffiti. We then summarize the history of the Red Cliff site and outline the photogrammetric recording techniques that are currently being explored there to produce a durable and analytically useful document of an emergent graffiti archive. In a discussion section we take up the interpretive frames outlined above (community of discourse, conflictual discourse, performance of authorship, crypto-public context, multitemporality) to highlight some of the ontological commonalities amongst diverse parietal arts that the Red Cliff case suggests.

2 Graffiti and graffiti art

The notion that contemporary graffiti is commensurate in some fashion with rock art has long been a recognizable trope (Baird and Taylor 2011), for example in cartoons that play on the notion that both represent a form of vandalism. Working in a graffiti idiom himself, Banksy's depiction of a workman pressure washing a wall covered with obviously ancient rock art motifs (a Lascaux-like horse, a swarm of stylized hunters, a stenciled hand; Danielsson et al. 2012, 4)

directly evokes this affinity. It elicits sympathy for the modern graffiti writer whose works are routinely effaced as part of an ongoing sanitization of public space, even as it operates mainly at the level of a jokey image-play. But is graffiti like rock art? Part of the difficulty in drawing such a comparison is the muddiness of the lexicon used to name these things. The very phrase "rock art" already makes two problematic assertions: that it refers to signs produced on rock surfaces, and that these signs can be considered art. However, signs applied to other public canvases, such as trees (arborglyphs), seem more or less equivalent to those applied to rock surfaces, even if they are rarer archaeologically (Stryd 2001; Kobiałka 2019). And of course, whether any of these signs are art hinges on our definition of the term. In the case of rock markings, does it include simple acts of graphical communication (finger flutings, handprints, directional indicators), conventional ritual signs (witch marks, crosses), or stock ideograms (representations of genitals), any of which might normally be considered less semantically complex than art? And does rock art embrace text? These ambiguities constitute important slippages around the concept, but perhaps bridges to a nominally more prosaic graffiti.

Unlike rock art, graffiti—usually taken to consist of more or less unsanctioned representational markings of some sort in a more or less public location—evokes an authority, typically a state authority, capable of proscribing such public or quasi-public acts. Perhaps for this reason, as well as its textual bent, graffiti emerges as an archaeological topic alongside interest in early Mediterranean states (Baird and Taylor 2011; Keegan 2014). Indeed, the terms *graffito* (singular) and *graffiti* (plural), from an Italian word usually translated as "scratched," were borrowed into English precisely as descriptors for the abundant vernacular wall markings at Pompeii (Baird and Taylor 2011). Besides a variety of unsanctioned (but not always actively proscribed) textual or graphical inscriptions in public and private architectural settings, graffiti can also be taken to include similar markings in caves, ownership marks added to manufactured objects, and the widespread genre of folk depictions of ships (e.g., Tiboni 2017). The latter have extraordinary time depth, and sometimes occur as painted or incised designs on cave walls and other rock surfaces (e.g., Sukkham et al. 2017). Whether these are petroglyphs or graffiti seems impossible to disentangle.

What is here referred to as contemporary graffiti, graffiti art, or graffiti writing consists of a more or less coherent set of illegal practices that emerged in the later twentieth century as gangs, cliques, and unaffiliated youths began to explore the novel technology of aerosol paint (only patented in 1951 [Seymour 1951]), and eventually media that resemble spray-painted graffiti, such as markers, charcoal, and paper "wheatpastes," to produce increasingly elaborate panels of text and imagery in and on public places. Emerging in Philadelphia and Chicago in the 1960s (Ley and Cybriwsky 1974), a distinctive style of prolific public tagging had spread to New York City by 1970, where it was embraced as a complement of hip-hop subculture (Dickinson 2008; Wacławek 2011; Merrill 2015). In the early 1970s, the competitive and monomaniacal application of stylized pseudonyms underwent a striking transformation into a complex visual discourse that covered

public walls, subway cars, and buses, spurring increasingly frantic (and costly) municipal anti-graffiti efforts.

A sustained program of criminalizing artists, cleaning trains, and securing train yards led to the declaration that the New York subway had become graffiti-free by 1988, but graffiti continued to flourish on the tunnels, overpasses, and other peri-urban surfaces where it had begun (Dickinson 2008, 36–37), seeding similar, and ongoing, florescences around the world. By at least the late 1970s, graffiti writing had also branched out into parallel, and superficially almost identical, forms that are broadly labeled street art, including the work of such publicly lionized visual artists as Jean-Michel Basquiat, Keith Haring, and, latterly, Banksy (Wacławek 2011). In recent years street art, often on a monumental, multi-story scale, has become an enormously popular genre, and is increasingly commissioned by civic and corporate entities as instances of what is more generically referred to as public art (Wacławek 2011; Merrill 2015). Ambiguously, some practitioners (including some of the St. John's writers considered here) both engage in illicit graffiti writing and accept public commissions. While contemporary graffiti art is recognizably continuous with the political, social, humorous, and scatological graffiti of past centuries (which show no signs of subsiding), it represents a historically distinctive cooptation of the medium in light of new technologies, social formations, visual art traditions, and legal milieus. Like those earlier forms, it is legible within an archaeological frame.

Although contemporary graffiti, as an insurgent, subcultural, social art movement, is usually held apart from ancient and historical graffiti in academic discourse and popular consciousness, typically eliciting only the sorts of ironic comparisons with ancient and/or non-Western parietal art noted previously, the parallels with rock art are rather difficult to shake (Clegg 1993; Schofield 2010; Ralph 2014). In the first place, the formal resemblance of graffiti to parietal art is not incidental but essential. Both employ found canvases, in the form of more or less vertical walls that are physically accessible to a standing or lightly scaffolded artist. The scale of the effective canvas is variable, especially with access to modern equipment, but is usually constrained by the bodily stature of the artist, the materials available, and the time that can be devoted to the work's production. The likelihood that finished works will endure also varies, depending on the motivations of subsequent artists, authorities, and iconoclasts, the durability of the materials or medium, and the accessibility of the piece. While the skills and motivations of the artists differ, along with numerous facets of the social context and semantic content of the imagery, the materiality and corporeal performance that characterize the art's production are similar. Of course, archaeologists are often concerned precisely with that culturally idiosyncratic content, but sole attention to it comes at the expense of understanding underlying practical homologies, like the ones explored here, that are equally a part of its meaning. The growing archaeological literature on graffiti, especially contemporary graffiti writing, is reviewed in the next section.

3 Archaeologies of graffiti

Despite the precocious attention to Pompeii's vernacular wall markings, past archaeological interest in graffiti tended to be highly compartmentalized, focusing on specific cultural settings in which the surviving record is particularly profuse. This is the case at Pompeii, which remains perhaps the best documented graffiti setting from the ancient world (Milnor 2014). Keegan attributes its 4504 instances of graffiti (incised text and images) and dipinti (in which pigment is applied) to a shared set of memory practices that fixed momentary experiences to their respective locations (Keegan 2011). However, graffiti is widely attested from protodynastic (3200–3000 BCE) and later periods in Egypt, where it takes a surprisingly wide variety of forms: depictions and invocations of gods, astronomical notations, observations on royal circuits and military victories, erotic reveries, magical incantations (Keegan 2014). The volume and diversity of these intimately localized, but essentially public, documents are even greater during later periods in the ancient world (Baird and Taylor 2011; Keegan 2014; Lovata and Olton 2015).

The tendency of scholarship to focus on particular regions and periods creates the impression that graffiti practices are similarly regionalized and punctuated, but this is not the case. For example, graffiti have been ubiquitous in the Maya world for two millennia or more (Hutson 2011; Patrois 2013; Navarro-Castillo et al. 2018). Spontaneously incised designs depicting people, animals, deities, buildings, and ceremonies, or merely illegible scribbles, occur in both private, domestic settings and on exterior, public walls. Based on their relationship to accumulated fill, Patrois (2013) argues that they were produced both while structures were in use and after their abandonment. The quality of the graphical execution, and height above ground level, suggest that Maya graffiti were created by both children and adults, with children's motifs sometimes in apparent intersubjective dialogue with nearby adult ones (Hutson 2011, 422).

Similar clusters of scholarship have emerged around Medieval British church graffiti (Pritchard 2008; Champion 2015) and, increasingly, modern examples produced by soldiers (Merrill and Hack 2012), laborers (Giles and Giles 2014), prisoners (Agutter 2014), undocumented migrants (Soto 2016), and others, often embodying the transitory, unfinished quality of the "non-places" (Augé 1995) symptomatic of late/post-/supermodernity. Recent investigations of homelessness (Kiddey and Schofield 2011) and urban exploration (Kindynis 2019) have similarly foregrounded the sorts of abject and interstitial urban spaces that tend to be heavily tagged with graffiti of all kinds, and the people who sometimes produce it. An emerging archaeology of the contemporary era (Graves-Brown et al. 2013; González-Ruibal 2019), concerned as it is with the ruined and abandoned buildings and other systemic margins that tend to attract the extemporaneous commentaries of transient occupants, might be expected to take graffiti as a key problem area, though this has not always been the case.

While vernacular graffiti continues to be generated as the surreptitious discourse it has been for millennia, the graffiti art that radiated from the

northeastern US in the late twentieth century represents a novel iteration. Contemporary graffiti borrows some of the former's media and canvases, and even, sometimes, its social logic, but constitutes a sociologically and aesthetically distinct practice centered on local communities of artistic discourse. Sociologists (Macdonald 2001; Monto et al. 2012), anthropologists (Dickinson 2008; Stewart and Kortright 2015), geographers (Merrill 2015), and linguists (Adams and Winter 1997) have dissected the closely knit, place-based crews that generate much urban graffiti, while art historians have documented the graffiti itself (Wacławek 2011; Schacter 2014). In the context of expanding disciplinary attention to the twentieth and twenty-first centuries, archaeologists have recently begun to contribute to this discussion.

A major impetus for this work comes from Australia, where a rich Aboriginal rock art record has fostered interest in parietal markings of all kinds. Clegg (1993) thoughtfully tackled a familiar assemblage of late twentieth-century roadside graffiti using a theoretical framework that Margaret Conkey had devised for analyzing Upper Paleolithic imagery, and found the former to be just as semiotically dense and analytically rewarding as the latter, while Winchester et al. (1996) read the gender and sexual politics of early twentieth-century Euro-Australian graffiti. Frederick (2009) deploys both conventional archaeological tropes and critical analyses of recurrent motifs in addressing contemporary graffiti from Perth and Melbourne. She sees the discord around the culturally appropriated Aboriginal "Wandjina" motif in particular, and the multiple discursive modes that operate simultaneously within contemporary graffiti more broadly ("play, protest, defacement, commemoration, response" [Frederick 2009, 231]), as illustrative of the kinds of conflictual discourses that likely circulated around the inherently multivalent rock art of the past. A themed number of *Australian Archaeology* documents the subsequent surge of interest in historical and contemporary graffiti production by, for example, Euro-Australian explorers and settlers (Fyfe and Brady 2014), prisoners (Agutter 2014), oppressed indigenous communities (Ralph and Smith 2014), and contemporary graffiti artists (Crisp et al. 2014). Frederick's (2014) own analysis of the material residues associated with a graffiti production site, especially hundreds of aerosol cans and the specialized nozzles that customized them, illustrates the utility of conventional archaeological heuristics. Edwards-Vandenhoek (2015) mapped out the performative "playscapes" in abandoned structures employed by street artists in Sydney, and indeed play seems to be a durable feature of graffiti, borne out in its humorous and scatological content, and in the playful dimensions of concealment and evasion of police and building owners.

There has been comparable literature growth in the U.K. and North America (e.g., Oliver and Neal 2010; Graves-Brown and Schofield 2011; Lovata and Olton 2015; Soto 2016; Hale et al. 2017). Hale et al. (2017) illustrate how innovative this research avenue has become, employing reflectance transformation imaging (RTI) and 3D photogrammetry (the results all archived for public access) in a "counter-archaeological" investigation of the Scottish heritage site of Dumbarton Rock, which has had its underside extensively tagged by the

community of rock climbers who have colonized it (and who collaboratively co-authored the paper). Historic England produced a manual for recording historical and contemporary graffiti that promotes the use of Structure from Motion (SfM) 3D photogrammetry, like that employed at Dumbarton Rock, as standard documentary procedure (Historic England 2015, 34). Graffiti has emerged as an archaeologically tractable vein of historical and contemporary material culture production that is consonant with a much longer global tradition of parietal marking. It often bears on the lives of subaltern groups, such as illegal migrants or the homeless, or a subaltern moment in the lifecourse, such as childhood or adolescence, and so provides archaeological access to fractions of society that are sometimes difficult to discern. Red Cliff, the graffitied-up detritus of a Cold War outpost in the northwest Atlantic, provides just such insight into a modern community of graffiti writers and their sophisticated visual grammar.

4 Red Cliff

St. John's, situated on the easternmost edge of the island of Newfoundland, was a principal staging point for the convoys that transported matériel and personnel from North America to Europe during World War II, and so by the end of the war was protected by a series of gun batteries: at the entrance to its harbor (Forts Amherst and Chain Rock), at Cape Spear to the south, and, from 1942, by an 8" gun emplacement at Red Cliff, 8 km north of the harbor and about 6 km north of the major American base at Fort Pepperell (Collins 2011). Red Cliff was decommissioned after the war and lay idle, until the growth of the Cold War spurred the American and Canadian governments to begin construction of trans-continental arrays of radar stations to detect incursions by Soviet aircraft (and later missiles). The first set to be constructed was the Pinetree Line, and Red Cliff was selected for the easternmost station (Fletcher 1990; Nicks et al. 1997; The Pinetree Line, n.d., Pinetreeline/homepage.html). Construction began in 1951 and the station became fully operational in 1954, staffed by up to a few hundred military and civilian personnel (Figure 16.1). Technological advances rapidly made Red Cliff obsolete, and in late 1961 the radars were shut down, the buildings stripped and the site abandoned. A series of photographs from mid-1966 (Pinetreeline/photos/photo37.html) show numerous bare building platforms and a small number of standing buildings, which were heavily scavenged in subsequent decades.

During the 1980s and '90s, Red Cliff was periodically used for Close Quarter Battle (CQB) and Fighting in Built-up Areas (FIBA) training by local Canadian Army forces and reserves, including the use of C4 plastic explosives "to blow man-sized holes through the reinforced concrete" (Peter Locke 1998, at Pinetreeline/other/other37/other37b.html). The building shells continue to be used by recreational paintballers for simulated combat and by young people as a site of concealment, and a local walking trail intersects the site, providing access for those attracted to the ruin and, increasingly, its graffiti. The site currently consists of three roofed buildings, at least 24 concrete building platforms, and an undetermined number of underground rooms and passages.

Figure 16.1 Red Cliff Radar Station, outside St. John's, Newfoundland, in June 1961, a few months before its decommissioning and abandonment.
Source: Photo by Robert Genge, courtesy of Military Communications and Electronics Museum, www.candemuseum.org.

Photographs from 1998 of the standing AN/CPS-6B radar building and adjoining operations building show mostly bare exterior walls and only occasional vernacular graffitied text and figures on the interiors (Pinetreeline/photos/p37-98a.html). In 2005, the building exteriors remained mostly bare, but some surfaces displayed small streetstyle monikers and simple images (Pinetreeline/photos/p37-05.html). A graffiti writer who produced a substantial body of work there (Tekar) suggested that the wider St. John's graffiti scene was starting up around this time (Matthew 2013). The city and local police eventually developed a Graffiti Management Plan (in 2007), identifying "60–80" downtown writers (Fitzpatrick 2010) and prosecuting the teenage Dr. West, one of the most prolific (Basha et al. 2007; Fitzpatrick 2010; The Telegram 2014). This seems to have only briefly suppressed the scene, as the city continues to battle downtown graffiti by buffing walls and commissioning public art (City of St. John's 2016), encouraging the public to report graffiti on a mobile app (ibid), prosecuting writers (Fitzpatrick 2010; Romaniuk 2012), and, as recently as fall 2019, re-convening an anti-graffiti task force (Mercer 2019). Red Cliff, meanwhile, beneath the civic radar, had emerged as a major canvas for graffiti writers by 2012, to judge by the earliest dates on interior and exterior pieces. Writers' skills vary widely, suggesting the involvement of accomplished artists (including self-designated kings), novices, or toys, and others using spray paint to produce vernacular (often scatological) graffiti outside the graffiti art idiom.

5 Photogrammetric methods

Inspired by Hale et al.'s (2017) approach to climbers' graffiti at Dumbarton, and by the beauty and complexity of the graffiti itself, a program of photogrammetric documentation was undertaken at Red Cliff. While the methodology is still being refined, it has so far entailed two primary techniques: (1) photogrammetry of interior spaces based on hand held digital photography and (2) exterior photo-grammetry of the entire site using drones. It is also possible to fly small camera-equipped drones in parts of the high-ceilinged operations building (as tested using the pocket-sized DJI Mavic Mini), but dangling structural elements (rebar, cables, ductwork) makes flying hazardous and the thick concrete shell interferes with the aircraft's GPS. Exterior spaces can likewise be documented from ground level using handheld photogrammetry, avoiding the bureaucratic hassle of drone flights and yielding better images of building walls, but the 3D models would be fragmentary and time-consuming.

5.1 Interior handheld photogrammetry

In the last several years archaeologists have become increasingly familiar with the potential to document artifacts, features, standing architecture, and ex-cavations three dimensionally with a handheld or drone-affixed digital camera (e.g., Porter et al. 2016; Hamilton 2017). A variety of commercial or free software employs SfM photogrammetry to align and assemble still images into computer models that stand as references, and can be exported to widely available viewing software (e.g., Adobe Acrobat), posted online (see, e.g., the vast assortment of archaeological objects at www.sketchfab.com), or materi-alized with a 3D printer. Although the graffiti of the architecturally unusual Red Cliff radar building, the interior of which has a regular dodecagonal (12-sided) plan with a central array of 12 pillars, can be documented, archived, and communicated as still images, the scores of decorated surfaces, and constant succession of new images on many of them, would require a com-mensurate number of photographs to do so. On the other hand, a low re-solution SfM model can be easily navigated on a computer screen and then individual high-resolution stills consulted as necessary. Between February 2018 and May 2020 six sets of images (mean of 324 photographs each) were generated that document every surface on the radar building's interior, in-cluding walls, pillars, floor, ceiling, and structural vagaries. Using Agisoft Metashape each set was assembled into a navigable 3D model. This allows any of the interior surfaces to be inspected from any perspective as it existed at the time of recording, hence changes over the course of this period can be finely characterized. The superposition of new wall images was of particular interest, but the accumulation and removal of floor debris such as expended spray cans and fuel for small fires, is also relevant for understanding building use. Single models of two heavily decorated rooms in the operations building have also been produced.

5.2 Exterior drone photogrammetry

The heavy recent overgrowth of alder at Red Cliff makes it difficult to navigate the site away from the road and open area surrounding the standing buildings. To gain a better sense of the surviving Cold War ruins a drone (DJI Matrice with a Zenmuse X4S camera) was used to generate an ortho-mosaic and 3D model based on aerial imagery (Figure 16.2). The drone was flown by James Williamson (under an SFOC) along a pre-programmed flight path created in DJI GS Pro, generating 472 images that were then assembled in Metashape. The site proved difficult to document in this fashion. The cables anchoring the taller of two nearby antennae truncate the mappable area just south of the operations building, powerful downdrafts in the prevailing westerlies made it inadvisable to fly too close to the sheer 120-m cliff on which the site perches, and a light mist on the flight day is visible in the orthophoto (Figure 16.2a). Graffiti is reasonably legible on renderings of the roofed buildings' exteriors (much more so in the individual stills) and the digital model, showing the topographic skeleton of the site without the draped orthophoto (Figure 16.2b), reveals fine structural detail in the building ruins.

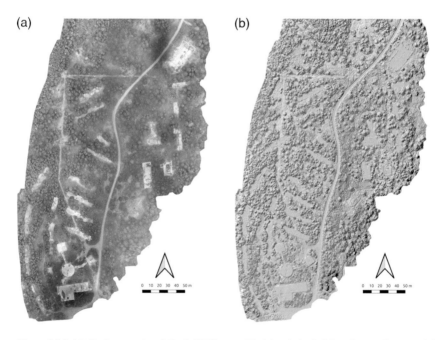

(a) (b)

Figure 16.2 (a) Orthomosaic of Red Cliff assembled in Agisoft Metashape, from aerial imagery captured with a DJI Matrice on October 30, 2019 (created by James Williamson); (b) Plan view of Metashape model with orthomosaic removed.

6 Graffiti ontologies

Although contemporary graffiti now circulates within a global cultural network, where it is relentlessly mimicked and co-opted, it is produced by a relatively tiny community of practitioners which itself is fragmented into a multitude of local crews and unaffiliated individuals who operate according to esoteric, subcultural logics. This is, in part, a deliberate effect of the premise of illegality, which restricts legitimate membership to those willing to embrace its legal jeopardy (Monto et al. 2012). Related to this, graffiti art (to a much greater extent than street art) seems to be overwhelmingly dominated by youth, like the 10–30-year-olds held responsible for downtown St. John's graffiti (Fitzpatrick 2010), which means that graffiti law inordinately criminalizes youth. There are clearly marked ontological shifts associated with sequential moments in the life course, consequent not only on physiological ageing (morally construed as "maturation") but on the very different social, economic, ethical, and legal conditions that circumscribe them. For Canadian youth this includes daily institutional (school) confinement from at least ages 6–16, legal minority up to ages 18 or 19, and prolonged economic dependency that, increasingly in recent years, lasts into the 30s. Ontological difference and autonomy, within this juridically engineered dependency, is expressed to varying degrees in virtually every facet of choice available to them, including the deliberate production of a field of creative expression that operates largely outside of (though sometimes in engaged opposition to) the sanctioned social system. Some of the operational features of this field, as they are expressed in the Red Cliff graffiti setting, are outlined below.

6.1 Communities of discourse

The models generated to date at Red Cliff document the persistent use of the site as a quasi-public gallery and practice space by self-conscious graffiti artists with varying levels of skill and experience. The names of artists are conventionally recorded in the tags that sign pieces (e.g., "TEKAR '13'" at upper left in Figure 16.3) or are encoded in throw-ups. They may also stand alone as "landmarks" on surfaces that cannot easily be overpainted by other artists or authorities. This could be seen as an outgrowth of, and ironic reflection on, a long-running vernacular graffiti discourse on identity and authorship that often includes names or initials (Adams and Winter 1997). The names of graffiti crews are also tagged (e.g., "RC," Rong Crew, at the center of the SEMY-SEONE piece in Figure 16.3), and their members' tags sometimes distributed across a piece (at the bottom of the large letters in Figure 16.3), instantiating a familiar micro-style that distinguishes them from other crews. The array of fireplaces (the cinder block feature in the foreground of Figure 16.3), fuel piles, beer cans, and other refuse speak to the communal experience of crews and others, gathered for nighttime tagging and/or recreation. Individual and crew tags also occur across the larger region, including other isolated sites

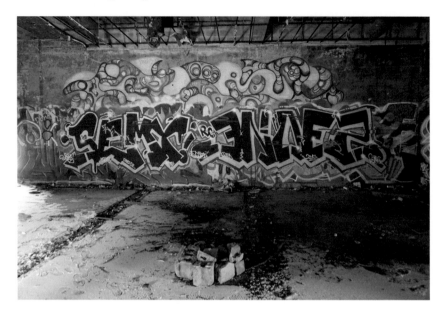

Figure 16.3 Graffiti on interior north wall of operations building at Red Cliff, March 4,
2018, with cinder block hearth in foreground.
Source: Photo by Peter Whitridge.

(World War II–era artillery batteries, abandoned industrial facilities) and public
downtown walls and alleys, where they are visible to a much wider audience and
attract the attention of municipal authorities. The use of a cryptic visual grammar
that is immediately legible to other artists tactically bounds a community of
discourse, and, indeed, a nested series of such communities: graffiti artists in
general, the local graffiti community, members of a particular crew.

6.2 Conflictual discourse

Formal conventions of respect and disrespect are enacted through the placement of
commentary and subsequent pieces beside or atop earlier ones (at least four large,
sequentially superimposed pieces are visible at the edges of SEMY-SEONE in
Figure 16.3). However, with a small community of writers, many of whom peri-
odically or permanently relocate to other cities or otherwise drift away from the
scene, the skill reflected in succeeding pieces is variable. The parallel vernacular
graffiti discourse intrudes through quickly sprayed and often profane annotations,
sometimes clearly intended as defacements of well-executed pieces, while deliberate
destruction of painted surfaces and architecture hastens the ongoing deterioration of
the buildings. The graffiti discourse is in many ways inherently conflictual: by virtue
of the limited available wall space new art must overwrite the old, while other wall
users compete for a discursive niche and authorities periodically sandblast or
overpaint the canvas, restarting the cycle. Ross et al. (2017, 415) refer to graffiti as

"an essentially performative process of 'narrative disruption'—an overlay, as it were, of countering, elaborating, competing and/or satirizing narrative." This narrative stratigraphy can frequently be discerned at Red Cliff, where older pieces that are stylistically distinct or employ different colors or paint types survive at the edges of later ones, and on the fragments that spall from the surface. Digital photogrammetry allows particular loci to be revisited at various moments in the past, isolating graffiti produced in the intervals: a snapshot of the radar building interior from 1998 can be precisely aligned with models generated in Meshlab based on 2018 and 2019 imagery (Figure 16.4), and a 2005 photograph of the exterior of the operations building with a model based on the 2019 Matrice flight (Figure 16.5). These examples are analogous to the use of imaging software to unstack the superimposed moments in long-running rock art discourses. Gunn et al. (2010) used D-Stretch's capacity to enhance subtle chromatic differences in pigments to discriminate ten overlapping instances of rock art production at the Jawoyn site of Nawarla Gabarnmung in Arnhem Land, Australia, sorting them into sequential episodes as a Harris matrix, and Tomášková (2015) similarly unpacked superimposed motifs at ancestral San sites in Eastern Cape, South Africa. In each case the materials, graphical idiom, idiosyncratic style, and discursive content can be read with the chronological evidence to discriminate the stylistic communities that produced the art.

6.3 Performance of authorship

Graffiti authorship is often explicitly claimed. Most obviously, pieces are signed with the writer's tag (or wholly based on it), throw-ups typically consist of stylized tags, and smaller tags often stand-alone. Artists also develop signature styles that are sometimes easily recognized. Tekar's work at Red Cliff and other locations around St. John's, Corner Brook, and Halifax can be discerned stylistically (characteristic signs, shapes, color combinations, and formal assemblies), and through the repeated incorporation of signature elements (e.g., for a period of time, a sharp-jawed

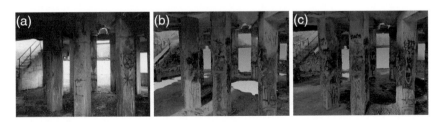

Figure 16.4 View of interior of radar building at Red Cliff, looking northwest; (a) May 1998; (b) February 10, 2018 (capture from Metashape model); (c) May 4, 2020 (capture from Metashape model).

Source: (a) Photo by Ralph Howell, courtesy of Military Communications and Electronics Museum, www.candemuseum.org.

Figure 16.5 View of exterior of operations building at Red Cliff, looking northeast; (a) May
26, 2005; (b) October 30, 2019 (capture from Metashape model).
Source: (a) Photo by Tony Roberts, courtesy of Military Communications and Electronics Museum,
www.candemuseum.org.

humanoid figure). Pieces were often photographed when fresh and posted in various
online graffiti archives (e.g., www.fatcap.com/artist/tekar.html). Many artists' pieces
employ a distinctive grammar that likewise assembles words, motifs, styles, and
colors into hermeneutically dense, and usually self-referential, texts (Figure 16.3).
The contemporary convention of claiming the status of king by incorporating a
crown motif in a piece expresses authorship with a playful swagger, as does the
deliberate creation of landmarks. The insistence on claiming authorship in some
form, however occluded, is a hallmark of graffiti art, anchoring it in the ancient
idiom of the name or initials scratched on a wall, but the deployment of idiosyncratic
elements of form, content, and pigment like those disentangled by Gunn et al.
(2010), whether self-conscious or not, also characterizes some rock art.

6.4 Crypto-public setting

The definitional illegality of graffiti restricts the sorts of art that can be produced
at different sites. In general, the more public the site, the more attenuated the
tag, but also the more renown that is returned to the writer who riskily executes a
piece or throw-up there. A site like Red Cliff that is vacant, accessible, and free
from surveillance constitutes an ideal crypto-public setting, affording the time
and security for careful artistry executed over a period of days, weeks, or months,
while guaranteeing wide viewership. Comparable abandoned buildings in the
outlying region are less accessible to both writers and viewers. The highest vis-
ibility walls that afford an opportunity for complex pieces, such as the footings of
highway overpasses and other abandoned military sites (which often fall under
the jurisdiction of Parks Canada), are liable to be buffed by public maintenance
crews. The advantages of crypto-public "accessible concealment" (and, to a
certain extent, shelter from the elements) is reflected in the much heavier graffiti
turnover on the insides than the outsides of the buildings at Red Cliff.

6.5 *Multitemporality*

Although the rate of graffiti production slows in winter and accelerates in summer, Red Cliff is visited year-round, accreting art and other traces of use (vernacular graffiti, fireplaces, refuse) even as the buildings undergo an inexorable structural deterioration. And like any archaeological site, Red Cliff is caught up in a longer temporal unfolding. After its abandonment Red Cliff was successively scavenged, used for military training, and scrawled with vernacular graffiti, before the recent surge in graffiti art. An extensive archive of personal photographs from 1952–1961 (Pinetreeline/photos/photo37.html) documents the everyday life of a remote, secretive military installation, while earlier coastal defense structures are scattered along the coast. The surrounding area had been logged and used for pasturage since at least the early nineteenth century, Gaulton et al. (2019) document incised graffiti on the Avalon Peninsula from the late seventeenth century, European fishers began visiting the region seasonally in the sixteenth century, and indigenous Beothuk were present when Europeans arrived. Although earlier traces are not always discernable, graffiti practice at Red Cliff directly engages with a prominent Cold War record. Seventy years of Red Cliff's history are persistently held in view, and reworked by its utilization, alteration, and deterioration as a contemporary graffiti art site. More so than the buried traces of earlier eras, contemporary archaeological sites such as Red Cliff broadcast their multitemporality, and specifically attract users eager to engage in a "time-play."

7 Conclusion

The social and cultural conditions of graffiti production at Red Cliff are not unusual in the contemporary world. The practice conventionally entails close-knit crews engaged in discursive entanglements with other crews in marginal, peri-urban settings such as abandoned buildings, reflecting and constituting their ontological distinctiveness. And all of these features—community, dialogue, performance, concealment, multitemporality—equally characterize many instances of graffiti and parietal art production in the past. The notion that ancient parietal art—which can often be presumed to have had powerful ritual associations—stands apart from contemporary graffiti is clearly true in some senses, but misses the point. There is no monolithic non-Western ontology from which parietal art emerges, but rather a historically vast array of locally situated communities of belief and practice that engaged with commensurately diverse sacred, social, and aesthetic discursive fields. Likewise, there is no monolithic Western ontology that frames contemporary graffiti production, although there is an emergent global graffiti discourse in which local crews variably participate. Contemporary graffiti can be taken as a special case of parietal art, but so too can any archaeological instance; each is likewise historically, sociologically, and aesthetically idiosyncratic, and demands its own close, local reading.

Surfaces accrete signs. The relative scarcity of ancient rock art shouldn't obscure the fact that people leave deliberate, legible traces of all kinds wherever they go, though only the most inaccessible and/or durable (like graffiti landmarks) manage to survive unscathed for millennia. Many of us carry writing implements that allow us to produce such marks whenever we like, and even when we are conditioned to confine them to socially appropriate surfaces they are liable to spill over onto other, illegitimate, ones. It seems likely that ephemeral, graffiti-like markings (sanctioned or not) were also periodically left on ancient perishable surfaces. The dichotomy between a pictographic rock art and a textual graffiti is both taphonomically blinkered and culturally chauvinist, like the prehistoric-historic one that demotes those without a written language to an ontologically subaltern stratum. Graffiti art represents a modern florescence of this widespread practice of routinized mark-making at a distinctive cultural moment, when a novel technology, pregnant with semiotic possibility, met a felicitous social and artistic milieu. The analogous fluorescences of rock art at different times and places in the past must similarly reflect the momentary constellation of mark-making practices, places, cultural meanings, and a community of practitioners interested in exploring them.

Acknowledgements

We would like to thank the C&E Museum for permission to reproduce archival images of Red Cliff, the Newfoundland and Labrador Provincial Archaeology Office for supporting purchases of a drone and computer, and Tekar, Rong Crew and many others for creating the wonderful graffiti art.

References cited

Adams, Karen, and Anne Winter. 1997. "Gang graffiti as a discourse genre." *Journal of Sociolinguistics 1* (3): 337–360.

Agutter, Rhiannon. 2014. "Illicit autobiographies: 1980s graffiti, prisoner movement, recidivism and inmates' personal lives at the Adelaide Gaol, South Australia." *Australian Archaeology 78*: 100–107.

Augé, Marc. 1995. *Non-Places: Introduction to an Anthropology of Supermodernity*. London: Verso.

Baird, Jennifer A., and Claire Taylor (eds). 2011. *Ancient Graffiti in Context*. New York: Routledge.

Basha, Joey, Kerri Breen, and Shalanda Phillips. 2007. "City cracks down on graffiti, artists unthreatened." *The Muse 57* (26): 8.

Champion, Matthew. 2015. *Medieval Graffiti: The Lost Voices of England's Churches*. London: Ebury Press.

City of St. John's. 2016. "Graffiti: Report and Remove." *City Guide Summer 2016*. www.stjohns.ca/sites/default/files/CSJ_FileUpload/CorporateServices/St.%20John %27s%20City%20Guide%20Summer%202016%20sp.pdf.

Clegg, John. 1993. "Pictures, jargon and theory—Our own ethnography and roadside rock art." *Records of the Australian Museum, Supplement 17*: 91–103.

Collins, Paul. 2011. "Fortress Newfoundland: How the fear of Nazi attack turned

Newfoundland into an armed camp during World War II." *Newfoundland and Labrador Studies 26* (2): 1719–1726.

Crisp, Andrew, Anne Clarke, and Ursula Frederick. 2014. "Battlefield or gallery? A comparative analysis of contemporary mark-making practices in Sydney, Australia." *Australian Archaeology 78*: 84–92.

Danielsson Ing-Marie Back, Fredrik Fahlander, and Ylva Sjöstrand. 2012. "Imagery beyond representation." In *Encountering Imagery: Materialities, Perceptions, Relations*, edited by Ing-Marie Back Danielsson, Fredrik Fahlander, and Ylva Sjöstrand, 1–12. Stockholm: Stockholm University.

Dickinson, Maggie. 2008. "The making of space, race and place: New York city's war on graffiti, 1970–the present." *Critique of Anthropology 28* (1): 27–45.

Edwards-Vandenhoek, Samantha. 2015. "Behind closed doors: A material-centered analysis of contemporary graffiti writings in situ from Sydney's recent urban past." *Journal of Contemporary Archaeology 2* (2): 283–308.

Fitzpatrick, Ashley. 2010. "Grappling with graffiti." *The Telegram*, July *31*, 2010.

Fletcher, Roy. 1990. "Military radar defence lines of Northern North America: An historical geography." *Polar Record 26* (159): 265–276.

Frederick, Ursula. 2009. "Revolution is the new black: Graffiti/art and mark-making practices." *Archaeologies 5* (2): 210–237.

Frederick, Ursula. 2014. "Shake well midden: An archaeology of contemporary graffiti production." *Australian Archaeology 78*: 93–99.

Fyfe, Jane, and Liam Brady. 2014. "Leaving their mark: Contextualising the historical inscriptions and the European presence at Ngiangu (Booby Island), Western Torres Strait, Queensland." *Australian Archaeology 78*: 58–68.

Gaulton, Barry C., Bryn Tapper, Duncan Williams, and Donna Teasdale. 2019. "The Upper Island cove petroglyphs: An Algonquian enigma." *Canadian Journal of Archaeology 43*: 123–161.

Giles, Katherine, and Melanie Giles. 2014. "Signs of the times: Nineteenth-twentieth century graffiti in the farms of the Yorkshire wolds." In *Wild Signs: Graffiti in Archaeology and History*, edited by Jeff Oliver and Tim Neal, 47–59. Oxford: BAR International Series 2074.

González-Ruibal, Alfredo. 2019. *An Archaeology of the Contemporary Era*. London: Routledge.

Graves-Brown, Paul, Rodney Harrison, and Angela Piccini (eds). 2013. *The Oxford Handbook of the Archaeology of the Contemporary World*. Oxford: Oxford University Press.

Graves-Brown, Paul, and John Schofield. 2011. "The filth and the fury: 6 Denmark Street (London) and the Sex Pistols." *Antiquity 85*: 1385–1401.

Gunn, R.G., C.L. Ogleby, D. Lee, and R.L. Whear. 2010. "A method to visually rationalize superimposed pigment motifs." *Rock Art Research 27* (2): 131–136.

Hale, Alex, Alison Fisher, John Hutchinson, Stuart Jeffrey, Sian Jones, Mhairi Maxwell, and John Stewart Watson. 2017. "Disrupting the heritage of place: Practising counter-archaeologies at Dumby, Scotland." *World Archaeology 49* (3): 372–387.

Hamilton, Scott. 2017. "Drone mapping and photogrammetry at Brandon House 4." *Historical Archaeology 51*: 563–575.

Harrison, Rodney, and Esther Breithoff. 2017. "Archaeologies of the contemporary world." *Annual Review of Anthropology 46*: 203–221.

Harrison, Rodney, and John Schofield (eds). 2010. *After Modernity: Archaeological Approaches to the Contemporary Past*. Oxford: Oxford University Press.

Historic England. 2015. "Recording historic graffiti: Advice and guidance." www.historicengland.org.uk/about/what-we-do/consultations/guidance-open-for-consultation.

Hutson, Scott. 2011. "The art of becoming: The graffiti of Tikal, Guatemala." *Latin American Antiquity 22* (4): 403–426.

Keegan, Peter. 2011. "Blogging Rome: Graffiti as speech-act and cultural discourse." In *Ancient Graffiti in Context*, edited by Jennifer A. Baird and Claire Taylor, 165–190. New York: Routledge.

Keegan, Peter. 2014. *Graffiti in Antiquity*. London: Routledge.

Kiddey, Rachael, and John Schofield. 2011. "Embrace the margins: Adventures in archaeology and homelessness." *Public Archaeology 10* (1): 4–22.

Kindynis, Theo. 2019. "Excavating ghosts: Urban exploration as graffiti archaeology." *Crime Media Culture 15* (1): 25–45.

Kobiałka, Dawid. 2019. "Living monuments of the Second World War: Terrestrial laser scanning and trees with carvings." *International Journal of Historical Archaeology 23*: 129–152.

Ley, David, and Roman Cybriwsky. 1974. "Urban graffiti as territorial markers." *Annals of the Association of American Geographers 64* (4): 491–505.

Lovata, Troy, and Elizabeth Olton (eds). 2015. *Understanding Graffiti: Multidisciplinary Studies from Prehistory to the Present*. Walnut Creek: Left Coast Press.

Macdonald, Nancy. 2001. *The Graffiti Subculture: Youth, Masculinity and Identity in London and New York*. New York: Palgrave.

Matthew J. 2013. "Tek Interview December 8, 2013." Accessed November 30, 2019. http://senselost.com/interviews/tek-interview.

Mercer, Juanita. 2019. "Getting a grip on graffiti in St. John's: City creates task force to tackle century old concern." *The Telegram*, September 16.

Merrill, Samuel. 2015. "Keeping it real? Subcultural graffiti, street art, heritage and authenticity." *International Journal of Heritage Studies 21* (4): 369–389.

Merrill, Samuel, and Hans Hack. 2012. "Exploring hidden narratives: Conscript graffiti at the former military base of Kummersdorf." *Journal of Social Archaeology 13* (1): 101–121.

Milnor, Kristina. 2014. *Graffiti and the Literary Landscape in Roman Pompeii*. Oxford: Oxford University Press.

Monto, Martin, Janna Machalek, and Terri Anderson. 2012. "Boys doing art: The construction of outlaw masculinity in a Portland, Oregon, graffiti crew." *Journal of Contemporary Ethnography 42* (3): 259–290.

Navarro-Castillo, Marx, Alejandro Sheseña, and Sophia Pincemin. 2018. "The Maya graffiti of Plan de Ayutla, Chiapas." *Latin American Antiquity 29* (2): 386–393.

Nicks, Don, John Bradley, and Chris Charland. 1997. *A History of the Air Defence of Canada 1948-1997*. Ottawa: Commander Fighter Group.

Oliver, Jeff and Tim Neal (eds). 2010. *Wild Signs: Graffiti in Archaeology and History*. Oxford: BAR International Series 2074.

Patrois, Julie. 2013. "Río Bec Graffiti: A private form of art." *Ancient Mesoamerica 24*: 433–447.

The Pinetree Line. n.d. www.c-and-e-museum.org/Pinetreeline/general.html.

Porter, Samantha Thi, Morgan Roussel, and Marie Soressi. 2016. "A simple photogrammetry rig for the reliable creation of 3D artifact models in the field: Lithic examples from the Early Upper Paleolithic sequence of Les Cottés (France)." *Advances in Archaeological Practice 4* (1): 71–86.

Pritchard, V. 2008. *English Medieval Graffiti*. Cambridge: Cambridge University Press.

Ralph, Jordan. 2014. "Graffiti archaeology." In *Encyclopedia of Global Archaeology*, edited by Claire Smith, 3102–3107. New York: Springer.

Ralph, Jordan, and Claire Smith. 2014. "'We've got better things to do than worry about Whitefella Politics': Contemporary indigenous graffiti and recent government interventions in Jawoyn Country." *Australian Archaeology 78*: 75–83.

Romaniuk, Tobias. 2012. "'Bomb' the streets, feed the rush." *The Telegram*, April 7.

Ross, Jeffrey, Peter Bengtsen, John Lennon, Susan Phillips, and Jacqueline Wilson. 2017. "In search of academic legitimacy: The current state of scholarship on graffiti and street art." *The Social Science Journal 54*: 411–419.

Schacter, Rafael. 2014. "The ugly truth: Street art, graffiti and the creative city." *Art & the Public Sphere 3* (2): 161–176.

Schofield, John. 2010. "'Theo loves Doris': Wild-signs in landscape and heritage context." In *Wild Signs: Graffiti in Archaeology and History*, edited by Jeff Oliver and Tim Neal, 71–79. Oxford: BAR International Series 2074.

Seymour, Edward. 1951. "Hermetically sealed package for mixing and discharging paint. US patent 2580132, issued December 25, 1951." Accessed May 15, 2020. https://worldwide.espacenet.com/patent/search/family/022530820/publication/US2580132A?q=pn%3DUS2580132.

Soto, Gabriella. 2016. "Place making in non-places: Migrant graffiti in rural highway box culverts." *Journal of Contemporary Archaeology 3* (2): 121–294.

Stewart, Michelle, and Chris Kortright. 2015. "Cracks and contestation: Toward an ecology of graffiti and abatement." *Visual Anthropology 28* (1): 67–87.

Stryd, Arnoud. 2001. *Culturally Modified Trees of British Columbia: A Handbook for the Identification and Recording of Culturally Modified Trees*. Vancouver: Archaeology Branch, B.C. Ministry of Small Business, Tourism and Culture.

Sukkham, Atthasit, Paul Taçon, Noel Hidalgo Tan, and Asyaari bin Muhamad. 2017. "Ships and maritime activities in the North-Eastern Indian Ocean: Re-analysis of rock art of Tham Phrayanaga (Viking Cave), Southern Thailand." *The International Journal of Nautical Archaeology 46* (1): 108–131.

The Telegram. 2014. "Another 'Rong Crew' member pleads guilty to damaging property." *The Telegram*, January 31.

Tiboni, Francesco. 2017. "Of ships and deer: Early western mediterranean ship graffiti reappraised." *The International Journal of Nautical Archaeology 46* (2): 406–414.

Tomášková, Silvia. 2015. "Digital technologies in context: Prehistoric engravings in the Northern Cape, South Africa." *Digital Applications in Archaeology and Cultural Heritage 2*: 222–232.

Wacławek, Anna. 2011. *Graffiti and Street Art*. London: Thames and Hudson.

Winchester, Hilary, Iain Davidson, and David O'Brien. 1996. "Historical graffiti in Northern Australia: Evidence of European settlement and society in the Selwyn range of Northwest Queensland." *Australian Archaeology 43* (1): 1–7.

17 More than one world?

Rock art that is Catholic and Indigenous in colonial New Mexico

Darryl Wilkinson

1 Introduction

The southern reaches of the Rio Grande Gorge, located in northern New Mexico, offer one of the densest concentrations of rock art in the Americas. In a landscape dominated by the deep canyon of the Rio Grande, the basaltic geology provides an excellent canvas for making petroglyphs. The canyon's many boulders and cliff-faces are covered by a thin veneer of manganese and iron oxides, and for millennia, the region's inhabitants have been removing these superficial oxides, creating images through the ensuing contrast between dark and light. Although their names are no longer remembered, the oldest rock art in the area was created by the hunting and gathering peoples of the Archaic Period (c. 5000–400 BC). Over time, various other Native peoples have contributed to this vast iconographic "archive," including the Pueblos, Comanche, Apache and Ute (Fowles and Montgomery 2019). One of the most distinctive petroglyph traditions of northern New Mexico, albeit relatively unstudied, originated during the colonial era, and is best described as "Catholic." In other words, its iconography (mostly Latin crosses) is clearly influenced by the arrival and spread of Christianity in the New World—in this case as a direct consequence of Spanish imperialism.

Catholic rock art is not unique to the Southwestern United States, and is present throughout virtually the entire Americas. For instance, it has been noted in New England (Hedden 2002), in Baja California (Viñas 2013, 192), along the Orinoco River in Venezuela (Riris 2017), throughout the central Andes (i.e., Peru and Bolivia) (Martínez 2009), in Chile (Troncoso et al. 2019) and across the insular Caribbean (Cooper et al. 2016). However, the "authorship" of this genre of rock art is not a straightforward matter. For example, the Christian iconography on the island of Mona (Puerto Rico) described by Cooper et al. (2016) is accompanied by written inscriptions in Spanish, associated with the names of known colonial-era officials. In such cases, we can be reasonably confident that the creators of the petroglyphs were born in Spain itself. In other contexts, the rock art appears to show images of Catholic priests as perceived by Indigenous communities (e.g., Troncoso et al. 2019). Although the *content* of such rock art might be considered Catholic (i.e., it depicts Spanish religious practices and

personages), it was not necessarily produced *by* Catholics. In other words, the creators of the images had not themselves undergone substantial missionization. Here we must contend with a number of definitional problems, in the sense that who exactly counts as "Catholic" depends on one's criteria, and these can often be contested. And in yet other cases, the Catholic imagery was created by people who were of mixed Indigenous and European ancestry, and who therefore had intimate knowledge of Christianity *and* a variety of Indigenous ritual traditions (e.g., Liebmann 2013, 35–37). Such people would likely have considered themselves to be Catholic, at least in some sense, but this status did not necessarily exhaust their "religious" identity.

In comparison with more ancient rock art traditions, colonial-era pictographs and petroglyphs have generally been subject to much less scholarly analysis. This situation is starting to change, however, with a growing interest in what is often termed "contact rock art" (Goldhahn and May 2018). That said, most research in this vein has so far come out of Australia and southern Africa, not the Americas. It is also interesting that contact-era rock art is normally interpreted through a theoretical lens increasingly divergent from its pre-contact counterpart. Put another way, while pre-contact (or prehistoric) forms of rock art are increasingly being reconceptualized in light of the ontological turn (e.g., Creese 2011; Dowson 2009; Fahlander 2013; Robinson 2013; for a comprehensive review, see Jones 2017), the same cannot be said for contact-era rock art. Instead, contact-era rock art is still largely understood within a "cultural" (i.e., non-ontological) paradigm, in which the main theoretical terms include notions like "hybridity" or "resistance." The dominant perspective in the study of contact rock art is that for Indigenous peoples, such imagery represents a form of symbolic resistance and/or resilience in the face of colonial trauma. For instance, Hays-Gilpin and Gilpin (2018) interpret post-contact Navajo rock art in this manner, while Recalde and González Navarro (2014) adopt a similar position on Indigenous rock art in colonial Argentina. Moreover, for Matthew Liebmann (2013, 41–43), the notion of hybridity incorporates (by definition) ideas of resistance, subversion, and mockery with respect to colonial power.

Why are specialists in prehistoric rock art much more keen to embrace "ontology" than those studying colonial contexts? Indeed, historical archaeology in general seems much less open to the ontological turn than its prehistoric counterpart, and not just in the realm of rock art studies. In my view, there are several substantive reasons for this, and it cannot just be attributed to the variable impact of theoretical fashions. The anthropological concept of "culture" was invented in order to make sense of human alterity. If it is self-evident that not all peoples are the same, culture was the basic framework for accounting for such variation. Whereas older paradigms largely accounted for human difference in natural (i.e., biological) terms, in the post-Boasian ethnology of the twentieth century, it was culture that became the primary basis for explaining human diversity (Stocking 1966). Later on, a series of dependent concepts were devised to explain why once very different cultures had eventually come to resemble each other—among the most common were "acculturation," "syncretism," "creolization," and

"hybridity." Such terms were (and still are) most frequently invoked in analyses of colonial encounters. There are lengthy and complex debates over which of these concepts are to be preferred, and how they should be properly defined (e.g., Loren 2015; VanValkenburgh 2013); if they should even be used at all (Silliman 2015). For example, hybridity is nowadays more fashionable than acculturation, because the former implies a two-way interaction and also attributes more agency to Indigenous peoples, whereas the latter implies influence in only one direction, and connotes Indigenous passivity (Liebmann 2013, 2015). But adjudicating such debates is not my present concern. For current purposes, the key point is that all these ideas are dependent on the culture concept that underpinned twentieth-century anthropology.

By contrast, the ontological turn completely rejects "culture" as the grounds for explaining human alterity. If we think of the differences between Amazonians and Europeans as "cultural," we must first assume a shared natural world that is fundamentally the same thing for all of humanity (Viveiros de Castro 1998). Indeed, from an ontological perspective, even to refer to humanity (in the singular) becomes suspect. Thus "culture" can only explain difference if we first recognize an *a priori* divide between culture and nature. In one formulation, this is expressed as allowing Indigenous peoples their own distinctive "worldviews," while still insisting that we all still live in the same "world" (see Alberti and Marshall 2009). Logically, any rejection of the culture concept requires us to also dismiss all its dependent terms, including acculturation, creolization, and hybridity (etc.) as equally outmoded. But whether or not we feel these terms have outlived their usefulness, they were still developed for a reason. They were an attempt to grapple with very real and commonplace phenomena; the sort of changes that often occur in the wake of colonial encounters. Whatever its faults, the culture paradigm at least had a language for the profound transformations that occur in post-contact scenarios—such as when Indigenous people start incorporating Christian images into their rock art. By contrast, the ontological turn has nothing to say about these things. Indeed, arguably it cannot even speak their name, because if we express alterity in terms of different "worlds," what happens when worlds collide?

Theorists of ontology would probably say that they could address "hybrid" phenomena, although it is telling that they almost never seem to do so. Their case studies are always chosen with care, so that they are "pure" in their Indigenous and/or prehistoric origins. Thus rock art is an increasingly favorite context for ontological analyses, but not the kind of Native-Christian amalgamations often encountered in colonial societies. I would argue that this is because the very existence of rock art that arises out of both Indigenous *and* Catholic traditions confounds the fundamental reliance on binaries that underpins the ontological turn itself. Almost all recent anthropological writings on ontology make an appeal to the contrast between a notional Western ontology (which typically also embraces secularism, science and modernity) and some sort of non-Western counterpart. The work of the Brazilian ethnographer Viveiros de Castro is a canonical example of this approach. Again and again, he describes core

features of Amerindian ontology as not simply different from modernity, but as an explicit *inversion* of it. For instance, according to Viveiros de Castro (1998, 470–472), Amazonians see animals as ex-humans, unlike Westerners, who (if they believe in evolution at least) regard humans as ex-animals. Similarly, whereas Westerners construe the world in terms of a multiplicity of cultures and a singular, shared nature, Amazonians perceive reality in precisely the opposite terms; a singular culture and a multiplicity of natures. Other scholars writing in the tradition of the ontological turn draw a frequent contrast between the "relational" ontologies of Indigenous peoples and the "non-relational" ontological framework attributed to modernity. This approach has certainly been commonplace in recent discussions of rock art (see Jones 2017).

To be clear, I am not critiquing Viveiros de Castro, or other theorists of ontology, for playing with binaries in this fashion. They do so knowingly, and the results are usually compelling and powerful. However, we must also recognize the limitations of such analyses. Even though the Indigenous peoples of Latin America have been engaging with Christianity for centuries, Viveiros de Castro's figure of the "Amerindian" is presented as one who has no apparent familiarity with Catholicism. To some extent then, the ontological turn has necessitated a revival of the "ethnographic present" in anthropological writings. The binary inversions upon which the ontological turn relies cannot easily operate where the Natives are *also* Catholic, and so they must be purified of such "exogenous" religiosity prior to their analysis. Thus Catholicism is not presented as an Indigenous ontology, even though today it is the world's largest Indigenous religion (unless, of course, one wants to insist that Native iterations of Catholicism are somehow less pure). Indeed, the only way Catholicism can be accommodated in an ontological analysis is for it to be deemed "European," and thus "modern." Consider Viveiros de Castro's (1998, 474–475) historical vignette—which he retells from Lévi-Strauss (1983)—about one of the earliest encounters between Spanish Catholics and Native Amazonians. While the Christian priests were divided on the subject of whether Amerindians possessed souls, the Amazonians were trying to find out if the Europeans had bodies; particularly ones that would putrefy after death. In this story (which offers yet another inversion), it is the perspective of the medieval Catholics that we are supposed to find familiar. Of course we disapprove of them for even entertaining the possibility than Native Americans lacked souls, but a least we comprehend the terms of the enquiry itself. In that sense, their offence is ethical, not ontological. But what of the Amazonians' lack of certainty over whether or not Europeans actually had physical bodies? This is clearly meant to be read by us as a form of radical alterity. It tells us something about the binary premises of the ontological turn, when even medieval Catholicism can stand in the role of the familiar (i.e., the modern).

I would suggest that historical archaeologists seldom engage with the ontological turn (including those who study contact-era rock art), precisely because binary analyses that invert the European and the Indigenous are inimical to their entire intellectual output over the past few decades. At every level—empirically,

politically, conceptually, aesthetically—they are inclined to reject such binaries, not reinforce them. In contrast, prehistorians are eminently more comfortable with such grand divisions—in part because their material more easily permits it. To describe eighteenth-century Puebloan and Spanish settlers as opposites of each other, is a very different prospect from drawing a similar binary contrast between, say, Neolithic Europeans and their modern counterparts.

All this lays out the problematic terrain that is our starting point when trying to understand a colonial-era corpus of rock art that is both Indigenous and Catholic. If we wish to appeal to the theoretical language of "admixture" (e.g., hybridity and creolization), we are inevitably engaging in a cultural analysis. But the recent literature on ontology warns us that to begin with "culture" as our analytical backdrop, already sets the terms of reality according to a Western framework. The alternative is an ontological analysis, but that always seems to lead to the invocation of sharp binaries. Thus the Indigenous component would inevitably start to appear "relational," while the Catholic/European contribution will start to look like its non-relational opposite—even though decades of post-colonial theory would insist that this kind of Othering of the colonized is deeply problematic. In what follows, I will attempt to work through this conundrum, first looking at the material from a Catholic point of view, and then from the perspective of Native American theory.

2 Cross petroglyphs as a form of penitent labor

Turning to the specific characteristics of Catholic rock art in New Mexico, unlike much other Christian iconography, its singular focus on cruciforms is note-worthy. Rather than scenes based on scriptural narratives—or depictions of Christ, the Virgin Mary and the Saints—the Catholic petroglyphs of the region are overwhelmingly comprised of Latin crosses. Sometimes they are embellished and decorated, but the most common style consists of just two simple lines, with the horizontal line slightly shorter than the vertical (see Figure 17.1). On occasion, the crosses are accompanied by text, indicating either a name or date, but most are anonymous. Since Catholic petroglyphs first appear during the colonial era, they were often made with metal tools, although in many cases more "traditional" implements were still used, such as quartzite hammerstones. Catholic petroglyphs are distributed throughout the entire Rio Grande gorge, and are most heavily concentrated in what would have been the main population centers of the colonial period; namely the agricultural villages founded under the Spanish viceroyalty. In particular, the settlements of Cieneguilla (founded in AD 1795, now called Pilar) and Embudo (founded in AD 1725, now called Dixon) both lie within relatively dense clusters of Catholic petroglyphs. A general in-dication of the distribution of known Catholic rock art in the region is indicated in Figure 17.2. The association of Catholic rock art with Spanish villages is not particularly surprising, insofar as we might expect Catholic petroglyphs to occur in proximity to the largest settled Catholic populations. However, as written history, oral history and archaeology all attest, the villages along the northern

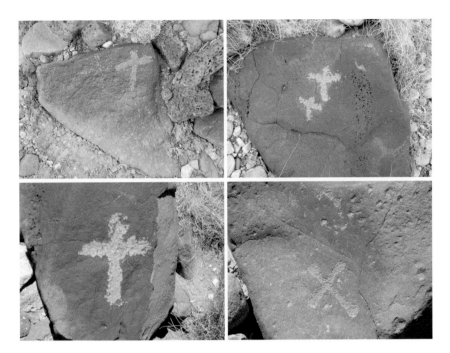

Figure 17.1 Petroglyphs in the form of simple Latin crosses from the Rio Grande Gorge.

frontier of the Spanish Americas quickly became populated by people with diverse genealogies. Intermarriage between Indigenous peoples and Spanish settlers was extremely common, and towards the end of the colonial era, all rural communities were highly "mixed" in terms of ancestry. For instance, the aforementioned village of Cieneguilla seems to have had a close association with several nearby Jicarilla Apache communities until at least the 1850s (Eiselt 2009).

Why create crosses, again and again, in the arid deserts of New Mexico? Especially the simple, undecorated kind, which are apparently lacking in any individuality, variability or narrative content. From a non-ontological paradigm, there is little difference between Catholic and non-Catholic rock art, beyond their specific cosmological content. Consider, for example, Chippindale and Nash's (2004, 1) description of the primary value of rock art studies, which they say,

> ... gives a direct record, made by ancient people, of ancient worlds as those ancient people saw and experienced them. Its central point is in the meaning of things, inviting an archaeology of human perception, or world-view and of religion.

In principle, this statement is no less applicable to Christian rock art as it is to its Indigenous counterparts. Catholic rock art reflects a Catholic cosmology, just as Puebloan rock art reflects a Puebloan cosmology. However, an ontological

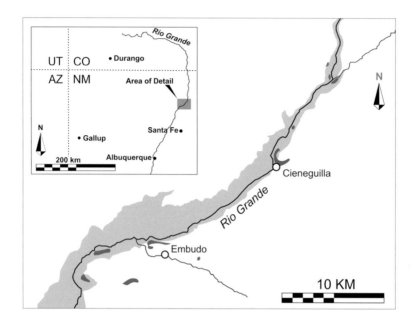

Figure 17.2 Map of the southern portion of the Rio Grande Gorge (light gray). Major clusters of Catholic rock art thus far identified in the survey are indicated (dark gray). The location of the survey area is shown in relation to the Four Corners region of the United States (top left).

perspective would begin with suspicion towards the universalizing dualism that is implicit in such formulations. It would, for example, question whether rock art is really an external expression (i.e., material culture) of interior mental re-presentations (i.e., worldview). Indeed, in the recent ontological literature on rock art, "symbolic" interpretations are often emphatically rejected. For instance, Andrew Meirion Jones (2017, 171) criticizes such symbolic approaches to rock art, because the "… ontological character of the image remains unquestioned." For Jones (2017, 171) this constrains rock art within a modern conception of the image, where the glyphs are reduced to "components of sign systems" that "have a variety of different meanings." Here I wish to make a similar argument about Catholic rock art along the Rio Grande, suggesting that it is not especially useful to understand it as the visual materialization of Christian cosmology. Instead, I will suggest that it is actually the product of an ancient Christian practice, which we might refer to as *penitent labor.*

In Roman Catholic theology, penance is considered a sacrament. Its most obvious manifestation is the absolution of sins confessed before a priest, who then prescribes some sort of penitential rite to be performed. Today, penitential rites generally entail the saying of a particular prayer a specified number of times (e.g., Ave Maria or the Rosary). Such rites are among the most basic expressions of penitent labor, which is often facilitated and quantified through mnemonic

devices like prayer beads. It is essentially a form of purgative work, and in Catholic thought is a necessary embodiment of the forgiveness of sins. Akin to penitent labor are acts of penitential suffering. In other words, experiencing pain or discomfort is often considered purgative in Catholic theology as well. Fasting is probably the most widespread form today, although other methods were once more common, such as the wearing of a *cilice* (hairshirt), often referred to as "mortification of the flesh." Most dramatic of all is the practice of flagellation, usually associated with penitent movements of the later Middle Ages, whose adherents (in imitation of Christ's suffering) would publicly whip themselves to seek absolution for themselves or others.

Although they differ in their reliance on toil versus pain, both penitential labor and penitential suffering draw on non-pleasurable experiences as the necessary embodiment of divine absolution. Talal Asad (2003) has written about the ways in which secular modernity tends to recoil (at least rhetorically) from suffering and pain, something it perceives as an inherently negative phenomenon (see also Fowles 2014, 162–163). Humanist thought in particular, regards the fulfillment of human potential as inversely proportional to the sum of human suffering in the world. And as is often the case with modernity, its deepest roots lie in Protestant critiques of Catholicism. Early Protestants almost universally rejected the idea of penance as a sacrament, since they believed in salvation by grace alone, rather than worldly deeds (Starr-LeBeau 2008, 413). Unlike Catholics then, Protestants were typically skeptical of the idea that any spiritual benefit could be derived from self-inflicted pain. It is also counter to Protestant thought to imagine the act of prayer as anything akin to "punishment." In Reformation theology, especially the Calvinist tradition, prayer is a dialogue with God, predicated on sincerity above all else. It should thus be an individualized expression of one's piety, not a penance that is prescribed and quantified by a priestly authority.

Adopting this logic of penitent labor, we can perhaps see cruciform petroglyphs along the Rio Grande in a quite different light, and begin to pivot away from more secular assumptions. And here it is worth noting that during the historic period, New Mexico saw the emergence of an influential Catholic fraternity called the Penitentes, widely associated with flagellation and other rites of penance (see Carroll 2002). Moreover, the two main villages in the study region (Cieneguilla and Embudo) both hosted chapters of the Penitentes brotherhood. So although penitent labor is a feature of Catholicism everywhere, it seems to have been especially important in the development of Catholicism along the Rio Grande gorge. Let us imagine then the makers of Catholic petroglyphs kneeling uncomfortably among the sharp rocks and even sharper cacti of northern New Mexico, toiling under a hot desert sun. With respect to the cruciform glyphs, in the end an image was undeniably produced, but the creation of iconography (i.e., expressing a cosmological idea through art) was not really the point of such practices. For the penitent at least, their primary concern was the realization of divine absolution through embodied suffering. In fact, the petroglyphic image is arguably little more than a byproduct of these rites of penance. What mattered more, was the repetitive act of chipping away at the

rock surface; a pious manifestation of one's absolution predicated on the per-
formance of labor and the experience of physical discomfort. This is why in the
Rio Grande context we see the constant repetition of the simple Latin cross. It is
not really an attempt at iconographic expression at all, so much as a conventional
series of bodily gestures that happen to leave a visible trace. In this respect, the
making of a cross petroglyph has less in common with religious art in the tra-
ditional sense, and more with the lighting of a votive candle, or the bodily gesture
of making the *signum crucis* (sign of the cross).

It is nonetheless true that because the medium in question is "rock art," a
permanent trace of the penitent labor is always left behind. But even though
petroglyphs are unusually durable, we should not assume that the penitent's
original aim was to make images for the benefit of posterity. It is a modernist
conceit to imagine that because an action gives rise to an image, the making
of "art" must have been its overriding motivation. Yet by focusing on penitent
labor, and thus decentering iconicity, we can also better explain the "excessive"
character of many of the Rio Grande cross petroglyphs, where the rock has been
pecked many more times than necessary had the aim simply been to produce
a cruciform image (see Figure 17.3). Indeed, some of the crosses are so "over-
pecked" that their basic shape has begun to disappear. This is not to say
that form was entirely irrelevant to the process, but it was secondary to, and
frequently overridden by, the penitential value of the labor itself.

The idea that rock art acts as an imagistic vehicle for meaning is now widely
critiqued within ontological archaeology, as is the related assumption that ico-
nography represents an external materialization of cosmology. Here I have
made a very similar critique in arguing that Catholic petroglyphs were acts
of penitent labor, largely unconcerned with image creation in the traditional
sense. However, the path my argument took was not the standard one. Typically,
archaeologists critique modernist assumptions through an appeal to non-Western
(especially Indigenous) ontologies. Yet I arrived at precisely the same juncture,
albeit using Catholic theology instead of Indigenous metaphysics. To my
knowledge, however, no participant in the ontological turn has described
(medieval) Catholicism as a species of "relational ontology," although in principle
there seems little reason why it could not be considered so.

3 Sacralisation through accretion

So far, I have considered the cross petroglyphs of the Rio Grande in terms of
deep-rooted Christian practices, particularly the centuries-old rites of penitent
labor that even now remain essential to everyday Catholicism. Still, the medium
ultimately matters, and we must acknowledge that rock art was basically absent
from medieval and early modern Europe as a living tradition. Because of this
contrast—one made explicit through the colonial encounter—American rock
art has an "Indigenous" character that cannot be ignored. Simply put, it is
impossible to create rock art in the Americas without being conscious of the fact
that you are contributing to a tradition that has been in existence for millennia.

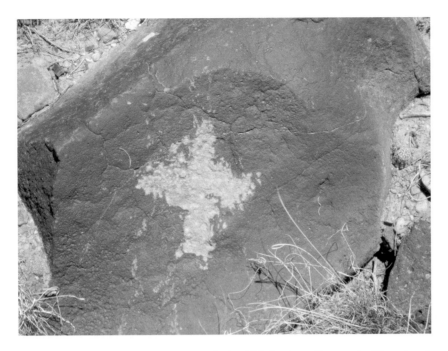

Figure 17.3 An example of a cross petroglyph which has been "overpecked," so that the cruciform shape has become less distinct.

In the new World, unlike in Europe, the making of rupestrian images never died out, and because petroglyphs are an especially durable medium, one is always aware of the rock art produced by previous generations. This is why rock art also has a distinctly *accretive* character. In astrophysics, the idea of accretion refers to the way in which matter attracts more matter to itself over time. Every body that has mass exerts a gravitational pull on every other, so as an accumulation of gas or dust becomes larger, its ability to draw more matter to itself increases. Rock art often amasses and agglomerates in a very similar way. In other words, the more petroglyphs that have been produced at a particular site, the more it seems to attract. In the American Southwest, some of the largest rock art panels have glyphs numbering in the hundreds; an often dense and overlapping accumulation of images that has accrued over many millennia. In describing such sites, rock art scholars often use the term "palimpsest," based on an analogy with a heavily overwritten manuscript, where it is possible to distinguish multiple and chronologically distinct layers of text.

Most media lack this tendency towards accretional growth. In the modern world at least, the few exceptions tend to be illicit and/or "low-brow" forms of media, such as graffiti and latrinalia (toilet wall graffiti). For instance, Sapwell (2017) discusses latrinalia as a form of cumulative art comparable to rock art, where texts and images are built up in explicit dialogue with each other.

He argues that a "community" of contributors gradually emerges in such contexts, linked together by their production of interrelated images at the same site over a period of time (Sapwell 2017, 372). But rock art accumulations are not quite the same as other kinds of palimpsest. Indeed, one of the key differences between rock art and latrinalia is the degree of chronological extension they entail. Specifically, rock art tends to give rise to associations that far exceed the temporal and spatial confines of any known cultures or cosmological orders. In comparison with something like latrinalia, the images on a rock art palimpsest are often separated by millennia, and so promote a dialogue of a radically different kind. Put another way, we might say that rock art is defined by its capacity to produce iconic interactions in which there is an acute awareness of alterity. Whether it is a modern researcher puzzling over the Palaeolithic paintings made by extinct hominins, or an Indigenous person who understands petroglyphs as traces left by the ancestors, rock art facilitates an awareness of *other kinds of being*. Although palimpsests are not unique to rock art *per se*, it is difficult to think of any other artistic medium that enables such engagement with ontological difference across deep time. From the perspective of the religious arts of medieval Europe at least, there was clearly no equivalent medium. It is in precisely this sense that we cannot understand Catholic rock art merely as a replication of existing iconography (i.e., cruciforms), albeit in a different material form. Nor can we view it as just another species of penitent labor, which happens to leave unusually durable traces.

To give a more concrete example of what I am talking about here, consider the petroglyph panel shown in Figure 17.4. The site is located along the southern reaches of the Rio Grande gorge, and its primary boulder exhibits a dense palimpsest comprised of 97 distinct petroglyphs. It is also clear the images on the rock surface were produced over a very extended period of time. Rock art is notoriously difficult to date with any precision, although relative chronologies are often apparent. A useful means of assessing relative chronological relationships is the extent of repatination that is visible on the individual glyphs (i.e., how much of the dark, oxidized surface has regenerated) (Schaafsma 1986, 13–14). For a single palimpsest panel, we can therefore arrange the glyphs in a relative chronological sequence by examining the degree of patina redevelopment on each. Moreover, digital colorimetry provides a less subjective indication of how much patina has developed, and is thus preferable to assessments made by the naked eye. In Figure 17.4, all the glyphs from the aforementioned palimpsest panel are expressed in terms of their (light-to-dark) colorimetric values. As indicated, the darkest (and so presumably oldest) glyphs all took the form of footprints. In later periods, other kinds of glyphs were also added—including abstract motifs, Latin crosses and texts. However, the production of footprint iconography never ceased, and continued right up until the colonial period. In general, footprint imagery was not a particularly common feature of colonial rock art in New Mexico, indicating that the more recent iconography at the site was heavily determined by its very long (and very *local*) graphical history. Thus whoever was producing the site's later rock art, they seem to have been more

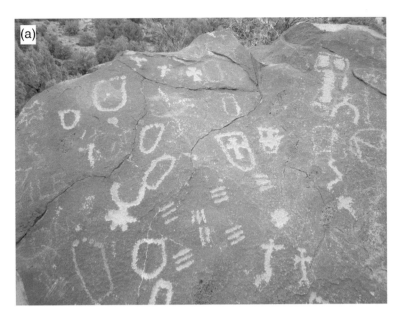

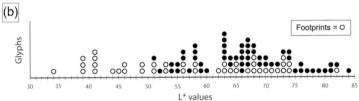

Figure 17.4 (a) One of the major palimpsest panels from the southern end of the Rio
 Grande Gorge; (b) A chart showing the range of light-to-dark colorimetric
 values for each glyph on the panel, using L* values in the L*a*b* color space.
 Higher L* values indicate less patination, and therefore a more recent date.
 Footprint glyphs are shown to occur across the entire chronological sequence.

influenced by what was already there, as opposed to some repertoire of visual
culture they had "brought with them."

I want to draw attention to one particular glyph on this panel (see Figure 17.5).
It takes the form of a cross, and is set inside what looks like a shield, apparently
made at the same time and by the same hand. However, when examined closely
the lightly patinated "shield" portion of the image almost completely overlies
an older footprint glyph. The difference between the colorimetric values for the
two overlapping images is considerable, indicating they were chronologically
very distinct. Pecked with stone tools and nearly fully repatinated, the earlier
footprint was almost certainly prehistoric in origin, and possibly even dates to
the Archaic Period. Essentially then, the ancient footprint glyph has been re-
interpreted (i.e., remade) as a shield-with-cross by a colonial-era visitor to the site.
How exactly should we conceptualize the authorship of such iconography?

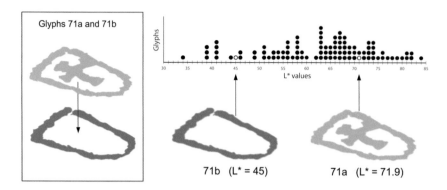

Figure 17.5 Left: Overlapping glyphs (71a and 71b) from the palimpsest panel shown in Figure 17.4. Right: The same two glyphs with their divergent colorimetric values highlighted.

Instead of reproducing images meaningful to their own (very different) "cultures," successive contributors to the rock art palimpsest at this site have taken the pre-existing imagery as their guide. Unlike latrinalia, where the dialogue emerges over (at most) several decades, and we can safely assume a fairly high degree of cultural similarity among the contributors, the rock art palimpsest points to a very different form of exchange. In the latter case, we encounter a dialogue that took place over centuries, and where we must assume that its participants (e.g., colonial Catholics and prehistoric peoples) lived in quite different worlds.

Traditionally, we think of visual cultures as synchronous and horizontal. Like water running up a beach, successive waves of culture flow over space, with each leaving a distinctive material trace. As each wave runs its course, it loses energy and fades away, although the flotsam and jetsam it carried is left behind, as evidence of its passing. So in the context of New Mexican rock art, we might think of Archaic rock art as providing the first wave (or waves), followed by a Puebloan wave, and then later the Apache, Comanche and Spanish (etc.) waves. In this view, the palimpsest emerges as each cultural horizon spreads across the landscape, adding its particular set of images to the accumulating mix. Yet this does not always accord with the rock art sites one actually encounters in the American Southwest. As we saw earlier, although there were likely successive groups of Archaic, Pueblo, Apache, Comanche, and Spanish individuals making rock art at this particular site, they replicated the same iconic forms again and again. Cultures came and went, so to speak, but the iconography was primarily the product of that particular place, and its hyper-local (but historically very deep) sets of visual relations. Even Catholic imagery at the site was shaped less by contemporary Christian imagery elsewhere in the world, and more by the prehistoric glyphs that had long been present on a single rock face. Thus, for such palimpsests, interactions between the glyphs were diachronic and vertical, rather than synchronic and horizontal. Instead of waves on the beach, the better

metaphor here might be a spring, with water constantly bubbling up from a single, deep source. Whereas waves are discrete entities and each one carries different material within it, the flow of spring water is constant, does not vary in its contents, and has only a limited horizontal expansion. However, the flow of a spring has much greater temporal endurance than a wave; and at the surface, the water is continuously replenished over time, but always from the same profoundly local source.

According to the Native American scholar Vine Deloria Jr. (2003), it is inherent to Western thought (itself a product of monotheism) to prioritize history over place. What happened is always primary; *where* it happened is generally a secondary consideration. Thus in a kind of ontological anthropology *avant la lettre*, Deloria (2003, 97–132) argued that Indigenous Americans took the opposite approach, tending instead to subordinate history to place. As a way of spatio-temporally situating cultures, populations and artefacts, the metaphor of the wave is ubiquitous in archaeological writing (as is its synonym, the "horizon"). Such language reflects the basic hierarchy of history over place that suffuses all modernist metaphysics. Although he did not explicitly use such terms, my alternative metaphor of the spring (as opposed to the wave) is inspired by Deloria's (2003) discussion of Indigenous American metaphysical commitments with regards to space and time. It provides a way of thinking about rock art that is determined primarily by deeply local, diachronic relations, rather than successive cultural horizons that move over space. In so doing, I have proffered an ontological analysis in the classic style, drawing a binary contrast between modernity and its Native counterpart. Using an Indigenous theory (i.e., Vine Deloria's writings) as my starting point, the rock art corpus in question has been read as an inversion of the typical Western hierarchy of history over place.

4 Conclusions

In this chapter, I have juxtaposed two very different interpretations of northern New Mexico's Catholic rock art. From one point of view, it can be seen as a colonial transference of a very old form of Christian piety; the tradition of penitent labor that extends back into the European middle ages, if not further. In this reading, the iconic qualities of the cruciform petroglyphs are something of a distraction. Our modernist obsession with images, and what they mean, can often inhibit our ability to understand phenomena that reflect quite different logics—particularly when they still come in the *garb* of images. In a sense, the Catholic petroglyphs of the Rio Grande are not really religious art at all, or at least not primarily so. Instead they are a byproduct of ritually charged bodily actions. Thus it has been possible to critique several modernist great divides, by recourse to a very long established mode of Catholic praxis. It is a reminder that modernity is not so much a totality as it is a hegemon; built on the historical and ongoing suppression of its own internal alterities. In particular, modernity universalizes a wide range of crypto-Protestant propositions, usually in opposition to (older) Catholic alternatives.

During the early years of the Reformation, perhaps the most fundamental dispute between Catholics and Protestants related to their understanding of the Eucharistic rite. According to Church doctrine, the bread and wine of the Holy Communion were transubstantiated into the literal body and blood of Christ. This practice originally arose from a scriptural reference to Christ's breaking of bread at the Last Supper, saying, "This is my body given for you; do this in remembrance of me" (Luke 22.19). The ensuing Protestant-Catholic dispute hinged around what exactly the word "is" meant in this piece of scripture, and so could hardly have been more ontological. The most radical Protestant view, represented by theologians such as Zwingli, held that in this context "is" really meant "signifies," and therefore rejected any consubstantiality between the Eucharistic bread and the actual body of Christ. So when scholars perceive rock art as a set of symbols, they are effectively recapitulating the Protestant critique of Catholic Eucharistic theology, albeit in a more secular form. Indeed, the archaeological conception of non-utilitarian material culture in general (i.e., as a vehicle for anthropogenic meaning) is arguably based on a universalization of Protestant polemics against the Eucharist. It is puzzling that theorists of ontology have to date shown so little interest in pointing out the Protestant foundations of modernity, or indeed the potential alterity of Catholicism (as well as other ancient forms of Christianity).

The second approach I presented looked at Catholic rock art as an expression of a Native American metaphysics in which place precedes history—an inversion of what we see for both modernity and monotheism. Here, the Catholic petroglyphs were understood within the logic of an inherently Indigenous medium, albeit one in which iconicity was essential to creating a multi-millennia dialogue between images. In several respects then, there is a contradiction between the two perspectives I offered, insofar as the logic of the petroglyphs can be read as fully Catholic, and yet also entirely Indigenous. Nonetheless, I still think both perspectives are equally valid. The traditional solution (as per most studies of contact rock art) would be to see this conjunction as a form of "hybridity," where two traditions have interacted, thereby creating something quite new from a "menu" of European and Indigenous ingredients. Yet it is not clear to me that anything has actually been blended in this particular instance. A mixture is always, *ipso facto*, a dilution of its primary components, even when something innovative is produced in the process. But the rock art I have been discussing does not seem to have suffered any watering down of either its Catholicity or its indigeneity. Moreover, I struggle to identify a third, "hybridized" entity that has been created from this encounter between Catholic and Native material practices. Instead, our two interpretive possibilities end up looking like an impossible mixture of oil and water.

Can the contradiction be resolved? Maybe. But perhaps the more important question is why should we expect such a resolution in the first place? As Carolyn Walker Bynum (2011) has discussed, modern thought is heavily grounded in dialectics, insofar as we strive for *synthesis* in the face of contradictory accounts. Hybridity is itself a kind of synthesis, and therefore represents

a classic instance of dialectical resolution in its own right. At the same time, the ontological turn has proven no less susceptible to this (ironically) rather modernist way of thinking. For example, its proponents will often insist that ontology is more than "just another word for culture," since ontology replaces and improves upon the theoretical labor previously performed by the culture concept. Recall that the nineteenth-century explanation for human difference was grounded in an appeal to nature (i.e., biology/race), which was later superseded by explanations based on culture. Thus in proper dialectical fashion, the ontological turn rejects both natural difference (*thesis*) and cultural difference (*antithesis*), and replaces them with natureculture (*synthesis*). But modernist dialectics is not the only intellectual impulse available to us. And again, we need look no further than the "subjugated" elements within our own Western tradition. Unlike moderns (and Protestants), Catholic theologians of the Middle Ages were far more comfortable with the articulation of paradox. Paradox is not dialectical, since "it is the simultaneous assertion (not the reconciliation) of opposites" (Bynum 2011, 34). For the medieval theologian, therefore, it is perfectly possible for God to be one and a trinity, just as it is for Christ to be entirely human and entirely divine. Despite all its skepticism towards modernity, the ontological turn has so far ignored the centrality of paradox to certain non-modern metaphysical traditions. I suspect this reflects too much emphasis on science as the basis for modernity, and too little critical reflection on its underlying Protestantism. In any event, perhaps the medieval theologians would remind us that synthetic resolution is not the only response when faced with contradiction. So in answer to our earlier question as to whether the rock art of the Rio Grande is Catholic or Indigenous, the best answer might be that it is fully, and paradoxically, both.

References cited

Alberti, Benjamin, and Yvonne Marshall. 2009. "Animating archaeology: Local theories and conceptually open-ended methodologies." *Cambridge Archaeological Journal* 19 (3): 344–356.

Asad, Talal. 2003. *Formations of the Secular: Christianity, Islam, Modernity.* Palo Alto: Stanford University Press.

Bynum, Carolyn Walker. 2011. *Christian Materiality: An Essay on Religion in Late Medieval Europe.* New York: Zone Books.

Carroll, Michael P. 2002. *The Penitente Brotherhood: Patriarchy and Hispano-Catholicism in New Mexico.* Baltimore: Johns Hopkins University Press.

Chippindale, Christopher, and George Nash. 2004. "Pictures in place: Approaches to the figured landscapes of rock-art." In *The Figured Landscapes of Rock-Art: Looking at Pictures in Place*, edited by Christopher Chippindale and George Nash, 1–36. Cambridge: Cambridge University Press.

Cooper, Jago, Alice Samson, Miguel A. Nieves, Michael J. Lace, Josué Caamaño-Dones, Caroline Cartwright, Patricia N. Kambesis, and Laura del Olmo Frese. 2016. "The Mona Chronicle: The archaeology of early religious encounter in the New World." *Antiquity* 90 (352): 1054–1071.

Creese, John. 2011. "Algonquian rock art and the landscape of power." *Journal of Social Archaeology 11* (1): 3–20.

Deloria, Vine Jr. 2003. *God is Red: A Native View of Religion.* Golden: Fulcrum Publishing.

Dowson, Thomas A. 2009. "Re-animating hunter-gatherer rock art research." *Cambridge Archaeological Journal 19* (3): 378–387.

Eiselt, B. Sunday. 2009. "The Jicarilla Apaches and the archaeology of the Taos region." In *Between the Mountains – Beyond the Mountains: Papers in Honor of Paul R. Williams*, edited by Emily Brown, Karen Armstrong, David M. Brugge, and Carol Condie, 57–70. Albuquerque: Papers of the Archaeological Society of New Mexico, Vol. 35.

Fahlander, Fredrik. 2013. "Articulating relations: A non-representational view of Scandinavian rock art." In *Archaeology after Interpretation. Returning Materials to Archaeological Theory*, edited by Benjamin Alberti, Andrew Meirion Jones, and Joshua Pollard, 305–325. Walnut Creek: Left Coast Press.

Fowles, Severin. 2014. "On torture in societies against the state." In *Violence and Civilization: Studies of Social Violence in History and Prehistory*, edited by Roderick Campbell, 152–178. Oxford: Oxbow Books.

Fowles, Severin, and Lindsay Montgomery. 2019. "Rock art counter-archives of the American West." In *Murals of the Americas*, edited by Victoria I. Lyall, 101–120. Denver: Denver Art Museum.

Goldhahn, Joakim, and Sally K. May. 2018. "Beyond the colonial encounter: Global approaches to contact rock art studies." *Australian Archaeology 84* (3): 210–218.

Hays-Gilpin, Kelley, and Dennis Gilpin. 2018. "Rock art and the transformation of history in the southwestern United States." *Australian Archaeology 84* (3): 294–304.

Hedden, Mark. 2002. "Contact period petroglyphs in Machias Bay, Maine." *Archaeology of Eastern North America 30*: 1–20.

Jones, Andrew Meirion. 2017. "Rock art and ontology." *Annual Review of Anthropology 46*: 167–181.

Lévi-Strauss, Claude. 1983. *Structural Anthropology*, Volume 2. Chicago: The University of Chicago Press.

Liebmann, Matthew. 2013. "Parsing hybridity: Archaeologies of amalgamation in Seventeenth Century New Mexico." In *The Archaeology of Hybrid Material Culture*, edited by Jeb J. Card, 25–49. Carbondale: Center for Archaeological Investigations, Occasional Paper No. 39. Carbondale: Southern Illinois University.

Liebmann, Matthew. 2015. "The Mickey Mouse kachina and other 'double objects': Hybridity in the material culture of colonial encounters." *Journal of Social Archaeology 15* (3): 319–341.

Loren, Diana DiPaolo. 2015. "Seeing hybridity in the anthropology museum: Practices of longing and fetishization." *Journal of Social Archaeology 15* (3): 299–318.

Martínez, José Luis C. 2009. "Registros andinos al margen de la escritura: El arte rupestre colonial." *Boletín del Museo Chileno de Arte Precolombino 14* (1): 9–35.

Recalde, Andrea, and Constanza María González Navarro. 2014. "Colonial rock art: A reflection on resistance and cultural change (16th and 17th century-Córdoba, Argentina)." *Journal of Social Archaeology 15* (1): 45–66.

Riris, Philip. 2017. "On confluence and contestation in the Orinoco interaction sphere: The engraved rock art of the Atures Rapids." *Antiquity 91* (360): 1603–1619.

Robinson, David W. 2013. "Transmorphic being, corresponding affect: Ontology and rock art in South-Central California." In *Archaeology after Interpretation. Returning Materials to Archaeological Theory*, edited by Benjamin Alberti, Andrew Meirion Jones, and Joshua Pollard, 59–78. Walnut Creek: Left Coast Press.

Sapwell, Mark. 2017. "Understanding palimpsest rock art with the art as agency approach: Gell, Morphy, and Laxön, Nämforsen." *Journal of Archaeological Method and Theory 24* (2): 352–376.

Schaafsma, Polly. 1986. *Indian Rock Art of the Southwest*. Albuquerque: University of New Mexico Press.

Silliman, Stephen W. 2015. "A requiem for hybridity? The problem with Frankensteins, purées, and mules." *Journal of Social Archaeology 15* (3): 277–298.

Starr-LeBeau, Gretchen. 2008. "Lay piety and community identity in the early modern world." In *A New History of Penance*, edited by Abigail Firey, 395–417. Leiden: Brill.

Stocking, George W. 1966. "Franz Boas and the culture concept in historical perspective 1." *American Anthropologist 68* (4): 867–882.

Troncoso, Andrés, Daniel Pascual, and Francisca Moya. 2019. "Making rock art under the Spanish empire: A comparison of hunter-gatherer and agrarian contact rock art in north-central Chile." *Australian Archaeology 84* (3): 263–280.

VanValkenburgh, Parker. 2013. "Hybridity, creolization, mestizaje: A comment." *Archaeological Review from Cambridge 28* (1): 301–322.

Viñas, Ramon. 2013. *La Cueva Pintada. Proceso evolutivo de un centro ceremonial, sierra de San Francisco, Baja California Sur, México. Monografías del SERP 9.* Barcelona: Universitat de Barcelona.

Viveiros de Castro, Eduardo. 1998. "Cosmological deixis and Amerindian perspectivism." *Journal of the Royal Anthropological Institute 4* (3): 469–488.

18 Kwipek, Mi'kma'ki

Pemiaq Aqq Pilua'sik Ta'n Tel Amalilitu'n Kuntewiktuk/Continuity and change in Mi'kmaw petroglyphs at Bedford, Nova Scotia, Canada

Bryn Tapper[1]

1 Introduction

Contact period rock art of Indigenous peoples provides important alternative lines of evidence to examine colonial encounters; evidence otherwise dominated by European accounts which have often censored or silenced Indigenous voices and narratives of the past (Paterson 2012, 80). Moreover, contact period rock art can reveal the 'reverse gaze' of colonial contact—documenting Indigenous observations of, and responses and adaptations to, profound and often devastating cultural change.

In many regions of the world, contact period rock art demonstrates how Indigenous peoples deployed imagery as a means to accommodate and/or resist change; it discloses Indigenous agency in the processes of encounter and engagement. In South Africa, San rock art has revealed the political and territorial resistance of San Bushman to European encroachment and aggression (Ouzman 2003), while throughout Australia, rock art demonstrates the various ways in which Aboriginal peoples have responded to cross-cultural encounters over the past 500 years (McNiven and Russell 2002; May et al. 2010; Taçon et al. 2012). Similarly, in the Americas, rock art was an important way for some Indigenous groups to express ongoing resistance to colonial oppression (Recalde and Navarro 2014), or to resist Christianization and forcible displacement from their lands (Carroll et al. 2019), or else shows how some groups accommodated rapid technological change (Klassen 1998).

It is in this context of culture contact that I examine the petroglyph site at Kwipek (Bedford), located at the head of Asoqmapskiajk (Bedford Basin) which is part of K'jipuktuk (Halifax Harbour) in Sipekni'katik (the traditional Mi'kmaw district covering much of central mainland Nova Scotia). Kwipek is one of several historic Mi'kmaw rock art sites known in Mi'kma'ki (the Mi'kmaw homeland corresponding to Nova Scotia, Prince Edward Island, eastern New Brunswick, part of the Gaspé in Québec, and southern Newfoundland). Making the case for a postcontact origin for the Kwipek petroglyphs I examine the ways in which they not only demonstrate Mi'kmaw spiritual resilience and political resistance to colonial persecution, discrimination, and marginalization, but how they also reveal the Mi'kmaw ontological commitments which guided responses to colonial encounter and conflict.

2 Mi'kmaw rock art in context

The rock art of Mi'kma'ki is part of a wider distribution of pictographs and petroglyphs created by the Algonquian-speaking peoples of central and eastern Canada. Most rock art sites are found in the vast expanse of the Canadian Shield and many traditions are thought to originate anywhere within the past five millennia and in some places continued to be made until the early twentieth century (Dewdney and Kidd 1962; Vastokas and Vastokas 1973; Conway 1992; Rajnovich 1994; Steinbring and Zawadzka 2019). Pictograph sites from the Québec North Shore and southwest Maine have been radiocarbon dated to the Early and Middle Woodland periods, between 3,000 and 1,000 years ago (Arsenault et al. 1995; Lenik 2002, 66), while the extensive petroglyph tradition at Machias Bay in eastern Maine comprises a chronological sequence of styles originating in the Late Archaic period and terminating in the nineteenth century (Hedden 2002, 2004). Algonquian rock art served several different purposes: it was related to the shamanic practices of medicine men; it was created by initiates during rites of passage; it structured ongoing social relations in the landscape; it was used to negotiate group territories; and it helped people navigate the labyrinthine waterways of the boreal forests (Vastokas and Vastokas 1973; Rajnovich 1994; Hedden 2004; Creese 2011; Zawadzka 2013, 2019).

The petroglyph sites known from Mi'kma'ki were made after European contact, with the largest concentrations occurring in Kespukwitk (the Mi'kmaw district encompassing southwest Nova Scotia) at Kejimkujik and McGowan Lakes. There, the petroglyphs narrate a number of socio-economic, religious, and political concerns which chronicle how some Mi'kmaq adapted to the challenges presented and opportunities afforded by a rapidly changing way of life during the eighteenth and nineteenth centuries (Molyneaux 1988, 1989). Like historic period petroglyphs from eastern Maine (Hedden 1989, 2002), much of the rock art from Kespukwitk reflects a concern to communicate oral histories, events, journeys, and experiences, and was used to preserve identities, values, and practices within a colonial setting. Within these graphic traditions, there is also evidence for the persistence of spiritual practices rooted in Algonquian animisms along with indications of the spiritual and religious syncretism characteristic of Algonquian societies that emerged following contact with Europeans and Roman Catholicism (e.g., Molyneaux 1988; Hedden 1989).

The Kwipek site comprises two petroglyphs engraved into the exposed bedrock of a gneissic ridge on the wooded slopes above the head of Asoqmapskiajk. Following their 'discovery' in 1983, the Mi'kmaw origin and significance of the petroglyphs was quickly established (Molyneaux 1990, 1995; Whitehead 1992). Following its designation as a National Historic Site in 1994 the petroglyphs have become spiritually significant for many Mi'kmaq and continue to inspire strong spiritual, political, and social responses; offerings of tobacco, coloured cloth, and other gifts are often made at the site.

The petroglyphs, engraved into a horizontal and slightly domed area of the bedrock, comprise a 'sun' motif and a 'fertility' motif (Figure 18.1). Although the

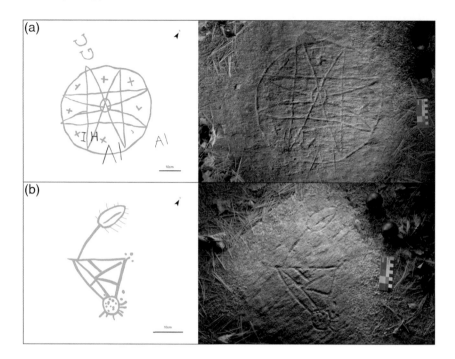

Figure 18.1 The Kwipek petroglyphs: (a) The "sun" motif; (b) The "fertility" motif.

date of the petroglyphs is uncertain, their manufacture technique and close proximity suggest are contemporaneous and related. Molyneaux (1990, 16) concluded that they had been pounded, abraded, gouged, drilled, and chiselled using blunt tools but acknowledged that weathering made it uncertain whether the apparent absence of 'evidence for sharp corners, lines or edges' necessarily precluded the use of a metal tool. Nevertheless, Whitehead (1992, 7) asserted that they had been made using stone tools and were therefore precontact in origin. Molyneaux (1990, 26, 1995, 163) was more circumspect, suggesting a *terminus ante quem* based on two sets of modern initials ('IH' and 'AI') superimposed on part of the 'sun' motif; he speculated that the initials were carved by local residents sometime in the first quarter of the twentieth century.

In recent years, different interpretations have emerged for the petroglyphs. The 'sun' motif has received particular attention and has been interpreted in several ways: for some, it is considered a political symbol uniting the seven traditional districts of Mi'kma'ki with Ktaqmkuk (Newfoundland); for others, it reflects the postcontact political reality connecting the seven districts with either the Roman Catholic Church or the Crowns of colonial regimes (the French until 1713, then the British until 1867). It has also been conceived as the depiction of a sweatlodge marking a place of ritual fasting (see Molyneaux 1995, 162), or to represent *kagwet* (the eight-legged starfish design) common in nineteenth-century Mi'kmaw quillwork (Whitehead 1980, 43). The motif has also been used as a

conceptual model symbolizing the tenets of a proposed Mi'kmaw justice system (Young 2016). Making a comparative analysis with petroglyphs recorded at Kejmikujik Lake and with ideograms found in *komkwejwika'sikl* (Mi'kmaw hieroglyphic writing) led Whitehead (1992) to interpret an animistic origin for the petroglyphs, and specifically, one based in precontact Mi'kmaw shamanic ritual.

Reassessing the chronology of the petroglyphs has significant implications for understanding archaeological and Indigenous narratives associated with this site. This relates to important questions that concern how archaeologists and historians understand the practice and expression of Mi'kmaw spirituality and political identity throughout the historic period, and perhaps more significantly, how Mi'kmaw agency and ontology (*ta'n telikjijitu'n*—'ways of being and knowing') in the postcontact realities of Mi'kma'ki are recognized and accepted.

3 The Kwipek petroglyphs

Recent analyses of the Kwipek site have cast doubt on the precontact origin of the petroglyphs. The results of a moulding exercise undertaken by Parks Canada (Harrington and Heinrichs 1993) and the application of Reflectance Transformation Imaging (Tapper 2017) demonstrate that many of the linear elements comprising both petroglyphs are square-cut with consistent dimensions, and show regular striated indentations in the bases of the grooved channels as if made by a chiselling and gouging action as the tool used was struck along the line. The indentations resemble the cut marks left by a metal tool, such as a flat-headed cold chisel (Figure 18.2). This strongly indicates a postcontact origin. Moreover, the site has yet to produce archaeological evidence of lithic debitage that would be expected to have resulted from the use of lithics to engrave the gneiss (Cottreau-Robins 2015). Perhaps most compelling are a set of serifed initials, 'GC,' engraved close to the 'sun' motif; the lines of these initials morphologically match the dimensions and manufacture technique found in those of the petroglyphs and may be directly related, possibly even belonging to the maker of the petroglyphs.

The 'sun' petroglyph comprises several elements: an eight-pointed 'star' is bound by a large outer circle, a smaller central circle and eight 'cross' motifs placed in the interstices of the points complete the arrangement. Whitehead (1992) suggested that the engraver drew inspiration from specific ideograms found in the system of hieroglyphs developed by the French Recollect priest Chrestien Le Clercq in 1677 which he used to facilitate the teaching of prayer and catechism to Mi'kmaq (Schmidt and Marshall 1995). Later missionaries such as Maillard (who was active among the Mi'kmaq between 1735–1762), Christian Kauder (who was active between 1859–1871), and Father Pacifique (active between 1894–1931) refined the system of hieroglyphs, introduced new signs, and translated more texts. Hieroglyphic writing continued to be regularly used by Mi'kmaq until the middle of the twentieth century (Schmidt 1993). Using a mid-twentieth-century manuscript to obtain English translations of a number of hieroglyphs, Whitehead noted the similarity between the petroglyph's motif attributes and specific ideograms used

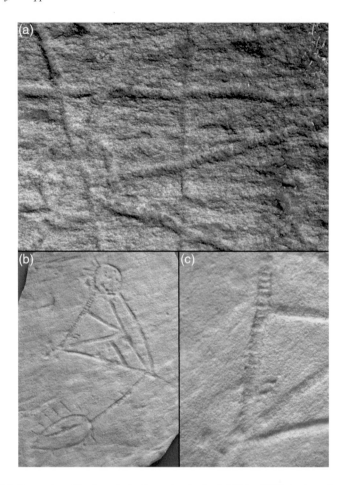

Figure 18.2 Examples of tool marks in the petroglyphs: (a) Using RTI, tool marks can been
 seen in the channelled grooves of the lines forming the "sun" motif; (b) Tool
 marks are clearly visible in the moulding cast of the "fertility" motif produced
 by Parks Canada in the early 1990s; (c) Details of tool marks in the moulding
 cast of the "fertility" motif.

to denote the sun and the stars (please see Figure 18.4). On this basis, she reasoned
that the eight-pointed 'star' within the bounding circle conceptually represents the
sun, while the small crosses represent stars. Specifically, Whitehead proposed that
the petroglyph signifies *Niskam*, the Sun, a powerful Grandfather and the oldest
male ancestor in Mi'kmaw cosmology.

 Whitehead suggested that the ideogram for the sun originated in precontact
Mi'kmaw iconography and that it was co-opted into hieroglyphic writing.
Certainly, Mi'kmaw cosmology, astronomical knowledge, and pictographic
traditions suggest that such iconography could be supported. Throughout the
seventeenth century, French chroniclers remarked how Mi'kmaq 'have the art

both of painting and carving, and make beasts, birds and men in stone and also in wood' (Lescarbot 1907–14[1609], III: 99), and depicted their band symbols (animal totems), as well as other motifs, on their clothing, canoes, and sailing vessels (Le Clercq 1910[1691], 39, 192–193; Lescarbot 1907–14[1609], II: 309). In fact, Le Clercq acknowledged that the system of hieroglyphs was inspired by a pre-existing Mi'kmaw pictographic tradition; he observed children 'making marks with charcoal upon birch-bark,' and perhaps more pertinently, noted how *puoin* (shamans) used pictography as part of their rituals (Le Clercq 1910[1691], 131, 397). Moreover, in the seventeenth and eighteenth centuries, a number of French missionaries noted that the Mi'kmaq venerated the Sun as the creator and giver of life (Biard 1897[1616], 133; Le Clercq 1910[1691], 143–144; Diéreville 1708, 162; Maillard 1758, 22–27). In fact, the importance of sun symbolism was recorded in early European accounts of other Algonquian and Iroquoian groups: in c. 1675 the Jesuit Louis Nicolas sketched sun designs included in the body painting of Anishinaabe (Odawa) people (Figure 18.3a),[2] while in 1750 the Swedish botanist Peter Kalm noted how some Huron wore tattoos incorporating sun, cross, and serpent motifs (Kalm and Benson 1964, 472). Kalm's account and Maillard's (1758, 55–56) description of 'curious devices and flourishes' made by Mi'kmaw women on the skins of their suitors may have inspired a late-eighteenth-century French illustration of a Mi'kmaw hunter bearing just such sun, cross, and serpent tattoos (Figure 18.3b).[3] Such a familiarity with pictography might explain the rapid adoption of hieroglyphs across Mi'kma'ki by the end of the seventeenth century.

However, a review of the limited precontact iconography across the Canadian Maritimes and adjacent areas of Maine and Québec has yet to reveal a motif matching the 'sun' petroglyph found at Kwipek. The motif does not appear in the geometric patterns incised on Late Archaic moose bone and swordfish rostrum daggers or slate bayonets found in Moorehead Phase burials from coastal Maine and southern New Brunswick (Sanger 1973; Byers 1979), nor on Middle Woodland incised siltstone pebbles from southwest New Brunswick (Hammon 1984). Even in the extensive precontact traditions of Machias Bay most imagery is figurative and abstracted rather than geometric (Hedden 2004), while early Middle Woodland pictographs from Nisula on the Québec North Shore comprise mainly linear and hatching elements with some figurative forms (Arsenault et al. 1995).

Yet, the eight-pointed 'sun' motif is commonly found in the quillwork commodity artworks widely produced by Mi'kmaq women for sale to Euro-Canadian markets during the nineteenth century (Whitehead 1980). Quillwork is documented from the seventeenth century onwards (Denys 1908[1672], 448), but craft objects incorporating the eight-pointed 'sun' motif (with all its elements) invariably date to the nineteenth century (Figure 18.4d, f–h). This motif, *kagwet*, was part of a repertoire of designs adopted by Mi'kmaq women; it was often set alongside others such as hearts, six-pointed compass stars, and whirling fylfot crosses found in the nineteenth-century Germanic folk-art of southwest Nova Scotia (Bird and Kobayashi 1981, 48–49). In fact, the

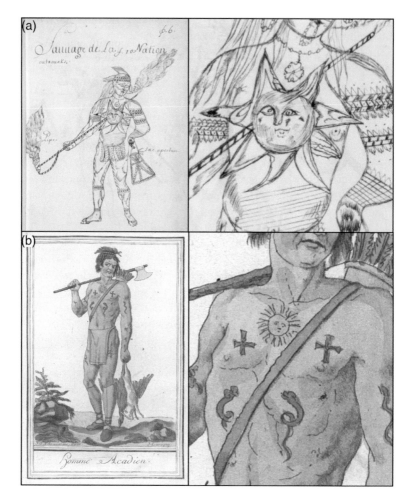

Figure 18.3 European illustrations of seventeenth- and eighteenth-century Algonquian "sun" tattoos: (a) "Sauvage de La Nation Outaouaks" by Louis Nicolas, *Codex Canadensis*, c.1675; (b) "Homme Acadien," 1788–1796.

Source: (a) © Gilcrease Museum, Pl. 6, GM 4726.7; (b) Library and Archives Canada, acc. no. R13133-185.

eight-pointed star element is widely referred to as the 'Le Moyne Star' (or 'Star of Bethlehem' or 'Lemon Star') in North American quilting traditions from the late eighteenth century onwards (Holstein 1973; Figure 18.4c). The design is thought to take its name from the prominent LeMoyne family which was integral to the late-seventeenth- and early eighteenth-century governance of New France (Hall and Kretsinger 1935, 54–55). One of the earliest surviving North American patchwork quilts, dating to 1726, comes from Québec and features an eight-pointed star as its centrepiece (Figure 18.4e).[4] Locally, the

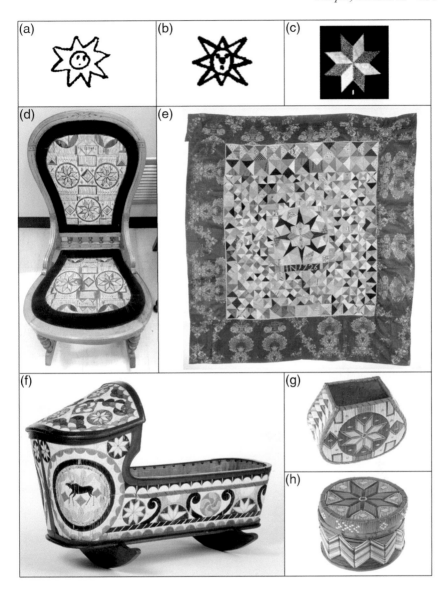

Figure 18.4 (a) Ideogram denoting "sun"; (b) 'Na'ku'set' ideogram denoting "sun"; (c) "Star-of- LeMoyne" quilt pattern; (d) Quillwork chair panels, Mi'kmaq, c.1890; (e) Quilt, Québec, 1726; (f) Cradle, Mi'kmaq, c.1868; (g) Container, Mi'kmaq, 1845; (h) Box, Mi'kmaq, 1865-1900.

Source: (a) E.S. Eaton manuscript, mid-twentieth century. William Dennis Collection, Nova Scotia Museum (after Whitehead 1992, 9); (b) After Schmidt 1993, 5; (c) Extract from Hall and Kretsinger 1935, Plate III, © Image reproduced by permission of The Caxton Printers Ltd., Caldwell, Idaho; (d) Nova Scotia Museum; (e) © McCord Museum, M972.3.1; (f) © DesBrisay Museum collection, Bridgewater, Nova Scotia (acc. 184); (g) © McCord Museum, ME954.5; (h) © McCord Museum, M115.0-1.

eight-pointed star is commonly found in early twentieth-century settler quilting from Kespukwitk (Robson and MacDonald 1995). Technically, there are strong similarities between the design and arrangement of the various elements of the Kwipek 'sun' petroglyph and the *kagwet* motif found in quillwork and the star pattern in quilting. The presence of the eight-pointed star motif in the material culture of early colonial New France suggests that the inspiration for the specific design and form of the 'sun' petroglyph is European in origin and likely based in the Roman Catholic iconography of French settlers. It is relevant that in Christian theology the eight-pointed star has religious and spiritual connotations relating to baptism, rebirth, and regeneration (Stafford 1942, 84).

The 'fertility' petroglyph at Kwipek comprises a circular 'head' that surmounts a triangular 'body' from which a line connects to a 'vulva.' These elements articulate to form an 'anthropomorph and vulva' petroglyph that has been interpreted as a fertility symbol (Whitehead 1992). Lines emanating from the 'head' of the petroglyph can be related to similar forms recorded in rock art traditions across the Canadian Shield (Figure 18.5a) where the 'rayed head' motif represents spiritual power and/or knowledge in the shamanism of Algonquian-speaking peoples. The rays or 'lines of power' of such 'solar figures' show how shamans derived their supernatural potency from the Sun, and they convey the shaman's visionary experience (Vastokas and Vastokas 1973; Conway 1989; Rajnovich 1994). This motif attribute represents the role of the shaman in their capacity as mediator of spiritual communication between powerful other-than-humans and human society.

The 'body' of the anthropomorph is segmented by a number of internal lines. Its geometric form has precursors in the region's precontact rock art traditions. Hour-glass-shaped anthropomorph and triangular-bodied '*Mide* spirit' motifs emerge in

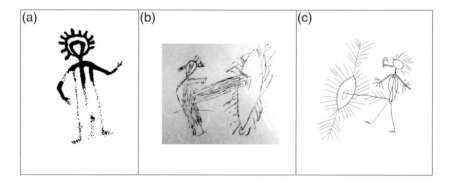

Figure 18.5 Examples of "sun figures" and "copulation motifs" in the rock art of Algonquian-speaking peoples; (a) Shamanic figure, Scotia Lake, northern Ontario; (b) Historic period copulation motif, Kejimkujik Lake, Nova Scotia; (c) historic period symbolic copulation motif, Upper Island Cove, Conception Bay, Newfoundland.

Source: (a) © Thor Conway (Conway 1989, Figure 3); (b) © Nova Scotia Museum, Mi'kmaq Cultural Heritage Collection, Creed Collection: O.2/10.23.327/ 3612/N21-274.

the late Middle Woodland sequence of petroglyphs at Machias Bay. There, internal lines running through the bodies of the anthropomorphs are interpreted as conduits through which spiritual power flows (Hedden 2004). The 'vulva' motif is widespread in North American rock art and often associated with female ancestor beings, such as the Moon and the Earth; it is also commonly interpreted as a 'metaphorical portal [and] a receptacle of spiritual power' (Duncan and Díaz-Granados 2004, 195). In the Middle–Late Woodland period petroglyphs recorded at the Kinoomaagewaabkong/Peterborough site in southern Ontario, anthropomorphs connected to vulvas are considered to represent symbolic copulation related to fertility rituals associated with themes of genesis and renewal (Vastokas and Vastokas 1973, Figure 24, 89). Specifically, such arrangements are thought to reflect shamanic efforts to establish and maintain the respectful and reciprocal relationships necessary between humans and other-than-human powers.

Together, the various elements of the 'fertility' petroglyph demonstrate a stylistic genealogy of considerable antiquity observed in some neighbouring rock art traditions. Regionally, similar concerns may be reflected in precontact petroglyphs of disembodied genitalia from Embden and Grand Lake Stream in eastern Maine (Hedden 1985; Lenik 2002, Figure 45), and in the form of 'copulation' motifs from postcontact sites at Kejimkujik Lake (Molyneaux 1984; Figure 18.5b), and Conception Bay in Newfoundland (Gaulton et al. 2019; Figure 18.5c). The 'fertility' petroglyph can be considered to represent a traditional form of stylistic and conceptual expression corresponding to aspects of Mi'kmaw cosmology which relate to the genesis of people and their kinship with other-than-human ancestors (Whitehead 2006, 9).

4 Juxtaposition of the petroglyphs and the syncretism of Mi'kmaw Catholicism

Whitehead (1992, 12) suggested that together the petroglyphs represent the place where 'the fertile power of the Sun as a luminary disc and as Oldest Male Ancestor was invoked,' and that the juxtaposition of the petroglyphs represents other-than-human *Niskam* in their original form (the 'sun' motif) and in their transformed human form (the 'fertility' motif) as mediated through the body of the shaman. In this way, the petroglyphs formed part of a ritual in which the creation of the images 'was the creation of power' and not simply a representation of that power (Whitehead 1992, 12). This corresponds to the role of rock art in the relational ontologies of Algonquian-speaking peoples in which it can have agency and the ability to effect spiritual and material outcomes in the world (Zawadzka 2019). In this interpretation, the Kwipek petroglyphs were produced to reaffirm medicine power and the ontological commitment of Mi'kmaw to ethics of reciprocity and the maintenance of good relations in the world (Sable and Francis 2012, 24). It accords with the multinaturalism of Mi'kmaw animism and the distribution of spiritual power (Hornborg 2008).

However, the reappraisal of the chronological evidence presented above heeds Molyneaux's (1995, 166) cautionary note to resist framing the petroglyphs 'as a

monument to timeless cultural ideals.' In doing so, archaeological narratives that have perpetuated interpretations of the petroglyphs as representative of pre-contact Mi'kmaw existence—a template of sorts for Mi'kmaw culture unsullied by European contact—can be questioned. Reframing the petroglyphs within a postcontact Mi'kmaw experience unravels Romantic notions that fossilize, however inadvertently, Mi'kmaw culture and which negate the agency of the creator(s) of the rock art in the construction of contact and colonial period realities. It allows the space for the petroglyphs to contribute to discussions relating to the nature of ontological encounters and conflicts in the past as well as the present (Blaser 2013). Stylistically, the two petroglyphs would appear to have their origins in different cultures, yet beyond their iconographic genealogies, their juxtaposition and reconfiguration together reveals how these motifs reflect the Mi'kmaw ontological negotiation of the impact of colonization and Catholicism in Mi'kmaw cosmology. In order to unpack this significance, it is the presence of the 'sun' motif in Mi'kmaw hieroglyphs—purposefully designed for religious instruction—that requires further scrutiny as to why and how the motif may have been so readily adopted and widely replicated in Mi'kmaw material culture.

Culture contact had ideational ramifications for both Mi'kmaq and Europeans. Examination of Indigenous responses to European trade goods has revealed the symbolically charged aesthetic and ideological values Algonquian groups invested in the properties of certain material substances, objects, and symbols (Miller and Hamell 1986). Certain European goods 'became identified within the established spectrum of indigenous valuables' (Phillips 2015, 174). For example, during the early contact period European copper kettles were highly prized by the Mi'kmaq. Their popularity stemmed from pre-existing Mi'kmaw values associated with the materiality and agency of copper objects and, as such, kettles were incorporated into Mi'kmaw relational ontology (Howey 2018). Colour was a particularly salient structuring agent, and objects endowed with luminous, brilliant, reflective, translucent, and light-coloured properties were especially valued by Algonquian and Iroquoian groups for their metaphorical connotations to positive cognitive and animate states, spiritual knowledge, and supernatural power (Phillips 2015, 188; Sable and Francis 2012, 33; Zawadzka 2011). Reinforcing this association, East, the cardinal direction most closely associated with the regenerative power of the Sun, is associated with the colours white, yellow, or red (Zawadzka 2011, 12). It is in this context, that the importance of sun imagery can be understood; it carried powerful cosmological and metaphorical meanings associated with the 'animating power of the sun as the supreme upper-world spiritual being' (Phillips 2015, 190). In Christian traditions, sun iconography has similarly positive connotations with divinity (Whone 1990, 179–180). In this sense, Christian insignia, regalia, paraphernalia, and material culture exhibiting sun imagery would have resonated with Algonquian groups and in this way the Mi'kmaw adoption of the specific eight-pointed 'star' motif can be seen to have been congruent with existing conceptions and usages of sun imagery.

However, exploiting this convergence, missionaries sought to first correlate and then overwrite Indigenous significations with Christian ones, and this transition can be observed in Mi'kmaw hieroglyphs. In the process of co-opting existing Mi'kmaw pictography, missionaries reconfigured meanings associated with certain significations that were deemed incompatible with Catholic doctrine. For example, certain other-than-humans in Mi'kmaw cosmology were replaced in the hieroglyphs by Christian 'equivalents' or stripped of their traditional 'power' altogether. The separate entities *Kisu'lkw* (the Creator) and *Niskam* (meaning 'Grandfather Sun' and derived from an honorific term for other-than-human *Na'ku'set*—the sun or literally 'the day shiner') were conflated by missionaries to become the abstract Christian concept of a masculine 'God' (Schmidt 1993, 4; Sable and Francis 2012, 30–31). In the hieroglyphic systems recorded from Maillard onwards, the ideogram for 'God' is termed *Niskam* and denoted by an equilateral triangle symbolizing the Trinity (Schmidt 1993, 4; Déléage 2013, 14). Moreover, a 'sun' ideogram (an eight-pointed 'star' motif) found in the hieroglyphs is termed '*Na'ku'set*' but has been stripped of its spiritual and honorific associations; essentially, it is reduced to an iconic and non-sacred representation of the solar object (Schmidt 1993, 5; Figure 18.4b). This suggests that, according to Catholic missionaries, the 'sun' ideogram was not intended to be considered a referential for a deity (i.e., *Niskam*/Grandfather Sun). However, Whitehead's identification of the 'sun' ideogram with the person of *Niskam* would require that, despite missionary attempts, the ideogram retained its animistic associations in postcontact Mi'kmaw religious life; the small faces (with eyes, noses, and mouths) contained within these ideograms may speak to this remembered personhood. In turn, this implies some form of resistance on the part of the Mi'kmaw maker of the 'sun' petroglyph. So, while Whitehead identifies a connection between the 'sun' ideogram and *Niskam*, it is evident that by the mid-eighteenth-century Catholic missionaries had in fact attempted to separate that connection; presumably as part of an ongoing effort to both suppress traditional Mi'kmaw cosmology and consolidate Catholic doctrine. Evidently, such attempts were unsuccessful as the survival of other animist concepts, such as *manitou*, into the seventeenth and eighteenth centuries and later demonstrate (Maillard 1758, 38; Denys 1908[1672], 117).

The adoption of hieroglyphs was intended not only to facilitate conversion, but also to undermine the authority of *puoin* who missionaries sought to replace as spiritual mediators. By promoting hieroglyphic literacy, missionaries endowed individuals with the ability to wield spiritual power which had previously been the preserve of the shamans. The presence of hieroglyph ideograms in Mi'kmaw rock art and material culture dating to the eighteenth and nineteenth centuries serves to illustrate this point. It is evident that the system of hieroglyphs was principally a form of 'attached writing' embedded in Catholic instruction (Déléage 2013), but their enduring importance also reflects the success with which Catholic missionaries were able to appropriate 'Mi'kmaw beliefs and rhetorical models' which were then directly associated with hieroglyphs (Schmidt 1993, 3). In fact, for many Mi'kmaq the hieroglyphs were themselves regarded as

sacred texts, and following the French loss of Acadia (1758) and Maillard's death (1762), the use of hieroglyphs became an important way for Mi'kmaq to preserve their Catholic faith and assert political independence in resistance to Protestant British colonial rule (Schmidt and Marshall 1995, 13). During the British regime, French priests were banned from missionizing to the Mi'kmaq and consequently Mi'kmaw *nujialasutma'tijk* (prayer leaders) assumed the role of instruction, copying texts and spreading knowledge and literacy of the hieroglyphs well into the twentieth century (Schmidt and Marshall 1995, 10–11). Reflecting this wide-spread literacy, ideograms specifically relating to piety, were carved into rocky surfaces and prominent boulders at several locales across Kespukwitk (Mallery 1894, Figure 551; Molyneaux 1984), and formed part of the designs found on diplomatic medals awarded to Mi'kmaw chiefs by French colonial authorities seeking to consolidate political alliance (Krieger 2002). Ironically, Mi'kmaw hieroglyphic literacy may have had a role in the 'democratization of shamanism' by enabling the space for Mi'kmaw Catholicism to retain elements of customary practices rooted in animism (Schmidt 1993, 5). The hiatus in Catholic missionary activity, during which *nujialasutma'tijk* were active, afforded Mi'kmaq the space to retain their particular syncretic form of Catholicism in the absence of further missionary attempts to consolidate conversion. In fact, this was not unusual and among the neighbouring Peskotomuhkati of eastern Maine, Hedden (2002: 239) identified a contemporaneous 'partial revival of shamanic healers and spirit protectors following the Jesuit hiatus' in late-eighteenth- and early-nineteenth-century petroglyphs.

In this context, it is conceivable that the convergence between Christian and Algonquian conceptions of sun imagery may have been more syncretistic than early missionaries realized or acknowledged. It is widely accepted that many aspects of Algonquian animisms persisted in the Canadian Maritimes following the arrival of Roman Catholicism with sustained European contact in the early seventeenth century (Chute 1992; Walker 2000; Krieger 2002; Hornborg 2006; Bilodeau 2013). However, early missionary work among the Mi'kmaq was sporadic until the second decade of the eighteenth century (Wicken 1994, 355). In this context, the Mi'kmaw Catholicism that developed reflected the preparedness of both Mi'kmaq and the Church to negotiate shared material and conceptual analogues. A desire to secure French political and economic cooperation prompted some early Mi'kmaw 'conversions' in which rites such as baptism were regarded as a form of 'alliance ritual' (Prins 1996, 80–82). Throughout New France, missionaries quickly understood that to gain purchase in their conversion efforts required inculturation before Christian teachings and practices could be fully imposed. On the other hand, Indigenous peoples selected those aspects of Christianity which converged with their ontological commitments while retaining other forms of shamanistic ritual (Morissette 2012, 326–327). In fact, some scholars have suggested that the Mi'kmaq divided their religious practices between public (Catholic) and private (animist) spheres (Wicken 1994, 355–357). Others have noted how Mi'kmaw religious practices continue to reflect a com-bination of Christian and non-Christian Indigenous influences (Robinson 2002).

In these ways, although Algonquian peoples adopted certain Christian rituals they often declined other aspects of doctrine and European morality (Pomedli 1989; Bilodeau 2013). As such, the adoption of certain Catholic practices and paraphernalia can be considered to stem from Algonquian conceptualizations of the efficacy of such things to make real changes to the condition of peoples' lives in the same way that traditional shamanistic rituals were expected to do. Undoubtedly, Roman Catholic sacramentalism profoundly influenced the perceived efficacy of the new religion and sacramentals were often used to augment existing spiritual practices (Wicken 1994, 356; Bousquet 2008; Bilodeau 2013). But, in effect, the efficacy of some Catholic practices may have been separated from certain theological positions (Bousquet 2008, 64).

Hieroglyphic writing reflected the negotiated and contested nature of Mi'kmaw Catholicism. While it was intended to restructure and reorientate Mi'kmaw spiritual beliefs it came to represent Mi'kmaw cultural, religious and political independence. By the mid-nineteenth century, when Kauder returned to the vacuum left by Maillard almost a century earlier, Mi'kmaw Catholicism had tradition and it was undoubtedly more relatable than the austere character of Protestantism that arrived with British colonial rule (Abler 1992, 33). Indeed, the British approach, predicated on the alienation of the Mi'kmaq, served only to reinforce the latter's resolve to maintain existing practices, customs and beliefs (Reid 1995). This included the tradition of hieroglyphic writing which had by that time been passed down through Mi'kmaw generations for over 150 years (Déléage 2013, 18). In fact, the Protestant clergyman Silas T. Rand recalled the difficulty he experienced in trying to convert Mi'kmaq, but also noted that during their celebrations of St. Anne, 'the mystic dances ofthe ancient Indians are not wholly omitted' (Rand 1894, xxxi). Furthermore, although the figure of the *puoin* was much diminished by the late-nineteenth century and increasingly associated with negative qualities, belief in their supernatural powers persisted (Erickson 1978). Archaeologically, the petroglyphs of Kejimkujik and McGowan Lakes provide some of the most tangible evidence of syncretism in Mi'kmaw Catholicism in the eighteenth and nineteenth centuries (Molyneaux 1988, 1989), while petroglyphs thought to reflect the survival of shamanism among the Peskotomuhkati in Maine demonstrates that this was not uncommon (Hedden 1989; Smith and Walker 1997).

The form of postcontact Mi'kmaw Catholicism provides the context in which the Kwipek petroglyphs can be framed. In fact, such a setting can still support the shamanic purpose proposed by Whitehead. To pursue her analysis further then, the juxtaposition of the petroglyphs reflects the resilience of a distinctly postcontact Mi'kmaw religious identity in which shamanistic practices grounded in Mi'kmaw relational ontology dictated the negotiation of the adoption of Roman Catholicism. In this, the 'sun' petroglyph can be understood to be an additive element to the traditionally powerful and semiotically complete 'fertility' motif. However, rather than being a duplicate and thus redundant signification, the 'sun' petroglyph alludes to an unfolding and emergent Mi'kmaw spiritual reality augmented with aspects of Roman Catholicism. Together, the

petroglyphs record the impact of Roman Catholicism on Mi'kmaw ontological commitments, and the ways in which relationships with powerful other-than-human beings were reconfigured (see Hornborg 2006, 314). Both petroglyphs comprise powerful 'solar' motif attributes which allude to themes of regeneration and renewal, one based in Algonquian cosmology and the other in Christian theology, but which may be seen to compliment (and challenge) one another, offering a visual and conceptual convergence (and divergence) of the other which acknowledges the relationality of postcontact Mi'kmaw spiritual realities. Recognition of the petroglyphs as the expression of postcontact Mi'kmaw spiritual practice does several things: (1) it dismantles notions which stereotype and 'other' Mi'kmaw agency in some form of primitivism, (2) it reveals the syncretic form of Mi'kmaw spiritual practices that emerged following contact but which were predicated on Mi'kmaw modes of relating (*ta'n telikjijitu'n*), and (3) in the context of ongoing efforts to decolonize the academy it compels archaeologists to critically examine the ways in which their own narratives attempt to shape and cut up reality differently.

5 Concluding thoughts: Marginal landscapes and Mi'kmaw resistance

Until the mid-eighteenth century, before the Euro-Canadian settlement of Bedford grew up around Fort Sackville (erected by the British in 1749), Mi'kmaq occupied summer campsites on the western shores of Asoqmapskiajk, one of which was located at the mouth of the Sackville River about half a kilometer east of the petroglyph site (Tolson 1979, 17). The site's location on the periphery of the modern town of Bedford is testament to the geographic marginalization of Mi'kmaq that became particularly pronounced following British colonial rule. Like other historic period petroglyph sites in Mi'kma'ki, Kwipek does not follow the typical geographic distributions observed in the Algonquian rock art traditions of the Canadian Shield or Machias Bay, that is, on the waterways travelled through the landscape and/or those liminal places suffused with spiritual potency, which attracted the creation of rock art (Creese 2011; Zawadzka 2019). Rather, sites such as Kwipek are found in places of exclusion where Mi'kmaq settled and traded during the colonial period; peripheral places, but with access to emerging Euro-Canadian settlements, transport routes, industries, and markets. In fact, Mi'kmaq were known to have been living in the vicinity of the Kwipek petroglyphs during the late-nineteenth century, and the inscription of a Mi'kmaw person's name (dated to 1908) not far from the site indicates a presence in the early twentieth century (Molyneaux 1995, 165). According to some contemporary Mi'kmaq, the petroglyphs may have been associated with the creation of new cultural landscapes following the marginalization of earlier Mi'kmaq from their traditional sites around Asoqmapskiajk (Roger Lewis, Curator of Mi'kmaw Cultural Heritage—Nova Scotia Museum, personal communication, 2019). If this is an engraving of cultural landscape renewal, reaffirming the Mi'kmaw concept of *weji-sqalia'timk* (expressing the roots

of Mi'kmaq in the landscape; Sable and Francis 2012, 17), can it also be seen as one of protest against the annexation of their homeland?

The various lines of evidence—manufacture technique, stylistic parallels in folk art and commodity artwork traditions, iconographic correlates in the hieroglyphs, the mid-eighteenth- to mid-nineteenth-century missionary hiatus, and the marginal geographic placement—suggest that the Kwipek petroglyphs were carved sometime between the mid-eighteenth century and the first quarter of the twentieth century. It is also apparent that Mi'kmaq, along with neighbouring Algonquian groups, weaved elements of Roman Catholicism into their existing ontological commitments. The survival of Mi'kmaw language reinforces this position; even after 400 years of European colonialism the language retains its central role as the vehicle of knowledge transfer. As a verb-based language, it retains Mi'kmaw ontological commitments to processes, flux, and connectedness, rather than the emphasis on objectivity, linearity and binary oppositions characteristic of modern Western ontology; in doing so, even borrowed European nouns are situated within this Mi'kmaw relational ontology (Inglis 2004, 394; Sable and Francis 2012, 30).

The Kwipek petroglyphs can be seen to be an expression of the 'reverse gaze,' in which Mi'kmaq articulated their cultural memory through visual and material expressions. In the context of colonial power relations, the use of the 'sun' motif in Mi'kmaw hieroglyphs, quillwork, and other media was a manifestation of Mi'kmaw identity operating 'beneath the surface of discourse' (Phillips 2015, 195). In the context of colonial encounter, in which any form of cultural equivalency or equity was not only rejected, but suppressed, the petroglyphs express a form of Mi'kmaq resilience and passive resistance to the cultural, social, political, and economic marginalization they experienced (Reid 1995, 103).

Just a few years after their 'discovery,' Molyneaux (1995, 165) noted that the petroglyphs had become 'instruments in the broader struggle for control of individual and social rights.' In this way, the Kwipek petroglyphs have moved on from the original intentions of their creators to be reconfigured, and cared for by subsequent generations. The site has accumulated further relevance and meaning in response to changing sociocultural and cross-cultural interactions. Today, the 'sun' motif is a widely used symbol of Mi'kmaw identity. In this sense, part of the importance and relevance of the petroglyphs lies in their ongoing use and care, and the ways in which they continue to incite ontological encounters and foster networks of relations (Norder 2012; Blaser 2013). In addition to conveying a Mi'kmaw reality of cross-cultural contact, the Kwipek petroglyphs continue to reflect the ongoing co-emergent realities of Mi'kmaq and non-Mi'kmaq alike.

Notes

1 I am grateful to Peter Mas'l Marshall, Thomas Christmas, Kenny Prosper, and members of the Mainland Mi'kmaq Grand Council for help with Mi'kmaw language concepts and terminology. I also thank Roger J. Lewis, Rob Ferguson, Chelsee Arbour, and Brian Molyneaux for comments on an earlier version of this chapter.

2 'Sauvage de La Nation Outaouaks' by Louis Nicolas. Late 1600s–early 1700s. *Codex Canadensis*, Pl. 6, GM 4726.7, Archives of Gilcrease Museum, Tulsa, Oklahoma. Accessed November 19, 2019. https://collections.gilcrease.org/object/47267
3 'Homme Acadien,' 1788–1796. Library and Archives Canada, acc. no. R13133-185.
4 M972.3.1, Quilt. McCord Museum. Accessed November 19, 2019. http://collections.musee-mccord.qc.ca/en/collection/artifacts/M972.3.1

References cited

Abler, Thomas S. 1992. "Protestant missionaries and native culture: Parallel careers of Asher Wright and Silas T. Rand." *American Indian Quarterly 16* (1): 25–37.

Arsenault, Daniel, Louis Gagnon, Charles Martijn, and Alan Watchman. 1995. "Le projet Nisula: Recherche pluridisciplinaire autour d'un site à pictogrammes (DeEh-1) en Haute-Côte-Nord." In *Archéologies québécoises*, edited by Anne-Marie Balac, Claude Chapdelaine, Norman Clermont, and Françoise Duguay, 17–57. Montreal: Recherches Amérindiennes au Québec.

Biard, Pierre. 1897 [1616]. "Relation of New France of its lands, nature of the country and of its inhabitants." In *Jesuit Relations and Allied Documents, Vol. III, Acadia 1611–1616*, edited by Reuben G. Thwaites. Cleveland: Burrows Brothers Company.

Bilodeau, Christopher J. 2013. "Understanding ritual in colonial Wabanakia." *French Colonial History 14*: 1–31.

Bird, Michael, and Terry Kobayashi. 1981. *A Splendid Harvest: Germanic Folk and Decorative Arts in Canada*. Toronto: Van Norstrand Reinhold Ltd.

Blaser, Mario. 2013. "Ontological conflicts and the stories of peoples in spite of Europe." *Current Anthropology 54* (5): 547–568.

Bousquet, Marie-Pierre. 2008. "A question of emotions and a matter of respect: Interpreting conversion to Catholicism among Quebec Algonquins." *Papers of the 39th Algonquian Conference, 2007*, 52–71. London: University of Western Ontario.

Byers, Douglas. 1979. *The Niven Shell Heap: Burials and Observations*. Andover: Phillips Academy, Robert S. Peabody Foundation for Archaeology.

Carroll, Beau D., Alan Cressler, Tom Belt, Julie Reed, and Jan F. Simek. 2019. "Talking stones: Cherokee syllabary in Manitou Cave, Alabama." *Antiquity 93* (368): 519–536.

Chute, Janet E. 1992. "Ceremony, social revitalization and change: Micmac leadership and the annual festival of St. Anne." *Papers of the 23rd Algonquian Conference, 1991*, 45–61. Ottawa: Carleton University.

Conway, Thor. 1989. "Scotia Lake pictograph site: Shamanic rock art in north-eastern Ontario." *Man in the Northeast 37*: 1–24.

Conway, Thor. 1992. "Ojibwa oral history relating to nineteenth century rock art." *American Indian Rock Art 15*: 11–26.

Cottreau-Robins, Katie. 2015. "Bedford Barrens petroglyph site (BeCw-2) trail monitoring project: HRP A2014NS073, Bedford, HRM." Unpublished report. Halifax: Nova Scotia Museum.

Creese, John L. 2011. "Algonquian rock art and the landscape of power." *Journal of Social Archaeology 11* (1): 3–20.

Déléage, Pierre. 2013. "L'écriture attachée des Mi'kmaq, 1677–1912." *Acadiensis 42* (1): 3–36.

Denys, Nicolas. 1908 [1672]. *The Description and Natural History of the Coasts of North America (Acadia [1672])*. Toronto: The Champlain Society.

Dewdney, Selwyn, and Kenneth E. Kidd. 1962. *Indian Rock Paintings of the Great Lakes*. Toronto: University of Toronto Press.

Diéreville, Nicolas. 1708. *Relation du voyage du Port Royal de l'Acadie ou de la Nouvelle France.* Rouen: Chez Jean-Bapstiste Besongne.

Duncan, James R., and Carol Díaz-Granados. 2004. "Empowering the SECC: The 'old Woman' and oral tradition." In *The Rock-Art of Eastern North America: Capturing Images and Insight*, edited by Carol Díaz-Granados and James R. Duncan, 190–218. Tuscaloosa: University of Alabama Press.

Erickson, Vincent O. 1978. "The Micmac buoin, three centuries of cultural and semantic change." *Man in the Northeast 15–16*: 3–41.

Gaulton, Barry, Bryn Tapper, Duncan Williams, and Donna Teasdale. 2019. "The Upper Island Cove petroglyphs: An Algonquian enigma." *Canadian Journal of Archaeology 43* (2): 123–161.

Hall, Carrie A., and Rose G. Kretsinger. 1935. *The Romance of the Patchwork Quilt in America.* New York: Bonanza Books.

Hammon, D.J. 1984. "A ceramic period coastal adaptation in Holt's Point, New Brunswick." MA thesis, University of New Brunswick.

Harrington, M., and P. Heinrichs. 1993. "Presentation of Kejimkujik moulding project." Ottawa Regional Group, IIC-CG, 24 March. Unpublished report. Canadian Conservation Institute and Canadian Parks Service.

Hedden, Mark. 1985. "Sexuality in Maine petroglyphs." *Maine Archaeological Society Inc. Bulletin 25* (1): 3–9.

Hedden, Mark. 1989. "Petroglyph evidence for a possible nineteenth century survival of Algonkian (Passamaquoddy) shamanism in Eastern Maine." *Maine Archaeological Society Inc. Bulletin 29* (1): 21–28.

Hedden, Mark. 2002. "Contact period petroglyphs in Machias Bay, Maine." *Archaeology of Eastern North America 30*: 1–20.

Hedden, Mark. 2004. "Passamaquoddy shamanism and rock-art in Machias Bay, Maine." In *The Rock-art of Eastern North America: Capturing Images and Insight*, edited by Carol Díaz-Granados and James R. Duncan, 319–343. Tuscaloosa: University of Alabama Press.

Holstein, Jonathan. 1973. *The Pieced Quilt: A North American Design Tradition.* Toronto: McClelland and Stewart Ltd.

Hornborg, Anne-Christine. 2006. "Visiting the six worlds: Shamanistic journeys in Canadian Mi'kmaq cosmology." *The Journal of American Folklore 119* (473): 312–336.

Hornborg, Anne-Christine. 2008. *Mi'kmaq Landscapes: From Animism to Sacred Ecology.* Aldershot: Ashgate Publishing Ltd.

Howey, Meghan C.L. 2018. "Dead kettles and Indigenous afterworlds in early colonial encounters in the Maritimes." In *Relational Identities and Other-Than-Human Agency in Archaeology*, edited by Eleanor Harrison-Buck and Julia A. Hendon, 51–71. Boulder: University Press of Colorado.

Inglis, Stephanie. 2004. "400 years of linguistic contact between the Mi'kmaq and the English and the interchange of two worldviews." *The Canadian Journal of Native Studies 24* (2): 389–402.

Kalm, Peter, and Adolph B. Benson. 1964. *The America of 1750: Peter Kalm's Travels in North America.* New York: Dover Publications.

Klassen, Michael A. 1998. "Icon and narrative in transition: Contact-period rock-art at Writing-On-Stone, southern Alberta, Canada." In *The Archaeology of Rock-Art*, edited by Christopher Chippindale and Paul Taçon, 42–72. Cambridge: Cambridge University Press.

Krieger, Carlo J. 2002. "Culture change in the making: Some examples of how a Catholic missionary changed Micmac religion." *American Studies International 40* (2): 37–56.

Le Clercq, Chrestien. 1910 [1691]. *New Relation of Gaspesia: With the Customs and Religion of the Gaspesian Indians*. Toronto: The Champlain Society.

Lenik, Edward J. 2002. *Picture Rocks: American Indian Rock Art in the Northeast Woodlands*. Hanover: University Press of New England.

Lescarbot, Marc. 1907–1914 [1609]. *The History of New France* (3 vols). Toronto: The Champlain Society.

Maillard, Pierre A.S. 1758. *An Account of the Customs and Manners of the Micmakis and Maricheets Savage Nations*. London: Hooper and Morley.

Mallery, Garrick. 1894. *Picture-writing of the American Indians, Extract From the Tenth Annual Report of the Bureau of Ethnology (1894)*. Washington, DC: Government Printing Office.

May, Sally K., Paul S.C. Taçon, Daryl Wesley, and Meg Travers. 2010. "Painting history: Indigenous observations and depictions of the 'other' in northwestern Arnhem Land, Australia." *Australian Archaeology 71*: 57–65.

McNiven, Ian, and Lynette Russell. 2002. "Ritual response: Place marking and the colonial frontier in Australia." In *Inscribed Landscapes: Marking and Making Place*, edited by Bruno David and Meredith Wilson, 27–41. Honolulu: University of Hawai'i Press.

Miller, Christopher L., and George R. Hamell. 1986. "A new perspective on Indian-White contact: Cultural symbols and colonial trade." *Journal of American History 73* (2): 311–328.

Molyneaux, Brian L. 1984. *An Analysis and Interpretation of the Micmac Petroglyphs of Kejimkujik National Park* (3 vols). Nova Scotia: Parks Canada.

Molyneaux, Brian L. 1988. "Images de la mer dans l'art rupestre des Micmacs." In *Les Micmacs et la mer*, edited by Charles Martijn, 49–64. Montreal: Recherches Amérindiennes au Québec.

Molyneaux, Brian L. 1989. "Concepts of humans and animals in post-contact Micmac rock art." In *Animals into Art*, edited by Howard Morphy, 193–214. Boston: Unwin Hyman.

Molyneaux, Brian L. 1990. *The Bedford Barrens Petroglyph Survey Project*. Toronto: Royal Ontario Museum.

Molyneaux, Brian L. 1995. "Representation and valuation in Micmac prehistory: The petroglyphs of Bedford, Nova Scotia." In *The Labyrinth of Memory: Ethnographic Journeys*, edited by Maria C. Teski and Jacob J. Climo, 159–171. Westport: Bergin & Garvey.

Morissette, Anny. 2012. "Does the integration of Algonquian rituals in Catholic churches imply a move towards decolonization?" *Papers of the 40th Algonquian Conference, 2012*, 326–345. Albany: SUNY University Press.

Norder, John. 2012. "The creation and endurance of memory and place among First Nations of Northwestern Ontario, Canada." *International Journal of Historical Archaeology 16* (2): 385–400.

Ouzman, Sven. 2003. "Indigenous images of a colonial exotic: Imaginings from Bushman southern Africa." *Before Farming 1* (6): 1–22.

Paterson, Alistair. 2012. "Rock art as historical sources in colonial contexts." In *Decolonizing Indigenous Histories: Exploring Prehistoric/Colonial Transitions in Archaeology*, edited by Maxine Oland, Siobhan M. Hart, and Liam Frink, 66–85. Tucson: University of Arizona Press.

Phillips, Ruth B. 2015. "'Dispel all darkness': Material translations and cross-cultural communication in seventeenth-century North America." *Art in Translation 2* (2): 171–200.

Pomedli, Michael M. 1989. "Transcending European presuppositions: Early native approaches to morality." *Actes du 20e Congrès des Algonquinistes, 1988*, 292–300. Ottawa: Carleton University.

Prins, Harald E.L. 1996. *The Mi'kmaq: Resistance, Accommodation, and Cultural Survival*. Fort Worth: Harcourt Brace.

Rajnovich, Grace. 1994. *Reading Rock Art: Interpreting the Indian Rock Paintings of the Canadian Shield*. Toronto: Natural Heritage/Natural History Inc.

Rand, Silas T. 1894. *Legends of the Micmacs*. New York: Longmans, Green & Co.

Recalde, Andrea, and C. González Navarro. 2014. "Colonial rock art: A reflection on resistance and cultural change (16th and 17th century-Córdoba, Argentina)." *Journal of Social Archaeology 15* (1): 45–66.

Reid, Jennifer. 1995. *Myth, Symbol, and Colonial Encounter: British and Mi'kmaq in Acadia, 1700–1867*. Ottawa: University of Ottawa Press.

Robinson, Angela. 2002. "'Ta'n Teli-Ktlamsitasimk (ways of believing)': Mi'kmaw religion in Eskasoni, Nova Scotia." PhD diss., McMaster University.

Robson, Scott, and Sharon MacDonald. 1995. *Old Nova Scotian Quilts*. Halifax: Nova Scotia Museum/Nimbus Publishing Limited.

Sable, Trudy, and Bernie Francis. 2012. *The Language of this Land, Mi'kma'ki*. Sydney: Cape Breton University Press.

Sanger, David. 1973. *Cow Point: An Archaic Cemetery in New Brunswick*. Archaeological Survey of Canada Mercury Series 12. Ottawa: National Museum of Man.

Schmidt, David L. 1993. "Écriture sacrée en Nouvelle-France: Les hiéroglyphes micmacs et transformations cosmologiques, 1677–1762." *Amerindia 19–20*: 377–382.

Schmidt, David L., and Murdena Marshall. 1995. *Mi'kmaq Hieroglyphic Prayers: Readings in North America's First Indigenous Script*. Halifax: Nimbus Publshing.

Smith, Nicholas N., and Willard Walker. 1997. "The changing role of shamans and their magic in the validation and maintenance of Wabanaki culture." *Papers of the 28th Algonquian Conference, 1996*, 365–371. Winnipeg: University of Manitoba.

Stafford, Thomas A. 1942. *Christian Symbolism in the Evangelical Churches with Definitions of Church Terms and Usage*. New York: Abingdon Press.

Steinbring, Jack, and Dagmara Zawadzka. 2019. "The Wakimika Lake petroglyph site in Northeastern Ontario." *Canadian Journal of Archaeology 43*: 74–93.

Tapper, Bryn. 2017. "Preliminary Fieldwork Report: Petroglyph Survey, Nova Scotia, 2016." Unpublished report (HRP A2017NS085) submitted to the Nova Scotia Museum of Natural History, Department of Communities, Culture & Heritage, Government of Nova Scotia, Halifax.

Taçon, Paul S. C., June Ross, Alistair Paterson, and Sally K. May. 2012. "Picturing change and changing pictures: Contact period rock art of Australia." In *A Companion to Rock Art*, edited by Jo McDonald and Peter Veth, 420–436. Somerset: Blackwell Publishing Ltd.

Tolson, Elsie C. 1979. *The Captain, the Colonel and Me (Bedford, N.S. since 1503)*. Sackville: Tribune Press.

Vastokas, Joan M., and Romas K. Vastokas. 1973. *Sacred Art of the Algonkians: A Study of the Peterborough Petroglyphs*. Peterborough: Mansard Press.

Walker, Willard. 2000. "The Passamaquoddies and their priests." *Papers of the 31st Algonquian Conference, 1999*, 420–427. Winnipeg: University of Manitoba.

Whitehead, Ruth H. 1980. *Elitekey: Micmac Material Culture from 1600 A.D. to the Present*. Halifax: Nova Scotia Museum.

Whitehead, Ruth H. 1992. "A new Micmac petroglyph site." *The Occasional 13* (1): 7–12.

Whitehead, Ruth H. 2006. *Stories from the Six Worlds: Micmac Legends.* Halifax: Nimbus Publishing Ltd.

Whone, Herbert. 1990. *Church, Monastery, Cathedral: An Illustrated Guide to Christian Symbolism.* Shaftesbury: Element Books.

Wicken, William C. 1994. "Encounters with tall sails and tall tales: Mi'kmaq society, 1500–1760." PhD diss., McGill University.

Young, Tuma. 2016. "L'nuwita'simk: A foundational worldview for a L'nuwey justice system." *Indigenous Law Journal 13* (1): 75–102.

Zawadzka, Dagmara. 2011. "Spectacles to behold: Colours in Algonquin landscapes." *Totem: The University of Western Ontario Journal of Anthropology 19* (1): Article 2.

Zawadzka, Dagmara. 2013. "Beyond the sacred: Temagami area rock art and Indigenous routes." *Ontario Archaeology 93*: 159–199.

Zawadzka, Dagmara. 2019. "Rock art and animism in the Canadian Shield." *Time and Mind 12* (2): 79–94.

19 Indigenous ontologies and the contact rock art of far west Texas

Jamie Hampson[1]

1 Introduction

One way of examining the relationships between ontologies, images, and Indigenous knowledge is to consider the concept of 'contact' rock art. But what do we mean by this? The phrase often appears in the literature of global rock art research as an unquestioned given, implicitly defined as apparently simple images of European settlers and their accoutrements (e.g., Bahn 1998; Chaloupka 1998). More recently, and more helpfully, Goldhahn and May (2019, 7) have suggested that contact rock art—or 'the visual testimonies of asymmetrical worldly encounters between colonialists and Indigenous … cultures around the world'—is an invaluable source 'for studying how the "Others" perceive cross-cultural interactions' (see also Taçon et al. 2012; Frieman and May 2020).

Focusing on specific motifs that occur at three rock art sites west of the Pecos River in Texas (Figure 19.1), however, affords us a new way of interrogating interactions between Indigenous and non-Indigenous groups in the Trans-Pecos region before, at, and after the European invasions of the 1500s. As with many so-called frontier societies worldwide, numerous groups lived here: Indigenous, and for the most part unknown and unnamed, hunter-gatherers; Jornada Mogollon, Jumano, and Athapaskan groups; and European–American colonists (Mallouf 1985; Cloud 2004; Hampson 2016a). That the physical and ontological interactions between them—and results of these interactions, including the production and consumption of rock art—were both complex and nuanced should come as no surprise.

The 'cultural-historical' framework imposed on the Texas Trans-Pecos has remained essentially intact since the 1930s (cf. Mallouf 1985; Cloud 2004; Hampson 2013). Partly because of the paucity of data, the generally accepted time-space 'grid' in west Texas remains environmentally driven—to the extent that cognitive archaeological approaches to the cultural material there have been marginalized or ignored. As a rock art researcher, it is important however to consider this ecologically determined framework, not least because rock art discoveries and analyses are (unhelpfully) supposed to 'fit' or 'confirm' the stratigraphic archaeological work that led to the grid's formulation. Although I have challenged this supposition (Hampson 2016a), arguing instead that the study of rock art in itself can and does yield important information about the past,

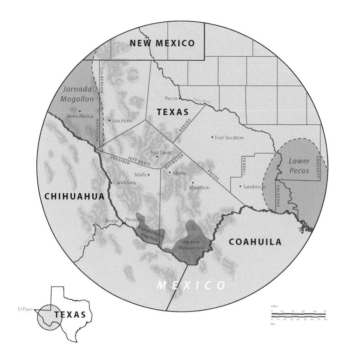

Figure 19.1 Map showing locations of 44 Trans-Pecos rock art sites. Meyers Springs is numbered 1, San Esteban 2, and Hueco Tanks 44.
Source: Courtesy of Center for Big Bend Studies (CBBS), Sul Ross State University.

I employ the west Texas culture-history framework as a baseline in order to start asking and answering questions about the significance of the region's rock art and Indigenous ontologies.

2 The Texas Trans-Pecos

Important for concepts of archaeological regionalism in the southwestern USA, and indeed elsewhere, the boundaries of the Trans-Pecos 'cultural area' have been defined in part *according to the presence or absence of certain rock art motifs* (Hampson 2016a). Most researchers (e.g., Mallouf 1985; Ohl 2008) agree that although boundaries were fluid and dynamic, it is helpful to define the *eastern* Trans-Pecos, comprising 80,000 km² (31,000 mi²), as stretching east to the Pecos River. The *Lower* Pecos region, east of the Pecos River, is justifiably famous and more easily defined; it contains a vast array of paintings, mostly from the Archaic era (in Texas, c. 6500 BCE–700 CE) (Kirkland and Newcomb 1967; Turpin 1986; Boyd 1996, 2003). The *western* Trans-Pecos, from c. 1000 CE (or perhaps as early as c. 450 CE (Sutherland 2006, 12), is characterized by the agriculturalist Jornada Mogollon culture and its features and artefacts such as pottery, pithouse villages,

and rock art. Western Trans-Pecos petroglyphs (engravings) and pictographs (paintings) at Hueco Tanks and other sites include 'mask' motifs, 'stepped-fret,' and 'blanket' designs, as well as other evidence of Mogollon and Mesoamerican influences such as Tlaloc-esque, Quetzalcoatl-esque, and other supernatural figures (Schaafsma 1980, 183–186, 198; 2003, 8); as we shall see, this is a form of contact rock art.

The Mogollon later formed the nucleus of many of the Puebloan peoples in the Greater Southwest, including the Hopi and Zuni with their kachinas, or deified supernatural beings. Persistent rock art motifs and iconography from other media, including pottery, also confirm the link between the Mogollon and Puebloan peoples (see Hays-Gilpin and Schaafsma 2010).

The Historic period in the Trans-Pecos traditionally starts at 1535 CE, the year when Spaniard Cabeza de Vaca travelled through the region. Often overlooked in the study of North American contact rock art, however, is the fact that Athapaskan-speaking groups (ancestors of the Apache) reached the Southern Plains of North America in the fifteenth century CE, and the Big Bend region of southern Texas by c. 1650 CE (Schaafsma 1980; Chipman 1992)—in other words, at about the same time as the Spanish invaders. By 1730 CE, Apaches were in control of the Rio Grande, only to be displaced by the Comanche and their Uto-Aztecan-speaking allies (Schaafsma 1980).

In North America, *historic* rock art is traditionally defined by evidence of European influence, including, but not limited to, domesticated animals (especially horses and cattle), European clothing, permanent or semi-permanent architecture (especially churches and missions), and European weapons. Crucially, however, in west Texas and elsewhere in North America, Historic *period* rock art also includes motifs indicating Athapaskan/Apache and Plains influence. Apache rock art in general includes 'sunbursts' and 'sun symbols' (circles with appended lines), as well as European animals, shields, bison, snakes, and stick-figure anthropomorphs (Kirkland and Newcomb 1967, 146–156; Schaafsma 1980, 333–342). Comanche rock art includes not only weapons and warriors, but also horses, cattle, and bison (Kirkland and Newcomb 1967, 213–214; García Rejón and Gelo 1995; Fowles and Arterberry 2013). In addition, both Apache and Comanche rock art features Thunderbirds and Christian icons and buildings.

In short, then, some Indigenous rock art clearly depicts Europeans and their accoutrements, while other motifs are integrations of external—but non-European—influences. Three rock art sites in the Texas Trans-Pecos contain numerous and particularly informative motifs. An analysis of these sites, all of which I visited numerous times between 2003 and 2013, allows us to re-consider what we mean by 'contact art.'

3 Three Trans-Pecos rock art sites

3.1 Site 1: Meyers Springs

The main panel at Meyers Springs (Figures 19.2 and 19.3) is 81 m long.

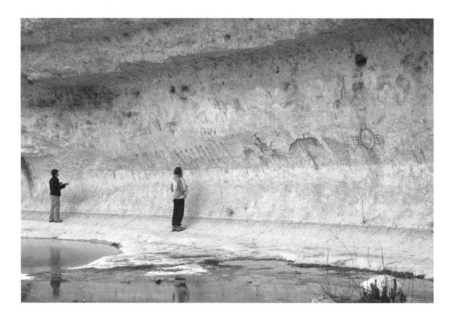

Figure 19.2 Main panel at Meyers Springs, west Texas.
Source: Courtesy of C. Harrell.

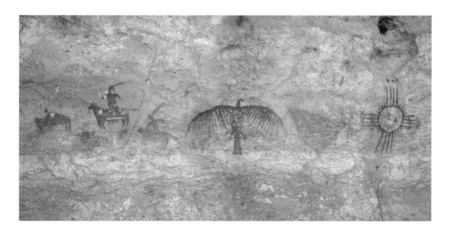

Figure 19.3 Historic period bison (marked 2), two horsemen with headdresses (3), Thunderbird (4), and sun symbol (5) superimposed *over* a line of six figures with "horned headdresses."
Source: Courtesy of Texas Archaeological Research Laboratory (TARL).

To investigate regional variations, I follow Kirkland and Newcomb (1967) and divide the images at Meyers Springs into three relative chronological periods based on superpositioning and the presence or absence of 'post-European contact' motifs (Hampson 2016a). Early figures at Meyers Springs were almost

certainly painted in the Archaic era. Next, Middle Period figures are often painted in pale red ochre, but this is not what defines them as Middle Period. More important criteria include subject matter and, to a lesser extent, superpositioning. A key question here, and wherever there is superpositioning at rock art sites, is whether or not these paintings were produced by a *different* group.

Examples of Middle Period figures include the line of humans (Figure 19.4, right). Note the horn-like emanations from the heads of the third and fourth figures from the left (Kirkland and Newcomb 1967, 113). As discussed further, these might indicate a Plains and/or Puebloan influence.

Examples of historic (post-European contact) paintings at Meyers Springs include what seem to be buildings (Figure 19.4) which, with associated geometric crosses, might reference missions and churches. Kirkland and Newcomb (1967, 123) point out that because the church was the:

> seat of the potent supernatural power of the Spaniard, it may have been reasoned that some of this power might be obtained by drawing such a building on the walls of a shelter. Such comments would apply as well to the cross.

This statement clarifies and underscores the crucial point that, as with the paintings from earlier periods at Meyers Springs, and at other sites, the Historic period images are not simple depictions—or even representations—of 'real' everyday items and events: they were and are powerful things in themselves (e.g., Schaafsma 1980, 2003; Hampson 2016a).

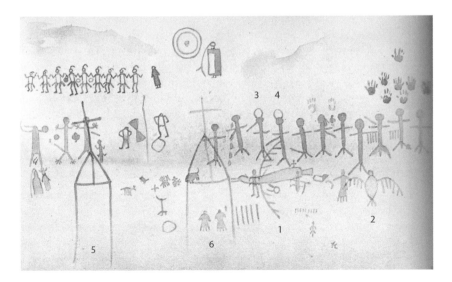

Figure 19.4 Line of humans (right centre), two of which have horns (marked 3 and 4). The two grey Thunderbirds (1 and 2) are probably from the Historic period, as are the two superimposed buildings with crosses (5 and 6).
Source: Courtesy of TARL.

Also remarkable are the following Historic period motifs:

- A shield-bearing anthropomorph and quadruped, probably a Plains Indian on horseback, surrounded by three human figures with shields and weapons. Shields are reliable historical indicators, and a secure form of relative dating, in post-European contact rock art (Turpin 1986, 1991, 2010). Kirkland and Newcomb (1967, 120) believed the horned headdress of the figure on horseback might indicate a Comanche.
- A human figure with a long cephalic emanation carrying a bow and arrow, which was not introduced into the eastern Trans-Pecos until c. 500 CE at the earliest; before this date, the primary weapon was the atlatl (Turpin 2004).

Other important figures include:

- The possible Apache or Plains *Gaan* or *Gaa'he* (mountain spirit) dancer. *Gaan* dancers today wear masks and headdresses and carry wooden 'weapons' or wands with cross pieces (Opler 1941, 87; Lamphere 1983, 747).
- A horse and a human figure holding a flintlock musket and shield (Figure 19.5).

3.2 Site 2: San Esteban

At the San Esteban site, a cross shape (marked 2 in Figure 19.6) might be connected with European settlers and their Christian missions. We know that de Vaca passed through La Junta, a mere 120 km (75 miles) to the south, in 1535 or 1536 CE (Boren 2008, 15), and that Indigenous groups throughout Texas considered de Vaca and his compatriots to be medicine men (Castañeda 1976). As in other regions colonized by Europeans, Christian influences were incorporated into, and contested within, Indigenous ritualistic frameworks. This creolization was a complex, two-way, and dynamic process of adoption (e.g., Lightfoot and Martinez 1995, 471; Smith and Ouzman 2004; Ouzman 2003, 2005; Challis 2008; Paterson 2011; Silliman 2015). An example of this overlooked complexity is de Vaca's realization that it would be to his advantage to concur with the locals' diagnosis of his elevated status: he 'cured' Indigenous people by making the sign of the Christian cross over the heads of the sick *and*, mimicking medicine men, by blowing on their bodies (Castañeda 1976, 70). As the Spaniards journeyed through Texas, "their fame as medicine men increased till their progress was seriously impeded by crowds clamouring to be healed, or even to touch their garments" (Bolton 1949, 9–10).

Captain de Mendoza's 1683 CE expedition passed close to San Esteban (Castañeda 1976, 271). Mendoza's diary states that he camped at or near San Esteban and erected a wooden cross (Bolton 1916, 326). As at Meyers Springs, perhaps the painter of the cross motif at San Esteban wished to harness the power of the Spanish explorers and the apparent vehicle of that power, their religion.

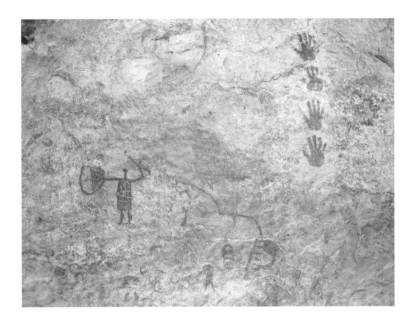

Figure 19.5 Handprints, horse, and human figure holding gun and shield at Meyers Springs.

Other motifs at San Esteban include a series of black horizontal designs, some of which have loops and hook-like appendages at one or both ends. These might be atlatls, but, at Plains sites north of Texas, Keyser and Klassen (2001, 236) have noted the occurrence of series of various replicated objects in their Plains Biographic Style, and refer to the possibility of tallying, perhaps in relation to war trophies ('counting coup'). The Apache, Comanche, and Kiowa may indeed have brought this tradition with them when they entered the Big Bend region from the north.

There are at least nine anthropomorphs at San Esteban. One is atop a quadruped (marked 6 in Figure 19.6), possibly a horse. Both of the first two human figures have what may be hats on their heads and one hand close to or on a hip. Even if the accoutrements on the figures' heads *are* hats, however, the figures themselves *do not necessarily* depict Europeans; West (1949, 83) tells us that European clothing, including hats, was sold to Native American labourers in the northern Mexican mines as early as the seventeenth century. Once again, I stress that creolization, adoption, and identity formation in frontier societies are complex, dynamic, and multi-directional processes.

The final San Esteban figure (marked 5) I consider is close to a group of quadrupeds, nine of which are probably cattle (marked 1); the remaining two might be dogs. Because of the proximity of the anthropomorph and the quadrupeds, researchers have suggested, unconvincingly, that the human figure is a

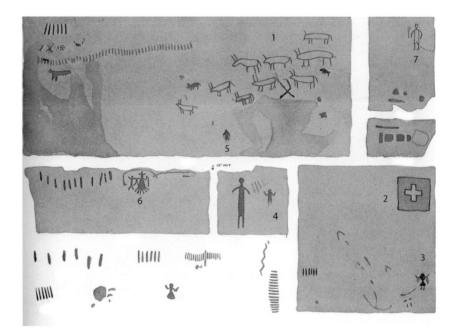

Figure 19.6 Motifs at San Esteban (including possible cattle, marked 1, and cross motif, marked 2).
Source: From Kirkland and Newcomb 1967, Plate 86.

herdsman (Kirkland and Newcomb 1967, 133; Boren 2008). Here again is the concept of rock art as a reflection of mundane scenes and events in the 'real' world, that is simply 'drawing what they saw.' Tellingly, however, the right half of the figure is deliberately smeared, and painted without feet or legs—indications of a ritualistic context (see e.g., Roberts 2005; Hampson 2016a).

3.3 Site 3: Hueco Tanks

Several periods of painting are evident at the famous site of Hueco Tanks. Jornada Mogollon (450–1400 CE) motifs include at least 24 'goggle-eyed' Tlaloc-esque motifs and more than 300 painted kachina-esque 'masks' or rain-bringing, supernatural, ancestral beings (Figure 19.7). Most of these figures are situated inside recesses in the walls of rock shelters, locations in themselves symbolic of the access to a tiered cosmos and 'the watery underworld and dwellings of the rain-bringing ancestral spirits represented by the masks' (Schaafsma 2003, 8). There are also plumed serpent motifs.

Apache figures at Hueco Tanks date from c. 1500 CE onwards. They are often white, curvilinear, and produced in what Sutherland (2006, 23) calls a 'fluid' manner. Kirkland and Newcomb (1967, 199–203) attributed many 'scenes' in this aesthetic style to mounted Mescalero Apache. These putative scenes include

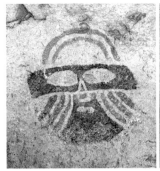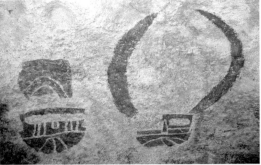

Figure 19.7 "Masks" at Hueco Tanks.
Source: Courtesy of J. McCulloch.

ceremonial 'victory' dances, with snakes, horses, musical instruments, and sexual acts as well as dancers. Other unambiguously historic motifs include cattle, missions, and people in European dress, some of which were probably painted by the Comanche or other Plains groups as well as the Apache (Sutherland 2006). I now consider the recurring contact motifs in more detail.

4 Contact art of the Trans-Pecos

4.1 Horns and headdresses

I noted earlier that there are horn-like emanations from the heads of several figures at Meyers Springs, and referred to the possible Plains or Puebloan influence. Without more detailed chronological resolution, however, it is difficult to determine which horns in the rock art of the Trans-Pecos are Indigenous—that is, more of a local or regional tradition (Hampson et al. 2002)—and which are indicative of an intrusive group from farther afield. Some emanations may be feathered or horned headdresses. The longer headdresses, which denote an intrusive influence from the Plains to the north, are unambiguous. Regardless, ethnography suggests that headdresses, whether horned or otherwise, are not only a status symbol but, like horns, are also often associated with ritual specialists (Schaafsma 1980; Hampson 2016a). Several other sites in the Trans-Pecos have human figures with cephalic emanations. At Owl Mesa, a human figure with raised arms has a long sinuous line emanating from its head—this line is clearly not a horn or headdress, but probably some form of cephalic potency (Hampson 2016a).

4.2 Thunderbirds

At Meyers Springs there are six depictions of Thunderbirds, a powerful spirit being and an important component of earth-sky dualism in several Native

American cosmologies (Ingold 2000, 279; Keyser and Klassen 2001, 34, 170, 187, 214). Thunderbird brings rain and hail, lightning shoots from his eyes, and his flapping wings create thunder. In several accounts—e.g., Ojibwa (Hallowell 2002)—thunder is the sonic incarnation of the Thunderbird, that is, thunder *is* the bird, and the Thunderbird is a 'phenomenon of experience' that blurs the 'material' and the 'spiritual' (Ingold 2000, 279). Much of Thunderbird's significance stems from earlier groups' beliefs about birds, liminal creatures that often feature as spirit guides (e.g., Schaafsma 1980; Whitley 2000; Keyser and Klassen 2001; Turpin 2010). Today, Thunderbird is important to many Puebloan groups; the Zuni, for instance, refer to Knife-wing, a mythological bird–man associated with warfare (Young 1988).

4.3 Plumed serpent, Tlaloc-esque, and 'mask' motifs

Although Mesoamerican and Jornada Mogollon ideologies are varied, heterogeneous, and distinct from prehistoric and Plains hunter-gatherer and nomadic belief systems, they too contain concepts of a tiered cosmos, and ritual specialists who move between realms (Schaafsma 2003). The role of the Mogollon and their relationships with both the later Puebloans and with the earlier Mesoamerican groups is complex (Hays-Gilpin and Schaafsma 2010; Boyd 2016). Following Schaafsma (e.g., 1980, 2003) and Boyd (e.g., 2016), I argue that perhaps as long ago as the 2nd millennium BCE, polytheistic Mesoamerican influences diffused from the south throughout the western Trans-Pecos and Greater Southwest, and, in time, and probably via the Mogollon people, became a nucleus of Puebloan beliefs (see also Sutherland 2006, 8). Indeed, Schaafsma (1997, 14) makes clear that Puebloan peoples share animistic beliefs with earlier Mesoamericans and Mogollon peoples, who also held that:

> the earth's surface is one of a series of vertical worlds, situated between the sky and the underworlds. Between these worlds there is a complex interaction and communication, realms inhabited by spiritual beings that impact life on the flat earth-surface plane. Travel from one world to another is possible through shamanic techniques of ecstasy.

One of the most important Mesoamerican-derived deities is the plumed serpent (Figure 19.8, left). In the Trans-Pecos, there are plumed serpents at three rock art sites. Erring on the side of caution, I refer to these as Quetzalcoatl-*esque* motifs. Often feathered and horned as well as plumed, Quetzalcoatl sometimes incorporates the characteristics of birds and jaguars, both of which are associated with dualistic ideologies and the Mesoamerican priesthood (see also Schaafsma 1980, 238; Reilly 2004, 130; Sutherland 2006, 12).

Quetzalcoatl is able to transmogrify, adopting human form. Tellingly, he opens sacred portals—including circular flagstones in the centre of ball courts in Mesoamerica (Schele and Freidel 1991)—and represents 'a moving energy that unified a dualistic universe, but the deity also incorporated the concept of

Figure 19.8 Left: Plumed serpent motif at Hueco Mountains from Schaafsma (1980, Figure 176). Right: One of many Tlaloc-esque motifs at Hueco Tanks.

regeneration, crucial to the Mesoamerican vision of the cosmos' (Sutherland 2006, 13). It is clear from these emphases on portals, regeneration and supernatural power that Mesoamericans, Mogollon, and Puebloan peoples borrowed much from earlier Archaic ontologies; I stress here that although there is evidence of dynamism and flexibility, especially in regional material manifestations of beliefs and practices, there is also evidence of conservatism and resilience of cosmological ontologies through space and time in the Greater Southwest (e.g., Schaafsma 2003). Indeed, the Hopi still believe their Sky God to be a horned and plumed serpent, and several Puebloan groups believe in a similar horned and plumed Sky or Water Serpent that lives in springs or on mountains—at times, these deities are fearsome or punitive, causing floods and earthquakes (Schaafsma 1980, 239). Reilly (2004, 128–129) demonstrates that, within the Mississippian Art and Ceremonial Complex, Native Americans considered a winged and horned serpent—that also took the form of a feline—to be the primary supernatural being in the watery underworld.

Another Mesoamerican influence is evidenced by anthropomorphic Tlaloc-esque motifs. Tlaloc is a rain deity who, like Quetzalcoatl, was also both beneficial and destructive. He lived within the tiered cosmos on sacred mountains, and also, once again, in caves and springs. In Mexico and farther south, Tlaloc was associated with Quetzalcoatl, kachina deities, and also with liminal species (turtles, lizards, and snakes) and deer—all of which held ritualistic significance to many Indigenous groups throughout North America (Schaafsma 1980, 242; Sutherland 2006).

Tlaloc-esque images, with a trapezoidal or rectangular head above a similar-shaped and limbless body, are found at several sites in the western Trans-Pecos (Figure 19.8). The eyes of these motifs are disproportionately large, and often ringed; these rings may represent snakes, which, like Tlaloc himself, are associated with water, or 'clouds heavy with rain' (Schaafsma 1980, 236). Patterns on the Tlaloc-esque torsos often resemble both Puebloan pottery designs as well as

conceptually similar rain-bringing cloud symbols, a similarity that according to Schaafsma (2003, 8) evokes and reinforces 'the concept of containers with all their associated metaphors including a linkage to springs and the underworld.' We know that caves, springs, lakes, and other openings into the earth have been—and, in many hunter-gatherer and Puebloan ideologies, still are—perceived as 'points of energy flow between the simultaneous levels of the Pueblo universe' (Naranjo and Swentzell 1989, 262). To Puebloan peoples, these openings not only symbolize the source of clouds and rain, they also lead to the underworld and the abode of the ancestor rain-makers (Schaafsma 2003, 4).

Before considering more traditional forms of contact art, that is motifs incorporating European influences, I finish this section with a brief comment on depictions of kachina-esque masks (Figure 19.7). Several ethnographic texts make clear that Puebloan kachinas functioned to *engage* the self-referenced and embodied supernatural ancestral beings in rain-generating rituals (Schaafsma 2003, 3). Further, in this sense, the kachina-esque images painted on rock shelter walls *were* the ancestral dead, and not mere representations thereof (Hampson 2016b).

4.4 European influences: Crosses, horses, cattle, guns, shields, buildings, and priests

Indigenous groups incorporated Christian cross imagery into their iconographic repertoires. We know too that Mescalero and other Apaches in the Trans-Pecos traded with Puebloan groups in New Mexico, many of whom had adopted Christianity (Kirkland and Newcomb 1967, 189). Caution is necessary, however, because the cross symbol was not derived exclusively by or from European priests. In various forms, the cross pre-dates European arrival at many archaeological sites throughout the Greater Southwest and south of the Rio Grande (Schaafsma 1980, 235; Boren 2008, 37). There are also Navajo depictions of possible archaeo-astronomical phenomena that resemble crosses (Schaafsma 1980; Roberts, personal communication). Similarly, in Mesoamerica the cross sometimes represents Venus as a guise of Quetzalcoatl (Schaafsma 1980, 217). More definitive of the historic period are horses (Figure 19.9), cattle, and guns, shields, and Christian buildings and priests.

At Meyers Springs, we do not know whether the depictions of mounted Apache and Comanche horsemen—Native American intruders from the north, riding horses and brandishing weapons introduced originally by the Spanish—were created by the Apache and Comanche themselves or by an earlier hunter-gatherer group. Although we know that the contact rock art at Meyers Springs and other sites in west Texas was created no earlier than the sixteenth century CE, commonly applied labels of Apache or Comanche suggest, misleadingly, that these were the only authors of horse-related art. Because most Native American groups adopted horses and horse pastoralism in one form or another, classification of groups into farmers, nomads, or hunter-gatherers is contentious, and perhaps impossible (Lamphere 1983; Challis 2008; Mitchell 2015).

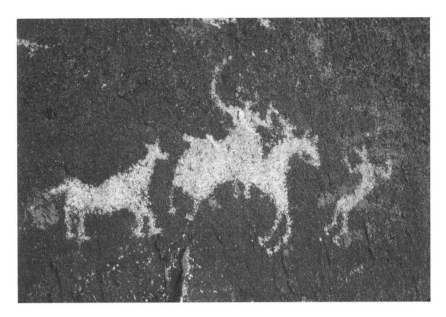

Figure 19.9 These horses and human figures from Alamo Mountain (New Mexico) are usually attributed to the Apache.
Source: Courtesy of J. McCulloch.

Depictions of cattle (*Bos primigenius*) can also be used as chronological indicators. Between 1493 and 1512 CE, approximately 500 cattle were shipped to the New World from Europe. Wild Criollos reached the Rio Grande by 1539 CE, and as early as 1604 CE eight cattle ranches were noted in the region of Santa Bárbara (Boren 2008, 81, 95).

As argued earlier, non-European artists were aware that the Spanish considered churches to be seats of supernatural power. Perhaps they saw priests (Figure 19.10) as somehow akin to their own ritual specialists. Regardless, it is certainly no surprise that Indigenous groups often attempted to incorporate intrusive groups and their material and religious cultures into their own worldviews.

5 Conclusion: A way forward

Under the umbrella of postcolonial theory, much has been written about the incorporation of new peoples and concomitant threats to established social orders (e.g., Lightfoot and Martinez 1995; Smith and Ouzman 2004; McDonald and Veth 2012; Mitchell 2015). Certainly, as illustrated by de Vaca's welcome as a medicine man, many of these themes apply in the Texas Trans-Pecos. I note again that because of numerous cultural interactions, the traditionally rigid and binary division between colonizer and colonized cannot be neatly applied, to people, to people's ontologies, or to rock art motifs. Indeed, researchers working in west Texas and elsewhere have demonstrated that nuances of cultural identity,

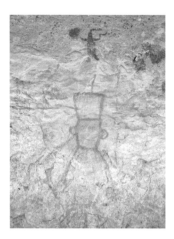

Figure 19.10 Priest at Meyers Springs.

adoption, and creolization—conceptually and in practice—are nearly always more complex than they at first appear.

Regardless of *which* Native American groups created images of European weapons, horses, cattle, and priests, I argue that they did so within a ritualistic and ontological framework. In the minds of the artists, the universe was still tiered, and ritual specialists still journeyed to other worlds to contact supernatural beings. Mescalero and Lipan Apache spiritual life was and often still is rich with ceremonies, including dances, when ritual specialists 'bring the supernatural into the human arena' (Lamphere 1983, 747). Similarly, the Comanche and the Apache believe in supernatural power that 'pervaded the universe and could be utilized … by ritual procedures known to priests or learned in personal revelation by shamans' (Kenmotsu and Dial 2005; see also Opler 1941).

Why did Native American groups paint and engrave images of non-Indigenous people, as well as introduced animals and objects? Clearly, more research is needed, but it is possible that Indigenous groups were attempting to harness the power of newcomers (e.g., Ouzman 2003, 2005). I have argued that they did not do so simply because they saw them, out there in the 'real world'—a proposition that in any case cannot be tested.

Irrespective of what contact rock art *means*, discovery and analysis of additional Mogollon-, Athapaskan-, and European-influenced motifs will continue to shed light on dynamic, nuanced, and overlapping ontologies in the Greater Southwest and beyond. This in turn might help us to understand better the meanings of, and motivations behind the creation of, rock art—and how these meanings and motivations create, maintain, and challenge ontological frameworks. Moreover, further discoveries and analysis of contact rock art motifs will enable us to better understand cross-cultural interactions and ontologies from the point of view of previously understudied, underrepresented, and marginalized groups.

Note

1 I thank everyone at the Centre for Rock Art Research + Management (University of Western Australia); Andy Cloud (Center for Big Bend Studies); and the Marie Curie Global Fellowship. Sven Ouzman, and Chris Chippindale made useful comments on earlier versions of this chapter.

References cited

Bahn, Paul. 1998. *The Cambridge Illustrated History of Prehistoric Art*. Cambridge: Cambridge University Press.

Bolton, Herbert (ed). 1916. *Spanish Exploration in the Southwest, 1542–1706: Original Narratives of Early American History*. New York: Scribner.

Bolton, Herbert. 1949. *Coronado: Knight of Pueblos and Plains*. Albuquerque: University of New Mexico.

Boren, Roger. 2008. *The Rock Art of San Esteban Shelter, Presidio County, Texas* (manuscript). Alpine: Center for Big Bend Studies.

Boyd, Carolyn. 1996. "Shamanic journeys into the otherworld of the Archaic Chichimec." *Latin American Antiquity 7* (2): 152–164.

Boyd, Carolyn. 2003. *Rock Art of the Lower Pecos*. College Station: Texas A&M University.

Boyd, Carolyn. 2016. *The White Shaman Mural: An Enduring Creation Narrative in the Rock Art of the Lower Pecos*. Austin: University of Texas Press.

Castañeda, Carlos. 1976. *Our Catholic Heritage in Texas, Volume I: The Mission Era, 1519–1693*. New York: Arno Press.

Challis, William. 2008. "The impact of the horse on the AmaTola 'Bushmen': New identity in the Maloti-Drakensberg Mountains of Southern Africa." DPhil diss., University of Oxford.

Chaloupka, George. 1998. *A Journey in Time: 50,000-year Story of the Australian Aboriginal Rock Art of Arnhem Land*. Sydney: Reed Publishing.

Chipman, Donald. 1992. *Spanish Texas, 1519–1821*. Austin: University of Texas.

Cloud, William. 2004. *The Arroyo de la Presa Site: A Stratified Late Prehistoric campsite along the Rio Grande, Presidio County, Trans-Pecos Texas*. Alpine: Reports in Contract Archaeology 9, Center for Big Bend Studies.

Fowles, Severin, and Jimmy Arterberry. 2013. "Gesture and performance in Comanche rock art." *World Art 3* (1): 67–82.

Frieman, Catherine, and Sally May. 2020. "Navigating contact: Tradition and innovation in Australian contact rock art." *International Journal of Historical Archaeology 24*: 342–366.

García Rejón, Manuel, and Daniel Gelo (eds). 1995. *Comanche Vocabulary*. Austin: University of Texas.

Goldhahn, Joakim, and Sally May. 2019. "Beyond the colonial encounter: Global approaches to contact rock art studies." *Australian Archaeology 84*: 2–10.

Hallowell, A. Irving. 2002 [1960]. "Ojibwa ontology, behaviour, and world view." In *Readings In Indigenous Religions*, edited by Graham Harvey, 17–49. New York: Continuum.

Hampson, Jamie. 2013. "Trans-Pecos Texas: Approaching rock art in understudied regions." *Time and Mind: Journal of Archaeology, Consciousness, and Culture 6* (1): 89–96.

Hampson, Jamie. 2016a. *Rock Art and Regional Identity: A Comparative Perspective*. London: Routledge.

Hampson, Jamie. 2016b. "Embodiment, transformation and ideology in the rock art of Trans-Pecos Texas." *Cambridge Archaeological Journal 26* (2): 217–241.

Hampson, Jamie, William Challis, Geoff Blundell, and Conraad de Rosner. 2002. "The rock art of Bongani Lodge and its environs, Mpumalanga Province: An introduction to problems of southern African rock-art regions." *South African Archaeological Bulletin 57*: 17–32.

Hays-Gilpin, Kelley, and Polly Schaafsma (eds). 2010. *Painting the Cosmos*. Flagstaff: Museum of Northern Arizona.

Ingold, Tim. 2000. *The Perception of the Environment: Essays on Livelihood, Dwelling and Skill*. London: Routledge.

Kenmotsu, Nancy, and Susan Dial. 2005. "The native peoples of the plateaus." Texas Beyond History website. Accessed September 14, 2017. https://texasbeyondhistory. net/plateaus/peoples/index.html.

Keyser, James, and Michael Klassen. 2001. *Plains Indian Rock Art*. Seattle: University of Washington.

Kirkland, Forrest, and William Newcomb. 1967. *The Rock Art of Texas Indians*. Austin: University of Texas.

Lamphere, Louise. 1983. "Southwestern ceremonialism." In *Handbook of North American Indians 10: Southwest*, edited by Alfonso Ortiz, 743–763. Washington, DC: Smithsonian.

Lightfoot, Kent, and Antoinette Martinez. 1995. "Frontiers and boundaries in archaeological perspective." *Annual Review of Anthropology 24* (1): 471–492.

Mallouf, Robert. 1985. "A synthesis of easternt Trans-Pecos prehistory." MA thesis, University of Texas.

Mallouf, Robert. 2005. "Late archaic foragers of eastern Trans-Pecos and the Big Bend." In *The Late Archaic Across the Borderlands: From Foraging to Farming*, edited by Bradley Vierra, 219–246. Austin: University of Texas.

McDonald, Jo, and Peter Veth (eds). 2012. *A Companion to Rock Art*. Oxford: Blackwell.

Mitchell, Peter. 2015. *Horse Nations: The Worldwide Impact of the Horse on Indigenous Societies Post-1492*. Oxford: Oxford University.

Naranjo, Tito, and Rina Swentzell. 1989. "Healing spaces in the Pueblo world." *American Indian Culture and Research Journal 13* (3–4): 257–265.

Ohl, Andrea. 2008. *Defining the Eastern Trans-Pecos as a Cultural Sphere* (manuscript). Alpine: Center for Big Bend Studies.

Opler, Morris. 1941. *An Apache Life-way: The Economic, Social, and Religious Institutions of the Chiricahua Indians*. Chicago: The University of Chicago Press.

Ouzman, Sven. 2003. "Indigenous images of a colonial exotic: Imaginings from bushmen in southern Africa." *Before Farming 6* (1): 239–256.

Ouzman, Sven. 2005. "The magical arts of a raider nation: Central South Africa's Korana Rock Art." *South African Archaeological Bulletin Goodwin Series 9*: 101–113.

Paterson, Alistair. 2011. *A Millennium of Cultural Contact*. Walnut Creek: Left Coast.

Reilly, F. Kent. 2004. "People of earth, people of sky: Visualizing the sacred in native American art of the Mississippian period." In *Hero, Hawk, and Open Hand: American Indian art of the Ancient Midwest and South*, edited by Richard Townsend, 125–138. New Haven: Yale University.

Roberts, Tim. 2005. "Prehistoric ritual destruction of some Lower Pecos River style pictographs: Making meaning out of what we do not see." *The Journal of Big Bend Studies 17*: 1–35.

Schaafsma, Polly. 1980. *Indian Rock Art of the Southwest*. Santa Fe: University of New Mexico Press.

Schaafsma, Polly. 1997. "Rock art, world views, and contemporary issues." In *Rock Art as Visual Ecology*, edited by Paul Faulstich, 7–20. Tucson: American Rock Art Research Association IRAC Proceedings, Volume 1.

Schaafsma, Polly. 2003. "Out of the underworld: Landscape, kachinas, and pottery metaphors in the Rio Grande/Jornada Rock-art tradition in the American Southwest." *Before Farming: The Archaeology and Anthropology of Hunter-Gatherers. 2003/4* 6: 1–11.

Schele, Linda, and David Freidel. 1991. "The courts of creation: Ball-courts, ballgames and portals to the Maya otherworld." In *The Mesoamerican Ballgame*, edited by Vernon Scarborough and David Wilcox, 289–315. Tucson: University of Arizona Press.

Silliman, Stephen. 2015. "A requiem for hybridity? The problem with Frankensteins, purees, and mules." *Journal of Social Archaeology* 15 (3): 277–298.

Smith, Benjamin, and Sven Ouzman. 2004. "Taking stock: Identifying Khoekhoen herder rock art in southern Africa." *Current Anthropology* 45 (3): 499–526.

Sutherland, Kay. 2006. *Rock Paintings at Hueco Tanks State Historic Site.* Austin: Texas Parks and Wildlife.

Taçon, Paul, Alistair Paterson, June Ross, and Sally May. 2012. "Picturing change and changing pictures: Contact period rock art of Australia." In *A Companion to Rock Art*, edited by Jo McDonald and Peter Veth, 420–436. Oxford: Blackwell.

Turpin, Solveig. 1986. "The Meyers Springs and Bailando Shelters: Iconographic parallels." *La Tierra* 13 (1): 5–8.

Turpin, Solveig. 1991. "Shields and shield bearers in the rock art of the middle Rio Grande." *La Tierra* 18 (2): 5–12.

Turpin, Solveig. 2004. "The Lower Pecos River Region of Texas and Northern Mexico." In *The Prehistory of Texas*, edited by Timothy Perttula, 205–265. College Station: Texas A&M University Press.

Turpin, Solveig. 2010. *El Arte Indígena en Coahuila.* Saltillo: Universidad Autónoma de Coahuila.

West, Robert. 1949. *The Mining Community in Northern New Spain.* Berkeley: University of California.

Whitley, David. 2000. *The Art of the Shaman: Rock Art of California.* Salt Lake City: University of Utah Press.

Young, Jane. 1988. *Signs From the Ancestors: Zuni Cultural Symbolism and Perceptions of Rock Art.* Albuquerque: University of New Mexico Press.

20 When the virtual becomes actual

Indigenous ontologies within immersive reality environments

David Robinson, Colin Rosemont, Devlin Gandy, and Brendan Cassidy[1]

As media fixed in place, but enduring through time, rock-art has long been recognized as anything but a singular phenomenon (Chippindale and Nash 2004). From the original maker of the artwork, to the contemporary viewers of that art, through subsequent generations to the present, rock art carries with it polyvalent possibly (Robinson 2013a). Its role and meaning changes through time. This is mostly because of the changing human relationship to rock-art as living memory gives way to oral history, legend, myth. But change also occurs through research and study, management, plus media, tourism, and sadly vandalism. Biochemical changes in the artwork itself, the stability of the host rock, the morphology of the landscape, hydrology, climate, and changes in the biotic communities living in the area likewise create new contexts for the art-through-time. As such, rock-art is part of many different assemblages, but these assemblages are not temporally static. Within this *longue durée* of change, the ontology of differing human communities plays an important part in how significant rock-art might be in any given moment or context. The relationship between multiple temporal ontologies creates complexities rarely explicitly considered in our discourse.

Yet while fixed in place, rock-art imagery is carried beyond its physical location. Whether in memory, drawing, photograph, or in digital coding, the replicated image can be transported into different relationships, instigating new possibilities for its furthering engagement within unanticipated situations. While we focus on rock-art here, these observations are not uniquely applicable to rock-art alone. At issue here is the way ontology itself transforms. And if we are to hold that different ontologies can exist at the same time, then the interactions between ontologies may lead to the emergence of something new, even novel. If so, this is something we should be paying close attention to. Here, we consider the emergence of a virtual reality (VR) rock-art platform called PleitoVR (Cassidy et al. 2018, 2019) (see Figure 20.1), charting the creation of new potentialities cutting across archaeological, computing, and Indigenous ontologies.

The increasing use of VR to create immersive environments in cultural heritage and archaeological sectors calls into question how differing ontologies—understood through differing relationalities across human and nonhuman kinds—interplay

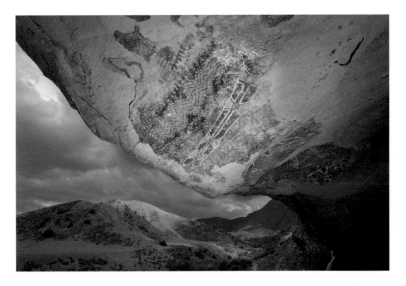

Figure 20.1 Photograph of Pleito Cave, looking south-east.
Source: Photograph by Devlin Gandy.

within such newly created experiential platforms. We will argue that the immersive platforms are not just simulacra of rock-art sites, but are novel and new entities in and of themselves.

According to DeLanda (2006, 2012, 2016), assemblages have both properties and possible capacities. A capacity is latent, or virtual as he puts it, in the sense that its properties have the possibility to act in an affective manner, but the capacity may or may not be exercised. For DeLanda, in his interpretation of Gilles Deleuze, the virtual is the structural space of possibility. He uses the ideas of a manufactured knife and a natural obsidian stone (2012, 13):

> … a knife has the actual property of being sharp and the virtual capacity to cut. If we imagined instead of a manufactured object a sharp obsidian stone existing before life, we could ascribe to it that same capacity to cut, a capacity it occasionally exercised on softer rocks that fell on it. But when living creature large enough to be pierced by the stone appeared on this planet the stone suddenly acquired the capacity to kill. This implies that without changing any of its properties the possibility space associated with the capacities of stone become larger.

For Delanda, the possibility space of the obsidian knife to kill (once an animal exists) is real, a real virtuality as he puts it (Delanda 2005, 83). But real is not the same as the actual. The actual only emerges when a catalyst enacts the cutting: so ontologically, we have a distinction between the virtual and the actual as defined by possibility space: one in which the structure presents possibilities, the other when such possibilities are actualized. Both are intrinsic to assemblages, but only

with actualization do assemblages operate as affective entities and express their capacities. Importantly, assemblages by definition are relational while being holistic: the way the parts relate determines how the assemblage as a whole expresses itself.

This discussion does not at first glance equate directly with what we normally term Virtual Reality, yet indirectly it is very relevant. Here, we are exploring how we can envision VR platforms, such as one we have developed on the Californian rock-art site of Pleito, ontologically. Certainly, PleitoVR is itself an assemblage, instantiated by headsets, photon's and soundwaves, and an interlocutor experiencing the immersive. Taking Johnson (2008a) arguments about virtual reality in novels from a Deleuzian perspective, we suggest that such VR assemblages are not simply new modes of representation of rock art, but entail decoding and recoding of the human body in an emergent context (see also Johnson 2008b). Or put another way, the VR begins a process of territorialisation that, while derived from the physical space of the rock art site, is a new and novel synthetic space (see DeLanda 2011). As Boellstorf (2016, 394) contends concerning online platforms, 'Virtual worlds do not mediate between places; they are places in their own right that persist as individuals log into and out of them. They exist even if no one is currently "inworld".' And so it is that there are virtual possibility spaces that the PleitoVR may hold which have yet to be fully considered. Not the least of which is to question what affect the Indigenous ontology which created the artworks at Pleito plays within this VR assemblage. So what are the virtual possibility spaces of an immersive reality platform, and what new actualities might emerge from this?

Pleito is of international importance. Located in South-Central California (Figure 20.2) it has the widest colour palette of any known site in the Americas, including reds, black/grey, white/creams, yellows/oranges, plus rare greens and blues (Bedford et al. 2018). Intense over-painting creates a complexity rarely seen in most painted sites (Robinson et al. 2016).

These series of superimposed layers clearly indicate multiple time periods (Kotoula et al. 2018), most of which likely were painted over the last 2,000 years (Robinson and Wienhold 2016). The paintings are extremely fragile, with the site in a remote location even if it was well occupied and utilized as a food processing locale during much of its prehistoric use (Robinson 2007). As researchers, we have occasion to inhabit this site and experience it in ways not normally available to the public, employing portable digital technologies in analytical and imaging approaches (Bedford et al. 2014, 2016; Kotuoula et al. 2018; Robinson et al. 2016). So, we created a VR with our original intentions for it to act as a means for people to experience the cave (Figure 20.3) (Cassidy et al. 2019).

Here, the user can move about the simulated cave environment, look closely and in detail at the paintings, and even handle baskets and other materials (see McArthur and Robinson 2016; Robinson 2017). We have included imaging data in the application and interactivity with superimposed paintings enabling the user to inhabit the VR space in ways very different than if one were to visit

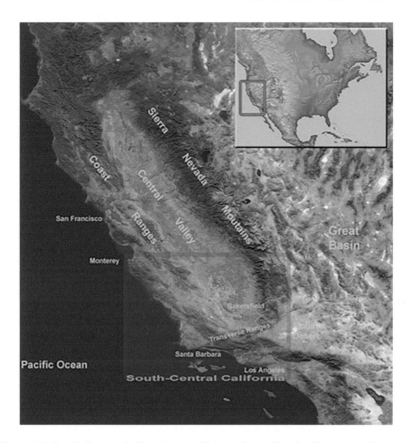

Figure 20.2 South-Central California area. Pleito is located in the Transverse Ranges.

the site in person. We particularly developed PletioVR for the use of the local Tejon Indian tribe, so that they can utilize the VR in their own cultural educational programmes (Cassidy et al. 2019).

The rock-art is attributable to Native Californian groups such as the Chumash and their neighbours. But even as the ontology that created the original Pleito is rightly called a relational ontology, it is different than Delanda's ontology. It could be called a 'relational animism' or 'agentive relationality' in a crude shorthand way. For instance, the rock itself was not passive, but likely to have been considered the petrified remains of mythological creates turned to stone during the mythic past (Robinson 2013b). Paintings may have drawn upon a kind of slumbering semi-sentience resident in the rock. Rather than inert media, pigment admixtures could be thought of as potent alchemical substances redolent with complex agencies connected to their place of extraction and enhanced via preparation and admixture (Robinson 2004). Painting was an act, a catalyst to put in motion the affects of those connections. This in part explains the many amorphous smears and apparently non-representational paintings that are very

Figure 20.3 Pleito Cave screenshot from PleitoVR application.

common in the region. And, rather than simply symbolic or even indexical, images could be relational agents, entities in partnerships with the artists, like marionette strings involved in the dance mechanics of native power, they were enactors of agency influencing supernatural, physical, and social worlds (Robinson 2013c). Key to Chumash understanding is the idea that things, substances, entities, persons, can all undergo transformation. Combining tranformations in collagic recipes increases potentialities. This is what has been termed 'transmorphism' by some who study the Chumash (Blackburn 1975, 40; Robinson 2013c). But the site, along with other rock art locales, was also part of a larger social assemblage, linked to wider land use practices and part of the process of the emergence of Chumash complex society which was encountered by colonial powers (Robinson 2010; Robinson and Wienhold 2016; Wienhold and Robinson 2017).

And so these rock art paintings as actants extend beyond the field of representation. It is not enough to simply classify what an image represents as an external referent to an internal mental process. In our analysis of a figure or a motif, we must incorporate the known ethnographic record of myths and stories with an ongoing process of developing theoretical frameworks to think through the possible ontological worlds in which such art was created. Our work thus becomes its own moving assemblage as we strive to incorporate theoretical constructions from anthropologies and philosophies with ongoing collaborations and insights from Indigenous scholars and communities alike. Indigenous understanding here does not simply entail trying to understand the ontology of people in the past who made the art (as important as that is), but to fully appreciate the influence of recent and contemporary Native viewpoints and philosophies in the very construction of our narratives and our theories. We take

seriously the Indigenous critique of ontological theorization as an extension of colonial appropriation and disenfranchisement. Zoe Todd (2016) aptly criticizes the lack of Indigenous representation in the theorizing of concepts attributed to the very ontological worlds from which they are at home. More to the point, the development of relational theory and New Animism in anthropological and archaeological discourse is derived from Indigenous peoples.

We seek a broader conversation through first considering what Native artists and theorists have already achieved in the role of cyberspace in Indigenous culture. The first application of an Indigenous VR was by Salish artist, Laurence Paul *Yexweluptun*, known more widely for his large mural paintings, but he was also the first person to create an immersive VR environment involving Indigenous cultural material and practices.

Titled, INHERENT RIGHTS, VISION RIGHTS (abbreviated as IRVR), *Yexweluptun's art*work created a virtual reality installation in 1992 (see Todd 1996) meant to expose the non-initiated and non-Indigenous into the world of spirits which he is so familiar with. *Yuxweluptun* means 'man of many masks,' a name that was bestowed on him by a secret mask society of the Coast Salish. Within that cultural context, engaging foreign cultures through a VR mask seems only fitting. On entering the artwork, the participant finds themselves outside a Coast Salish Longhouse—itself a sacred space of dance, worship, prayer, and healing. Participants are able to enter the longhouse, witness ceremony, hear the song and sounds of the space, and interact with spirits and beings that are potentially present.

Importantly, this experience is framed within a relational engagement. There are no avatars, the participant should feel as if they are themselves present in the experience. Emphasis is on the participant to explore and evaluate their decisions: 'Are you actually supposed to be here,' 'If, regardless, you are here, how will you conduct yourself in this space?' (King 2017). If you misconduct yourself, the beings resident in the space have no obligation to you.

As a non-traditional artwork which blurred the lines of materiality, IRVR's critical reception by Indigenous scholars and theorists has had far reaching impact in Indigenous virtual theory. One of the first to approach this was Cree/Métis theorist Loretta Todd. Drawing from N. Katherin Hayle's, *How We Became Post Human*, Todd emphasizes her concern with VR as a colonial technology. Tracing the history of cyber space through Western/Christian cosmologies of salvation, ascension, transcendence and aversion to nature—Todd emphasizes the discord with Indigenous relational lifeways. In experiencing IRVR firsthand Todd notes the reversal of usual modes of VR experiences. Instead of distributed subjectivity, she finds 'embodied virtuality.' That within the 1s and 0s of IRVR the Coast Salish Spirits might be ever-present. In particular, Todd (1996) and King (2017) both argue that IRVR 'rejects the bodiless escapism offered by other VR projects' by challenging the user to portray herself in relation to the spirit figures and the setting of a longhouse (King 2017, 191). Mohawk artist and academic Jackson 2bears expands on this notion, arguing IRVR offered the possibility of re-contextualizing the Western 'ontology of the

virtual,' expanding Indigenous consciousness of relational epistemologies into ever- expanding digital territories (2Bears 2013). As 2Bears puts it, '… there is in Yuxweluptun's work a return to the flesh in something similar to what Hayles would call embodied virtuality—virtuality, that is, where the myth of transcendence and disembodied immortality is demystified and embodiment and material embeddedness is written back into our concept of posthuman subjectivity' (2Bears 2013, 149). In Yuxweluptun's work, the mind/body Cartesian dichotomy is denied by a network of relations played out by embodied embeddedness.

This same network of relations has also fuelled new forms of Indigenous representation and culture through what has come to be called Indigenous Futurism. According to Ashinabe director, Lisa Jackson, '[Indigenous Futurism] looks to break through that tendency to stereotype everything Indigenous as stuck in the past and incapable of moving into our present, or our future' (in Dechausay 2018 (www.cbc.ca/arts/exhibitionists/imagine-if-toronto-were-reclaimed-by-nature-this-indigenous-futurism-vr-experience-takes-you-there-1.4828320). For our discussion, artists taking part in the Indigenous Futurism movement have created remarkable outputs in the VR world which offer important and meaningful methods, ethics, and purposes to consider when using VR in archaeological contexts. Jackson, for example, is the creator of the Indigenous VR epic, BIID-AABAN: First Light. The VR narrative explores an Indigenous future in a post-apocalyptic Toronto where Indigenous values and lifeways have found new meaning and purpose as Indigenous communities rise from a dystopic future and begin to co-exist with their environment. Jackson gives special consideration to the spiritual and social ontological underpinnings of VR. Utilizing Wendat, Mohawk, and Ojibway instead of English, participants are immersed in a future where relational engagement with an animate world is reawakened.

Throughout Indigenous futurism, Indigenous thinkers, theorists, and creatives have sought to reformat Western or Colonial technologies and repurpose or Indigenise them. In doing so, Indigenous artists and theorists have shown cyberspace as something intricately connected to life and spirit, not devoid of it.

At first glance, these Indigenous modalities ascribing the kind of vibrancy to cyberspace more akin to Bennet's views (2010) than from how computing ontology is typically characterized. The workings of computing is usually viewed as mechanical, structural, and ultimately impersonal. As Wellen and Sieber (2013, 159) put it, computing ontologies serve data (or metadata) consisting of classes, properties, instances, and rules. Or, as Cripps et al. (2004, 3) describe, a computing

> ontology is an explicit formal declaration (with a standardised vocabulary) of how to represent object concepts and other classes assumed to exist in some area of interest (a domain) and the relationships between them. In this sense an ontology is a specification of a conceptualization. Ontologies provide a shared and common understanding of data.

As such, computing ontologies can be recognized as consuming the Indigenous

through this process of standardisation. In other words, another pernicious form of colonialism threatens to work within computing domains. This is problem recognized by some, such as Reid and Seiber in their geospatial work with First Nation people, who argue 'that universality through ontologies can potentially perpetuate homogenization of concepts,' thus contributing to assimilation of Indigenous peoples (Reid and Sieber 2019, 1). They recognize that a fundamental problem is that the purpose of an ontology is to provide a universally shared common understanding of reality as it exists and is represented (ibid, 30). Their solution is to propose a hermeneutic approach for a 'place-based Indigenous ontology that could partner with western ontology instead of being subsumed by it' (ibid, 12). In our work in California we have long adopted just such a hermeneutic approach looking for points of articulation between Indigenous philosophy and academic interpretation (see Robinson 2004). Amongst those we have drawn upon Vine Deloria's views:

> The best method of communicating Indian values is to find points at which issues appear to be related. Because tribal society is integrated toward a centre and non-Indian society is oriented toward linear development, the process might be compared to describing a circle surrounded with tangent lines. The points at which the lines touch the circumference of the circle are the issues and ideas that can be shared by Indians and other groups. There are a great many points at which tangents occur, and they may be considered as windows through which Indians and non-Indians can glimpse each other. Once this structural device is used and understood, non-Indians, using a tribal point of view, can better understand themselves and their relationship to Indian people.
>
> (1970, 12)

It is crucial that such interactions between Indigenous and academic are partnerships rather than appropriations. It is indeed problematic that we, as academics, are embedded in institutions with ontologies and research traditions that categorizes reality in non-relational ways. While we may recognize the 'Otherness' of relational ontologies, we typically do so by standing back from it, reifying it by our practice, if not in our intent, in the very separation that we argue is a falsity, at least in the object of our study. We interpret the spectacular polychromatic rock art of Pleito in the ontological context of a range of different evidences, from ethnography to archaeology to philosophy. Ultimately, we think that the art was created within an ontology which does not separate Nature from Culture and which recognizes different forms of sentience, agency, and affect which are all situated and contextual (Robinson 2004, 2013b, c). Painting was not simply cognitive representations of the inner workings of a 'shaman,' but enactments in the creation of polyvalent agents within changing assemblages through time and thus were important aspects of Indigenous social power. And so as we have stated above, these rock art paintings extend beyond the field of representation. Our work thus becomes its own assemblage as we strive to

incorporate theoretical capacities from anthropologies and philosophies with ongoing collaborations and insights from Indigenous scholars and communities alike. For instance, in our creation of the PleitoVR, we have worked with the Tejon Indian Tribe to include traditional singing. As one starts the application, a Chumash welcome song performed by Jake Hernandez (a Kitanemuk Indian) is heard in the headset as a greeting to this new space. The song was recorded in the cave itself and is deemed appropriate for non-native speakers to hear. The singing to life the cave is something that in all likelihood returns a tradition lost there for at least 150 years, so for the listener it creates a new kind of engagement with the site which is privileged. We also have the ambient sound taken from the cave. In it, we hear the stream running below, the wind in the trees, the pecking of a woodpecker, and other animal sounds. All the sound waves of the recording interacted with the cave itself, so that the place is immanent in the sonic experience. Hearing the song and the sounds from the cave both engages the listener with the site *as if one was there*, but also is enlivening as the Native voice relates to the space in a way not heard before by a modern audience.

This kind of engagement we argue touches on something more than just the hermeneutic and the 'glimpsing' between Native-and-non-Native. The privileged experience of the sonic in the cave is part of a new formation between actants, of which the VR is a vital component. This is understandable not strictly an Indigenous mode of ontology nor in the typical Cartesian ontology, as these ultimately may prove to be inaccurate dichotomies anyway. A long history of vitalist philosophies can be traced back through our Western thought tradition, from Spinoza to Bergson to Deleuze, theorizing the potentials of a vital force in matter. The relational, intersubjective space, between that which is perceiving and that which is being perceived, translates into a transference of certain qualities from one source to another. Latour (1993) takes issue with the strict dualistic divide between Nature and Culture, diagnosed by post-Enlightenment thinkers as a fixture of the modern age, a metanarrative distinguishing 'us' from the sentient worlds of the Indigenous, worlds in which natural-is-social, fully imbricated and intertwined with the human-is-social. There is an irony in that Latour's findings which interlock with Deloria's tangents to resonate with Indigenous ontologies arise largely from his focus on his 'anthropology of the moderns' (Latour 2010, 601–603) modern in ways which make the Cartesian seem naïve. As he further states (Latour 2010, 605), in the 'modernist idiom, matter is not a taken-for-granted category, but a historically contingent amalgam of at least two entirely different elements: the way we know (which is generated by the reference chain of science) and the way entities reproduce themselves.'

Latour's many nods to the continued interworking of nature-culture hybrids in the era of the anthropocene have demonstrated the faith based approach to much of our post-enlightenment thinking, we might have believed that human beings have separated themselves from the natural world, controlling many of its aspects in a classical Baconian sense, but in actuality, the forces of nature and culture are not separable from one another. Our own contribution here, is in the way in which a cave in the middle of the Southern California backcountry, a

cave albeit that was obviously home to rich cultural ongoings, is becoming enmeshed in our own technological circuits, bringing the experience of this landscape into a totally new, immersive, environment.

Our principal inquiry here is how this newly constructed environment potentiates new ontological relations with the space itself, and, sticking with our theme, how the virtual qualities of the rock art and the cave can become actualized through the experiences of the VR. We argue that the virtual environment catalyses new possibilities for the relationship the viewer can have with the art at Pleito cave.

In other words, this something other than creating a VR as a service to Indigeneity, the native perspective is fundamental to the VR itself. While yes, this very space correlates to the mode of relationality gesturing towards the animistic ontologies of the world through which the paintings were created, it also expresses a dynamism that begins to emerge as something further. In Delanda's terms, a territorialisation is occurring in the new possibility space of the virtual. Rather than creating a new hybrid entity, made out of the combined particles to form a new object, this is a polyvalent process creating new relations within which embody perspectives experience something novel. Eduardo Viveiros de Castro (henceforth EVC) cultivates an evocative theory of 'Amerindian perspectivism,' looking to situate his metaphysics both in a tradition of Western philosophy, but moreover as inspired by his fieldwork with his comparative studies of animistic cultures. For EVC, Amerindian thought does not simply take Western categories of nature and culture and reformulate them, but rather these categories take on a different status entirely. They no longer refer to discrete ontological provinces; they emerge through exchangeable perspectives and relational-positional contexts, or points of view.

In contrast to the ontological mapping of his contemporary Descola (2013), in which animism is but one of a host of ontological types scattered across the world, EVC's approach emphasizes a much more totalizing ontology: He defines it as full-blown but implicit metaphysics embedded in Indigenous practices. Not wanting Amerindian perspectivism to become 'just another curio in the vast cabinet of curiosities [EVC] accuses Descola of seeking to build,' EVC approaches perspectivism like a bomb 'with the potential to explode the whole implicit philosophy so dominant in most ethnographers' interpretations of their material' (Latour 2009).

This vein of animism elicits a sense of intentionality that facilitates the body as holding the point of view from which the Subject emerges. Deleuze (1993, 19) takes us further in conceptualizing the subject created by the point of view:

> It is not exactly a point but a place, a position, a site, a "linear focus," a line emanating from lines. To the degree it represents variation or inflection, it can be called *point of view*. Such is the basis of perspectivism, which does not mean a dependence in respect to a pregiven or defined subject; to the contrary, a subject will be what comes to the point of view, or rather what remains in the point of view.

Insofar as perspectives are embodied in specific dispositions, an apperceptive reckoning ensues that calls upon the body as the origin of perspectives—a body with no fixed shape that is an 'assemblage of affects or ways of being that constitute a habitus' (Viveiros de Castro 1998, 478). EVC's theory offers, on the one hand, a broad, essentialized mythic structure applicable across Amerindian societies, while on the other hand, focuses in on each type of body as an 'affectual singularity' with its own perceptual apparatus (Viveiros de Castro 2012, 114). Elaborating on the difference of embodied perspective, EVC states (Viveiros de Castro 2004a, 6):

> Rather, such difference is located in the bodily differences between species, for the body and its affections (in Spinoza's sense, the body's capacities to affect and be affected by other bodies) is the site and instrument of ontological differentiation and referential disjunction.
>
> Deleuze (1988, 48)

> The affections (*affectio*) are the modes themselves. The modes are the affections of substance or of its attributes [...] At a second level, the affections designate that which happens to the mode, the modifications of the mode, the effects of other modes on it.

Through the experience of VR, a shifting perspective engenders a new experiential compass, unlocking lines of communication in the emergence of unspoken relations. Throughout Indigenous cultures of the Americas resides the latent capacity for perspectival shifts, engaging in dialogue with spirits and nonhuman 'others,' changing form in order to see nonhumans as they see themselves. In the West, the apprehending human subject detaches and distinguishes herself from that which is inherent in the object—a thing that is known only insofar as it is objectified, inscribed with the projections of the knowing subject. So-referenced modes of being enable individuals to cross ontological boundaries, to adopt the perspective of nonhuman subjectivities and engage in reciprocal exchanges of intentional communication.

Here we might think of our nonhuman others as the artworks themselves, and perhaps they gain a personhood of sorts, or at least an agency working with us in the VR. Just as EVC states that Amerinidan objects can be subjects (Viveiros de Castro 2004b) the paintings have never been simply static images waiting to be apprehended but rather enacted with people in the past as they do for visitors to the site today: this occurs in the VR in corollaries to the those ways but with additional properties added and subtracted. Part of the reason for this is us, the academics writing this chapter, who have brought our own practice into this assemblage in the creation of new possibility spaces. During the course of our analytical work on the paintings, we applied the visual enhancement tool called dStretch into our 3D model and then into the VR application (Figure 20.4).

This enables the user to experience the art and cave in full immersive dStretch mode. Images difficult to see are suddenly vivid, but made explicit in a new

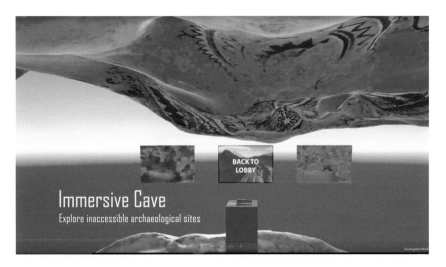

Figure 20.4 View from PleitoVR in back of cave in dStretch mode.

colour spectrum, while others normally dominant, become muted or suppressed. Walking in the dStretch cave, new vistas into the relationships between paintings, overpaintings, inter-referencing from one image to another, the artwork transmorphs. We added in a 'flashlight' tool which then lets the user tack back-and-forth between the regular non enhanced view of the paintings and the dStretch version (Figure 20.5), allowing the user to interplay with visualizations in ways impossible at the 'real' site. Another property we developed is let the user 'grab' panels or even individual figures (Figure 20.6).

Thus the paintings can come off the wall at us, engage in a visual yet (dis) embodied dialogue. Yet while the body engages with the site, the art, and novel ways of experience, the material is intangible, including one's own body in the VR realm. You cannot touch the paintings, but you can hold them. You can move about the cave, but the rock is a reference to the solidity of itself rather than feeling solid. The (dis)embodied experience of the VR cave challenges the person to consider their body anew, entering a new spatial relation with new capacities and affordances towards the artwork in question (see Wright 2014). And with their imaginations in tow, stimulated by the sights and sounds of the cave site, one might begin to consider their own body as permeable to the environment at present. A certain perspectival shift might occur, as they exit their temporality and enter into the androgynous time of the virtual cave site, a space of alterity and of potentiality. For a few brief moments, while in the VR space
we have access to an other-than-human perspective of the virtual. Here, one can move through different imaging textures, move through the rock itself, see the curvature while passing through, experiencing space in ways not immediately possible at physical site itself.

Figure 20.5 View from PleitoVR in dStretch mode with "flashlight" feature: note how the focus area of "flashlight" reveals the original non-dStretch texture version of the painting allowing for the user to tack back and forth between dStretch and normal textures.

Figure 20.6 View from PletioVR showing the user "grabbing" an image from the cave ceiling and interacting with the painted figure.

Furthermore, one can enter the VR environment in tandem with others using avatars, but do that remotely from anywhere in the world where one can access the PleitoVR application online. For instance, we performed a demonstration of this possibility at the Society for American Archaeology Meetings in Washington, DC, in 2018. There, we had a projection of the PleitoVR shown on a large screen, but had four participants from around the world participate: a Tejon representative from their offices in Bakersfield, California; a Ranger from the land owners at the Wind Wolves Preserve; our VR designor Brendon Cassidy from his house in Blackpool, UK; and co-author Devlin Gandy at the conference itself (Figure 20.7).

The Pleito VR gives us pause to think how Indigenous ontologies—relationships to substance, matter, agency, vitality, permeability—might be invoked by these new environments. Ones that reorient subjective and intersubjective gaze, in a sense bringing the space to life in the exchanging and reorienting of perspectives, or points of view. So, we do not see the VR version of Pleito as a reproduction or even straightforward 4D representation of the physical site itself. It is something other than that, with its own virtual possibility spaces. Each time it is utilized, when the user bodily inhabits it space, it moves from the virtual to the actual and is an entity in its own right.

But can we really claim that the PleitoVR application is an entity in its own *ontological* right? Deleuze and Guattari point to the nomadic warrior con-stellation of the 'man-animal-weapon, man-horse-bow' as an assemblage of speed that created a historically specific assemblage actualizing its capacity in the act of battle (Deleuze and Guattari 1987, 446). It emerged, in their terms, from a 'technological lineage' of the constituent part of that assemblage. This

Figure 20.7 Screenshot of PleitoVR with avatars of two of the remote participants during the 2018 SAA meetings in Washington, DC.

technology groups together from the 'affective parts or qualities of traits of expression' of the part, and thus can be seen in their terms as a 'machinic phylum' (Deleuze and Guattari 1987, 446–448). Just as Delanda takes these ideas of 'affective parts' as that of capacity, the affective capacities are expressed in sandstone, painting/painter, digital capture, computer processing, VR gear, VR user certainly comprise a machinic assemblage. However, the ontological perspectivism of the original artists and contemporary Native Americans likewise expressed their capacities within this assemblage in the creation of the art, its form, and in the cave singing. But the entire output of this assemblage emerges as something drawn—from but different—to the rock art site itself. This occurs through the unpredictability inherent when existing entities interact in novel combinations such as bricolage or polyvalence. Polyvalence is apt here as it describes a process of ambiguous potentiality, or the "inherent capacity for different or multiple outcomes to occur from a given set of factors" (Robinson 2013a, 304). There are unforeseen capacities that become possible in the ongoing interplay between the past, the present, and the future in such entangled contexts involving archaeology, Colonial landscapes, Indigenous assertion, and new technologies. Deterritorializations and new territorializations may occur as gradients shift. However, we do not know how prolonged this specific PleitoVR will endure, and in what manner it may provide a means of embodied perspectivism. For Deleuze and Guattari (1987, 448), a machinic emergence should only be considered a 'phylum' or 'technological lineage' when its operations are prolonged and thus have endurance. But we do know that Indigenous futurist are actors in similar polyvalent circumstances, with cadres of others working in similar realms (for instance Gard and Bucolo 2005; Gaertner 2015; Wyeld and Pumpa 2007; Wyeld et al. 2007a, 2007b). We agree with Bollestorf who, drawing upon Viveiros de Castro, sees the 'derealization' of the digital in the similar light of the 'derealization' of native ontologies brought about from some academic discourse (Bollestorf 2016, 397). As involved participants of this assemblage making, in participation with a wide range of other actants, including the Tejon Indian tribe, we suspect that the actualizing power of such Virtual Realities will enact the capacities of Indigenous ontologies in ongoing processes of emergence.

Post-script

As we write this in mid-May of 2020, the world is in the grip of the Covid-19 pandemic. Living in lockdown, the site of Pleito is completely inaccessible now. The PleitoVR remains fully operational. The coronavirus has destabilized global institutions, making most museums, archaeological sites, and other places of cultural importance largely inaccessible. This has created a much greater demand for virtual access to sites now out of bounds to the public. As one newspaper put it, a kind of Virtual renaissance is taking place (www.theguardian. com/culture/2020/apr/08/art-virtual-reality-coronavirus-vr). As of this moment of writing, there are extreme uncertainties with coming out of the

'lockdown.' Covid-19 has created a polyvalent situation as we draw upon existing resources to create new combinations to deal with social distancing needs. While we don't yet understand the characteristics of, or know how prolonged this new assemblage will be, it seems that the ideas we have been exploring here are prescient and worthy of ongoing discourse.

Note

1 The authors wish to thank the Tejon Tribe, including Sandra Hernandez and Colin Rambo for their involvement and support of this research. Special thanks to Jake Hernandez for allowing permission for us to record his singing in Pleito Cave. We also thank Landen Peppel, Mellisa Dambulamanzi, and all the staff at the Wind Wolves Preserve for their permission and support for this work. Thanks to Julie Bernard, Dan McArthur, Gloria Brown, Joshua Roth, Allison Hill, Jon Piccioulo, and the entire field work team. Funding for this project was provided by the University of Central Lancashire and the Arts and Humanities Research Council (AHRC) 'Unravelling the Gordian Knot: Integrating Advanced Portable Technologies into the Analysis of Rock-Art Superimposition' (Project reference AH/M008894/1). Thanks to project team members Jenn Perry, Matthew Baker, Eleni Kotoula, Rick Bury, and Antoinette Padget. Finally, my heartfelt thanks to Oscar Moro Abadía and Martin Porr for inviting us to contribute and for their apparently limitless patience!

References cited

2Bears, Jackson. 2013. "A conversation with spirits inside the simulation of a Coast Salish Longhouse." In *Critical Digital Studies, a Reader*, edited by Arthur Kroker and Marilouise Kroker, 144–161. Toronto: University of Toronto Press.

Bedford Clare, David W. Robinson, and Devlin Gandy. 2018. "Emigdiano blues: The California Indigenous pigment palette and an in situ analysis of an exotic colour." *Open Archaeology 4*: 152–172.

Bedford, Clare, David W. Robinson, Fraser Sturt, and Julienne Bernard. 2014. "Making paintings in South Central California: A qualitative methodology for differentiating between *in situ* red rock art pigments using portable XRF." *Society for California Archaeology Proceedings 28*: 286–296.

Bedford, Clare, David W. Robinson, Jennifer E. Perry, Matthew J. Baker, James Miles, Eleni Kotoula, Devlin Gandy, and Julienne Bernard. 2016. "Unravelling the Gordian Knot: Combining technologies to analyse rock art in Pleito Cave." *Society for California Archaeology Proceedings 30*: 183–195.

Bennett, Jane. 2010. *Vibrant Matter: A Political Ecology of Things*. Durham: Duke University Press.

Boellstorff, T. 2016. "For whom the ontology turns: theorizing the digital real." *Current Anthropology 57*(4): 387–407.

Blackburn, Thomas. 1975. *December's Child: A Book of Chumash Oral Narratives*. Berkeley: University of California Press.

Boellstorff, T. 2016. "For whom the ontology turns: Theorizing the digital real." *Current Anthropology 57* (4): 387–407.

Cassidy, Brendan, Gavin Sim, David Wayne Robinson, and Devlin Gandy. 2018. "A virtual reality platform for analyzing remote archaeological sites." *Proceedings of the 32nd International BCS Human Computer Interaction Conference (HCI 2018)*: 1–5.

Cassidy, Brendan, Gavin Sim, David Wayne Robinson, and Devlin Gandy. 2019. "A virtual reality platform for analyzing remote archaeological sites." *Interacting with Computers 31* (2): 167–176.

Chippindale, Christopher, and George Nash. 2004. "Pictures in place: Approaches to the figured landscapes of rock-art." In *The Figured Landscapes of Rock-Art: Looking at Pictures in Place*, edited by George Nash and Christopher Chippindale, 1–36. Cambridge: Cambridge University Press.

Cripps, Paul, Anne Greenhalgh, Dave Fellows, Keith May, David Robinson. 2004. *Ontological Modelling of the Work of the Centre for Archaeology*. CIDOC CRM technical paper.

Dechausay, Lucius. 2018. "Imagine if Toronto had been reclaimed by nature. This Indigenous futurism project takes you there." *CBC Arts*. www.cbc.ca/arts/exhibitionists/imagine-if-toronto-were-reclaimed-by-nature-this-indigenous-futurism-vr-experience-takes-you-there-1.4828320.

DeLanda, Manuel. 2005. "Space: Extensive and intensive, actual and virtual." In *Deleuze and Space*, edited by Ian Buchanan and Gregg Lambert, 80–88. Toronto: University of Toronto Press.

DeLanda, Manuel. 2006. *A New Philosophy of Society: Assemblage Theory and Social Complexity*. London: Bloomsbury.

DeLanda, Manuel. 2011. *Philosophy and Simulation: The Emergence of Synthetic Reason*. London: Bloomsbury.

DeLanda, Manuel. 2012. "Emergence, causality and realism." *Architectural Theory Review 17* (1): 3–16.

DeLanda, Manuel. 2016. *Assemblage Theory*. Edinburgh: Edinburgh University Press.

Deleuze, Gilles. 1988. *Spinoza, Practical Philosophy*. San Francisco: City Lights Books.

Deleuze, Gilles. 1993. *The Fold: Leibniz and the Baroque*. Minneapolis: University of Minnesota Press.

Deleuze, Gilles, and Félix Guattari. 1987. *A Thousand Plateaus. Capitalism and Schizophrenia*. Translated by B. Massumi. Minneapolis: University of Minnesota Press.

Deloria Jr., Vine. 1970. *We Talk, You Listen: New Tribes, New Turf*. New York: Macmillan.

Descola, Philippe. 2013. *Beyond Nature and Culture*. Chicago: The University of Chicago Press.

Gaertner, David. 2015. "Indigenous in cyberspace: CyberPowWow, God's Lake Narrows, and the contours of online Indigenous territory." *American Indian Culture and Research Journal 39* (4): 55–78.

Gard, Stephan, and Salvadore Bucolo. 2005. "Capturing Australian indegenous perception of the landscape: Virtual environments with cultural meanings." *VSSM 2005: Proceedings of the Eleventh International Conference on Virtual Systems and Multimedia: Virtual Reality at Work in the 21st Century: Impact on Society*: 3–7.

Johnson, John. 2008a. "Abstract machines and new social spaces: The virtual reality novel and the dynamic of the virtual." *Information, Communication Society 11* (6): 749–764.

Johnson, John. 2008b. *Allure of Machinic Life: Cybernetics, Artificial Life, and the New AI*. London: MIT Press.

King, Sarah. 2017. "In/consequential relationships: Refusing colonial ethics of engagement in Yuxweluptun's inherent rights, vision rights." *BC Studies 193*: 187–192.

Kotoula, Eleni, David W. Robinson, and Clare Bedford. 2018. "Interactive relighting, digital image enhancement and inclusive diagrammatic representations for the analysis

of rock art superimposition: The main Pleito Cave (CA, USA)." *Journal of Archaeological Science 93*: 26–41.

Latour, Bruno. 1993. *We Have Never Been Modern*. Cambridge: Harvard University Press.

Latour, Bruno 2009. "Perspectivism: 'type' or 'bomb'?" *Anthropology Today 25* (2): 1–2.

Latour, Bruno. 2010. "Coming out as a philosopher." *Studies of Social Science 40* (4): 599–608.

McArthur, Dan S., and David W. Robinson, 2016, "'Getting caned?' Assemblage theory and the analysis of cane material from California." *Society for California Archaeology Proceedings 30*: 196–223.

Reid, Genevieve, and Renee Sieber. 2019. "Do geospatial ontologies perpetuate indigenous assimilation?" *Progress in Human Geography 44* (2): 1–19.

Robinson, David W. 2004. "The mirror of the sun: Surface, mineral applications, and interface in California rock art." In *Soils, Stones and Symbols: Archaeological and Anthropological Perspectives on the Mineral World*, edited by Nicole Boivin and Mary Ann Owoc, 91–106. London: University College London Press.

Robinson, David W. 2007. "Taking the bight out of complexity: Elaborating South-Central Californian interior landscapes." In *Socialising Complexity: Structure, Integration, and Power*, edited by Sheila Kohrning and Stephanie Wynne-Jones. Oxford: Oxbow.

Robinson, David W. 2010. "Land use, land ideology: An integrated geographic information systems analysis of the Emigdiano Chumash rock-art, South-Central California." *American Antiquity 74* (4): 792–818.

Robinson, David W. 2013a. "Polyvalent metaphors in South-Central Californian missionary processes." *American Antiquity 78* (2): 302–321.

Robinson, David W. 2013b. "Drawing upon the past: Temporal ontology and mythological ideology in South-Central Californian rock-art." *Cambridge Archaeological Journal 23* (3): 373–394.

Robinson, David W. 2013c. "Transmorphic being, corresponding affect: Ontology and rock-art in South-Central California." In *Archaeology After Interpretation: Returning Materials to Archaeological Theory*, edited by Benjamin Alberti, Andrew Jones, and Joshua Pollard, 59–78. Walnut Creek: Left Coast Press.

Robinson, David W. 2017. "Assemblage theory and the capacity to value: An archaeological approach from Cache Cave, California, USA." *Cambridge Archaeological Journal 27* (1): 155–168.

Robinson, David W., Matthew J. Baker, Clare Bedford, Jennifer Perry, Michelle Wienhold, Julienne Bernard, Dan Reeves, Eleni Kotoula, Devlin Gandy, and James Miles. 2016. "Methodological considerations of integrating portable digital technologies in the analysis and management of complex superimposed Californian pictographs: From spectroscopy and spectral imaging to 3-D scanning." *Digital Applications in Archaeology and Cultural Heritage 2* (23): 166–180.

Robinson, David W., and Michelle Wienhold. 2016. "Household networks and emergent territory: A GIS study of Chumash households, villages, and rock-art in South-Central California." *World Archaeology 48* (3): 363–380.

Todd, Loretta. 1996. "Aboriginal narratives in cyberspace." In *Immersed in Technology: Art and Virtual Environments*, edited by Mary Anne Moser and Douglas Macleod, 179–194. Cambridge: MIT Press.

Todd, Zoe. 2016. "An indigenous feminist's take on the ontological turn: 'Ontology' is just another word for colonialism." *Journal of Historical Sociology 29* (1): 4–22.

Viveiros de Castro, Eduardo. 1998. "Cosmological deixis and Amerindian perspectivism." *Journal of the Royal Anthropological Institute 4* (3): 469–488.

Viveiros de Castro, Eduardo. 2003. "(Anthropology) and (science)." *Manchester papers in Social Anthropology 7.* http://nansi.abaetenet.net/abaetextos/anthropology-and-science-e-viveiros-de-castro.

Viveiros de Castro, Eduardo. 2004a. "Perspectival anthropology and the method of controlled equivocation." *Tipiti: Journal of the Society for the Anthropology of Lowland South America 2* (1): 3–20.

Viveiros de Castro, Eduardo. 2004b. "Exchanging perspectives: The transformation of objects into subjects in Amerindian ontologies." *Common Knowledge 10* (3): 463–484.

Viveiros de Castro, Eduardo. 2012. *Cosmological Perspectivism in Amazonia and Elsewhere. HAU Masterclass Series*, Volume 1. Manchester: HaU Journal of Ethnographic Theory.

Wellen, Christopher C., and Renee E. Sieber. 2013. "Toward an inclusive semantic interoperability: The case of Cree hydrographic features." *International Journal of Geographical Information Sciences 27* (1): 168–191.

Wienhold, M., and David W. Robinson. 2017. "Geographic information systems and rock art." In *Oxford Handbook of the Archaeology and Anthropology of Rock Art*, edited by Bruno David and Ian McNiven, 787–810. Oxford: Oxford University Press.

Wright, Rewa. 2014. "From the bleeding edge of the network: Augmented reality and the 'software assemblage'." *Postscreen Conference and Festival 2014: Device, Medium, Concept*: 42–50.

Wyeld, Theodor G., and Malcolm Pumpa. 2007. "Narratological constructs in the Gestalt of the 3D game environment: Aboriginal knowledge and its connection to the data landscape metaphor." *11th International Conference information Visualization (IV '07)*: 397–401.

Wyeld, Theodor G., Joti Carroll, Craig Gibbons, Brendan Ledwich, Brett Leavy, James Hills, and Michael Docherty. 2007a. "Doing cultural heritage using the Torque game engine: Supporting indigenous storytelling in a 3D virtual environment." *International Journal of Architectural Computing 2* (5): 417–435.

Wyeld, Theodor G., Brett Leavy, Joti Carroll, Craig Gibbons, Brendan Ledwich, and James Hills. 2007b. "The ethics of indigenous storytelling: Using the Torque game engine to support Australian Aboriginal cultural heritage." *Situated Play, Proceedings of the DiGRA 2007 Conference*: 261–268.

Index

Note: *Italicized* page numbers refer to figures, **bold** page numbers refer to tables

Hoffmann, D. 103
Hoffmann, H. 35
Holbraad, M. 18
Homer 43
hominins 98
Homo erectus 98
Homo ergaster 98
Homo habilis 98
Homo post-néanderthalensis 95
Homo sapiens 91, 92, 94, 105
Hope, J. 140
Hopis 7, 397, 405
horns 403
horses 406–7, *407*
How We Became Post Human (Hayle) 417
Howell, F. 98
Howitt, A. 149, 151
Hueco Tanks rock art 402–3, *403*
Huichoi 245, 253, 258
human chauvinism 283
Hume, D. 43
hunter-gatherers 49–52, 58–9, 62, 78, 154, 200, 201–2, 223, *224*, 225, 233–4, 238, 240, 245, 249, 250, 259, 273, 294, 296–7, 320, 327, 328, 332, 395, 404, 406; *see also* agriculturalists/agricultural/agrarian rock art
hunters 327–8
hunting marks 95
hunting with stories 165
Huron people 379
hybridity 358, 360
hylomorphic habit 167
hyperobjects 37–41
hyper-time 46

iconography 3
images and image making: in Canadian rock art 274–5; defined 264; incarnated 253–9; in Neolithic Britain and Ireland 52–5; ontological flux in 239–40; ontology of 49–62, 75–6; relational ecology of 50–2; in southern Scandinavian late Neolithic and Bronze age 55–8
Images in the Making (Back Danielsson) 51
inamic 254
index objects 167
Indian Sora 328
Indigenous peoples: art 12; arts 13, 15, 21; Christian influences 386, 400; collaboration with archaeologists 13, 18; contact period rock art 357, 374;

contact rock art 357; epistemologies 168–9; intermarriage with Spanish settlers 361; and New Animism 417; otherness 24; relational knowledge practices 161; relational ontologies of 265–71, 359; religion 286; rock art 74, 129, 276; worldviews 358
Ingold, T. 18, 60, 167, 182, 183–4, 189, 276
Inherent Rights, Vision Rights (IRVR) 417
Injalak Hill 206, *207*, *208*
Inkan rock art 59
Innu 162, 265
interior handheld photogrammetry 345
Interior Salish (Nlaka'pamux) 265
intermarriage 361
interpretive archaeology 3
Iron Age 92
Islam 79

Jackson, L. 418
Jawosyn site 349
Jelderks, J. 16
jidalbirringki 123
Jochim, M. 326, 330
Johnson, J. 414
Jones, A. 3, 19, 20, 69, 72, 77–8, 264, 285, 319, 320, 321, 324, 362
Jornada people 395
Ju|'hoansi 237–8, 240
Judaism 79
Jumano people 395
jungkayi 119, 120, 131n4

kachinas 397, 406
Kaggen 233–4
kagwet 376, 379
kajaja 132n4
Kalahari 225
Kalm, P. 379
Kamandarringabaya 121, 124
kanku 132n4
Kanozero rock art 330
Kant, I. 36–7, 39–40, 50
Karoo 225
Katsina Friends 7
Kauder, C. 377
Kearney, A. 121
Keegan, P. 341
Keith, A. 93–4
Kennewick Man 16
Kenniff Cave 136
Kerpel, D.M. 254, 256